CAMBRIDGE CLASSICAL STUDIES

General Editors: W. K. C. GUTHRIE, A. H. M. JONES, D. L. PAGE

MINOAN STONE VASES

MINOAN
STONE VASES

PETER WARREN

Research Fellow in Arts
Durham University

CAMBRIDGE
AT THE UNIVERSITY PRESS
1969

Published by the Syndics of the Cambridge University Press
Bentley House, 200 Euston Road, London N.W.1
American Branch: 32 East 57th Street, New York, N.Y.10022

© Faculty of Classics, University of Cambridge 1969

Library of Congress Catalogue Card Number: 69-13794

Standard Book Number: 521 07371 5

Printed in Great Britain
at the University Printing House, Cambridge
(Brooke Crutchley, University Printer)

To Elizabeth

CONTENTS

CONTENTS

ILLUSTRATIONS

TABLES

ACKNOWLEDGEMENTS

It is with great pleasure that I am here able to thank the many archaeologists and scholars who have helped me in a variety of ways.

I owe a particular debt of gratitude to Mr Sinclair Hood who has encouraged, helped and taught me much and has at all times put at my immediate disposal the benefits of his own knowledge and experience.

The following museum Directors and officials have generously made available material under their care: above all Dr Stylianos Alexiou and his staff in Herakleion who, during the many months I was working there, gave me complete access to all parts of the museum and always responded to my frequent calls upon their time; Dr R. Higgins of the British Museum; Mr R. W. Hamilton, Dr H. Catling, Mrs Brown and Mrs Payne at the Ashmolean Museum; Mr B. Cook of the Metropolitan Museum and Dr E. Kohler in Pennsylvania; Dr Kohler most generously sent drawings of all the Minoan vases under her care; Mrs N. Leipen in Toronto; Mr H. Smith, Reader in Egyptology at London University; Mrs B. Philippaki, Mrs. A. Xenaki-Sakellariou and the authorities of the National Museum at Athens; Messrs J. Betts and J. R. Green, who provided information about the material in New Zealand; Dr A. Khasab of the Greek and Roman Department of the Egyptian Museum, Cairo.

For generous permission to make full use of unpublished material from their excavations I am greatly indebted to Dr Alexiou, for Katsamba and Lebena; Professor J. L. Caskey, for the Kea material; Mr Hood and the Managing Committee of the British School at Athens, for the Knossos material; Professor G. Huxley and Mr N. Coldstream, for Kythera; Professor D. Levi, who twice gave Rhadamanthine hospitality at Phaistos, for Phaistos and Kamilari; Professor N. Platon, who allowed me to study the material from Galana Kharakia, Mirsine, Platanos and other sites, and also the outstanding treasures from his Zakro excavations; Mr M. Popham and Mr H. Sackett and the Committee of the British School, for Palaikastro; and the Committee for permission to use the Notebooks of the original Palaikastro excavations; Mr J. Sakellarakis, for Arkhanes; Mr J. Tzedhakis, for Khania; and Lord William Taylour, for the material from his Mycenae excavations. Miss E. Waszink kindly provided the information about the vases in Leiden.

Dr S. R. Nockolds, F.R.S., and Dr M. Black in Cambridge had petrological and mineralogical specimens sectioned for me and also provided generously of their

time to discuss identifications. Professor J. Papastamatiou, Director of the Institute for Geology and Subsurface Research, in Athens, and Mr Ellis of the British Museum, Natural History, also kindly analysed specimens and Drs D. Smith, K. Bowen and B. Butler in Oxford undertook the analysis of the emery samples. In Crete Mr M. Dialinas has often provided valuable information on the island's rocks and minerals.

For the original printing of most of the photographs I am grateful to Mr G. Xylouris of Herakleion.

Much profit has been derived from discussion with a number of friends. In particular Dr Colin Renfrew and Dr Keith Branigan have always been most ready to talk informatively with me about Aegean matters. Other friends have generously discussed aspects of Aegean and Egyptian prehistory: Dr Alexiou, Mr J. Betts, Mr J. Boardman, Dr J. Bouzek, Messrs G. Cadogan, M. Cameron, N. Coldstream, K. Davaras, Dr R. Higgins, Mrs H. Hughes-Brock, Mr R. W. Hutchinson, Dr V. E. G. Kenna, Professor D. Levi, Messrs G. Martin, M. Popham, J. Reich, H. Sackett, J. Sakellarakis, Dr F. H. Stubbings, who, with Mr Hood, has been my teacher in Aegean prehistory, and Mr J. Tzedhakis. I am also indebted to a group of friends from Newnham College, Cambridge, especially Miss B. S. Crisp, and to Miss H. Gebbett for help in preparation of the illustrations and typescript.

Figure 7 is reproduced from *Archaic Egypt* by W. B. Emery by permission of the publishers, Penguin Books Ltd.

I also thank the Faculty Board of Classics of Cambridge University and in particular Professor Denys Page, for generously agreeing to publish the book in this series; Corpus Christi College, Cambridge, for a research Fellowship which enabled the latter part of the work to be carried out; and the British School at Athens, so frequently a home from home.

For the production of this book I am very much indebted to the staff and officers of the University Press.

Finally I thank my wife for her constant advice, help and encouragement.

P.W.

ABBREVIATIONS
PUBLICATIONS

AA	*Archäologischer Anzeiger.*
AJA	*American Journal of Archaeology.*
Annuario	*Annuario della Reale Scuola archeologica di Atene.*
Arch. Delt.	Ἀρχαιολογικὸν Δελτίον.
Arch. Reps.	*Archaeological Reports*, British School at Athens.
Ath. Mitt.	*Mitteilungen des deutschen archäologischen Instituts. Athenische Abteilung.*
BCH	*Bulletin de Correspondance Hellénique.*
BM *Guide* (1922)	British Museum. A *Guide* to the Fourth, Fifth and Sixth Egyptian Rooms and the Coptic Room. 1922.
Boll. d'Arte	*Bollettino d'Arte.*
BSA	*Annual of the British School at Athens.*
Eph. Arch.	Ἐφημερὶς Ἀρχαιολογική.
Ἔργον	Τὸ Ἔργον τῆς Ἀρχαιολογικῆς Ἑταιρείας.
ILN	*The Illustrated London News.*
Jahrbuch	*Jahrbuch des deutschen archäologischen Instituts.*
JEA	*Journal of Egyptian Archaeology.*
JHS	*Journal of Hellenic Studies.*
Kr. Khron.	Κρητικὰ Χρονικά.
Mem. R. Inst. Lomb.	Memorie del Reale Istituto Lombardo.
Mon. Ant.	*Monumenti Antichi pubblicati per cura della R. Accademia dei Lincei.*
Penn. Anth. Publ.	*University of Pennsylvania, The Museum, Anthropological Publications.*
PM	Sir. A. Evans, *The Palace of Minos at Knossos*, I–IV (1921–35). London.
PPS	*Proceedings of the Prehistoric Society.*
Praktika	Πρακτικὰ τῆς Ἀρχαιολογικῆς Ἑταιρείας.
Rendiconti	*Rendiconti della R. Accademia dei Lincei.*
Transactions Pennsylvania	*Transactions of the Department of Archaeology of the University of Pennsylvania.*

xiii

Troy Blegen, C. W., Boulter, C. G., Caskey, J. L., Rawson, M. & Sperling, J. *Troy. Excavations conducted by the University of Cincinnati, 1932–8*, I–IV (1950–8). Princeton.

MUSEUMS

Several museums are written thus: Khania M., for Khania Museum, Crete. Other abbreviations are as follows:

AM	Ashmolean Museum, Oxford.
A. Nik. M.	Aghios Nikolaos Museum, Crete.
BM	British Museum, London.
CAIRO	The Egyptian Museum, Cairo.
FM	Fitzwilliam Museum, Cambridge.
HM	The Archaeological Museum, Herakleion, Crete.
K	Apotheke of the American Excavations, Kea.
KSM	The Stratigraphical Museum, Knossos, Crete.
LEIDEN	Rijksmuseum der Oudheden, Leiden.
MET. MUS.	The Metropolitan Museum of Art, New York.
NM	The National Archaeological Museum, Athens.
OTAGO	The University of Otago Museum, New Zealand.
Penn.	The University of Pennsylvania Museum.
Phaistos Strat. Mus.	The Stratigraphical Museum, Phaistos, Crete.
PIG.M.	Museo Preistorico Pigorini, Rome.
TORONTO	The Royal Ontario Museum, Toronto.
UC	The Flinders Petrie Collection, University College, London.

I

INTRODUCTION AND CHRONOLOGY

The study of the prehistory of Crete began about seventy-five years ago with the exploratory journeys of Evans, Halbherr, Taramelli and others. Shortly afterwards, in the first decade of this century, came most of the great excavations which revealed the Minoan civilisation. Since then discoveries have continued, if not at so great a pace, yet with results hardly less spectacular. In the last twenty years we have witnessed the splendid discoveries in the Middle Minoan levels at Phaistos, the uncovering of a notable series of houses at Mallia, the Palace of Zakro, the five Early Minoan tholos tombs at Lebena, of singular importance for the development of the Early Bronze Age in Crete. In addition large deposits of pottery, covering almost all periods of the Bronze Age, have been found in stratigraphic excavations at Knossos; the Neolithic mound under the Palace has also been extensively explored. At Arkhanes, south of Knossos, a richly productive cemetery, again covering almost all Minoan periods, is currently being investigated. These are but some of the major discoveries. A great number of other excavations, especially of tombs and cemeteries, has also taken place. One result of all this work has been the production of a very great amount of material. Individual excavations and their publication will continue to enrich our knowledge of particular sites in particular periods, but for an understanding of the civilisation as a whole we cannot hope to have elicited the maximum information from the discoveries until we can examine in detail the history and development of the various classes of material. The present work is an attempt to examine one such class. With a few exceptions the stone vases have been studied *in corpore* by the writer. This was the more necessary since much of the material has not previously been published or has not been fully published. That the subject merits study is suggested by the quality and amount of material, about 3500 vases, their long period of use in Crete, from about 2600 B.C. to 1100 B.C., and their importance, as exports, for Minoan foreign relations.

A main consideration has been to try to make the book readily usable, both for material found to date and for future finds. To enable readers to track down published vases a distribution table of types by sites is given, as is a concordance of museum numbers and types. The substantial number of drawings and photographs should help in this and, it is hoped, may also be of use for placing future finds. A

list of datable stone vase sites in Crete is included to facilitate reference. The names given to the types are intended as the simplest possible; many are already established, like alabastron, chalice or rhyton; others are simply descriptive, like jars with incurved or flaring sides, or teapots. Egyptian and Syro-Palestinian vessels exported to Crete have been included. They are part of the corpus of prehistoric stone vases in the island and are of particular interest for the light they throw on Minoan trade, foreign connexions and chronology.

All measurements are in centimetres: e.g. 5.65 = 5·65 cm.

CHRONOLOGY

Table 1 indicates the dates and periods used in the book. Several points require comment:

(A) The evidence for a long Early Bronze Age is of three kinds, none entirely satisfactory, but persuasive when taken together since each is independent of the others. (1) Predynastic–VIth Dynasty Egyptian vases in Crete, see type 43. (2) Many links between Early Minoan I and Troy I and contemporary or earlier N.W. Anatolian sites (see Warren 1965 b, forthcoming); the beginning of Troy I cannot be much, if at all, later than 2800 B.C. since Troy I is approximately contemporary with Karanovo VII in Bulgaria (Georgiev 1961, 88, 94 and Colour Chart) and the Karanovo VI culture ends by or before 3000 B.C. on the evidence of a substantial series of radiocarbon dates (Kohl & Quitta 1966). (3) Radiocarbon dates from Eutresis and Lerna, even when taken at their face value (which is probably far too low), demonstrate a beginning for Early Helladic II not long after 2400 B.C. and for points in EH I before 2600 B.C. (cf. Weinberg 1965, 311). EH II has many connexions with Early Cycladic II (Weinberg op. cit. 302–4. Caskey 1964 a, 13, 19, 21, 27–8) which in its turn has links with Early Minoan II (see type 33 and pp. 182–3. Renfrew 1964, 120–5).

(B) Early Minoan III (mainly the white on dark style of East Crete) is largely but not entirely contemporary with MM IA in the rest of Crete. It is not entirely contemporary because an EM III horizon exists before MM I at Knossos at least (Hood 1966, *Bulletin of the Institute of Classical Studies*, 13 110).

(C) MM II is a distinct period at Knossos and Phaistos (and the Kamares Cave). Elsewhere in the island MM I A–B pottery types continued in use.

(D) A major destruction overtook the island in LM I B, *c.* 1450 B.C. A little later came the final destruction of Knossos, by which time, *c.* 1400–1380 B.C., other sites had been reoccupied. See p. 187.

TABLE I. CHRONOLOGICAL TABLE

B.C.		
	Neolithic	
3000		
	Early Minoan I	
Beginning of stone vase making → 2600		
	Early Minoan II	
2200	Early Minoan III (Centre)	
	(Centre)	(East)
2000		(East)
	Middle Minoan I A	← First palaces built
	Middle Minoan I B	
1700	MM II (palaces)	← Destruction of first palaces
	Middle Minoan III	
1550		
	Late Minoan I A B	Major destruction of all sites (Santorini explosion)
1450		
End of stone vase making → 1400	Late Minoan II-III A 1	Final destruction of palace of Knossos
	Late Minoan III A 2	
1300		Post-Palatial Age
	Late Minoan III B	
1200		Destructions and abandonments
	Late Minoan III C	
1100		

3

II

TYPES

The types are arranged alphabetically. Each type has first a discussion, then a catalogue which is either complete or, if the number of vases in the type is large, representative. Vases from Cretan sites are listed first, then Minoan vases from mainland sites. In the discussion of each type the shape and any varieties of it are analysed, the distribution and materials noted and the dating of the type assigned. In the catalogue an asterisk means the vase is unpublished, though in some cases it has been mentioned in publications; N.F.C. means that there is no recorded or published find context; **D** followed by a number, e.g. **D 181**, refers to the drawing of the vase and **P** with a number, e.g. **P 204**, to the photograph in the plates. Vases are listed by their museum numbers, e.g. HM 2641 is Herakleion Museum Stone Catalogue 2641. For museum abbreviations see p. xiv.

In the catalogues dates are not given unless they are of special interest. Where they are given *they always refer to the context in which the vase was found*. This may differ from the date of manufacture or *floruit* of the type, assigned in the discussion. As a check on the dates of a site reference may be made to the dated site list on pp. 193. EM, MM, LM stand for Early Minoan, Middle Minoan and Late Minoan.

The table at the end of the chapter records the distribution and numbers of the vases by sites and types.

1. ALABASTRONS

A. A small low-bellied pot with moulded rim and base, often with diagonal and horizontal grooves, sometimes with circular holes for inlay

An EM III–MM I type coming almost exclusively from the Mesara, with four from Mallia. Two were exported to Samos, one to Euboea and one to Gezer in Palestine. There are a few survivals in LM contexts at Elounda, Khania, Palaikastro and one in a Hellenistic–Roman context at Knossos. The materials are varied: breccia, chlorite, limestone of several kinds including dolomitic, and marble.

There is an Egyptian XIIth Dynasty example of exactly this form (Petrie 1937, pl. XXIX 605) but the type does not seem common there and influence one way or the other is not certain. It may just be that the form was copied from Crete in view of its popularity in the island at precisely this time.

4

A. Triadha HM 373*. Dolomitic limestone (or marble), white with thick grey/black band. Large Tholos. **P 1.**

Elounda Neapolis M.9. Dolomitic marble, grey and white mottled. (Van Effenterre 1948, 58 O 115.)

Gournia HM 309. Chlorite. N.F.C. (Boyd Hawes 1908, pl. V 21.)

HM 554. Conglomerate, creamy white filled with grey/black pebbles. House Tomb. MM I. (Boyd 1905, 188 and fig. 6 II*b*.) **P 2.**

Kalyviane HM 2173*. Breccia, brick red matrix with black, white and grey pieces. Band of incised chevrons. N.F.C. **P 3.**

Khania Khania M. Λ 1019. Dolomitic limestone. No rim; horizontal grooves all over. LM III B tomb. (Jantzen 1951, 76.)

Knossos KSM (RR/61/211)*. Chlorite with serpentine. No rim; incised band with vertical bars round body; three circular holes for inlay. Hellenistic–Roman (JK Ext. 5).

Koumasa HM 712. Serpentine. Tholos B. (Xanthoudides 1924, pl. XXIII.)

HM 716. Breccia, white matrix, purple, brown and green/black pieces. Tholos B. (*Ibid.* pl. XXIII.) **P 4.**

Mallia HM 2217. Dolomitic marble, grey and white mottled. Nécropoles des Pierres Meulières, Chambre II. MM I. (H. & M. Van Effenterre 1963, pl. XXXIV.) **D 1.**

HM 2218. Breccia, grey matrix with green, green/black and maroon pieces. As last. (*Ibid.* pl. XXXIV.) **D 2. P 5.**

Palaikastro HM 910. Dolomitic limestone, grey and white. Block X hoard. LM I B. (Dawkins 1923, pl. XXX B 2.) **P 6.**

Platanos HM 1682. Chlorite. Incised triangles with horizontal bars and circular inlay holes. (Xanthoudides 1924, pl. LIII*a*.)

HM 1683. Chlorite. Inverted triangles with horizontal bars, circular inlay holes with white limestone quatrefoil inlays. (*Ibid.* pl. LIII*a*.) **P 7.**

HM 1684*. Chlorite. Incised triangles with horizontal bars above a band of criss-cross incised decoration. **P 8.**

HM 1689. Breccia, black matrix with brick red pieces outlined by white veins. Horizontal grooves round upper part and criss-cross decoration on belly. (*Ibid.* pl. XII.) **D 3. P 9.** All Tholos A annexes.

Porti HM 2088. Chlorite. Incised triangles with horizontal bars and four circular inlay holes. (*Ibid.* pl. XXXIX*a*.) **D 4. P 10.**

Gezer Istanbul M. 2496*. Serpentine, green with light patches. N.F.C. (Macalister's excavations, 1908.)

Oxylithos Euboea Khalkis M. 401 G. Breccia? (called 'red porphyry, containing white hornblende'). Apparently from Oxylithos Tholos tomb, i.e. a survival to LH III. (Hankey 1952, 95, fig. 10.)

Samos Breccia, black pieces in lighter matrix. Tigani. Neolithic–Bronze Age deposit. (Heidenreich 1935–6, 169–70 and pl. 54 I.) Another, serpentine. Fragment. (*Ibid.* 170.)

21 plus 25 others. **Total 46**

B. Large. A group with wide flat rims often decorated with linked spirals in relief; three figure-eight shield handles on the shoulder

There are seven in white gypsum from the Throne Room at Knossos, two from Mycenae, and one in serpentine from Sellopoulo (Knossos) Tomb II (LM III A 2–B). The use of gypsum for stone vases occurs almost exclusively in LM II/III A (Warren 1967*b*), with a few vases from LM III B contexts which are almost certainly survivals. Because of the considerable group of gypsum vases in Crete (*ibid.*) and the exact parallels for the Mycenae alabastrons at Knossos the two from the mainland can

safely be considered imports from Crete. The type is however of further interest for the relations between Crete and Mycenae in LM II–IIIA I.

The Throne Room vases have a type of spiraliform decoration on their wide rims which is purely Mycenaean in character (see the photographs). It is done in shallow relief with a solid circle at the centre of the spirals. The workmanship is very careful, almost mechanical. This decoration is exactly parallelled on the Mainland from LH IIA onwards (cf. the ivory pyxis from the Routsi/Pylos tholos, Marinatos & Hirmer 1960, pl. 225 left, and the carving on the Treasuries of Atreus and of Minyas, *ibid.* pl. 149 top right and below, and pl. 161). This type of shallow relief spiral carving, found again at Knossos on the stone friezes from the palace destruction debris[1] and on the giant stone amphora which was being made at the time of the destruction, is otherwise unparalleled in Crete. This is an important confirmation of the Mycenaean character (Linear B, griffins round the throne, the formal Palace style) of the final years of the Palace. The shape of the alabastrons seems to copy that of the clay form popular at Mycenaean centres from LH II onwards but of which there is only one Cretan example before LM II/IIIA I (Deshayes & Dessenne 1959, 57, from Mallia House Zb; cf. Popham 1964a, 351–2 and n. 15).

Knossos Throne Room HM 882. Ht. 12.5. Diam. 49.0. (*PM*, IV, fig. 910 bottom.)
 HM 883. Ht. 13.5. Diam. 58.0. (*Ibid.* top left.)
 HM 884. Ht. 11.0. Diam. 46.2. (*Ibid.* top right.)
 HM 61*. Diam. 35.0.
 HM 62*.
 AM AE 767*. **P 11.**
 AM 1911.611*. **P 12.**

Sellopoulo HM unnumbered. Serpentine. (Hood, *Arch. Reps. for 1957*, 25 and pl. 2d.)
Mycenae NM 2769*. Ht. 12.0. Diam. 34.0. Decayed surface; no decoration on rim. Chamber Tombs, context not known.
 NM 3163. Ht. 12.0. Diam. 49.5. Decayed surface, no decoration on rim. Chamber Tomb 88, context not known. (Warren 1967a, Group A 2.)

For the lids of these alabastrons see type 27 II C.

Total 10

2. BASINS

A homogeneous group of very large open bowls, each having its own distinctive features. They were perhaps used for ritual lustrations.

The Mallia fragment is MM I–II, from the First Palace, and is comparable with the large serpentine bowls in vogue in that period (type 10 **B**). The other examples were found in LM IB (A. Triadha) and LM II–IIIA I (Knossos) contexts. The use of gypsum for one of the Knossos bowls is distinctive of vases of the end of the Palace

[1] Cf. exactly the frieze from the N.W. Palace angle at Knossos (*PM*, II, fig. 368) and a fragment from Mycenae (*B.S.A.* 1921–3, XXV, 236, fig. 47).

period at that site. The Mycenae basin could be Minoan or Mycenaean: all its parallels are in Crete and relief spirals are found on the large jar from Knossos (type 25). On the other hand spiraliform decoration is popular at Mycenae. The material, very possibly Antico Rosso, is used for Minoan lamps. The balance seems in favour of Crete.

Ht. pres. 6.6. Diam. 30.0 plus. Width of fragment 7.8. Serpentine. Rim fragment with everted rim and raised band below, with incised decoration below of diagonal grooves. Broken on three edges. Mallia Palace Room III 8, under floor of later Palace. MM I–II. HM unnumbered. (Chapouthier & Charbonneaux 1928, 16.)

Ht. 25.8. Diam. 59.0. Width across handles 76.7. Sandstone ?, grey/brown with tiny black particles. Carved spout with spiraliform or ivy pattern terminals. Two horizontal body handles. A. Triadha Palace, LM I B. HM 185. (Halbherr 1903, 15 and figs. 4–5.)

Ht. 26.7. Diam. 91.0. Limestone, purple/maroon with gritty inclusions (not 'purple gypsum' or 'porphyry'). Rolled rim; moulded base. Complete. Knossos, Corridor of Stone Basin. Now in Knossos, Antechamber of Throne Room. (Evans 1899–1900, 43, figs. 8–9. *PM*, III, 25 and fig. 13.)

Ht. pres. 11.75. Diam. 70.0. Gypsum, white (decayed). Lower part of body and base preserved. Knossos, Room of Spiral Cornice. *In situ*. (*PM*, III, 25 and plan, fig. 9.)

Ht. 15.3. Diam. 34.0. Serpentine. Open rim spout, two horizontal bow-shaped handles and a lug opposite the spout. For the shape cf. HM 2126, **P 169.** Complete though cracked and somewhat decayed. KSM (unprovenienced material)*. N.F.C. This may be the large basin from the basements beneath the presumed N.W. Corner Entrance of the Palace (*PM*, II, 599), which is not otherwise traceable. It would then have been amongst the Palace destruction debris.

Ht. 12.8. Diam. 55.0. Limestone, purple/maroon, fine grained with small white inclusions. About a third of rim restored. Carved with large linked spirals in relief round the outside and small ones round the rim. Slightly moulded base. Mycenae. Context not known. NM Mycenaean Room*.

Evans refers to another gypsum example, from the Room of the Lotus Lamp (*PM*, III, 25 and plan, fig. 9). This fourth Knossian basin is not traceable and may have rotted away. It is also possible that it never existed, for in the original report (1899–1900, 43–4) there is no mention of a basin from the Room of the Spiral Cornice, though that from the Lotus Lamp *is* described. Possibly then, there was *one* basin, moved from the Room of the Lotus Lamp to that of the Spiral Cornice after excavation. **Total 6 or 8**

3. BIRD'S NEST BOWLS

A plain bowl with rounded shoulder and smallish mouth, not unlike a bird's nest in shape. It sometimes has a small raised collar.

This is by far the commonest type of Minoan stone vase. There are about 500

examples (including those with raised collar), forming 14.5 per cent of the whole corpus. The distribution shows that this is predominantly a Mesara vase, since this area supplies over two-thirds of the total. Platanos alone produces nearly half. The bulk of these Mesara vases belong to MM I but some have incised decoration and are usually of chlorite, so manufacture probably began in EM III, *c.* 2200 B.C. (see below). Unfortunately, the fifty-nine from the three major E. Cretan sites, Gournia, Palaikastro and Pseira, are almost entirely unpublished, so that their find contexts are not known. This is all the more regrettable since the group forms over 10 per cent of the total and would have provided further information on the relations between E. Crete and the Mesara in EM III/MM I. One MM I example comes from Khania, one was exported to Kea (breccia, K 4.140) and one to Kythera (breccia, Excavation no. 432). After MM I/II the type is rare, except for a group of larger size, usually of serpentine, in LM I and later contexts (see below). Not unexpectedly, a few MM I examples continue in use and are found in later contexts.

Figures for the most frequent occurrences are shown in Table 2.

TABLE 2. TOTALS OF BIRD'S NEST BOWLS IN MAIN REGIONS AND SITES

Mesara

Platanos	204	Porti	2	
Koumasa	44	Voros	2	
Kamilari	33	A. Eirene	1	
Apesokari	14	Lebena	1	
A. Triadha Tholoi	8	Marathokephalon	1	
Khristos	3	Mesara	1	
Siva	3	Phaistos	9	
Dhrakones	2			
				328

Galana Kharakia	12

East Crete

Gournia	22	Mochlos	7	
Palaikastro	22	Zakro	2	
Pseira	16	Vasilike	1	
				70

Knossos	22
Mallia	13

The great majority have a height which is about half or somewhat under half the diameter. The low flat examples occur only in the Mesara (19 at Platanos, 2 others from the Mesara) and the higher forms, usually high-shouldered, are not characteristic of that region. The main features of the EM III–MM I/II vases are their small

size, under 5.0 high and 10.0 diameter, and the variety of materials they display including breccias, chlorite, dolomitic limestone or marble, limestones and serpentine. The fact that steatite is not used and that there is a variety of harder stones is an indication that Bird's Nest Bowls are later than the earliest stone types.

There is a small group of Bird's Nest Bowls from LM I contexts, of high and high-shouldered form, large in size (usually over 12.0 diameter) and made of serpentine. These vases are an undecorated form corresponding to the decorated serpentine Blossom Bowls and Grooved Bowls. Hence the group, from A. Triadha, Knossos, Mallia, Vathypetro and Zakro, is of MM III–LM I manufacture. Others which may also be of this date, and so are included in the list below, are from the Knossos Temple Tomb and from Tepheli. The matter is complicated by the question of survivals, for other Bird's Nest Bowls, usually of limestone or dolomitic limestone, from LM I–III contexts, probably date from MM I. Such are the vases from Arkhanes (HM 2902★. LM IB context, excavated 1964), Elounda (Neapolis M. 2★, 4, van Effenterre 1948, 57 and pl. XLVII O 113), where most of the other stone vases are survivals from MM I, Khania (Khania M. 1016. Jantzen 1951, 73), Palaikastro (Dawkins 1923, pl. XXX a 2, b 1, 3; Sackett, Popham & Warren 1965, 306–7, no. 55), Prasa House A (HM 2448. Platon 1951 b, 253, fig. 6 top row 2nd from right) and Vrokastro (Penn. MS 4544, 4754, Hall 1914, 114, Rooms 30 and 36, Geometric context).

The group of MM III–LM I date from LM I–III contexts is as follows:

A. Triadha 1: PIG. M. 71944. Palace. (Borda 1946, 72 no. 10 and pl. LI 10.)

Knossos, Hogarth's Houses, 2: KSM. (HH/58/18, HH/58/80.)

Knossos, Temple Tomb, 1: HM 2277. (*PM*, IV, 1006 and figs. 953 and 960 g.)

Mallia, Palace, 1: HM 2115. (Chapouthier & Joly 1936, 39 and pl. XX b; XXXIV a.)

Mallia, House Z b, 1: HM 2425. (Deshayes & Dessenne 1959, 64 and pl. XVII 4 left.)

Mallia, House E, 2: HM 2426. (*Ibid.* 134 and pl. XLVIII 8.) **D 12. P 28.**

HM 2427. (*Ibid.* 134 and pl. XLVIII 7.)

Tepheli 1: HM unnumbered★. (Mentioned Platon 1956, 416.)

Vathypetro 1: HM unnumbered★. (Mentioned Marinatos 1951, 261–2.)

Zakro (1962), Building B, Room O, 1: HM 2667★.

Zakro (1963), Building D, Area N, 1: HM 2754★.

Total 12

It is very probable that some of the unpublished vases from Gournia, Pseira and Palaikastro came from LM I contexts, whilst several of the dozen from Galana Kharakia are of high form, have high shoulders and are of dark serpentine. They suggest, as do other objects (Site List p. 194 n. 2), that this burial cave may have continued at least into MM III.

The development of the type may be summarised as follows. It begins soon after EM II with low flat examples of chlorite with incised decoration and circular

inlay holes (cf. types 1 **A** and 4). These decorated chlorite vases always have the interior drilled out with a simple hole ⌒ and drill rings are prominent. But the art of drilling and cutting was further developed and many bowls, probably all MM I, have a more elaborate, undercut interior ⌒. This feature is well shown on the MM I Platanos vases (**D 7, 11**). In MM I the type flourishes all over the island with all ranges of shape, though the vases are usually small (Xanthoudides 1924, pl. LII, 1808, 1809 are two notable exceptions, though they are fairly flat) and/or have the maximum diameter about half-way up. The materials are varied. The type continued to be made through MM III to LM I, when there are examples similar to the Blossom and Grooved Bowls. These vases are larger than the EM III–MM I forms. The LM III and later examples from Arkhanes, Elounda, Khania, Palaikastro, Prasa and Vrokastro are probably MM I survivals, those from the Knossos Temple Tomb and Tepheli LM I. Serpentine is regular for the post-MM I vases and these, like the Blossom and Grooved Bowls, always have a simple drilled-out interior.

Because the number is so large a catalogue is not given. The drawn examples are as follows (Platanos except HM 2426): HM 1772, **D 5**. HM 1823, **D 6**. HM 1739, **D 7**. HM 1801, **D 8**. HM 1917, **D 9**. HM 1787, **D 10**. HM 1733, **D 11**. HM 2426 (Mallia, Deshayes & Dessenne 1959, 134 and pl. XLVIII 8), **D 12**.

The photographs illustrate the range from the flattest to the highest varieties: HM 1849, Platanos, **P 13**. HM 1819, Platanos, **P 14**. HM 1834 (Xanthoudides 1924, pl. XI), Platanos, **P 15**. HM 1608 (Paribeni 1913, 17 no. 2), Siva, **P 16**. HM 1138, HM 1137 (Zervos 1956, pl. 148 centre and left), Pseira, **P 17**, **P 18**. HM 2268 (Marinatos 1930–1, 157–8, fig. 20 top row 3rd from right), Voros, **P 19**. HM 2269 (*ibid.* top row 3rd from left), Voros, **P 20**. HM 919, Palaikastro, **P 21**. HM 1256 (Seager 1912, fig. 32 XX 2), Mochlos Tomb XX, **P 22**. HM 1733, Platanos, **P 23**. HM 1135, Pseira, **P 24**. HM 1787, Platanos, **P 25**. HM 1143, Pseira, **P 26**. HM 2209 (H. & M. van Effenterre 1963, 63 and pl. XXV), Mallia, MM I ossuary on coast, **P 27**. HM 2426 (Deshayes & Dessenne 1959, 134 and pl. XLVIII 8), Mallia, House E, **P 28**.

Only a small number have ever been published. Apart from those cited above the main instances are:

Apesokari Schörngendorfer 1951, pl. 6 21–4.

Dhrakones Xanthoudides 1924, pl. XLIII (HM 1020 is from Tholos Δ but has the high form and size typical of LM examples. The adjacent Tholos Z was reused in LM III).

Galana Kharakia B.C.H. 1955, 303, fig. 18.

Kamilari Levi 1961–2, figs. 120–1.

Koumasa Xanthoudides 1924, pl. XXII.

Mochlos Seager 1912, fig. 46 (Tomb III, MM).

Palaikastro Bosanquet 1901–2a, pl. XVII. Dawkins 1923, pl. XXX A 2, B I, B 3, MM I survivals in LM I context.

Platanos Xanthoudides 1924, pls. XI–XII.

Porti Ibid. pl. XXXIX a. **Total 478**

In addition to the regular type there is a much smaller class which has a small raised collar and usually a small moulded base. Half the examples are from the Mesara and all are probably MM I since they are small, of varied materials and in MM I or mixed contexts, with five late survivals (Palaikastro, Knossos and Elounda).

Kamilari 1: Levi 1961–2, fig. 121 B (F 59 2727).

Koumasa 3: 2*, the other Xanthoudides 1924, pl. XXII 700, **P 29**.

Platanos 8*.

Elounda 1: Van Effenterre 1948, 57, pl. XXI, XXXIV O 109.

Khamaizi 1: Xanthoudides 1906, pl. XI 5, **P 30**.

Knossos 1: KSM fragment*, LM IB–II context, from Royal Road.

Knossos Mavro Spelio 2: Forsdyke 1926–7, 254, fig. 41 and pl. XX no. III 20. *Ibid.* 254 and pl. XX no. III 24. Both Tomb III (LM I–III). HM 2154 and 2160.

Knossos Warrior Graves 1: Hood and de Jong 1952, 275 V 5 and fig. 13 (wrongly numbered V 4). LM II context. HM 2434.

Mallia 1: Chapouthier & Charbonneaux 1928, 58 and pl. XXXI 2 right, **D 13**. HM 2118.

Palaikastro 2: 1*, the other Dawkins 1923, pl. XXX B 5. HM 918, **D 14**, **P 31**.

Pseira 3*: HM 1142*, **P 32**. HM 1144*. HM 1146*, **P 33**.

Tylissos 1*: HM 2047*.

Crete 2*: MET. MUS. 26.31.434*. LEIDEN 1935 14II*. **Total 27**

4. BLOCK VASES (Kernoi)

This type, sometimes called kernoi, has several variant forms: **A**, rectangular with two cylindrical cups; **B**, much rarer, square with four cups; **C**, elliptical with two cups; **D**, two small joined bowls, best classed as a variety of block vase; **E**, three or more than four cups: Forms **A**, **B**, and **C** have incised decoration (see the plates), and holes drilled through the edge in the middle of the long sides. For these forms and for **D** chlorite is the most popular material.

The vases are mainly confined to the Mesara (Platanos, Koumasa and Dhrakones in particular) and Palaikastro, though there are outliers at Pseira, Gournia, Vasilike and Mallia in the east, at Knossos in central Crete and at A. Marina in the far west of the island.

Most of the special forms, **E**, including the one from Mycenae, are found in late contexts and all save two are made of serpentine, the characteristic LM material. It may be that they are not survivals from EM–MM I, but from MM III–LM I, though the presence of suspension lugs and the use of dolomitic marble for the Mycenae vase and the finding of an example at Galana Kharakia slightly favour the earlier date. But in view of their contexts post-palatial LM III manufacture cannot be ruled out, though there is no firm evidence for the manufacture of stone vases at this date. At any rate their find contexts imply a long continuity of cult tradition for this type of vase. Xanthoudides discussed the ritual nature of the general class of kernoi (1905–6).

The main forms **A**–**D** are found in MM I or mixed contexts including MM I. On

stylistic grounds however there is good reason to believe that the type started in EM III, for chlorite as a predominant material and incised decoration are characteristic of the earliest group of vases, found in EM II. The incised decoration of these Block Vases is however more elaborate than that of the early group and includes curvilinear patterns and circular inlays. In this it is comparable with some of the small alabastrons (type IA). EM III–MM I is then very probably the period of manufacture. These 'periods' are largely contemporary in the east and centre of the island (cf. pp. 2–3). What is being suggested therefore is that this type began to be made c. 2200 rather than 2000 B.C.

Evans (*PM*, IV, 980 sqq.) noted some Egyptian Predynastic parallels for this form but it is difficult to see a direct connexion here in view of the time gap. Moreover the Egyptian vases (very rare) are not exactly parallel to the Cretan ones, being basically tallish cylindrical conjoined cups.

It is difficult to decide about the rather crudely shaped vase, with five cups, from the Temple Tomb at Knossos. It may be another Cretan example of material resembling chlorite, though it is heavy, or it might just be Egyptian. It has no morphological connexion with the four main forms.

References are to Xanthoudides 1924 and the material is chlorite unless otherwise stated.

A. Ht. 4.9. Length 10.9. Width 5.8. Chipped at one corner. Koumasa Tholos B. HM 678. (Xanthoudides 1924, pls. III, XXIV *a*.) **D 15. P 34.**

Koumasa HM 679. Pl. XXIV *a*. **P 35.**
 HM 680. Pl. XXIV *a*.
 HM 684. Pl. XXIV *a*. All Tholos B.
 HM 681. Tholos E. Pl. XXXI.
Lebena HM unnumbered★. Fragment. Tomb II A. MM IA.
Platanos HM 1620. Limestone, deep maroon pink, with silvery calcite veins. Tholos A. Pl. LII. **P 36.**
 HM 1622. Pl. X. **P 37.**
 HM 1624. Pl. X.
 HM 1625. Pl. X.
 HM 1626★. **P 38.**
 HM 1627, Pl. LII.
 HM 1628, Pl. X.
 HM 1629. Pl. X. **P 39.**
 HM 1630★. Made in two parts, divided horizontally. 99 n. I. **P 40.** Plus three others, also from Tholos A.

The above are from the Mesara tombs. The following are from other sites.

A. Triadha PIG.M. 75159. Fragment. Palace ? N.F.C. (Borda 1946, 72–3 no. 12 and pl. LII 4.)
Gournia HM 334. Serpentine. LM I. (Boyd Hawes 1908, pl. V 25.) **P 41.**
Kalamaphka AM AE 220★. Serpentine ?, dark brown. Fragment, with incised decoration of zig-zags and arcs round the edges. N.F.C.
Katelionas Siteia HM 2899★. Decoration of vertical and horizontal ladders, vertical bars and rectangles incut for inlays. N.F.C. (chance find 1965).
Knossos HM unnumbered★, N.F.C.
 KSM (HH/G2)★, fragment from Hogarth's Houses, LM I.
Mallia HM 2315. Fragment. House D a. LM I.

(Demargne & de Santerre 1953, 58 and pl. XXVIII.)
HM 2328. Lower half of horizontally divided example. Houses S. of Palace. EM III–MM I. (Chapouthier, Demargne & Dessenne 1962, 15 (for date of house), 56 and pl. XLII.)
HM 2476*. Fragment. House E. N.F.C. (Mentioned, Deshayes & Dessenne 1959, 138.)
Palaikastro HM 148*. N.F.C. **P 42.**
HM 621*. N.F.C. **P 43.**
HM 622*. Serpentine ?, brown, brown/black.

N.F.C. (surface find, sketched in Excavation Notebook for 1904). **P 44.** Block vases from EM–MM ossuaries are mentioned by Dawkins (1923, 135).
Phaistos HM 223. MM I–II. (Pernier 1904, 472–3, fig. 79.) PIG.M. 77269. LM I (cf. HM 2315 above for the context). (Borda 1946, 37 no. 31 and pl. LII 11.)
Pseira HM 1124. (Seager 1910, fig. 15c.) **P 45.** HM unnumbered*. HM Apotheke box. Both N.F.C.

B. Ht. 5.4. Length 11.0. Width 10.82. Limestone, deep maroon pink. Cracked and very friable all over. Platanos Tholos A. HM 1619. (Xanthoudides 1924, pl. LII.)

Koumasa HM 677. Pl. III. **P 46.**
Palaikastro HM 448*. Serpentine. N.F.C. **P 47.**

Crete HM 1547*. N.F.C. Bought from a villager of A. Varvara.

C. Ht. 2.25. Length 7.65. Width 4.0. Very clear drill rings. Koumasa Tholos B. HM 682. (Xanthoudides 1924, pl. III.) **D 16. P 48.**

A. Marina Khania M. Λ 1024. Serpentine, brown/grey. (Marinatos 1928.)
Dhrakones HM 1025. Pl. XLIII.
HM 1027. Serpentine, khaki green/brown. Pl. XLIII a.
Galana Kharakia HM unnumbered (A 2). Serpentine. Strap handle on top. (*B.C.H.* 1955, 303, fig. 18 top row 3rd from left.)
HM unnumbered (A 3). Serpentine. Two vertically pierced double lugs at centre of long sides. (*Ibid.* fig. 18 top row left.)
Knossos KSM* (unprovenienced stone material). Serpentine. Decoration of arcs with bars. N.F.C.
Koumasa HM 683*. Tholos E.

Platanos HM 1631. Tholos A. Pl. LII.
HM 1632. Tholos A. Pl. LII. **P 49.**
HM 1633. Tholos A. Pl. X. **P 50.**
HM 1634. Tholos A. Pl. XI. **P 51.**
HM 1635. Tholos A. Pl. XI.
HM 1636 Marble, grey and creamy white mottled. Pl. LII.
Praisos A. Nik. M. 1090*. Serpentine. N.F.C.
Vasilike Penn. MS 4546*. Serpentine. N.F.C.
Mesara HM unnumbered*. Steatite, green with brown and creamy white. Tiny roughly shaped piece.
Crete ? AM Bomford Collection 291 BIS*. Chlorite with serpentine.

D. Ht. 2.5. Length 7.9. Spout and part of rim restored. Porti. HM 1056. (Xanthoudides 1924, pl. XXXIX a.) **D 17. P 52.**

Ht. 1.15. Length 5.08. Rim of one cup chipped. Palaikastro. N.F.C. HM 1004*. **D 18.**

The following are as HM 1056.

Dhrakones HM 1024, HM 1026. Both with vertical grooves on the shoulder. Pl. XLIII a. **P 53, 54.**
Koumasa HM 749. Tholos B. Pl. XXIV a.

HM 845*. Marble, banded grey, grey/white, grey/black. N.F.C.
Mochlos? BM 1935, 10–16 3*. Rim spout on preserved bowl. N.F.C. (gift to BM).

13

E. All serpentine unless otherwise stated.

A. Triadha HM 380. Three conjoined cylindrical cups. Cemetery. N.F.C. (Paribeni 1904, 701 and fig. 11.) **P 55.**

Galana Kharakia HM unnumbered (A 4). Three conjoined cups in trefoil shape with strap handle. (B.C.H. 1955, 303, fig. 18 top row, 2nd from left.)

Gournia HM 548. Conjoined cylindrical cups, one and part of a second preserved. Aisa Langadha (LM IIIA) or Alazzomouri (LM IIIB) burials. (Boyd Hawes 1908, pl. X 27.)

Palaikastro HM 447. Type as Galana Kharakia vase. Block B, room 47. LM I. (Hutchinson et al. 1939–40, pl. 15 z. Mentioned Bosanquet 1902–3, 289.) HM 914. Limestone, black with mottled white veins. Eight conjoined cups in two rows of four. Block X hoard. LM I. (Dawkins 1923, 134–5, fig. 116.) **P 56.**

Phaistos HM 2569. Magnificent rectangular vase of twelve cylindrical cups, a palatial cult vessel. Room LIV. MM II. (Levi 1955, 143, fig. 5, 146 fig. 8c.)

Prasa HM 2442. Six cups in two rows of three. House A. MM III–LM I. (Platon 1951b, 253, fig. 6 lower row right.) **P 57.**

Stamnioi HM 2459. Rectangular, five cylindrical cups (one in the centre), two vertically pierced double lugs at centre of long sides. Chamber tomb. LM IIIB. (Platon 1952b, 626, fig. 6.) **P 58.**

Mycenae NM 4559*. Dolomitic marble, grey, white mottled. Five cylindrical cups, made as four together with central hole drilled out to form fifth; four tiny lugs on sides. Chamber Tomb 99. **Total 72**

5. BLOSSOM BOWLS

A high-shouldered bowl carved with flower buds or petals in relief, canonically six, sometimes more or less. The material is always serpentine.

Over 120 of these bowls are known. Nearly ninety are from excavated sites, but of these the precise find contexts of only about forty are known. Among these the Nirou Khani, Akhladhia Riza, Gournia, Katsamba, Zakro, Kea and Phylakopi examples show that the canonical type flourishes in LM I. A number of others which have no recorded find context (Gournia, Palaikastro, Pseira) are from predominantly LM I towns. But of the forty dated vases about a dozen are from LM III (or LH III) contexts. These are almost certainly all survivals continuing in use in later tombs.

Although LM I is the predominant context of those with known find places the type is to be dated MM III–LM I. On most sites in Crete MM III passes into LM I without any major stratigraphical break so that, although we can observe substantial changes in pottery styles, we cannot say that a stone vase found in an LM I context was not made in MM III. Moreover several types known predominantly from LM I contexts elsewhere in Crete turned up in pure MM III deposits in the 1957–61 Knossos stratigraphical excavations. In the case of Blossom Bowls we have an example from the burial cave at Galana Kharakia, a site which is

mainly MM I but which seems to have continued at least to MM III (see Site List p. 194 n. 2).[1] A prototype comes from Koumasa Tholos E (HM 687) and this cannot be later than MM I/II. This seems to be an experimental vase trying out the possibilities of the form. It was not afterwards repeated.

In MM III–LM I exports went to Argos, Byblos, Kea, Kythera, Mycenae, Naxos, Phylakopi and Troy. The recent Kythera excavations have also produced imitations in clay (*Arch. Reps. for 1963–4*, 25, fig. 30).

The canonical form of 'flower' has a vertical central rib with a groove down it. Occasional variants on this are flowers with no central rib, or double flowers, that is carved at the edge as if one were superposed on another. These regular and variant forms are illustrated in the plates.

Where no date is given in the catalogue the context is LM I.

Ht. 7.5. Diam. 11.45. Serpentine, pale grey. Slightly chipped. Drill rings round the interior, as in most Blossom Bowls. Four flowers in low relief, in two pairs, with a narrow flower between each pair. Horizontal grooves round lower part. Unique in form and the earliest in date. Koumasa Tholos E. HM 687. (Xanthoudides 1924, pl. XXXI.) An open clay vase of calyx form with grooved decoration on the lower part also comes from Koumasa, *ibid.* pl. XXX 4978. **D 19. P 59.**

Ht. 10.55. Diam. 16.4. Serpentine. Slightly cracked and a few patches restored. Drill rings round interior. Six flowers in medium relief with raised central rib with vertical groove. The canonical form. Nirou Khani, room 7 A. HM 2081. (Xanthoudides 1922, 13 and fig. 11.) **P 60.**

Akhladhia Siteia HM 2605★. N.F.C. Type as **P 61** and **P 63.**

Akhladhia Siteia Riza Villa HM unnumbered★. (Platon 1959, 376.)

Ambelos Pharmakokephali HM 5★. N.F.C. (Mentioned Evans 1895, 119.)

Arkhanes Troullos HM 895★. N.F.C.

A. Triadha HM 2345★. N.F.C. In a box contaminated in the Museum by an earthquake in 1928, and so it might possibly be from Phaistos. Type as **P 62.**
HM unnumbered★. N.F.C.

Dhamania HM 2132. LM III B tomb. (Xanthoudides 1916, fig. 2.)

Elounda Neapolis M. 6. LM III tomb. (Van Effenterre 1948, 57 and pl. XXI, XXXIV O III.)
A. Nik. M. 48★. N.F.C.

Neapolis M 194★. N.F.C. Neapolis M. 5. LM III tomb. (*Ibid.* pl. XXI O 110.)

Episkope Pedhiadha HM 2463. LM III tomb. (Platon 1952 b, 622, fig. 3 lower row.)

Galana Kharakia HM unnumbered. For date of site see discussion above. (*B.C.H.* 1955, 303, fig. 18 top row 3rd from right.)
HM 2594★. N.F.C. (Platon 1956, 416.)
HM unnumbered★. Small raised collar. N.F.C. Mnemouria deposit.

Gournes HM 2041. Eight flowers. Tomb II. LM III B. (Hatzidhakis 1918, 78 and fig. 22 6.)

Gournia HM 80, HM 81, Penn. MS 4148 (Boyd Hawes 1908, pl. V 6, 5, 7.)
HM 82★, HM 94★ (4 flowers and a single petal), HM 290★, HM 291★, HM 2342★ (type as **P 61** and **P 63**). These 5 N.F.C., but almost

[1] A fragmentary unfinished example from Kastellos Lasithi is dated to MM III but there is no mention of its flowers in the publication. It may therefore be a large MM I Bird's Nest Bowl with a small interior (cf. HM 1801 and HM 1809, Xanthoudides 1924, pl. LII). It is included here with a query.

certainly from the LM I town like the published ones.

Itanos HM 1542*. N.F.C.

Kalo Khorio Arkalokhori HM 2344*. N.F.C. A. NIK. M. 263*. N.F.C.

Kastellos Lasithi HM unnumbered. Blossom Bowl ? Unfinished. MM I–III. (H. W. Pendlebury *et al.* 1937–8, 49 and 51 no. 25 and pl. III.)

Katsamba HM unnumbered*. LM I house. (Platon 1956, 415–16.)

Keraton Viannos HM 1601*. N.F.C. Gift of Seager.

Khania Khania M. 1010. LM IIIA 2–B tomb. (Jantzen 1951, 73.)

Knossos HM 888. Zapher Papoura Tomb 99. LM IIIB. (Evans 1905, 89 no. 99*e* and fig. 100.) HM 889. Zapher Papoura Tomb 35. LM III. (*Ibid.* 441 no. 35*b*.)

Ibid. no. 35*c*; vase not traceable.

Zapher Papoura Tomb. 72. LM III. (*Ibid.* 466; vase not traceable.)

HM 890*. Zapher Papoura. N.F.C. Very probably one of the last two vases. 12 vertical grooves forming 6 quasi-flowers.

HM 2148. Mavro Spelio Tomb XII. LM I. (Forsdyke 1926–7, 272 XII 1 and pl. XX.)

HM 2149. Mavro Spelio Tomb VIIB. LM III mainly. (*Ibid.* 263 VIIB 8.)

HM 2150. Tomb III. LM I–III. (*Ibid.* 254 III 21.)

HM 2151. (*Ibid.* 254 III 21.)

HM 2152. Two flowers, opposite. Tomb II. LM I probably. (*Ibid.* 251, II 1 and pl. XX.)

HM 2404. Eight flowers. LM IIB tomb near Temple Tomb. (Hutchinson 1956*b*, 73 no. 21 and fig. 2 and pl. 7*g* right.)

HM 2406. As last. (*Ibid.* no. 20 and fig. 2 and pl. 7*f* right.)

HM unnumbered (Sell. 57/72)*. Sellopoulo Tomb I. LM IIIA 2–B. (For site Platon 1957*a*, 332–3.)

KSM (KSP/60/10*, 11*, 12*), LM III tomb; (*Arch. Reps. for 1960–1*, 27).

KSM (RR/D22)*, fragment, LM IB–II/IIIA. In early Christian Basilica Church, 6th cent. A.D. context. (Frend & Johnston 1962, 195, 231 and fig. 8.)

AM AE 385*, AM 1938.618*. Both N.F.C. (possibly one of these is from Zapher Papoura Tomb 72). In Palace, between South Propylaeum and Room of Stone Vases (Central Treasury). Palace destruction context. Vase not traced. (Evans 1899–1900, 16. Boardman 1963, 13 and n. 2.) MET. MUS. 11.186.65*. N.F.C.

Kritsa A. Nik. M. 170*. LM IIIB tomb. (Platon 1951*a*, 444–5.)

Krousonas HM 2414*, HM 2415*, HM 2416*. N.F.C. Found by villager 1952.

Lastro MET. MUS. 24.150.1. N.F.C. (Richter 1953, pl. 8*f*.)

Mallia HM 2116. Palace Room X, 1. (Chapouthier & Joly 1936, 39 no. 2 and pl. XX*c* and XXXIV*d*.) **P 61**.

HM 2237. Palace Room in W. part. (Chapouthier, Demargne & Dessenne 1962, 57.)

Milatos AM AE 213. N.F.C. (Evans 1895, fig. 123.)

Mokhos HM* ? N.F.C. (Platon 1953, 491.)

Nipidhito MET. MUS. 53.5.2. Type as **P 61**. N.F.C. (Halbherr 1901, 282–3, fig. 10 left.)

Palaikastro HM 442. House B Room 26. LM IIIB reoccupation. (Bosanquet 1901–2*a*, 316.)

HM 624*. Five flowers. **D 20**.

HM 623*, HM 625*, HM 943* (type as **P 62**), HM 945*. These last five N.F.C. Apart from HM 442 five other Blossom Bowls from Palaikastro are recorded, though not published, from LM I–III contexts: Bosanquet 1902–3, 276, N.F.C.; Dawkins 1905–6, 1, two bowls, LM IB context; *ibid.* 5, one bowl, LM IB–III; Dawkins & Tod 1902–3, 335, LM I. The Palaikastro Excavation Notebook for 1904, entry 15, records 18 Blossom Bowls from various parts of the excavations. FM GR. 202.1907*. N.F.C. Very probably one of the 18. Knossos Apotheke PK/63/67. Fragment. LM IB. (Sackett, Popham & Warren 1965, 307 no. 58.)

Pseira Seven examples, all N.F.C. HM 1128*, **P 62**. HM 1129 (Zervos 1956, pl. 151 left). HM 1130 (*ibid.* pl. 151 right). **P 63**. HM 1132*a*. Eleven flowers (*ibid.* pl. 151 centre). **P 64**. HM 1133*. HM unnumbered*. Penn. MS

4514*. Seager 1910, fig. 15 J, K records the form with central rib (cf. **P 60**) and those without (HM 1128, HM 1130, **P 62–3**).

Rethymno Province Rethymno M.* Three grooves down each flower. N.F.C.

Tymbaki HM 2343*. N.F.C.

Xeniako HM 2349*. N.F.C.

Zakro HM 105. (Hogarth 1900–1, 136.)
HM 2346*. Very probably from town (LM I).

Crete Siteia HM 6*. Horizontal grooves on upper part of flowers. N.F.C.

E. Crete MET. MUS. 24.150.2*. N.F.C.

Crete LEIDEN 1935 14 V BIS*. N.F.C.
MET. MUS. 26.31.433*. Upper part of flowers grooved at edges. N.F.C.
MET. MUS. 26.31.436*. Three grooves down each flower. N.F.C.

Crete ? BM 1914 3–21 I*. Form as **P 61** and **P 63**. N.F.C.
DETROIT Institute of Arts 66.43*. N.F.C.
RICHMOND, Museum of Fine Arts (Williams Fund, 1957)*. N.F.C.

Argos NM 3338. Heraion Tholos. LH II. (Wace 1921–3, 336.)

Byblos Context, XVIIIth Dynasty—Roman. (Dunand 1939, 418 pl. 150 no. 6498.)

Delos ? Blossom Bowl mentioned, without reference, by Scholes 1956, 38.

Kea K 1.573*. LH III C. (Mentioned Caskey 1962, 281.) K 3.119*, eight flowers; K 3.207*, four flowers, each with three vertical grooves; K 4.110*; K 0.9*, shallow vertical grooves; this, like K 3.207, just possibly made by colonist lapidaries on Kea who had forgotten the canonical form. Contexts of these four not known. K 6.116*. Area G. LM I and a little LM IIIA I.

Kythera Excavation no. 6076*. N.F.C., but from Vothonas Valley where LM I tombs are situated. Three others, chance finds, Kythera Mus. nos. 23–5*.

Mycenae N.F.C.* (Mentioned Bosanquet & Welch 1904, 197.) Chamber tomb 103. LH I–II. Perhaps the vase mentioned by Bosanquet & Welch. Lion Gate. (Wace 1921–3, pl. VII a.)

Naxos Naxos M. 339. Fragment. Kamini. LC III. (Kondoleon 1950, 279 and fig. 12 (wrongly published as marble).)

Phylakopi NM 5808 3. Four from Third City (LM I–II). (Bosanquet & Welch 1904, 197, figs. 166–7.) Fragment of another, context not stated (Dawkins & Droop 1910–11, 22).

Troy N.F.C. (Dörpfeld 1902, 391, fig. 373.)

Total 125 plus

6. BOWLS WITH CARINATED OR CURVED PROFILE

A plain bowl, without moulded rim or base. The point of carination or curvature may come about half-way up the vase, **A**; high up, to form a high shoulder, **B**; or low down, to form a low-bellied vase, **C**. These divisions have no chronological meaning but are adopted as a simple way of classifying the different forms. Occasionally the assignation to a particular group is somewhat arbitrary. This type always has most of the inside drilled out; thus the high-shouldered forms, not unlike Bird's Nest Bowls in profile, differ from them internally, for the Bird's Nest Bowls have a mouth diameter of limited size. About three-quarters of the total are made of serpentine, the rest of different varieties of limestone, marble, calcite and chlorite (materials other than serpentine are stated in the catalogue).

A sketch of the different forms is given in figure 1.

A few of group **A** have incised grooves on the shoulder, as has one of group **B**. The type seems to be entirely MM I, the Khamaizi and Galana Kharakia sets being basic (the latter site is mainly MM I, see Site List p. 194 n. 2). This dating is confirmed by examples from MM I contexts at Apesokari, Khristos, Palaikastro (HM 139) and Voros, whilst nearly all the rest are in contexts which include MM I. The type is not exclusive to any one part of the island.

I Carinated II Curved

A

B

C

FIGURE I. FORMS OF BOWLS WITH CARINATED OR CURVED PROFILE

A. 1. Ht. 4.0. Diam. 6.65. Serpentine. Slightly chipped. Drill rings. Mallia, Khrysolakkos cemetery. HM 2286. (Demargne 1945, 51 and pl. LXIII.) **D 21. P 65.**

Apesokari HM 2812. Breccia, grey/white and maroon/grey, with green/grey pieces. (Schörngendorfer 1951, pl. 5, 4 and pl. 25, 6.)

Arvi AM AE 209. Serpentine. N.F.C. (but find group probably all MM I). (Evans 1895, fig. 117.) **P 66.**

Galana Kharakia HM 2596*. **P 67.**
HM 2597*. **P 68.**
HM unnumbered (B 27)*. **D 22.** (For the site, Platon 1954a, 512; 1956, 516–17; *B.C.H.* 1955, 303, fig. 18.)

Gournia Penn. MS 4507*. N.F.C.

Khristos HM unnumbered. (Xanthoudides 1924, pl. XL*b* 2nd row last on right.)
HM unnumbered. (*Ibid.* 3rd row 3rd from right.)

Knossos KSM (unprovenienced material)*. Unfinished; interior gouged out all over, outside not polished and edges not smoothed. N.F.C.

Koumasa HM 704. Chlorite. Incised grooves on shoulder. Tholos B. (Xanthoudides 1924, pl. XXII.) **P 69.**

Mochlos HM 1261. Tomb XI, E. side. MM IA deposit. (Seager 1912, fig. 28 XX 10.) **P 70.**

Myrtos KSM. Pyrgos site. Surface find. (Hood, Warren & Cadogan 1964, 96 and fig. 20, 3.)

Palaikastro HM 139. Ossuary VII. MM I. (Bosanquet 1901–2a, 291–7 and pl. XVII, fig. 3 lower row centre. Dawkins 1904–5, 267.)

Platanos HM 1858*. Chlorite with grey calcite veins. Incised grooves on shoulder. Tholos A annex. **D 23. P 71.**

Pseira HM 1147*. N.F.C. (but marked with a tomb number so from cemetery).

Voros HM 2270. (Marinatos 1930–1, 157 and fig. 20 top row 2nd from left.)

Zakro HM 2666*. Building B. Context not known.

18 plus 18 others. **Total 36**

A. 2

Galana Kharakia HM 2600*. **P 72.**

Gournes HM 2015*. Banded Tufa. Probably from MM I tombs.

Gournia HM 308*. N.F.C. **D 24.**

Episkope Pedhiadha HM unnumbered. LM III A–B tomb. Survival. (Marinatos 1933–5, 52, fig. 5, 5.)

Khamaizi HM 460*. **P 73.**

HM 461*. **D 25. P 74.**

HM 469*. Limestone, banded, grey, grey/black. **D 26.**

Knossos HM 2163. Mavro Spelio Tomb XVIII, undated. (Forsdyke 1926–7, 282, XVIII 6 and pl. XX.) **D 27.**

Mallia HM 2211. House A. Mainly MM I.

(Demargne & de Santerre 1953, 17 and pl. X.) **P 75.**

Pseira HM 1141*. Breccia, brick red matrix with white patches. Incised grooves on shoulder. N.F.C. (but marked with tomb number, so presumably from cemetery). **D 28.**

HM 1148*. **P 76.**

HM 1149* (also marked with tomb number). Penn. MS 4518*. N.F.C. **D 29.**

Penn. MS 4535*. N.F.C. **D 30.**

MET. MUS. 14.89.15*. N.F.C.

Sphoungaras Penn. MS 4545*. Deposit B. EM II–MM I. (Mentioned Hall 1912, 54–5.)

16 plus 10 others. **Total 26**

B. 1. Ht. 4.6. Diam. 7.55. Chipped. Drill rings. Mochlos. N.F.C. BM 1911, 6–20, 11*. **D 31. P 77.**

Galana Kharakia HM unnumbered (B 29)*. **D 32.**

Gournes HM 2014. Serpentine, pale grey/buff

with network of grey/black veins. MM I A tomb. (Hatzidhakis 1915, 61–2 and fig. 3.)

3 plus 5 others. **Total 8**

B. 2. Ht. 6.4. Diam. 9.8. Banded Tufa, creamy white with translucent bands. About a quarter restored. Mallia House A. Mainly MM I. HM 2206. (Demargne & de Santerre 1953, 17 and pl. X.) **P 78.**

A. Triadha HM 370*. Marble, white translucent with darker patches. Small Tholos. **P 79.**

Kamilari HM 2848 ? Chlorite with serpentine. (Levi 1961–2, fig. 120 B i (wrongly numbered F 2724 a, actually F 2726 b).) **D 33.**

Khamaizi HM 467. Limestone, grey, grey/black banded. (Xanthoudides 1906, pl. XI 10.) **P 80.**

Palaikastro HM 144*. Breccia, creamy matrix with black and maroon pieces. N.F.C. but from early ossuaries. EM–MM I.

Platanos HM 1865*. Tholos A annex. HM 1868*. Calcite, creamy white translucent. As last.

7 plus 10 others. **Total 17**

C. Ht. 3.95. Diam. 9.15. Serpentine, pale yellow/green with network of green/black veins. Slightly chipped. Gournia. N.F.C. HM 304. (Boyd Hawes 1908, pl. V 23.) **D 34. P 81.**

Kamilari Phaistos Strat. Mus. F 59 3166*. Dolomitic limestone, grey and white mottled. **D 35.**

Khamaizi HM 462*. HM 564*. **P 82.**

Koumasa HM 818*. Serpentine, pale grey with network of grey/black veins. Tholos E. MM I. **D 36.**

HM 838*. Marble, white with mottled maroon patches. Tholos E.

Lebena HM unnumbered (L III 22)*. Tomb III. EM II–MM I.

Platanos HM 1880*. Banded Tufa, creamy white banded with translucent golden brown. Tholos A annex. **P 83.**

Pseira HM 1155*. Limestone, grey/black mottled with white veins and patches. N.F.C. **P 84.**

9 plus 2 others. **Total 11**

Type Total 98

7. BOWLS WITH CARINATED OR CURVED PROFILE AND LUGS ON THE SHOULDER

This type originates in EM III–MM I in a low flattish form, **A**, sometimes with incised vertical grooves on the shoulder between the lugs. The materials are varied but chlorite is the most popular. Most of the examples are from the Mesara tombs.

Contemporary is a form, **B**, where the diameter about equals the height. This form is well dated to MM I by the Khamaizi and Galana Kharakia sets but, unlike form **A**, several examples are found in MM III–LM I contexts and one in LM II–III A I. The Phylakopi fragment had an LM I–II (Third City) context. But these vases are few and probably all survivals from MM I. Serpentine is used almost exclusively for this form. Hardly any examples are from the Mesara, so that it is reasonable to conclude that the flat form in chlorite and limestones is predominantly a Mesara type and the higher form in serpentine North, Central and East Cretan.

There is a third form, **C**, with a high shoulder. The vases are bigger than those of group **B** (**C** vases nearly all have a width over 10.0, **B** under 10.0), and all save one are made of serpentine. There is some evidence that the group is later than **A** and **B**. One vase is in an MM II and one (possibly two) in an LM I context. None are certainly MM I. There are few examples (though HM 168 and HM 2768 from Zakro in group **B**, in MM III–LM I contexts, approach this form), so certainty of date is not possible. The form may have begun in MM I but it seems more probable that it derived from the smaller EM III–MM I vases and was made up to and into LM I. Its larger size also suggests this since the bulk of the stone vases down to MM I/II are small and of varied materials, those of LM I larger and, if not in hard stones, very often of serpentine.

Context MM I and material serpentine unless otherwise stated.

A. Ht. 2.4. Diam. 6.4. Width 7.2. Dolomitic limestone (probably), grey with grey/black bands. Drill rings. A. Triadha. Large Tholos. HM 641. (Banti 1930–1, 182 and fig. 50 *p*.) **D 37.**

Dhrakones HM 1028. Chlorite. Incised grooves on shoulder. (Xanthoudides 1924, pl. XLIII *a*.) **P 85.**

Galana Kharakia HM unnumbered (B 18)*.

Knossos KSM (unprovenienced material)*. Chlorite. Incised grooves on shoulder in six groups. N.F.C.

Koumasa HM 697. Marble, white crystalline. Tholos E. (Xanthoudides 1924, pl. XXXI.) **D 38.**

Mallia HM 2293. Quartier Γ. (Demargne & de Santerre 1953, 36 and pl. XV.) **D 39. P 86.**

Nipidhito MET. MUS. 53.5.1. Chlorite. Grooves on shoulder. N.F.C. (Halbherr 1901, 282–3, fig. 10 right.)

Platanos HM 1860. Chlorite. Tholos A. Incised and inlay decoration. Bird's Nest Bowl save for lugs. (Xanthoudides 1924, pl. LII.) **P 87.**
HM 1861*. Chlorite. Tholos A annex.
HM 1862*. Limestone, banded, light grey and grey/black with maroon patch. Tholos A annex. **D 40.**

Pseira Penn. MS 4526*. N.F.C. **D 41.**

Tylissos HM 1558*. N.F.C. **P 88.**
Voros HM 2271. Chlorite. Incised grooves on
shoulder. (Marinatos 1930–1, 157–8, fig. 20 top row 4th from left.)

13 plus 8 others. **Total 21**

B.

Arvi AM AE 206. N.F.C. (but find group probably all MM I). (Evans 1895, fig. 114.)
Galana Kharakia HM 2598*. **D 42.**
HM unnumbered (B 16)*. **D 43.**
Gournia Penn. MS 4505. LM I. (Boyd Hawes 1908, pl. V 9.)
Khamaizi HM 456. (Xanthoudides 1906, pl. XI 16.) **P 89.**
HM 457*.
HM 458. (*Ibid.* pl. XI 15.) **P 90.**
Knossos HM 610. Calcite, white opaque with translucent golden brown patches. Isopata Royal Tomb. LM II–III A I. (Evans 1905, 538 no. 7 and fig. 125 S 7.)
Koumasa HM 816*. Tholos B. **D 44. P 91.**
Mallia HM 2213. Dépotoirs du bord de la Mer. Mainly MM I. (H. & M. van Effenterre 1963, 65 and pl. XXVI.) **D 45.**
HM 2214. As last. (*Ibid.* 65 and pl. XXVI.) **P 92.**

HM 2216. Nécropoles des Pierres Meulières. Mainly MM I. (*Ibid.* 93 and pl. XXXV.) **P 93.**
HM 2232. Khrysolakkos. (Demargne 1945, 51 and pl. LXII 2 and LXIII.) **D 46.**
HM 2235. N.F.C. (Chapouthier, Demargne & Dessenne 1962, 56 and pl. XLIV.) **P 94.**
Pakhyammos HM 2071*. MM I–III. (Mentioned Seager 1916, 18, Group VII.)
Prasa HM 2452*. (For the site Platon 1951 b.)
Pseira HM 1156*. N.F.C. **D 47. P 95.**
HM 1157*. N.F.C. **D 48. P 96.**
Zakro HM 168*. Pit. (Mention of stone vases from Pit, Hogarth 1900–1, 124.)
HM 2768*. Building A Area Λ. MM III–LM I. (For the site Ἔργον 1963, 160.)
Phylakopi NM. Third City (LM I–II). (Bosanquet & Welch 1904, 198.)

21 plus 18 others. **Total 39**

C. Ht. 5.9. Diam. 9.7. Width 10.7. About one-third restored, including part of one lug. Drill rings. Gournia. N.F.C. HM 301*. **D 49.**

Mallia HM 2212. Dépotoirs du bord de la Mer. Mainly MM I. (H. & M. van Effenterre 1963, 65 and pl. XXVI.) **D 50. P 97.**
Phaistos HM 2559. Room XXVII. MM II. (Levi 1952–4, 581, fig. 63.)
Pseira HM 1159*. N.F.C. **D 51. P 98.**
Penn. MS 4536*. **D 52.**

Vathypetro HM 2618*. LM I. **P 99.**
Zakro HM 169*. House G. LM I. Hogarth's excavations.

7 plus one other. **Total 8**
Type Total 68

8. BOWLS WITH CARINATED OR CURVED PROFILE AND EVERTED RIM

After Bird's Nest Bowls and Lamps this is the most popular of Minoan stone vase forms and there are many variants.

A. Shallow, open forms with gently curved underside
B. Shallow, open forms with slightly carinated underside
C. Markedly carinated forms (far outnumbering all others)

21

D. Form **C**, but vases tall in proportion to diameter

E. Deep bowls with strongly curved or carinated profile

F. Tall forms like **D** but with a curved instead of carinated profile

G. Forms like **C** but with a markedly curved profile

H. Forms like **C** and **G** but with a raised collar rather than everted rim

I. Forms like **C** and **G** but without the everted rim

J. A few special vases

K. A group of Late Minoan vases, morphologically like forms **A** and **E** above but not connected with them chronologically. It is worth noting that one of these (HM 2735, Zakro, LM IB) is very similar to bowls carried by Keftiu in the Tomb of Senmut and by what are probably Keftiu in those of Rhekmire and Menkheper-reseneb (Furumark 1950, figs. 22, 24, 25. Cf. **D 99**).

The main group **A–J** is found everywhere in the island, most examples coming from Mochlos and the Mesara, with a number from Knossos and Mallia. This is the most important type for linking Mochlos with the rest of the island, for many of the other Mochlos vases do not have parallels elsewhere. The group dates from the latter part of EM II to MM I/II. One or two from Phaistos have MM II and a few others later contexts, including one from Pakhyammos in an LM III tomb. This vase is of form **A** and it is almost certainly a survival. There were four survivals at Karphi. Two fragmentary examples were found on the Aspis site at Argos, where the pottery was EH III–MH. This context thus corresponds well to the Minoan date for the type (Volgraff 1906, 38, fig. 68). Most of the group are small, under 8.0 high, and were funerary. The deep bowls, **E**, and one or two of **C**, were probably for practical use, later put in tombs with the dead.

As usual in the EM–MM I/II period materials of all the Cretan varieties are found, serpentine, chlorite, steatite, breccias, banded tufa, calcite, limestones, marble, dolomitic limestone and dolomitic marble. The LM group shows the usual combination of dark serpentine and fine stones, obsidian and Egyptian alabaster, with some of gypsum.

A. *A. Triadha* HM 636. Serpentine. Large Tholos. (Banti 1930–1, 182.) **D 53.**

Knossos AM 1924.30*. Dolomitic marble, grey and white. N.F.C. **D 54. P 100.** Plus eight others.

Mochlos HM 1178. Marble, grey with grey/white patches. Tomb XVI. (Seager 1912, fig. 16 XVI 7.) **D 55.** Plus one other.

HM 1181. Chlorite. Tomb VI. (*Ibid.* fig. 22 VI 10 and pl. VI.) **P 101.**

HM 1183. Chlorite. Tomb XX. (*Ibid.* 75.) **D 56. P 102.**

HM 1267. Marble, grey, grey/black banded. Tomb XIII. (*Ibid.* fig. 32 XIII*e* and pl. IV.) **D 57. P 103.**

BM 1921 5–15 23*. Marble, as last. N.F.C. **D 58. P 104.**

Pakhyammos HM 2402. Serpentine. LM III A 2–B tomb. (Alexiou 1954a, 403 no. 8, 412 and pl. H 2 left.)

E. Crete Hierapetra M.* Serpentine. N.F.C.

Crete HM 1535*. Serpentine. N.F.C. **Total 20**

B. *A. Photia* MET. MUS. 24.150.8*. Dolomitic marble. Cf. HM 1268, 1297 below. Burial cave. N.F.C.

Knossos FM GR. 9.1936*. Limestone, grey/black with mottled white veins. Cf. HM 2526. N.F.C. Plus three others.

Koumasa HM 739*. Chlorite. N.F.C. **P 105**. Plus two others.

Mochlos HM 1281. Serpentine. Tomb XI, probably MM I. (Seager 1912, fig. 28 XI 15.) **D 59. P 106**. Plus one other.

HM 1182. Marble, creamy white with grey/black bands. Tomb VI. (*Ibid.* fig. 22 VI 16 and pl. VII.) Plus five others.

HM 1180. Marble, grey and white mottled. Tomb II. (*Ibid.* fig. 7 II g.) **D 60. P 107**.

HM 1268. Breccia, pink matrix with black pieces. N.F.C. Surface find. (*Ibid.* fig. 47 M 15.) **D 61. P 108**.

HM 1297. Banded Tufa. N.F.C. Surface. (*Ibid.* fig. 47 M 13.) **D 62. P 109**.

Platanos HM 2526*. Serpentine, mottled grey/buff with dark grey veins. Tholos A annex. **P 110**. Plus one other.

Porti HM 1075. Serpentine, grey with network of grey/black veins. (Xanthoudides 1924, pl. XXXVIII.) **P 111**. **Total 22**

C. 1. Miniature and very low examples

Mochlos HM 1265. Chlorite. Tomb XIII. (Seager 1912, fig. 32 XIII f.) **D 63. P 112**.

HM 1299. Steatite, green/black with creamy veins. Tomb I. (*Ibid.* fig. 4 I g.) **D 64**.

HM 1300. Steatite, green/black with creamy green patches. Tomb II. (*Ibid.* fig. 7 II n.) **D 65**.

HM 1301. Limestone, grey, creamy grey banded. Tomb VI. (*Ibid.* fig. 22 VI 7 and pl. VI.) **D 66**.

Platanos HM 1871*. Steatite, brown, black, green. Tholos A annex. **P 113**.

5 plus 9 others. **Total 14**

2. Small examples

Mochlos HM 1262. Serpentine. Tomb XIX. (*Ibid.* fig. 4 XIX 3.) **D 67. P 114**.

HM 1263. Serpentine. Tomb I, probably MM I. (*Ibid.* fig. 4 I c.) **D 68**.

HM 1264. Limestone, grey/black with white veins. Tomb XI. (*Ibid.* fig. 28 XI 2.) **D 69. P 115**.

3 plus 20 others. **Total 23**

3. Medium examples

Karphi HM unnumbered. Serpentine. LM III C. (*B.S.A.* 1937–8, 123 no. 185 and pl. XXX 1.)

Mallia HM 2194. Limestone, black with white veins. (Demargne & de Santerre 1953, 17 and pl. X.) **D 70. P 116**.

HM 2195. Limestone, grey and black banded. (*Ibid.* 18 and pl. X.) **D 71. P 117**. Both House A.

Mochlos BM 1921 5–15 24*. Limestone, grey/black with white patches. N.F.C. **D 72. P 118**.

4 plus 35 others. **Total 39**

4. Large examples

Mochlos HM 1280. Serpentine. Tomb XI, probably MM I. (Seager 1912, fig. 28 XI 17.) **D 73. P 119**.

Plus six others, HM 655–6 (A. Triadha Large Tholos), HM unnumbered (Mavro Spelio Tomb III), HM 2247 (Mallia House A), HM 151 (Palaikastro, Early Ossuaries) and HM 2090 (Porti). **Total 7**

Group C: Total 83

D. *Itanos* HM 236*. Dolomitic marble, grey and white. N.F.C. **D 74. P 120**.

Karphi HM unnumbered. Serpentine. LM III C. (*B.S.A.* 1937–8, 123 no. 530 and pl. XXX 1.)

Koumasa HM 715. Breccia, creamy matrix with maroon/black and green pieces. (Xanthoudides 1924, pl. XXIII.) **D 75. P 121**.

Mochlos HM 1275. Limestone, grey with white vein. N.F.C. Surface find. (Seager 1912, fig. 47 M 21.) **D 76. P 122.**

Palaikastro HM 908. Breccia, white and maroon matrix with black pieces. N.F.C. (Hutchinson *et al.* 1939–40, pl. 15*w*.) **D 77. P 123.**

BM 1907 1–19 227*. Limestone, black with mottled white veins. N.F.C. **D 78. P 124.**

Siva HM 1606. Banded Tufa. South Tholos. (Paribeni 1913, 17 no. 4 and fig. 3.) **D 79. P 125.**

Plus four others, AM AE 207 (Arvi, Evans 1895, fig. 115), Neapolis M. 8 (Elounda, van Effenterre 1948, 58 and pl. XXI O 116), HM 471 (Khamaizi, Xanthoudides 1906, pl. XI 17), HM 2579 (Phaistos, Room LI, Levi 1952–4, 416, MM II context). **Total 11**

E. *Mallia* HM 2192. Banded Tufa, white with light grey bands. Nécropoles des Pierres Meulières (mainly MM I). (H. & M. van Effenterre 1963, 64–5 and pl. XXVI.) **P 126.**

Mochlos HM 1231. Marble, milky grey with darker bands. Tomb XIX. (Seager 1912, fig. 4 XIX 4.) **D 80. P 127.**

HM 1232. Limestone, grey/black with yellow calcite. Tomb II. (*Ibid.* fig. 7 11*a* and pl. II.) **D 81. P 128.**

BM 1921 5–15 28*. Marble, milky grey with darker patches. N.F.C. **D 82. P 129.**

Phaistos HM 2541. Marble, grey, dark grey, banded. Room IL. MM II. (Levi 1952, fig. 19.) **D 83. P 130.**

Trapeza HM 2366. Calcite, creamy with darker patches. (H. W. Pendlebury 1935–6, fig. 23, 9 and pl. 16.) **P 131.**

E. Crete Hierapetra M.* Marble, white. Fragment. Cf. previous vase. N.F.C. **Total 7**

F. *Apesokari* HM 2795*. Chlorite. (Schörngendorfer 1951, 15.)

Kamilari Phaistos Strat. Mus. F 59 2549*. Breccia, white matrix with maroon and green/grey patches.

Mallia HM 2236. Dolomitic limestone, grey and white. Palace. N.F.C. (Chapouthier,

Demargne & Dessenne 1962, 56–7 and pl. XLIII.) **P 132.**

HM 2248. Limestone, orange/red/brown. House A. (Demargne & de Santerre 1953, 18 and pl. X.)

Pseira HM 1154*. Limestone, light green/grey. N.F.C. (but marked with tomb number so probably from early cemetery). **P 133.**

Plus one other (Knossos). **Total 6**

G. *Galana Kharakia* HM 2595*. Serpentine, light green/grey, brown. (For the site Platon 1956, 416.) **P 134.**

Platanos HM 1989*. Serpentine. Tholos A annex.

Tsoutsouros HM 4*. Serpentine. N.F.C. Gift of Evans. **P 135.**

Plus six others, 4 Mesara, 1 Galana Kharakia, 1 Crete. **Total 9**

H. *Koumasa* HM 714*. Chlorite. Tholos B.

Mallia HM 2193. Brecciated serpentine, maroon with grey/black and green/grey pieces. Nécropoles des Pierres Meulières (mainly MM I). (H & M van Effenterre 1963, 65 and pl. XXVI.) **P 136.**

Platanos HM 1694*. Serpentine, mottled light brown and grey/black. Tholos A annex. **P 137.**

HM 1695. Serpentine. As last. (Xanthoudides 1924, pl. LIII*a*.)

HM 1876*. Limestone, mottled maroon and white. As last. **P 138.**

Plus six others, 5 Mesara, 1 Galana Kharakia. **Total 11**

I. *Koumasa* HM 781*. Marble (or limestone), grey with white veins and patches. Tholos A. **D 84.**

Platanos HM 2529*. Breccia, grey/white with maroon, grey/black and green pieces. Tholos A annex. **D 85.**

HM 2530*. Serpentine, mottled buff and greenish grey. As last. **D 86.**

Porti HM 1086*. Serpentine. **D 87. P 139.**

Pseira ? HM unnumbered*. Serpentine. HM Apotheke box. **D 88.**

Trapeza HM 2383. Serpentine, pale grey with yellowish tinge and network of grey/black veins. (H. W. Pendlebury 1935–6, fig. 24, 21.) **D 89.**

6 plus 7 others. **Total 13**

J. *Arkhanes* HM 3051*. Two solid horizontal lugs on belly with vertical nicks. Cf. HM 1260 below; also type 36 **A** Voros and Kea which have lugs but lack the everted rim. Steatite and serpentine. Rectangular tomb with child burials. LM ?I. ("Εργον 1966, 141.)

A. Triadha HM 643. Dolomitic marble, grey and white mottled. Large Tholos. (Banti 1930–1, 183.) **D 90. P 140.**

Gournia HM 88. Serpentine. 'Hill House.' Context not stated. (Boyd Hawes 1908, pl. V 22.) **D 91. P 141.** Plus two others, close to this, from Platanos and Prasa.

Mochlos HM 1260. Steatite, green and green/black with creamy patches. Tomb IV. (Seager 1912, fig. 18 IV 6 and pl. VII.) **D 92. P 142.**

Plus 3 others (Knossos). **Total 9**

There are nine fragments from Knossos. Their precise groups within **A–J** cannot be determined. **Groups A–J: Total 200**

K. 1. *Mochlos* HM 1170. Serpentine, brown with patches. Decorated with LM I Foliate Band carved in relief. Town site. Block A. LM IB. (Seager 1909, 280–1, fig. 4 top row right.) **D 93. P 143.**

BM 1921 5–15 27*. Serpentine. Bowl similar to last, with horizontal grooves below rim. **D 94. P 144.**

2. Imitations of LM clay cups. All fragments.

Knossos HM 583*. Calcite, white with one or two fine orange bands. Hogarth's Houses (1900 excavations). LM I. **D 95.**

AM AE 1502*. Alabaster, Egyptian. N.F.C. **D 96.**

HM 2398*. Serpentine. Rim fragment; shape close to last but more carefully carved; shallow spirals with solid centres (cf. Alabastrons, type 1 **B**) carved on outside. Probably LM II–III A I. Acropolis Hill, W. of Palace. N.F.C.

HM unnumbered*. Serpentine. LM IIIA bowl imitation with small sharp-edged everted rim. Sellopoulo. LM IIIA–B tombs. (For the site, *Arch. Reps. for 1957*, 24–5.)

3. Individual bowls

A. Triadha HM 346*. Serpentine. Horizontal flutings below rim. Palace. LM I. **P 145.**

Katsamba HM unnumbered*. Gypsum, white with brownish tinge. Fragment of large bowl with whorls in relief round rim. Plundered tomb by Cinema, probably LM II–IIIA I like most of cemetery. (Site, Platon 1959, 385.)

Knossos AM 1938.464*. Serpentine. Body fragment of fine, thin-walled bowl, shape ? as HM 346, with LM I Foliate Band in relief. N.F.C. **D 97.**

AM 1938.466*. Obsidian, black, fuzzy. Rim fragment of deep bowl with ribbed decoration round rim. N.F.C. **D 98.**

AM unregistered*. Gypsum, grey/white. Rim fragment of deep bowl with horizontal flutings below rim. N.F.C.

Pseira HM 1145*. Serpentine. Thick-walled bowl with slightly everted rim. N.F.C. **P 146.**

Tylissos HM 1554. Serpentine, brown with grey/black patches. Large bowl. Thickened rim. LM I. (Hatzidhakis 1921, 54, fig. 28 b.)

Zakro HM 2735*. Calcite, translucent creamy. Thin-walled deep bowl with everted rim, on small foot. Palace Room Ee. LM IB. **D 99.**

Total 14
Type Total 214

9. BOWLS WITH HORIZONTAL GROOVES OR DIAGONAL FLUTING

A. High-shouldered, profile as Blossom Bowls, with shallow, fluted, horizontal grooves round the shoulder.

B. High-shouldered, profile as Blossom Bowls, with diagonal fluting over the body.

A. The type begins in MM I–II (one example from Knossos) but flourishes in MM III–LM I. There are examples in LM I contexts at Gournia, Mallia, Palaikastro and Vathypetro and one in an MM III B context at Knossos. A few are from predominantly LM I sites without contexts and a few others survive into LM II–III A I and later LM III. Two were exported to Kea and one to Kythera.
Serpentine unless otherwise stated. If no date is given the vase is from an LM I context.

Galana Kharakia HM unnumbered*, ditto*. Mnemouria deposit 2 and 3. N.F.C. (For the site Platon 1954a, 512; 1956, 416–17.)
Gournia HM 83. (Boyd Hawes 1908, pl. V 4.)
HM 84*. N.F.C. **D 100.**
Penn. MS 4153*, probably from LM I town.
Kamilari HM 2860*. (Tomb in use to LM III.)
Karteros Mapheze HM 2176. LM III B tomb. (Marinatos 1927–8, 70, 72 and pl. I, 12.)
Knossos KSM (1957–61). Fragment; Hogarth's Houses; MM I–II (HH/B8). Fragment; Hogarth's Houses; MM III B (HH/K 28).
HM 2405. LM II B tomb near Temple Tomb. (Hutchinson 1956b, 73 no. 19 and fig. 2 and pl. 7f.)
Mallia HM 2133. Palace Room XXVII 3. (Chapouthier & Joly 1936, 39 no. 3 and pl. XXI a, XXXIV e.)
Palaikastro HM 150. Limestone, hard grey (not steatite, as published). House B Room 29. (Bosanquet 1901–2a, 316, and Excavation Notebook for 1902, under B 29.)
HM 627*. N.F.C.
HM unnumbered*. Box in Museum Apotheke

marked X 47, and so if from that room, LM III context (*B.S.A.* 1904–5, pl. X).
Pseira HM 1131. (Maraghiannis 1911, pl. XIX below 3.) **P 147.**
HM 1132. (*Ibid.* pl. XIX above 2.)
HM 1134*.
HM unnumbered* (Apotheke box). Penn. MS 4529*. All N.F.C., but type shown as LM I (Seager 1910, fig. 15g).
Vathypetro HM unnumbered*. (Mentioned Marinatos 1951, 261–2.)
Kea K 4.213*. K 3.95* (not stratified, near modern surface).
Kythera Kythera M. Three additional grooves above base. Tomb C, 1963 excavations. Mainly MM III. (Huxley, *Arch. Delt.* 19, 1964, 147 and pl. 150a.)
Phylakopi NM 5808 I. Third City. (Bosanquet & Welch 1904, 197 and fig. 169.)
A special form, best classified here, is from Khersonesos, AM AE 212, breccia, pink/brown, pink/grey, in maroon matrix. N.F.C. (Evans 1895, fig. 122.) **Total 25**

B. In this group all are serpentine and all probably MM III–LM I, though only one had a clear LM I context.

Galana Kharakia HM unnumbered (A 17)*. Fragment. For site see Site List p. 194 n. 2.
Gournes HM 2044. Tomb 4. LM III B. (Hatzidhakis 1918, 83 and fig. 27, 5.)
Knossos HM 2153. Marvo Spello Tomb III.

LM I–III B. (Forsdyke 1926–7, 254, 289 and pl. XX III 19.) **P 148.**
Mallia HM 2117. LM III burials. (H & M van Effenterre 1963, 124 and pl. L.) **P 149.**
Palaikastro Block N. Too rotten to be pre-

served. L M I B. (Sackett, Popham & Warren 1965, 306.)

Crete H M 423*. Mirabello district. N.F.C. **P 150.**

Phylakopi N M 5808 2. Third City. (Bosanquet & Welch 1904, 197 and fig. 168.) **Total 7**

10. BOWLS WITH RIM LUGS OR HANDLES

Open bowls with rim lugs (usually two or four, occasionally one or three), or handles, sometimes with moulded base. There are five main forms.

A. Open bowls with lugs level with the rim, of varied materials, chlorite and steatite together being used for over a third of the examples. This form is most popular at Mochlos (13 examples) and occurs sporadically through the rest of the island. The fact that Mochlos and other N. Cretan sites, Knossos, Krasi, Mallia, Mirsine, Pseira and Trapeza, provide nearly two-thirds of the total is the more interesting since this form is linked to the Cycladic Syros Group (contemporary with the latter part of E M II and with E M III). One vase, of banded tufa, was exported to Phylakopi. Two of the Mochlos vases are from tombs where the few clay pots are E M II, one from where they are E M II–III, whilst the Lebena and Mirsine vases had E M II–MM I contexts. In view of this and the popularity of chlorite and steatite it may be concluded that the type began in the latter part of E M II and continued to be made in M M I. None of the vases has incised decoration and only one has a pierced lug, so they will be later than the earliest group. That marble is popular at Mochlos and Mirsine has no chronological significance since it is not rare in that region. There are seven varieties of Form **A.**

1. *Mallia* H M 2204. Serpentine, network of grey/black veins. Palace, W. Façade. N.F.C. (Chapouthier & Demargne 1942, 67, fig. 41 and pl. LIV 3 c.)
Mochlos H M 1592*. Breccia, creamy matrix with grey/black pieces. **D 101.**
Palaikastro H M 934*. Calcite, translucent deep brown with opaque white patches. N.F.C.
Porti H M 1052. Chlorite. (Xanthoudides 1924, pl. XXXVIII.)
H M 1063. Banded Tufa. (*Ibid.* pl. XXXVIII.)
Trapeza H M 2361. Serpentine, light brown/buff with grey/black patches. (H. W. Pendlebury 1935–6, fig. 23, 14.) **P 151.**
Plus fragments of two others, E. Crete.

2. *Lebena* H M unnumbered (L II 30)*. Serpentine, mottled red/brown, grey/black, pale green/buff. Tomb II. EM II–MM I A.
Mochlos H M 1277. Limestone, grey/black with white calcite vein. Tomb XV. (Seager 1912, fig. 37 XV c.) **P 152.**
H M 1251. Banded Tufa. Tomb XVI. (*Ibid.* fig. 37 XVI 2.)

Praisos A. Nik. M. 1089*. Chlorite. N.F.C. (chance find).
Siva H M 1614. Chlorite. S. Tholos. (Paribeni 1913, 17 no. 3 and fig. 2.)
Phylakopi British School at Athens M. Banded Tufa. N.F.C. (surface). (Bosanquet & Welch 1904 196, fig. 165.)

Plus fragment of one other, E. Crete.

3. *Koumasa* H M 746. Chlorite. Tholos B. (Xanthoudides 1924, pl. II.)
Krasi H M unnumbered*. Chlorite with serpentine. Slight carination below rim. N.F.C. (chance find by tholos).
Mochlos H M 1177. Marble, grey/black, grey/white banded. Tomb XIX. (Seager 1912, fig. 4 XIX 5.) **D 102. P 153.**
H M 1288. Marble, milky grey. N.F.C. (*Ibid.* fig. 47 M 14.)
H M 1290. Chlorite. N.F.C. (*Ibid.* fig. 47 M 8.)
Plus 2 others, fragments.
Mirsine H M unnumbered*. Marble, light and dark grey banded. Tholos.
Palaikastro H M 620*. Chlorite. Ossuary II.

EM II–MM I. (Dawkins 1903–4, 197 (see also fig. 1 *ibid.*, and Dawkins 1904–5, 269 for context). Knossos Apotheke PK/63/156*. Marble, grey, grey/white banded. EM II deposit below Block X Room 4 (1963 excavations).

Trapeza HM 2362. Chlorite. Small carination below rim. (H. W. Pendlebury 1935–6, fig. 23, 12.)

HM 2364. Marble, grey, creamy white banded. (*Ibid.* fig. 23, 11.)

Plus three others (Platanos, Pseira, Trapeza)

4. *Koumasa* HM 844*. Steatite, purple with olive green patches. Tholos E.

Mochlos HM 1289. Marble, grey, grey/black banded. Tomb v. (Seager 1912, fig. 18 v*f*.) **D 103**.

Platanos HM 1890. Chlorite. Tholos A. (Xanthoudides 1924, pl. LIV (wrongly numbered 1915).)

HM 1974*. Chlorite. Tholos Γ.

Porti HM 1049. Marble, grey/white with dark grey bands. Three lugs and hook handle. (*Ibid.* pl. XXXVIII.) **P 154**.

Pseira Penn. MS 4530*. Serpentine. N.F.C.

Trapeza HM 2363. Steatite, blue/black with browny tinge. (H. W. Pendlebury 1935–6, fig. 23, 19.) **P 155**.

5. *Mochlos* HM 1283. Chlorite. Tomb XVI.

(Seager 1912, fig. 37 XVI 3.) **P 156**.

HM 1284. Chlorite. Tomb XI. (*Ibid.* fig. 28 XI 9.) **P 157**.

HM 1291. Calcite, golden brown translucent with opaque creamy white patches. Tomb II. (*Ibid.* fig. 7 II *m* and pl. II.) **P 158**.

Plus one other (Crete, probably E. Crete)

6. *Kamilari* Phaistos Strat. Mus. unnumbered*. Chlorite.

Mochlos HM 1285. Chlorite. Tomb XVII. (Seager 1912, fig. 46 XVII*c*.) **D 104**. **P 159**.

7. A group of four individual vases.

Galana Kharakia HM unnumbered*. Serpentine, rust brown with grey/black patches. Everted rim, curved profile and two upright solid lugs from rim to belly. N.F.C.

Marathokephalon HM 2029. Banded Tufa. (Xanthoudides 1918, Παρ. 19, fig. 5 centre row left.) **D 105**.

Maronia HM unnumbered*. Serpentine. Two horizontal grooves below rim. Burial cave. N.F.C. (perhaps EM II, cf. pyxis HM 2339, type 33 **A**). (For site Platon 1954a, 511.)

Siva HM 1615. Chlorite. (Paribeni 1913, 18 no. 9.) **D 106**. **P 160**. **Total 49**

B. A larger open bowl with two lugs or two horizontal or vertically arched, bow-shaped handles, set just below the rim. The largest examples have the bow-shaped handles (*a*), whilst the lugs, horned or curved (*b*) are sufficient for the smaller ones. This is also a clay shape, with bow handles (pp. 169, 170 n. 13).

The type is found from MM I to LM I with examples well dated to MM I, MM II, MM III and LM I. Whereas group **A** is funerary these larger bowls are found in settlements (over twenty at Knossos) and were clearly for domestic use. One comes from the MM II Sanctuary at Mallia. Two were exported to Kea and three to Kythera.

(*a*)

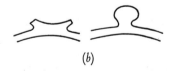

(*b*)

The material is serpentine unless otherwise stated.

Amnisos HM 2471*. N.F.C.

Galana Kharakia HM unnumbered (A 6). (*B.C.H.*

1955, 303, fig. 18 second row 3rd from right.)

HM unnumbered (A 7). (*Ibid.* second row 3rd from left.)

HM unnumbered (D 13)*, HM unnumbered Mnemouria Deposit 8*. Last N.F.C., first three from burial cave. They and HM 2225 are the only examples not from settlements.

Gournia HM 321. LM I. (Boyd Hawes 1908, pl. V 11.)

Kastellos Lasithi HM unnumbered. MM I–III. (H. W. Pendlebury 1937–8, 51 and fig. 20 no. 39 and pl. III.) Plus fragments of two others.

Knossos AM 1924.31*. N.F.C. **P 161.** Fragments of twenty-nine others, in contexts from MM IA onwards.

Mallia HM 2252. Palace, W. Façade. N.F.C. (Chapouthier, Demargne & Dessenne 1962, 57 and pl. XLIII.)

HM 2127. Quartier Γ. (Demargne & de Santerre 1953, 37 and pl. XIV.) **P 162.**

HM 2246. House A. (*Ibid.* 18 and pl. X.)

HM 2225. Band of incised decoration below rim. Cemetery. MM I. (H & M van Effenterre 1963, 66 and pl. XXVI.)

HM 2613*. MM I House, excavated 1957.

HM unnumbered*. Houses. MM I–LM I. Schist, grey with greenish tinge. **P 163.** MM II Sanctuary. With horned lugs. (Poursat 1966, 543, fig. 40 top right.) MM II Sanctuary. With bow-shaped handles and band of incised decoration below rim, as HM 2225. (*Ibid.* fig. 40 top left.) Plus 2 others, N.F.C.

Palaikastro HM unnumbered*. N.F.C. (HM Apotheke). Parts of several bowls of this type are sketched in the Palaikastro Excavation Notebooks, some from the LM I town. KSM (PK/62/5). Block N. LM IB. (Sackett, Popham & Warren 1965, 306–7, no. 57.)

Phaistos HM 2584 ? (F 1952 285)*. Room IL. MM II. (Levi 1952, Fiandra 1961–2 for date of room.) Phaistos Strat. Mus. F. 60 3531*, F 63 4536*, both MM contexts.

Pseira HM 1098*, HM 1125*, Penn. MS 4521*, HM unnumbered* (Apotheke box). (Seager 1910, 36, fig. 16, MM context, is one of these.)

Crete AM 1916.49*. Rim-body fragment. N.F.C.

Kea K 3.599*. K 6.381*, horned lugs.

Kythera Kythera M. 21*, 22*, 27*. Three bowls each with horned lugs. N.F.C. (To be published in forthcoming Kythera excavations report.)

There are nine larger and somewhat thicker examples of this shape.

Mochlos HM 1175. Tomb IV. MM III stratum. (Seager 1912, fig. 18 IV 1.)

HM 1590. Limestone, coarse white. Tomb XV. (*Ibid.* 66 XV g.)

Pakhyammos HM 2068*. MM. (Mentioned Seager 1916, 18.) **D 107. P 164.**

Palaikastro HM 900*. N.F.C. **P 165.**

HM unnumbered* (Apotheke). N.F.C.

KSM (PK/62/6). Fragment, with incised horizontal and diagonal lines below rim. EM III–MM I, below Block N. (Sackett, Popham & Warren 1965, 306–7 no. 56.)

Prasa HM 2438*. Apothete 4.30–5.0 m. MM I. (Site, Platon 1951 b, 246.) **P 166.**

Zakro HM 2636*. Building A, Room A lower level. MM III ? (For excavation, Ἔργον 1961, 221 sqq.; 1963 100.)

E. Crete Hierapetra M.* Limestone, soft white. Rim-body fragment. N.F.C.

Finally there are seven special examples.

Knossos HM 891. Bowl with curved profile, everted rim and one vertical handle from rim to lower belly, with grooved decoration. It was made in LM I–II in view of this grooving and the fact that it imitates LM I–II bronze bowls (from Basement Cell by Stepped Portico, Knossos, *PM* II, Fig. 395 a, b, c; from N.W. Treasure House, *PM* II, figs. 402–5; from the Tomb of the Tripod Hearth, *PM* II, fig. 398 b) with its handle, everted rim and incut interior base. Zapher Papoura Tomb 99. LM III B. (Evans 1905, 479 no. 99 d and fig. 100 d.) **D 108. P 167.**

Mallia HM 2125. Quartier Γ. (Demargne & de Santerre 1953, 37 and pl. XV.) **P 168.**

HM 2126. Quartier Γ. (*Ibid.* 37 and pl. XV.) **D 109. P 169.**

Palaikastro HM 1006*. Calcite, dark brown translucent with opaque white patches. Two

fragments, one with roll handle with horizontal grooves. The largest vase in this material. Block Ƶ, Room 2. N.F.C. (For the site, Dawkins 1903–4, 207–12.)

Phaistos HM 2546*. Gabbro. Everted rim, moulded base and one vertical strap handle from rim to base (handle has been restored too thick). Room L. MM II. (Mentioned Levi 1952–4, 445.) **P 170.**

HM 2582*. Two bow-shaped handles and two solid lugs. MM II ? Probably from Room L or LI (Levi 1952–4, 393 sqq.).

E. Crete Hierapetra M.* Body-base fragment, form as HM 2546. **Total 80**

C. A shallow bowl, open, with one bow-shaped handle or lug (one with strap handle). Pale mottled serpentine and chlorite are the materials and the form is confined to the Mesara, save for one example from Mallia. Six are from the Phaistos Palace, the remainder from the Mesara tombs. One of the Phaistos vases is from the shrine facing the West Court, so the form may have been for libations at shrine and tomb, but was probably also for domestic use. The Phaistos vases are MM IB–II and none of the tomb vases need be earlier than MM I.

A. Triadha HM 374. Small Tholos. (Paribeni 1904, 700 and fig. 10, 5.) **P 171.**

HM 634. Large Tholos. (Banti 1930–1, 182 and fig. 45a.)

Kamilari HM 2862. (Levi 1961–2, fig. 121c.)

Khristos HM unnumbered. (Xanthoudides 1924, pl. XL b 3rd row left.)

Koumasa HM 830*. Tholos B.

Mallia HM 2224. Loop handle restored, probably wrongly. MM I. (H. & M. van Effenterre 1963, 65 and pl. XXVI.)

Phaistos HM 633. West Court Shrine, Room VIII. MM II. (Pernier 1935, 226–7, fig. 104 left.) **P 172.**

HM 2566. Room LIV. MM II. (Levi 1955, 146, fig. 8i.)

HM 2558*. Room IL area East. MM II ? (Levi 1952; Fiandra 1961–2 for date of room). Phaistos Strat. Mus. F 55 934a*. Vertical strap handle. Ditto F 56 2083*. Lug, curving downwards. Ditto unnumbered*, as last.

Porti HM 1048. Straight stick handle. (Xanthoudides 1924, pl. XXXVIII.)

HM 1061. Stick handle, curving down. (*Ibid.* pl. XXXVIII.) **D 110. P 173.**

Siva HM 1607. South Tholos. (Paribeni 1913 18 no. 5). **Total 15**

D. A group of eight deep bowls, the first having a slightly everted rim and solid or pierced lugs below the rim, the others being plain bowls with ledge handles or solid horizontal lugs just below the rim. All are of serpentine, save one (HM 2784) of white limestone, and they are LM I. They come from the towns of Palaikastro and Zakro and from Knossos, where one is from an LM II Warrior Grave.

Knossos HM 2094*. N.F.C. **P 174**

HM 2435. Warrior Grave v. (Hood and de Jong 1952, 275 V 4, fig. 13 and pl. 56b.) (Reference Hood & de Jong, *ibid.* to another such vase, HM 2024, from Mallia, is wrong for the vase is HM 2094, from Knossos.)

Palaikastro HM 906. Block X hoard. LM IB.

(Dawkins 1923, pl. XXX, D 3.) **P 175.**

HM 545*. N.F.C. **D III. P 176.**

HM 899*. N.F.C.

FM GR. 206.1907*. N.F.C.

Zakro HM 2643*. Building B (1961).

HM 2784*. Building B, Room K (1963). Both LM IB. **Total 8**

E. Seven thin-walled bowls with two upright arched handles on the rim. Both handles and rim are carved with fine ribbed decoration and there are horizontal grooves below the rim. All are made of serpentine and the date of the form is MM III–LM I. They may well be imitations of metal forms.

Knossos KSM. Small fragments of three bowls. 1957–61 excavations. MM IIIA–LM I/II (RR/E 31). Unprovenienced material*. Rim-body fragment with one handle preserved.

Palaikastro HM 896. Block X hoard. (Dawkins 1904–5, 279 and fig. 10; 1923, 134, fig. 115 and pl. XXX, D 2.) **P 177.**

HM 897. As last. (*Ibid.* pl. XXX F 2.)

AM AE 890*. As last. (*Ibid.* 1904–5, 279.) **P 178.**

KSM (PK/62/17). Fragment. Block N. LM IB. (Sackett, Popham & Warren 1965, 306–7 no. 54.)

Total 8

Type Total 160

11. BOWLS WITH RIM SPOUT AND STRAP HANDLE AT RIGHT ANGLE TO SPOUT

This type has two forms. The first, **A**, is more elaborate, with rim lugs, incised nicks round the edge of the rim (like Tankards) and horizontal grooves round the body. It is an MM III–LM I form with four examples from the LM I towns of Pseira and Gournia and one exported to Kea. Though rather elaborate they would seem to have been for domestic use.

The second form, **B**, is without decorative detail and is an imitation of an LM III/LH III clay cup shape (see p. 171 n. 23). The Dendra and Mycenae vases may be of Mainland manufacture and the Minoan examples, found in LM III (probably A) contexts, Cretan, since the clay form occurs in both areas. Since the shape does not occur in clay before LM III the stone imitations were probably made then too, presumably in Crete early in LM IIIA before the fall of Knossos and the end of the palatial period. This form seems to have been for funerary use, all examples coming from tombs.

The material for both forms is always serpentine.

A. Decorated

Ht. 6.9. Diam. 11.8. Width, spout to lug, 14.35, lug to handle, 15.0. About half the handle and a few patches on the body restored; cracked. Drill rings round the interior. Gournia. HM 320. (Boyd Hawes 1908, pl. V 2.) **P 179.**

Ht. 7.95. Width, spout to lug, 15.1, lug to handle, 14.5. Complete. Drill rings round interior. Very carefully and neatly made. Lid. Pseira. N.F.C. but very probably from LM I town. HM 1113. (Seager 1910, 36 and fig. 15*i*. Maraghiannis 1911, pl. XIX above 6.)

Pseira HM 1110. N.F.C. (Maraghiannis 1911, pl. XIX below 5.)

HM 1112*. N.F.C. **P 180.** Both probably from town, LM I.

Crete MET. MUS. 26.31.430*. N.F.C. The handle is opposite the spout. Given by Seager and so very possibly from Pseira.

Kea K 6.302*. Fragment. **Total 6**

B. Plain

A. Triadha HM 375. Serpentine, pale grey/green with network of grey/black veins. Painted sarcophagus tomb. LM III. (Paribeni 1904, 717–18 and fig. 20.) **P 181.**

Knossos HM unnumbered (57/70)*. Serpentine, as last. Sellopoulo Tomb I. LM IIIA 2–B. (For site *Arch. Reps. for 1957*, 24–5.)

Dendra Tomb I. LH III. (Persson 1931, 86 and fig. 59.)

Mycenae NM (no. not visible)*. Chamber tombs. Context ?

Total 4

Type Total 10

12. BOWLS WITH VERTICAL GROOVES

These vases are usually shaped like Bird's Nest Bowls but sometimes have a curved profile like vases of type 6. The distinctive feature is the decoration of vertical grooves, usually from mouth to base, but in one instance only to the point of greatest diameter. The type has a wide distribution, though none are from the Mesara tombs. Serpentine is the commonest material, but chlorite and banded tufa are also used. Several examples are in MM I contexts and the small size, type of grooved decoration and varied materials confirm this dating for the whole class. One or two however (Phaistos) might be LM I because of their context and larger size. But their grooves are more typical of EM III–MM I/II incised decoration; LM I vases, like the Grooved Bowls (type 9), have either shallow and carefully fluted or more delicately carved grooves.

The material is serpentine unless otherwise stated.

Ht. 8.4. Diam. 16.45. Serpentine, light grey with light brown patches. Complete. Palaikastro, Aspa. LM IIIA tomb. HM 619. (Currelly 1903–4, 231.) **P 182**.

Elounda Neapolis M. 3. LM IIIB–C tomb. (Van Effenterre 1948, 57 and pl. XXI O 112.)

Gournia HM 550. MM I ossuary. (Boyd Hawes 1908, 56 and fig. 40, 9 (published originally, Boyd 1905, 188, fig. 6 11*g*, wrongly drawn as a Blossom Bowl).)

Katsamba HM unnumbered*. Plundered tomb (by Khronos Cinema). Probably LM IIIA. For the site Platon 1959, 385.

Knossos KSM (unprovenienced material)*. Small raised collar. N.F.C.

KSM, two fragments* (marble, pale–dark blue grey, orange, LM I and scraps of ? LM III; chlorite, MM–LM IA, with much MM IA) from 1957–61 excavations.

Mochlos HM 1257. Tomb XI, E. side deposit (MM I). (Seager 1912, fig. 28 XI 12.) **D 112**. **P 183**.

Palaikastro HM 145. Banded tufa, creamy brown, gypsum grey and pink. Ossuary VII. MM I. (Bosanquet 1901–2*a*, 296 and pl. XVII 3 top row 2nd from right. Dawkins

1904–5, 269 for date of ossuary). **D 113**. **P 184**.

Phaistos PIG.M. 77267. Palace Room 63*d*. LM IB. Vertical grooves down to point of greatest diameter. (Borda 1946, 37 no. 33 and pl. LI 12. Banti 1951, 177 no. 8 and fig. 108.)

HM 2564. Chlorite. Room LIV. MM II. (Levi 1955, 146, fig. 8*g*.)

Prasa HM 2449*. Serpentine, pale grey with network of grey/black veins. Fragment. Context not known.

Pseira HM 1140. Chlorite. N.F.C. (Zervos 1956, pl. 150 left.) **P 185**.

Tylissos HM 1570. Chlorite. With lid. N.F.C. (Hatzidhakis 1921, fig. 26 2nd row 2nd from left.) **P 186**.

OTAGO M. E.28.4*. N.F.C.

Crete TORONTO 964.116*. Serpentine, light mottled. N.F.C.

Kea K 4.306*, chlorite. K 7.23*, chlorite, with serpentine. Five separate groups of vertical grooves.

Total 18

13. BRIDGE-SPOUTED BOWLS

These may be divided into two groups: **A**, with wide flat collars and white-filled circular inlays on the body, from Knossos, and **B**, those without inlay, of more varied materials, from Knossos, Phaistos and Mycenae. Both groups have two arched handles on the shoulder. Several of the first group are from the North Lustral Basin and the Khyan lid stratum at Knossos, which is MM III (cf. Hood, *Nestor*, August 1964), characterised by pottery with white dots on a black ground. Two fragments come from LM contexts at Knossos. Hence we must date the type to MM III. On present evidence there are insufficient grounds for suggesting that it continues to be made in LM. Cf. Ewers, type 19 **A**.

The second group consists first of four superlative gabbro examples (see chapter III under Gabbro) exported to Mycenae, two from the LH II chamber tomb published by Bosanquet (1904), one from Tomb 76, also LH II, and a fragment from the Acropolis. Three of these vases are exactly parallel in shape (note especially the grooved handles) to polychrome MM II bridge-spouted bowls (*PM* I, figs. 197, 199 a, e; Pelagatti 1961–2, pl. Δ 2, Festos F 583) and were probably manufactured in MM II. Of the same date are two unpublished fragments from Phaistos. The Isopata vase is an MM II–LM I clay shape and might have been made in LM I. The separate spout from the Temple Tomb had no context and cannot be more closely dated than MM II–LM III A I. It is now paralleled by a Minoan spout fitted to an Egyptian early Dynastic bowl from the Zakro Palace Treasury, probably in LM IB, HM 2695, type 43 (Platon 1964 b, fig. 9).

A. Ht. 15.3 approx. Diam. 15.5. Width 18.6. Serpentine ?, brown (not limestone). One piece survives comprising part of the rim, a small part of the spout, part of one handle and part of the body, but broken off above the base. Knossos, North Lustral Basin. HM 1366. (*PM* I, 412–13, fig. 297.) **D 114. P 187.**
Ht. 10.95. Diam. 13.75. Width 14.8. Chlorite (not brown limestone, as published). Spout restored. Knossos. Isopata, Isolated Deposit near Tomb of Double Axes. Not a dated context. HM 1367. (Evans 1914, 3, fig. 1. Cf. *PM* I, fig. 298 a.) **P 188.** One other example has been restored: Serpentine ?, brown, from the Khyan lid stratum. AM AE 835*; there are fragments from at least two, perhaps four others in Oxford (AM 1938.469*, AM AE 836 (1)*, (2)*, AM AE 837*), another fragment in Herakleion, unnumbered*, and fragments of two more at Knossos, KSM (unprovenienced material)*, whilst fragments of two others were found in the 1957–61 excavations (HM 2792*, Chlorite, LM I–III context (Hogarth's Houses); Knossos RR/57/86, serpentine, brown, LM I context).

Total 10 or 12

B. Ht. 10.5. Diam. 12.0. Gabbro (not steatite, as published). About a quarter restored, including all one handle. Thin-walled. Handles grooved. Lid. Mycenae Chamber Tomb 102. NM 4922. (Bosanquet 1904, 325 and pl. XIV d.)

Ht. 23.9. Diam. 26.4. Width 29.9. Banded Tufa, creamy white translucent with thick greyish translucent bands. Most of upper part restored, but over half of whole survives, including both handles. Knossos, Isopata Royal Tomb. LM II–III A I. HM 598. (Evans 1905, 539 no. 12 and fig. 125 s 12.) **P 189.**

The other Mycenae gabbro examples are NM 4921, from Tomb 102 (Bosanquet 1904, pl. XIV c); NM 3050*, from Tomb 76; NM 2878, from the Acropolis, N.F.C. (Tsountas & Manatt 1897, 269, figs. 138–9). This has a Minoan Linear inscription of four or five characters on the handle, confirming the Minoan origin of this gabbro group. From Phaistos is a fragment in grey and white mottled marble, HM 194*, and one of chlorite, HM 491γ* (mentioned Pernier & Banti 1951, 389. N.F.C.). This latter has carefully cut shallow spirals (contrast those of the EM II pyxides, close together, like wire laid on in relief) corresponding to those of MM II clay vases (cf. Pendlebury 1939, fig. 23, 9). **P 190.** Another fragment from Phaistos (PIG.M. 77268 (Borda 1946, 37 no. 34 and pl. LII 10)) may be from a vase of this type. It has two rows of circular inlay holes separated by a raised band with incised criss-cross decoration. It is not from a rhyton, as Borda argues. LM I context. The spout, HM 2280, was a surface find at the Temple Tomb (*PM* IV, 976 and Supplementary Plate LXVI a 1, 2). Evans (1905, 539, under no. 12) notes an MM* fragment from the Palace. **Total 10**

14. BUCKET-JARS

A large cylindrical jar, the sides sometimes sloping in to the base, with a spout, usually bridged, at the rim, two horizontal handles on the body (normally near the top) and, usually, a button handle on the body opposite the spout.

At Mallia one example is well dated to MM I (HM 2333, Khrysolakkos) and three from Quartier Γ (HM 2123, 2313, 2314) very probably to MM I, since there was little later material from that area and all the other stone vases from it are MM I types. Thus the type began in MM I and the examples from Kastellos Lasithi and Knossos confirm its existence in MM times. The *floruit* however is LM I, on the town sites of Gournia and Pseira, in the villas of Tylissos and at A. Triadha and in the settlement at Kea. It was clearly for domestic use, perhaps for oil.

It is found in LM II–III A I contexts at Knossos, Isopata and Katsamba. These are probably survivals from MM III–LM I as is that in the LM III B tomb at Stamnioi Pedhiadha. The one Mainland example, from the LH III Nauplion tombs, is almost certainly Minoan in view of the popularity of the form in Crete (Mallia alone has eight examples) and its absence otherwise on the Mainland. Four were exported to Kea.

The material is usually serpentine but dolomitic marble, banded limestone, white limestone and banded tufa are also found.

Ht. 20.6. Width, spout to handle, 27.65. Serpentine. About half the body, a third of base, one handle and half the other, and the button handle survive. Many clear drill rings round the interior. Mallia Quartier Γ. HM 2123. (Demargne & de Santerre 1953, 36 and pl. xv.) **D 115. P 191.**

Ht. 34.0. Diam. 30.0. Serpentine. About a third, including whole profile and one handle preserved, rest restored. No button handle. Tylissos. HM 1553. LM I. (Hatzidhakis 1921, 53, fig. 28 a.)

Ht. 19.15. Diam. 21.2. Width (spout across) 23.5. Limestone, banded, grey, grey black. Complete, save slightly worn near base. Knossos, Isopata Royal Tomb. LM II–III A I. HM 599. (Evans 1905, 149–50 no. 14 and fig. 123 s 14.) **P 192.**

A. Triadha HM 1010*. Serpentine. N.F.C., but probably Palace, LM I.

Amnisos HM 2904*. Serpentine. Motel site (excavations of Alexiou, 1963). LM I.

Gournia HM 324. Serpentine. Sloping sides. LM I. (Boyd Hawes 1908, pl. III 61.)
HM unnumbered*. Serpentine. N.F.C., but probably from town.

Kastellos Lasithi HM unnumbered. Serpentine. Many pieces of body missing. MM I–III. (H. W. Pendlebury *et al.* 1937–8, 49, 51 and fig. 20 nos. 40, 43 and pl. III.)
HM unnumbered. Serpentine. Base fragment. MM I–III. (*Ibid.* 51 no. 19.)

Katsamba HM 2882. Serpentine. The largest and finest of the type. Tomb H. LM III A I. (Ἔργον 1963, fig. 192. Alexiou 1965, 33, fig. 5.)

Knossos HM 25*. Banded tufa, creamy white with thick darker wavy bands. Palace. N.F.C., but probably destruction context (1st year of excavs.).
KSM (1957–61), Hogarth's Houses E. Ext. 44*, MM II ? A. Spout preserved. Also 12 other fragments* mostly from MM IIIB–LM I contexts.

Mallia HM 2421. Dolomitic marble, white and grey/black mottled. House Zb. LM I. (Deshayes & Dessenne 1959, 65–6 and pl. XIX 4.) **P 193.**
The lower part of another, serpentine, was found in the same house. (*Ibid.* 64 no. 11 and pl. XIX 6.)

HM 2428. Limestone, pale buff to brown. House E. MM I–LM I. (*Ibid.* 134 no. 2 and pl. L I.) **P 194.**

HM 2313. Serpentine. With lid. Quartier Γ. (Demargne & de Santerre 1953, 56 and pl. xv.)

HM 2314. Serpentine. Quartier Γ. (*Ibid.* 56 and pl. xv.)

HM 2112. Serpentine. LM III burials. (H. & M. van Effenterre 1963, 124 and pl. L.)

HM 2333. Serpentine. Khrysolakkos. (Demargne 1945, 51 and pl. LXIII.)

Pseira HM 1096. Serpentine. LM I. (Seager 1910, 36–7, fig. 15 h (probably).)

HM 1097. Serpentine. Three solid handles at the rim, one solid ledge handle below the rim. (*Ibid.* fig. 15 l (possibly).)

Stamnioi Pedhiadha HM 2461. Serpentine. With lid. LM IIIB. (Platon 1952 b, 626, fig. 6.)

Kea K 1.572*. Limestone, soft white.
K 1.552*. Limestone, soft pale grey/buff. Base fragment.
K 4.451* Serpentine. Base fragment, probably from Bucket Jar.
K 6.340*. Serpentine. Area G. LM IB and a little LM III A I.

Nauplion NM 3524*. Serpentine. Everted rim with horizontal groove round it. LH III A–B tombs. **Total 39**

15. CHALICES

A tall goblet on a pedestal base, which is sometimes made separately.

Until recently these magnificent vases were known only from the Mycenae Shaft Graves and Rhyton Well, from Thera, and through one on the Tiryns gold ring (Marinatos & Hirmer 1960, pl. 207a). There is also a probable example on the Knossos Camp Stool Fresco. But in 1963 seven whole or fragmentary examples in stone were found in the Zakro Palace (Platon 1964b, figs. 11–13) whilst Professor Caskey has discovered three in the settlement on Kea. Four objects, whose nature has not previously been determined, can now be seen to be bases of such chalices, so that the total for the type is twenty-two. All are Minoan, MM III–LM I. Their function was clearly ritual, as shown by find context and representation on the ring and fresco. They show great variety of material, examples occurring in obsidian, lapis Lacedaemonius, gabbro, Egyptian alabaster, and polychrome mottled and banded limestones. They are amongst the finest products of the MM III–LM I lapidaries and the Zakro obsidian vase, for technical achievement as well as aesthetic effect, must rank as one of the supreme creations of the Aegean prehistoric world.

Ht. 28.6. Diam. 13.25. Obsidian, black with white spots, translucent. Complete, though cracked. Horizontal grooves below the rim and above pedestal base, and ribbed decoration and mouldings on base. Zakro Palace Treasury. LM I. HM 2725. (Platon 1964b, fig. 11.) **P 195.**

Karnari HM unnumbered*. Lapis Lacedaemonius, dark green matrix with light green crystals. Fragment, most of base. N.F.C. From Minoan settlement on S.W. side of Mt Juktas, S. of Knossos. (For site Marinatos 1949, 108–9; 1950, 251; *B.C.H.* 1949, 311; Platon 1949, 594.)

Knossos HM 2108. Limestone, banded polychrome, grey/purple and creamy yellow. A base. Found with LM IA sherds. (*PM* II, 127, fig. 62a.) **P 196.**

KSM (HH/58/22*, K 11). Obsidian, black with white spots and veins. Small fragment of a base with decoration of horizontal grooves. Hogarth's Houses. LM IB.

Mallia Limestone, white, marble-like. Fragment of a base. House E. N.F.C., but house mainly LM I. (Deshayes & Dessenne 1959, 137 and pl. L 2 centre.) Serpentine. Fragment of base. House E, as last. (*Ibid.* pl. L 2 right.)

Pseira Penn. MS 4525*. Serpentine. Part of vase without a base; might be part of the goblet of a chalice. N.F.C.

Zakro HM 2734. Limestone, banded light grey, grey/black. Quatrefoil shape, probably imitating metal. Separate base with stepped mouldings at its top and bottom. Palace Treasury. LM I. (Platon 1964b, fig. 13.)

HM 2711*. Gabbro. Complete. Base separate. Palace Treasury.

HM 2726. Limestone, mottled polychrome, white/grey/maroon. Carved with shallow horizontal flutings. Separate base. Palace Treasury. (Platon 1964b, fig. 12.)

HM 2777*. Limestone, mottled and banded, light–dark grey and maroon. Made in one piece. Base and lower part of body, and non-joining rim fragment preserved. Horizontal mouldings at base of body. Palace Treasury.

HM 2793 & 2794 BIS*. Alabaster, Egyptian. Most of separate base and one body fragment preserved. Horizontal mouldings at bottom of base. Palace Treasury.

HM 2792*. Limestone, soft white, *covered with bronze*. A base, fragmentary. Horizontal mouldings. Unique in technique of plating with bronze. Palace Room Ee. LM I.

Kea K 0.14*. Limestone, polychrome, greenish grey and purple/maroon. Quatrefoil shape. Base (separate) missing. Each of the quatrefoil corners has horizontal flutings. LM IB destruction context. (Mentioned Caskey 1962, 272.)

K 1.457*. Antico Rosso ?, purple maroon, fine grained. Upper part preserved, base missing. LM IB context, as last. (Mentioned *ibid*.)

K 1.84 A–B*. Marble, grey banded, fine grained crystalline. Rim fragment and fragment of base of goblet preserved. Quatrefoil or multifoil shape. Context as last. (Mentioned, *ibid*., as pyxis.)

Mycenae NM 600. Limestone, creamy translucent, marble-like (almost calcite). Separate base. Most of body restored. Horizontal flutings below rim and at top and bottom of base. IVth Shaft Grave. (Karo 1930–3, pls. CXXXVIII–CXXXIX.)

NM 854. Limestone, white, marble-like, translucent. Made in one piece. Mouldings at top and bottom of base. (*Ibid.* pl. CXXXVIII.) Vth Shaft Grave. **D 116.**

Nauplion M. Limestone, as previous. Base only. Rhyton Well. LH III pottery but stone vase fragments original MM III–LM I imports. (Wace 1919–21, 201–2 and pl. XII B.)

Nauplion NM 3522. Limestone, polychrome banded, white, beige, deep pink, purple and orange in pastel shades. Base only. Tomb II. LH III. (*PM* II, 127, fig. 62 b.) Evans (*ibid.*) speaks of a pair; one is on display in NM.

Thera NM 3964. Alabaster, Egyptian. N.F.C. but probably from MM III–LM I settlement. (Zervos 1957, pl. 9.) **Total 22**

There are two chalices of slightly different form, both serpentine and from LM IB contexts, the A. Triadha Chieftain Cup and a similar vase, without decoration, from Pseira.

A. Triadha HM 341. The Chieftain Cup. Palace. LM I. (*PM* II 742 sqq., 790 sqq. Forsdyke 1952. Marinatos & Hirmer 1960, pls. 100–2.) **P 197.**

Pseira HM 1123. (Seager 1910, 36, fig. 15 m. Zervos 1956, pl. 489.) **D 117.** **Total 2**

16. CONICAL CUPS

This class copies the common MM III–LM I clay conical cup. It is found at Knossos, Mochlos, Palaikastro and at Kea and in the Vapheio tholos. One of the Knossos vases is from an MM IIIB context. The others from Knossos and elsewhere that have clear contexts are LM I. Ordinary serpentine is the predominant material; there are three examples in soft white limestone and one probably in antico rosso.

Knossos KSM (1957–61): (1) Hogarth's Houses, serpentine, MM IIIB (D 5).

(2) Royal Road, soft white limestone, LM IB (JK 65).

Parts of five others (two of soft white limestone, three of serpentine).

Mochlos HM 1185. Serpentine. Tomb XV. MM–LM I. (Seager 1912, fig. 37 xv f.) **D 118.**

HM 1595*. Serpentine. N.F.C. (Perhaps from the town (LM I) in view of its shape and the fact that it is not recorded as coming from the tombs). **D 119. P 198.**

Also HM 1184*, serpentine, twin of HM 1185.

Palaikastro HM 504. Serpentine. Rim-body fragments, one with Linear A inscription. Block E Room 33. LM IB. (Dawkins 1902–3,

295. *PM*, I, 631, fig. 469. Evans & Bosanquet 1923, 144, fig. 126. Brice 1961, 14 no. I 12 and pl. XIX.)

Crete AM AE 1505*. Serpentine. Perhaps from Knossos. N.F.C.

Kea K 4.328*. Serpentine. Rim fragment.

Vapheio NM 1851–3*. Fragments of three (one antico rosso ?, two serpentine). Tholos. LH IIIA (= LM IB). **Total 16**

17. CUPS

There are a number of variant forms but the common feature is a bowl with a handle, meant for drinking and perhaps libations.

A. The first and largest group, found almost exclusively in the Mochlos and Mesara tombs, has a shallow bowl with a straight or hook handle extending from the rim. These vary from tiny or small examples (**1**), to larger shallow vases of the same form (**2**), and a group of fine, slightly deeper cups from Mochlos with the same type of handle (**3**). Steatite and chlorite are popular for the small examples, which probably date from the latter part of EM II and EM III. The whole group almost certainly flourished into MM I in view of the numbers from the Mesara tombs. The materials are varied as usual at this time, serpentine, chlorite, steatite, marble, limestones, banded tufa and breccias. From its find circumstances the group is clearly funerary, the vases presumably being used for offerings or to accompany the dead. One vase, probably a cup, was exported to Asine.

B. A deeper form with straight sides curving into the base and vertical strap or circular section handles. These vases, of marble and serpentine, are found in tombs and in settlements and were probably for practical use, sometimes being placed with the dead. Some are in MM I contexts and all probably belong to the EM III–MM I period. A fragment of one was found at Karphi, a survival.

C. A small group, of MM I–II date, imitating the standard forms of carinated thin-walled polychrome clay cups of this period, and two imitating an MM IB metal type with crinkly rim.

D. Individual forms of varied materials, some in MM I contexts, all probably EM III–MM I.

E. A group of deep cups with strap handle. The handle is usually decorated with vertical grooves. The type begins in MM IA (Knossos, cf. Platanos) and flourishes in LM I, when the vases are closely comparable to a standard LM I pottery shape. Most come from LM I contexts at Palaikastro. The Arkhanes royal tholos example is probably LM I in view of its material and decoration, but in shape it is close to an LM IIIA 2 cup from the tomb. Serpentine is the predominant material.

F. A few special LM I or later examples, including two very finely worked imitations of clay or metal Vapheio cups.

A.1. *A. Triadha* HM 376. Serpentine, pale grey with network of grey/black veins. Small Tholos. (Paribeni 1904, 700 and fig. 10 1.) **D 120. P 199.**

Koumasa HM 744. Chlorite. Tholos B. (Xanthoudides 1924, pl. XXII.) **D 121.**

HM 745. Chlorite. As last. (*Ibid.* pl. XXII.) **D 122. P 200.**

Mochlos HM 1217. Marble, creamy brown, grey, grey/black banded. Tomb V. (Seager 1912, fig. 18 V*e*.) **D 123. P 201.**

HM 1219. Steatite, green/dark green translucent with creamy patches. Tomb XI. (*Ibid.* fig. 28 XI 4.) **P 202.**

HM 1221. Chlorite. N.F.C. Surface. (*Ibid.* fig. 47 M 9.) **D 124. P 203.**

HM 1223. Steatite, dark green/black with creamy patches. Tomb V. (*Ibid.* fig. 18 V*h*.) **D 125.**

HM 1224. Chlorite. N.F.C. Surface. (*Ibid.* fig. 47 M 4.) **D 126. P 204.**

HM 1225. Steatite, dark green/black translucent. Tomb XI. (*Ibid.* fig. 28 XI 7.) **D 127. P 205.**

Palaikastro HM 924. Serpentine. Ribbed decoration on handle; small spout on rim. Block X hoard. LM I (survival). (Dawkins 1923, pl. XXX A 4.) **D 128. P 206.**

Porti HM 1042. Chlorite. (Xanthoudides 1924, pl. XXXVIII.) **D 129. P 207.**

HM 1043. Chlorite. (*Ibid.* pl. XXXVIII.) **D 130. P 208.**

HM 1044. Chlorite. (*Ibid.* pl. XXXVIII.) **D 131.**

HM 1046. Limestone, pale grey/green merging to pink. (*Ibid.* pl. XXXVIII.) **P 209.**

HM 1047. Serpentine, pale green/grey with grey/black veins. (*Ibid.* pl. XXXVIII.) **P 210.**

Asine Chlorite. Settlement. Early Helladic fill. (Frödin & Persson 1938, 243 no. 1.) Probably this type, though it might be a bowl with one rim lug.

16 plus 23 others. **Total 39**

2. *A. Triadha* PIG.M. 75158. N.F.C. (Borda 1946, 72 no. 11 and pl. LII 2.)

Koumasa HM 740. Serpentine, brown with greenish and grey/black patches. Tholos B. (Xanthoudides 1924, pl. XXII.) **D 133. P 211.**

Porti HM 1076. Chlorite. (*Ibid.* pl. XXXVIII.)

3 plus 3 others. **Total 6**

3. *Mochlos* HM 1214. Marble, grey, grey/black banded translucent. Tomb XXI. (Seager 1912, fig. 46 XXI 3.) **D 134. P 212.**

HM 1215. Banded Tufa. Tomb XVI. (*Ibid.* fig. 37 XVI 5.) **D 135. P 213.**

HM 1216. Breccia, creamy white matrix with black and a few orange/red pieces. Tomb XVI. (*Ibid.* fig. 37 XVI 6.)

HM 1226. Marble, creamy brown, grey, grey/black banded. Tomb XVIII. (*Ibid.* fig. 46 XVIII*a*.) **D 136. P 214.**

4 plus 1 other. **Total 5**

B. *Kalyvia Mesara* HM 180. Serpentine. LM III. Survival. (Savignoni 1904, 553 no. 6, fig. 37 top row 2nd from right.) **P 215.**

Karphi HM unnumbered. Serpentine. (*B.S.A.* 1937–8, 123 no. 209 and pl. XXX 1.)

Mallia HM 2289. Serpentine. Quartier Γ. (Demargne & de Santerre 1953, 37 and pl. XV.) **P 216.**

Porti HM 1064. Serpentine ?, dark brown with tiny black and gold particles. (Xanthoudides 1924, pl. XXXIX*a*.) **D 137. P 217.**

4 plus 5 others. **Total 9**

C. *A. Triadha* HM 377. Chlorite, bright green. Horizontal flutings, imitating metal work. Small Tholos. (Paribeni 1904, 699–700 and fig. 10 6.) **P 218.**

Kato Sime Viannos AM AE 218*. Serpentine. Cup with crinkly rim on pedestal foot. Exact parallel in silver from Gournia, MM I ossuary (Boyd 1905, fig. 61*e*). N.F.C. **P 219.**

Knossos KSM (unprovenienced material)*.
Marble, white. Fragment, carinated profile.

Mallia HM 2233. Serpentine. Cf. HM 2552
below. Cemetery, Second Charnier. MM I.
A standard MM I clay form. (Demargne 1945,
24 and pl. XXXI 2 and XLIII.) **P 220.**

Phaistos HM unnumbered*. Serpentine. Cari-
nated profile, crinkly rim as AM AE 218.
N.F.C.

HM 491 *a*★. Chlorite. Carinated profile, linked
relief spirals and chevrons below. N.F.C.
(Mentioned Pernier & Banti 1951, 389.)
P 221.

HM 491 *b*. Chlorite. Carinated profile. Frag-
ment, with circle surrounded by small
circles, cut out for inlays. N.F.C. (*Ibid.* 382
and fig. 243 *e*.) **P 222.**

HM 2552. Calcite, pale grey/white trans-
lucent. Carinated form. Room LIV. MM II.
(Levi 1955, 146, fig. 7.) **D 138.** **Total 8**

D. *Knossos* HM 892★. Serpentine. Zapher
Papoura. LM III (probably A). Probably MM I
survival in view of small size and everted
rim; cf. HM 2145 though HM 892 does not
have the moulded base or little spout.

HM 2144. Serpentine, light green/grey with
grey/black mottled veins. Small spout at
right angles to handle, similar to small jugs.
Mavro Spelio Tomb XVII. MM IIB (or ? MM
III). (Forsdyke 1926–7, 280 and pl. XX no. 17
P 15). **P 223.**

HM 2145. Chlorite, with serpentine. Tiny
cup with everted rim, moulded base and
small rim spout. Mavro Spelio Tomb VII.
MM II/III–LM III. (*Ibid.* 263 and pl. XX no. 7 A
21.) **P 224.**

Mallia HM 2307. Banded tufa. Small spout
at right angles to handle. Quartier Γ.
(Demargne & de Santerre 1953, 37.) **D 139.**

Platanos HM 2523★. Serpentine, mottled buff,
brown, dark grey. Tholos A annex.

Porti HM 1055★. Chlorite with gritty black
inclusions. **D 140.**

HM 1069. Limestone, hard white. (Xanthou-
dides 1924, pl. XXXIX *a*.) **D 141.**

Plus HM 2522★ (as HM 2523), HM unnumbered
Galana Kharakia A 8 (as HM 2144), HM 1893★
(Platanos) **P 225** (cf. also with Group A 1), and
HM 2868 (Kamilari), as HM 1055. **Total 11**

E. Serpentine unless otherwise stated.

Arkhanes HM 2909★. Groove below rim;
grooved and fluted decoration on handle.
Royal Tholos. LM III A 2.

A. Triadha HM 348★. Limestone, grey. Palace.
N.F.C. but probably LM I. **P 226.**

Knossos KSM (1957–61) RR/58/151 (plus joining
fragments)★. Royal Road MM IA (F 26 A and
other levels).

Palaikastro HM 445★. Marked B 40 so probably
LM I context.

HM 446★. Patema. N.F.C. **D 142. P 227.**

HM 901★. Block X hoard. LM I. **D 143. P 228.**

HM 902. As last. (Dawkins 1923, pl. XXX F 1.)
P 229.

HM 903★. As last. **P 230.**

HM 904★. As last. **P 231.**

HM 905★. As last. **D 144. P 232.**

HM 930★. As last. **D 145. P 233.**

HM 931. As last. (Dawkins 1923, pl. XXX E 1.)
D 146. P 234.

KSM 3 cups (PK/62/24, 62/47 (with small rim
spout), 62/48) as HM 930, Block N. (Sackett,
Popham & Warren 1965, 306–7 nos. 51–3.)

Platanos HM 1887★. Very close to the LM I vases
but it cannot be later than MM IB/II. Tholos
A annex. **P 235.**

Zakro HM 2700★. Serpentine, brown with grey
patches. Moulded foot. Palace Room Φ.
LM IB.

Crete ? AM Bomford Collection 293★.

Plus seven handle fragments from Knossos,
Mallia and Zakro. **Total 25**

F. The first two are the imitation Vapheio
cups.

Knossos HM 2098. Marble, light/dark grey
banded, bluish tinge. South House. LM I.
(*PM*, II, 380, fig. 212.) **D 147. P 236.**

Palaikastro HM 444★. Serpentine. No handle. N.F.C. **D 148. P 237.**

Mirsine HM unnumbered★. Gypsum, white. Open bowl with carinated profile, moulded base and handle. Tomb I B, 12. LM IIIB– ? C. Probably LM II/III A manufacture.

HM unnumbered★. Gypsum, white. Similar to last and same tomb.

Pseira Penn. MS 4528★. Serpentine. Cylindrical cup with strap handle. N.F.C.

Zakro HM 2680★. Limestone, soft white. Large thick-walled cup with solid vertical handle and two solid lugs just below rim; perhaps unfinished. Palace Room H. LM IB.

Total 6

Type Total 109

18. CYLINDRICAL JARS

A. The vases of this group are fairly small (height not above 8.0) with the diameter usually a little more than the height. Sometimes a low form is found, e.g. HM 1022 where the diameter much exceeds the height. Nearly all are of serpentine. They are distributed all over the island. Examples are found from MM I or earlier to LM I. They may have been made down to LM I but as the bulk of the known contexts is MM I or earlier it seems slightly more probable that this was the period of manufacture and that the two LM I examples are survivals. One was found at Karphi, certainly a survival.

The vases of group **B** are individual cylindrical jars, sometimes with special features, and of varied materials. Their only common feature is the cylindrical form. Notable is the group in white gypsum, often with figure-eight shield handles, from Katsamba and Knossos. In material, decoration and date of context these are to be compared with the large alabastrons (type I **B**). Both types are among the vases made in the final palace period at Knossos, LM II–III A I.

The large unfinished limestone vessel from Knossos is a storage jar comparable with the large amphoras and pithoi (type 25) from the same site. In shape it is like the Bucket Jars but has no spout.

A. Material ordinary serpentine unless otherwise stated.

Arvi AM AE 208. N.F.C. (but find group probably all MM I). (Evans 1895, fig. 116.) **P 238.**
HM 9★. N.F.C. (cf. previous).

Dhrakones HM 1022. Serpentine, pale grey with greeny patches and fine grey/black veins. Tholos Δ. (Xanthoudides 1924, pl. XLIII a.) **P 239.**

Galana Kharakia HM unnumbered (B 5)★. Serpentine, pale grey with network of grey/black veins.

Koumasa HM 826★. N.F.C.

Mallia HM 2205. Nécropoles des Pierres Meulières. Mainly MM I. (H. & M. van Effenterre 1963, 94 and pl. XXXV.) **P 240.**
HM 2291. Limestone, fairly hard, compact, white. House Da. LM I. (Demargne & de Santerre 1953, 58 and pl. XXVIII.) **P 241.**

Mochlos HM 1591. Tomb III. (Seager 1912, 39 III d.) **D 149.**

Pseira HM 1118★. Limestone, mottled grey/black and white with grey/brown patches. N.F.C. (but marked with tomb number so from cemetery). **P 242.**

HM 1119*. Limestone, grey with grey/black bands. N.F.C. (tomb number, as last). **P 243**.

HM 1120*. Limestone, speckled light grey with grey/black flecks. N.F.C. (tomb number, as last). **P 244.**

Trapeza HM 2384. (H. W. Pendlebury 1935–6, fig. 24, 23 and pl. 16.)

Vasilike Anoyia HM 1033*. N.F.C. **P 245.**

Zakro HM 2767*. Building B (Platon's excavations). Context probably LM I.

14 plus 15 others. **Total 29**

B. *Apodhoulou* HM 2479 + 2480 (two non-joining fragments). Serpentine. Raised band above base. Linear A inscription. Villa. MM III–LM I. (Marinatos 1935, 247, fig. 2. 1933–5, Παρ. 54–5 and fig. 11. Marinatos & Hirmer 1960, 66 and pl. 116 below left. Brice 1961, 14 no. I 13 and pl. XX top left.) **P 246.**

Katsamba HM unnumbered. Gypsum. Base of large cylindrical jar with one figure-eight shield handle preserved on the side just above base. Plundered tomb. Probably LM II–III A I like most of cemetery. One of the 'alabaster' vases mentioned (Platon 1959, 385. Warren 1967 b).

Knossos HM 2281. Gypsum. Three vertical figure-eight shield handles on body. Temple Tomb. LM II–III A I deposit. (*PM*, IV, 1006, figs. 953, 960 j.) Fragments of two other gypsum vases, probably cylindrical jars, one with figure-eight shield in relief; same context, unpublished (HM 2282, 2284).

HM unnumbered (57/69)*. Gypsum. Base of cylindrical jar. Sellopoulo Tomb II. LM III A 2–B. (*Arch. Reps. for 1957*, 24–5.)

HM unnumbered*. Limestone, purple/maroon. Ht. 37.0. Diam. 50.0. Four thick, unfinished handles below rim; punch tool marks over the inside. Interior base over a third of its area drilled right through the bottom in a series of holes. Perhaps a mistake in manufacture? N.F.C.

Palaikastro HM 913. Antico Rosso (very possibly). Raised band round upper part of body; flat lid; no bottom. Block X hoard. LM I B. (Dawkins 1923, pl. XXX C 3.) **P 247.**

HM 151 (Glass Catalogue)*. Rock Crystal. Ht. pres. 8.6. Body/base part of cylindrical jar. Block Π Room 26. LM I B. (Mentioned Dawkins 1903–4, 212. Also mentioned in Excavation Notebook.) Base fragment of another such vase, apparently rock crystal, from Block X (mentioned Dawkins, *ibid.*).

Phaistos HM 2547*. Limestone, banded pale grey, grey, dark grey. Low, cylindrical pot with rim spout and lid to cover vase and spout. Room LI. MM II. (For the room, Levi 1952–4.) **P 248.**

Argos NM 3339. Alabaster, Egyptian. Ht. 18.5. Diam. 13.0. Raised band below rim and above base (cf. HM 913). Heraion Tholos. LH II. An MM III–LM I import in view of its date/context and shape. (Wace 1921–3, 336 no. 58 and pl. LV a.) **Total 12**

19. EWERS

There are two distinct forms, but since both are large, graceful jugs intended for ritual purposes they may be classified under one type.

A. Piriform vase with a separate 'pulley-shaped' neck and separate handle. Relief decoration of plait-work, arcades or spirals over the body.

B. Vase of the same shape with a tall, slender, high spout, which may be made separately. No decoration. Material Egyptian alabaster.

The first group is from Knossos and all save two from the North Lustral Basin deposit or the contemporary Khyan lid deposit a few metres to the west. These

ewers, like the Bridge-Spouted Bowls with circular white-filled inlays (type 13 **A**), seem securely dated to MM III because of the accompanying pottery, black ground with white dots (*PM*, I 410–12. Hood, *Nestor*, August 1964).

The second group, MM III–LM I in date, comprises a complete vase and an exquisite separate spout from the Zakro Palace and two complete vases from the Mycenae chamber tombs. That from Tomb 68 is of special interest since it is an example of the conversion of an Egyptian alabastron (cf. type 42 Mallia and Mycenae, and type 43 B). This adaptation with the addition of the common Minoan pulley-shaped neck and separate handle shows that it was an MM III–LM I export to Mycenae. The vase from Tomb 102 also looks from the publication very much as if it too is a converted alabastron with addition of a separate neck ring and spout. The spout, we may notice, is closely parallel to the separately made spout, also of Egyptian alabaster, from Zakro. The vase was exported to Mycenae in MM III–LM I, like other stone vessels from the same tomb.

A similar shape is frequently depicted on Minoan gems and there is a clay example, also from Zakro (Platon 1964a, fig. 6) and one from Gournia with a double rim (Boyd Hawes 1908, pl. VII 37).[1]

A. Ht. 47.0. Diam. 23.7. Breccia, dark creamy brown matrix with grey/black pieces and a few maroon/brown patches. There survive about half the foot, with a little of the lower body, a piece of the upper body and shoulder, the whole of the neck ring, most of the lower part of the neck and nearly all the handle. Neck separate; handle separate, incut at its top to fit lip and with a rivet hole at its lower end; it is of rectangular section with its four corners bevelled. Plait-work decoration on body, shallow horizontal flutings on shoulder. Knossos, floor of North Lustral Basin. HM 1364. (*PM*, I, fig. 296.) **P 249.**

Knossos AM AE 850*. Limestone, mottled maroon and grey/white. Plait-work decoration. Restored, about a third surviving. Khyan lid deposit.

AM AE 1500 & AM 1909.343. Limestone, white, marble-like. Neck fragment and body fragment with plait-work decoration. North Lustral Basin. (*PM*, IV, fig. 176.)

AM 1938.465. Obsidian, black with white spots. Body fragment with relief spiral decoration. North Lustral Basin. (*PM*, I, 412.)

KSM (unprovenienced material)*. Serpentine. Body fragment with shallow grooved spirals. N.F.C.

AM 1938.462. Dolomitic marble, grey and white mottled. Relief decoration with triple arcades. Body fragment. North Lustral Basin. (Cf. *PM*, II, fig. 538.)

[1] There are six other Minoan vases with double rims: from Palaikastro (Bosanquet 1923, 43–4, fig. 32), a classic LM I B vase with spirals, arcades and Foliate Band; from the Zakro Palace Treasury (Ἔργον 1963, fig. 179); from the LM I settlement on Kea (Caskey 1964b, 328 and pl. 56d); from the IIIrd Shaft Grave at Mycenae, in faience, also LM I (Karo 1930–3, pls. CXLVIII–CXLIX); two from Phylakopi (Edgar 1904, pl. XXVII 8, 9). The Gournia, Palaikastro, Kea and Mycenae examples are all ewers of group B form. A seventh vase with double rim (Stubbings 1947, 57–8, pl. 14, 8) might be Mycenaean or Minoan. It was found in a cave on Mt Hymettos but the figure-eight shield with spirals on each side is an LM II motive.

HM 587*. Limestone, pale grey with mottled grey/black bands. Base fragment, preserving lower part of sides which are decorated with vertical flutings. N.F.C.

HM 2413. Limestone, soft white. Body fragment, probably of ewer, with relief decoration of arcades. LM IIB tomb. (Hutchinson 1956a, 73 no. 23 and fig. 2.)

B. Ht. 27.6. Diam. 15.3. Alabaster, Egyptian. Globular body with tall flaring neck with moulded rim; strap handle and small circular foot. Zakro Palace Treasury. LM I. HM 2718. (Platon 1963, pl. 150a.)

Ht. 21.3. Diam. 6.55. Alabaster, Egyptian. Spout, tall, slender. Flanged to fit mouth of ewer. For shape cf. NM 4920. Over half restored, but whole profile preserved. Zakro Palace Room Ee. LM I.

HM 2757*. (Cf. in clay Platon 1964a, fig. 6, in seals Kenna 1960, pl. 8, 179; 10, 262; on the Tiryns gold ring Marinatos & Hirmer 1960, pl. 207a.)

Ht. 24.0. Diam. 12.0. Alabaster, Egyptian. Most of handle and lower part of spout where handle joins restored. Mycenae Chamber Tomb 102. LH II. NM 4920. (Bosanquet 1904, 327 and pl. XVIf.) NM 3080. Alabaster, Egyptian (body); neck and handles possibly of white, marble-like limestone—both are much restored. The body is an XVIIIth Dynasty alabastron, turned upside-down, the original mouth filled and a hole cut out of the old base to receive the separate neck; the neck and handle are each separately made. Chamber Tomb 68. (Warren 1967a (Q 5).)

A jug fragment with a circular section handle, of Egyptian alabaster and from the Zakro Palace Treasury, HM 2759*, probably belongs to this group.

8 plus 5. **Total 13**

20. JARS WITH INCURVED OR FLARING SIDES

This is a popular shape, found chiefly in the Mesara tombs and at Mallia, with a few examples from Kastellos Lasithi, Knossos, Mochlos, Myrtos, Pseira, Palaikastro and Tylissos. There was one survival, in an LM IIB tomb at Khania. One of the Mochlos vases is from Tomb XIX (only clay pots EM II) but the type is best dated EM III–MM I because of its predominance in the Mesara (many from Kamilari which was built in MM I) and because it has shape links with the MM I clay tumbler (see pp. 169, 170 n. 15).

There are two forms: **A**, tumbler with height about equal to diameter, and **B**, rather lower and wider with diameter greater than height. Materials are varied: serpentine, chlorite, marbles and limestones, including dolomitic, banded tufa and breccia. Steatite is not used, in view of the large total a good sign that this is not among the earliest types.

One went to Kea. It is of gabbro, very rarely used in MM I and so probably considered a good quality export. Another was exported to Kythera.

There are two beautiful MM III–LM I vases, form **C**, shape as HM 2087, but having no connexion with the early group.

A. *Kastellos Lasithi* HM unnumbered. Serpentine. MM III. (H. W. Pendlebury *et al.* 1937–8, 51 nos. 41 and 38 and fig. 20 and pl. III.)

Koumasa HM 730. Chlorite. Tholos B. (Xanthoudides 1924, pl. XXIII.) **D 150. P 250.**

Mallia HM unnumbered. Dolomitic marble, grey and white. Palace. MM I. (Chapouthier 1938, 13 and fig. 3*b*.) **D 151. P 251.**

HM 2119. Limestone, grey/black with white veins. Palace. N.F.C. (Chapouthier & Charbonneaux 1928, 58 and pl. XXXI 2 left.) **P 252.**

HM 2201. Chlorite ?, black. House A. MM I. (Demargne & de Santerre 1953, 17 and pl. X.) **P 253.**

Phaistos HM 2550. Eleven miniature vases from a cult set. Limestone, hard white. Personal examination revealed a few tiny traces of gold leaf, proving that the vases were covered with it originally. Room LI. MM II. (Levi 1952–4, 413, fig. 33.) **P 254.**

Platanos HM 1644. Breccia, creamy white matrix with maroon/black pieces. Tholos A annex. (Xanthoudides 1924, pl. LIII.) **D 152. P 255.**

18 plus 24 others. **Total 42**

B. *A. Triadha* HM 378. Serpentine, green/grey with lighter patches. Small Tholos. (Paribeni 1904, 695 no. 2.) **P 256.**

Khania Khania M. Λ 1023. Serpentine, pale green/grey with dark brown/buff patches. LM IIIA–B tomb. Survival. (Jantzen 1951, 76.)

Koumasa HM 761*. Serpentine, brown with grey/black patches. N.F.C. **P 257.**

Mallia HM 2199. Marble, black, grey and white mottled. House A. MM I. (Demargne & de Santerre 1953, 17 and pl. X.) **D 153. P 258.**

HM 2241. Dolomitic limestone, white and grey. Palace, West Façade. N.F.C. (Chapouthier, Demargne & Dessenne 1962, 57 and pl. XLIV.) **P 259.**

Mochlos HM 1228. Calcite, creamy white translucent. Tomb VII. (Seager 1912, fig. 46 VII*a*.)

Phaistos HM 2542. Dolomitic marble, grey and white mottled. Room IL. MM II. (Levi 1952, fig. 19 lower row right.) **D 154.**

HM 2105. Gabbro. Room XI. MM II. (Pernier 1935, 250 and fig. 128 right.) **P 260.**

HM 2560. Serpentine. MM IIA. Room XXVIII. (Levi 1952–4, 442 and fig. 77, 615.)

HM 2574*. Serpentine, pale yellow/green with mottled black patches. A. Photini. MM–LM I. **D 155.**

Platanos HM 1998. Breccia, white matrix with black pieces. Tholos A annex. (Xanthoudides 1924, pl. LIII*b*.) **D 156.**

Porti HM 2087. Breccia, black matrix with red pieces outlined by white veins. (*Ibid.* pl. XXXIX*a*.) **D 157. P 261.**

Pseira HM 1115*. Serpentine. N.F.C. **P 262.**

Tylissos HM 2017. Serpentine, mottled brown, grey, green/grey. LM I ? (Hatzidhakis 1921, fig. 25 top row centre.) **P 263.**

Kythera Kythera M. 26*. Serpentine.

15 plus 63 others. **Total 78**

C.

Knossos HM 51*. Limestone, pale pastel shades, grey, buff, purple, sandy, pink and maroon, banded. N.F.C.

Zakro HM 2737*. Limestone, grey, dark grey banded. Palace Treasury. LM IB. **Total 2**

21. JARS WITH STRAIGHT SLOPING SIDES

The first group, **A**, consists of jars varying from those with height about equal to diameter to those where the diameter is much greater (cf. type 18). The group is MM I, with one or two in MM II contexts at Knossos and Phaistos. It is a Mesara type with five examples from Knossos and one survival from Elounda.

As with types 18 and 36 this is a common small funerary form of the period and

it exhibits the characteristic variety of materials, banded tufa, calcite, chlorite, gabbro (one example), limestones, marble, including dolomitic, and serpentines. Limestones and serpentines predominate. There is a small pot from Kythera of this shape (NM 4578, Evans 1897, 349–50 and figs. 23–4; Smith 1965, 8–9 and fig. 10) but it bears an Egyptian inscription with the name of the sun temple of Weserkaf, the first king of Dynasty V. It is presumably an Egyptian vase, but we cannot say whether it reached Kythera directly or, perhaps, *via* Crete.

Group **B** consists of one or two larger jars of this shape, apparently MM III–LM I, from domestic contexts and not connected with group **A**. The series forming group **C** are of coarse white limestone, save one or two of sandstone and one of serpentine. They might be better considered as small crude circular libation tables. They have a shallow central bowl and are sometimes more or less cylindrical, though they are more conveniently placed here as one group. Their date is MM III–LM I. Perhaps they were all made in LM I, as the contexts suggest.

A. *A. Triadha* HM 661. Calcite, opaque creamy white with grey and translucent golden bands. Large Tholos. (Banti 1930–1, 184 and fig. 50*i*.) **D 158**.

Elounda Neapolis M. 1. Serpentine. (Van Effenterre 1948, 58 O 114.)

Kamilari Phaistos Strat. Mus. F 59 2879*b*. Limestone, dark grey with mottled white veins. (Levi 1961–2, fig. 120 *cf*.)

Knossos AM 1938.582*. Calcite, milky white translucent with pale orange vein. MM II stratum in '3rd m. Olive Press' (Evans' writing on vase).

Koumasa HM 690. Serpentine. Tholos E. (Xanthoudides 1924, pl. XXXI.)
HM 776*. Serpentine. Tholos B.

Phaistos HM 2567. Limestone, pale grey. Eight-sided. Room LIV. MM IIB. (Levi 1955, 146, fig. 8*d*.) **D 159. P 264**.

Platanos HM 1648*. Banded tufa, creamy white, orange, pink, brown. Tholos A annex. **P 265**.
HM 1903*. Gabbro, black matrix, massed white phenocrysts with fine green veins. Tholos A annex. **P 266**.
HM 2003*. Serpentine, pale grey/green with grey veins and patches. Tholos B. **P 267**.
HM 2005*. Limestone, orange banded. Tholos A annex. **P 268**.

Vasilike Anoyia HM 1034*. Limestone, white, pale grey, banded. N.F.C. **P 269**.

12 plus 28 others (A. Triadha, Apesokari, Kamilari, Koumasa, Platanos and Porti).

Total 40

B. *A. Triadha* HM 347*. Limestone, grey. N.F.C. (but probably from Palace, LM I). **P 270**.

Knossos KSM*. Unprovenienced material. Serpentine. Rim/body fragment of a vase, apparently a jar of this type, with vertical incised herringbone decoration. N.F.C. Date ? KSM (1957–61), base fragment of large jar, serpentine, Acropolis Trials, LM I–II.

Pseira HM unnumbered*. Calcite, white translucent. Rim/body fragment, shape as HM 347. House B. LM I. (Mentioned Seager 1910, 37–8.) **Total 4**

C. *Phaistos* HM 197. Serpentine, mottled green/grey and rust brown. N.F.C. (Pernier & Banti 1951, 377.)
HM 205*. Limestone, coarse soft white. N.F.C. **P 271**.

Zakro HM 2707*. Limestone, soft white. Palace, Shrine Treasury. LM I.

3 plus 34 others (5 Phaistos, 29 Zakro).

Total 37

22. JUGS

A. Small jugs with carinated body. This is the commonest form, too small for much practical use and nearly always found in tombs. The majority are MM I, with vases from Gournia, Kamilari, Khamaizi and Mallia in clear contexts, and that from Mycenae having a corresponding context (Middle Helladic). Four from Mochlos however come tombs where the only clay vases were EM II (Tombs I and VI), so that the type may have begun in the latter part of this period. The materials show the usual variety, serpentine, limestone, marble, breccia and steatite, but only one in chlorite.

B. Larger, higher jugs, sometimes with more rounded body, often with a strap handle. These vases, found in the palaces and houses, are for practical use. But three from Phaistos have no base and so may have been ritual in character. The group dates from MM I to LM I. The Kythera jug, imported from Crete, is close to that from the Zakro Pits, whilst the other Zakro jug is from the Palace Treasury and is of Egyptian alabaster. It was probably used for ritual libations. On Late Minoan and Late Helladic gems and rings genii are depicted with jugs or ewers (e.g. on the Tiryns gold ring, Marinatos & Hirmer 1960, pl. 207, and see also *PM*, IV, 447–50).

C. From LM I–II/III A I contexts comes a small group of large, globular-bodied jugs which were for use in the palaces. The rarity of the jug in stone in MM III–LM I, which sees the acme of the lapidary art in Crete, is probably due to the frequency of metal forms (for a list see *PM*, index, 46). As with the Teapot (type 41) the form is not easy to produce in stone.

D. Finally there is a group of individual jugs of funerary, practical and ritual use, dating from EM II (probably) to LM I.

A. *Mallia* HM 2121*. Serpentine. Thin walls as in MM IB/II pottery. N.F.C. **D 160. P 272.** HM 2424. Gabbro. House Zb. LM I. This hard stone was used occasionally in MM I and the vase belongs morphologically with this MM I group, so it is almost certainly a survival. It was too difficult to attempt a handle in this stone. (Deshayes & Dessenne 1959, 61 and pl. XIX 3, and pl. XXIX A I.) **D 161. P 273.**

Mochlos HM 1205. Marble, grey, creamy grey banded. Tomb VI. (Seager 1912, fig. 22 VI 18.) **D 162. P 274.**

HM 1206. Marble, grey, grey/black banded. Tomb VI. (*Ibid.* fig. 22 VI 14 and pl. VI.) **D 163. P 275.**

HM 1207. Breccia, black matrix with small creamy white pieces. Tomb VI. (*Ibid.* fig. 22 VI 4.) **D 164. P 276.**

HM 1212. Limestone, pink, yellow and chocolate banded. Tomb XV. (*Ibid.* fig. 37 XV *d*.) **D 165. P 277.**

Mycenae Nauplion M. 10808. Serpentine, pale grey with network of grey/black veins. Two tiny 'ears' just below rim (cf. HM 2121 above). Ht. 4.7. Prehistoric cemetery (Middle Helladic), Grave 25. (Wace 1952, fig. 4 left.)

7 plus 19 others. **Total 26**

B. *Mallia* HM 2290. Serpentine. Perhaps a jug though only a tiny trace of a spout survives. House Da. MM I–LM I. (Demargne & de Santerre 1953, 58 and pl. XXXVIII.) **P 278.**

Phaistos HM 2583. Serpentine, mottled brown with grey/black veins. Room L, West Area. MM II. (Levi 1955, 154, fig. 26.)

HM 2544*. Serpentine. No base. Room IL. MM II. (Levi 1952, Fiandra 1961–2 for Room IL). **P 279.**

HM unnumbered F 1953.702. Dolomitic marble, white and grey mottled. No base. Room LI. MM II. (Levi 1952–4, 405 and fig. 26.)

HM 2561*. Serpentine, light grey with mottled grey/black veins. No base. N.F.C.

Prasa HM 2443*. Limestone, light green/grey. Apothete 3.20–3.50 m. MM I. (Site, Platon 1951 b.)

Zakro HM 546*. Marble, light and dark grey banded. Pits. MM III–LM IA. (Mentioned Hogarth 1900–01, 124.) **P 280.**

HM 2765*. Alabaster, Egyptian. Palace Treasury. LM IB.

Kythera NM 3946. Marble, light and dark grey banded. N.F.C. but from Vothonos valley (the main tomb area of the new excavations where the tombs are chiefly MM III–LM I). (Wolters 1891, 53–4. Zervos 1957, pl. 27 b.)

9 plus 2 others. **Total 11**

C. *A. Triadha* HM 349*. Dolomitic marble, grey and white mottled. Palace. LM I.

Knossos HM 50. Limestone, light and dark grey banded. N.F.C. but possibly palace destruction. (Zervos 1956, pl. 494.) **D 166. P 281.**

HM 2347*. Dolomitic marble, grey and white mottled. N.F.C. Chance find. **P 282.**

Mallia HM 2243. Serpentine. Rim-body fragment with handle. N.F.C. (Chapouthier, Demargne & Dessenne 1962, pl. LIV 3 a.)

Total 4

D. *A. Triadha* HM 664. Dolomitic marble, grey and white mottled. Unique form; rim spout and three handles. (Banti 1930–1, 186 and fig. 52 a and b.) Large Tholos. **P 283.**

Gournia HM 93. Serpentine. Double spout. Perhaps for ritual use. LM I. (Boyd Hawes 1908, pl. III 8.)

Kavousi Cave Penn. MS 4591*. Banded Tufa. EM II–III burial cave. (Hall 1914, 183 no. 2.) Cf. closely HM 1201.

Koumasa HM 686. Serpentine, grey with network of fine black veins. Three conjoined cylindrical cups with interconnecting holes, and spout at one end. Probably for ritual use. Tholos E. (Xanthoudides 1924, pl. XXXI.) **D 167.**

Mochlos HM 1201. Banded Tufa. Tomb VI. (Seager 1912, fig. 22 VI 2 and pl. V. Marinatos & Hirmer 1960, pl. II right.) **D 168. P 284.**

Phaistos HM 193. Marble, grey, grey/black banded. Spout at right angles to handle. N.F.C. Chance find. (Pernier & Banti 1951, 381 and fig. 247 a.) **D 169. P 285.**

HM 227. Serpentine, mottled. Upper half, with no base (perhaps not intended to have a lower half). N.F.C. Chance find. (*Ibid.* fig. 246 g.) **D 170. P 286.**

Mycenae NM 592. Alabaster, Egyptian. Tall slender jug, almost certainly a Minoan import. Stained green through contact with bronze, probably bronze fittings. IVth Shaft Grave. LM I (LH I–IIA). (Karo 1930–3, pl. CXL.) **Total 8**

Type Total 49

23. LADLES

Shallow heart-shaped vases, usually called ladles.

A. The Platanos vase is of chlorite and has finely incised decoration all over. It belongs to the earliest group of stone vases (types 33 and 37 **A**) and is close in shape

to the Lebena bowl (type 37 **A**, L II 158 a), which was found in an EM II context. The Koumasa vase is contemporary or slightly later and those from A. Triadha and Khristos are probably EM III–MM I because of their materials. A clay example occurred in an MM IA or earlier stratum at Knossos (*PM*, I, 623–4, fig. 460).

B. An MM III–LM I group, as the contexts show. This group is more carefully made and shaped than the EM–MM I ladles; moulded rims and bases and ribbed decoration are found.

The purpose of the group was ritual or votive, as Xanthoudides (1909) and Evans (*PM*, I, 622 sqq.) suggested, since all in Crete are from cult rooms or cult contexts. The Linear A inscription of the Arkhanes/Troullos ladle may be ritual.

In addition to the imported chlorite example from Kea there is another of local manufacture (not included).

A. *A. Triadha* HM unnumbered★. N.F.C. (chance find). Serpentine.

Khristos HM 2267. Limestone, soft white. (Xanthoudides 1924, pl. XL*b* second row second from right.)

Koumasa HM 692*a*. Chlorite. Tholos E. (*Ibid.* pl. XXXI.) **P 287.**

Platanos HM 1997★. Chlorite. Finely incised herringbone decoration. Area AB. **D 171. P 288.** **Total 4**

B. *Arkhanes/Troullos* HM 1545. Marble, white, fine grained. Linear A inscription. MM III. (Xanthoudides 1909. *PM*, I, 625, fig. 462. Brice 1961, 14–15 no. 1, 16 and pl. XX.)

Juktas Peak Sanctuary HM 1602. Limestone, grey and white, mottled and banded. Traces of Linear A inscription. MM III. (*PM*, I, 624, fig. 461.)

AM AE 769★. Chlorite.

AM 1938.427★. Limestone, polychrome light and dark grey banded and orange. (See *PM*, I, 622–3.)

Knossos HM 2101. Serpentine. House of the Frescoes. LM I. (*PM*, II, 438–9, fig. 256*c*.)

HM 2102★. Serpentine. N.F.C. **P 289.**

Palaikastro HM 907. Serpentine, brown with blue/grey/black patches. Block X hoard. LM I. (Dawkins 1923, pl. XXX C 2.) **P 290.**

Phaistos HM 187. Serpentine. Room 8. LM I. (Pernier & Banti 1951, 109–10, fig. 55*a*, and 243 lower row right.) **D 172. P 291.**

Kea K 6.93★. Chlorite. Troullos. LM I B.

Mycenae NM 2918★. Serpentine. Chamber Tomb 58. LH I–II. **Total 10**

24. LAMPS

The standard form[1] consists of a circular bowl with two wick cuttings in the rim and two solid pendent handles below. These lamps may be low, that is without any pedestal (usually then with a moulded base), medium, with a pedestal intermediate between those without one and those with tall columnar pedestals, which make up

[1] Persson (1942, 102–8) has a good discussion. His classification is akin to that presented here save that I do not include his forms 4 (small bowls with hook handles) and 13–14 (ladles) for there is no indication that these were used as lamps, nor are the Minoan ladles all scorched by intense heat as he claimed.

the third, high, form. Apart from plain undecorated examples the low form frequently has a beautifully decorated rim with raised coils or whorls, or with foliate band, petals, lilies, raised disks, tricurved arch pattern, crescents or linked spirals, or else the rim is stepped with circular raised bands, or is flat with horizontal grooves and flutings round the outside edge, or it has vertical grooves round the outside edge or circular grooves round the top surface (see examples below). The medium and high-pedestalled forms have plain rims usually but sometimes there is a decorative relief band round the centre of the pedestal, for example plain horizontal mouldings or the ivy scrolls of the Palaikastro lamp. An elaborate variant of the low type consists of very large lamps often with tripartite bowls (group 13 below).

In addition to the stone forms there are closely parallel examples in clay (see pp. 169, 170–1 n. 17). These clay lamps, which have distinctive, highly polished red/brown paint, are nearly all Middle Minoan (Boyd Hawes 1908, pl. II 75 from Gournia is an exception, LM I), during which period the stone form, without decoration, does occur but is rare. The stone example (group **II C**) from the Knossos Stratigraphic Excavations shows that the type was made in this material from MM IA onwards. The Phaistos First Palace example confirms this, as do six fragments from MM I–II levels of the new excavations at Knossos. Hence it is clear that parallel clay and stone types, low and medium, simple, undecorated save for circular mouldings round the flat rim, began in MM I, the polished clay forms being much the more popular. In MM III–LM I the stone forms, low, medium and high, become very common whilst the clay forms die out.[1] In this period the elaborate and beautiful decoration is comparable with that of other stone vase types. After LM I and LM II–III A I at Knossos manufacture ended in Crete, for the few examples in LM III contexts are survivals.[2]

In LM I low lamps were put on stands of clay (Bosanquet 1923, 70. Dawkins, *op. cit.* fig. 120a) or stone (*ibid.* fig. 120b). Another fine LM I stone example has been found in the Zakro Palace.

A different type is the stone hand lamp with a straight stick handle and a wick cutting in the bowl opposite the handle. This form had been very popular in clay in MM times, especially in MM I–II. It lasted into LM I. The stone examples which imitate it are relatively few but occur from MM I to LM I.

Finally there are a few individual examples, usually imitating the common MM clay hand lamps.

[1] Fragments of about sixteen stone lamps occurred in pure MM III levels in the 1957–61 Knossos excavations; this is the first time MM III stone lamps have been demonstrated stratigraphically.

[2] Hence the stylistic/typological development proposed by Dawkins for LM III (1923, 130, 138–9) is to be disregarded.

The development of the stone and clay forms is summarised in table 3.

TABLE 3. OCCURRENCES OF STONE AND CLAY LAMPS

	Clay	Stone
Stand lamps		
M M I–II	Usual (low and medium)	Present, but less common than in clay
M M III–L M III A	Very rare	Common (low, medium and high)
Hand lamps (stick handle)		
M M I–II	Very common	Fairly rare
M M III–L M III A	Fairly rare	Fairly rare

From this we see that the most usual form of lamp in M M I–II was the clay hand lamp, in M M III and later the stone pedestal lamp. Clay and stone lamps occur throughout the whole period but in M M III and later stone has in general replaced clay.

Serpentine of the dark blue/black mottled variety is by far the most common material. Limestone, greyish or whitish, is also used and so is the maroon/red marble Antico Rosso (for which see chapter III). This last does not occur in use before L M I save for one isolated piece (type 38).

The standard low, medium and high forms are found on all the main L M I sites and among the Knossos destruction material. A number are found on the Mainland, at Asine, Dendra, Eleusis, Mycenae, Nauplion, Thorikos and Vapheio, and in the islands at Phylakopi, Kea and Kythera. These were all very probably exported from Crete in M M III–L M I, the Dendra, Mycenae, Phylakopi and Vapheio examples being in L H I–II contexts. This was the most popular of the exported stone types. Most are of serpentine but several seem to be made of Antico Rosso. This marble is only found in the Mani peninsula of the southern Peloponnese, but this does not argue for Mainland manufacture of the Antico Rosso lamps since the stone was exported to Crete and used for vases there. That all the Mainland lamps were imported from Crete is also shown by their date, shape and decorative details, all of which are paralleled many times in the island (Warren 1967a).

Two low lamps however, one from the dromos of the Lion Tomb at Mycenae, the other from the tholos tomb at Thorikos, are somewhat problematical. Both are said to be of white marble and both have a petaliform pattern round the rim, exactly like inverted Blossom Bowl petals (Wace 1921–3, pl. LIIa). There are six similarly decorated Minoan low lamps (group **II A 4** below), whilst one of high form from Palaikastro and another of medium height from Nirou Khani have an almost exactly similar decorative pattern. But the 'white marble' of the Mycenae and Thorikos vases was rarely used in Crete (though see below AM 1910.199,

group **II C**). The parallels in shape and decoration strongly suggest that these two vases are Minoan but the possibility of their being Mainland copies in Cycladic marble cannot be ruled out. Equally Cycladic marble could have been exported to Crete in this period when the island was importing several fine stones for vases. The lamps might however be of white marble-like limestone, sometimes used for fine MM III–LM I vases such as the Lioness Head rhyton from the Knossos Central Treasury, and thus certainly Minoan.

Another well-known lamp is that found at Atchana. On grounds of shape, material and decoration it is very probably Minoan (see group **II A 8**). The Troy vase (group **II A 4**), either a lamp or a libation table, was almost certainly an original MM III–LM I import.

I. Middle Minoan I–II

Low and medium forms, all of ordinary serpentine. For the relation to clay forms see the discussion above and pp. 170–1 n. 17.

Knossos KSM (RR/61/315*). Medium pedestal flaring to base. Wide rim, two wick cuttings, undecorated. Ht. 24.4. Diam. 38.2. Royal Road. MM IA (LA 107). **P 292.**

Phaistos HM 211. Ht. 9.8. Diam. 19.0. Low, with tiny moulded base. Two wick cuttings, two oval protuberances in very slight relief at right angles to wick cuttings; undecorated. N.F.C. but probably from First Palace as close to the last example below. (Pernier & Banti 1951, 387 and fig. 243 c.) **P 293.**

HM 2562. Ht. 26.0. Thick pedestal, medium height. Bowl in shape of double axe. Two wick cuttings, extending over only part of rim.[1] Room LIV. MM II. (Levi 1955, 146, fig. 8 a.)

HM 2572*. Ht. 33.4. Diam. 26.7. Medium pedestal flaring to moulded base. Two wick cuttings and two pendent handles. Room LIII. MM II. Phaistos Strat. Mus.* Ht. 17.9. Diam. 28.0. Low, no pedestal (but base rough, perhaps indicating that broken off and higher originally), two wick cuttings, not extending over whole rim, and two

pendent handles; groove round outside of rim, giving concave moulded profile. Palace. MM (recently found). Cf. HM 211 above for shape of top surface.

Plus fragments of six others from the Knossos Stratigraphic Excavations and one from E. Crete (Hierapetra M. 97*), probably MM I–II for it has a wide flat rim sloping into the bowl and two small wick cuttings (cf. RR/61/315 above). Five stone lamps were found in an MM I house at Vasilike (Seager 1907, 125–6). Two of these were able to be preserved but their shape is not described. Hierapetra M. 97* might be one (though in default of direct evidence it is counted separately here). The three that were rotted were of the pedestal class, one being described (surely in error!) as 62.0 diam. Presumably all were of serpentine. **Total 17**

II. Middle Minoan III–Late Minoan

A. Low form. Material serpentine and context LM I unless otherwise stated.

1. Plain undecorated

CRETE

A. Triadha P IG.M. 71939. Ht. 6.0. Diam. 12.0. Palace. (Borda 1946, pl. LI 11.)

[1] Boyd Hawes made the interesting observation, now confirmed by two of these Phaistos lamps, that the MM lamps had the cuttings for the wick extending only three-quarters of the way across the rim, whereas the cuttings of the LM examples extended right across (1908, 30 and pl. V 73).

Gournia HM 77. Ht. 9.0. Diam. 21.0. (Boyd Hawes 1908, pl. II 69.)

Khondhros HM unnumbered. Rousses House Shrine, Room A. (Platon 1957*b*, 146 and pl. 73*b*.)

Knossos HM 2097. Ht. 7.75. Diam. 11.1. Basement cell by stepped portico (S.W. of South House). Found with LM I bronze hoard. (*PM*, I, 633 and fig. 395*p*.) **P 294.** AM 1910. 202*. Ht. 7.05. Diam. 12.6. N.F.C. **D 173. P 295.** Six others (*PM*, II, fig. 59), from entrance to spring chamber by caravanserai N.F.C.

Mallia HM 2321. Ht. 5.95. Diam. 17.75. House Db. (Demargne & de Santerre 1953, 59 and pl. XXVIII.)

Myrtos KSM. Lamp and part of another, possibly of this type. Pyrgos site. N.F.C. (Hood, Warren & Cadogan 1964, 96 and fig. 20, 4.)

Phaistos HM unnumbered (F 58.2454). Ht. 7.5. Diam. 14.7. A. Photini, Room Π. (Levi 1961–1962, 475 and fig. 154.)

Prasa HM 2446. Diam. 28.0. HM 2447. Ht. 11.0. Diam. 18.0. House A. (Platon 1951*b*, 253, fig. 7 1 and fig. 6 lower row centre.)

Pseira HM 1105*. Ht. 10.25. Diam. 18.0. N.F.C. **P 296.**

Tylissos HM 1557. (Hatzidhakis 1921, 48, fig. 22*b*.)

13 plus 40 others (Amnisos, Gournia, Kalyvia Mesara, Knossos, Mallia, Palaikastro, Pseira and Tylissos). **Total 53**

MAINLAND; AND ISLANDS

Argos NM 3338. Fragments of two lamps. Heraion tholos. LH II. (Wace 1921–3, 336.)

Dendra NM 7315. Ht. 8.0. Diam. 17.0. Tomb 2. LH IIIB. (Persson 1931, 101 and fig. 78.) Nauplion M. Ht. 9.0. Diam. 16.2. Tholos. LH IIB–IIIA I. (*Ibid.* 37–8 and fig. 23.) Plus one other fragment, from Tomb 11. (Persson 1942, 101.)

Kea K 4.305*. Ht. 7.8. Diam. *c*. 14.5. Horizontal grooves and flutings on handles and below wick cuttings. Limestone, soft white.

Phylakopi NM. Three lamps (one is NM 5807. Antico Rosso). Third City (LM I–II). (Bosanquet & Welch 1904, 209.)

Vapheio NM 1902–3. Two lamps (one Antico Rosso ?). Tholos. LH IIA. (Tsountas 1889, 154 and pl. 7, 20.) **Total 11**

2. Raised coils or whorls round the rim

CRETE

A. Triadha HM 357. Ht. 7.8. Diam. 12.8. Palace. (Marinatos & Hirmer 1960, pl. 115 above.) **P 297.**

Knossos HM 32. Ht. 12.0. Diam. 20.0. Limestone, maroon with creamy white inclusions. Palace, Room of the Saffron Gatherer. LM II–IIIA I. (*PM*, III, 26 and n. 1.) HM 612. Ht. 9.25. Diam. 20.2. HM 613. Ht. 8.6. Diam. 16.1. Isopata Royal Tomb. LM II. (Evans 1905, 150 nos. 15–16 and figs. 123 S 15, S 16, and 126–7.) **P 298.**

Mallia Mallia Apotheke. Ht. 9.0. House E, Room XLVII. (Deshayes & Dessenne 1959, 135 and pl. XLVIII 9.)

Palaikastro HM 933. Ht. 8.3. Diam. 13.4. Block X hoard. (Dawkins 1923, pl. XXX F 3.)

Phaistos HM 1515. Ht. 11.0. Diam. 22.0. N.F.C. (Pernier & Banti, 1951, 385–6 and fig. 253.)

7 plus 3 others. **Total 10**

MAINLAND

Asine Ht. 7.0. Tomb 1: 2. LH II–III. (Frödin & Persson 1938, 378.)

Dendra Ht. 6.6. Tomb 2. LH IIIB, a survival. (Persson 1931, 101.)

Kythera Kythera Mus. Diam. 27.5. N.F.C., chance find. (Benton 1931–2, 245 and pl. 42*c*.)

Mycenae NM 1322. Ht. 8.8. Diam. 16.3. Hollow inside through to base. Acropolis. N.F.C. (Warren 1967*a*. N 33.) NM 4924. Ht. *c*. 9.0. Diam. 18.75. NM 4925, Ht. *c*. 15.0. Diam. 28.8. Tomb 102. LH II. (Bosanquet 1904, 324–5 and pl. XIV *a–b*.)

NM*. Ht. 6.7. Diam. 13.8. Tomb 99. LH II ? This lamp may well be NM 3167. (Tsountas & Manatt 1897, fig. 30.)

Nauplion M. Unnumbered*. Ht. pres. 7.65. A linked groove outlines the bases of the raised whorls. Citadel House (64–254). LH III B.

Nauplion Nauplion M. 10002. Ht. 14.0. Diam. 22.8. Serpentine, pale creamy buff with grey mottled patches. LH III A I tomb. Probably Minoan, but this variety of serpentine is unusual. (Kharitonidhes 1953, 200, fig. 6.)

Total 9

Five lamps have decoration similar to the above, those from Argos and Knossos spirals rather than whorls or coils, the other two linked spirals shallowly grooved. The latter are very probably Minoan but in view of the popularity of this type of spiral at Mycenae in LH III A the Eleusis and Mycenae vases could be Mainland copies. On the contemporary occurrence of this type of spiral at Knossos however, see under Alabastrons (type I **B**).

Argos NM 3338. Ht. 11.0. Diam. 23.0. Raised spirals round rim, foliate band below wick cutting; for the spirals cf. the Zakro Palace rhyton, *Arch. Reps. for 1963–4* fig. 39 (Type 34 **B2**, NM 2764). Heraion tholos. LH II. (Wace 1921–3, 336 and pl. LV *b*.) Plus fragment of another.

Eleusis ? Eleusis M. Ht. 13.0. Diam. 27.0. N.F.C. Probably from the Mycenaean settlement or tombs at Eleusis. (Mylonas 1932, 149 and fig. 123.)

Knossos AM 1938.606*. Ht. pres. 1.9. Width 8.2. Diam. *c*. 26.0. Antico Rosso ? N.F.C.

Mycenae NM 3161*. Ht. 7.5. Width 18.5. Tomb 88. Probably LH II.

Total 5

3. Foliate Band

Katsamba Limestone. Lapidaries Quarter. N.F.C. (*PM*, II, 238.)

Knossos KSM (Unprovenienced Material)*. Ht. 6.8. Diam. 13.7. Chlorite. N.F.C.

Mochlos HM 1168. Ht. 13.0. Diam. 26.8. Antico Rosso ? Town site. (Seager 1909, fig. 21 left.)

Palaikastro BM 1907 1–19 230*. Ht. 7.8. Diam. 16.25. Limestone, maroon/red with small white crystalline inclusions. N.F.C. **P 299.**

Phaistos HM 209. Ht. 13.5. Diam. 31.0. Limestone, soft white, *painted red*. N.F.C. Probably from Palace, final destruction (LM I B). (Pernier & Banti 1951, 384–5 and fig. 252. Zervos 1956, pl. 463.)

Pseira HM 1106. Ht. 11.2. Diam. 19.8. Antico Rosso ? Town site (LM I). (Seager 1910, 35–6 and fig. 17. Maraghiannis 1911, pl. XIX below 2.) **P 300.**

HM 1109*. Ht. 4.6. Diam. 8.0. Chlorite. N.F.C. but nothing from Pseira later than LM I B. **P 301.**

Total 7

4. Petaliform pattern

CRETE

Khondhros HM unnumbered. Ht. *c*. 18.1. Diam. *c*. 27.3. Limestone, soft grey. Kephala Settlement, Room A. LM III A–B. Survival. (Platon 1957 *b*, 143 and pl. 68 *b* lower row centre (the main fragment).)

Knossos AM 1924.40*. Ht. pres. 8.9. Diam. *c*. 32.0. Fragment. N.F.C. Cf. **P 303–4** below for the pattern.

Mallia HM 2432. Ht. 8.6. approx. Diam. 19.5. approx. Much restored. House Zb. (Deshayes & Dessenne 1959, 63 and pl. XVII 2.) **P 302.**

Nirou Khani HM 2079. Ht. 11.5. Diam. 28.2. (Xanthoudides 1922, 14 and fig. 11 top row left.) **P 303.**

Phaistos HM 492. Fragment. N.F.C. (Pernier & Banti 1951, 386–7 and fig. 247 *b*.)

Vathypetro HM 2470. Ht. 12.7. Diam. 28.75. Villa, Room of the Olive Press. (Marinatos 1950, 248, fig. 8.) **P 304.**

Total 6

MAINLAND, ETC.

Mycenae NM 2921. Ht. 13.2. Diam. 28.5. Marble or marble-like limestone, white. Lion Tomb (Tholos). LH II. (Wace 1921–3, 329 and pl. LII *a*.)

Thorikos NM*. Ht. 7.8. Diam. 17.7. Material as

last. Tholos. LH II. (Mentioned Staes 1895, 225.)

Troy Ht. 9.0. Diam. (foot) 8.4. Small columnar pedestal with disk base. Petals carved on rim (might even be Foliate Band). From shape it might be a Libation Table, but these are not usually decorated. N.F.C. Found in foundations of a Roman monument. Original MM III–LM I import. (*Troy*, III, *i*, 230; *ii*, pl. 298, 38–116.) **Total 3**

5. Lilies

Knossos HM 2348★. Ht. 5.23. Diam. 6.9. N.F.C. Found N.W. of Royal Villa. **P 305.**

Mallia HM 2309. Ht. 6.9. Diam. 8.6. House E. (Deshayes & Dessenne 1959, 135 and pl. XLIX 4. Zervos 1956, pl. 464.) **Total 2**

6. Stepped rim

Mallia HM 2420. Ht. 11.5. Diam. 19.0. House E. Room XXXIX. (Deshayes & Dessenne 1959, 134 and pl. XLVIII 4.)

HM 2430. Ht. 12.0. Diam. 23.0. House E. (*Ibid.* pl. XLVIII 6.)

Palaikastro HM 439★. Ht. 10.8. Diam. 19.3. N.F.C.

KSM (PK/62/49). Ht. 11.6. Diam. *c.* 25.0. Brecciated limestone. Block N. LM IB. (Sackett, Popham & Warren 1965, 306–7 no. 64.)

Zakro HM 2790★. Ht. 17.4. approx. Diam. 28.0. approx. Palace, Shrine Treasury.

5 plus 6 others (Knossos, Phaistos, Zakro and E. Crete). **Total 11**

7. Horizontal grooves and flutings round outside of rim

A. Triadha HM 359★. Ht. 6.55. Diam. 10.7. In the centre of the bowl a hole was picked out (not drilled), over which is a circular cover with grooves at its edges, diam. 4.2. A long wick was probably kept in the hole under the cover and drawn up into the bowl and on to the wick cuttings as needed; a unique arrangement. Palace. **P 306.**

Mallia HM 2431 Ht. 9.6. Diam. 17.85. House

E. (Deshayes & Dessenne 1959, 135 and pl. XLVIII 5.)

Nirou Khani HM 2080. Ht. 13.2. Diam. 30.4. Room 3. (Xanthoudides 1922, 14, fig. 11 top row right. Zervos 1956, pl. 465.) **P 307.**

Pseira HM 1107★. Ht. 5.6. Diam. 12.6. Chlorite. N.F.C. but nothing from town later than LM IB. **P 308.**

HM 1108. Ht. 5.6. Diam. 15.95. N.F.C. as last. Petaliform pattern on underside. (Seager 1910, 38 and fig. 19. Maraghiannis 1911, pl. XIX below 7.)

Zakro HM 2693★. Ht. 7.05. Diam. 13.6. Palace, Room Ee.

6 plus 4 others (A. Triadha, Gournia, Palaikastro and Phaistos). **Total 10**

8. Vertical grooves round outside of rim

Knossos KSM (1957–61). Rim Fragment. Hogarth's Houses. MM III ? B. (K 28).

Pseira HM 1103★. Ht. 12.8. Diam. 29.5. The top surface of the rim is slightly stepped and the low foot below the bowl is moulded with horizontal grooves. Very finely made. N.F.C. but from LM I town. (Warren 1967a, pl. V.) **P 309.**

Atchana BM 1950 1–25 1. Ht. 16.15. Diam. 32.1. Limestone, maroon with small white inclusions. Tricurved arch pattern carefully carved on underside and vertical ribbed moulding on base. The tricurved arch is an LM II–III A 1 vase pattern (cf. the stirrup vase from the Royal Villa at Knossos, Evans 1902–3, fig. 87) and also LH IIB (see Furumark 1941, 391, fig. 68, motive 62,9). This would suggest that the lamp was made in this period, the second half of the 15th century. There are however a number of instances of the tricurved arch in LM I, though some are less sharply drawn than the careful LM II–III A 1/LH IIB pattern. See *PM*, III, fig. 50, the silver siege rhyton from Mycenae Shaft Grave IV; *PM*, II, fig. 457b, the Ladies in Blue fresco from Knossos; *PM*, III, fig. 194, a fresco fragment with dress pattern from Knossos, the dress pattern on

the plaster relief of a lady from Pseira, *PM*, III, fig. 15*a*, being comparable, and lastly *PM*, II, fig. 321*f*, a Marine Style rhyton from Pseira. It is thus not possible to date the lamp firmly to LM I or LM II–III A I. For MM III–LM I are the large number of low lamps made in this period, some in this material, the Pseira example above, HM 1103, with the same system of vertical grooves, and the fact that MM III–LM I is the great period of Minoan overseas expansion; for LM II–III A I is the careful carving of the tricurved arch pattern on the underside, which carving is paralleled at this time in Crete and on the Mainland. That the vase is Minoan and not Mycenaean is strongly suggested by all the type parallels in Crete and the fact that Mainland stone vases cannot be shown to have been manufactured before LH III B. The bowl of the lamp is cut into a series of divisions and the drill core holes left. Perhaps it was thus adapted in Syria. Atchana Level II (1350–1275 B.C.). (Kantor 1947, 99–100 and pl. XXV F. Woolley 1953, 140 and pl. 42.) **P 310a–b.** **Total 3**

9. Circular grooves round top surface of rim

Gournia HM 323*. Ht. 6.7. Diam. 14.1. N.F.C. but almost certainly from LM I town.

Kea K 6.342*. Ht. 11.4. Diam. 20.6. Channel round flat rim. Area G. LM I B and a little LM III A I.

Mycenae NM*. Ht. 10.8. Diam. 24.65. Tomb 82. LH II (probably).

Plus 3 others (Gournia, Knossos and Phaistos). **Total 6**

10. Disks in relief on top surface of rim

Katsamba HM unnumbered*. Ht. pres. 5.7. Diam. *c.* 19.0. Rim fragment. N.F.C.

Palaikastro HM 133*. Ht. 10.2. Diam. 20.5. Serpentine, pale green/grey with network of grey/black veins. N.F.C. **Total 2**

11. Tricurved arch pattern over rim

Knossos AM 1924.39*. Ht. pres. 9.15. Diam. *c.* 27.0. Antico Rosso ? Rim fragment with part of one pendent handle preserved. N.F.C. Possibly MM III–LM I in date, perhaps more probably LM II–III A I because of carefully carved pattern. Cf. above on the Atchana lamp. **Total 1**

12. Crescents in relief on the rim

Phaistos HM 210*. Ht. 10.5. Diam. (bowl) 10.5. N.F.C. **Total 1**

13. Large low lamps.

A special group of very large low lamps with a small disk or ring base. Some are circular, some of tripartite bowl form. They are MM III–LM I.

Gournia HM 73. Ht. 11.8. Diam. 40.0. Limestone, greyish. Circular form with three bowls. (Boyd Hawes 1908, pl. V 29.)

HM 74. Ht. 11.5. Diam. 36.3. Limestone, lightish brown. Circular with three handles and three wick cuttings. (*Ibid.* pl. V 28.)

HM 75. Ht. 15.0. Diam. 42.0. Limestone ?, grey. Circular form with four handles and two wick cuttings. (*Ibid.* pl. V 26.)

HM 76. Ht. 12.0. Width 35.0. Limestone, lightish brown. Square form but each side has curved mouldings and there is a wick cutting at four points of the circular bowl. (*Ibid.* pl. V 27.)

Knossos Diam. 42.0. Top of large, low, circular lamp with wide flat rim and four wick cuttings. House of Fallen Blocks. MM III. (*PM*, II, 298, fig. 174 B.)

Mallia HM 2226. Ht. 8.3. Length approx. 38.5. Serpentine ?, light green/grey. Oval shape with central bowl and smaller bowl at each end. Palace, East Wall. (Chapouthier & Demargne 1942, 68, fig. 43 and pl. LIV 1, 2.)

HM 2249. Diam. 48.0. Serpentine, grey. Circular with four pendent handles and two wick cuttings. Palace Room XVII. (Chapouthier, Demargne & Dessenne 1962, 57 & pl. XLIV.)

HM 2323. Ht. 10.5. Length 39.0. Width 27.2. Limestone, grey. Circular form with central bowl and smaller bowls at each end. Channel in centre of main bowl. House Db. (Demargne & de Santerre 1953, 59 and pl. XXVIII.)

HM 2419. Ht. 13.0. Length 36.7. Width 26.0. Serpentine or Limestone, light greenish grey. Large oval bowl with smaller bowl at each end; two solid lugs on each of long sides. House Zb. (Deshayes & Dessenne 1959, 64 and pl. XVIII 1–3.)

Mochlos HM 1169. Ht. 8.0. Length 38.5. Width 20.0. Limestone, brownish white. Oval shape, with wick cutting at each end; faceted moulding on underside. House D in town. (Seager 1909, figs. 17, 18, 21 right.)

Prasa HM 2445. Diam. 35.0. Serpentine, light green/grey. Circular form with two wick cuttings. House A. (Platon 1951 b, 253 and fig. 7r.)

11 plus 4 others (Gournia ?, Knossos and Palaikastro). **Total 15**

Group **II A: Total 155**

B. Tall, columnar, pedestalled form (heights from *c*. 35.0 upwards). Many have three raised bands or mouldings round the centre of the pedestal, consisting of a broad band round the middle with a smaller band, above it and below it. The material is serpentine and the context LM I unless otherwise stated.

A. Triadha PI G.M. 71949. Ht. 39.5. Diam. 17.0. Limestone, soft white. Palace. (Borda 1946, 73 and pl. LIII 3.)

Kalyvia Mesara HM 182. Ht. 35.6. Diam. 15.6. One wick cutting. Foliate Band round rim. LM IIIA tomb. Survival. (Savignoni 1904, 551–2 and fig. 36.)

Knossos HM 27. Ht. pres. 38.0. Diam. 28.0. Antico Rosso. The Lotus Lamp. Column and underside of bowl in shape of a lotus flower, the bowl itself quatrefoil with indented decoration imitating metalwork round the rim. Room of the Lotus Lamp. LM II–III A I (Palace Destruction). Very possibly made in MM III–LM I. (Evans 1899–1900, 44. *PM*, II, 521–2, fig. 325. *PM*, III, 26 and fig. 14 a 1–2. Zervos 1956, pl. 467.)

HM 28. Ht. 51.0. Diam. 27.0. Antico Rosso. Quatrefoil bowl. Room of the Saffron Gatherer. Context as last. (Evans 1899–1900, 44. *PM*, III, 26 and fig. 14 b (miscalled steatite). Palmer 1963 a, 119 (quoting Day Book for 4 May 1900).)

HM 30. Ht. 36.0. Diam. 27.0. Roughly cut diagonal grooves on the column. Passage S. of Room of the Stone Vases (i.e. Central Treasury deposit). Context as last. (Mentioned Evans 1899–1900, 32. Palmer 1963 b.)

HM 66. Ht. pres. 22.0. Diam. 10.5. Antico Rosso. Part of pedestal of columnar lamp, decorated with diagonal bands of linked ivy. South East House. MM III (or ? LM I—cf. the lilies from a fresco in the house, *PM*, I, pl. VI (opp. p. 537), with those on a vase from the newly found LM I B deposit at Knossos, Hood 1962, fig. 15). (Evans 1902–3, 7–8 and fig. 3. *PM*, I, 344–5 and fig. 249 (restored drawing) and 429 n. 3. Zervos 1956, pl. 468.)

HM 2871. Ht. 51.0. Diam. 22.5. Antico Rosso. Moulding of three bands round column. Royal Villa. LM II–III A I (Palace destruction context/date). (Evans 1902–3, 144 and fig. 89. *PM*, II, 404.) Limestone, soft white. Column with bulbous mouldings from top to bottom. Unfinished, wick cuttings not cut. House of the Fallen Blocks. MM III. (*PM*, II, 298, fig. 174 a.) At least five other high-pedestalled lamps from the Palace are referred to (*PM*, I, 390; II, 599; III, 399; IV, 920) as well as six more lamps (type not stated) from the House of the Fallen Blocks (*PM*, II, 298). Some of these may be among the three from Knossos in the twenty-eight others not catalogued here, but there is no way of making individual identifications. There are parts of six tall pedestalled lamps without provenience in the Stratigraphic Museum. These are not included in

the total as they are probably among those referred to in *PM* above.

Mallia HM 2475. Ht. 39.5. Limestone, coarse white, banded. Quatrefoil bowl. Moulding of three raised bands round column. House E, Room XXXIV. (Deshayes & Dessenne 1959, 135–6 and pl. XLIX 2.)

Meixorrouma Rethymno M.* Ht. 56.0. Diam. 28.4. N.F.C. but from LM I villa site. (Mentioned Alexiou 1960*b*, 272. On the site see Hood and Warren 1966, 175–6.)

Nirou Khani HM 2077. Ht. 41.0. Rim carved with petaliform pattern or pendent leaves (cf. above Group **II A** 4). Moulding of three raised bands round column. (Xanthoudides 1922, 13–14 and fig. 11 lower row left.)
HM 2078. Ht. 37.0. Undecorated. (*Ibid.* fig. 11 lower row right.)

Palaikastro HM 616. Ht. 46.15. Diam. 23.2. Antico Rosso. Moulding of three raised bands round column with linked ivy decoration (exactly as HM 66 above) round large central band. Same decoration in shallow relief round rim. N.F.C. (Dawkins 1923, 139 (no evidence given for LM III date) and fig. 121 A. Zervos 1956, pl. 466.)

Tylissos ? TORONTO 931.23.1*. Ht. 37.0. N.F.C. (said to be from Tylissos).

Vathypetro HM 2468*. Ht. 38.65. Diam. 29.9. Moulding on column. Top of rim carved out and raised crescents left to form divisions (cf. top of Lotus Lamp and HM 2429, below Group **C**). Villa.

Dendra NM. Ht. 52.0. Diam. 24.5. Stepped rim (cf. Group **II A 6** above); moulding of three raised bands round pedestal. Tomb 2. LH IIIB. Original MM III–LM I import. (Persson 1931, 101 and fig. 77.)
Nauplion 8875. Ht. pres. 22.0. Diam. 18.4. Moulding of three raised bands, carefully carved, round column. Tomb 9. LH II–III. (Persson 1942, 57 and fig. 64.)

Kythera Kythera Mus. 47*. Ht. 40.0. Plain column (cf. Tylissos ? above). N.F.C. Found in two pieces, very probably from Tomb D (of new excavations) originally, where the

finds were predominantly LM I A (see forthcoming excavation report).

Mycenae NM 3159. Ht. 52.8. Diam. 32.5. Antico rosso with one grey/green vein. Quatrefoil top with four wick cuttings (cf. under Knossos above); moulding of three raised bands round pedestal, flaring to disk base. Chamber Tomb 88. LH. (Warren 1967*a* (N 34).)
NM 3160. Ht. 48.0. Diam. 23.2. Stepped rim (cf. Group **II A 6** above); moulding of three horizontal bands at top of pedestal and three above disk base. Chamber Tomb 88. LH. (Warren 1967*a* (N 35).)

Phylakopi NM. Moulding of three raised bands round column. Third City (LM I–II). (Bosanquet and Welch 1904, 210.)

26 plus, plus 33 others. **Total 59 plus**

C. Medium pedestal, 20.0–35.0 high.

Usually plain save for raised mouldings on pedestal of some. Many flare widely to base, some have semi-spherical deep bowls (e.g. HM 617) on a flaring foot. The material is serpentine and the context LM I unless otherwise stated.

Gournia HM 561. Ht. 32.0. Plain flaring pedestal. (Boyd Hawes 1908, pl. II 77. Cf. pl. II 75 for an LM I parallel in clay, red polished.)

Knossos AM 1910.199*. Ht. 34.2. Diam. 26.3. Marble, white (this provides supporting evidence for the Mycenae and Thorikos low lamps being Minoan; cf. introduction to the Type). N.F.C. **P 311.**

Mallia HM 2110. Ht. 29.0. Diam. 17.5. Disk base. Palace destruction (LM IB). (Chapouthier & Charbonneaux 1928, 58 and pl. XXXI 1.)
HM 2429. Ht. 20.8. Diam. 30.2. Top of rim decorated with deep curved grooves (cf. HM 2468 above, from Vathypetro). House E, Room XXXVIII. (Deshayes & Dessenne 1959, 135 and pl. XLIX 3.) **P 312.**

Mochlos HM 1548. Ht. 23.2. Diam. 30.3. Plain. Town site. (Seager 1909, 302, fig. 21 centre.)

Palaikastro HM 437. Ht. 28.0. Diam. 30.0. Plain,

flaring pedestal. N.F.C. (Dawkins 1923, 139
and fig. 119 C.)

HM 617. Ht. 27.0. Diam. 24.5. Drum-shaped
bowl on flaring pedestal. N.F.C. (*Ibid.* fig.
121 B.)

Pseira HM 1101. Ht. 23.2. Diam. 20.3. Plain;
one thick raised band round centre of flaring
pedestal. LM I town site. (Seager 1910, fig.
150.) **P 313.**

8 plus 13 others (A. Triadha, Gournia, Knossos,
Palaikastro, Vathypetro, Zakro and E. Crete).
Total 21

There are also fragments of 51 lamps of low,
medium or pedestal type from the 1957–61
excavations at Knossos. These pieces are too
small to be classified as Group **A**, **B** or **C**.
Total 51

III. Lampstands

Flat circular tables with two pendent handles,
on tall columnar pedestals with disk bases.
Of serpentine or white limestone. Most
have contexts and these are always LM I.
Tall stands in clay are also found in LM I,
either columnar or of tripod form (see Boyd
Hawes 1908, pl. II 65, and Dawkins 1923,
fig. 120 A).

Palaikastro HM 435. Ht. 47.0. Diam. 26.4.
Serpentine. N.F.C. (Dawkins 1923, 138 and
fig. 120 B.)

HM 938*. Ht. pres. 32.0. Diam. 33.3.
Limestone. A slightly raised band round the
top edge of the table was painted red; traces
of the paint survive. N.F.C.

Tylissos HM 1550. Ht. *c.* 50.0. Diam. 23.0.
Serpentine. This and HM 1551 have a hole
drilled in the centre of the table top, for the
attachment of the lamp. (Hatzidhakis 1921,
47–8, fig. 22*a*.)

HM 1551. Ht. 43.0. Diam. 31.0 Serpentine.
Central drilled hole and two pairs of smaller
holes for the attachment of a low lamp.
(*Ibid.* fig. 22*c*.)

Zakro HM 106. Ht. 28.0. Diam. 24.0. Lime-
stone, light grey. Thick pedestal. House M.
(Hogarth 1900–1, 136, fig. 47.)

HM 2684*. Ht. 62.35. Diam. 31.8. Limestone,
white, fine-grained. Palace.

HM unnumbered*. Ht. 60.0. Diam. 30.7.
Serpentine. Palace. **Total 7**

IV. Hand lamps

These have straight 'stick' handles and one
wick cutting, opposite the handle. An MM–
LM I stone type, imitating the common
contemporary clay forms.

Knossos KSM (1957–61): (1) Fragment preserv-
ing part of bowl. Serpentine. MM IIA Royal
Road (= B 23). (2) Part of bowl and half rim
preserved; rim decorated with two grooves.
L. pres. 12.2. Serpentine. MM IIB. Gypsadhes
tholos (F 8).

Mallia HM 2134. Ht. 3.9. Length 16.9. Schist,
pale grey, fine grained. Palace, Room XI 2.
LM I. (Chapouthier & Joly 1936, 40, fig. II
and pl. XXXIV*e* right.) **P 314.**

HM 2474. Ht. 4.2. Width *c.* 12.2. Serpentine.
Small raised collar round bowl and small
moulded base. House E. Room XXVII.
(Deshayes & Dessenne 1959, 137 and pl. L 2
left.)

Mochlos HM 1279. Ht. 3.2. Length 12.3.
Serpentine. Stitch type decoration round
rim, small moulded base, three grooves at
end of handle. Tomb XII. MM III–LM I.[1]
(Seager 1912, fig. 47, XII*a* and pl. IX.) **D 174.**

Palaikastro HM 1309. Ht. 4.5. Length 17.85
approx. Serpentine, pale mottled. Distinct

[1] Seager (1912, 61) dated this tomb to MM III, but its contents cannot be more closely dated than MM III–
LM I. One of the two bronze vases (cf. the prominence of bronze in LM I villas and houses) is a Vapheio cup,
the only other metal examples being those from the LH II A (LM I B) Vapheio tomb; the three-sided carnelian
seal is LM I (cf. Kenna 1960, 69 on this type); and the heart-shaped bead (Seager, fig. 30 XII*j*) has now several
parallels on a necklace from an LM I house at Palaikastro (Sackett, Popham and Warren 1965, colour Plate).
(The one clay vase (Seager, fig. 31 XII*m*) is unique and so cannot be used for dating.)

base. LM I ? Probably Dawkins 1923, pl. XXX A 3, but the vase is marked Σ 5 and so is probably from that area and not from the Block X hoard (as implied by Dawkins). **P 315.**

Phaistos MM I–II (fill of first Palace). (Pernier 1935, fig. 236 bottom row left.) Material not stated.

Pseira HM 1111. Ht. 4.4. Length 17.45. Antico Rosso. Twin of HM 1279 above. Town (LM I). (Seager 1910, 37 and fig. 18. Zervos 1956, pl. 239.) **P 316.**

8 plus 11 others (Gournia, Knossos, Palaikastro, Zakro, Central Crete (Rethymno M.)). There is one from Kea, made of chlorite; it is unfinished and was thus being made on the spot. It is not included in the site or materials tables. **Total 19**

V. Individual forms

Gavdhos Levi 1927, 183 reports half of a stone saucer lamp but does not give a drawing, picture or comparisons. Perhaps it was an ordinary Group **II A I** piece. Material not stated.

Khamaizi HM 451. Ht. 6.1. Length 16.75. Serpentine. Hand lamp with loop handle. Imitation of standard MM I clay type (e.g. Xanthoudides 1924, pl. XXXVII 5090). MM I. (Xanthoudides 1906, 149 and pl. X top row right.) **P 317.**

HM 452. Ht. 6.85. Diam. 10.75. Length 15.0. Serpentine. Bowl with vertical handle and rim opposite moulded into lamp spout, which is blackened through burning. MM I. (*Ibid.* pl. X top row centre.) **P 318.**

Knossos KSM (1957–61): (1) Fragment, probably part of hand lamp with horse-shoe shaped handle (cf. HM 2577 below) 5.3 × 5.2 Royal Road. MM IIIA (LA 23). (2) Unfinished small lamp, without handle or wick cutting; lozenge shape with squared ends; roughly worked hollow in centre. Ht. 7.4. Length 7.7. Width 6.8. Royal Road. MM IIIB (JK ext. 54).

Phaistos HM 186. Ht. 5.4. Length 13.2. Chlorite. Hand lamp; centre cut out to leave a hollow cylinder with a hole in its side at the bottom; also a bar left across spout cutting. These features are for keeping the wick in place. Palace Room 8. LM I. Very possibly an MM survival. (Pernier & Banti 1951, figs. 57–8.) **P 319a–b.**

HM 2577*. Ht. 4.4. Length 12.68. Serpentine, dark brown with tiny golden particles. Hand lamp with one horizontal bow-shaped handle opposite spout cutting. Imitation of clay form, e.g. Pernier 1935, fig. 263 top left; bottom 2nd from right. Room LV. MM II. (Levi 1956, 238–70 for the room.) **P 320.**

Prasa HM 2441*. Diam. 13.5. Serpentine. Hand lamp (probably). Bird's Nest Bowl shape with horizontal bow-shaped handle. Spout cutting not preserved. House A (probably).

Total 8
Type total 337 plus

25. LARGE AMPHORAS OR PITHOI

These are the largest Minoan stone vessels and display great mastery by the lapidary over his material. Most of the group are from the Knossos Palace destruction material but there are serpentine examples from A. Triadha and Tylissos. These two are from LM I contexts and should be dated MM III–LM I. HM 22, HM 23 and HM 60 from Knossos are probably of the same date. But definitely LM II–III A I are the giant amphora and the smaller unfinished amphora (HM 20 and HM 24) for these were being worked at Knossos at the moment of destruction. HM 15 from Avdhou was

probably looted from the Palace after it fell. It too is unfinished and is made of gabbro, easily the largest vase in this material and a remarkable attempt on so hard a stone. The pithoid jar from Mycenae, NM 2790, closely resembles HM 23 from Knossos, and was probably imported into Mycenae in LM I. There were fragments of two or three large stone pithoi, resembling the Knossos Medallion Pithoi in clay, from the Tomb of Clytemnestra at Mycenae. In view of the Minoan connexions (see below) it is almost certain that these vases were imported from Crete.

A. Triadha HM 345*. Serpentine. Large high-shouldered jar with one handle. Palace, almost certainly LM I context. **P 321.**

Avdhou Pedhiadha HM 15*. Gabbro. Small amphora. Unfinished. Ht. 24.0. Four knob handles on the shoulder; everted rim; mouldings on the neck. Only a small part of interior removed; cylindrical holes where a few cores drilled out. N.F.C. Gift of Xanthoudides.

Knossos HM 20. Banded tufa, creamy brown/white with darker brown bands. Giant stone amphora. Unfinished. Ht. 67.6. Carefully carved with shallow linked spirals (see under Alabastrons, type I B). Lapidary's Workshop. LM II–IIIA I. (*PM*, IV, 896–900, figs. 875a, b, and 876.) **P 322.**

HM 22. Serpentine. Large jar with thick linked spirals in relief round the body. Room of the Saffron Gatherer. Stratified position not certain; very probably from final Palace destruction like the other large stone vessels from this area (cf. Basins and Lamps). Evans quotes Middle Minoan spirals as parallels but one may equally compare the popularity of the spiral on LM I pottery. The relief spirals on a bronze ewer (LM I) from the Vth Shaft Grave are of exactly this type (*PM*, II, fig. 411 B. *PM*, III, 20–1, fig. 10.) **P 323.**

HM 23. Serpentine. Pithos, with three vertical handles on shoulder and two raised bands below moulded rim; disk base. Passage S. of Room of Stone Vases (Central Treasury), fallen from upper floor and probably belonging to Central Treasury deposit originally. LM II–III A I. (Warren 1965.) **P 324.**

HM 24. Banded tufa, as HM 20 above. Smaller amphora than HM 20, without decoration, unfinished, only small part of interior removed; chisel tool marks all over. Lapidary's Workshop. LM II–III A I. (*PM*, IV, 897 and 900, fig. 876.)

HM 60*. Limestone, maroon with grey calcite veins. Lid of same material with bow-shaped handle. Ovoid amphora. N.F.C., but very probably Palace destruction context. **P 325.**

Tylissos HM 1552. Serpentine. Large jar resembling HM 345 and HM 23, with two horizontal handles on body. LM I. (Hatzidhakis 1921, 54, fig. 28c.)

Mycenae NM 2790. Serpentine, rust brown with grey/black patches. Four vertical handles on shoulder and two raised bands below moulded rim; disk base. Chamber Tomb 27. LH. (Warren 1967a (R 4).) NM. Serpentine. Pithos with medallions in relief and incised herringbone decoration. Pairs of holes for fitting separate handles. Ht. c. 90. (restored). Tomb of Clytemnestra. LH III. Manufactured in MM III/LM I–III A I. The nearest parallel is the Medallion Pithos from Knossos, Xth Magazine, which, with its figure-eight shields handles and rosettes, is closely comparable with the Throne Room alabastrons and their lids. The Mycenae vase is almost certainly a Minoan import because of its material, Knossos clay parallel and the occurrence of other stone pithoi at Knossos (see above and cf. Warren 1965). (Wace 1921–3, 367–8, fig. 80. Evans 1929, 86–9, fig. 66.)

Wace (*ibid.* 368) refers to fragments of a

second pithos, with medallions like the last and also of serpentine. This was also restored and both are in the storerooms of NM. The evidence for two is a difference in width of the bands of herringbone decoration (2.5–2.8, and 3.6). But both vases are very substantially restored and all the fragments could easily be from one pithos with bands of slightly varying width. In each of the two restored vases the material and type of decoration is exactly the same and both have pairs of holes for separate handles.

NM. Antico Rosso ? Fragments of large vase, ? pithos, found as last. (Wace 1921–3, 366.) Again almost certainly Minoan (cf. Lotus Lamp and other Knossos Palace destruction lamps in Antico Rosso). **Total 11 or 12**

26. LIBATION TABLES

There are a number of different forms but the basic shape is a square receptacle (sometimes round, form **7**) with a circular central bowl round which there may be a raised collar. The sides may slope into a flat base, or there is a moulded base or no defined base; an underside cut with inverted 'steps' is not uncommon. A few vases are on small pedestals (form **4**), others are low on four small feet (form **5**) and there are one or two individual examples (form **8**). Some of the Middle Minoan examples have incised and inlaid decoration.

That they were for religious uses, presumably for libations and offerings, is assured by their find spots, peak sanctuaries (Koumasa, Palaikastro Petsofa), sacred caves (Patsos, Psykhro), and shrines in the palaces and houses. Several have Linear A inscriptions (Brice 1961) which are presumably connected with the cult.

The materials are more varied among the small Middle Minoan tables (form **1**), breccia, calcite, chlorite, limestones (including dolomitic) marble, sandstone and serpentines, whilst from MM III onwards ordinary serpentine and coarse white limestone exclude almost all other stones, save for one or two of gypsum (form **6**) which were very probably made in LM II–III A I.

The type begins in MM I, if not in EM III, for the Koumasa peak sanctuary example (form **1 B**) had incised and inlaid decoration exactly like that of the Block Vases (type 4). Small examples (form **1**), sometimes decorated, continue through MM times into LM I whilst from MM III onwards large examples occur (form **2**). These and the circular tables are popular in LM I. Two of gypsum very probably date from the final Palace period at Knossos whilst a third of this form occurred in the Central Treasury deposit. Its context is thus LM II–III A I and it was probably made then although other vases from that deposit are MM III–LM I. In general the MM I–III small examples may be clearly distinguished from the larger tables of more varied forms, often with Linear A inscriptions, of MM III–LM I (forms **2–7**).

I. **Small, square, with various forms of base.** MM with a few in LMI contexts which are probably MM survivals (Arkhanes, and Palaikastro) and one from Kea. Three others (**B**, Apodhoulou, **E**, Gournia and **G**, Gournes) are in LMI contexts and are almost certainly MMIII–LMI in date.

A. Low form with sides sloping into flat base

Katsamba HM 2589*. Limestone, polychrome pastel shades, wavy banded, sandy buff, maroon, purple, grey. N.F.C. Chance find 1955. **P 326.**

Knossos HM 271. Serpentine. Temple Repositories. MMIIIB. (*PM*, IV, 497, fig. 355, probably 2nd from left.) **P 327.**

HM 272. Breccia, grey/black matrix, brick red patches and veins, white pieces. As last. (*Ibid.* fig. 355 left.) **D 175.**

HM 2394. Serpentine. Linear A inscription. Corner fragment, original perhaps of large size as form **2** below. N.F.C. (Davies 1926–7, 297. Brice 1961, 14 no. I 9 and pl. XIX.)

Phaistos HM 188. Serpentine. Corners cut off; incised decoration of vertical hatched band down centre of each side, triangle cut out for inlay on each side of band, finely carved rosette on face of each cut-off corner, double scroll cut out with incised circle joining each scroll at centre on top surface of vase at each corner; cut out scrolls and interstices of rosettes filled with red paint. Palace Room VIII (Shrine complex). MMII (cf. rosette and scroll patterns). (Pernier 1935, 227–8 and fig. 105.) **P 328.**

HM 2570*. Chlorite. Corners cut off and each decorated with three vertical grooves; on top surface at each corner diamond cut out and filled with quatrefoil type inlay of white stone. Room LIV. MMIIB. (For room Levi 1955, 141 sqq.) **D 176. P 329.**

Plus 6 others (Arkhanes (LMI context), Gournia, Knossos (2 Temple Repositories), Palaikastro). **Total 12**

B. Same form but high sides, sloping into flat base near the bottom

Apodhoulou HM 2478. Serpentine. In two parts, divided horizontally; inlay hole at each corner of top surface. Linear A inscription. Villa. (Marinatos 1935, 247–8, fig. 2 left. Brice 1961, 14 no. I 14 and pl. XX.) **P 330.**

Koumasa HM 1017. Serpentine. Large circular inlay hole at centre of each side; incised decoration of arcs with vertical bars in a semicircular pendent band on each side; the pattern is found on Block Vases (cf. **P 40**) and so the vase is not later than MMI. It is thus the earliest datable Libation Table. Peak Sanctuary. MM. (Xanthoudides 1924, pl. XXXIII 1017 (wrongly numbered 5017).)

Phaistos HM 216. Limestone, mottled hard white with maroon and grey/black patches. Corners cut off. Palace Room VI. MMII. (Pernier 1935, 221, fig. 99.) **P 331.**

HM 2551. Marble, grey of different shades, mottled. Room LI (1st phase). MMIIA. (Levi 1952–4, 412 and fig. 41 569.) **P 332.**

Plus 4 others (3 Phaistos, 1 Porti). **Total 8**

C. Square or circular base

Phaistos HM 191. Chlorite. Circular inlay hole at each corner of top surface; incised cross ✕ on each side. N.F.C. (Pernier & Banti 1951, 376, 379–81, figs. 243 *a* and 247 *d*.)

HM 1514. Chlorite. Rectangular with deeply cut box-like interior and incut corners. On each of main sides two incised wood-pigeons (ring doves, *columba palumbus*); rectangles cut out for inlay on the rim. Room VIII (Shrine complex). MMII. (Pernier 1935, 235–8, fig. 113.) **D 177. P 333.**

PIG.M. 77260. Chlorite. Octagonal with vertical grooves at each corner; rounded base. From under Room XXV. Context not later than MMI. (*Ibid.* 140, fig. 60. Pernier & Banti 1951, fig. 242. Borda 1946, 37 no. 30 and pl. LII 5.)

Plus 1 other **Total 4**

D. Simple flat base without mouldings

Inatos HM 2630*. Limestone, light and dark grey banded. Square, vertical sides. Cave of Eileithyia. Sub-Minoan to Geometric.

Kamilari HM 2866. Serpentine, pale brown with mottled patches. Corners cut off. (Levi 1961–2, fig. 120 C *i*.)

Mallia HM 2114. Serpentine. (Demargne 1945, pl. LXIII. Not mentioned in text but from one of the MM I cemeteries.) **P 334.**

Phaistos HM 214. Dolomitic limestone, grey/black and white. Corners cut off and decorated with vertical grooves. N.F.C. (Pernier & Banti 1951, 375.) **P 335a.**

Kea K 3.319*. Breccia, black pieces in white matrix, red veins.

Plus 2 others (Gortyn, Phaistos). **Total 7**

E. Small square, with sides thickened near top; square cut interior. This form is MM III–LM I. Cf. Group 3 below with stepped bases.

Gournia HM 333. Sandstone, pale creamy grey, porous with gritty inclusions. LM I. (Boyd Hawes 1908, pl. V 17.)

Knossos KSM (1957–61): (1) Royal Road, soft white limestone, LM IB (JK 65). (2) Fragment, soft white limestone, LM I (JK 67).

Palaikastro BM 1907 1–19 229*. Serpentine. N.F.C. **Total 4**

F. As E but with mouldings on base

Knossos HM 1093*. Calcite, translucent creamy, banded. Raised band above base (which consists of a circular knob, ? dowel for insertion in stand) with vertical ribbed moulding. N.F.C. **P 335b.**

Phaistos HM 189. Serpentine. Stepped top surface, raised moulding round base. Room VIII (Shrine complex). MM II. (Pernier & Banti 1951, fig. 246 lower row left.) **P 336.**

Rethymno Province Rethymno M.* Chlorite, with some serpentine. Raised band with vertical ribbing round top of body and round base; raised lug at each corner of top surface. N.F.C. **Total 3**

G. Underside with inverted 'step' moulding

Gournia HM 316. Chlorite. LM I. (Boyd Hawes 1908, pl. V 15.) **D 178.**

Phaistos HM 190. Chlorite. Steps unevenly cut. Room VIII (Shrine complex). MM II. (Pernier & Banti 1951, fig. 246 upper row centre.) **P 337.** **Total 2**

Form 1: Total 40

2. Large tables (over 13.0 × 13.0), low and flat. A: with plain or elaborately moulded bases, all serpentine; **B:** higher, with inverted stepped pyramidal undersides, serpentine unless otherwise stated. Both groups may have linear signs or Linear A inscriptions.

These large vases are the successors of the MM small Libation Tables. One is from an LM I context and those with Linear A inscriptions are presumably MM III or later. The use of ordinary serpentine and limestone confirms this dating, in contrast with the variety of MM materials.

A. *Knossos* KSM (1957–61) fragment; Royal Road (JK ext. 24), MM–LM I.

Phrati[1] HM 2172*. Low circular base; two incised horizontal grooves round sides. N.F.C. **P 338.**

Psykhro Cave HM 576. Underside slopes into base, as form **I A–B.** Incised marks (? signs), one ? fish. MM–LM. (Hogarth 1899–1900*b*, fig. 50 and pl. XI 2.)

BM 1907 1–19 232. Elaborately moulded underside (see Drawing and Plate). This and BM 1907 1–19 231 are the finest surviving

[1] Three miniature Libation Tables were found in the Archaic city of Arkadhes (Phrati) (Levi 1927–9, 47, fig. 27). In view of their crude forms and tiny size they were probably products of the Archaic period rather than Minoan survivals. They are not included in the catalogue.

Libation Tables. Context as last. (*Ibid.* pl. XI 5.) **D 179. P 339.** Fragment. N.F.C. (Demargne 1902, 582.) **Total 5**

B. *Knossos* HM 54*. Limestone ?, brownish grey. Palace. N.F.C. It might be the vase mentioned by Evans (1899–1900, 21) from West Magazine II.

HM 2100. Limestone, grey/black and creamy grey, horizontally banded. Linear A inscription. House of the Frescoes. LM I. (*PM*, II, 438–9 and fig. 256 A, B, D. Zervos 1956, pl. 627. Brice 1961, 13 no. I 8.) **P 340.**

Palaikastro HM 438. Rim cut into cruciform pattern with zigzags between the points of the 'cross'. This rim arrangement has no Minoan parallels and may well be a later adaptation. N.F.C. Found at Palaikastro, taken to the Church of A. Nikolaos nearby, covered with whitewash and used as an incense burner, until discovered by the excavators. (Dawkins 1923, 137 and fig. 119 A and pl. XXXI 1.)

HM 618. Linear A inscription. N.F.C. Found at the mouth of a cave on the lower slopes of Petsofa. (Dawkins 1923, 141–2, fig. 122 and pl. XXXI 2. Zervos 1956, pl. 600. Brice 1961, 12–13 no. I 3.) **Total 4**

3. Box shape, on incut base. Tables of coarse, soft white limestone, square or rectangular with the interior fully cut out so that the whole resembles a box on a moulded or inverted stepped base; the inside base has a square or circular hole cut in it, which prompted Boardman (1961) to suggest that these might not be Libation Tables but lamp- or torch-holders. Many do have marks of burning, but the presence of Linear A inscriptions or linear signs on some suggests that they were consecrated to ritual use as part of the cult furniture. Two are from LM I contexts and the presence of the signs and inscriptions is confirmatory of an MM III–LM I date for the group.

Gortyn Kannia Horns of Consecration carved on one side, 'lettere minoiche' (? Linear A inscription) on another. Villa Room XV. LM IIIB (Shrine reoccupation). (Levi 1959, 249 and fig. 23 and 253, fig. 24.)

Patsos HM 585. Incised grooves marking off body from moulded base. On one side is an engraving of a ship. (Warren 1966b.) N.F.C. Cave of Hermes Kranaios, where sherds collected by Hood, Warren and Falconer (May 1965) were LM I (Hood & Warren 1966, 186). **P 341.**

Pseira HM 1099*. Inverted step moulding. N.F.C. (but nothing from Pseira is post-LM I).

Psykhro Cave AM AE 219. Inverted stepped base. Linear signs on sides. MM–LM. (Boardman 1961, 64–6 no. 272 and fig. 29 and pl. XXIII.) **D 180.**

AM AE 800. Tall elaborately cut pedestal. MM–LM. (Hogarth 1899–1900b, 114 and pl. XI 3. Boardman 1961, 66 no. 273 and fig. 29 and pl. XXIII.)

FM GR. 201.1907*. Moulded base. This form is said by Hogarth (*ibid.*) to occur in the 'upper' 'Geometric' stratum but this stratum (*ibid.* 98) seems to have been mixed, post-'Kamares' LM–Geometric. Hogarth, pl. XI 6 is probably this vase.

Tylissos HM 1556. Moulded base (one 'step'). LM I. (Hatzidhakis 1921, 48 and fig. 23 b.)

Crete HM 2593. Rectangular, base crudely carved with inverted stepped moulding. Linear A inscription of about 10 signs on one long side. N.F.C. Found in HM Apotheke, 1957. (Platon 1958b, 317–18 and pl. 3. Brice 1961, Appendix no. 1, 18 and pl. XXI.) **Total 8**

4. Pedestalled form. Three from Palaikastro and one from Knossos. Those from Palaikastro have Linear A inscriptions and are of serpentine, so presumably MM III–LM I. They are probably all (one certainly) from the Petsofa peak sanctuary and that from Knossos is from an LM I house shrine.

Knossos KSM. Limestone, buff. *Arch. Reps. for 1957*, 22 and fig. 7 centre.

Palaikastro HM 942. (Brice 1961, 13 no. 1 5.)
HM 1341. Probably Petsofa. (Bosanquet 1923, 143 no. 4. Brice 1961, 13 no. 1 4.) **D 181. P 342.**

HM 1585. Petsofa (HM catalogue). (Evans & Bosanquet 1923, 143 no. 3, fig. 124 and pl. XXXII B. Brice 1961, 13 no. 1 7.)

Total 4

5. **Low form, with or without four short legs.** Serpentine is the material, save where stated. The group is well dated to MM III–LM I by the Gournia, Khondros Rousses, Mallia and Palaikastro (probably) examples. Only the Khondros and possibly Dreros vases were found in cult contexts.

Arvi AM AE 2*. N.F.C. Said to have been found on Tartari Hill a little below the monastery. But the main Minoan site at Arvi is at Kamini, which is below the monastery but is distinct from Tartari (which is further from the monastery). A number of stone vase fragments have been found at Kamini (Hood, Warren & Cadogan 1964, 90–1, 96–8). (Mentioned Evans 1897, 357. *PM*, I, 497 n. 1 and 630.) **D 182.**

Dreros HM 2556. Archaic period context. (Demargne & Van Effenterre 1937, 17, fig. 10.)

Gournia HM 322. LM I. (Boyd Hawes 1908, pl. V 18.) HM 1307. Limestone, coarse soft white (brown/grey surface). Arched moulding on each side. (*Ibid.* pl. V 19.) **P 343.**

Khondhros Rousses HM unnumbered. Serpentine, pale grey with network of grey/black veins. Raised band round edge of top surface. House Shrine. LM I (for the date cf. Hood, Warren & Cadogan 1964, 82, and p. 195

n. 1). (Platon 1957b, 146, pl. 73 B. *B.C.H.* 1958, 779, fig. 3 centre.)
HM unnumbered. Limestone, creamy white to dark brown. Fragment, may have been rectangular like AM AE 1 (form **8**). Raised band round edge of top surface and incut horizontal band round all four sides. LM I. As last. (*Ibid.* pl. 73 B. *B.C.H.* 1958, 779, fig. 3 right.)

Mallia HM 2287. Horizontal groove incut round sides. LM I. House E. (Deshayes & Dessenne 1959, 136 and pl. XLIX 5.)

Palaikastro HM 443*. Limestone, light maroon. No feet. Probably LM I (? LM I A). Block K. (See Dawkins 1903–4, 203–4.)

E. Crete Hierapetra M. Unnumbered*. Corner fragment; one foot and parts of two bowls preserved. Incised herringbone decoration round the sides. N.F.C.

Plus two others (Knossos (1957–61), LM I).

Total 11

6. **Form with square, elegantly moulded base.** Three of the four examples are of gypsum. Two of these are from Knossos and might well have been in the Palace destruction debris though their context is not known, and the third is from a chamber tomb at Mycenae. Their date is probably LM II–III A I like that of other gypsum vases from the Palace and its environs. The other Knossos example, of limestone, might be MM III–LM I or LM II–III A I.

Knossos HM 55. Limestone, white, fairly hard. Central Treasury deposit. (*PM*, II, fig. 537e.) **P 344.**
HM 2099. Gypsum, white. Court of the Altar. From excavations of 1922 or 1923, but find position not known. (The Court of

the Altar is also the Central Clay Area or the Hellenic Temple. For work here in 1922–3 see Boardman 1963a, 17). (Warren 1967b.)

Mycenae NM 2263. Gypsum, white. Tomb 26. LH. (Mentioned Tsountas 1888, 144.)

Plus 1 other (Knossos, N.F.C.). **Total 4**

7. Circular, in shape like the plain, undecorated low lamps (D 173) but without wick cuttings. Those of Group **A** are low, those of **B** have a higher foot so that the height roughly equals the diameter. A few of **A** are like large, low lamps (diam. over 20.0), otherwise all are fairly small vases. The form is to be dated MM III–LM I; the clear contexts are LM I. The material is coarse white limestone save where stated. The Palaikastro fragment has a Linear A inscription. This piece and those from Traostalos and Psykhro were found in cult contexts. Most of those from Zakro were inside a pithos and had perhaps fallen from an upper storey.

A. *Gournia* HM 562. Banded tufa, creamy white, brown, greyish. Diam. 26.0. Two pendent handles. LM I. (Boyd Hawes 1908, pl. II 54.)

Palaikastro HM 1586. Serpentine. Fragment. Diam. 28.5. Linear A inscription. N.F.C. Petsofa. (Evans & Bosanquet 1923, 142 no. 2, fig. 123 and pl. XXXII a. Brice 1961, 13 no. I 6.)

Psykhro Cave AM AE 211. Serpentine. MM–LM. (Evans 1895, 122, fig. 121. Boardman 1961, 66 no. 271, fig. 29 and pl. XXIII.) A large example, not traceable, serpentine (probably), diam. 27.5. Cf. HM 562 and HM 1586 above. MM–LM. (Hogarth 1899–1900b, pl. XI no. 1.)

Zakro HM 2679*. Cf. AM AE 211. LM I. Palace Room H (Eta).

E. Crete Hierapetra M. 374*. Limestone, purple maroon. No moulded foot. N.F.C.

Plus 6 others (Zakro Palace, 2 without moulded base). **Total 12**

B. *Gournia* HM 325. Serpentine. LM I. (Boyd Hawes 1908, pl. V 14.)

Palaikastro HM 134*. N.F.C. **D 183. P 345.**

Traostalos HM unnumbered*. About six from the Minoan peak sanctuary recently excavated by K. Davaras in E. Crete.

Zakro HM 2671*. LM I. Palace Room H (Eta). Plus four others like it. **Total c. 13.**

8. Individual examples

Anatole Hierapetra HM 102*. Limestone, white. Large flat open circular bowl with circular sinking in centre; on pedestal foot. ? MM–LM in date. N.F.C. **P 346.**

Knossos AM 1938.872. Dolomitic marble, grey and white mottled. Circular bowl with carination into base. Linear A inscription. Found N. of Palace. N.F.C. (*PM*, IV, fig. 641. Brice 1961, 14 no. I 11 and pl. XIX.)

KSM (1957–61), small square table with roughly circular bowl. Soft white limestone. Royal Road. LM IB (JK 65).

Phaistos HM 215*. Dolomitic marble, grey and white mottled. Solid cylindrical drum, slightly broadening to top, with raised band round the flat top surface. Probably a Libation Table. N.F.C. Date MM–LM I.

HM 2563. Serpentine. Solid cylindrical drum with slight raised collar and shallow bowl; two cuttings on sides as hand grips; carination into base. Room LIV. MM IIB. (Levi 1955, 146 and fig. 8b.)

Prasa HM 2444. Limestone, creamy buff. Plain rectangular box. Linear A inscription. House B. LM I. (Platon 1951b, 253, fig. 6 lower row left; 1958b, 305–17, pls. I–II. Brice 1961, 28, no. I 18 and pl. XXI.) **P 347.**

Psykhro Cave AM AE 1. Serpentine. The Psykhro Libation Table. Rectangular with three shallow bowls; low circular foot under centre of vase and four small feet. In view of its general similarity to those of form **2 A** and the invariably short legs of form **5** Evans' restoration is unlikely to be correct. The original form was probably much as now (i.e. non-restored part) with the corner legs a little longer. Linear A inscription. MM–LM. The main bibliography is: *PM*, I, 625–30; IV, 157 n. 3 and refs. Caratelli 1957, 165 sqq. Boardman 1958; 1961, 63 sqq. Brice 1961, 12 no. I 1.

BM 1907, 1–19, 231. Serpentine. Superbly moulded, square top with circular bowl and raised collar, on circular pedestal

foot with mouldings at its top and bottom. MM–LM. (Hogarth 1899–1900*b*, pl. XI 4.) **D 184. P 348.** *Tylissos* HM 1559*. Limestone, coarse soft white. Plain rectangular box. Cf. Prasa above. N.F.C. though very possibly from LM I villas. **Total 9**

Type total *c.* **110**

27. LIDS

Stone lids are found in great numbers from the earliest pyxis covers, such as the Mochlos dog lid, through the whole Bronze Age. One or two lids of white gypsum are of LM II–III A I date and simple, rather crude, pierced disks were in use at Karphi and Vrokastro in LM IIIC and Geometric times.

There are two main forms. Each has a pawn-shaped handle, one a plain underside , the other incut to fit the mouth of the vase . These are found in roughly equal numbers, about 125–30 of each coming from known contexts. Occasionally there are slight refinements such as a bevelled top surface , or a neatly finished edge at the base of the pawn handle . A few examples have incised decoration on the top surface, a star pattern being the most frequent. Occasionally a dome-shaped, a cylindrical or an arched instead of a pawn handle is found . In a few instances the lid is a simple disc with no handle but sometimes with a dowel hole for fitting a separate handle. A heart-shaped instead of circular form has several examples, the purpose being to cover the spout as well as the mouth. Most of the decorated lids and variant forms (Group **C 2, 3, 4, 5, 7** below) are EM III–MM I/II.

In the early period, EM II late–MM IB/II, the lids are usually small, under 8.0 in diameter, and the materials varied, though serpentine is by far the most popular, followed by chlorite. Two of MM I date from the Knossos Vat Room deposit are of gypsum, the only use of it for vase material before LM II–III A I. This lid size, under 8.0, corresponds to the proliferation of small vases at this time. A few larger examples are found. In MM III–LM I serpentine is used almost exclusively and the lids are larger, over 8.0 in diameter, to fit the larger vases now being made, especially Blossom Bowls.

Very few lids have been found on or with their vases but most types that can take a lid seem to have had one. Bird's Nest Bowls, Carinated and Curved Bowls and Cylindrical Vases in the early period (types 3, 6, 7, 8, 18, 20), Blossom and Grooved Bowls, Tankards and other bowls in the late (types 5, 9, 11, 40) are obvious forms for lids, whilst open Spouted Bowls for example, and Miniature Amphoras or Goblets were clearly not meant to have them.

Apart from this main type there are only three special classes. **A.** Pyxis lids of several forms. Some have been discussed under Pyxides because they form an integral part of the vase. This class always has a flanged underside, whilst the top surface is domed or flat. Usually there are small holes for fastening down the lid, corresponding to pierced lugs on the vase. Where they have a context these pyxis lids are early, EM II–MM I, except for an exquisite rock crystal miniature from Knossos which is not likely to be pre-MM III–LM I. **B.** Large lids of serpentine, 20.0 or more in diameter, used for pithoi and large clay or stone vessels like Bucket Jars. These lids have bow-shaped handles and the underside plain or incut like the ordinary smaller lids. They seem to begin in MM (Kastellos Lasithi) but date mainly from LM I, those from the Knossos Palace surviving to the destruction. **C.** The gypsum lids of the Knossos Throne Room alabastrons (see type I **B** for the vases). These have finely carved rosettes on the top surface and usually figure-eight shield handles. All are LM II–III A I, with one in a later context. One made of chlorite was found at Mycenae.

A few examples of the main types and their variations and of the special classes are given.

I. A. Plain underside

Galana Kharakia HM 2603★. Serpentine, green/grey with light brown patches. **D 185.** About 130 others of this form.[1]

I. B. Incut underside

Mochlos HM 1275 BIS. Limestone, grey/black with white veins. N.F.C. Surface. (Seager 1912, fig. 47 M 21.) **D 186. P 122.** About 125 others of this form.

I. C. Variants

1. Bevelled top surface and ring at base of pawn handle

Palaikastro BM 1907 1–19 106★. Serpentine, pale grey with network of grey/black veins. N.F.C. **D 187. P 349.**

2. Star and other incised patterns on top surface

Knossos HM 2275★. Chlorite. Star pattern.

Temple Tomb. Probably LM II–III A I. Survival. **D 188.**

There are six others with very similar star patterns: HM 2899 BIS.★ Chlorite. Katelionas Siteia, chance find with Block Vase, 1965; PI G.M. 70377, from Phaistos, N.F.C. (Borda 1946, 37 no. 29 and pl. LII 6); Hierapetra M. Unnumbered★; Phaistos Strat. Mus. F 59 2846★ (probably MM I–II context); Khania M. Λ 1046★ (Monastiraki, mentioned Kirsten 1951, 36, probably MM I–II context); NM, from Phylakopi (Phylakopi Case) (Bosanquet & Welch 1904, 199 and pl. XXXVIII 18). There are also nine others, mainly with MM I–II contexts, with incised patterns, plus one (Hierapetra M. 343★) with carved LM I Foliate Band decoration (like the Mochlos bowl type 8 **K**, HM 1170), and one from Kea (K 6.16★) with a quasi-foliate band.

[1] An ordinary lid of serpentine (type I **A** or **B**) is said to have come from Kahun (Evans 1895, 122, fig. 120). This is the only Minoan stone vase or lid reported from Egypt, but it is not improbable that the piece was exported there from Crete in MM I–II; MM II sherds were found at Kahun (cf. *PM*, index, 78).

3. Dome-shaped handle

Mochlos HM 1253 BIS. Marble, grey, grey/black. Tomb XXI. (Seager 1912, fig. 46 XXI 4.) **D 189.**

Plus one other (Palaikastro).

4. Cylindrical handle

Platanos HM 2536*. Serpentine, buff/brown mottled. Tholos A annex. **D 190.**

Plus 5 others (Palaikastro, Platanos (*ibid.*), Zakro Pits and Phylakopi).

5. Arched handle

A. Triadha HM 361*. Gabbro. Small Tholos. (Mentioned Paribeni 1904, 696.) **D 191. P 350.**

Plus 2 others (Kamilari, Mallia cemeteries).

6. Simple disc with hole

Knossos KSM (1957–61), one with three holes, another with two holes and a scalloped circumference; chlorite, MM I–LM I and serpentine, LM I? A.

Mochlos HM 1599*. Serpentine. N.F.C. **D 192.**

There are ten examples from Karphi (*B.S.A.* 1937–8, 124 and pl. XXX 4) and others are mentioned at Vrokastro (Hall 1914, 139). These are almost certainly LM IIIC in date for their workmanship is very poor and this pierced form is not found earlier, apart from the carefully cut and decorated Mochlos example.[1] They illustrate the demise of stone working in Crete by this date.

7. Heart-shaped

Mallia HM 2234. Gabbro. Khrysolakkos. (Demargne 1945, 51 and pl. LIII.) **D 193. P 351.**

Mochlos HM 1207 BIS. Breccia, grey/black matrix with white pieces. With jug HM 1207. Tomb VI. (Seager 1912, fig. 22 VI 4.) **D 194. P 276.**

Plus seven others, MM I (Koumasa (HM 693), Mallia, Palaikastro and Phaistos). **Total** *c.* **336**

II. Special forms

A. Pyxis lids. See also **D 246, 250, 255, 256** and **P 452a–b, 456a–b, 457** with pyxides.

1. Flanged shape. Form as that of lids of pyxides HM 13 and HM 1282. Khania M. Apodhoulou. Linear A signs inscribed on the lid, probably in MM III–LM I (date of site). Lid itself probably EM II (not seen by the writer). (Kirsten 1951, 138–9 and pl. III 4–5.) K I. 369*. Kea. Perhaps of local make. Found near modern surface. Both these are of chlorite.

2. Domed type. K 3.101*. Chlorite. Horizontal grooved decoration, with two small suspension holes. Kea. **D 195.** Plus two others, from Phaistos, HM 184* and HM 230*, mentioned Pernier & Banti 1951, 381. N.F.C.

3. Miniature, flat topped. HM unnumbered. Rock crystal. Walls eight-tenths of a millimetre thick. Knossos. (*PM*, III, 410, fig. 272*c, d, e.*) **D 196.** Plus two others (EM) from Sphoungaras and Trapeza.

There is also a beautiful breccia imitation of an EM I–II clay shape, HM 1276, Tomb XXI, (Seager 1912, fig. 46 XXI 6). **D 197. P 352.** Cf. in clay from Koutsokera (Xanthoudides 1924, pl. XLa bottom row 3rd from right). Lastly an inverted saucer shape with suspension holes, from Trapeza, HM 2374 (H. W. Pendlebury 1935–6, fig. 24, 22). **Total 16**

B. Large Pithos or Bucket-Jar lids

One example is from an MM I context (HM 2294, Mallia Quartier Γ), one from MM I–III (Kastellos Lasithi), one from MM III? B (Knossos, Gypsadhes Tholos), twelve from LM I or II–III A I (Knossos, Mallia, Palaikastro, Pseira, Tylissos and Vathypetro) and there are two survivals, one in an LM IIIB tomb at Stamnioi (HM 2461, Platon 1952*b*, 626, fig. 6) and the

[1] The material of each of these disks is not stated in the publications and so they are not included in the figures for materials in chapter III.

other from Karphi (*B.S.A.* 1937–8, 123–4 no. 372). One without context, but probably palace destruction, comes from Knossos. There are fragments of ten others from Knossos (1957–61), mainly in MM IIIB–LM I contexts. For illustrations see **P 324** and the Tylissos set (Hatzidhakis 1921, fig. 24). One from Vrokastro, diam. 30.0, has a central hole. This form is not known earlier and the lid is probably of LM IIIC or later date. (The material is not stated so it is not included in the figures for materials.) See Hall 1914, 139, fig. 83 right.

Total 29

C. Alabastron rosette lids

Apart from three of gypsum from the Throne Room at Knossos (HM 63, HM 64 and AM AE 768, see *PM*, IV, fig. 910) and the Mycenae example* in chlorite (NM Chamber Tomb Case, Tomb 17) with shield handle but no rosette, there are two others, from Knossos, Temple Tomb, LM II–III A I context (HM 2285, gypsum, *PM*, IV, 1006, figs. 953, 957, 960*j* 2 **P 353**) and from the LM IIIB tomb at Karteros Mapheze, east of Herakleion (Marinatos 1927–8, 70, 72, 81 and pl. I, 10, gypsum), probably taken from the palace destruction debris.　**Total 6**

D. Individual lids. The Mallia piece is possibly a stand.

Knossos HM 2554*. Serpentine. Relief decoration of a sacral knot apparently in a floral setting. N.F.C. Chance find 1956. **P 354**.

KSM (1957–61), fragment of lid with raised edge carved with coil moulding, serpentine. Royal Road. LM IB–II/IIIA.

Mallia HM 2223. Limestone, hard brick red. Three small handles or legs. Alternatively this object might not be a lid but rather some kind of reel with hooks, perhaps connected with weaving. Nécropoles des Pierres Meulières. Mainly MM I. (H. & M. van Effenterre 1963, 82 and pl. XXXIII.)

Pseira HM unnumbered*. Serpentine. Cylindrical with moulded rim, raised band round side, and two rectangular lugs, each with two holes, for fastening lid to vase. N.F.C.

Total 4

28. MINIATURE AMPHORAS

This class, found almost exclusively in the Mesara and at Mochlos, is datable mainly to EM III–MM I/II. It seems to have begun in EM II for one Mochlos vase is from Tomb XI and another from an EM II level in the town. The materials are varied, serpentine, marble, limestone, banded tufa, chlorite and steatite.

The type has close parallels in Egypt. Small alabaster amphoras are found from the Ist to the XIIIth Dynasties and are popular from the VIth Dynasty to the Middle Kingdom. They fit in with the proliferation in this latter period of small and miniature vases in Egypt, when, for instance, Middle Kingdom kohl pots are found in such abundance. Together with the little cylindrical jars with everted rim and base (type 30 **D**) the type provides important evidence on the Cretan side for intensified relations between the island and Egypt in this period (cf. spiraliform decoration and the arrival of Egyptian scarabs). It is worth noting that the proliferation of small and miniature stone vases in Egypt at this time is paralleled by that in Crete where the hundreds of small funerary vases flourish from the latter part

of EM II to MM I. It is perhaps due to chance that not one import or imitation of the most popular Egyptian form, the kohl pot, has been found in the island. This may however suggest that the main period of Egyptian influence was the First Intermediate Period and very early Middle Kingdom, before the kohl pot became really popular.

Photographs are included to illustrate Vth and XII–XIIIth Dynasty Egyptian miniature amphoras. **P 355-7.**

A. Triadha HM 655. Dolomitic marble, grey and white mottled. Large Tholos. (Banti 1930–1, 184 and fig. 50*f*.) **D 198. P 358.**

Kalyvia Mesara HM 179. Dolomitic limestone, grey and white. Horizontal grooves. LM IIIA tomb. Survival. (Savignoni 1904, 552–3, fig. 37 top left.) **P 359.**

Mallia MM II sanctuary. Eight tiny handles in two rows, and two raised bands with diagonal incisions. Marble grey and white mottled. (Poursat 1966, 543 and figs. 41 and 45.)

Mochlos HM 1234. Steatite, highly polished mottled green, black and cream. Town, EM II level. (Seager 1909, 288–9 and pl. VIII 2.) **D 199. P 360.**

HM 1236. Chlorite. Tomb II. (Seager 1912, fig. 7 II*j*.) **D 200. P 361.**

HM 1238. Steatite, green/black with white patches. Tomb II. (*Ibid.* fig. 7 II*k*.) **D 201. P 362.**

HM 1244. Steatite, dark green and grey with white mottling. Tomb V. (*Ibid.* fig. 18 V *g*.) **D 202. P 363.**

Palaikastro HM 147. Dolomitic limestone, pale grey banded. Ossuary VII. MM I. (Bosanquet 1901–2*a*, 296, pl. XVII, fig. 3 top row left.

Dawkins 1904–5, 269 for chronology of ossuary.) **P 364.**

Platanos HM 1665. Banded tufa. The collar imitates a typical Egyptian form (Petrie 1937, pl. XXV, 460, 466, 468). (Xanthoudides 1924, pl. XII.) **D 203. P 365.**

HM 1668. Limestone, grey/black with white veins. (*Ibid.* pl. LIII*a*.) **P 366.**

HM 1671. Limestone, grey/black with white mottled veins. (*Ibid.* pl. LIII*a*.) **P 367.**

HM 1672. Dolomitic limestone, grey and white. (*Ibid.* pl. LIII*a*.) **D 204. P 368.** All Tholos A annexes.

Pyrgos S. of Knossos AM 1924.168. Dolomitic marble, grey and white mottled. LM IA larnax burial. Survival, as HM 179. (*PM*, II, 75, fig. 34 A.)

13 plus 14 others. **Total 27**

There is one other miniature amphora, a white gypsum copy of the large Palace Style clay form. It is from the A. Triadha cemetery, Liliana, and dates from LM II/IIIA I, when the clay form flourished.

A. Triadha HM 1092. Gypsum, white. LM IIIB. (Savignoni 1904, 645–6, fig. 114.) **Total 1**

29. MINIATURE GOBLETS

A large proportion of these vases comes from Mochlos or the Trapeza Cave and thus it seems to be mainly an east and north Cretan type. Eight or nine have been found in the Mesara. Only three are from reasonably closely dated contexts (Mochlos Tombs VI and XIX), which are probably EM II, but of these two are individual variants of the main type. Most of the remainder are from mixed contexts, EM I–MM I. The

four larger examples, **B**, imitate the standard EM II Vasilike Ware goblet shape. For the main form the materials used are almost exclusively chlorite and steatite. Both these belong mainly to the earliest stone vases, steatite being rarely used in MM I. Accordingly the date range seems EM II–III, the probability being that most were made in the latter half of EM II.

A. Ht. 4.8. Diam. 2.95. Steatite, green with creamy white. Mochlos Tomb IV (which contained one EM III cup). HM 1240. (Seager 1912, fig. 18 IV 3.) **D 205. P 369.**

A. Triadha HM 651. Serpentine. Rather wide form, cf. HM 2020. Large Tholos. (Banti 1930–1, 184 and fig. 51.) **P 370.**

HM 657. Steatite. Wide foot. Large Tholos. *Ibid.* fig. 50 *b*.) **D 206.**

Koumasa HM 849. Steatite. Form as HM 657. Tholos B. (Xanthoudides 1924, pl. III.) **P 371.**

Lebena HM 2619. Chlorite. Tomb I. EM II–MM I. (Alexiou 1960*a*, 226, fig. 11.)

Marathokephalon HM 2020. Steatite, black. (Xanthoudides 1918, Παρ. 19, fig. 5 top row 3rd from left.) **D 207. P 372.**

Mochlos HM 1235. Serpentine, metallic grey. Piriform body, small raised collar, ring foot. Tomb XIX. (Seager 1912, fig. 4 XIX 2.) **D 208. P 373.**

HM 1241. Steatite, green with brown and white. Tomb II. (*Ibid.* fig. 7 II *h*.) **D 209. P 374.**

HM 1242. Chlorite. N.F.C. (*Ibid.* fig. 47 M 2.) **D 210. P 375.**

HM 1243. Steatite, green/black with creamy veins. Tomb XIX. (*Ibid.* fig. 4 XIX 6.) **D 211. P 376.**

HM 1248. Limestone, cocoa brown and butterscotch yellow. N.F.C. (*Ibid.* fig. 47 M 7 and pl. II.) **D 212. P 377.**

HM 1293. Limestone, grey/black banded. On square pedestal base; four tiny lugs below rim. Tomb VI. (*Ibid.* fig. 22 VI 13 and pl. V.) **D 213. P 378.**

HM 1302*. Chlorite. N.F.C. **D 214. P 379.**

HM unnumbered*. Steatite, green with creamy veins. N.F.C. **D 215.**

Platanos HM 1673. Chlorite. Tholos A. (Xanthoudides 1924, pl. LIV.) **P 380.**

HM 2517*. Limestone, soft white. Tholos A annex. **P 381.**

HM 2518*. Steatite, brown with blue patches. As last. **P 382.**

Pseira Penn. MS 4532*. Steatite. N.F.C.

Trapeza HM 2376. Chlorite. (H. W. Pendlebury 1935–6, fig. 24, 31 and pl. 16.) **P 383.**

HM 2377. Steatite, dark green and creamy brown. (*Ibid.* fig. 24, 28 and pl. 16.) **P 384.**

HM 2378. Steatite, dark green and purple. *Ibid.* fig. 24, 32.) **P 385.**

HM 2379. Steatite, dark green with creamy white. *Ibid.* fig. 24, 30 and pl. 16.)

HM 2380. Steatite, dark green and purple. (*Ibid.* fig. 24, 33 and pl. 16.)

HM 2381. Chlorite. (*Ibid.* fig. 24, 29 and pl. 16.) **P 386.**

HM 2382. Steatite, green with white veins. *Ibid.* fig. 24, 27 and pl. 16.)

Mesara HM unnumbered*. Chlorite. N.F.C. **P 387.**

B. Ht. 5.75. Diam. 7.55. Marble, mottled grey/black with grey/white patches. Mochlos Tomb XXI. HM 1230. (Seager 1912, fig. 46 XXI 7.) **D 216. P 388.**

Ht. 6.85. Diam. 6.95. Serpentine. Trapeza. HM 2385. H. W. Pendlebury 1935–6, fig. 24, 24 and pl. 16.) **D 217. P 389.**

Trapeza HM 2388. Marble, white and grey banded. (Pendlebury 1937–8, 2 no. 1, fig. 1 *a*.) **P 390.**

HM 2389. Chlorite. (H. W. Pendlebury 1935–6, fig. 23, 20.) **P 391.**

Two variants are best classed here, the first imitating the standard MM IA eggcup. Trapeza, HM 2386, calcite, grey/white translucent (*ibid.* fig. 24, 26), **P 392.** HM 2387, calcite, as last (not 'crystal' as published) (*ibid.* fig. 24, 25), **P 393.**

Total 32

30. MINOAN IMITATIONS OF EGYPTIAN VASES

The Egyptian vases imitated are pre-Dynastic to XIth Dynasty in date, but the Minoan imitations, except group **D**, were very probably made in MM III–LM III A I, for the Egyptian vases and the imitations are in contexts of this period and the imitations are usually in fine, hard stones which are known from other types to have been worked mainly in MM III–LM I.[1] There is one exception, in group **A**. This is from an MM IIB context at Knossos and it dates the beginning of this imitative group to this period.

A. Bowl with flat collar and solid roll handles on the shoulder. HM 56 is an example of the type imitated. It has solid, unpierced handles (a IIIrd Dynasty indication in Egypt when this old pre-Dynastic form is dying out). This does not necessarily mean that only the IIIrd Dynasty form is being copied. The Minoan vases are probably imitating the general form of late pre-Dynastic to early Dynastic large bowl, which has pierced handles down to the IInd Dynasty. Evans noted the similarity of AM AE 204 from Elounda to the Egyptian type, but there are about seventeen others belonging to the Minoan group.

That Egyptian types are being copied is also shown by the Minoans' selection of their hard stones (to correspond to the hard Egyptian stones) and by the actual copying of an internal base ring, an Egyptian early Dynastic feature (cf. Petrie 1937 and Emery 1961, 218 nos. 72 and 83 for such internal rings).

EGYPTIAN HM 56. Syenite. Knossos, South Propylaeum. N.F.C. See type 43 **A** no. 7. **D 314. P 592.**

MINOAN

A. Triadha HM 350*. Ht. 8.5. Gabbro. **D 218. P 394.**

HM 351*. Ht. 6.1. Limestone, white with dark blue/grey patches. **D 219.**

HM 352. Ht. 8.8. Gabbro. (Halbherr 1903, 63, fig. 50.) **D 220. P 395.**

HM 353*. Ht. 8.1. Basalt ?, grey/brown, fine grained with tiny crystalline particles. Shape near HM 350. **P 396.**

HM 1091. Ht. 12.3. Limestone, white with blue/grey patches. (Halbherr 1903, 64, fig. 49.) **D 221. P 397.** All from Palace (LM I).

Elounda AM AE 204. Ht. 8.6. Gabbro. N.F.C. (Evans 1895, fig. 112. *PM,* I, fig. 33.) **D 222. P 398.**

Gournes HM 2042. Ht. 7.15. Limestone, mottled pink, maroon, pearl grey. LM IIIB tomb.

[1] Of the imitations Evans demonstrated those grouped here as **C** and, with one Cretan copy, **A**. He also showed that **D** was copying an Egyptian form (though he produced VIth Dynasty parallels (*PM,* I, 92–3), whereas the closest are end of VIth Dynasty to XIth Dynasty). But the significance of HM 128 for this group has not, to the writer's knowledge, been recognised. The imitations grouped as **A I** and **B** and the components of **A** (save AM AE 204) are proposed by the writer.

Survival from LM I. (Hatzidhakis 1918, 78 and fig. 22, 7.) **D 223. P 399.**

Katsamba Trypete HM 2334*. Ht. 7.9. Dolomitic marble, grey and white mottled. N.F.C. Chance find in a tomb. **P 400.**

HM 2083*. Ht. 8.1. Gabbro. N.F.C. Chance find in a garden in 1919. **P 401.**

HM 2625*. Ht. 6.1. Diorite ?, dark green/grey, speckled with grey/white. N.F.C. Chance find, 1959. **D 224. P 402.** All three vases very probably belonged originally to the LM II–III A I cemetery.

Knossos HM 2146. Ht. 8.9. Gabbro. Mavro Spelio Tomb III. LM I–III. (Forsdyke 1926–7, 253 and pl. XX no. III, 17.) **D 225. P 403.**

KSM (unprovenienced material)*. Gabbro. Three fragments, one with part of circular hole for spout, from one bowl; fragments of three others, possibly from vases of this shape, and another fragment, of lapis Lacedaemonius, also very possibly of this shape.

KSM (1957–61): 1, fragment (half preserved), dolomitic marble. Gypsadhes Tholos. MM IIB (C 8). 2, fragment, antico rosso (probably). Gypsadhes Tholos. LM IA. (E 9 A).

Palaikastro HM unnumbered*. (Apotheke box.) Ht. 4.5. Gabbro. Marked X 47 so probably from LM IB Block X hoard. For shape cf. HM 2625.

Tsoutsouros HM 3*. Diorite ? Ht. 6.2. For shape cf. HM 2625. N.F.C. **Total 20**

A. Variant form

EGYPTIAN HM unnumbered (Katsamba 1957), HM unnumbered (Isopata Royal Tomb). See type 43 **D** nos. 2, 4.

MINOAN

Praisos HM 7*. Ht. 7.3. Gabbro. N.F.C. Gift of Evans. **P 404.** **Total 1**

B. Heart-shaped jar.
Egyptian: HM 911, AM unregistered 8, AM AE 384 (not certainly Egyptian). See type 43 **B**. A very close Middle–Late Predynastic parallel in mottled

serpentine. Ht. 7.5, comes from Mostagedda. **P 405.**

MINOAN

Kalyvia Mesara HM 178, Ht. 10.0. Gabbro. LM tomb. (Savignoni 1904, 552 and fig. 37 bottom left.) **D 226. P 406.**

Palaikastro HM 909. Ht. 8.2. Gabbro. Block X hoard. LM IB. Not closely similar but it seems to imitate the general type. (Dawkins 1923, pl. XXX C 4.) **D 227. P 407.** **Total 2**

C. Shallow carinated bowls.
For a VIth Dynasty parallel from Egypt see **P 408**, with a cartouche of ID Y.

EGYPTIAN HM 590, AM 1938.583, AM 1910.283, AM 1938.409a, AM unregistered 2. See type 43 **E**.

MINOAN

Knossos HM 591. Obsidian, black with white spots. MM context ? (*PM*, I, 86 and fig. 55c.) **D 228. P 409.** **Total 1**

D. Cylindrical jar with everted rim and base.
One, probably of late VIth Dynasty date, was imported into Crete. Its date is suggested by its size and everted base. Before the VIth Dynasty the body of this miniature form slopes gradually into the base, which is therefore less everted (see **P 410–12**, Dynasties III–VI, V and IV, from El Kab, Mostagedda and El Kab respectively). The form with more sharply everted rim and base which was imitated in Crete is characteristic of the late VIth to XIth Dynasties (see **P 413**, Dynasties IX–XI, from Qua Tomb 914; **P 414**, Dynasty XI, from Dendereh Grave 543), but it also goes into the XIIth Dynasty (**P 415**, from Harageh Tomb 661). The more usual Middle Kingdom form however has the gradual curve into the base (e.g. Petrie 1937, pl. XII, 109–27). Other examples from the First Intermediate Period with the everted base are Fitzwilliam M. 21/1899, 22/1899 (Petrie 1901b, pls. XXIX W 157, XXVIII Y 250), of the Xth Dynasty.

EGYPTIAN HM 128 (**D 324. P 600**). See type 43 **F**.

MINOAN All from the Mesara except HM 1294 from Mochlos.

A. *Triadha* HM 340. Ht. 4.0. Limestone, white with patches of serpentine. Small Tholos, annex. (Paribeni 1904, 700 no. 16.) **P 416**.
HM 381. Ht. 3.45. Limestone, red/brown. As last. (*Ibid.* fig. 10, 3 no. 18.) **P 417**.
HM 382. Ht. 3.52. Dolomitic marble, grey and white mottled. As last. (*Ibid.* fig. 10, no. 17.) **P 418**.
HM 660. Ht. 4.35. Calcite, brown translucent with opaque white patches. Slightly wider form. Large Tholos. (Banti 1930–1, 184 and fig. 50c.) **D 229. P 419**.
HM 663. Ht. 5.32. Dolomitic marble, grey and white mottled. As last. (*Ibid.* fig. 50d.) **D 230. P 420**.

Kamilari HM unnumbered (F 59 2746). Ht. 5.2. Chlorite. (Levi 1961–2, fig. 120 c 6.) **P 421**.
Marathokephalon HM 2021. Ht. 4.1. Banded tufa, golden brown translucent with opaque creamy white patches. (Xanthoudides 1918, Παρ. 19, fig. 5 top row 2nd from left.) **D 231. P 422**.
Mochlos HM 1294. Ht. 4.05. Dolomitic limestone, grey and white. N.F.C. Surface. (Seager 1912, fig. 47 M 3 and pl. II.) **D 232. P 423**.
Platanos HM 1904. Ht. 4.6. Dolomitic limestone, grey and white. Tholos A annexes. (Xanthoudides 1924, pls. XI and LIII b.) **D 233. P 424**.
HM 1637. Ht. 5.4. Calcite, as HM 660. Tholos A annexes. (*Ibid.* pl. LIII b.) **P 425**.
Porti HM 1057. Ht. 3.7. Dolomitic limestone, grey and white. (*Ibid.* pl. XXXIX a.) **D 234. P 426**.

Total 11

Type total 33

31. PLAIN BOWLS

Vases of group **A** date from EM II to MM I and illustrate the variety of materials used in the latter part of this period, including several examples of marble. Since the form is so simple it is found all over the island in tomb contexts, those from the Mesara predominating. Two white marble vases of this shape are almost certainly Cycladic imports, saucers of the Syros Group.

The few vases of group **B** are distinguished from those of **A** only by their carinated profile.

Group **C** consists of plain, open, domestic bowls varying from *c.* 7.0 in diameter to over 30.0. The form was in use continuously from MM I onwards and has a wide distribution. Serpentine is the usual material, especially at Knossos, but antico rosso, gypsum, lapis Lacedaemonius, limestone, marble and obsidian examples are also found.

A. *A. Triadha* PIG.M. 71943. Limestone, grey. Large Tholos. (Banti 1930–1, 182. Borda 1946, 72 no. 6 and pl. LI 8.)
PIG.M. 72043. Chlorite. Groove below rim. N.F.C. (*Ibid.* 72 no. 8 and pl. LI 7.)
PIG.M. 75156. Chlorite. Groove below rim. N.F.C. (*Ibid.* no. 9 and pl. LI 9.)

Knossos KSM (B I 13, Box 253). Chlorite. Fragment, probably of open bowl, with incised decoration of groups of straight lines. The pattern resembles some on Knossos Neolithic pottery (cf. Evans 1964, pl. 49 5–6 and 53 3) and it may be that the bowl was made in MM I imitating Neolithic decoration

which would be observed on sherd material exposed on clearing the Knossos hill for the building of the first Palace. The pattern and the firmly incised grooves are not EM II workmanship. The associated pottery is Neolithic to subneolithic with 6 MM IA sherds. (Furness 1953, 132 and pl. 32 B 9.)

Lebena HM 2621★. Serpentine, grey to light brown. Tomb I. (Mentioned *B.C.H.* LXXXIII, 1959, 744.)

HM unnumbered (L II 116)★. Chlorite. Horizontal grooves round body. Tomb II. EM II (found with local Vasilike Ware, information from St. Alexiou).

Marathokephalon HM 2031. Steatite, black. (Xanthoudides 1918, Παρ. 19, fig. 5 top row 2nd from right.) **P 427.**

Mochlos HM 1266. Marble, grey and white mottled patches and bands. Tomb XXI. (Seager 1912, fig. 46 XXI 9.) **P 428.**

HM 1269. Chlorite. Horizontal groove below rim and vertical nicks on side of rim. N.F.C. (*Ibid.* fig. 47 M 10.) **P 429.**

HM 1298. Marble, grey/black banded. Tomb XI. (*Ibid.* fig. 28 XI 3.) **D 235. P 430.**

Palaikastro HM 441★. Marble, grey and white mottled patches. N.F.C. **D 236.**

BM 1907 1–19 228★. Calcite, golden brown translucent with opaque creamy patches. N.F.C. **D 237.**

Phaistos HM 2545. Serpentine ?, dark brown with tiny golden particles. Small protrusion, quasi handle, on one side. Room L. MM II. (Levi 1952–4, 458, fig. 96.)

Platanos HM 1888★. Breccia, maroon/purple matrix with white, maroon/black and black/green patches. Tholos A annex. **D 238. P 431.**

Trapeza HM 2371. Chlorite. H. W. Pendlebury 1935–6, fig. 23, 10.) **P 432.**

HM 2372. Chlorite. (*Ibid.* fig. 23, 1.) **P 433.**

Total 16 plus 33 others (Galana Kharakia, Khamaizi, Koumasa, Mallia, Marathokephalon, Mochlos, Myrtos (body fragment, serpentine, grey with network of blue/black veins; it could also be from a cup or bowl with base, type 32, or spouted bowl, type 37; from Fournou

Korifi settlement, EM II), Palaikastro, Phaistos, Platanos, Porti and Trapeza). **Total 50**

CYCLADIC (not included in type total or materials and sites tables).

Knossos KSM (E I 7, Box 620)★. Marble, white. Rim/body fragment; inturned rim. From W. of North-West Lustral Basin, outside foundations. Pottery EM I–II (plus I or 2 Neo.)

Trapeza HM 2373. Marble, white. Ht. 2.48. Diam. 6.05. The rim is bevelled, sloping slightly out and down. (For the type cf. Tsountas 1898, pl. 10, 9. Zervos 1957, pls. 4–5 (from Amorgos; shallower, but note bevelled and inturned rim). Papathanasopoulos 1961–2, pls. 60, 69 (Naxos).)

B. *Koumasa* HM 748. Steatite, with serpentine. Tholos B. (Xanthoudides 1924, pl. XXIII.) **P 434.**

Platanos HM 1902★. Marble, white translucent. Tholos A annex. **D 239. P 435.**

Plus two others (Koumasa, Platanos). **Total 4**

C. *Karteros* HM 2177. Gypsum, white. Ht. 2.2. Diam. 7.2. Mapheze Tomb. LM IIIB. (Marinatos 1927–8, 70, 72 and pl. I 9.)

Knossos KSM (1957–61) (I) (RR/59/521★). Serpentine. Ht. 11.6. Diam. *c.* 35.0. Royal Road. MM I (B 39, C–E 23).

(2) (HH/58/23★) Antico rosso. Rim fragment. Ht. pres. 3.2. Diam. *c.* 19.0. Hogarth's Houses. LM I and later (K 14).

HM 2165. Serpentine. Ht. 7.7. Diam. 10.4. Mavro Spelio Tomb III. LM I–III. (Forsdyke 1926–7, 254 no. III 22 and pl. XX.)

HM 2358. Serpentine. Rim fragment, apparently from an open bowl, with a relief scene on the outside. It seems to depict masonry above and another object below. Ht. pres. 3.9. Diam. *c.* 9.0. N.F.C. (from Little Palace or adjacent area according to HM Cat., found in 1922). **P 436.**

AM 1938.584★. Obsidian, black with white spots. Rim fragment of large bowl. Ht. pres. 3.7. Diam. *c.* 15.0. N.F.C.

KSM (Unprovenienced material)*. Gabbro. Body fragment of large, thick-walled bowl. 12.4 × 6.2. N.F.C.

Mallia HM 2198. Serpentine. Ht. 4.6. Diam. 14.25. Cemetery, Dépotoirs du Bord de la Mer. MM I. (H. & M. van Effenterre 1963, 64 and pl. XXVI.)

HM 2308. Serpentine. Ht. 5.35. Diam. 18.62. Khrysolakkos. MM I. (Demargne 1945, 51 and pl. LXIII.)

HM 2311. Serpentine, pale grey with network of grey/black veins. Ht. 6.6. Diam. 9.5. Behind House Da. MM (perhaps MM III–LM I). (Demargne & de Santerre 1953, 58 and pl. XXVIII.) **P 437.**

Myrtos KSM. Serpentine. Ht. 5.78. Diam. *c.* 13.0. Pyrgos site. (Hood, Warren & Cadogan 1964, 96 and fig. 20, 2.)

KSM Serpentine. Ht. 6.7. Diam. *c.* 22.0. (*Ibid.* fig. 20, 5.)

Pseira HM unnumbered. Marble, grey/white, grey banded. Ht. pres. 5.15. Diam. *c.* 7.4. House B. LM IB. (Mentioned, Seager 1910, 37–8.)

Tylissos HM unnumbered*. Serpentine. Ht. 11.5. Diam. *c.* 26.0. N.F.C.

Plus 25 others (including one body fragment, probably of an open bowl, Knossos (area above the Little Palace), lapis Lacedaemonius (N.F.C.), and two rim fragments from Kea, one serpentine, the other of pale orange limestone, K 1.372*; K 4.74*. Also from Kea are fragments of open bowls in the local grey/black marble. These are not included in the type total or the tables). **Total 40**

Type total 94

32. PLAIN BOWLS WITH MOULDED BASE

These may be conveniently classified into five groups:

A. Small examples (up to 5.0 high), almost exclusively from the Mesara tombs, EM III–MM I in date;

B. Larger, usually with a groove below the rim, also from the Mesara, EM III–MM I; one was exported to Asine;

C. A group from domestic and palatial contexts, over half from Knossos and in use from MM I onwards;

D. A few from LM III contexts. Their date of manufacture cannot be securely fixed. A number of survivals into LM III contexts are known (e.g. Blossom Bowls, and MM vases at Elounda, p. 194 n. 1) and this is probably the case with group **D**. The Katsamba vase is in an LM III A I context, so the group might date from the last Palace phase or from MM III–LM I. But the majority are so similar in shape (with the groove or grooves below the rim) to the vases of group **B** that it is difficult not to believe them all EM III–LM I survivals. The early vases from Dreros, Elounda, Karphi and Vrokastro lend support to this;

E. A few large examples, *c.* 30.0 diam., from domestic or palatial contexts, MM–LM II/III A I.

The materials of **A** show the usual variety of this period, breccia, chlorite, gabbro, limestones, marble, schist, serpentines and steatite; group **B** has three of chlorite

and one of serpentine; those of **C** are of varied stones, limestone, including dolomitic, obsidian, rock crystal and serpentine; **D** are serpentine save one of chlorite and **E** again varied, banded tufa, gypsum, mottled limestone and trachyte.

A. *A. Triadha* HM 371★. Serpentine, pale grey with fine grey/black veins and creamy buff patches. Small Tholos (probably).
HM 372★. Breccia, purple matrix with green, grey and black pieces and white veins. As last.
HM 635. Schist, purple with circular light green/grey bands. Large Tholos. (Banti 1930–1, 182.) **P 438.**
Khamaizi HM 473★. Serpentine.
Knossos HM unnumbered. Marble, grey with dark grey bands, bluish tinge. Vat Room deposit (mainly MM IA). (*PM*, I, fig. 120 top right.)
Phaistos HM 2549. Limestone, hard white. Room LI. Part of the cult set; see type 20 **A.** MM II. (Levi 1952–4, 413, fig. 33.) **D 240. P 254.**
HM 2568. Serpentine. Near to flaring tumbler shape. Room LIV. MM IIB. (Levi 1955, 146, fig. 8 e.)
Platanos HM 1867★. Limestone, orange brown with darker brown bands. Tholos A annex. **D 241. P 439.**
HM 2524★. Steatite. Tholos A annex. **P 440.**
HM 2528★. Serpentine, green/grey, brown, buff mottled. Groove below rim (close to group **B**). As previous. **P 441.**
Porti HM 1077. Steatite. (Xanthoudides 1924, pl. XXXVIII.)
HM 1342. Chlorite, with steatite. Incised decoration of fringed arcs. (*Ibid.* pl. XXXVIII.)
HM 1343★. Serpentine ?, brown, fine grained with tiny gold particles. Two horizontal grooves below rim (close to though smaller than group **B**). **P 442.**

13 plus 27 others (Apesokari, Kamilari, Khristos, Knossos (1 from an EM III level), Koumasa, Lebena, Phaistos and Platanos). **Total 40**

B. *Koumasa* HM 734. Chlorite. Groove below rim. Tholos B. (Xanthoudides 1924, pl. XXII.) **P 443.**

HM 735. Chlorite. Groove below rim. Tholos B. (*Ibid.* pl. XXII.) **D 242. P 444.**
HM 822★. Serpentine. Tholos B.
Siva HM 1611. Chlorite. Groove below rim. South Tholos. (Paribeni 1913, 18 no. 7.) **P 445.**
Asine Serpentine. Settlement, Early Helladic fill. (Frödin & Persson 1938, 243 no. 2.) **Total 5**

C. *Katsamba* HM 2606★. Serpentine. N.F.C.
Knossos HM 2617★. Obsidian, dark grey, translucent, fuzzy. Base fragment; diagonal bands on bowl and vertical ribbed decoration round base. N.F.C. Probably MM III–LM I by decoration and material.
HM unnumbered. Rock crystal. Incurve in rim at one point. Fragment. Domestic Quarter, Store Room and Closet. MM III–LM I. (*PM*, III, 409–10, fig. 272 a, b.) Also a base fragment of another rock crystal bowl★, N.F.C.
Mallia HM 2331★. Serpentine. Houses (probably therefore MM–LM I). N.F.C. **P 446.**
Mochlos HM 2396★. Marble, grey, milky grey banded. N.F.C. **D 243.**
Myrtos KSM. Serpentine. Parts of two bowls. Pyrgos site. (Hood, Warren & Cadogan 1964, 97 no. 7 and fig. 20, 7, and no. 9.)
Phaistos Phaistos Strat. Mus. F 59.3083★. Dolomitic limestone, light to dark grey banded. Ht. 7.0. Diam. 18.0. approx.
Prasa HM 2454★. Limestone, dark grey, grey, creamy orange banded. Rim/body fragment with moulded rim and three horizontal grooves below rim; perhaps moulded base originally. Houses, and as it is finely made, probably MM III–LM I.
Zakro HM unnumbered★. Serpentine. Building B, Room B. LM I.
Kea K 1.333★. Serpentine. Base fragment. One other fragment from Kea (not included in the total) is of this type but in local grey/black banded marble, manufactured on the site.
 Total 27

D. *Karphi* HM unnumbered. Serpentine. Ht. 4.7. Diam. 8.5. Groove below rim. Settlement. LM IIIC. (*B.S.A.* 1937–8, 123 and pl. XXXI 600.)

Katsamba HM 2884. Serpentine. Two horizontal grooves below rim, Ht. 6.35. Diam. 11.7. Tomb H. LM III A I. ("Εργον 1963, fig. 192.)

Knossos HM 59★. Chlorite, with serpentine. Three grooves below rim, four round body. Incrustation on one side of the bowl, over which grooves do not continue. Inside not finished off. Palace. N.F.C. Perhaps LM II/III A I since unfinished; incrustation perhaps due to burning. **P 447.**

Kritsa A. Nik. M. 171★. Serpentine, light green/grey with grey/black mottled patches. Ht. 6.0. Diam. 7.8. Two horizontal grooves below rim. Tomb A. LM IIIB. (Mentioned Platon 1951a, 444.)

Stamnioi Pedhiadha HM 2462★. Serpentine, pale green/buff, pale grey. Ht. 5.4. Diam. 10.1. Tomb E. LM IIB late–? C. (Mentioned Platon 1952a, 475.) **Total 5**

E. *Katsamba* HM unnumbered★. Gypsum, brownish-greyish white. Base fragment. Plundered Tomb. Probably LM II/IIIA since it contained several gypsum vase fragments and this is the period of the cemetery. (Mentioned Platon 1959, 385.)

Knossos HM 53★. Banded tufa, greyish cream, wavy banded. Ht. 18.6. Diam. 33.5. Palace. N.F.C., but doubtless LM IIIA I destruction debris (it is from the 1900 excavations). **D 244. P 448.**

Mallia HM 2330 = 2457 ?★ (Not seen by the writer). Serpentine. Ht. 9.0. Diam. 29.7. N.F.C.

Phaistos HM 2553★. Limestone, mottled light to dark maroon and grey/white. Room IL. MM II. (For the room, Levi 1952, 320 sqq.) **D 245. P 449.**

Tylissos HM 2067. Trachyte, hard grey igneous lava with small black crystalline particles; material perhaps imported or vase itself imported (see type 45), or perhaps a stray Cretan piece. Published as Roman without context or reference. HM label says, Under floor of House Γ, so it is possibly MM I. (Hatzidhakis 1934, 110 and pl. XXXI 1.)

Total 5
Type total 82

33. PYXIDES

The general type can be grouped into seven forms; the first five, **A–E**, are circular vases, the other two, **F–G**, rectangular. Chlorite is almost invariably the material. Forms **A**, **B** and **F** largely make up the earliest group of Minoan stone vases, manufactured in early EM II (Warren 1965b). Their common factors include the early find contexts, the system of all over, lightly incised, juxtaposed triangles, and the material, chlorite.

A. Two-part vases, divided horizontally, so that they consist of a shallow bowl with a twin bowl inverted on top of it. The only complete example, the famous Maronia pyxis, has a lid. Several have incised relief spirals (that from Vrakhasi on the inside), and incised fretwork triangles; nearly all have lightly incised, juxtaposed triangles. The two from Palaikastro have EM II A contexts, when together with Vasilike Ware fine grey incised ware was still in use, and that from Phaistos seems to be from an EM context. The early EM II date for the group is confirmed by similarly decorated pyxides in Group **B**, and by Ladles (type 23 **A**) and Spouted Bowls (type 37 **A**), from EM II A contexts.

Group **A** is of interest because the relief spirals and fretwork decoration and also the material are found on the well-known group of hut pyxides from the Cyclades (Åberg 1933, Abb. 132–4; cf. also Abb. 153. Zervos 1957, pls. 28–30). Hence Marinatos, who published the Maronia pyxis in 1937, considers that it might well be a Cycladic import (Marinatos & Hirmer 1960, 117). This view was based not just on the Cycladic similarities but also on the assumed absence of parallels for the Maronia vase in Crete. The recognition of Group **A** however and the linking of the group by material, context and decoration with other Minoan pyxides, ladles and spouted bowls strongly suggests that the Maronia vase is Cretan. Moreover the possibility that the four hut pyxides from the Cyclades are Cretan products should not be dismissed.[1] It must also be remembered that there is part of a pyxis of just this shape and probably this material (described as green basalt), though without decoration, from the Early Helladic levels at Tiryns (Schliemann 1886, 58–9, fig. 2).[2]

A.

A. Triadha HM 637. Chlorite. Lower half preserved. All-over pattern of lightly incised triangles. Large Tholos. (Banti 1930–1, 182 and fig. 44.) **P 450.**

Itanos HM 235★. Chlorite. Lower half preserved. Fretwork triangles as Maronia and Platanos vases. N.F.C. (Mentioned Pendlebury 1939, 296.) **P 451a–b.**

Maronia HM 2339. Chlorite. Upper half and lid decorated with relief spirals and fretwork triangles; lower half with fretwork and lightly incised triangles. Maronia Cave. N.F.C. (Marinatos 1937, 227, fig. 7. Marinatos and Hirmer 1960, pl. 7.) **D 246. P 452a–b.** HM 2340★. Chlorite. Lower part. Lightly incised lines. N.F.C., found with HM 2339.

Palaikastro HM 503★. Schist, dark grey with greeny tinge. Fragment. Earliest ossuary, EM IIA. Cf. the stamped triangles of the grey clay vase from this deposit (Bosanquet 1901–2a, fig. 3) with those of the Maronia, Itanos and Platanos pyxides. (Mentioned Bosanquet 1901–2a, 291.) **P 453.**

HM 134 BIS★. Chlorite. Eight body fragments of a pyxis. Lightly incised triangles on lower part, as Maronia pyxis. As HM 503, EM IIA. (Bosanquet, *ibid.*)

Phaistos Phaistos Strat. Mus. Chlorite. Rim/body fragment with relief spirals on outside. West Court, fill under pavement of First Palace, above EM house. (Levi 1957–8, 173 and fig. 351c.)

Platanos HM 1904a. Steatite, maroon with creamy patches. Miniature globular pyxis. Relief spirals all over and fretwork triangles on the base. Tholos B. (Xanthoudides 1924, 102 and pl. XI.) **D 247. P 454.**

Vrakhasi HM 2633★. Chlorite. Body fragment with relief spirals on inside; lightly incised triangular pattern outside. N.F.C. (Mentioned Platon 1955, 568.) **P 455.**

Crete Chlorite. Lower part. Incised triangles. Said to be from near Herakleion. N.F.C. Stathatos Collection 2. (Caskey 1953–4, 269 and fig. 2.) **D 248.**

As last. Stathatos Collection 1. (*Ibid.* 268–9 and fig. 1.) **D 249.** **Total 11**

[1] It is important to note that there is no connexion between the relief spirals on stone and those of the Cycladic frying pans of the Syros Group, which are mainly stamped concentric rings (Zervos 1957, pls. 214–23). On the other hand an *earlier* group of frying pans bears incised spirals very similar to the stone relief ones (Zervos 1957, pls. 224–8), so that there is approximate contemporaneity with the stone form (EM II in Cretan terms, Pelos Group/Syros Group overlap in Cycladic).

[2] There is a stone pyxis in Munich, said to be from Crete (*PM*, I, fig. 81a), with incised, scroll-like spirals. If it did come from Crete it was almost certainly a Cycladic import for it is not closely related to the earliest Minoan group.

B. This group consists of the three chlorite dog-lid pyxides, two of which have all-over incised triangles and are from EM II contexts.[1]

A. Triadha HM 1013. Chlorite schist. Lid with dog handle. N.F.C. (Money-Coutts 1936, pl. XXIX.) **P 456a–b.**

Mochlos HM 1282. Chlorite. Lid of pyxis with dog handle. Lightly incised juxtaposed triangles. From a pyxis like HM 2719. Tomb 1 (only pots EM II). (Seager 1912, fig. 41 *i* and fig. 5.) **D 250. P 457.**

Zakro HM 2719. Chlorite. Pyxis and lid with dog handle. Decoration as last. Cave Tomb in Zakro Gorge. EM IIA. (Platon 1963, pl. 154*b*; 1964*b*, 351 and fig. 3.) **Total 3**

C. A simpler form of **B**, namely a cylindrical pyxis with everted base and corresponding lid. All three are of chlorite. That from Marathokephalon may well be EM II (cf. the early EM II grey ware vase from the Kyparissi Cave, Alexiou 1951, pl. I Δ, fig. 2, 13). The other two are probably a little later, EM III, because of their decoration of vertical bars and ladders, analogous to that of Block Vases (type 4).

Two pyxides of this type, but made of white marble, come from A. Onouphrios. They are imports from the Cycladic Keros–Syros Culture (**P 458, 459**).[2]

A. Triadha HM unnumbered★. Incised decoration of vertical bars and ladders. N.F.C., chance find. **D 251.**

Marathokephalon HM 2032. Roughly incised horizontal grooves. It might just be a pyxis lid. (Xanthoudides 1918, Παρ. 19, fig. 5 centre row right.) **P 460.**

Phaistos HM 491 e★. Incised decoration of vertical bars, as A. Triadha above. Palace. N.F.C. **Total 3**

D. A group of ten small, two-part vases, in form like **A**. All save one are from the Mesara and all save one are made of chlorite. They have individualistic, finely incised patterns, often characterised by a tassel-like fringe. This decoration is more complex than the simple triangular patterns of Forms **A**, **B** and **C**. Some of the patterns, ladders ⊨ and semi-circles with vertical bars ⏢ , are also found on the Block Vases (type 4). ⊨ Consequently these pyxides are best dated somewhat after the earliest group, EM III–early MM I. All are found in contexts including this period.

A. Triadha HM 652. Chlorite. Incised ladders in triangles. Large Tholos. (Banti 1930–1, 182 and fig. 45*b*.) **D 252.**

Koumasa HM 755★. Chlorite. N.F.C. Cf. exactly HM 1610 below.

Mallia HM 2251★. Chlorite. Crudely incised pendants with fringed arcs. N.F.C.

Phaistos HM 491 d★. Chlorite. Ladders and fringed arcs in triangles. N.F.C.

HM 491 3★. Serpentine ?, brown. Finely incised lines and fringed arcs. N.F.C. **P 461.**

Platanos HM 2488★. Chlorite. Incised triangles with punctured dots, arcs with vertical bars. Tholos A annex. **P 462.**

[1] In the writer's opinion the stone bowl and lid with separate bull handle from Byblos (Money-Coutts 1936) are almost certainly not Aegean. The incised decoration (concentric circles, close together, with diagonal hatching between them) is not found on Minoan vases. The bowl shape is not recognisedly Minoan and there is plenty of Near Eastern evidence for representation of bulls in art (cf. Money-Coutts, *op. cit.* who notes that the attitude of the bull is 'purely Mesopotamian').

[2] Cf. from the Cyclades Renfrew 1964, pl. Σ T 4 (Syros) and p. 123; Hall 1915, pl. XIII 3 (British Museum); Åberg 1933, fig. 156 (British School at Athens); from Mycenae Grave Circle B, an original Cycladic import, Athens NM, Grave Circle B Case, Grave N, mentioned Mylonas 1957, 151.

Porti HM 1051. Chlorite. Incised triangles, every third one with cross-hatching. Ossuary Γ. MM IB/II. (Xanthoudides 1924, pl. XXXVIII.)

Siva HM 1610. Chlorite. Fringed arcs in triangles. North Tholos. (Paribeni 1913, 25, no. 1 and fig. 18.) **D 253.**

With these may be compared a small shallow bowl (Porti HM 1342) with moulded base (type 32 **A**). It has the same decoration as HM 1610, but cannot be classed as a pyxis since it has no flat rim to support an upper half.

Two other pyxides are of this shape, **D**, but have thick grooved decoration: Koumasa Tholos B, HM 751*, serpentine, blue/green, **D 254, P 463**; Mesara, HM unnumbered*, chlorite, N.F.C. **Total 10**

E. There are two other circular pyxides, not unlike each other in shape. The first is probably EM II because of its material and raised band with incised decoration (cf. type 41 **A**, A. Triadha). On the second, from Kythera, we see this decoration in a more developed form, with two bands of double lines. In the main bands of decoration the incised ⊂ spirals and running, linked **S** spirals are MM IB–II motives and the vase should be considered an import into Kythera at that time.

Lebena HM 2620. Pyxis with curved profile; raised band with ∧∧∧∧ decoration round belly; lid. Steatite, dark brown with creamy white. Tomb I. EM II–MM I A. (Alexiou 1960*a*, fig. 11 right.)

Kythera NM 6231. Pyxis with curved profile; small vertically pierced lugs on belly; two pairs of small holes on upper part for fastening lid. Lightly incised band of linked ⊂ spirals round shoulder (cf. Levi 1957–8, 95–6

no. 155 and fig. 220, sealing from the Phaistos Archive; *PM*, II, 200, fig. 110 A, K, MM fresco fragment); two bands of linked, running **S** spirals round lower part (cf. Zervos 1956, pl. 424, Mallia leopard axe-head, also incised); two bands of incised double zigzags round belly. Chlorite. LH III Chamber Tomb. (Staes 1915, 192, fig. 1. *PM*, II, 199–200 and fig. 117 B. Kantor 1947, 26 and pl. IV D.) **Total 2**

F. Little rectangular boxes with incut ends. Nearly all are of chlorite and like groups **A** and **B** have incised triangular decoration all over. One is from an EM II A context at Palaikastro and all are to be dated to this period. It is of interest that two survived, at Khania and Dreros, to Late Minoan and Geometric times.

Dreros HM 2557. Serpentine, brown with darker mottling. Incised triangles with vertical and diagonal bars. Geometric context. (Van Effenterre 1948, 40, 64 (D 41) and pl. XXI.)

Khania Khania M. Chlorite. Fragment, one incut end preserved. Kastelli settlement. LM IIIB–C. (Tzedhakis 1965, 568 and pl. 712 γ.)

Koumasa HM 846. Chlorite. Incised triangles with vertical bars. Lid. Tholos Γ. (Xanthoudides 1924, pl. III.)

Palaikastro AM 1909.375*. Chlorite. Fragment of lid, as next piece, with same pattern. Earliest ossuary (probably), EM II A. (Group mentioned Bosanquet 1901–2*a*, 290–1.) **D 255.**

Crete Stathatos Collection 4. Chlorite. Lid only. Two small holes for fastening to vase. All-over incised triangles. Said to be from near Herakleion. N.F.C. (Caskey 1953–4, 269–70 and fig. 4.) **D 256.**

Plus two others (Koumasa, Crete). **Total 7**

G. Two rectangular boxes with everted bases. The tiny Koumasa vase is probably EM II by material and very general resemblance to group **F**. The larger box from Palaikastro is not closely datable. It is made of serpentine and has holes for fastening a lid. It was probably made between EM II and MM I.

Koumasa HM 752. Chlorite. Lid missing. Tholos B. (Xanthoudides 1924, pl. XXIII.) **D 257. P 464.**

Palaikastro HM 631. Serpentine. Lid missing. N.F.C. (Hutchinson, Eccles & Benton 1939–40, pl. 15γ.) **D 258.** **Total 2**

Type total 38

34. RHYTONS

There are over a hundred examples of this type in stone, dividing into five groups. The whole class seems to be of MM III–LM I date. The majority of those with clear find contexts are from the LM I sites, A. Triadha, Gournia, Palaikastro, Pseira, Sklavokampos, Tylissos and Zakro. A fragment of a conical rhyton of Egyptian alabaster comes from an MM IIIB level at Knossos, showing that the type existed in this period. It is possible that others were made in MM III, though this cannot be proved. That the form was popular in LM I is amply demonstrated by two facts: the stone shape is exactly parallel to the clay forms painted in the Marine Style, and this form of decoration is found on some of the stone relief examples. The vases of the Knossos Central Treasury deposit, LM II–III A I by context, are almost certainly of MM III–LM I manufacture.[1] The Zakro Treasury and other rooms of the Palace have added most richly to the corpus and the relief Peak Sanctuary Rhyton from that site gives one of the most interesting and complete pictorial representations of the Minoan world. A number of other rhytons have scenes carved in relief (chapter VII).

The feature common to all these vases is that they have holes in the bottom, through which libations would be poured (ῥέω). Group **A** is represented on frescoes by the Cupbearer at Knossos, but of greater importance is the representation of some of these vases in Egyptian tomb paintings of the earlier part of the XVIIIth Dynasty at Thebes (*PM*, II, 534 sqq., 736 sqq. Furumark 1950).

A. Conical, pointed, straight sides, usually with moulded rim and raised, elaborately carved strap handle.

B1. Pear-shaped, round shouldered, usually with separate neck and sometimes separate neck ring, pointed end.

B2. As I but round-bottomed instead of with pointed end.

C. Ostrich egg shape, with usual pulley-shaped neck.

D. Bull's Head Rhytons.

[1] Indications of the MM III–LM I date are: the exact parallels for the rhytons and their separate necks in shape, details of technique and decoration, and materials among the rhytons from the LM IB sites, HM 40 for example being almost a twin of HM 1126 from Pseira; the closely parallel Shell Vases (type 35) from the LM IB sites; whilst the existence of the small rectangular Treasury room, exactly as that in which the Zakro deposit has been found, suggests that the Knossos room too was of MM III or LM I construction.

E. Lion and Lioness Head Rhytons.

F. Shape uncertain.

A. Ht. 36.7. Diam. 11.3. Alabaster, Egyptian. A few patches restored. Offset pieces on rim and body for fitting handle, each piece having two small holes for the fitting pins. Ribbed moulding on rim. Knossos Central Treasury. HM 35. (*PM*, II, 822, fig. 537 O.) **P 465.**

Ht. 40.0 approx. Diam. 12.45. Alabaster, Egyptian. Preserved are most of rim, part of handle and bottom tip. Carefully cut ribbed moulding on rim; handle has grooved decoration, probably carved in imitation of metal form. Knossos Central Treasury. HM 885*. **P 466.**

Ht. 39.8. Diam. 11.65. Limestone, grey and light grey banded. A few small patches on body and upper part of strap handle restored. Three horizontal grooves below rim. Handle carved with shallow groove in imitation of metal form. A. Triadha Palace. LM I. HM 336*. **P 467.**

Ht. 33.3 approx. Diam. 10.4. Antico rosso, deep reddish maroon marble (apparently), fine grained, with green/grey patches. All rim and about two-thirds of top part of body restored. Carved with thirty-two vertical flutes. Hole in bottom made smaller with a plug, to prevent liquid from running out too quickly. Gournia. HM 103. (Boyd Hawes 1908, 36 and pl. V 13. Zervos 1956, pl. 583.) **P 468.**

A. Triadha HM 342 & 498 & 676. Serpentine. The Boxer Vase. Palace. LM I. (Halbherr 1905. Marinatos & Hirmer 1960, pls. 106–7.) **P 469.** Plus two other conical rhytons from here.

Katsamba AM 1938.604*. Chlorite. Strap handle fragment carved in LM II–III A I style with argonauts in relief. N.F.C. (Mentioned *PM*, IV, 129.) **P 470.**

Knossos HM 34*. Limestone, polychrome mottled and banded, grey/black, grey/white and orange. Central Treasury. **P 471.**

HM 255. Serpentine. Body fragment. Relief scene with boxers. LM I B. (Evans 1900–1, 96 and fig. 31. *PM*, I, 690–1 and fig. 510.) **P 472.**

HM 257. Serpentine. Relief scene with bearded archer among rocks. N.F.C. (Evans 1900–1, 44 and fig. 13 and 75. *PM*, III, 100 and fig. 56.) **P 473.**

HM 426. Serpentine. Body fragment. Relief scene with two men bearing vessels before a building, ? shrine, with monumental stone façade. N.F.C. (Evans 1902–3, fig. 85. *PM*, II, 752 and fig. 486.) **P 474.**

HM 2329. Serpentine. Body fragment. Relief scene, interpreted by Evans as one boxer knocking out another. N.F.C. Chance find above Little Palace, 1933. (*PM*, IV, 600 and fig. 595.) **P 475.**

HM 2397. Serpentine. Body fragment. Relief scene with a man before a basin at a peak sanctuary on rocks. N.F.C. Two joining fragments found on different occasions many years apart on Gypsadhes Hill. (Alexiou 1959 a, pls. ΛΔ, ΛΕ.) **P 476.**

AM AE 1247. Serpentine. Body fragment. Relief scene with shrine of isodomic masonry, horns of consecration on top, a man, ? fighter, walking off left, and part of another man sitting. N.F.C. (This was the first fragment of a relief vase known to Evans, given to him on a visit to Knossos in 1894. *PM*, II, 614–16 and fig. 386.) **P 477.**

AM AE 1569*. Serpentine. Body fragment. Part of a bull-leaping scene with forepart of bull, including most of head and one leg, and the two outstretched hands of the leaper. 7.7 × 2.7 × 1.58.

HM unnumbered*. Limestone (or marble), burnt brown/black. Body fragment. Relief decoration with figure-eight shields and their straps; part of rosette preserved on one edge. Burnt. N.F.C. Discovered in an unlabelled box in the Stratigraphic Museum, 1964. The armorial decoration suggests LM II–III A manufacture (cf. the handles of the gypsum alabastrons, type 1 **B**), and as the piece is burnt it would have belonged

to a vase destroyed in the final conflagration in LM II–III A I. **P 478.**

Palaikastro HM 993. Serpentine. Body fragment. Relief scene with charging boar. Originally covered with gold leaf. N.F.C. (Dawkins 1923, 136–7, fig. 118.)

Sklavokampos HM 2260. Limestone, grey and grey/white banded. (Marinatos 1939–41, 85 and pl. III 6.)

Zakro HM 2732★. Limestone, mottled and banded grey and brown with grey/white veins. Carved with horizontal flutings from top to bottom (cf. Platon 1964b, fig. 12). Palace Treasury. LM I B.

HM 2748. Brecciated serpentine, mottled maroon and gold with small orange and dark pieces and grey/white patches. Carved with shallow vertical flutings terminating at the top in arcades; superbly carved handle with shallow groove and ribbed decoration on its edges. Palace Treasury. (Platon 1963, pl. 147a.) Plus nine other conical rhytons from Zakro.

Crete ? Boston M. Chlorite ? burnt brown. Fragment with part of relief scene showing two boxers. See chapter VII. (Benson 1966.)

Delphi Marble ?, white. Fragment with ribbed rim and four horizontal grooves below. N.F.C. (Perdrizet 1908, 208 no. 698. *PM*, II, 833 n. 2.)

Mycenae Nauplion M. 8352. Lapis Lacedaemonius, green/black matrix with yellowy green crystals. Lower part preserved. Carved with vertical flutings. Rhyton Well. LH III

pottery in well. An original MM III–LM I import in view of the great frequency of the type in Crete and its rarity on the Mainland. (Wace 1919–21, 201 and pl. XI.)

NM 2669. Marble, banded, grey, blue/grey. Body fragment carved with vertical flutings. Acropolis N.F.C. Almost certainly another Minoan import. (Wace 1921–3, 1.) Fragment of fluted 'red stone' rhyton from the Granary. Perhaps antico rosso (not seen by the writer). Cf. exactly HM 103 above, from Gournia. (Wace 1919–21, 201.) Another 'red stone' fluted fragment ending in double arcades at the top with horizontal grooves above and a ribbed rim. Cf. HM 2748 above. From fill behind wall of Pillar Basement. MH, LH II, LH III. (Wace 1921–3, 183–4, fig. 36.)

Finally there are eleven other fragments or handles, five from Knossos (one fluted), one from Prasa House A (LM I), a handle (Platon 1951b, 253, fig. 6 top right), two from Pseira (one a handle), a separate bottom end, vertically fluted, from A. Triadha, a rim fragment (Antico Rosso ?), vertically fluted with a moulded rim having three horizontal bands, from Asine, LH II–III (Tomb 1 2) (Frödin & Persson 1938, 377–8 and fig. 247), and a fragment, very possibly of a rhyton, from the Mycenaean-Geometric deposit on Delos (de Santerre & Treheux 1947–8, 239–40 and fig. 37). It seems to be either gabbro or lapis Lacedaemonius and has a hole in it. **Total 47**

B1. Ht. 34.5. Diam. 14.1. Limestone, mottled maroon, light grey, orange/pink. A few patches restored. Knossos Central Treasury. HM 38★. **P 479.**

Ht. 22.6. Diam. 9.75. Obsidian, translucent dark grey banded against the light. Parts of body restored. About two-thirds of the whole survives. Separate neck, flanged at base to fit the rhyton. Tylissos. LM I. HM 1573. (Hatzidhakis 1921, 52, fig. 27.) **P 480.**

Ht. 38.2. Diam. 15.15. Limestone, grey/white, grey/black and orange. About one-third of body and part of neck restored. Carved with 16 vertical flutings ending at the top in triple arcades. Separate neck, flanged to fit mouth of rhyton, and carved with a ring, with the usual ribbed decoration. Knossos Central Treasury. HM 42. (*PM*, II, 822 and fig. 537b.) **P 481.**

Ht. 43.05. Diam. 13.95. Antico rosso ?, purply red, fine grained with finely mottled silvery grey patches. Somewhat cracked and burnt. Carved with 25 shallow vertical flutings; separate neck and separate ring fitting base of neck. Edge of lip of neck decorated with close-ribbed border.

Three pairs of holes drilled through flange of neck corresponding to holes drilled through top of rhyton. Bronze pegs effected the join, of which three survive, two still in their holes. Zakro Palace Treasury. HM 2699. ("Εργον 1963, fig. 180. Platon 1963, pl. 147c.)
Ht. 32.7 (rhyton only). Diam. 15.25. Limestone, mottled grey/white with maroon vein. A third to a half survives. Surface cracked through burning. Carved with shallow vertical flutings, the ribs between which are grooved. Knossos Central Treasury. HM 37. (*PM*, II, fig. 537d.) **P 482.**

Arkhanes HM 3041. Alabaster, Egyptian. Rectangular Tomb with Child Burials. LM ? 1. ("Εργον 1966, 141 and fig. 165.)

Knossos HM 39*. Limestone, banded grey, grey/white, grey/black. Central Treasury. **P 483.**
HM 1365. Breccia, dark brown matrix with black pieces and red/brown patches. Wide shallow vertical flutings. Hall of the Double Axes. (*PM*, III, 346 and fig. 230.)
AM AE 501*. Limestone, banded grey, blue/grey, orange, dark red. Shape as HM 38. Central Treasury.

Zakro Palace Treasury HM 2694*. Limestone, mottled and banded, grey–dark grey, reddish maroon. Shape as HM 38.
HM 2712. Lapis Lacedaemonius, light brown matrix with pale yellow/green crystals. Separate neck. (Platon 1963, pl. 147b.)
HM 2721. Rock crystal. Separate neck ring composed of thinly cut ℂ shaped pieces with gold joinings, and a separate handle of 14 rock crystal beads held together by a bronze wire. Platon 1964b, fig. 16.
HM 2727*. Limestone, mottled creamy, maroon, dark brown. Much burnt. Separate neck with moulded ring at base with ribbed decoration.
HM 2733*. Alabaster, Egyptian. Made in one piece.
HM 2746*. Limestone, banded grey/white, dark grey. Badly burnt. Separate neck (HM 2750).

B2. Ht. 31.1 (without neck). Diam. 13.85. Chlorite, brown in parts from effect of fire. A few patches restored. Seven fragments of gold leaf still adhering. The Peak Sanctuary Rhyton. Relief scene with a sanctuary built of isodomic masonry on several levels; in the centre of it is an elaborate doorway with linked relief spiral decoration all round. Sitting over the doorway are four agrimis, heraldically placed; crowning the walls at several points are Horns of Consecration and below the doorway is an altar with incurved sides; flanking the doorway are tall poles with rectangular 'boxes', as found on the Boxer Vase and the relief fragment with another peak sanctuary (HM 2397 above); for an interpretation of these poles with boxes as Minoan flagstaffs see Alexiou 1963a. Birds are poised over the Horns of Consecration or are perched on the poles (as on the A. Triadha sarcophagus). The whole sanctuary is set in a rocky landscape, which occupies much of the lower part of the vase. Amid the rocks are flowers and plants, including crocuses. A magnificent agrimi leaps across the rocks below at full 'flying gallop'. The base of the rhyton is carved with a rosette. Separate neck (HM 2722) with tiny coils in relief round the edge of the rim, covered in gold leaf. The neck probably but not certainly belongs to the rhyton. Zakro Palace Rooms Ee and Ψ. HM 2764. (Platon 1963, pls. 152b, 153, 154a; 1964b, figs. 10 and 15.)
Ht. 31.2. Diam. 12.25. Limestone, banded, grey/black, orange/grey. About a quarter of body restored. Knossos Central Treasury. HM 40*. **P 484.**
Ht. 32.4. Diam. 17.85. Breccia, creamy white matrix with black pieces and a few orange/red patches. A few patches restored. Collar undercut, upper surface carved with shallow flutings. Two pairs of holes on shoulder to receive fittings of handles. Knossos Central Treasury. HM 36. (*PM*, II, 822, fig. 537a.) **P 485.**
Ht. 19.0. Diam. 11.6. Gabbro (not blue steatite as published!). Complete. Palaikastro, Block X hoard. LM IB. HM 912. (Dawkins 1904–5, 279; 1923, 135–6 and fig. 117.) **P 486.**

Ht. pres. 18.4. Max. Width 11.9. Limestone, white coarse. Elliptical in section. Top part broken off and missing. Two octopus tentacles in high relief. N.F.C. 'Found in the earth of excavations of the tombs, 1929' (HM Catalogue). Knossos Mavro Spelio. HM 2229. (Zervos 1956, pl. 514.) **P 487.**

Knossos Central Treasury HM 41. Limestone, creamy white, translucent, marble-like. Carved with 30 vertical flutings. Made with a separate base which does not survive, but the vase is most probably of **B 2** form. (*PM*, II, 822 and fig. 537c.)

Pseira HM 1126. Breccia, brick red matrix with black pieces and a few white calcite veins. Almost a twin of HM 36 above. LM IB. (Seager 1910, 37 and pl. VIII.) **D 259. P 488a.**

Zakro Palace Treasury HM 2697. Limestone, grey, grey/white, grey/black banded with maroon patch at centre. Shape as HM 40 above but much larger, Ht. 42.15. (Platon 1963, pl. 148a; 1964b, fig. 8.)

HM 2749*. Alabaster, Egyptian. Separate neck.

Plus one fragment from Knossos, **B 1** or **B 2**.

B 1 plus B 2: total 25

There are two fragments from Knossos of group **A** or **B**. One is of Egyptian alabaster and is from an MM IIIB context. Hogarth's Houses (G 7 B). **Total 2**

In addition there are six typical 'pulley-shaped' necks which probably belong to rhytons of group **B** but might belong to those of **C** or even to Ewers, type 19.

Knossos HM 37 BIS (does not go with HM 37). Serpentine. Central Treasury. (*PM*, II, 822, fig. 537g.)

HM 43*. Serpentine. Central Treasury ? Both these have a carved cable pattern decorating the neck ring.

HM unnumbered*. Chlorite. Neck broken off vase which was made in one piece. On preserved top bit of body is Marine Style rock work decoration in relief, so this may well have been a vase like the Ambushed Octopus Rhyton (group **C** below). Found with relief shields fragment (group **A**) in unlabelled box in Stratigraphic Museum.

HM unnumbered*. Banded tufa, pale pink, grey, grey/white. Carved cable pattern round neck ring. Sellopoulo (57/72) Tomb II. LM IIIA. (Mentioned Platon 1957a, 334.)

Zakro HM 2758*, HM 2762*, both Egyptian alabaster, the latter a plain neck ring. Both Palace Treasury. LM IB. **Total 6**

C. Ht. approx. 9.6. Diam. 11.0. Steatite or serpentine, black. The Harvester Vase. Lower half and small part of rim restored. A. Triadha Palace. LM I. HM 184. (Savignoni 1903. Forsdyke 1954. Marinatos & Hirmer 1960, pls. 103–5.)

Ht. 11.0. Diam. 12.8. Serpentine. Parts of body and lip restored. Made in two pieces, top half flanged to fit lower; small moulded base. Decorated with rockwork and octopuses in relief. The one fully preserved octopus has eight tentacles and is an excellent example of the classic LM IB Marine Style. Part of a second octopus is preserved. Mycenae Chamber Tomb 26. NM 2490. (Tsountas 1888, 144 and pl. 7, 1.)

Ht. 23.0. Diam. 15.35. Limestone, grey/black, grey/white, wavy banded (perhaps marble). One large piece of body and part of lip of neck restored. Knossos Mavro Spelio Tomb III. Tomb not dated. HM 2141. (Forsdyke 1926–7, 254 and 290 and fig. 42.) **P 488b.**

Knossos HM 254. Chlorite. Body fragment. Relief scene with beautifully carved octopus partly hidden behind seaweed and rock work, but with one eye open wide. All in typical

LM IB Marine Style. Throne Room. LM II–III A I. (*PM*, II, figs. 130 and 307.)

AM 1938.605. Serpentine. Body fragment. Relief scene with Marine Style rock work

and a dolphin. N.F.C. (*PM*, II, 502 and fig. 308.)

AM 1938.698. Steatite, or serpentine, black.

Body fragment. Relief scene with a man, a goat and a helmet. N.F.C. Found N.W. of Palace. *PM*, III, fig. 128. **P 488 c.** **Total 6**

D. Ht. 20.0 (mouth to top of head). Serpentine. Horns, ears, left eye and part of cheek restored. Libation hole in top of head and in mouth. Ears, horns and back plate fitted separately. Curls in relief on top of head, lightly incised patterns over rest of surface, including double axe on centre of forehead between the eyes. Knossos Little Palace. LM II–III A I. HM 1368 and 1550. (Evans 1914, 79–84 and figs. 87–9. Marinatos & Hirmer 1960, pl. 98.) **P 489.**

Ht. *c.* 14.8 (mouth to top of head). Width, ear to ear, 13.1. Chlorite. Of the back plate all survives except about half the flange; of the head itself all of the upper part and most of the left side, half of the forehead, most of the right eye and both ears survive. The curls extend right down the forehead so far as it is preserved and are of four locks each, very finely carved. On the surviving side are curvilinear patterns as on the Little Palace head. On top at the back of the head the skin folds are very well rendered. Libation hole in top of head, 1.0 diam. Ears fitted separately into square-cut dowel holes, the ends of the ears being cut with square section to fit the holes. One hole for fitting of horn preserved, 0.75 diam. Eyes incut to receive inlay, which does not survive. Zakro Palace Room E. HM 2713. (Platon 1963, pl. 152a; 1964b, fig. 7.)

There exist fragments of a number of other Bull's Head Rhytons from Knossos, Palaikastro and Mycenae.[1] The form is not uncommon in clay in Crete and there is also the silver example from the IVth Shaft Grave (Karo 1930–3, pls. CXIX–CXXI. Marinatos & Hirmer 1960, pl. 175), almost certainly an MM III–LM I product.

Knossos AM 1938.603. Serpentine. Two ears, and quatrefoil inlays from the head. Tomb of the Double Axes. LM II–III A I. (Evans 1914, 53 and fig. 70.)

AM 1938.799. Serpentine. Head fragment with curls, each lock having three or four strands. From drain beneath south border of Royal Road. MM IIIB–LM I. (*PM*, II, 531, fig. 335 and 576 n. 2.

HM 259*. Serpentine. Head fragment carved with locks of four strands. N.F.C. **P 490.**

HM 2104*. Serpentine. Cheek fragment with curls each of three strands, and part of cutting for the eye. Gypsadhes Hill (Evans). N.F.C. **P 491.**

HM 2790 (from KSE 1957–61)*. Chlorite. Fragment with carved curls, from rear

part of cheek; one hole and part of another preserved, perhaps for fitting to back plate. Hogarth's Houses. LM IIIA 2–?B (K 5).

KSM (1957–61). Fragment broken on all edges; preserves corner of eye and tear duct; finely carved over surface, save round eye. Chlorite with serpentine. Royal Road. LM IB (JK 65).

KSM (1957–61) unnumbered*. Serpentine. Ht. pres. 10.2. Length pres. (front to back) 9.8. Width 8.2. Part of a Bull's Head with mouth, throat and most of cheeks surviving. N.F.C. Found on Gypsadhes Hill, December 1962. **P 492.**

Palaikastro HM 995. Chlorite. An ear, 4.1 × 2.4. Block E. LM IB. (Dawkins 1903–4, 207.)

Mycenae NM 6247 (I). Chlorite. Upper part of

[1] I can offer no firm opinion on the Seltman bull's head rhyton (Seltman 1951), as I have not seen the piece. From photographs (*ibid.* pls. 1–2) I would say its genuineness should certainly not be ruled out, though the angular decoration on the side of the head (pl. 2 A) looks rather like a hesitant attempt to copy literally the firm angular decoration on the Knossos Little Palace rhyton. The material of the Seltman rhyton, chlorite, is entirely correct. Mr R. W. Hutchinson kindly tells me that he examined the piece very carefully and considered it to be Minoan.

head preserved with curls in long, mainly triple strands. Length 13.0. Rhyton Well. LH III pottery in the well, but this and the other stone vase fragments are original MM III–LM I imports. (Wace 1919–21, 202 c and pl. XIII I C; 2 c, d.)

NM 6247 (2). Chlorite. Fragment of side of head with eye socket and carefully carved curls. Ht. pres. 11.0. Width 6.0. (*Ibid.* 202 d and pl. XIII I D; 2 a, b.)

NM 2706. Serpentine. Part of throat and dewlap and of back edge for fitting back plate survive. Ht. pres. 9.0. Width 7.0. N.F.C. Found by Tsountas on Acropolis. (*Ibid.* 203 and pl. XIII 3 a–c.)

NM 6248. Serpentine. Top part of back of head preserved with part of hole in top of head and part of flat rear edge for back plate, with one small dowel hole to receive this plate. 10.0 × 7.0. (*Ibid.* 203–4 and pl. XIII 3 d–e.) Context, pre-LH III fill below floor of closet in the Palace.

Nauplion M. (64/253)★. Chlorite. Fragment including eyebrow and part of ear socket. 8.6 × 7.2. Citadel House. LH IIIB–C. One other fragment, 64/128★, probably from an animal and perhaps from a Bull's Head rhyton. Context as previous. **Total 16**

E. Ht. 17.0. Length 29.5. Limestone, creamy white, translucent, marble-like. Almost complete. Libation holes in top of head, nose and mouth. Series of holes round edge at back for fitting back plate. End of nose probably of different material originally, now missing. Knossos Central Treasury. HM 44. (Evans 1914, 84–7, fig. 91. *PM*, II, fig. 537 i, 542 a, b and supplementary plate XXXI a. Marinatos and Hirmer 1960, pl. 99.)

Knossos AM AE 784. Alabaster, Egyptian (not 'native', i.e. Cretan, alabaster, as published). Parts restored. Central Treasury. (*PM*, II, figs. 544–5.) **P 493.**

AM AE 1181★, and 12 unregistered fragments. Alabaster, Egyptian. From another Lion or Lioness rhyton. Central Treasury. (Mentioned *PM*, II, 827.)

Delphi Limestone, white, marble-like. Large part of Lioness Head rhyton. Found under the Temple of Apollo. (Perdrizet 1908, 3, fig. 13. Evans 1914, 87. *PM*, II, fig. 549.) **Total 4**

F. Finally there are five fragments of vases from Knossos with relief scenes which are probably from rhytons, but of which the shape is uncertain.

AM 1924.41★. Serpentine. Marine style scene with part of an octopus and rock work.

BM 1907 I–19 217★. Serpentine. Marine style scene showing part of a dolphin and rock work. **P 494.**

HM 258. Serpentine. Part of a relief scene with a pole with rectangular 'box' and the folded leg of a bull or agrimi on top of it. This would seem to be the right interpretation in view of the closely similar scene on the Peak Sanctuary Rhyton. (*PM*, I, 688 and fig. 507; II, 702.) N.F.C. Found just N. of the South Propylaeum. **P 495.**

HM 256★. Serpentine. Scene with part of a man preserved, in excellent relief. N.F.C. (The Knossos provenience is not absolutely certain). **P 496.**

KSM (unprovenienced material)★. Chlorite. Rim fragment of rhyton ?, with rows of grain in relief separated by raised bands with vertical nicks. Cf. HM 2169, **P 585**, but not from same vase. N.F.C. **Total 5**

Type total 111

35. SHELL VASES

Imitations of the triton or dolium shell, both found in Cretan waters. These vases were made in MM III–LM I, at least one of the Knossos examples being used at the time of the destruction of the Palace in LM II–III A I, and that from Kalyvia Mesara in LM III. Like the Chalices and Rhytons they are witness to the astonishing technical skill of the Minoan lapidaries. They do not have holes in the base and so are not rhytons. One Knossos vase comes from the Central Shrine Treasury and as conch shells are frequently found in religious contexts in Crete, this would seem to have been a ritual stone class.

Ht. 31.7. Max. width 13.7. Alabaster, Egyptian. A third to a half preserved, including bottom end, all of lip and top part of body. Four holes drilled in lip for a metal attachment. Knossos Central Treasury. HM 45. (*PM*, II, 822–3 and fig. 537*h*, and 539.)
Ht. 28.5. Width 19.0. Obsidian, black with white spots, translucent. Patches on body restored. A. Triadha Palace. LM I. Dolium shell (all the others are tritons). HM 360. (Mosso 1910, 287, fig. 181. *PM*, II, supplementary plate XXXI B. Zervos 1956, pl. 445.) **P 497.**

Kalyvia Mesara HM 177. Alabaster, Egyptian. LM I–III tomb. (Savignoni 1904, 555–6 and fig. 40. Marinatos & Hirmer 1960, pl. 115 B.) **P 498.**
Knossos KSM (unprovenienced material)*. Serpentine, brown. Fragment. Cf. Sklavokampos example below. N.F.C.
Palaikastro HM 505*. Serpentine. Two fragments, from which the vase has been restored. N.F.C. **P 499.**

HM 1008*. Obsidian, dark grey translucent with white spots. Five non-joining fragments. Block Y 4, so probably LM I context. Provenience given in Palaikastro Excavation Notebook, 19/5/04 entry. **P 500.**
Sklavokampos HM unnumbered. Serpentine, soft reddish brown. Fragment. (Marinatos 1939–41, 85 and pl. 3, 3 centre, upper row.) **P 501.** **Total 7**

36. SMALL POTS

There are three main forms: **A**, globular or slightly flattened globular body with neck and/or out-turned rim (those from Voros and Kea have no raised rim); **B**, small open pots, usually with everted bases; **C**, small tubular cylindrical pots with or without defined rims. One or two of group **A** have a carinated profile or have tiny lugs on the body.

All groups come mainly from the Mesara tombs or Mochlos and date mainly from EM III to MM I. The type probably began in the latter part of EM II, for not a few are made of chlorite and steatite and two from Mochlos are from Tombs VI and XI. Other materials used are banded tufa, breccia, calcite, limestones and serpentine.

One or two come close to the Miniature Amphoras (type 28), e.g. HM 656 and HM 1245, whilst others are generally comparable in shape with Egyptian miniature vases of this date, e.g. HM 1246 with Petrie 1937, pl. XXVIII, 551, 595 and HM 1250 with *ibid*. 597. Close to HM 1246 is a little pot of Chephren diorite in the Fitzwilliam Museum, Cambridge (FM E 284/1954).

A. *A. Triadha* HM 667. Breccia, black with pink pieces edged by white veins in creamy matrix. Large Tholos. (Banti 1930–1, 186 and fig. 50*k*.) **D 260. P 502.**

Lebena HM unnumbered★. Steatite. Tomb III. MM I (upper stratum). Cf. closely HM 1239 and HM 1246.

Mochlos HM 1239. Steatite. Tomb XXI. (Seager 1912, fig. 46 XXI 2.) **D 261. P 503.**

HM 1245. Chlorite. Tomb XI. (*Ibid.* fig. 28 XI 8.) **D 262. P 504.**

HM 1246. Steatite. Tomb VI. (*Ibid.* fig. 22 VI 9 and pl. V.) **D 263. P 505.**

HM 1250. Calcite, golden brown translucent with creamy white patches. Tomb II. (*Ibid.* fig. 7 II *o* and pl. II.) **D 264. P 506.**

Phaistos HM 226. Steatite. Room V. MM II. (Pernier 1935, 219, fig. 95, 3.) **D 265. P 507.**

Platanos HM 1675★. Steatite. Tholos A annex. **P 508.** HM 2497★. Steatite, with serpentine. Tholos A annex.

With lugs and/or carinated profile.

Koumasa HM 717★. Serpentine, pale grey with network of fine grey/black veins. Curved profile, raised collar, two tiny solid lugs. Tholos B. **P 509.**

Mochlos HM 1249. Steatite. Slightly flattened globular; four flat, slightly incurved lugs on body. Tomb II. (Seager 1912, fig. 7 II *d* and pl. II.) **D 266. P 510.**

Platanos HM 1697★. Serpentine, pale green/grey. Carinated profile; two lugs at point of carination. Tholos A annex.

HM 1916★. Steatite. Carinated profile; two tiny lugs, vertically incised, at point of carination. Tholos B. **D 267. P 511.**

Voros HM 2253. Steatite. Curved profile, small moulded base, two small lugs on shoulder.

Tomb B. (Marinatos 1930–1, 153 and 161, fig. 23 3rd row centre.) **P 512.**

Kea K 6.119★. Serpentine. Curved profile, one lug preserved on shoulder. **Total 15**

B. *Knossos* HM 424★. Calcite, white translucent with banding. Top elliptical, moulded rim and base, each with diagonal incised nicks. N.F.C. **D 268. P 513.**

Mochlos HM 1247. Marble, white and grey/black mottled. Two horizontal grooves below rim. Tomb II. (Seager 1912, fig. 7 II *f*.) **D 269. P 514.**

HM 1253. Banded tufa, creamy with light brown veins. Horizontal groove below rim. Tomb XXI. (*Ibid.* fig. 46 XXI 4.) **D 270.**

HM 1295. Banded tufa, translucent creamy grey with brown, pale chocolate and gypsum colour bands. Low pedestal foot. N.F.C. (*Ibid.* fig. 47 M 11.) **D 271. P 515.**

HM 1296. Calcite, creamy white translucent. Flaring bowl, tiny raised foot. (Not Cycladic). N.F.C. (*Ibid.* fig. 47 M 12 and pl. IX.) **D 272. P 516.**

Platanos HM 1990. Chlorite. Everted rim, moulded base. Tholos A annex. (Xanthoudides 1924, 102 and pl. LIV.) **D 273. P 517.**

Total 6

C. *A. Triadha* HM 656. Calcite, translucent brown and creamy white. Defined rim. Large Tholos. (Banti 1930–1, 184 and fig. 50 *a*.) **D 274. P 518.**

HM 658. Calcite, ice-colour, translucent. Large Tholos. (*Ibid.* fig. 50 *h*.) **D 275. P 519.**

HM 659. Chlorite. Tapers to base; slightly moulded rim. Large Tholos. (*Ibid.* fig. 55 *b*.) **P 520.**

Gournia HM 1543★. Breccia, grey/black matrix with salmon pink and creamy white veins

and pieces. Four horizontal grooves below rim. Cf. HM 1247, under **B** above. N.F.C. **P 521.**

Knossos AM 1936.590. Banded tufa, creamy white, gypsum grey, brown wavy banded. Two horizontal grooves below rim. These grooves are sharp-edged like those of certain bridge-spouted bowls (type 13 **A**) which are MM III and other fine vases which are LM I. So this pot might be a single example of that period rather than EM III–MM I. N.F.C. (*PM*, IV, fig. 91.) (It has no connexion with Egyptian forms or material.) **P 522.**

Mallia HM 2128. Dolomitic marble, creamy white and grey mottled. Four-sided, sides slightly convex. Quartier Γ. MM I. (Demargne & de Santerre 1953, 37 and pl. XIV.) **D 276. P 523.**

Marathokephalon HM 2022. Chlorite. Everted rim; tapers slightly to base. (Xanthoudides 1918, Παρ. 19, fig. 5 top row 4th from left.) **D 277. P 524.**

HM 2024. Steatite, black. Miniature; incurved sides and tiny raised collar. (*Ibid.* fig. 5 top row 3rd from right.) **D 278. P 525.**

Mochlos HM 1237. Steatite. Tapers towards top; tiny lid with pawn handle. Tomb II. (Seager 1912, fig. 7 II *e* and pl. II.) **D 279. P 526.**

A. Nik. M. 1695*. Banded tufa, brown, orange, white wavy banded. Raised band with diagonal incised decoration below rim; below this band and above the base horizontal incised grooves; between these, over the body, incised diagonal grooves. N.F.C.

Platanos HM 1640. Chlorite. Tiny moulded rim and base. Tholos A annex. (Xanthoudides 1924, pl. LIII.) **P 527.**

HM 2515*. Limestone, soft white coarse. Tholos A annex. **P 528.**

HM 2516*. Chlorite. Rough horizontal grooves below rim and above base. As last. **P 529.**

Tylissos HM 2046. Limestone, black veined with white and brick red. Shape as HM 658 above. House Γ under the floor, i.e. MM (MM I) context. (Hatzidhakis 1934, pl. XXI *e*.) **P 530.**

Plus 4 others (Koumasa Tholos B and Platanos).

Total 18
Type total 39

37. SPOUTED BOWLS

There are several different forms. The first, **A**, consists of eight individual vases linked by their incised decoration and material, chlorite or chlorite schist. The decoration is that found on the earliest ladles (type 23 **A**) and pyxides (type 33 **A**), an all-over pattern of finely incised lines, usually in triangular groups. These eight spouted vases make up, with the ladles and pyxides, the earliest group of Minoan stone vessels (Warren 1965*b*). As with the pyxides several are from EM II or EM IIA contexts. Here the Lebena excavations have been outstandingly valuable in producing three bowls from early EM II contexts. The whole group is an indigenous creation, owing nothing to Egypt or other external influences, though linked generally to the Cyclades by the relief spirals of some of the pyxides and the triangular system of incised decoration. The early date of the group is also shown by the fact that all these vases were made with a flat-edged chisel, the marks of which are clearly visible on the interiors. The tubular drill had not yet come into use.

A. Incised chlorite bowls. The group is published in Warren 1965 b.

Lebena HM unnumbered (L II 169a). Chlorite schist. Shape and decoration as HM 134A and B below. Tomb II. EM IIA (immediately above A. Onouphrios Ware of lowest stratum. Information from St. Alexiou).

HM unnumbered (L I B 20). Chlorite schist. Graceful boat-shaped vase with all-over pattern of incised triangles. Tomb I B. EM II (on floor of tomb). (*B.C.H.* 1960, 888 and 890, fig. 7.) **D 280.**

HM unnumbered (L II 158a). Chlorite schist. Shallow bowl with spout having a hole on each side; all-over pattern of juxtaposed triangles with bars. Tomb II. EM IIA (immediately above EM I stratum). **D 281** (underside).

Palaikastro HM 135. Chlorite schist. All-over pattern of lightly incised triangles. Earliest ossuary, EM IIA (cf. type 33 **A**). (Bosanquet 1901–2a, 290–1 and pl. XVII fig. 1, 3 top centre.) **D 282. P 531.**

HM 134B. Chlorite schist. Two fragments of bowl, as HM 135, including pattern. Ossuary, as HM 135. (Mentioned *ibid.*)

HM 134A. Chlorite schist. Rim fragment with one vertically pierced lug. Band of incised fine criss-cross pattern below rim, lightly incised lines below. This fragment might be from a pyxis. As HM 135. (Mentioned *ibid.*)

Platanos HM 2487. Chlorite. Boat shape, as HM unnumbered (L I B 20) above. Incised bands with diagonal bars. Tholos A annex. (For the site Platon 1953, 592; 1955, 568.) **D 283. P 532.**

Trapeza HM 2359. Chlorite. Shallow bowl with spout and three rim lugs, each with two holes. Incised triangular pattern. (H. W. Pendlebury 1935–6, fig. 23, 18.) **Total 8**

B. Open bowls with rim spouts and usually rim lugs.

These bowls are either fairly low and shallow, or taller, with the height approaching the diameter. Materials are varied, comprising marble, chlorite, light and dark serpentines, banded tufa, breccias and limestones. There is one from Kea in steatite; it is probably Minoan, though the long, thin spout is not usual in Crete. The large examples from Mochlos are amongst the most graceful and elegant of all Minoan stone vases. The form is especially popular at Mochlos and is also found in North Crete at Khamaizi, Krasi, Mirsine, Sphoungaras and Trapeza. As with bowls with rim lugs (type 10) it has Cycladic Syros Culture connexions.[1] There is not however any connexion between the large Mochlos bowls and Cycladic or Mainland sauceboats. The latter have a very distinct form, not found in Crete, whilst the Mochlos vases belong to a large Cretan class, of which they form the most exotic examples. Several of the Mochlos vases are from Tombs I, VI or XI, where the only clay pots were EM II, and two more are from Tombs V and VIII, where no pots were later than EM III. There are a number of Mesara examples, especially from Platanos and Koumasa; the Sphoungaras vase is from an EM III–MM I context and that from Khamaizi MM I. The form began then in the latter part of EM II and probably continued to be made in MM I. It perhaps continued to be made in MM III for there are two serpentine examples of this date from Knossos. But they may well have survived in use from MM I. One did survive at Karphi and another at Zakro (HM 110), where it was found in a Geometric context (cf. Hogarth 1900–1, 148).

I. Fairly low or shallow form

Mallia HM 2610*. Serpentine. MM I house excavated by van Effenterre 1957. **D 284.**

Mochlos HM 1187. Marble, dark grey with grey/white patches. N.F.C. (Seager 1912, fig. 47 M 19.)

[1] NM 6136.4 (Naxos), NM 5110 (Syros Tomb 347). The latter is made of chlorite, like many Minoan examples, but has the Cycladic lug, placed well down on the body. These two bowls have the straight, Minoan type of spout. Others are also similar to the Cretan group but have a more curved, Cycladic spout (NM 5359, Naxos. NM 5076, 5156, Syros).

HM 1191. Banded tufa. Tomb I. (*Ibid.* fig. 4
1 *f.*) **D 285. P 533.**

HM 1193. Chlorite. Tomb XVI. (*Ibid.* fig. 37
XVI 4.) **D 286.**

HM 1195. Chlorite. Tomb VIII. (*Ibid.* fig. 46
VIII *a*.) **D 287. P 534.**

HM 1197. Steatite, green, greeny brown with
white patches. N.F.C. (*Ibid.* fig. 47 M 6.)

HM 1596*. Chlorite. N.F.C. **D 288. P 535.**

Total 7, plus 47 others, 54

2. Similar, but large individual vases

Mochlos HM 1176. Marble, grey to grey/black
banded. Tomb IV. (Seager 1912, fig. 18 IV 4.)
D 289. P 536.

HM 1179. Marble, as last. Tomb I. (*Ibid.*
fig. 4 1 *j*.) **D 290. P 537.**

HM 1204. Marble, as last. Tomb VI. (*Ibid.*
fig. 26 VI 3. Marinatos & Hirmer 1960,
pl. II left.) **D 291. P 538.**

A. Nik. M. 280*. Banded tufa. On three
tiny feet. N.F.C. (Mentioned Platon 1960*a*,
527.)

Palaikastro HM 898. Serpentine. LM I. (Dawkins
1923, pl. XXX E 2.) (This might just be an
MM III–LM I bowl comparable with others of
LM I date from Palaikastro in type 10). **P 539.**

Total 5, plus 3 others, 8

3. Taller form

Lithines Siteia HM 2626. Breccia, creamy brown
matrix, grey/black pieces. N.F.C. (chance find).
(Platon 1960*a*, 526; 1960*b*, 261 and pl. 226 B.)
This vase and HM 1068 below have lugs on
the body, not on the rim. This feature is
very rare in Crete but is not uncommon on
the Cycladic vases corresponding to this
Cretan group. **P 540.**

Marathokephalon HM 2025. Chlorite. (Xanthou-
dides 1918, Παρ. 19, fig. 5 centre row 4th
from left.) **D 293. P 541.**

Mochlos HM 1188. Banded tufa. Tomb XXI.
(Seager 1912, fig. 46 XXI 1.) **D 294.**

HM 1303. Limestone, buff. Tomb II. (*Ibid.*
fig. 7 II *i*.)

Porti HM 1068*. Chlorite.

Total 5, plus 13 others, 18

4. Flat based, almost cylindrical form

Gournia HM 318. Serpentine. N.F.C. (Boyd
Hawes 1908, pl. III 59.) **P 542.**

Knossos KSM (1957–61). Rim/body fragment
with straight-sloping sides; rim lug opposite
the spout. Cf. HM 2025 in group **3** for the
shape. The Knossos vase is of larger size and
so is better classed in group **4**. Serpentine.
Gypsadhes Tholos. MM III ? B (F 7).

Mochlos HM 1227. Marble, cream and grey.
Tomb VI. (Seager 1912, fig. 22 VI 17 and
pl. VII.) This vase, from a context with
EM II pots, is closely parallel in shape to the
EM II bowl in the earliest group, HM 135
above. **D 295. P 543.**

Platanos HM 1884. Serpentine, pale brown/buff
with mottled green, grey and black patches.
(Xanthoudides 1924, pl. LIV.) **Total 4**

5. Small vases, forms as 1 and 3, but with hook handle opposite spout or at right angles to it. Cf. Cups, type 17 A 1.

Koumasa HM 723*. Chlorite. Tholos A. HM
829*. Chlorite. Tholos Δ.

Mochlos HM 1211. Marble, grey/black and
cream. Tomb I. (Seager 1912, fig. 4 1 *h*.)
D 296. P 544.

Platanos HM 1912. Steatite, blue/black with
brown patches. (Xanthoudides 1924, pl.
LIV.)

Siva HM 1612. Chlorite. (Paribeni 1913, 18 no.
6 and fig. 4.) **Total 5**

C. Bird's Nest Bowl shape with spout. This group has the Bird's Nest Bowl shape with a
spout in the shoulder and two arched shoulder handles. The seven Mesara examples are of
chlorite, that from Knossos is dolomitic marble. It was found in an MM II context. The form

95

probably begins in EM III for the inlay holes, incised decoration and material of the Mesara vases are all early features.

Kalyvia Monophatsiou HM 2350★. Chlorite. N.F.C. (chance find).

Knossos AM AE 962★. Dolomitic marble, grey and white mottled. Grooved handles as MM II polychrome hole-mouthed jars. Found with MM II polychrome pottery (AM card). **D 297. P 545.**

Koumasa HM 718. Chlorite. (Xanthoudides 1924, pl. XXIII.) **D 298. P 546.**

Platanos Tholos A. HM 1872. Chlorite. (*Ibid.* pl. LII.)

HM 1873. Chlorite. (*Ibid.* pl. LII.)

HM 1874. Chlorite. (*Ibid.* pl. LII.) Tholos B.

HM 1910. Chlorite. (*Ibid.* pl. LII.) Tholos A.

HM 1911. Chlorite. (*Ibid.* pl. LII.)

Total 8

D. Other forms. The Gournes vase, close to form **B 3** above, is of white gypsum and was found in an LM IIIB context. Being of gypsum it was probably made in LM IIIA or LM II (Warren 1967b). The Gournia vase on three legs is MM III–LM I, as probably are those from Mallia, all three being domestic vessels, like the large bowl from Kea.

Arkhanes HM 3042★. Large deep bowl, one horizontal lug opposite spout. Marble, light-dark grey, straight banded. LM I Palatial building. Because of large size and thin walls, and consequently being very liable to break, it is probably LM I, although slightly reminiscent of the EM bowls from Mochlos (group **B 2** above). For a large, thin-walled MM III–LM I vase of the same material see type 42 **B** Knossos HM 126.

Gournes HM 2045. Gypsum, white. Tomb 4. LM IIIB. (Hatzidhakis 1918, 83 and 82, fig. 27, 8.)

Gournia HM 317 a. Serpentine, green/grey, grey/black, maroon. LM I. (Boyd Hawes 1908, pl. III 57.) **P 547.**

Mallia HM unnumbered★. Serpentine. Houses ? **P 548.**

Mallia ? HM unnumbered★ (Apotheke box). Serpentine, mottled light green/yellow and dark grey. A large open bowl as type 10 HM 2613, with rim spout.

Kea KEA unnumbered★. Serpentine, brown mottled. Shape as HM 2126, type 10, with spout, two horizontal handles and one solid lug.

Total 6

Type total 111

38. TABLES

These comprise **A**: a group of circular vases, with or without feet; **B**: rectangular vases with four feet. All are flat-topped except HM 2319 and usually have a slight raised band round the edge of the top surface. They are normally found in domestic contexts (those from the Mochlos tombs perhaps being of domestic use originally) and were presumably tables or stands on which other vases or materials were placed. They would seem not to have been Libation Tables since they are not provided with bowls for offerings. The flat, rectangular ones, **B 2**, may have been used for the preparation of food (cf. the writer in Sackett, Popham & Warren 1965, 306 on the Palaikastro LM IB examples). There is one from Kea in the local grey/black marble.

Group **A** are MM I–LM I while those of **B** date from EM II–III onwards but are mostly MM III–LM I.[1] The circular vases, **A**, are made of serpentine, antico rosso and marble, the more domestic rectangular tables, **B**, usually of hard grey limestone with a few of schist, serpentine or marble.

A. *Knossos* KSM (RR/58/390*, B 33). Serpentine. One of the three legs preserved. Two grooves round outside of bowl. MM IIA and some IIIB. HM 65. Serpentine. Three legs carved in the shape of half rosettes. Probably covered with gold foil originally. North East Magazines. MM III–LM I. (Evans 1900–1, 74–5, fig. 24. *PM*, I, 387. Zervos, 1956, pl. 462.) **P 549.**

HM 2317 plus AM 1938.416. Antico rosso (probably), maroon/red, fine grained. An isolated import of this stone in MM IA. It is not otherwise used for vases before MM III–LM I. Two fragments, without feet, but with elaborately moulded edge. House B, below West Kouloura in West Court. MM IA. (H. W. & J. D. S. Pendlebury 1928–30, 71, fig. 12. *PM*, IV, fig. 46 and supplementary pl. 45 B.) Fragments of four* others (1957–61, from MM I–IIA to LM I?A contexts), all serpentine.

Mallia HM 2320. Serpentine. Three feet of rectangular section; moulding of two horizontal flutings round sides. House E, Room XXXVIII. LM I. (Deshayes & Dessenne 1959, 136 and pl. XLIX 7.)

Tylissos HM 1565. Marble, grey/white. Disk-shaped, without feet. LM I. (Hatzidhakis 1921, 75 and fig. 39 top centre.)

Plus 1 other (Knossos Palace, as HM 1565). **Total 10**

B.1. Rectangular with two box-like compartments.

Mallia HM 2319. Serpentine. Wide horizontal groove round sides. House Δγ. LM I. (Demargne & de Santerre 1953, 59 and pl. XXIX. Zervos 1956, pl. 598.) **P 550.** **Total 1**

2. Flat, rectangular, on four feet.

Mallia HM 2312. Serpentine, light green/grey with network of grey/black veins. Behind House Δα. MM I–III. (Demargne & de Santerre 1953, 58 and pl. XXVIII.)

HM unnumbered. Limestone, reddish brown. LM I. House Zb. (Deshayes & Dessenne 1959, 63 and pl. XIX 5.) HM 2418. Schist, greenish grey. As last. (*Ibid.* 62–3 and pl. XIX 2.)

Mochlos HM 1173. Limestone, light grey. Tomb V. (Seager 1912, 43 V *j* (probably).)

HM 1174. Limestone, light grey. Tomb II. (*Ibid.* 37 and fig. 13 (probably).)

Plus 11 others (Gournia, Mallia, Mochlos, Palaikastro (1962–3 excavations, 1 MM IIIB, 1 LM I (probably), 2 LM IB; 1, N.F.C., from the old excavations) and E. Crete). **Total 16**

39. TALL GOBLETS

Both of these fine vases are from the A. Triadha Royal Villa and are of MM III–LM I manufacture.

Ht. 24.0. Diam. 10.8. Limestone, grey and white banded. About two-thirds preserved, including all lower part. Small semicircular cutting in the rim with two holes drilled vertically

[1] Flat rectangular stone slabs or palettes, popular in the Mesara tombs, are not included in this study since they cannot properly be classed as vases.

into it, for attachment of spout or handle. HM 339. (Halbherr 1903, 61–2, fig. 47.) **D 299.**
P 551.
Ht. 22.5. Diam. 9.75. Limestone, grey and white banded, with maroon patch. Part of rim
restored. HM 338. (Zervos 1956, pl. 584.) **Total 2**

40. TANKARDS

A cylindrical jar with slightly incurved sides, incised nicks round the rim and
horizontal grooves below the rim and above the base. All are of serpentine. It is an
MM III–LM I type, some from contexts not exclusively of this period. The distribu-
tion is mainly in E. Crete though exports went to Kea and Kythera. The concentra-
tion in E. Crete is probably due to chance since it is the E. Cretan sites which provide
the bulk of the LM I material. There is a copy in clay, LM I, from Mallia House Za
(Demargne & de Santerre 1953, 89 no. 13 and pl. XLI 3). The type seems to have
been for domestic use, sometimes put in tombs with the dead.

Ht. 10.6. Diam. 10.38. About a third of base restored. Drill rings round interior. Mochlos Tomb
XX. HM 1278. (Seager 1912, fig. 32 XX 3.) **D 300. P 552.**

Gournia HM 92. (Boyd Hawes 1908, pl. V 3.)
HM 89*, HM 90*, Penn. MS 4503*, MET.
MUS. 14.89.14*, all N.F.C. but probably from
LM I town.
Knossos HM 2143. Mavro Spelio Tomb III.
LM I–III. (Forsdyke 1926–7, 254 III 23 and
pl. XX.
AM unregistered* (Evans Bequest 1941). Rim
fragment. N.F.C. Knossos ?
Petras Siteia BM 1907 1–19 152*. LM I ? (For
site Bosanquet 1901–2*b*, 282–5.) Perhaps
this is the vase referred to on p. 285.
Pseira HM 1116*. **P 553.**

HM 1117*. **P 554.**
HM unnumbered*, ditto* (these two in HM
Apotheke box).
Penn. MS 4517*. Penn. MS 4533*. All
unpublished but type shown as LM I. (Seager
1910, fig. 15*f*.)
Crete Siteia HM 115*. N.F.C.
Crete HM unnumbered*. N.F.C.
Kea K 1.134*. Base fragment.
Kythera 1965 excavations, no. 713, LM IB
context. Cf. HM 1116 above for the shape.
(Huxley & Coldstream 1966, 28 and fig. 6.)
Total 19

41. TEAPOTS

This type, common in clay from EM II to MM I, has nineteen stone examples. Except
for group **D** they are imitations of the pottery forms, since the shape is not natural
to and is harder to work in stone. Five, group **A**, are copies of the EM II Vasilike
Ware long-spouted teapot (two also copying its ring base), and of these five one
was found in a context where the only clay vases were EM II (Mochlos Tomb VI).
Five others, **B**, copy the EM III–MM IA clay form with a flat base, more globular
belly and shortened spout (Paterikies Ware). Three, **C**, imitate MM I clay forms
with higher body and tubular spout. Of these one is from an MM I context (Khamaizi),

one MM II (Phaistos) and one LM I (Gournia), a survival. Six others, **D**, have carinated bodies and a short spout set very close to the body. They resemble some clay examples, especially in their carinated bodies, but the clay ones usually have a fully formed, longer spout. The stone examples are EM III–MM I, that in an LM I context from Mallia very probably being a survival.

For the clay forms see, group **A**, Marinatos & Hirmer 1960, pl. 8 above; group **B**, Paribeni 1904, 696, fig. 8; Xanthoudides 1924, pl. XLI 4962, 4964 and 5682; Fiandra 1961–2, pl. K; group **C**, Xanthoudides 1924, pl. XXX 4977, 4149; group **D**, Seager 1912, fig. 32 XIIIc; Zervos 1956, pls. 137 left, 336 centre, 364 left, all examples with spout set close to the body.

A. Ht. 8.05. Diam. 10.1. Length approx. 16.85. Chlorite. Handle and part of body and foot restored. Porti. HM 2086. Xanthoudides 1924, pl. XXXIXa. **D 301. P 555.**

A. Triadha HM 646. Chlorite. Large Tholos. (Banti 1930–1, 186 and fig. 53.) **P 556.**

Mochlos HM 1203. Marble, grey, grey/black banded. Tomb VI. (Seager 1912, fig. 22 VI 1 and pl. V.) **D 302. P 557.**

HM 2395. Banded tufa. Found by M. S. F.

Hood in fallen wall behind Tomb VI. (Platon 1948, 589 and fig. 18.) **D 303. P 558.**

A. Nik. M. 278*. Breccia, light grey matrix, black and a few orange/brown pieces. N.F.C. (Mentioned Platon 1960a, 527.)

B. Ht. 5.45. Diam. 8.25. Length 11.85. Serpentine ?, dark brown. Tip of spout and parts of all three lugs restored. A. Triadha Small Tholos. HM 356*. **P 559.**

Gournia HM 560. Serpentine. (Cf. very closely in clay Seager 1912, fig. 49 nos. 47–8. Boyd Hawes 1908, pl. V 1.)

Mallia HM 2316. Serpentine. House E. MM I–LM I. (Deshayes & Dessenne 1959, 133–4 and pl. XLIX 1.)

Phaistos HM unnumbered*. Serpentine. Spout/ body fragment. N.F.C.

Platanos HM 1886. Chlorite. Tholos A. Probably EM III; it retains the eye dots on the spout. (Xanthoudides 1924, pl. LIV.) **P 560.**

C. Ht. 8.3. Diam. 9.21. Length 14.4. Serpentine, pale grey with brown/buff patches. About one-third preserved including most of spout and whole profile. Khamaizi. HM 470. (Xanthoudides 1906, 150, pl. XI 19.) **P 561.**

Gournia HM 91. Serpentine. LM I. (Boyd Hawes 1908, pl. III 60.)

Phaistos HM 265. Limestone, white and grey mottled. Palace Room VI. MM II. (Pernier 1935, 221 and fig. 98.) **P 562.**

D.

Knossos HM unnumbered. Banded tufa, opaque white and golden brown in broad bands. Spout/body fragment. Vat Room Deposit. MM IA (mainly). (*PM*, I, 170 and fig. 120r.)

Mallia HM 2113. Serpentine. Carinated profile. Palace Room XI 1. LM I. (Chapouthier & Joly

1936, 39 and pl. XX d and XXXIVc.) **P 563.**

HM 2591. Limestone, grey and white mottled. Pair of double, vertically pierced lugs below rim on each side. House Za. LM I. (Demargne & de Santerre 1953, 94 and pl. XLII 8–9 and LVIII 1.) **P 564.**

Mochlos HM 1202. Banded tufa, creamy white, orange/pink, chocolate, grey and brown. Three solid lugs on body. Tomb v. (Seager 1912, fig. 18 v i and pl. iv.) **D 304. P 565.**
BM 1912 7–8 19★. Serpentine, pale green/ buff with network of grey/black veins. N.F.C. **P 566.**
MET. MUS. 24.150.5★. Chlorite. Carinated profile; spout set right against body. N.F.C. **Total 19**

42. MISCELLANEOUS VASES

These may be conveniently divided into the following groups: **A.** EM–MM vases; these are mainly domestic vases of MM I date from Mallia, with a few EM–MM from the Mochlos tombs and a few others from Knossos and Phaistos, MM I–II. Materials are varied but serpentine is common at Mallia and marble at Mochlos. Those from Mallia make an important contribution to our knowledge of MM I domestic vessels. **B.** Middle Minoan III–Late Minoan individual vases. Many are from the Knossos Palace whilst LM I sites, A. Triadha, Mallia, Tylissos and Zakro and the Mycenae Shaft Graves (LH I–IIA, equals LM I) provide others. Many of these vases are superlative individual creations, often in fine stones like Egyptian alabaster, gabbro and rock crystal and are comparable with other types of this period, e.g. rhytons and chalices. There are also a few white gypsum pieces of LM II–IIIA I date. **C.** A small group of vases made in the shape of animals, birds or insects. That from Platanos is MM I, the remainder MM III–LM I. **D.** Finally there is a number of fine handles or feet of vases, especially from Knossos.

A. *Gournia* Penn. MS 4693★. Banded tufa, brown veined. Jar with sloping sides, everted rim and two horizontal handles on body. The material suggests an EM–MM I date. N.F.C. **D 305.**

Knossos HM 261★. Chlorite. Small jar flaring to rim (everted); no base; two (probably) up-right arched handles, so that shape is a small basket (κάλαθος). Material, size and possible comparison with MM I flaring clay tumblers suggest MM I–II date. Palace. N.F.C.

KSM (1957–61) (RR/58/242★). Marble, grey and white mottled. Parts of fine straight-sided jar with three grooves below the rim. MM IA (F 27 B and other levels).

KSM (1957–61). Low, oval dish. Serpentine. Cf. HM 2124 below. Royal Road. MM IIB (F 25 A).

Mallia HM 2111. Serpentine. Shallow bowl on pedestal foot; two pendent handles. Khryso-lakkos. MM I. (Demargne 1945, 51 and pl. LXII I.)

HM 2124. Serpentine. Elliptical dish on pedestal foot. Quartier Γ. MM I. (Demargne & de Santerre 1953, 37 and pl. xv.) **P 567.**

HM 2210. Serpentine. Flaring open bowl on short foot; pointed cone in centre of bowl. Fruit-squeezer or pricket? Villa A. MM I. (*Ibid.* 18 and pl. IX.)

HM 2288. Serpentine. Shallow, flaring open bowl (cf. HM 2210). Quartier Γ. (*Ibid.* 37 and pl. xv.) **P 568.**

HM 2327★. Serpentine. Shape as HM 2111 above. Houses S. of Palace. EM III–MM I (cf. Chapouthier, Demargne & Dessenne 1962, 13–17). For contemporary clay parallels see below, p. 171 n. 20.

Mochlos HM 1199. Marble, light to dark grey horizontal bands. Open bowl on small pedestal foot. A Cycladic Syros group form, (NM Syros Tomb 378). Tomb II. (Seager 1912, fig. 7 II *q* and pl. III.) **D 306. P 569.**

HM 1200. Marble, grey/black with whitish mottled patches. Bowl with rim spout and three rim lugs, on small pedestal foot. Tomb XVI. (*Ibid.* fig. 37 XVI I and pl. I.) **D 307. P 570.**

HM 1229. Calcite, white translucent with diagonal banding. Bowl on low foot; slight raised collar and four solid vertical lugs below rim. Not Cycladic (as Seager), though it may ultimately be derived from a common Pelos Group type, e.g. Tsountas 1898, pl. X nos. 16 and 17. Tomb XXI. (*Ibid.* fig. 46 XXI 10 and pl. III.) **D 308. P 571.**

HM 1233. Breccia, black, orange and grey pieces in creamy matrix. Tall cylindrical vase with spout, two vertically pierced lugs and one button handle. Tomb XXIII. (*Ibid.* fig. 46, XXIII *a* and pl. III.) **D 309. P 572.**

Penn. MS 4539*. Breccia. Lower part, including foot, of a tall goblet (Ht. pres. 10.6). EM–MM I by material and general shape. N.F.C.

Phaistos HM 224. Chlorite. Crescent-shaped dish with horizontal grooves round outside; hole in one corner so that perhaps a small cult vessel. Graffito on base ⊞. N.F.C. By size and material probably from MM I–II Palace. (Pernier & Banti 1951, 381 and fig. 243 *d*.) **P 573.**

HM 1513. Chlorite. Biconical vase with vertical handle; cone with rounded top in centre of bowl. Fruit-squeezer or pricket ? Cf. HM 2210 above. Room X. MM II. (Pernier 1935, 243 and fig. 117 *a*.) **P 574.**

HM 2548. Limestone, hard white. Bowl with carinated profile, moulded base and two upright arched handles. Main vase of cult set (see type 20 **A**). Room LI. MM II. (Levi 1952–4, 413 and fig. 33.) **D 310. P 254.**

Platanos HM 1895. Limestone, coarse white. Vase in shape of a melon. Tholos A annexes. (Xanthoudides 1924, pl. LIV.)

B. *A. Triadha* HM 354*. Alabaster, Egyptian. Tall vase, straight sides sloping into base; top and ? handles broken off; no base. Perhaps in shape of human figure originally; or imitating LM I clay form (cf. Zervos 1956, pl. 556, from A. Triadha). Palace. **P 575.**

HM 355*. Gabbro. Low bowl of Bird's Nest type on very small foot (cf. HM 2423 below, from Mallia). Palace. **P 576.**

Gournes HM 2043. Gypsum, white. Ht. pres. 12.8. Diam. 20.2 approx. Base of large, low-bellied vase, much rotted. Tomb 2. LM IIIB. (Hatzidhakis 1918, 78 and fig. 22 2.)

Gournia HM 547. Serpentine, pale grey with network of grey/black veins. Bowl with carinated profile and two vertical strap handles from rim to belly; small pedestal foot. Probably a survival from LM I though the shape is reminiscent of Grey Minyan Ware as well as MM I polychrome vases (cf. Dawkins 1923, pl. XI A). Aisa Langadha tombs. LM IIIA. (Boyd Hawes 1908, pl. X S 28.) **P 577.**

Katsamba HM unnumbered*. Gypsum, white tinged brownish grey. Rim fragment of bowl with everted rim. Finely carved LM IIIA pattern of a band of concentric arcs (cf. Evans 1905, fig. 23. Bosanquet 1923, fig. 68 I, Palaikastro LM IIIA deposit). N.F.C. From plundered tomb. The cemetery is LM II–IIIA. (Mentioned Platon 1959, 385.)

HM unnumbered*. Gypsum, as previous. Body fragment of large vase with handle bearing relief decoration of carved chevrons (LM IIIA pattern, cf. Evans *ibid.*). Plundered tomb. Mentioned *ibid.*

Knossos HM 21. Serpentine. Very large bowl. Two horizontal bow-shaped handles. Also large lid. Palace, passage S. of Room of Stone Vases (Central Treasury). LM II–III A I. (Warren 1965 *a*.) **P 578.**

HM 43. Rock crystal. Lower part of bowl with curved profile; two fine raised bands below rim. Lustral Basin of Throne Room. (*PM*, IV, 930–1, fig. 901 *a*, *b*.) **P 579.**

Total 18

HM 49. Alabaster, Egyptian (possibly Cretan banded tufa). Bowl on moulded foot. Perhaps a converted Egyptian alabastron (turned upside down). Central Treasury. (*PM*, II, fig. 537*l*.) **P 580.**

HM 52. Banded tufa, creamy white, grey, grey/brown wavy bands. Large bowl with spout, undercut to prevent drips running down; two solid lugs below rim and button handle. Central Treasury. (*Ibid.* fig. 537*n*.) **P 581.** These four vases are all from the LM II–IIIA I destruction but may very well be of MM III–LM I manufacture in view of the wide range of types and sizes in that period.

HM 126. Marble, creamy grey to blue/grey horizontal bands. Cup, flaring mouth, two large handles from rim to base. Hogarth's Houses. LM IB. Probably imitating a metal form; cf. a similar cup in gold from the IVth Shaft Grave, Marinatos & Hirmer 1960, pl. 192 below. (Hogarth 1899–1900*a*, 75 and fig. 20.) **D 311. P 582.**

HM 280*. Serpentine. Fragment of bowl with moulded handle; relief decoration of incised chevrons and large spirals, shallowly grooved. Probably LM II–IIIA I. Cf. Katsamba fragment above for chevrons and Throne Room alabastrons for spirals (type I **B**). N.F.C. **P 583.**

HM 887*. Serpentine, pale grey with network of grey/black veins. Ht. 9.5. Diam. 25.0. Bowl, low, straight-sided, curving to flat base; three short legs and three solid lugs below rim, over each leg; rim spout. Palace. N.F.C.

HM 2103*. Serpentine. Tall tubular stand with two small vertical handles near the top and a hole through the side, also near the top. Top drilled out only 3.9 deep, making a small bowl. N.F.C. **P 584.**

HM 2169*. Serpentine. Rim/body fragment of bowl with relief decoration of thick raised bands carved with thin Foliate Band and incised dashes, with oats or grain pattern carved on the main surface between the bands. From an LM relief vase, perhaps LM II–IIIA I in view of the style of the

Foliate Band (cf. Evans 1905, figs. 73, 83, Zapher Papoura). N.F.C. **P 585.**

HM 2408. Gabbro. Small vase apparently in form of a human figure with a long robe and large shoulder pads; no head, which was presumably made separately. LM IIB tomb near Temple Tomb. (Hutchinson 1956 *b*, 68, 72, fig. 3 17, 73 and pl. 8*c* and *d*.)

HM unnumbered*. Limestone, light maroon with grey band. Jar with straight sides sloping out to bottom; everted rim, no base. Pair of small holes drilled through just above bottom. (Possibly the vase should be taken the other way up). Sellopoulo Tomb 2. LM IIIA 2–B. (Mentioned Platon 1957*a*, 333. *Arch. Reps. for 1957*, 24–5.)

KSM (1957–61): (1) (HH 57/30 and 58/145*). Dolomitic marble, grey and white mottled. Small barrel-shaped jar (Ht. pres. 10.7) with everted rim, four lugs below the rim in the shape of double buttons and two raised bands round the belly, with diagonal nicks. Hogarth's Houses. LM IIIA 2–B (K 5, JK 5). The vase may equally well have made in MM III–LM I.

(2) Fragments of open bowl with parts of four horizontal flutings; rim turns out at one point, probably spout. Walls only one millimetre thick in one place. Obsidian, black translucent with white spots. Royal Road. LM IB–II (B 30 A and other levels).

(3) Vase of irregular shape hollowed out of a pebble; bowl of cinquefoil shape; depressions carved out on sides; small hole on each side just below rim, probably for fastening lid. Breccia, black pieces outlined by white veins, in orange matrix. Royal Road. LM IIIA 2 (D 3).

(4) Rim/body fragment of large vase with curved profile. Marble, white with grey band. Royal Road. LM IB (JK ext. 28 A).

(5) Rim/body fragment of jar; slightly moulded rim with two fine horizontal grooves below. Gabbro. Road Trials. Protogeometric–Hellenistic (D 20).

AM 1938.607*, HM unnumbered*. Rock

crystal. Fragments of five vases, one a flat-bottomed vase with solid horizontal handle above the base, four others body fragments, one with LM I coiled rope decoration on the outside. All probably from the Palace. N.F.C.

Mallia HM 2238. Serpentine. Bowl on pedestal foot, with two solid horizontal handles just below rim. Form as HM 2111 and HM 2327 in group **A**. Perhaps survival from MM I. Palace. LM I. (Chapouthier, Demargne & Dessenne 1962, 57 and pl. XLIII.)

HM 2393. Alabaster, Egyptian. Ht. 40.0. An Egyptian XVIIIth Dynasty baggy alabastron (see type 43 **I**) turned upside down by the Minoan lapidary, its base cut out to form the mouth, a separate Minoan neck added, of the usual 'pulley-shape' for rhytons, and a separate white limestone solid base. Holes drilled in the shoulder for attaching the handles, which do not survive; they may have been **S** shaped, cf. NM 389 below. Handles of this type would have needed a double neck and although the surviving neck fragments do not come from two necks, the vase may well have been so fitted (cf. p. 43 n. 1 for other vases with double necks). House Za. LM IB. Published, with full discussion, as a rhyton; since however it has no hole in the bottom, but has a separate base, it is not, strictly speaking, a rhyton. It was not moreover seen that it is an Egyptian alabastron reused and adapted. (De Santerre 1949. Demargne & de Santerre 1953, 95–6 and pl. XLIII 6–7.)

HM 2423. Gabbro. Bowl, low open with moulded foot; rim slopes down into bowl. Cf. HM 355, A. Triadha above. House Zb. LM I. (Deshayes & Dessenne 1959, 64 no. 7 and pl. XVII 4 right.)

Tylissos HM 1555*. Serpentine, pale green/buff, grey, greeny yellow. Open bowl with overhanging rim and two pendent handles. Cf. generally, but not rim, HM 2423 above. Probably from the LM I villas.

Zakro HM 2720. Limestone, polychrome banded, pale grey, grey/black, maroon. Ht. 37.85. Diam. (bowl) 21.0 (lip) 17.3. Large globular-bodied vase with double neck (cf. above, HM 2393), two high-swung handles from lip to body, and moulded foot. Vase, handles, main neck and ring, and upper neck all made separately. Cf. generally NM 389, Mycenae, below; for handles HM 126, Knossos, above; for necks, rhytons type 34 **B**. Palace Lustral Basin. LM IB. (Έργον 1963, 168 and fig. 179.)

HM 2728*. Alabaster, Egyptian. Ht. 26.2. Width 17.9. Flask, flattish ovoid, with oval mouth and oval pedestal foot; two curving strap handles from lip to shoulder. For an MM IIIB clay example of this shape from Zakro, Zervos 1956, pl. 448; LM IB, the octopus flask from Palaikastro, Bosanquet 1923, pl. XVIII*a*. Palace Shrine Treasury.

HM 2743*. Alabaster, Egyptian. Ht. 20.8. Diam. 14.65. Jar, tall, profile curving in slightly to rim; two vertically pierced double suspension lugs at rim, with bronze wire for suspension preserved in one. Palace Shrine Treasury.

Crete AM AE 217*. Gabbro, low cylindrical jar with everted rim. Probably LM I. Cf. generally HM 2423 and HM 1555 above. N.F.C. **P 586**.

Mycenae NM 389. Limestone, white marble-like. Ht. 24.3. Diam. 15.7. Bowl with flaring quatrefoil mouth, carinated profile and pedestal foot; three horizontal grooves separated by sharp edges round the body at the point of carination; three fluted handles, made separately. Minoan import: (*a*) handles (cf. handles of rhytons, type 34 **A**, and of ewers, type 19, and, closely parallel, the handles of the polychrome clay vases from Isopata, Zervos 1956, pl. 705. A score of such vases, unpainted, with these handles, comes from the Zakro Palace, LM IB); (*b*) fluted grooves (cf. types 13 and 34); (*c*) material (see chapter III, Limestone); (*d*) date. The vase is comparable with HM 2720 above from Zakro. Shaft Grave IV. LH I–IIA (LM I). (Karo 1930–3, pls. CXXXVIII–CXXXIX. Marinatos & Hirmer 1960, pl. 213.)

NM 829. Alabaster, Egyptian. Ht. 14.5. Jar with shoulder handles and moulded base; hole cut for attachment of separate spout; gold leaf round rim, handles and foot. This is an Egyptian XVIIIth Dynasty baggy alabastron reused by the Minoans (cf. HM 2393 from Mallia, above, and HM 2695 and HM 2714, type 43 **A**, from Zakro). It was turned upside-down, the base cut out to form the new mouth, on which was put a bronze fitting covered with gold leaf. The new base (i.e. the original Egyptian mouth) was plugged (this was noticed by Karo, *op. cit.* 147), wooden handles with a gold leaf covering were added, a hole was cut out and tiny holes drilled round it for the separate spout and the band of gold leaf was put round the foot. Like that of the three parallels cited this will have been MM III–LM I workmanship, when the vase was exported to Mycenae. Shaft Grave V. LH I. (Karo 1930–3, I, 147, II, pl. CXXXVII.

NM 3225*. Alabaster, Egyptian. Vase resembling a teapot or coffee jug, with a tall pear-shaped body with rhyton neck (type 34 **B**), handle, rim to shoulder, with horizontal ribbing, tall spout and small pedestal foot. Ht. 29.0. Diam. 12.4. Minoan import: rhyton neck, ribbed handle, pedestal foot (cf. Zakro flask, HM 2728, above, and parallels cited), material and probable context. Chamber Tombs, probably. LH I–II. Context not known. **Total 38**

C. *A. Triadha* HM 110 (Sculpture Catalogue). Calcite, creamy white to pale orange translucent. Vase in form of a sitting monkey, with pendent breasts and hands over belly. Ht. 9.3. Monkeys are well known from Knossos frescoes (Saffron Gatherer, and Blue Monkey from House of the Frescoes). There is a sitting monkey in ivory from the Trapeza Cave, EM III–MM I (J. D. S. Pendlebury *et al.* 1935–6, 97 and pl. 14.) The present piece is thus not more closely datable than EM III–LM II–III A I. From rectangular tomb (with scarab of Queen Tiyi). LM III. (Paribeni 1904, 727–8 and fig. 25 (head only).) **P 587.**

Platanos HM 1894. Limestone, coarse white. Vase in form of a scarab beetle, with circular central cup. Probably made in imitation of the Egyptian scarabs first appearing in Crete at this time. Tholos A annexes. (Xanthoudides 1924, pl. LIV. Zervos 1956, pl. 180.) **P 588.**

Mycenae NM 8538. Rock crystal. Bowl in form of a duck with reversed head. Ht. 5.7. Length 13.2. Probably Minoan. Cf. the extensive use of rock crystal for MM III–LM I vases (see chapter III, Materials tables), and for a reversed duck's head a carnelian seal from Palaikastro (Evans 1901–2, 39, fig. 19). On the other hand its being an Egyptian import cannot be ruled out; the reversed duck's head is typically Egyptian. Cf. *ibid.* fig. 20 for a carnelian seal with a cartouche of Amenhotep III; trussed geese with reversed heads and made of alabaster occur in Egypt (Cairo 88073, Dynasty VI, and four of Middle Kingdom date, Cairo Room 32 Case P) as do wooden bowls with reversed heads, very similar to the Mycenae vase (Cairo Room 34 U). From Perati, Attica (Tomb 12, LH III B–C context) comes a bronze knife with a reversed duck's head handle (Jakovidhes 1954, 96, fig. 6) but it is uncertain whether this is Mycenaean or an import. That the rock crystal vase is of Mycenaean manufacture may be ruled out at this date, MH III. Grave Circle B, Grave O. MH III–? LH I. (Mylonas 1957, pls. 60–1. Marinatos & Hirmer 1960, pl. 212 below.) **Total 3**

Reference may be made here to two Hittite exports to Crete. These are the two serpentine sphinxes, from A. Triadha (HM 384: Paribeni 1904, 749–53, figs. 44–5. Della Seta 1907, 701 sqq. *PM*, III, 420 sqq. and fig. 286. Zervos 1956, pl. 587) and Tylissos (*PM*, III, 425–6, fig. 291).

D. 1. Handles

Knossos KSM (M IV, Box 1242)★. Alabaster, Egyptian. Bow-shaped handle with two pairs of small holes for attachment to vase horizontally. Very finely made. 4.0 × 3.1. Palace, Area of East Slope Fireplaces. MM I, LM I–III associated pottery.

KSM (unprovenienced material)★. Obsidian, black with white spots. Fragment of thick handle. 2.75 × 3.5 × 2.3. N.F.C.

KSM (1957–61): (1) Arched handle with circular section; made separately for attachment to vase; incut at each base and two tiny holes preserved at one end for attachment pins. Marble, blue/grey–pale grey banded. Gypsadhes Tholos. MM III–LM I A (A 3).

(2) Circular section handle, made separately to fit vase; for which one end is grooved. Limestone, white marble-like. Hogarth's Houses. LM I ? A (G ext 15).

(3) Fragment of small handle, made separately for vase. Egyptian alabaster. Royal Road. LM I B–II (C–E 15).

Nine other handles, including one of Egyptian alabaster.

Zakro HM 2779★. Alabaster, Egyptian. Two elegant handles (cf. those of HM 126 group **B** above), made separately to be fitted to vase; incut at top to fit vase, and fine holes for attachment. Ht. 8.85. Diam. 1.02. Palace Shrine Treasury.

HM 2795★. Alabaster, Egyptian. End of large, curving handle, and decorated with horizontal ribbing; pair of holes for attachment and back edge cut to fit vase. Ht. pres. 11.1. Cf. much smaller handles of type 10 **E** bowls, **P 177–8**. **Total 17**

2. Feet

Knossos HM 886. Dolomitic marble, grey and white mottled. Foot ? of large vase, carved with relief scalloped or triple arcade decoration. The pedestal of the vase is not in the centre of the foot and one part of the circumference of the foot is cut out, leaving a lunate space. Ht. pres. 11.9. Diam. 23.6. Original form of vase quite uncertain. Palace, Central Treasury deposit. (*PM*, II, 822, fig. 537*f* and fig. 538.)

Zakro HM 2763★. Alabaster, Egyptian. Foot of same shape as previous, cut out on underside; pedestal not in centre of flaring foot. Ht. pres. 8.4. Diam. 10.65. Palace Shrine Treasury. The find places of both these pieces suggest they had some ritual use.

Total 2

43. EGYPTIAN VASES

There are a number of reasons for including the Egyptian stone vessels imported into Crete. They are part of the assemblage of stone vases in the island; some indeed have been classed as Minoan vases since they were altered and reused in a different way by the Minoans (see types 19 **B** and 42 **B**). Others, classed here, were slightly adapted by the Minoans (**A 3, A 8** below). They are also of fundamental importance for Minoan chronology, especially in the Early Bronze Age (Warren 1965 *b*), and they provide, together with Egyptian alabaster, the best evidence of Egyptian trading patterns with Crete, particularly in the Late Bronze Age (see p. 190). The presence of ten XVIIIth Dynasty vases in a single tomb, the Royal Tomb at Isopata, is a graphic illustration of the intensity of contact between the two countries at this time. Those from the Mainland are also included since, as will become clear, the discussion would be incomplete without them.

There are over thirty vases of Predynastic, Early Dynastic and Old Kingdom date from Crete. The types consist of at least one Predynastic large spheroid bowl and one Predynastic heart-shaped jar, large spheroid, open, high-shouldered and shallow/carinated bowls, one cylindrical jar and various individual vases, all of early Dynastic to VIth Dynasty date.

Several of these, because of their early find contexts in Crete, are basic for Early Minoan chronology. (1) **C1** (see Catalogue below), a fragment of a Ist–IInd Dynasty bowl, is from an EM II context at Knossos; (2) **G4**, a cylindrical pyxis of Chephren diorite, is from the Large Tholos at A. Triadha, EM II–MM IB/II. There are also fragments of three vases from the 'Late Neolithic' houses below the Central Court at Knossos. These however are problematical, since two cannot be traced, the material of the third is not certainly Egyptian, and the Late Neolithic context is not secure. If one accepts the context, for which there is a reasonable case, then the pieces must be Egyptian (at this date) and may be taken with **C1** and **G4** above. These two pieces, **C1** and **G4**, do not give precise correspondences between Egyptian Dynasties and Early Minoan periods but they do demonstrate *by their contexts* links between Crete and Egypt during the island's Early Bronze Age. Further it is reasonable to suppose that the other Predynastic to VIth Dynasty vases (groups **A–G**), from unstratified or later contexts, also reached Crete at about the time of their *floruit* in Egypt. This is a more reasonable assumption than the alternative, that vases made in one period were exported years later in another.[1]

For Late Minoan chronology the Egyptian vases are not so helpful since there does not exist any detailed typological study of XVIIIth Dynasty alabaster vessels in Egypt. But we may note from the table below that the high point in relations with Egypt was MM III–LM IIIA 1, from which time we have twenty-seven alabaster vases. In this period too alabaster was coming to Crete for the production of Minoan vases, and some of the XVIIIth Dynasty alabastrons and early Dynastic heirlooms were being altered and reused.

The distribution in Crete is mainly at Knossos and its environs (59 + 4?) but we also find examples at Arkhanes (1), A. Triadha (2 + 1?), Kalyvia Mesara (2), Khania

[1] This is suggested by Vercoutter (1956, 407–8), who argues that Crete and Egypt were not in contact before *c.* 2200 B.C. My conclusion, that the stone bowls arrived in Crete at about the time of their *floruit* in Egypt, is also reached by W. S. Smith (1965, 10) writing from the Egyptian side and discussing early Egyptian trade.

There are a few Old Kingdom vases in Late Bronze contexts in the Near East, but it is an open question when they arrived there from Egypt. Nothing is against their having come in Old Kingdom times and survived as valuable heirlooms. The vases are from Amarna (Frankfort & Pendlebury 1933, 39, pl. 32 no. 4 left), Beth Shan, Temple of Seti I (Rowe 1940, 18, pl. 52 A 6), Beth Shemesh (Grant 1931, 76, pl. 16; 1932, 35, pl. 47, 3 no. 132; 30, pl. 47, 4 no. 1666) and Tell Beit Mirsin (Albright 1936–7, 56 and pl. 31, 5). I am greatly indebted to Mr Gerald Cadogan for these references.

(1), Mallia (1, adapted, type 42 **B**), Palaikastro (2 + 1 ?), Zakro (3), Central Crete (1 ?). The great importance of Knossos as the commercial capital of the island, with its harbour town of Katsamba, stands out clearly from these figures. From the Knossos area there are nearly twice as many Egyptian vases as from all the rest of Crete and Greece and nearly five times as many as from the rest of Crete.

While the total from Crete is nearly eighty, those from the Mainland number twenty-five (five Predynastic–early Dynastic, twenty XVIIIth Dynasty). The importance of Mycenae, like Knossos, is reflected in the distribution: Argos 1, Asine 1, Dendra 2, Mycenae 16, Nauplion 2, Vapheio 3. But of these twenty-five vases it is highly probable that fourteen came first to Crete and went from there to the Mainland. The vase from Shaft Grave I (type 42 **B**) and the ewer from Chamber Tomb 68 are converted XVIIIth Dynasty alabastrons, like the converted alabastron from Mallia (type 42 **B**). Conversion and adaptation of Egyptian vessels were much in vogue in Crete in M M III–LM I (see **A3**, **A8** below). In the time of Shaft Grave I stone vessels were not being made on the Mainland. For the ewer there are good parallels in Crete. The vases from Mycenae Chamber Tomb 102, Argos, Dendra and Vapheio were all found together with imported Minoan stone vessels and all save those at Dendra in the time of the greatest Minoan overseas influence. The remaining five of the fourteen are the Predynastic–early Dynastic vases from Asine and Mycenae. Two of these (Mycenae Acropolis and House of the Sphinxes) have been altered, just as were two early Dynastic vessels at Zakro (**A3**, **A8** below), which suggests Minoan work on them before they reached the Mainland. The other three (Asine, Mycenae Chamber Tomb 55 and Chamber Tomb 518) are unlikely to have reached the Mainland by direct contact with Egypt in Predynastic and early Dynastic times. We know however (see above) that Crete did have such contacts. Almost certainly the three vases came originally to Crete and were exported to the Mainland along with nearly eighty Minoan (Warren 1967a) stone vases in M M III–LM I.

Table 4 summarises the evidence of find contexts of XVIIIth Dynasty vases in Crete and on the Mainland (see the catalogue groups **H–J**, Crete and Mainland). If my suggestions above are correct it will be seen that the remaining Mainland vases (third column) came directly to Greece at the time of the great Mycenaean overseas expansion, LH III, which is what one would expect.

The vases are classified as Groups **A** to **J**. **A** to **G** are Predynastic to VIth Dynasty, **H** are Middle Kingdom or XVIIIth Dynasty, **I–J** are XVIIIth Dynasty (save **J** Knossos HM 263, Hyksos).

TABLE 4. CHRONOLOGY AND TOTALS OF EGYPTIAN XVIIITH DYNASTY STONE VASES IN THE AEGEAN

Crete		Mainland			Mainland (excluding from Crete)	
MM IIIB	1†	LH I	Shaft Grave 1	1§		
LM IB	3	LH IIA	Vapheio	3§		
LM I?	1	LH II	Mycenae Tomb 102	1§		
			Argos	1§		
LM IB–IIIA	3†					
LM I–III	2	LH I–III	Dendra Tomb 6	1§		
			Mycenae Tomb 68 (type 19 B)	1§		
LM II–IIIA I	11					
LM IIIA I	5					
LM II–III ?B	1†					
LM IIIA 2–B	1	LH IIIB	Mycenae, Shields and Citadel Houses	4	LH IIIB	5
			Dendra Tomb 2	1		
LM IIIB–C	1†	LH III	Nauplion Tombs	2	LH III	2
MM I–LM III, PG	1†	MH–LH III	Mycenae: Atreus and Clytemnestra	2	MH–LH III	2
MM II/III–LM III	1†					
No find context	10‡	No find context		3	No find context	3
	41			20		12

† Knossos Stratigraphic Excavations (1957–61).

‡ 2 are from the Isopata cemetery (LM I–IIIA), 1 from Katsamba (MM III–LM IIIA is the *floruit* of the site) and 1 from Palaikastro.

§ Vases suggested above to have come to the Mainland from Crete.

CRETE

A. Large spheroid bowls with flat collars and usually with horizontally pierced roll handles on the shoulder. Pre-Dynastic to IInd Dynasty.

1. Spheroid bowl, flat collar, two perforated roll handles. Ht. *c.* 13.7. Gabbro. HM 2092. Knossos, unstratified deposit N.W. of Palace. Predynastic. Cf. Petrie & Quibell 1896, pl. VIII 1. For examples from Ist Dynasty contexts, Petrie 1901 *a*, pl. XLIX O 131, U 130, U 132.[1] (*PM*, II, 30, fig. 12; Pendlebury 1930, no. 22.) **D 312. P 589.**

[1] Mr H. S. Smith tells me that one chronological distinction for these bowls is that the globular form with sharp rim is Predynastic, the high-shouldered form with not so clearly cut and defined rim early Dynastic. Hence HM 2092 is Predynastic, as Evans and Pendlebury, *contra* Reisner (1931 *a*), argued.

2. Spheroid bowl, flat collar (not undercut), flat base. Ht. 11.2. Gabbro. AM 1910.201. Knossos, as **1**. Dynasty II, probably (absence of handles and collar no longer undercut). (*PM*, I, 65, fig. 32; Pendlebury 1930, no. 25.) **P 590.**

3. Spheroid bowl, vertically fluted, small raised collar with ribbed decoration, two perforated roll handles, separate ring base to act as support. Originally the bowl had the usual wide, flat collar, which was cut down by the Minoans. From it was made the base ring; the present small collar remaining on the bowl was then given the common MM III–LM I ribbed decoration. This explains the two non-Egyptian features, base ring and ribbed collar. The roll handles were not according to Minoan usage, so holes were drilled vertically through them and looped bronze wires inserted. Cf. **A 8** for adaptation by the Minoans. Ht. 12.0. Porphyritic rock (basalt porphyry, white crystals in brown matrix). An exact parallel for this rare stone is Cairo 11935, from the Ist Dynasty tomb of 'Menes' at Nagadeh. HM 2714. Zakro Treasury. LM IB context. Late Predynastic–Ist Dynasty, because of fluting. Cf. Petrie 1901*a*, pl. XLIX T 129; de Morgan 1896–7, fig. 684. (Platon 1963, pl. 150*b*.) **P 591.**

4. Bowl, flat collar, two solid roll handles, flat base. Ht. 18.35. Diorite. HM 2410. Katsamba, Tomb of the Blue Bier. LM IIIA I. IIIrd Dynasty, because of solid handles. (Hutchinson 1954*b*, pl. VIII.) **D 313.**

5. Fragment of large bowl, type as no. **1** ? Diorite, speckled? Knossos, Late Neolithic house, upper level.[1] Predynastic–Dynasty II (if Egyptian). (*PM*, II, 16 and fig. 7 A.)

6. Body fragment of spheroid bowl. Ht. pres. 6.6. Gabbro, dark green hornblende matrix with splodgy white feldspar crystals. KSM (Unprovenienced material)★. N.F.C. Late Predynastic–early Dynastic. Type probably as HM 2092.

7. Spheroid bowl, flat collar, two solid roll handles, flat base. Ht. 11.4. Syenite. HM 56. Knossos South Propylaeum. N.F.C. Probably IIIrd Dynasty because of solid handles. (*PM*, I, 65, fig. 28; Pendlebury 1930, no. 26; Warren forthcoming.) **D 314. P 592.**

8. Bowl, undercut collar, roll handles originally, cut off in Minoan adaptation. After removing the Egyptian handles the Minoans drilled holes through the walls of the bowl for the attachment of their own handles or for bronze wire handles (as **A 3**) but these do not survive. A separately made spout was also added, with pieces cut out of it to receive inlays, in imitation of the scattered crystals of the vase itself. Ht. 16.45. Porphyritic rock, white crystals in brown matrix (as **A 3**). HM 2695. Zakro Palace Treasury. LM IB context. Ist–IIIrd Dynasties. (Platon 1964*b*, fig. 9.) **P 593.**

9. Body fragment of spheroid bowl; small hole drilled through wall, perhaps for fitting handle. 4.5 × 4.0. Porphyritic rock, black matrix with large grey-white crystals (material as **G 2**). KSM (1957–61). Knossos, Royal Road. LM IA (LA 78). Predynastic–early Dynastic.

10. Body fragment of thick-walled bowl. 5.1 × 2.1. Marble ??, dark maroon with pale yellow/green vein. AM 1938.653. Knossos, Late Neolithic house, upper level, i.e. probably EM I context

[1] The upper level of this house almost certainly belongs to the beginning of EM I for the pottery includes a typical Pyrgos chalice (*PM*, II, fig. 4) and a carinated bowl with raised collar and bridge-spout (*ibid.* fig. 3 *x*). The shape of the latter bowl (but not the spout) is frequent in A. Onouphrios ware. It should be noted however that the flimsy remains of this stratum (*PM*, II, fig. 8 A) were almost level with the Central Court. Cf. J. D. Evans 1964, 184, 188, where the houses were shown stratigraphically to belong to the latest stratum, I, which contained Minoan as well as Neolithic pottery. The stone vase fragments from the house might be Minoan pieces, perhaps even from the Palace destruction debris (nos. **A 5** and **A 10**; **5** has not been traced by the writer and all that can be said of **10** is that the stone is not otherwise used by the Minoans, though it might easily be a Cretan serpentine).

(see **A 5** above). Possibly not Egyptian (? no parallels for material). If from Egypt, Late Pre-dynastic–Early Dynastic. (*PM*, II, 16–17, fig. 7*c*.)

B. Heart-shaped jar. Predynastic and ? Early Dynastic.

1. Heart-shaped jar, two perforated handles on shoulder. Ht. 9.45. Basalt. HM 911. Palaikastro, Block X hoard. LM IB context. Late Predynastic. Cf. exactly Brunton 1937, 99 and pl. XLII 11 (BM Egyptian 63091, **P 405**). (Dawkins 1923, pl. XXX C 1. Warren forthcoming.) **D 315. P 594.**

2. Fragment of upper part of similar jar, no handles. Ht. pres. 5.7. Porphyritic rock. AM un-registered 8★. Knossos (probably, Evans Bequest 1941). Late Predynastic–IInd Dynasty.

3. Jar, slightly undercut collar, moulded base, no bottom. This strange vase has a typically Egyptian collar (see type 28, HM 1665) but the carved base is not Egyptian. The material does not seem to be Cretan and as the vase has the general form of the Egyptian heart-shaped jar it may well be Egyptian, the base probably carved by the Minoans. Ht. 11.3. Hard green/yellow stone with network of black veins. AM AE 384★. Central Crete. Early Dynastic? **D 316. P 595.**

C. Early Dynastic deep open bowls

1. Rim/body fragment of open bowl. Ht. pres. 4.4. Diorite. KSM box 788, H 1 2★. EM deposit on South Front of Palace, first room. Pottery context EM II (with 2 MM I sherds). Ist–IInd Dynasties. Cf. Emery 1961, 218 no. 72; Petrie 1937, pl. XVI 182, 213, 215, 218; XVII, 239, 243. (Warren forthcoming.) **D 317.**

2. Rim fragment of deep bowl. Ht. pres. 5.55. Diorite. AM unregistered 9★. Knossos (probably, Evans Bequest 1941). Ist–IIIrd Dynasties. A typical early Dynastic form. Cf. Emery 1961, 218 no. 88. **D 318.**

3. Body fragment of bowl, probably deep open. 5.3 × 4.3. Porphyritic rock, black matrix with sparsely scattered white crystals. AM unregistered 20 (given by Evans 1937–8). Knossos, unstratified deposit N.W. of Palace. Early Dynastic. (Mentioned *PM*, II, 30.)

4. Base fragment of bowl, with internal base ring. Ht. pres. 1.95. Gabbro. AM 1938.408. Knossos, unstratified deposit N.W. of Palace. Ist–IInd Dynasties. The internal base ring is a typical early Dynastic feature (see Petrie 1937, Emery 1961, 218 nos. 72 and 83 for examples). (*PM*, II, 30–1, fig. 28.) **D 319.**

5. Lower part of bowl with slightly raised base. Gabbro. Knossos, unstratified deposit N.W. of Palace. Predynastic–early Dynastic (not seen by the writer). (*PM*, II, 30, mentioned.)

6. Body fragment of open bowl. 3.35 × 3.25. Diorite, Chephren variety. AM 1938.409 *b*★. Knossos. N.F.C. Ist–IVth Dynasties.

D. Bowls, high-shouldered with small undercut collar. Mainly Dynasties III–IV.

1. Bowl, undercut collar. Ht. 11.5. Diorite. HM 2883. Katsamba Tomb H. LM IIIA 1. IIIrd–IVth Dynasties. This type is common in the IIIrd–IVth Dynasties, succeeding the earlier spheroid bowl with roll handles. Cf. Lacau & Lauer 1959, pl. II 1; Firth, Quibell & Lauer 1935, pl. 104 B 22, for IIIrd Dynasty; Reisner 1931*b*, 187, 45, for IVth Dynasty. See also Emery 1958, pl. 36 z 9 for a Ist Dynasty example and Emery 1949, 145 for the IIIrd–IVth Dynasty *floruit*. (Ἔργον 1963, 183, fig. 192.) **D 320. P 596.**

2. Bowl, type as **D 1** but lower, and mouth wider in proportion. Ht. 6.7. Marble, white. HM unnumbered (Katsamba 1957)★. Katsamba, MM IIB–LM I A. IIIrd–IVth Dynasties. (Mentioned Platon 1957, 336.) **D 321. P 597.**

3. HM 3050★. Bowl, type as **D 1–2**; slightly moulded base. Ht. 11.9. Diorite, white and green/black mottled. Arkhanes, Rectangular Tomb with Child Burials. LM ? I. Early Dynastic. (Ἔργον 1966, 141. Sakellarakis 1967, 279 fig. 8 top centre.)

4. Bowl, type as **D 1** though smaller. Ht. pres. 3.95. Diorite. HM unnumbered. Knossos, Isopata Royal Tomb. LM II–III A I. IIIrd–IVth Dynasties. (Evans 1905, 541, figs. 123 and 128; Pendlebury 1930, no. 31.)

5. Bowl, type as **D 2** but a miniature form. Ht. 1.7. Porphyritic rock, black matrix, white crystals with fine green veins. HM 391. Might be Egyptian because of material and shape, or Minoan, though true porphyritic rock is not known in Crete and it is very doubtful if such undercutting could have been achieved in MM I–II which, because of its tiny size, would probably be the vase's date of manufacture. A. Triadha. LM I. Egyptian date? (Halbherr 1903, 64 no. 9.) **P 598.**

E. Shallow, carinated, open bowls. Dynasties IV–VI.

1. Open, shallow, carinated bowl. Ht. *c.* 4.3. Diorite, Chephren variety. HM 590. Knossos, in south wall of 'Room of False Spouted Vessels', S.E. part of Palace. MM III. IVth–VIth Dynasties. See type 30 **C** and the publications for references. (Evans 1901–2, 121–3; *PM*, I, 85–6, fig. 55 b; Pendlebury 1930, no. 27.) **D 322. P 599.**

2–5. Fragments of four bowls★, type and material as **E 1**. Hts. pres. 3.2, 1.9, 1.5, and a body fragment 4.1 × 3.4. **2.** AM 1938.583. **D 323. 3.** AM 1910.283. **4.** AM 1938.409 a. **5.** AM unregistered 2. Knossos, N.F.C. IVth–VIth Dynasties. (Cf. *PM*, I 85–6.)

F. Cylindrical jar with everted rim and base. Dynasty VI.

Cylindrical jar with everted rim and base. Ht. 10.08. Alabaster. HM 128. Knossos, N.W. part of Palace site. Hogarth's Excavations. N.F.C. VIth Dynasty. See type 30 **D**. (*PM*, IV, 123–4 (called a IVth Dynasty type; not clearly said to be Egyptian). Warren 1965 b.) **D 324. P 600.**

G. Individual vases. Predynastic to Dynasty VI.

1. Block vase with five cylindrical cups in a row. Length 24.4. Serpentine or chlorite ?, soft heavy stone. Knossos, Temple Tomb. MM III B. HM 2276. Very possibly Egyptian Predynastic, though the type is rare in Egypt. This vase is not closely related to the Minoan block vases (type 4). (*PM*, IV, 978–82, figs. 939 and 953.) **P 601.**

2. Large carinated bowl. Ht. 13.25. Porphyritic rock.[1] HM 611. Knossos, Isopata Royal Tomb. LM II–III A I. Early Dynastic. (Evans 1905, 536 and figs. 123 s 1, and 124.) **D 325. P 602.**

3. 'Moustache Cup.' Ht. pres. 5.3. Diorite, Chephren variety. HM 2170. Knossos, unstratified deposit N.W. of Palace. IVth Dynasty. (*PM*, II, 57–8, fig. 27 B. Pendlebury 1930, no. 28.) **D 326. P 603.**

4. Cylindrical pyxis. Ht. 4.3. Diorite, Chephren variety. HM 666. A. Triadha Large Tholos. EM II–MM I B/II context. Not recognised as Egyptian and published as marble. An exact shape parallel, in red and white breccia, is Cairo 18419 (Room 49, Case κ), undated. The diorite vase

[1] In the writer's view this is an Egyptian vase. It is not made of Spartan basalt, lapis Lacedaemonius, as Evans stated (1905, 536), but of a quite different and typically Egyptian porphyritic rock with large white crystals in an almost black matrix. Cairo 4844, 88288, 6056 are of exactly this stone. There do not seem to be shape parallels but Mr Geoffrey Martin tells me that vase hieroglyphs of this form are known. The vase has no Cretan connexions whatever and it is not, as Evans suggested it was, derived or related to the form of group **E**.

is presumably VIth Dynasty or earlier. See discussion above. (Banti 1930–1, 182, fig. 46. Warren forthcoming.) **D 327. P 604.**

5. Fragment of flat dish with trough spout. Ht. 8.7. Granite, grey/black with pink vein. AM 1924.38*. Knossos. N.F.C. Presumably Egyptian because of its material (sometimes used for statues in Egypt, e.g. one of Horus, Cairo 12001 (Gallery 13, lower floor)). Probably Predynastic or early Dynastic because of material.

6. Base fragment of small cylinder jar. 'Limestone' (? alabaster). Knossos, Late Neolithic house, lower level. Context apparently end of Late Neolithic (but cf. above on **A** 5). Predynastic–early Dynastic (if Egyptian). (*PM*, II, 15–16, fig. 6.)

H. Middle Kingdom or XVIIIth Dynasty globular alabastrons. All alabaster.

Kalyvia Mesara HM 176. LM I–III tomb. (Savignoni 1904, 555 and fig. 39.)

Knossos HM 48. Central Treasury. LM II–III A I. (*PM*, II, 823–4 and fig. 537 *k*.) **P 605.**

Zakro HM 2736*. Shrine Treasury. LM I B. Ostrich egg shape. Hole drilled in base by Minoans for use as rhyton.

For the form compare Cairo 18719 (de Morgan 1895, 37, fig. 78) from Dahchour, Middle Kingdom; Cairo 47771, from Sakkara Tomb 129 A, Middle Kingdom; from the Tomb of Rensenb, Hyksos Period (*J.E.A.* XVI, 1930, pl. XXXIX 5); from the Tomb of Amenhotep I, XVIIIth Dynasty, *c.* 1546–1526 B.C. (*J.E.A.* III, 1916, 152 and pl. XXI 12); Cairo 41359, from Abydos Tomb 1043, XVIIIth Dynasty, time of Tuthmoses III.

I. XVIIIth Dynasty (and Second Intermediate Period) baggy, flat-bottomed alabastrons.

For the form see under Pendlebury 1930, no. 33 and following. Also, from the Tomb of Amenhotep I, as above, pl. XXII 1–4; Cairo 66206 (large form), from the Tomb of Ramose and Hatnufer, XVIIIth Dynasty, time of Tuthmoses III; Cairo 65371, from Deir el Bahari, XVIIIth Dynasty; Cairo 62165, 62167, from the Tomb of Tutankhamun. The Cretan imports range from small squat examples to the huge vessel from Kalyvia. All are alabaster save HM 502 from Palaikastro.

In addition to these imports there are three more XVIIIth Dynasty alabastrons (not included in the type total) which were converted into elaborate Minoan vases (see type 19 **B**, NM 3080; type 42 **B**, HM 2393 and NM 829).

A. Triadha HM 343. Ht. 20.2. Palace. LM I. (Halbherr 1903, 62–3 and fig. 48. Pendlebury 1930, no. 9.) **P 606.**

Kalyvia Mesara HM 175. Ht. 46.0. LM I–III tomb. (Savignoni 1904, 554, fig. 38. Pendlebury 1930, no. 19.) **P 607.**

Knossos HM 47. Ht. 24.2. Central Treasury. (*PM*, II, fig. 537*j*.) **P 608.**

HM 601. Ht. 18.85. Isopata Royal Tomb. LM II–III A I. (Evans 1905, fig. 125 S 3. Pendlebury 1930, no. 33.) **P 609.**

HM 602. Ht. 10.15. As last. (Evans, fig. 125 S 4. Pendlebury 1930, no. 34.) **P 610.**

HM 603. Ht. 7.4. As last. (Evans, fig. 125 S 5. Pendlebury 1930, no. 35.) **P 611.**

HM 604. Ht. 5.2. As last. (Evans, fig. 125 S 6. Pendlebury, no. 36.) **P 612.**

HM 606. Ht. 10.1. As last. (Evans, fig. 125 S 10. Pendlebury, no. 38.) **P 613.**

HM 1583. Ht. 11.1. Isopata. N.F.C. (Evans 1914, fig. 3. Pendlebury, no. 46.) (Another part of this vase is in Knossos Strat. Mus. Box T 1 *i*.) **P 614.**

HM 1584. Ht. pres. 10.8. As last. N.F.C. (Evans 1914, fig. 4.)

HM 2142*. Ht. 16.25. Mavro Spelio Tomb VII. MM II/III–LM III. **P 615.**

KSM (1957–61), fragments of 7 baggy alabastrons, all alabaster, including one from an MM IIIB context (Hogarth's Houses, D 5).

This example is the earliest dated in Crete. There are fragments of 4 more alabastrons in KSM, all N.F.C.

Palaikastro HM unnumbered*. Ht. pres. 14.75. Block O. Probably LM I.

HM 502*. Ht. pres. 26.1. Diam. 20.5. Very hard stone, pale yellow/green with black massed crystals scattered all through; possibly diorite. Not a Cretan stone and as the shape is Egyptian the vase may well be an import. A very fine piece. N.F.C. **P 616.**

Khania Khania M. 1009*. Ht. 10.7. Museum catalogue says 'Selinon 1899' but vase almost certainly from Khania LM IIIA 2–B tombs since it is with all this material and is probably the 'Alabasterschale' mentioned by Jantzen (1951, 77). Cf. HM 602 above for the shape.

J. Individual Hyksos (HM 263) and XVIIIth Dynasty alabaster vases

Katsamba HM 2409. Ht. 29.8. Ovoid vase on pedestal foot, with cartouche of Tuthmoses III. Tomb of the Blue Bier. LM IIIA 1. (Alexiou 1952, fig. 1. Hutchinson 1954b, pl. IX; 1962, fig. 50.)

HM 2411. Ht. 11.1. Globular bowl with moulded base and two wedge-shaped handles on the shoulder. Probably Egyptian rather than Minoan vase in Egyptian alabaster. Tomb as last. (Hutchinson 1954b, pl. VIII.)

HM 2171. Vase in the shape of a kneeling pregnant woman, with a Minoan hole in the bottom for use as a rhyton. N.F.C. (*PM*, II, 256, fig. 150.) To be added to Evans' parallels is another in Cairo, 18421, XVIIIth Dynasty.

Knossos HM 263. Lid with cartouche of Hyksos king Khyan. MM III. (*PM*, I, 419, fig. 304b. Pendlebury 1930, no. 30.)

HM 46. Large jar with two vertical handles on the body. Cf. HM 2409. Central Treasury. (*PM*, II, fig. 537m.) **P 617.** There are other examples of the type in Cairo, Room 49, Case I.

HM 600. Jug. Isopata Royal Tomb. (Evans 1905, fig. 125 S 2. Pendlebury 1930 no. 32.) **P 618.** Close parallels are Cairo 33778 (Maherpra), 62143–4 (Thebes, Tombs of the Kings), all XVIIIth Dynasty.

HM 605. Pot with cylindrical neck and everted rim. As last. (Evans, 1905, fig. 125 S 9. Pendlebury 1930, no. 37.) **P 619.**

HM 607. Pot, globular, cylindrical neck, pedestal foot. As last. (Evans, 1905, fig. 125 S 8. Pendlebury 1930, no. 39.) **P 620.** Cf. exactly Cairo 56401, Sakkara, late XVIIIth Dynasty.

HM 608. Open bowl with moulded base. As last. (Evans, 1905, fig. 125 S 11. Pendlebury 1930, no. 40.) **P 621.** Cf. Cairo 31736 (from Mahasna ?).

HM 609. Bowl similar to last. As last. (Evans, 1905, fig. 125 S 13. Pendlebury 1930, no. 41.) **P 622.**

HM 2403. Hydria with small cylindrical neck and handle on shoulder. Hole drilled in base by Minoans for use as rhyton. The material is Egyptian alabaster but the shape is Syro-Palestinian. A remarkable clay parallel painted with dolphins entirely Minoan in style comes from Lisht in Egypt. It is dated to the Second Intermediate Period and links with Middle Bronze IIB in Syria. See Kantor 1954, fig. 4, where the Palestinian import is drawn together with three parallels, one from Megiddo, two from Jericho. With regard to the present alabaster vase the only unresolved question is whether it is actually Syro-Palestinian or Egyptian, made in the Second Intermediate Period in imitation of the Syro-Palestinian shape. The vase provides a second most important cross-link for Crete, Egypt and Syria/Palestine in the Second Intermediate Period, after the Lisht jug, and strengthens the meagre cross-links between Egypt and Crete in this period, first established by the lid of Khyan. LM IIB tomb near the Temple Tomb. (Hutchinson 1956a, 68, 71, fig. 2, 18 and pl. 7e.) **P 623.**

HM 108 (Sculpture catalogue)*, HM 179 (Sculpture)*, fragments of two thick handles of Egyptian alabaster. N.F.C. **Total 77**

MAINLAND

B. Heart-shaped jar

Mycenae NM (Mycenaean Room, Case 2)*. Heart-shaped jar; two horizontal pierced lugs on shoulder. Diorite, black speckled with white. Ht. 14.8. Chamber Tomb 55. LH. (Mentioned Evans, *PM*, II, 31 n. 1.) Predynastic, cf. group **B** above. This fine vase is, with **A 1** and **B 1**, the oldest import into the Aegean world. **Total 1**

D. Bowls, high-shouldered with small undercut collar

Asine High-shouldered bowl with small collar, not undercut, and two pierced handles on shoulder; slightly moulded base. Porphyritic rock, white crystals in dark matrix. Ht. 13.5. Tomb 1, 2. LH II–III. (Pendlebury 1930, no. 149. Frödin & Persson 1938, 377 and fig. 247.) Early Dynastic (probably III–IV), cf. **D 1** above.

Mycenae NM 2778*. High-shouldered bowl. Ht. 14.0. Gabbro (or perhaps diorite), hard, grey/black/brown with white massed crystals. Rope or coil mouldings carved round edge of rim; three pairs of holes on rim near mouth for addition of separate handles. This is presumably a Minoan adaptation (cf. type 42 **B** Mallia and Mycenae; and above, **A 3** and **A 8**). Mycenae Acropolis (1886). N.F.C.
NM. Rim fragment of bowl with small, slightly undercut collar. Porphyritic rock, white crystals in black matrix. Width 5.5. Tomb 515. LH I–IIIA. (Pendlebury 1930, no. 97. Wace 1932, 84 and 223.) Early Dynastic I–IV.
Nauplion M. 11505. Rim/body fragment of high-shouldered bowl. Three shallow grooves cut round flat collar; this is a Minoan adaptation, for which cf. exactly type 30 **A**, HM 1091. Gabbro, grey/white,

black, green/black, splodgy. Ht. pres. 7.4. House of the Sphinxes. LH IIIB. (Wace 1956, 116 and pl. 24 *b* lower left.) Ist–IVth Dynasties. **Total 4**

I. XVIIIth Dynasty (and Second Intermediate Period) baggy, flat-bottomed alabastrons

Argos NM 3336. Diam. 14.0. Heraion Tholos. LH II. (Wace 1921–3, 336 no. 59. Pendlebury 1930, no. 104.)
Dendra NM. Ht. 19.0. Tomb 2. LH IIIB. Persson 1931, 101 and fig. 79. For shape cf. HM 603 above.
NM. Ht. pres. 14.0. Tomb 6. LH I–III. (Persson 1942, 24 and fig. 27.)
Mycenae NM. Earth in front of doorway of Treasury of Atreus. (Wace 1921–3, 356. Pendlebury 1930, no. 99.)
NM. Earth in doorway and dromos of Tomb of Clytemnestra. LH I–III. (Wace 1921–3, 367. Pendlebury 1930, no. 100.)
NM 6251. Ht. 30.0. N.F.C. This is probably Pendlebury 1930, no. 101.
Nauplion M. 12359 (53–162)*. Ht. approx. 13.4. House of the Shields. LH IIIB. Cf. HM 47 above.
Nauplion M. 12356 (53–787)*. Body fragment. 8.8 × 3.1. House of the Shields. LH IIIB. From large alabastron.
Nauplion M. unnumbered (59–230)*. Ht. pres. 2.5. Rim fragment. Citadel House. LH IIIB.
Nauplion M. unnumbered (64–774)*. Body fragment. 5.55 × 3.15. Citadel House. LH IIIB.
Nauplion NM 3523*. Ht. 7.7. LH III tombs. Cf. HM 602, HM 1583 above.
Vapheio NM 1851 (probably)*. Fragment. Width *c.* 7.0. Tholos. LH IIA.
NM 1889. Elongated, elliptical in section. Ht. 18.7. Tholos. LH IIA. (Tsountas 1889, 153–4 and pl. VII. Pendlebury 1930, no. 72.)
NM 1890. Ht. 12.0. Tholos LH IIA. (Tsountas, *op. cit.*; Pendlebury 1930, no. 74.) Cf. HM 601–2 above. **Total 14**

J. Individual XVIIIth Dynasty alabaster vases. In addition to the four individual alabaster vases cited here we must note two Minoan conversions of XVIIIth Dynasty alabastrons, the ewer (type 19 **B**, NM 3080) and the vase from Shaft Grave I (type 42 **B**, NM 829), both from Mycenae.

Mycenae NM 3225 ? Amphora, with two handles joining the neck. Ht. 27.0. N.F.C. (Pendlebury 1930, no. 102.) Not found by the writer. (Pendlebury calls it no. 3225, but this is the number of a vase, type 42 **B** Mycenae, which is not an amphora with two handles joining neck.)

NM 4923. Jug with globular body, cylindrical neck, strap handle passing round neck in two prongs. Ht. 18.0. approx. Tomb. 102. LH II. (Bosanquet 1904, 325–6 and pl. XIV e. Pendlebury 1930 no. 98 (N.B. it is *not* NM 6252).) Mid-XVIIIth Dynasty (Tuthmoses III, Amenophis II). Cf. HM 600 above.

NM 6252*. Jug, body fragment. Ht. of vase 30.8 approx. Type as HM 600, NM 4923. N.F.C.

Nauplion NM 3524 BIS*. Low cylindrical bowl on small foot; everted rim, raised band round centre of body and another above base. Ht. 5.15. XVIIIth Dynasty. Cf. Ben-Dor 1945, shape E, types I–III. Its form is quite distinct from my type 44.　　**Total 4**

Grand total 23

44. SYRO-PALESTINIAN FOOTED CUP

This vase, a cylindrical bowl on a raised foot, with projecting bands round the body, is made of gypsum and is one of a common class of Syro-Palestinian vases in vogue in the fourteenth and thirteenth centuries B.C. On these vases and on how they differ from Egyptian alabaster vases of similar types (e.g. type 43 **J**, Nauplion) see Ben-Dor (1945). Our vase is of Ben-Dor's shape E, type 4. It thus provides, like the Tripod Mortars and possibly the hydria (type 43 **J** Knossos), an important cross-link with the Syro-Palestinian region in the Late Bronze Age.

Knossos HM 2283. Ht. 6.0. Diam. 8.25. Gypsum, white. Temple Tomb. LM III A I. (*PM*, IV, 1006, figs. 953, 958 and 960 *i*.) **P 624.**

Total 1

45. SYRO-PALESTINIAN TRIPOD MORTARS

It has recently been argued by H.-G. Buchholz in a fundamental article (1963) that the stone tripod mortars found in Crete are Syro-Palestinian imports. About 150 are listed by Buchholz from the Syro-Palestinian region; Cyprus was a centre of manufacture of the form with incised decoration, while it seems that those with a trough spout are an Aegean variety. The extensive Syro-Palestinian distribution does suggest that the twenty from Crete are imports. There are however several points that give pause. The material of most of the Cretan mortars is altered igneous lava (lightish grey with tiny black and sometimes white crystals) of trachytic

composition. It is indistinguishable in appearance from the material of a quernstone, examined in Athens.[1] Such a common object as a quern is most unlikely to have been imported into Crete. Moreover the occurrence of altered igneous lava in Crete has been determined by M. Dialinas (see chapter III, Trachyte). It has not however been shown that this is the material of the tripod mortars. But we must note that three mortars, from Gournia, Khondhros and E. Crete, are spouted, i.e. belong to Buchholz' Aegean variety, and are made of trachyte. Another, probably from A. Triadha, is made of serpentine. It could thus easily be Cretan, though serpentine is not of course restricted to Crete. Another, from Palaikastro, is made of limestone, so that it too could easily be Cretan. One other vase, a bowl from Tylissos (type 32 **E**), is made of trachyte. Only the question of material is against its being Minoan.

Whether then the mortars in Crete are imports or local products is not yet finally resolved. At present the weight of evidence seems in favour of Buchholz' view that they are imports.

In Crete the mortars were used with pestles or stone pounders for grinding, the trachyte providing a good abrasive surface. There is no evidence of their use for powdering of substances for ritual decoration of the body, a usage which Buchholz finds for the eastern examples (1963, 62–7).

The known contexts are LM I, save that from Khondhros and two fragments from Knossos. The material is trachyte unless otherwise stated. The A. Triadha?, Knossos 1957–61, Palaikastro and E. Crete vases are additional to those in Buchholz. It may also be noted that there are fragments of four from Kea, of which two are made of trachyte.

A. Triadha HM unnumbered*. Serpentine. Ht. 11.1. In HM Apotheke with material probably from A. Triadha. N.F.C.

Gournia HM 99. Ht. 8.0. (Boyd Hawes 1908, pl. III 46.) **P 625.**
 HM 402. Ht. 22.0. (*Ibid.* pl. III 64.)
 HM 403. Ht. 16.0. (*Ibid.* pl. III 65.) Penn. MS. Ht. 14.2. (*Ibid.* pl. III 66.)
 HM 404*. Ht. 13.0. HM unnumbered*. Ht. 18.8. Trough spout. With Gournia material in HM Apotheke. Published ones, LM I context, others very probably from LM I town.

Khondhros Kephala HM unnumbered. Diam. 25.0. LM IIIA–B. Probably a survival from MM III–LM I. (Platon 1957*b*, 143 and pl. 70*b* lower row centre.)

Knossos KSM (1957–61), fragments of three*, from contexts not earlier than LM I (LM I?A, LM IIIA 2–B/C, LM I–III).

Mallia HM? Ht. 11.5. Palace Quartier XII. (Chapouthier and Demargne 1942, pl. LIV 4.)

[1] A specimen from a quern from Palaikastro was examined by Professor J. Papastamatiou. It was igneous lava with much biotite (the typical dark mineral of trachytes, Kemp 1961, revised, 67) and some epidote. The rock is usually called trachyte in publications and as its composition is trachytic it is best to retain the name. It is possible that Buchholz' basalt is what is here termed trachyte.

TYPES: SYRO-PALESTINIAN TRIPOD MORTARS

HM 2322. Ht. 14.0. House Db. (Demargne and de Santerre 1953, 59 and pl. XXIX.)

HM 2422. Ht. 12.5. House Zb. (Deshayes and Dessenne 1959, 63 and pl. XIX.) All from LM I contexts.

Nirou Khani HM 2082. Ht. 18.1. (Xanthoudides 1922, 14 and fig. 11.)

Palaikastro HM 939*. Ht. 9.9. N.F.C. **D 328. P 626.**

HM 940* (probably). Ht. 22.4. Limestone, soft greenish grey. N.F.C.

KSM (PK/62/55). Block N. (Sackett, Popham & Warren 1965, 307 no. 59 and fig. 22 and pl. 79f.)

E. Crete Hierapetra M. 397*, 398*. Hts. 9.2, 9.5.

HM 398 has a cutting in the rim to serve as a spout; it also has a pestle. Both N.F.C.

Total 20

TABLE 5. SITE LIST FOR THE DISTRIBUTION OF TYPES

(Figures in italics indicate the number of vases of a type.)

A. Eirene	3 A *1*
Akhladhia	5 *2*
A. Marina	4 C *1*
Ambelos	5 *1*
Amnisos	10 B *1*; 14 *1*; 24 II A I *1*
Anatole	26 8 *1*
A. Nikolaos	6 A I *1*
A. Onouphrios	8 C *1*; 27 I B *1*, I C *1*
Apesokari	I A *1*; 3 A *14*; 6 A I *1*; 8 F *1*; 20 A *2*, B *1*; 21 A *2*; 27 I B *1*; 32 A *3*
A. Photia	8 B *1*; 20 B *1*
Apodhoulou	18 B *1*; 26 I *1*; 27 II A *1*
Arkhanes: Juktas	23 B *3*
Troullos	5 *1*; 23 B *1*
Town	3 A *1*; 26 I *1*; 37 D *1*
Cemetery	8 J *1*; 17 E *1*; 34 B I *1*
Arvi	3 A *1*; 6 A I *1*; 7 B *1*; 8 C *1*, D *1*; 18 A *2*; 26 5 *1*; 27 I A *1*, I B *2*
A. Triadha: Tholoi	I A *2*; 3 A *8*; 6 B 2 *1*; 7 A *1*; 8 A *1*, C *9*, G *1*, J *1*; 10 C *2*; 17 A *1*, C *1*; 20 A *1*, B *2*; 21 A *1*; 22 D *1*; 27 I A *2*, I B *3*, I C *1*; 28 *3*; 29 A *2*; 30 D *5*; 31 A *1*; 32 A *3*; 33 A *1*, D *1*; 36 A *1*, C *3*; 37 A *3*; 41 *2*
Palace	2 *1*; 3 A *1*; 4 A *1*?; 8 K *1*; 15 *1*; 17 E *1*; 21 B *1*; 22 C *1*; 24 II A I *1*, II A 2 *1*, II A 7 *1*, II B *10*, II C *1*?; 25 *1*; 30 A *5*; 34 A *4*, C *1*; 35 *1*; 39 *2*; 42 B *2*
LM Tombs	II B *1*; 28 *1*; 42 C *1*
N.F.C.	4 E *1*; 5 *2*; 14 *1*; 17 A *1*; 21 A *1*; 23 A *1*; 24 II A 2 *2*; 27 II A *1*; 31 A *2*; 33 B *1*, C *1*; 34 A *1*
Avdhou	25 *1*
Dhamania	5 *1*
Dhrakones	3 A *2*; 4 C *2*, D *2*; 7 A *1*; 8 G *1*; 18 A *1*
Dreros	26 5 *1*; 33 F *1*

117

TABLE 5 (*cont.*)

Elounda	I A *1*; 3 A *2*, B *1*; 5 *4*; 8 D *1*; I2 *1*; 2I A *1*; 30 A *1*
Episkope Pedhiadha	5 *1*; 6 A 2 *1*; 8 C *1*
Galana Kharakia	3 A *12*; 4 C *2*, E *1*; 5 *3*; 6 A I *9*, A 2 *2*, B I *2*, B 2 *1*; 7 A *2*, B *6*; 8 C *5*, G *2*, H *1*; 9 A *2*, B *1*; IO A *1*, B *4*; I7 B *2*, D *1*; I8 A *2*; 20 B *3*; 27 I A *7*, I B *12*; 3I A *3*; 37 B *1*
Gavdhos	22 A *1*?; 24 V *1*?
Gortyn (including Kannia)	3 A *2*; 26 I *1*, 3 *1*
Gournes	5 *1*; 6 A 2 *1*, B I *1*; 9 B *1*; 27 I A *1*; 30 A *1*; 37 D *1*; 42 B *1*
Gournia: Town	4 A *1*; 5 *3*; 7 B *1*; 9 A *1*; IO B *1*; II A *1*; I4 *1*; 22 D *1*; 24 II A I *1*, II A I3 *4*, II C *1*, IV *1*; 26 I *1*, 5 *2*, 7 A *1*, 7 B *1*; 34 A *1*; 37 B *1*, D *1*; 38 B *1*; 40 *1*; 4I *1*
Tombs.	I A *1*; 3 A *2*; 4 E *1*; 8 C *1*, J *1*?; I2 *1*; 22 A *2*; 42 B *1*
N.F.C.	I A *1*; 3 A *20*; 5 *5*; 6 A I *1*, A 2 *2*, B 2 *1*, C *1*; 7 B *1*, C *1*; 9 A *2*; I4 *1*; I8 A *1*; 20 B *1*; 24 II A I *3*, II A 7 *1*, II A 9 *2*, II B *1*, II C *1*, IV *1*; 26 I *2*; 27 I A *11*, I B *14*, I C *3*; 3I C *1*; 36 C *1*; 38 B *1*; 40 *4*; 4I *1*; 42 A *1*
Inatos	26 I *1*
Itanos	3 A *1*; 5 *1*; 33 A *1*
Kalamaphka	4 A *1*
Kalo Khorio	3 A *1*; 5 *2*
Kalyvia Mesara	3 A *1*; I7 B *1*; 24 II A I *1*, II B *1*; 27 I B *1*; 28 *1*; 30 B *1*; 35 *1*
Kalyvia Monophatsiou	37 C *1*
Kalyviane	I A *1*
Kamilari	I A *4*; 3 A *33*, B *1*; 6 B 2 *2*, C *1*; 7 A *1*; 8 F *1*; 9 A *1*; IO A *1*, C *1*; I7 D *1*; I8 A *2*; 20 A *4*, B *14*; 2I A *2*; 22 B *1*; 26 I *1*; 27 I A *5*, I C *2*; 30 D *1*; 32 A *3*
Karnari	I5 *1*
Karphi	8 C *3*, D *1*; I7 B *1*; I8 A *1*; 27 I B *2*, I C *10*, II B *1*; 32 D *1*; 37 B *1*
Karteros Mapheze	9 A *1*; 27 II C *1*; 3I C *1*
Kastellos Lasithi	3 A *1*; 5 *1*?; IO B *3*; I4 *2*; 20 A *3*; 27 I A *3*, I B *2*, II B *1*
Katelionas Siteia	4 A *1*; 27 I C *1*
Kato Sime Viannos	I7 C *1*
Katsamba	5 *1*; 8 K *1*; I2 *1*; I4 *1*; I8 B *1*; 24 II A I *1*, II A IO *1*; 26 I *1*; 27 I A *1*; 30 A *3*; 32 C *1*, D *1*, E *1*; 34 A *1*; 42 B *2*
Kavousi Cave	22 D *1*
Keraton	5 *1*
Khamaizi	3 A *2*, B *1*; 6 A I *1*, A 2 *5*, B 2 *1*, C *2*; 7 B *4*; 8 C *1*, D *1*; 22 A *2*; 24 V *2*; 27 I A *4*, I B *7*, I C *1*; 3I A *1*; 32 A *1*; 37 B *1*; 4I *1*
Khamalevri	8 C *1*
Khania	I A *1*; 3 A *2*; 5 *1*; 20 B *1*; 33 F *1*
Khersonesos	9 A *1*
Khondhros: Boubouli	37 B *1*
Kephala	24 II A 4 *1*
Rousses	24 II A I *1*; 26 5 *2*

Khristos	3 A *3*; 6 A I *2*; 8 C *1*; 10 C *1*; 20 B *1*; 23 A *1*; 32 A *1*
Knossos: Palace and Environs	I B *7*; 2 *3*; 3 A *2*; 5 *1*; 8 K *5*; 13 A *5*,† B *1*; 14 *1*; 15 *1*; 17 F *1*; 19 A *5*; 20 C *1*; 21 A *1*; 22 C *1*; 23 B *1*; 24 II A I *1*, II A 2 *1*, II A 13 *2*, II B *8*, II C *2*; 25 *5*; 26 I *4*, 2 B *2*, 6 *2*; 27 I A *2*, I B *1*, II A *1*, II B *2*, II C *3*, II D *1*; 30 C *1*; 31 A *1*, C *2*; 32 A *1*, C *1*, D *1*, E *1*; 34 A *9*, B I *8*, B 2 *3*, C *3*, D *3*, E *3*, F *1*; 37 C *1*; 38 A *3*; 41 *1*; 42 A *1*, B *5*, D *2*
Gypsadhes Tholos‡	3 A *1*; 6 A I *1*; 8 B *1*, A–J *1*;§ 10 A *1*, B *6*; 14 *2*; 18 A *2*; 24 II A I *3*, II B or C *1*, IV *1*; 26 5 *1*; 27 I A *1*, II B *2*; 30 A *2*; 31 C *3*; 37 A *2*; 38 A *1*; 42 D *1*
Hogarth's Houses‡	3 A *6*; 4 A *1*; 7 B *1*; 8 A *1*, I *1*, J *2*, A–J *2*; 9 A *2*; 10 B *14*; 13 A *1*; 14 *8*; 15 *1*; 16 *3*; 17 E *2*; 18 A *1*; 20 A *1*; 21 A *3*; 24 I *1*, II A I *6*, II A 8 *1*, II A 9 *1*, II B *1*, II B or C *1*, IV *2*; 26 5 *1*; 27 I A *6*, I B *2*, II B *5*; 31 C *6*; 32 C *5*; 34 A or B *2*, D *1*; 38 A *2*; 42 B *2*,‖ D *3*
LM IIIA Tomb‡	5 *3*
Royal Road‡	I A *1*; 3 A *3*, B *1*; 5 *1*; 6 A I *1*, B 2 *2*; 7 B *1*; 8 A *1*, B *2*, F *1*, J *1*, A–J *5*; 10 B *7*, E *3*; 12 *1*; 13 A *1*; 14 *3*; 16 *4*; 17 E *3*; 18 A *2*; 21 A *1*; 24 I *3*, II A I *5*, II B *2*, II C *3*, II B or C *45*, IV *4*, V *2*; 26 I *2*, 2 A *1*, 8 *1*; 27 I A *10*, I B *3*, I C *2*, II B *2*, II D *1*; 31 C *8*; 32 A *2*, C *9*; 34 A *1*, D *1*; 38 A *1*; 42 A *2*, B *3*, D *8*
Others‡	7 B *2*; 8 A *1*, A–J *1*; 10 A *1*, B *2*; 12 *1*; 20 A *1*; 21 B *1*; 24 I *3*, II A I *2*, II A 6 *1*, II B *1*, II B or C *4*; 27 I A *3*, II B *2*; 31 C *3*; 32 C *1*; 34 A *1*, B I *1*, D *1*; 38 A *1*; 42 B *1*
Ailias	3 A *1*; 6 A 2 *2*, C *1*; 27 I B *1*
Isopata	7 B *1*; 13 A *1*, B *1*; 14 *1*; 24 II A 2 *2*; 27 I A *3*, I B *1*
LM IIB Tomb	5 *2*; 9 A *1*; 19 A *1*; 27 I A *1*; 42 B *1*
Mavro Spelio	3 A *8*, B *2*; 5 *5*; 6 A 2 *1*; 8 C *1*; 9 B *1*; 17 D *2*; 27 I A *1*; 30 A *1*; 31 C *1*; 34 B 2 *1*, C *1*; 40 *1*
Sellopoulo	I B *1*; 5 *1*; 8 K *1*; 11 B *1*; 18 B *1*; 42 B *1*
Temple Tomb	3 A *1*; 13 B *1*; 18 B *3*; 27 I A *1*, I B *3*, I C *1*, II B *1*, II C *1*
Warrior Graves	3 B *1*; 10 D *1*
Zapher Papoura	5 *5*; 10 B *1*; 17 D *1*
Others and N.F.C.	2 *1*; 3 A *2*; 4 A *1*, C *1*; 5 *4*; 6 A I *1*; 7 A *1*, B *1*; 8 A *3*, B *1*, C *2*, K *1*; 10 B *1*, D *1*, E *1*; 12 *1*; 13 A *2*; 17 C *1*, E *1*; 18 B *1*; 19 A *2*; 20 B *1*; 21 B *1*; 22 C *1*; 23 B *1*; 24 II A I *9*, II A 2 *2*, II A 3 *1*, II A 4 *1*, II A 5 *1*, II A 6 *1*, II A II *1*, II B *7*, II C *1*, IV *1*; 26 I *3*, 4 *1*, 6 *1*, 8 *1*; 27 I A *1*, I B *4*, II B *1*; 30 A *5*; 31 C *2*; 32 C *2*; 34 A *5*, B I *1*, D *2*, F *4*; 35 *1*; 36 B *1*, C *1*; 42 B *8*, D *1*

† Three of these are probably but not certainly from the North Lustral Basin or Khyan Lid stratum.

‡ This is the material from the 1957–61 Stratigraphical Excavations. Nearly all of it comes from the environs of the Palace. The Gypsadhes Tholos and Hogarth's Houses are on Gypsadhes Hill, immediately south of the Palace; the Royal Road runs west from the northern edge of the Palace.

§ Pieces listed under type 8 A–J are fragments too small to be assigned to a particular group within A to J.

‖ One of these is HM 126, the only stone vase from the original, 1900, excavation of Hogarth's Houses.

TABLE 5 (cont.)

Koumasa	I A 4; 3 A 44, B 3; 4 A 5, B 1, C 2, D 2; 5 1; 6 A I 2, C 2; 7 A 3, B 2; 8 B 4, C 4, D 1, G 1, H 2, I 1; 10 A 2, C 1; 17 A 12; 18 A 1; 20 A 3, B 13; 21 A 5; 22 A 4, D 1; 23 A 1; 26 I 1; 27 I A 7, I C 2; 29 A 1; 31 A 4; 32 A 4, B 3; 33 D 2, F 2, G 1; 36 A 1, C 1; 37 B 10, C 1
Krasi	8 C 1; 10 A 1; 37 B 1
Kritsa	5 1; 32 D 1
Krousonas	5 3; 6 B I 1
Lastro	5 1
Lato	3 A 1
Lebena	3 A 1; 4 A 1; 6 C 1; 8 C 1; 10 A 1; 29 A 1; 31 A 2; 32 A 2; 33 E 1; 36 A 1; 37 A 3, B 2
Lithines Siteia	37 B 1
Mallia: Palace	2 1; 3 A 2, B 1; 5 2; 6 A I 1; 7 B 2; 8 F 1; 9 A 1; 10 A 1, B 1; 20 A 2, B 2; 22 A 2, C 1; 24 II A I3 2, II C 1, IV 1; 27 I A 1, I B 1; 32 E 1; 41 1; 42 B 1
Houses	I A 1; 3 A 5; 4 A 3; 6 A 2 1, B 2 1; 8 C 3, F 1, I 1; 10 B 3; 14 3; 15 2; 17 E 1; 18 A 1; 20 A 1, B 2; 22 A 2, B 1; 24 II A I 2, II A 2 1, II A 4 1, II A 5 1, II A 6 2, II A 7 1, II A 13 2, II B 1, II C 1, IV 1; 26 5 1; 27 I A 3, I B 2, I C 1; 31 C 1; 32 C 1; 37 B 1, D 1; 38 A 1, B 5; 41 2; 42 A 2, B 2
Quartier Γ	I A 1; 3 A 2; 6 A 2 1; 7 A 1; 10 B 3; 14 3; 17 B 1, D 1; 27 I A 3, I B 8, II B 1; 36 C 1; 42 A 2
MM II Sanctuary	10 B 2; 28 1
Cemeteries	I A 2; 3 A 2; 7 B 5, C 1; 8 A 2, E 1, H 1; 9 B 1; 10 B 1, C 1; 14 2; 17 A 1, C 1; 18 A 1; 20 A 1, B 2; 26 I 1; 27 I A 1, I B 2, I C 2, II D 1; 31 C 2; 42 A 1
N.F.C.	3 A 2; 8 C 1; 10 B 2; 17 B 1; 18 A 1; 27 I A 5, I B 1, II B 1; 31 A 1; 33 D 1; 37 D 1
Marathokephalon	3 A 1; 8 C 2; 10 A 1; 17 A 1; 20 B 2; 27 I A 1, I B 1; 28 1; 29 A 1; 30 D 1; 31 A 2; 33 C 1; 36 C 2; 37 B 1
Maronia	10 A 1; 27 II A 1; 33 A 2
Meixorrouma	24 II B 1
Milatos	3 A 1; 5 1; 27 I B 1
Mirsine	10 A 1; 17 F 2; 27 I B 1; 37 B 1
Mochlos: Tombs and N.F.C.	3 A 7; 4 D 1; 6 A I 1, B I 1; 8 A 5, B 6, C 11, D 1, E 3, J 1, K 1; 10 A 13, B 2; 12 1; 16 3; 17 A 14, B 1; 18 A 1; 20 B 3; 22 A 8, D 1; 24 IV 1; 27 I A 3, I B 6, I C 6, II A 2; 28 3; 29 A 9, B 1; 30 D 1; 31 A 8; 32 C 1; 33 B 1; 36 A 5, B 4, C 2; 37 B 26; 38 B 3; 40 1; 41 6; 42 A 5
Town	8 K 1; 24 II A 3 1, II A 13 1, II C 1; 28 1
Mokhos	5 1
Monastiraki	27 I A 2, I C 1
Myrtos: Fournou Korifi	31 A 1
Pyrgos	6 A I 1; 20 A 1; 24 II A I 2(1?); 27 I A 1; 31 C 4; 32 C 2

TABLE 5 (*cont.*)

Nipidhito	5 *1*; 7 A *1*
Nirou Khani	5 *1*; 24 II A 4 *1*, II A 7 *1*, II B *2*
Pakhyammos	3 A *2*; 7 B *1*; 8 A *1*; IO B *1*
Palaikastro: Town	I A *1*; 3 A *2*; 4 E *2*; 5 *5*; 9 A *2*, B *1*; IO A *1*, B *3*, D *1*, E *4*; 16 *1*; 17 A *1*, E *11*; 18 B *3*; 23 B *1*; 24 II A I *2*, II A 2 *1*, II A 6 *1*, II B *3(1?)*, II C *4*, III *2*, IV *1*; 26 I *1*, 5 *1*; 27 I A *3*, I B *1*, I C *1*, II B *2*; 30 A *1*, B *1*; 34 B 2 *1*, D *1*; 35 *1*; 37 B *1*; 38 B *4*
Tombs	3 A *7*; 4 A *1*; 6 A I *1*, B 2 *1*; 8 C *3*; IO A *1*; I2 *2*; 20 B *1*; 27 I A *1*, II A *1*; 28 *1*; 33 A *2*, F *1*; 37 A *3*, B *2*
Others and N.F.C.	3 A *12*, B *2*; 4 A *2*, B *1*, D *1*; 5 *15*; 6 B 2 *1*, C *1*; 8 B *1*, C *1*, D *2*; 9 A *1*; IO A *1*, B *3*, D *3*; 17 E *1*, F *1*; 22 A *2*; 24 II A I *1*, II A 3 *1*, II A 6 *1*, II A 7 *1*, II A IO *1*, II A I3 *2*, IV *1*; 26 I *1*, 2 B *2*, 4 *3*, 7 A *1*, 7 B *2*; 27 I A *2*, I B *3*, I C *5*; 31 A *3*; 33 G *1*; 34 A *1*; 35 *1*; 38 B *1*
Patsos	26 3 *1*
Petras Siteia	40 *1*
Phaistos: Palace and Environs	I A *1*; 3 A *9*; 4 A *2*, E *1*; 6 A I *1*, A 2 *1*, B I *1*, B 2 *1*; 7 B *1*, C *1*; 8 C *1*, D *1*, E *1*; IO B *5*, C *6*; I2 *2*; 13 B *3*; 17 C *4*; 18 B *1*; 20 A *13*, B *5*; 21 A *1*, C *7*; 22 A *1*, B *4*, D *2*; 23 B *1*; 24 I *4*, II A I *1*, II A 2 *1*, II A 3 *1*, II A 4 *1*, II A 6 *1*, II A 7 *1*, II A 9 *1*, II A I2 *1*, IV *1*, V *2*; 26 I *15*, 8 *2*; 27 I A *10*, I B *5*, I C *4*, II A *2*; 28 *2*; 31 A *3*; 32 A *4*, C *1*, E *1*; 33 A *1*, C *1*, D *2*; 36 A *1*; 37 B *1*; 41 *2*; 42 A *3*
Phrati	26 2 A *1*
Platanos: Tholos A and annexes†	I A *15*; 3 A *191*, B *7*; 4 A *11*, B *1*, C *6*; 6 A I *2*, A 2 *1*, B I *1*, B 2 *3*, C *1*; 7 A *6*; 8 B *2*, C *10*, G *1*, H *5*, I *3*, J *1*; IO A *2*; 17 A *5*, D *3*, E *1*; 20 A *5*, B *15*; 21 A *15*; 27 I A *3*, I B *2*, I C *2*; 28 *12*; 29 A *3*; 30 D *2*; 31 A *9*, B *1*; 32 A *10*; 33 D *1*; 36 A *3*, B *1*, C *5*; 37 A *1*, B *9*, C *4*; 41 *1*; 42 C *1*
Tholos B	I A *1*; 3 A *8*, B *1*; 6 A I *1*, B 2 *1*; 8 C *3*; 17 A *1*; 20 A *1*; 21 A *5*; 27 I A *1*, I B *2*; 31 A *3*; 32 A *2*; 33 A *1*; 36 A *1*, C *1*; 37 B *1*, C *1*
Area AB	3 A *1*; 4 A *1*; 8 C *1*, H *1*; 17 A *1*; 23 A *1*
Tholos Γ	3 A *4*; 8 C *1*; IO A *1*; 31 B *1*
Porti	I A *1*; 3 A *2*; 4 D *1*; 6 A I *1*; 8 A *1*, B *2*, C *6*, G *1*, H *1*, I *2*; IO A *3*, C *2*; 17 A *9*, B *1*, D *2*; 21 A *1*; 26 I *1*; 27 I A *1*; 30 D *1*; 31 A *2*; 32 A *3*; 33 D *1*; 37 B *4*; 41 *1*
Praisos	4 C *1*; IO B *1*; 30 A i *1*
Prasa	3 A *1*; 4 E *1*; 7 B *1*; 8 J *1*; IO B *1*; I2 *1*; 22 A *1*; 24 II A I *2*; 32 C *1*; 34 A *1*
Prinos	3 A *1*; 27 I B *1*
Pseira	I A *1*; 3 A *16*, B *3*; 4 A *2*; 5 *7*; 6 A I *2*, A 2 *6*, C *1*; 7 A *2*, B *4*, C *3*; 8 C *3*, F *1*, I *2*, K *1*; 9 A *5*; IO A *2*, B *4*; II A *3*; I2 *1*; I4 *2*; I5 *2*; 17 F *1*; 18 A *5*; 20 B *3*; 21 B *1*; 24 II A I *6*, II A 3 *2*, II A 7 *2*,

† The Platanos vases HM 1619–1903 are all from the north-east annexes of Tholos A. The vases from Platon's excavation are from another annex to A and are included with the others.

TABLE 5 (*cont.*)

Pseira (*cont.*)	II A 8 *1*, II B *2*, II C *1*, IV *1*; 26 3 *1*; 27 I A *8*, I B *12*, I C *1*, II B *1*, II D *1*; 28 *1*; 29 A *1*; 31 C *1*; 34 A *2*, B 2 *1*; 37 B *1*; 40 *6*
Psykhro Cave	26 2 A *3*, 3 *3*, 7 A *2*, 8 *2*
Pyrgos	28 *1*
Siva	3 A *3*; 8 D *1*; 10 A *2*, C *1*; 27 I B *1*; 32 B *1*; 33 D *1*; 37 B *1*
Sklavokambos	27 I A *1*; 34 A *1*; 35 *1*
Sphoungaras	6 A 2 *1*; 17 A *1*; 27 II A *1*; 37 B *1*
Stamnioi Pedhiadha	4 E *1*; 14 *1*; 27 I A *1*, II B *1*; 32 D *1*
Stavrokhori	37 B *1*
Tepheli	3 A *1*
Traostalos Siteia	26 7 B *6*
Trapeza	8 A *1*, B *1*, E *1*, I *1*; 10 A *5*; 18 A *1*; 27 I B *1*, II A *2*; 29 A *7*, B *5*; 31 A *4*; 37 A *1*, B *1*
Tsoutsouros	8 G *1*; 30 A *1*
Tylissos	3 B *1*; 7 A *1*; 8 C *1*, K *1*; 12 *2*; 14 *1*; 20 B *1*; 24 II A I *2*, II B *1?*, III *2*; 25 *1*; 26 3 *1*, 8 *1*; 27 I A *5*, I B *2*, I C *1*, II B *4*; 31 C *1*; 32 E *1*; 34 A *1*; 36 C *1*; 38 A *1*; 42 B *1*
Tymbaki	5 *1*
Vasilike	3 A *1*; 4 C *1*; 24 II A I *5*; 37 B *1*
Vasilike Anoyia	18 A *1*; 21 A *1*
Vathypetro	3 A *1*; 7 C *1*; 9 A *1*; 24 II A 4 *1*, II B *4*, II C *1*; 27 II B *1*
Voros	3 A *2*; 6 A I *1*; 7 A *1*; 20 B *1*; 27 I B *1*; 36 A *1*
Vrakhasi	33 A *1*
Vrokastro	3 A *2*; 27 I A *1*, II B *1*
Xeniako	5 *1*
Zakro: Palace and Houses	3 A *3*; 5 *1*; 6 A I *1*; 7 B *2*, C *1*; 8 B *1*, K *1*; 10 B *1*, D *2*; 15 *7*; 17 E *2*, F *1*; 18 A *1*; 19 B *3*; 20 C *1*; 21 C *30*; 22 B *2*; 24 II A 6 *3*, II A 7 *1*, II B *3*, II C *1*, III *3*, IV *1*; 26 7 A *7*, 7 B *5*; 27 I A *6*, I B *2*, I C *1*; 32 C *1*; 34 A *11*, B I *10*, B 2 *3*, D *1*; 37 B *1*; 42 B *3*, D *4*
Pits	22 B *1*
Tombs	27 II A *1*; 33 B *1*; 37 B *1*
East Crete†	6 B I *1*; 8 A *1*, E *1*, I *1*; 10 A *3*, B *2*; 17 A *1*, B *1*; 22 B *2*; 24 I *1*, II A 6 *1*, II A 13 *1*, II B *3*, II C *1*; 26 5 *1*, 7 A *1*; 31 C *1*; 37 A *6*; 38 B *2*; 40 *1*
Mesara	3 A *2*; 4 C *1*; 18 A *2*; 20 A *1*; 33 D *1*
Crete	I A *1*; 3 A *3*, B *2*; 4 B *1*, C *1*; 5 *9*; 6 A I *1*, A 2 *1*, B 2 *1*; 7 B *1*; 8 A *2*, C *1*, G *1*, I *1*; 10 A *1*, B *1*; 11 A *1*; 12 *1*; 16 *1*; 17 E *1*; 20 A *1*; 24 II A I *1*, II B *1*, II C *1*, IV *1*; 26 I *1*, 3 *1*; 27 I A *6*, I B *5*, I C *9*, II A *1*; 29 A *1*; 31 C *1*; 32 A *1*; 33 A *2*, F *2*; 34 A *1*; 37 B *3*; 40 *1*; 42 B *1*
Argos	5 *1*; 8 C *2*; 18 B *1*; 24 II A I *2*, II A 2 *2*
Asine	17 A *1*; 24 II A 2 *1*; 32 B *1*; 34 A *1*

† Mostly the vases in Hierapetra Museum.

TABLE 5 (cont.)

Atchana	24 II A 8 *1*
Byblos	5 *1*
Delos	5 *1*?; 34 A *1*
Delphi	34 A *1*, E *1*
Dendra	II B *1*; 24 II A I *3*, II A 2 *1*, II B *2*
Eleusis	24 II A 2 *1*
Gezer	I A *1*
Kahun	27 I A *1*
Kea	3 A *1*; 5 *6*; 9 A *2*; 10 B *2*; 11 A *1*; 12 *2*; 14 *4*; 15 *3*; 16 *1*; 20 A *1*; 23 B *1*; 24 II A I *1*, II A 9 *1*; 26 I *1*; 27 I A *8*, I C *1*, II A *2*; 31 C *2*; 32 C *1*; 36 A *1*; 37 B *1*, D *1*; 40 *1*
Kythera	3 A *1*; 5 *4*; 9 A *1*; 10 B *3*; 20 B *1*; 22 B *1*; 24 II A 2 *1*, II B *1*; 33 E *1*; 40 *1*
Mycenae	I B *2*; 2 *1*; 4 E *1*; 5 *3*; 11 B *1*; 13 B *4*; 15 *3*; 19 B *2*; 22 A *1*, D *1*; 23 B *1*; 24 II A 2 *6*, II A 4 *1*, II A 9 *1*, II B *2*; 25 *3* or *4*; 26 6 *1*; 27 II C *1*; 34 A *4*, C *1*, D *6*; 42 B *3*, C *1*
Nauplion	14 *1*; 15 *2*; 24 II A 2 *1*
Naxos	5 *1*
Oxylithos Euboea	I A *1*
Phylakopi	5 *5*; 9 A *1*, B *1*; 10 A *1*; 24 II A I *3*, II B *1*; 27 I A *3*, I C *2*
Samos	I A *2*
Thera	15 *1*
Thorikos	24 II A 4 *1*
Troy	5 *1*; 24 II A 4 *1*
Vapheio	16 *3*; 24 II A I *2*

The totals from the main sites are as follows:

Knossos	637	A. Triadha	120
Platanos	431	Galana Kharakia	87
Palaikastro	185	Kamilari	82
Mochlos	184	Porti	50
Mallia	180	Mycenae	50
Koumasa	167	Kea	45
Phaistos	152	Khamaizi	38
Pseira	135	Tylissos	34
Zakro	131	Trapeza	31
Gournia	124	Apesokari	26
			2889

These twenty sites account for 83% of the total. The first eleven account for 70%.

The four Palace sites	31%	
Mesara tholoi (including A. Triadha)	23%	77.9% of the total
Towns (including cemeteries) and villas	19%	
Exported vases	4.9%	

III

MATERIALS

The geology of Crete has only recently begun to be studied systematically. The pioneers were Spratt, whose two volumes, *Travels and Researches in Crete* (1865), include many geological observations in the text, an appendix to the second volume on the geology of the island and a geological map, and Raulin, whose *Description Physique de l'Isle de Crète* (1869) gives a thorough account of Cretan geology, his map being based on Spratt's. Two studies of particular areas of the island have appeared, Khalikiopoulos' *Sitia, Die Osthalbinsel Kreta's* (1903), and Claude Pareyn's geological study of the Mallia region (H. and M. van Effenterre and others 1963). Hutchinson (1962) has a useful geological discussion and a map, based on those of Spratt and Liatsikos. Evans (1897 and *The Palace of Minos*) has many incidental remarks on the subject and Pendlebury (1948, 42) described the typical stones of Mochlos. Allbaugh's Rockefeller Survey (1953, 50, 66) lists the occurrences of minerals, especially talc and gypsum. A Geological Map was published by the War Office but is not very detailed (Geographical Section, General Staff, no. 4410 B, sheets G 19 and 20).

During the last few years a complete geological survey of the island has been started by the Greek Institute for Geology and Subsurface Research, under the direction of Professor J. Papastamatiou, as part of the preparation of the geological maps of Greece. So far however only four sheets have been published for Crete, covering the eastern end of the island and one area in the west. When completed this series will supersede all previous work on Cretan geology.

Crete consists of a mass of limestones of different periods on a schist, phyllite or crystalline limestone bed. These limestones range through the Tertiary period, Upper Cretaceous, Jurassic, Triassic and Permian to Permian or Carboniferous. There are Tertiary marls, conglomerates, sandstones and white limestones, dark grey to black Upper Cretaceous limestones, whilst those of the Jurassic are blue/black to grey/black. The Triassic is characterised by a good deal of grey to black dolomite or dolomitic limestone. Permian–Triassic phyllites with crystalline limestones above them form the metamorphic series, in which there are many outcrops of gypsum (Allbaugh notes 165 quarries and 10 mines). Permian or Carboniferous are masses of bluish crystalline limestone of which, for example, the Orno range

north-east of the Hierapetra isthmus is composed, while the Thripte range east of the isthmus is dolomite. Over the island as a whole the dark limestones, dolomites and dolomitic limestones make up the main mountain masses, the White Mountains in the west, the Ida massif in the centre and the Dikte range to the east. In the far west the schist and phyllitic series predominate, whilst on the low-lying areas of the north coast, the central region between the Ida and Dikte ranges, and on the Hierapetra isthmus it is the Tertiary limestones and the marls. At a number of places intrusive igneous rocks or altered igneous rocks are found in the limestones. For instance in the Kalo Khorio region small outcrops of granite and diorite penetrate the Upper Cretaceous limestones and north of Skordilon in East Crete a little amphibolite is intrusive in the phyllitic series. Of particular bearing on the stone vases are the much more extensive outcrops of serpentine, talc and chlorite which are found in the northern and southern foothills of the central Ida massif and on both sides of the Asterousia range south of the Mesara and eastwards in the Viannos–Arvi region along the south coast. It was from these sources that the Minoans drew their materials. These altered rocks and limestones are used for the majority of vases, the former predominating over the much more frequently occurring lime-stones because of their greater attractiveness and their comparative softness for the lapidary.

The system adopted below is to discuss all the materials used by the stone vase makers, noting the description, appearance and, where necessary, the composition of the rock, its location in Crete, or outside it if the stone is imported, and the types of vase for which it was used. The tables at the end of the chapter list the numbers of vases in each type according to their materials, so that one may see at a glance what stones were favoured for what types.

ALABASTER, Egyptian

Egyptian 'alabaster'[1] is composed of the mineral calcite. See Lucas (1962[4], 75 and 463) for its occurrence and use in Egypt, where many thousands of stone vessels were made of it. A distinctive feature is the presence of fine crinkly bands in the creamy stone 〰〰〰, resulting from the formation of the calcite crystals.

There are nearly forty Minoan vases made of it, mainly MM III–LM I chalices, ewers, rhytons and fine individual vases. Further proof of the importation of the raw material into Crete in this period is supplied by waste pieces of it

[1] The term is so common that it is best retained, though it is inaccurate. Strictly speaking alabaster is not calcium carbonate (calcite) but calcium sulphate (gypsum).

found in the 1957–61 Knossos excavations. For the importance of the alabaster trade see pp. 186, 190 below. Apart from the raw material in Crete there are some forty-two Egyptian vases made of it.

ANTICO ROSSO

This is a beautiful, hard, maroon or deep purplish red marble (recrystallised limestone), sometimes with greenish grey veins or with small greyish markings. It appears to exist in Greece only in the Mani district of the southern Peloponnese, in the hills above Kyprianon. Waterhouse and Hope Simpson have given an excellent discussion of its location and use (1961, 119–21).[1] The pottery from the prehistoric site connected with the quarries was Late Helladic. The stone was imported into Crete and used for lamps, rhytons and a few other vases in MM III–LM IIIA. There is one earlier instance of its use, for an MM IA circular table from Knossos.

Unlike the blocks of lapis Lacedaemonius also imported from the southern Peloponnese antico rosso as raw material is rare in Crete. But there is a small sawn block of it, probably worker's waste, from an LM IIIA 2 context at Knossos (1957–61 excavation), and from an MM I stoneworker's atelier in the Palace at Mallia come pieces of a stone called 'quartzite rose' (Chapouthier & Demargne 1942, 54 and pl. LII 2c), perhaps also antico rosso.

The well-known Minoan (see type 24 II A 8) lamp from Atchana, published by Woolley as red porphyry (*Antiquaries Journal* 1948, 5) is almost certainly not antico rosso, but a fine-grained maroon/red limestone with white inclusions, paralleled for example by a lamp from Palaikastro (type 24 II A 3, **P 299**).

Because it is sometimes difficult to distinguish antico rosso from fine-grained maroon limestone several of the lamps under these two materials in the tables may have been wrongly classified.

BANDED TUFA

This material, variously called 'wavy-banded alabaster' or 'polychrome stalactite' in publications, is calcite in a banded form best called Banded tufa. Calcareous tufa or travertine would not be wrong, though it is not known that the source of the stone was in cave formations, to which the term travertine strictly applies. It is creamy white with beautiful orange, brown, grey and pink wavy bands. The red/

[1] From their list of antico rosso vases the large stone basin from north of the Throne Room at Knossos should be deleted. It is made of a fairly soft and flaky Cretan maroon limestone.

brown colours are from staining, mainly iron, the white, cream or grey being the uncoloured calcite. Tufa is a term used when the stone is porous and forms from spring deposits. The precise location of the rock in Crete is not known but specimens very like it have been picked up by the writer from the Kakon Oros breccia site just east of Herakleion and from the hills behind the bay of Mallia on the north coast. Banded tufa was especially popular at Mochlos and is used most often for bowls with lugs and/or spouts (types 10 and 37). Apart from these it is fairly rare, not occurring above four times for any other type, and with a period of use from late EM II to MM I.

BASALT

One vase, imitating an Egyptian Early Dynastic type (HM 353, type 30 A), is of fine-grained grey/brown fairly hard stone with tiny crystalline particles, very probably a basalt. The vase is certainly Minoan and the material most probably so, from some small outcrop of basic intrusive rock (cf. Diorite below).

BRECCIA

Two distinct kinds of breccia were used for stone vases. The term itself denotes structure, not composition, breccias being rocks with sharp-edged pieces in a matrix of a different material. One variety is that found at Kakon Oros, a few kilometres east of Herakleion. On this hill, which is about a kilometre in breadth, falling straight to the sea, the brilliant jumble of rocks produces breccia with black dolomite pieces in a yellow limestone matrix or one of pink haematite, or else there is a black dolomite matrix with red pieces and veins, which are themselves sometimes outlined by white calcite veins. Associated with this breccia, sometimes in the same lump of rock, is banded tufa close to that used for vases, and a beautiful pastel-shaded limestone (see Limestone below).

Evans noted the Kakon Oros source as well as one near A. Nikolaos and he found that it also occurred near Viannos, east of the Mesara plain (*PM*, IV, 234). This was perhaps the source for the large column bases in the Phaistos Palace. Seager said that the breccia used for the Pseira rhyton (Kakon Oros type) occurred in large masses close to the site (1910, 37) and the Greek geological map records breccias at several places in East Crete. A variety akin to that of Kakon Oros, grey/black, pink, sometimes with outlining white veins, occurs around Sellia and westwards along the south coast in the Rethymno province. Its appearance is to be expected in disturbed limestone areas or along faults.

The material was popular for vases of many types (e.g. Teapots, Bird's Nest Bowls, Rhytons) from late EM II to LM I.[1]

The second form is not such a true breccia as that of Kakon Oros. It consists of green, maroon and black pieces in a white calcite matrix. The green pieces are steatite, the maroon haematite or haematite-stained and the black is dolomite. The exact source is not known but one may have been somewhere near Knossos since the material is used for column bases in the Palace. Like Kakon Oros breccia it is found everywhere in use for vases. It was most favoured from late EM II to MM I, a large number of vases of it coming from the Mesara tombs. The types are mainly Bird's Nest Bowls, Alabastrons, Bowls with carinated profile and everted rim, Cylindrical Jars and a few small vessels characteristic of that early period.

CALCITE

A number of vases are made of fairly pure translucent calcium carbonate (calcite). There are two forms, translucent creamy white and translucent golden or honey brown with opaque creamy white patches. This second form, sometimes called alabaster in publications, is close to banded tufa in composition and sometimes comes near it in appearance. But the term Calcite is best applied, as here, when no banding is observable. No exact location in Crete is known but in predominantly limestone country it is obvious that calcite will appear frequently. A number of small pieces, brown translucent, turned up in the Knossos excavations. The white variety is not to be confused with marble, which it sometimes resembles in appearance. Three Mochlos vases (Seager 1912, fig. 46 VII*a*, XXI 10, fig. 47 M 12 and pls. III and IX) which Seager thought probably of Cycladic origin because of their white translucent material are ordinary calcite, not marble, and are of Cretan manufacture. A core of just this white translucent calcite was found on the Mochlos town-site (HM 1594★).

Both varieties are used for EM II–MM I/II vases but it is not a common material. Vases with carinated profile and everted rim and a few lids are the types for which it was most popular, the golden and white form being found more frequently than the translucent white.

[1] In Dürer's painting 'Beweinung Christi' (Munich, Alte Pinakothek no. 704) a figure holds a red and black breccia jar with a perfect pawn-handled lid.

CHLORITE or CHLORITE SCHIST

As noticed above altered basic intrusive rocks appear at numerous points through the limestones of Crete. These altered rocks are a mixture of minerals. In some serpentine predominates and so, though not covering all the constituents of the rock, is the most reasonable name. Others have much talc (steatite or soapstone), others again much chlorite, which is opaque greyish green, merging almost to black in some of the Mesara vases. It is usually called green steatite in publications.

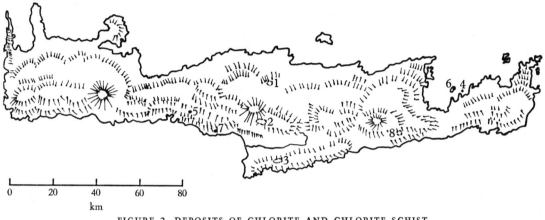

FIGURE 2. DEPOSITS OF CHLORITE AND CHLORITE SCHIST

1 Gonies	2 Kamares-Zaros	3 Miamou-Krotos	4 Mochlos
5 Preveli Gorge	6 Pseira	7 Saktouria	8 Sarakina Valley

Sometimes these chloritic rocks have a sugary, crystalline appearance which is probably produced by fine particles of altered feldspar. The variety most frequently employed for vases is compact, green/grey with lighter patches where worn or chipped.[1] But the chlorite of some vases shows a schistose structure so that they are best called Chlorite Schist. Here again the material is not purely chlorite for there is an admixture of other minerals. Since Crete has considerable schist and phyllite regions the appearance of chlorite schists is to be expected.

Chlorite and chloritic limestones are found in the foothills of the Ida massif around the village of Gonies, a little to the west of which are found the major serpentine deposits (see Serpentine below). They also occur on the lower southern slopes of this range, specimens having been collected at several points on the road between Zaros and Kamares. In the Asterousia range south of the Mesara plain around the villages of Miamou and Krotos extensive deposits of steatite are found

[1] A typical specimen was sectioned by Mr Ellis of the British Museum, Natural History, who reported that it is a fine-grained aggregate of pale green chlorite with granular streaks of carbonate.

and chloritic rocks are almost certainly associated with these. Further east in the Sarakina valley north of Myrtos excellent deposits of steatite occur and chlorite is found with them. The writer has also picked up specimens in the north on Mochlos and Pseira and in the west below Saktouria and around the head of the Preveli gorge. It is certain that there are many other occurrences. Those recorded here are shown on the map (figure 2).

This material is most popular for vases in the Mesara and it may well have been from the southern Ida and Asterousia sources that the lapidaries obtained it. It was used for the earliest of all stone vases, in the first part of EM II, and remained popular through to LM I, primarily because it is fairly soft and easy to carve. The wonderful Zakro Peak Sanctuary Rhyton (Platon 1964b, figs. 10 and 15) is in this material. After the serpentines it is the most popular stone for vases, occurring in all the EM–MM I/II types, with a hundred examples of Bird's Nest Bowls.

CONGLOMERATE

There are just two vases, a Bird's Nest Bowl and a small Alabastron (**P 2**), both EM III–MM I, in which the pieces within the matrix are small rounded pebbles, not sharp and angular. Hence they are true conglomerates, basically limestone and dolomite.

DIORITE

One vase (HM 2625, type 30 A, **P 402**) is made of a hard rock with dark green/grey matrix speckled with small grey/white patches. It is very probably a diorite, close in appearance to a common variety of Egyptian speckled diorite used for early Dynastic vases. The vase is Minoan and the material almost certainly so. Several small outcrops of diorite are shown on the Greek Geological Map (Hierapetra Sheet) around Gournia and westwards towards Kalo Khorio. The writer has found samples in West Crete at Kato Preveli and west of Meixorrouma, both in the A. Vasileios eparchy of the Rethymno province.

DOLOMITIC LIMESTONE

This has two forms, grey and white in well-defined areas, like dolomitic marble, but not apparently crystalline, and secondly pale grey and grey/black straight banded. On the latter variety the powdery incrustation left by the magnesium can sometimes be felt. Vases of this banded form are very rare (it is not very attractive) but a number of waste pieces were found in the Knossos excavations. Some of the

vases classed as dolomitic limestone, grey and white variety, might be dolomitic marble. On the use of the term Dolomite and the occurrence of the rock in Crete see under Dolomitic Marble.

The types are mainly MM I/II, though three examples are from the A. Triadha palace, imitating an early Dynastic form (type 30 A). The rock was probably chosen because it is fairly hard, harder than limestone and marble, though softer than gabbro.

DOLOMITIC MARBLE

There are approaching a hundred vases, of many types and dating from late EM II onwards, of a rock with grey and white patches either separately defined or mottled together. A typical vase fragment was sectioned in Cambridge by Dr M. Black and turned out to be a true dolomitic marble (compound of calcium and magnesium carbonates), crystalline in both grey and white areas. Many vases of this material were tested for reaction in Crete and classed as Dolomitic Marble when a crystalline structure seemed to be present and as Dolomitic Limestone when it did not, and when there was little or no surface reaction in either case. But it is often difficult to determine whether a crystalline structure is present or not and so some vases may have been put under the wrong material. The plain term Dolomite might be more correct for both the crystalline and non-crystalline forms but the proportions of magnesium present are not known and the additional distinction into Limestone and Marble seems useful. Dolomite, as seen in the introductory section, occurs in large masses in Crete.

The material was most used for Bird's Nest Bowls, Bowls with carinated profiles, small Alabastrons and Lids in late EM II–MM I/II, and for a few fine individual vases in MM III–LM I.

GABBRO

This attractive stone, not previously recognised for Minoan vases, is a partly altered basic igneous rock in which the white feldspar phenocrysts are massed together and have very fine green veins running through them. It was one of the hardest materials employed by the Minoan lapidaries, though softer than rock crystal and obsidian. There are approaching forty vases made of it, ranging in date from MM I–LM I. There can thus be little doubt that it is a Cretan stone, although the writer has not been able to find its source. However the occurrence of a little gabbro among the serpentines in the Gonies region (see Serpentine below) has been established by Papastamatiou.[1]

[1] Information in a letter of 13 Nov. 1964.

It is to be noted that although there are approaching forty vases of gabbro there are only eight objects from Crete in a truly porphyritic rock with phenocrysts well scattered. Four of these are almost certainly Egyptian and three are of lapis Lacedaemonius. The eighth is a little cylinder from Platanos (Xanthoudides 1924, pl. XI) and this has the fine green veins running through the white phenocrysts. It is not lapis Lacedaemonius as Xanthoudides thought. In view of its material it might well be an Egyptian cylinder but the possibility remains that there might be a small deposit of this rock in Crete, for the composition of the cylinder's material is almost identical to that of the gabbro, though it has not been metamorphosed to such a degree.

Gabbro was attacked occasionally in MM I for cylindrical pots (e.g. **P 260**), lids (**P 351**) and a few other shapes, and was used for a fine larger bowl found in an MM II context at Phaistos (type 10 B, HM 2546). The splendid bridge-spouted bowls from the Mycenae chamber tomb are MM II or III (type 13). The rock was favoured, like other hard stones, for fine vases in MM III–LM I. One of the Zakro Palace chalices is the best example, though the largest attempt in this material is the unfinished amphora from Avdhou, probably looted from the Knossos destruction debris (type 25, HM 15).

GYPSUM

The Rockefeller Survey (Allbaugh 1953, 66) noted 165 gypsum quarries and 10 mines in Crete, the stone appearing everywhere in outcrops. It was much used by the Minoans as a building material in the palaces, and Gypsadhes Hill immediately south of the Knossos Palace is composed of it.[1]

Apart from one or two MM I lids from the Knossos Vat Room deposit the stone was only used for vases in the final Palace phase at Knossos, LM II–III A I (Warren 1967b). The Throne Room alabastrons are the best examples but there are several white gypsum vases from post-palatial LM III tombs. These are very probably survivals from the last Palace.

The stone is very easy to work and can be scratched by the finger nail.

LAPIS LACEDAEMONIUS

This is a true porphyritic rock, in which the light green feldspar phenocrysts are embedded in a dark green hornblende matrix. Sometimes the matrix turns brown through oxidisation and the phenocrysts kaolinise to a pale yellow colour. This

[1] See Hood, Warren & Cadogan 1964, 99 for a note on some of its occurrences. There is for instance a mass of it in the remote south-west corner of Crete, opposite the offshore islet of Elaphonisi. A Minoan site was found at this point by Mr and Mrs Hood and the writer in 1963 (Hood 1965b, 102–4).

feature, as well as the normal light and dark green surface, can be seen on the large store of blocks in the Lapidary's Workshop at Knossos.

As far as is known this fine rock only occurs in the southern Peloponnese near ancient Krokeai. Its location and usage have been well discussed by Waterhouse and Hope Simpson (1960, 105–7). It was extensively used in Roman times for wall panelling.[1]

As a material for stone vases it is extremely rare. The Zakro rhyton found in 1963 (type 34 B 1, HM 2712) is the first complete vase (entirely brown with yellow phenocrysts through burning). There are two bowl fragments from Knossos and an unpublished chalice base from Karnari. From the rhyton Well at Mycenae came the lower part of the rhyton in Nauplion Museum, which might be Mycenaean because of the rather unskilled working on the inside, though there are a number of exactly this fluted form from Crete. The famous bowl from Isopata however is not of this stone (type 43 G).

The blocks from Knossos were part of the Palace destruction debris. There were also several pieces of workers' waste from the recent Knossos excavations, none earlier than LM I. The vases in Crete are MM III–LM I. The stone was used a number of times for seals (Kenna 1960, 159 lists ten examples) in the Late Bronze Age, Dr Kenna dating two others to MM III. The name Spartan Basalt is often used.

LIMESTONE

In such predominantly limestone country as Crete it occasions no surprise that many vases are made from different varieties of the material. Ten may be distinguished and it may be recalled that banded tufa is also a form of limestone and that calcium carbonate, as well as being calcite, also makes up much of the breccias. There are also some crystalline limestones (see Marble below) and Dolomitic Limestone and Dolomitic Marble.

At least ten varieties can be distinguished: (1) coarse, usually soft, white (Tertiary, 'kouskouras' when soft); this is sometimes greyish or creamy buff; (2) grey/black with irregular mottled white calcite veins, **P 115**; (3) polychrome mottled and banded, often marble-like in appearance (**P 467** and **471**), as with many of the Zakro rhytons, and sometimes close to if not actually marble; (4) occasionally used, grey

[1] There was a magnificent Roman amphora of it in the Northwick Collection of the late Captain Spencer-Churchill. A piece was used, or reused, in the Middle Ages for a late eleventh-century Byzantine plaque of the Virgin at Prayer (Victoria and Albert Museum, A 1–11927). Other instances of Medieval use or reuse are found in ornamental surrounds and panelling for religious books in the Schatzkammer of the Residenz in Munich.

and white mottled, apparently non-crystalline, but which does react (rocks of this appearance usually being dolomitic marble or sometimes dolomitic limestone); (5) plain grey; (6) pale grey and grey/black banded, often close to (3) but without the addition of orange and maroon patches; (7) deep reddish maroon, which may have an occasional fine silvery calcite vein, used for a few EM III–MM I Bird's Nest Bowls and Block Vases, for the large stone basin in the Ante-Chamber of the Knossos Throne Room, and for one or two other vases; (8) a white, translucent, marble-like variety, non-crystalline, only used in MM III–LM IIIA I for a few rhytons and other fine vases; (9) fine grained green/grey; and (10) a mixed bag of other limestones. These are sometimes bichrome, but most are predominantly orange or, in the case of lamps, maroon with white inclusions.

All are Cretan stones, found in many parts of the island. The soft white limestone, for example, is typical of the low level Tertiary areas, whilst the maroon variety forms all the area around Galana Kharakia south of Viannos, extending east and south-east of Mt Keraton through the foothills. The source of the polychrome mottled and banded varieties used for the rhytons is not known, but the delicate yellow and pink pastel-shaded variety of a few vases (e.g. HM 51) comes from the Kakon Oros breccia area just east of Herakleion, being found in the same lumps of rock as the breccia. It is a banded sediment, the yellow limestone layers being Cretaceous or Tertiary.[1]

The limestones were used from EM III–MM I onwards for nearly all shapes. As they are attractively coloured and easy to work they are, with the serpentines and chlorite, the most popular material for the vases. The light and dark grey banded variety, mottled with maroon and/or orange, and the white translucent, marble-like variety were only used in MM III–LM IIIA I, for rhytons and other fine vases, the sources presumably being discovered at that time.

MARBLE

Unlike the Cyclades Crete possesses little good marble (strictly, crystalline limestone metamorphosed by heat and pressure) although good fine-grained grey varieties are found in a few metamorphic areas. For example there are deposits north of A. Nikolaos, used as a building stone in the town, whilst good specimens can be picked up among the boulders in the remote gorge of Samaria in the far west. White marble is equally rare. An outcrop was found in 1963 by Mrs H. Hughes-Brock, Dr Colin Renfrew and the writer at Xeropotamos, a point 15 km. along the road

[1] A specimen sectioned at Cambridge contained post-Palaeozoic microfossils.

from A. Nikolaos to Gournia on the north coast. The writer has also picked up white marble beach pebbles at Khersonesos on the north coast and at Matala on the south, and there are small outcrops on the hills between Rogdhia and A. Pelagia on the north-west corner of the bay of Herakleion.

A grey and white mottled variety, of which the dolomitic form is equally popular, was used for vases, as were pale grey to grey/black banded marbles. At Mochlos the banded marbles often have a bluish tinge. This site provides a high proportion of the marble vases and the material is found on the island, both mottled and banded.

About twenty white marble vases of Minoan manufacture occur, in a variety of shapes. There is also one instance of plain grey marble.

All varieties were used in EM III–MM I for bowls and other small vases, spouted and lugged bowls being common at Mochlos. The grey and white mottled form (see also Dolomitic Marble) and white marble continued in use occasionally to LM I.

It is sometimes not easy to distinguish true marbles from limestones without expert knowledge and it is possible that some of the vases classed as marble are not so in fact, so that the figures for this material may be a little high. But many of the vases are from Mochlos and these are certainly marble, usually horizontally banded.

OBSIDIAN

As a material for vases[1] obsidian has two varieties: black (grey/black translucent against the light), and black with white spots.

The latter variety has often been called liparite because of its assumed source, the Lipari Islands north of Sicily. Evans first recognised the resemblance (*PM*, I, 23). The latest researches however show that the white-spotted variety in Crete comes in all probability from the islet of Gyali off Nisyros in the Dodecanese and that it definitely does not come from the Aeolian islands (Cann and Renfrew 1964, 114 and 122. Renfrew, Cann & Dixon 1965, 235, 237, 239–40). That Gyali was a source of translucent obsidian was observed by Evans (*PM*, II, 14), followed by Pendlebury (1939, 39), whilst Hope Simpson & Lazenby, who recently explored Nisyros (1962, 169), also refer to the semi-translucent obsidian of the neighbouring islet. But none of these writers mentions the white-spotted variety. Moreover no varieties other than the white-spotted seem to be native to Gyali (Renfrew, Cann & Dixon 1965, 232).

The plain black variety was very rarely used for vases. There are only three

[1] For the single instance of the white-spotted variety being used for a sealstone (from Mochlos) see Hughes and Warren (1963).

examples, one being the Tylissos rhyton (type 34 B I, HM 1573, **P 480**). It would seem, contrary to expectation, that this obsidian is not Melian. It may, like several pieces of black obsidian from Knossos, come from a south Anatolian source.[1] If this is correct it is of considerable interest as demonstrating the importation in MM III–LM I of a fine stone from a distant source. It also explains why fragments of black obsidian vases are rarer than those of the white-spotted variety from Gyali.

The latter variety is most recently illustrated by the astonishing chalice from the Zakro Palace (**P 195**). Apart from this there are eight other whole or fragmentary vases including the lovely dolium shell from the A. Triadha Palace (**P 497**), the imitation of the Egyptian shallow carinated bowls and an exquisite fragmentary bowl with horizontal grooves below the rim from Knossos (1957–61 excavations). All the obsidian vases are very probably of MM III–LM I manufacture, although only about half have good LM I contexts. One however is from the MM III North Lustral Basin at Knossos (type 19 A). The Egyptian bowl imitation (type 30 C) was almost certainly made in MM III.[2]

The white-spotted variety was imported as raw material from as early as MM I. The stoneworker's atelier at Mallia is of this date and its contents included a block of white-spotted obsidian (Chapouthier & Demargne 1942, 24, 54–5 and pl. LII 2b), **P 627**. The recent Knossos excavations produced one waste piece from an MM IIA context and two from MM III contexts. A large block, 43.0 cm high, was said to have been found in an MM II context in the Palace at Knossos (*PM*, I, 87 n. 1; Mosso 1910, 363 and fig. 198). There are also pieces from LM contexts at Knossos (1957–61 excavations), Tylissos (Hatzidhakis 1921, fig. 25 top row 2nd from left) and Palaikastro, where waste pieces turned up occasionally in the old excavations, and, without context, from Katsamba (*PM*, IV, 895).

ROCK CRYSTAL

This fine stone, a colourless variety of quartz, was used from the Early Minoan period onwards for beads, pendants and other small objects, but for vases almost certainly not before MM III–LM I. Small crystals are found in Crete (Marinatos 1931) on the northern foothills of Mt Ida, especially round Axos and the villages of

[1] Renfrew, Cann & Dixon 1965, 240, on its not being Melian. Renfrew 1966, 39, 66 on Cappadocian obsidian at Knossos.

[2] It had no find context, but the form was also imitated in clay, with white spots on a black ground (*PM*, I, 87 and fig. 127f), a fashionable style in MM III. The sharp carination of the obsidian bowl is comparable in technique with the sharp-edged flutings of the MM III bridge-spouted bowls (type 13). The sealstone of white-spotted obsidian referred to above is also MM III.

Kalyvos and Livadhia in the Rethymno province. A fine crystal in the writer's possession was picked up by Sinclair Hood at A. Pelagia on the north-west corner of the bay of Herakleion. But Marinatos pointed out that the large crystals needed for the LM I vases, of which the rhyton found in the Zakro Palace in 1963 (Platon 1964b, fig. 16) is the finest example, must have been imported from abroad. Other fine stones from external sources, Egyptian alabaster, antico rosso, lapis Lacedaemonius and obsidian reached the ateliers of the Minoan lapidaries in this period. Against this is the reported occurrence of a vein of rock crystals among iron ores with some crystals big enough for vases like the Zakro rhyton.[1] It may be that such veins, when found, were worked to supply the lapidaries with large and small crystals.

About a dozen vases only, including fragments, are known from Crete. These include the exquisite pyxis lid (type 27 II A) with walls eight-tenths of a millimetre thick. Most of the pieces come from Knossos, where also about nine inlay fragments and twenty pieces of workers' waste were found in the recent excavations. These were probably all connected with the manufacture of sealstones or inlays.

SANDSTONE

Two rather crude shallow cylindrical bowls from the libation set in the Zakro Palace seem to be of sandstone rather than the usual soft white limestone, as does a libation table from Gournia. The large basin from A. Triadha (type 2) may be a compact sandstone but this is not certain since the material has not been analysed.

SCHIST

About a dozen vases of the EM–MM I period are of schist, usually greyish in colour. More are of chlorite schist because it is of more attractive appearance. Schists, as noted in the introductory section, occur frequently in Crete but were hardly used for vases because the stone splits easily and is not attractively coloured. Exceptions are one or two small open vases, bowls or cups, of a delicate pale green/grey and maroon, e.g. **P 438**. These are EM III–MM I and from the Mesara. Presumably a small outcrop was once found and used. Purple/maroon schists appear in masses, for example in the region about Adhravastos between Palaikastro and Zakro in East Crete, but these were never used, the purplish maroon vases being all of limestone.

[1] Near Arolithi, south of Argyroupolis on the western border of the Rethymno province. Information (9 Sept. 1965) from Mr M. Dialinas.

SERPENTINE

This material is an altered basic rock, called steatite in Minoan publications.[1] It was used for about 47 per cent of all Minoan stone vessels. There are several varieties:

(1) By far the commonest, consisting mainly of serpentine with other minerals in smaller proportions, chiefly steatite, chlorite and calcium carbonate.[2] The rock is blue/grey/black with green, brown and pale buff patches; sometimes the whole is predominantly lightish grey.

(2) Popular in the Mesara, is lighter in colour, light brown, green or greyish. This material is probably richer in steatite than the first variety since it is softer and soapier.

(3) Pale grey, occasionally merging to yellowish green, with a network of black veins all through. A typical specimen sectioned in Cambridge consisted of serpentine with some talc.

These three are the main varieties. The others are much less common:

(4) Rust brown, due to haematite staining through the oxidization of the iron ore, with grey/black patches.

(5) Rarely used, dark brown, with minute golden particles. This is probably a serpentine but no specimen has been available for analysis.

(6) A few others, not classified in the above groups.

In 1897 Evans published (1897, 328) the information of his discovery of 'plentiful beds of steatite of a translucent greenish hue' in the Sarakina valley above Myrtos on the south-eastern coast. He referred to 'equally prolific' deposits along the coast near Arvi and further west in the Asterousia range, but did not visit these deposits. He was correct in calling the Sarakina material steatite (see Steatite below) but he also gave this name to the ordinary serpentine vases from nearby Arvi. Since then all have followed him in calling almost any Minoan vase 'steatite' if it is not an exotic stone or some form of limestone, marble or breccia. The term steatite must however be restricted to those vases and objects of true steatite, that is talc or soapstone, and serpentine applied to the much greater number which are predominantly of this material.

It has recently been possible to determine what was probably the major source of the commonest variety for the lapidaries. Extensive deposits, indistinguishable in

[1] Boardman (1963 *b*, 15–16) has discussed the misnomer in connexion with the island gems, making the point that most are serpentine.

[2] An entirely typical vase fragment was sectioned by Dr S. R. Nockolds at Cambridge and other typical pieces were examined in Athens by Professor Papastamatiou.

appearance from that used for vases, occur on both sides of a narrow valley called Lepria, at a spot immediately south of the road about 2.3 km west of Gonies in the northern foothills of Mt Ida.[1] Moreover on the flat top of the serpentine hill forming the eastern side of this narrow valley, in the area called Sta Alona, remains of a Minoan settlement were discovered. The pottery dates from MM I (egg-cup bases) to LM, just the period in which serpentine was so extensively used for vases. There would have been an accessible route for getting the material to Knossos, down the Gonies valley past the Minoan villa of Sklavokampos (LM I), on to Tylissos and then down to the coastal plain and Knossos. For the location of these deposits, of

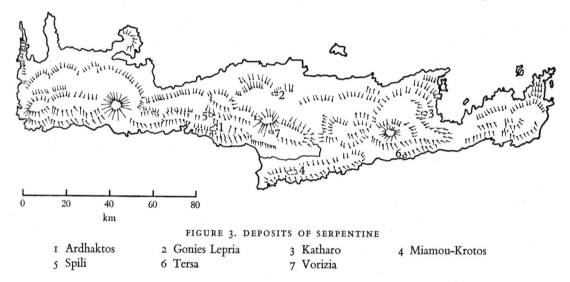

FIGURE 3. DEPOSITS OF SERPENTINE

| 1 Ardhaktos | 2 Gonies Lepria | 3 Katharo | 4 Miamou-Krotos |
| 5 Spili | 6 Tersa | 7 Vorizia | |

small outcrops (much chloritised) near Vorizia on the Zaros–Kamares road and of serpentine at Katharo, east of Lasithi (Faure 1966, 49), see figure 3.

A mass of serpentine forms a hill, occupied by a Minoan site, just west of Spili in the Rethymno province and there is a much larger area south of this in the hills behind and to the west and north of Ardhaktos (Hood & Warren 1966, 166). Another source is on the south coast between Myrtos and Arvi just west of the hamlet of Tersa (or Terzi). Spratt (1865, I, 298) referred to a mass of 'porphyritic trap' along this part of the coast. This serpentine is almost black in colour, with lighter patches, and was not used for vases.

From EM III–MM I onwards serpentine is used for almost all types of stone vases, excluding almost all other materials save the fine hard stones in MM III–LM I. It was

[1] Mr M. Dialinas, who first found this serpentine, most kindly took Dr K. Branigan and the writer to the area and the deposits were examined and samples collected. See Warren 1965 a.

especially used for big vases like bucket-jars, libation tables and lamps, as well as exclusively for Blossom Bowls.[1] The commonest variety occurs with vases all over the island, the network variety is popular round Mallia (and is used for a door jamb in the Palace) and the lighter brown/green variety is very common in the Mesara. The source for vases of this latter variety was most probably in the Asterousia mountains in the rich steatite regions about Miamou and Krotos. This variety is hardly used after MM I/II.

STEATITE

There are seventy vases of steatite and practically all of these date from the EM–MM I period. A number of them belong with the incised chlorite group to the earliest stone vases. The material was undoubtedly chosen because it is so soft, takes a high glossy polish and is attractive in its mottled olive green, purple, brown and creamy white hues.

Two specimens from the Knossos excavations were sectioned and both were almost pure talc (i.e. steatite or soapstone). The purple, green and brown colours, the latter due to iron staining, are from surface material. When mined the deeper veins produce the pure white so much sought after (talcum powder).

Evans found the extensive deposits in the Sarakina valley (1897, 328),[2] and the Allbaugh survey mentioned three to six appearances of talc, but did not give the locations (1953, 50). The map (figure 4) shows the sources known to the writer.[3] The Miamou–Krotos deposits, those on the coast immediately west of the village of Lenda (Faure 1966, 52), and that between Kamares and Grigoria on the southern slopes of Mt Ida probably supplied the material for the Mesara vases, just as the former deposits probably supplied the brown/green Mesara serpentines also.[4] The Katharo mountain deposits east of the Lasithi plain, near Kritsa, which are said to be the largest and finest in the island, and that in the Phodhele region do not seem to have been used in Minoan times.

The material was employed mainly for miniature goblets, small pots, some very small cups with hook handles and a few spouted bowls. It was hardly ever used for

[1] The LH IIIB stone vases from the House of the Shields at Mycenae were correctly called serpentine by Wace (*Arch. Reps. for 1954*, 49).

[2] There is a lump from here in the Ashmolean Museum and the writer has a number of pieces.

[3] Help and information were generously given by Messrs J. Miliarakis, Th. Kouphakes, G. Papadhianos and E. Phoundoulakes in Herakleion, owners of land with talc deposits.

[4] Cf. Faure (1966, 52) who has noted the rich variety of metamorphic rocks on the coast south of Miamou about 5 minutes west of ancient Lasaia and has pointed out that the ancient quarries here must have been a source for the materials of the Mesara stone vases. The quarry site has sherds from the end of EM onwards.

Bird's Nest Bowls (2 out of over 500) and its rarity among other predominantly MM I types suggests it passed out of use in that period. Mochlos has the most steatite vases and there are a few from Trapeza. In MM III–LM I the material of the Harvester Vase and one or two other carved rhytons seems to be black steatite, the softness of which favoured the relief carving.

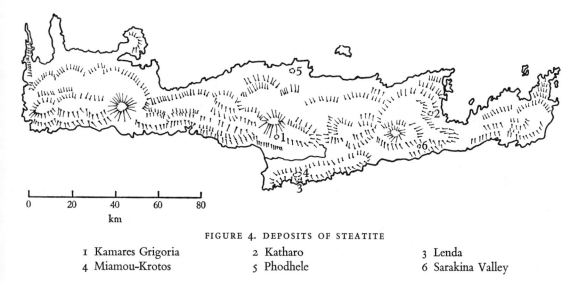

FIGURE 4. DEPOSITS OF STEATITE

| 1 Kamares Grigoria | 2 Katharo | 3 Lenda |
| 4 Miamou-Krotos | 5 Phodhele | 6 Sarakina Valley |

TRACHYTE

One bowl (type 32 E) is made of a hard, grey stone with small, black, crystalline particles throughout. The material closely resembles the igneous lava of the tripod mortars (type 45) and is probably a trachyte. The vase may be of the Minoan period, though there is a difficulty about its context. It might also be a Minoan product. Mr M. Dialinas of Herakleion has explored pillow lavas in the region of Panaghia in the Mesara.

CONCLUSIONS and SUMMARY

The following general conclusions will be seen to be valid from the discussion of the materials above and the chronology and distribution of each type in chapter II. For determining at what times different rocks were in use there are four fairly distinct chronological periods, the first part of EM II (EM IIA), EM II late (EM IIB) to MM I/II, MM III–LM IIIA I (mostly MM III–LM I), and LM IIIA 2–C.

At the end of the chapter table 6 gives a complete record of the materials of each type.

(1) Chlorite or chlorite schist is used for the earliest group of vases (see types 23 A, 33, 37 A), which were made in the first part of EM II. The vases are found in all parts of the island. Steatite is also used at this period.

(2) In the great age of small funerary vases, late EM II to EM III/MM I, a variety of stones was used all over the island, banded tufa, breccia, calcite, chlorite, conglomerate, dolomitic limestone, dolomitic marble, gabbro (occasionally), limestone, marble, schist, serpentine and steatite. Of these banded marble is especially popular at Mochlos and its environs, light mottled brown/green serpentine in the Mesara and network-veined serpentine at Mallia. It is partly on these grounds that the Block Vases (type 4) from A. Marina in West Crete, and Gournia, Palaikastro, Pseira and Vasilike in the east may well be considered imports from the Mesara, where chlorite and serpentine were so much used.

(3) Serpentine of all forms had been used in the early period along with many other rocks. In MM III–LM I, and probably LM II–III A I also, the blue/grey/black variety with green, brown or buff patches was used in enormous quantities, especially for very large vessels (see Serpentine above). By contrast the varieties of softer stones were now hardly in use at all, save for soft white limestone, the other varieties of serpentine and some chlorite. Instead a series of fine and usually hard rocks, some imported, came into use. These were Egyptian alabaster, antico rosso, gabbro, lapis Lacedaemonius, obsidian and rock crystal, and they bear witness to the astonishing technical skill of the lapidaries of this age in not merely producing simple vessels in these materials but adding delicately carved and perfectly symmetrical mouldings of all kinds, cavettos, ribbing, undercutting, flutings, raised bands and coil or rope moulding. In addition to these hard rocks two new stones, mottled and banded polychrome limestone, grey, black, orange and maroon, and white marble-like limestone came into use, mainly for rhytons, but also for chalices and tall goblets (types 34, 15 and 39). Blocks of the imported materials or workers' waste pieces, antico rosso (probably), Egyptian alabaster, lapis Lacedaemonius and obsidian, as well as smaller pieces of other fine stones, are found in the Palaces and their workshops.

(4) In the last period of the Knossos Palace, LM II–III A I, another new stone, white gypsum, came into use (Warren 1967 b). Several vases of this material are found in LM III post-palatial tombs. Most of these tombs are in the environs of Knossos (e.g. Gournes and Karteros Mapheze) and it is most probable that all the gypsum vases are survivals from the last, pre-destruction period of the Palace. Ordinary serpentine vases from post-palatial tombs, notably Blossom Bowls and Grooved Bowls, are survivals from the MM III–LM III A I period, when they are found in abundance.

(5) From the percentages table below we see that serpentine was used for almost

half of all Minoan stone vases. Three rocks, serpentine, chlorite and limestones, account for three-quarters. Twelve rocks make up under 5 per cent of the total, and vases of imported rocks (ninety-seven in number) amount to under 3 per cent.

(6) The relative hardness of the main materials used is of interest. Steatite was the softest (hardness 1.0–1.5 on Mohs' scale), then gypsum (hardness 2), chlorite (2.0–2.5) and the schists, alabaster, and calcite (3), serpentine (2.5–4.0), banded tufa, breccia, limestones, including dolomitic, and marbles, including dolomitic and antico rosso; the dolomitic stones are slightly harder (dolomite is 3.5–5.0). Above these come gabbro and lapis Lacedaemonius, obsidian (6.0–6.5) and finally rock crystal (7), the hardest stone used for vases. Thus we see that at first, in EM II, the softest materials were used, namely chlorite and steatite. From later EM II down to MM I/II steatite is not much used but alongside chlorite harder stones come in, banded tufa, breccias, limestones, marbles, dolomitic rocks and serpentine. At this time too a few vases are made of gabbro which is much harder than the other stones. In the next major period, MM III–LM IIIA, serpentine predominates but the technique of vase making reaches its peak in the use of much harder materials, lapis Lacedaemonius, obsidian and rock crystal. In the last phase of manufacture, LM II–IIIA, work in these hard stones may have gone on, though we cannot show that it did; but we end with gypsum, a material so soft that it can be scratched by the finger nail.

It is worth stressing that hardness is not the only indicator of mastery over materials. Composition of the rock and cleavage are very relevant. Breccias and dolomitic stones have constituents of different hardnesses and textures which would need care in the drilling. Obsidian is not only hard but brittle and must have been especially difficult to work. Serpentine was probably so popular not just because it is attractive and not too hard but also because it is fairly even in composition and so would be less liable to fracture in manufacture.

TABLE 6. MATERIALS

(The figures are for the Minoan types (1–42), including those vases from outside Crete. A dagger indicates an imported stone.)

	Vases
†Alabaster, Egyptian	40
†Antico rosso	27
Banded tufa	58
Basalt	1?
Breccia: (1) Kakon Oros	83
(2) White, maroon, green	53
(3) Others	4

TABLE 6 (*cont.*)

	Vases
Calcite: (1) White	26
(2) Golden and white	32
Chlorite including chlorite schist	505
Conglomerate	2
Diorite	2?
Dolomitic limestone: (1) Pale grey and grey/black banded	3
(2) White and grey patches	39
Dolomitic marble	98
Gabbro	38
Gypsum	37
†Lapis Lacedaemonius	5
Limestone: (1) Coarse white	148
(2) Black veined with white	89
(3) Polychrome banded/mottled	37
(4) Grey and white mottled	16
(5) Grey	46
(6) Banded, pale grey and grey/black	51
(7) Maroon	32
(8) White, marble-like	16
(9) Green/grey	2
(10) Others	48
Marble: (1) Banded light to dark grey, and mottled	121
(2) White	21
(3) Others (grey)	1
†Obsidian: (1) Black	3
† (2) Black with white spots	9
?†Rock crystal	13
Sandstone	5
Schist	13
Serpentine: (1) Bluish grey/black with green, brown or pale buff patches	1256
(2) Light mottled, brown/green	245
(3) Pale grey with network of grey/black veins	87
(4) Rust brown with darker patches	27
(5) Dark brown with tiny particles	19
(6) Others	8
Steatite	69
Trachyte	1
Not known (mostly lids) or not stated	38
Total	3474

TABLE 7. PERCENTAGES OF MATERIALS

(The numbers after each material refer to the particular varieties. See table 6 and the relevant materials in chapter III.)

	Per-centage	Per-centage		Per-centage	Per-centage
Serpentine: (1)	36·10		Dolomitic marble		2·82
(2)	7·04		Steatite		1·99
(3)	2·52		Banded tufa		1·67
(4)	0·78		Calcite: (1)	0·75	
(5)	0·55		(2)	0·92	
(6)	0·23				1·67
		47·22	Dolomitic limestone: (1)	0·09	
Chlorite:	—	14·49	(2)	1·12	
Limestone: (1)	4·26				1·21
(2)	2·55		†Alabaster, Egyptian		1·15
(3)	1·07		Gabbro		1·09
(4)	0·46		Gypsum		1·07
(5)	1·33		†Antico rosso		0·78
(6)	1·47		?†Rock crystal		0·37
(7)	0·92		Schist		0·37
(8)	0·46		†Obsidian: (1)	0·09	
(9)	0·06		† (2)	0·26	
(10)	1·37				0·35
		13·95	†Lapis Lacedaemonius		0·14
Breccia: (1)	2·48		Sandstone		0·14
(2)	1·53		Conglomerate		0·06
(3)	0·12		Diorite		0·06
		4·13	Basalt		0·03
Marble: (1)	3·49		Trachyte		0·03
(2)	0·60		Not known		1·09
(3)	0·03				100·00
		4·12			

TABLE 8. THE MINOAN VASE TYPES AND THEIR MATERIALS

	I		2	3		4					5	6	7	
	A	B		A	B	A	B	C	D	E			A	B
Alabaster, Egyptian
Antico rosso	.	.	1
Banded tufa	.	.	.	3	4	.	.
Basalt
Breccia: (1)	4	.	.	35	1	1	.	.
(2)	5	.	.	27	1	3	.	.
(3)	1?
Calcite: (1)
(2)	.	.	.	1	1	3	.	2
Chlorite and chlorite schist	11	.	.	102	4	27	2	9	6	.	.	4	12	.
Conglomerate	1	.	.	1
Diorite
Dolomitic limestone (1)	1	1	.	.
(2)	7	.	.	8	2	1	1
Dolomitic marble	5	.	.	30	3	1
Gabbro
Gypsum	.	9	1
Lapis Lacedaemonius
Limestone: (1)	2	.	.	3
(2)	1	.	.	48	2	1	.	1	.	.
(3)	.	.	.	2	1	.	.
(4)	1	.	.	2
(5)	1	1	1
(6)	.	.	.	4	2	.	.
(7)	.	.	1	10	1	1	1
(8)	1	.	.
(9)
(10)	.	.	.	8	2	1	.	.
Marble: (1)	.	.	.	6	.	.	.	1	1	.	.	2	.	1
(2)	2	1	.
(3)	.	.	.	1
Obsidian: (1)
(2)
Rock crystal
Sandstone	.	.	1?
Schist	1
Serpentine: (1)	1	.	3	76	2	1	1	6	.	6	116†	50	3	30
(2)	7	1	.	96	9	1	.	1	.	1	2	7	1	2
(3)	.	.	.	4	1	5	11	.	2
(4)	.	.	.	9	1	.	.

† This does not include the two queried Blossom Bowls.

TABLE 8 (*cont.*)

	1		2	3		4					5	6	7	
	A	B		A	B	A	B	C	D	E			A	B
Serpentine: (5)	1?	1	1	.	.
(6)	1
Steatite	.	.	.	2	.	.	.	1	.	.	.	1	.	.
Trachyte
Not known

	7	8		9		10					11		12
	C	A–J	K	A	B	A	B	C	D	E	A	B	
Alabaster, Egyptian	.	.	1
Antico rosso
Banded tufa	1	3	.	.	.	5	1
Basalt
Breccia: (1)	.	7	.	.	.	1
(2)	.	6
(3)	.	.	.	1
Calcite: (1)	.	5	2
(2)	.	6	.	.	.	2	1
Chlorite and chlorite schist	.	24	1	.	.	15	1	6	5
Conglomerate
Diorite
Dolomitic limestone: (1)
(2)	1?
Dolomitic marble	.	10	1
Gabbro	1
Gypsum	.	.	2
Lapis Lacedaemonius
Limestone: (1)	.	2	5	.	1
(2)	.	11	.	.	.	1	1
(3)	.	3
(4)	2
(5)	.	2	.	1
(6)	.	9	.	.	.	1
(7)
(8)
(9)	.	1
(10)	.	3
Marble: (1)	.	14	.	.	.	11	1
(2)	.	1
(3)

TABLE 8 (*cont.*)

	7	8		9		10					11		12
	C	A–J	K	A	B	A	B	C	D	E	A	B	
Obsidian: (1)	.	.	1
(2)
Rock crystal
Sandstone
Schist	1
Serpentine: (1)	7	58	6	23	7	3	64	4	3	8	6	4	8
(2)	.	13	.	.	.	2	1	5	1	.	.	.	2
(3)	.	8	.	.	.	1	3	1
(4)	.	4	1	.	.	2	1	.	3
(5)
(6)	.	2
Steatite	.	8	.	.	.	2
Trachyte
Not known

	13		14	15	16	17						18	
	A	B				A	B	C	D	E	F	A	B
Alabaster, Egyptian	.	.	.	2	1
Antico rosso	.	.	.	1	1?	1?
Banded tufa	.	1	1	.	.	2	.	.	1
Basalt
Breccia: (1)	1	1	.
(2)
(3)
Calcite: (1)	.	1	1	.	.	.	2	.
(2)	1
Chlorite and chlorite schist	2	2	.	.	.	19	.	3	4	.	.	.	1
Conglomerate
Diorite
Dolomitic limestone: (1)
(2)
Dolomitic marble	.	.	1	1	.	1	.
Gabbro	.	4	.	1
Gypsum	2	5
Lapis Lacedaemonius	.	.	.	1
Limestone: (1)	.	.	4	1	3	1	.	.	1	.	1	1	.
(2)
(3)	6
(4)	1	1	.

TABLE 8 (*cont.*)

	13		14	15	16	17						18	
	A	B				A	B	C	D	E	F	A	B
Limestone: (5)	I	.	.	.
(6)	.	.	I	I	.	I	2	I
(7)	I
(8)	.	.	.	4	.	I
(9)
(10)	I	I	.
Marble: (1)	.	I	.	I	.	5	2	.	.	I	.	.	.
(2)	I
(3)
Obsidian: (1)
(2)	.	.	.	2
Rock crystal	2
Sandstone
Schist	I
Serpentine: (1)	.	.	31	4	12	2	4	3	2	22	2	15	.
(2)	6	I	.	2	.	.	I	.
(3)	.	.	I	.	.	2	.	.	I
(4)	I	.	I
(5)	8	I
(6)
Steatite	6	I	.
Trachyte
Not known	.	I

	19		20		21			22				23	
	A	B	A–B	C	A	B	C	A	B	C	D	A	B
Alabaster, Egyptian	.	5	I	.	I	.	.
Antico rosso
Banded tufa	.	.	I	.	2	2	.	.
Basalt
Breccia: (1)	I	.	4	I
(2)	.	.	4
(3)
Calcite: (1)	.	.	2	.	I	I	.	I
(2)	.	.	I	.	2
Chlorite and chlorite schist	.	.	14	.	5	.	.	2(I?)	I	.	.	2	2
Conglomerate
Diorite
Dolomitic limestone: (1)

TABLE 8 (cont.)

	19		20		21			22				23	
	A	B	A–B	C	A	B	C	A	B	C	D	A	B
Dolomitic limestone: (2)	.	.	3	1
Dolomitic marble	1	.	7	.	1	.	.	1	1	2	1	.	.
Gabbro	.	.	4	.	1	.	.	1
Gypsum
Lapis Lacedaemonius
Limestone: (1)	1	.	16	.	2	.	28	1	.
(2)	.	.	7	.	1	.	.	1
(3)	1	.	.	1	.	.	.	2	1
(4)	1	.	.	.	1	.	.	.	1
(5)	.	.	1	.	1	1	4	.	1
(6)	1	.	.	1	2	1	.	.	.
(7)
(8)	1
(9)
(10)	.	.	1	.	3	.	1
Marble: (1)	.	.	6	.	1	.	.	7	2	.	1	.	.
(2)	2	1
(3)
Obsidian: (1)
(2)	1
Rock crystal
Sandstone	3
Schist
Serpentine: (1)	1	.	20	.	6	2	.	7	3	1	2	1	5
(2)	.	.	25	.	7	.	1
(3)	.	.	2	.	1	.	.	1	1	.	1	.	.
(4)	.	.	1
(5)
(6)	1
Steatite	.	.	1	2
Trachyte
Not known

TABLE 8 (*cont.*)

	24								25	26				
	I	II				III	IV	V	I	I	2		3	4
		A	B	C	B/C						A	B		
Alabaster, Egyptian
Antico rosso	.	6(3?)	5	.	.	.	1?	.	1?
Banded tufa	2
Basalt
Breccia: (1)	4
(2)
(3)
Calcite: (1)	1	1
(2)	1
Chlorite and chlorite schist	.	4	1	.	8
Conglomerate
Diorite
Dolomitic limestone: (1)
(2)	1
Dolomitic marble
Gabbro	1
Gypsum
Lapis Lacedaemonius
Limestone: (1)	.	8	15	2	1	2	.	.	.	3	.	.	8	1
(2)
(3)	1
(4)
(5)	.	8(1?)	.	.	.	1	.	.	.	1	.	1	.	.
(6)	1	.	1	.	.
(7)	.	5	2	1	1
(8)	1
(9)
(10)	.	9†	1	1
Marble: (1)	2
(2)	.	3(1?)	.	1
(3)
Obsidian: (1)
(2)
Rock crystal
Sandstone	1
Schist	1
Serpentine: (1)	16	100	36	18	45	3	14	5	5	11	5	2	.	3
(2)	.	5	.	.	.	1	1	.	.	2

† Mostly maroon with white inclusions.

TABLE 8 (cont.)

	24								25	26				
	I	II				III	IV	V		I	2		3	4
		A	B	C	B/C						A	B		
Serpentine: (3)	1	4	.	.	4	.	1
(4)	1
(5)	1
(6)	.	1
Steatite
Trachyte
Not known	.	2	.	.	.	1	1

| | 26 | | | | | 27 | | | | | 28 | | 29 | 30 | |
| --- | --- | --- | --- | --- | --- | --- | --- | --- | --- | --- | --- | --- | --- | --- |
| | 5 | 6 | 7 | | 8 | I | II | | | | A | B | | A | B |
| | | | A | B | | | A | B | C | D | | | | | |
| Alabaster, Egyptian | . | . | . | . | . | . | . | . | . | . | . | . | . | . | . |
| Antico rosso | . | . | . | . | . | . | . | . | . | . | . | . | . | 1 | . |
| Banded tufa | . | . | 1 | . | . | 5 | . | . | . | . | 1 | . | . | . | . |
| Basalt | . | . | . | . | . | . | . | . | . | . | . | . | . | 1 | . |
| Breccia: (1) | . | . | . | . | . | 10 | 1 | . | . | . | . | . | . | . | . |
| (2) | . | . | . | . | . | 3 | . | . | . | . | . | . | . | . | . |
| (3) | . | . | . | . | . | 1 | . | . | . | . | . | . | . | . | . |
| Calcite: (1) | . | . | . | . | . | 3 | . | . | . | . | . | . | 2 | . | . |
| (2) | . | . | . | . | . | 5 | . | . | . | . | . | . | . | . | . |
| Chlorite and chlorite schist | . | . | . | . | . | 45 | 11 | . | 1 | . | 3 | . | 8 | . | . |
| Conglomerate | . | . | . | . | . | . | . | . | . | . | . | . | . | . | . |
| Diorite | . | . | . | . | . | . | . | . | . | . | . | . | . | 2? | . |
| Dolomitic limestone: (1) | . | . | . | . | . | . | . | . | . | . | . | . | . | . | . |
| (2) | . | . | . | . | . | 6 | . | . | . | . | 5 | . | . | . | . |
| Dolomitic marble | . | . | . | . | 2 | 16 | 1 | . | . | . | 4 | . | 2 | . | . |
| Gabbro | . | . | . | . | . | 3 | . | . | . | . | . | . | . | 11 | 2 |
| Gypsum | . | 3 | . | . | . | 3 | . | . | . | 5 | . | 1 | . | . | . |
| Lapis Lacedaemonius | . | . | . | . | . | . | . | . | . | . | . | . | . | 1 | . |
| Limestone: (1) | 2 | 1 | 6 | 8 | 4 | 1 | . | . | . | . | . | 1 | . | . | . |
| (2) | . | . | . | . | . | 9 | . | . | . | . | 4 | . | . | . | . |
| (3) | . | . | . | . | . | 2 | . | . | . | . | . | . | . | 1 | . |
| (4) | . | . | . | . | . | . | . | . | . | . | . | . | . | 2 | . |
| (5) | . | . | 1 | 4 | . | 2 | . | . | . | . | . | . | . | . | . |
| (6) | . | . | . | . | . | 4 | . | . | . | 1 | . | 1 | . | . | . |
| (7) | 1 | . | 1 | . | . | 2 | . | . | . | . | . | . | . | . | . |
| (8) | . | . | . | . | . | 1 | . | . | . | . | . | . | . | . | . |

TABLE 8 (*cont.*)

	5	6	7A	7B	8	I	IIA	IIB	IIC	IID	28A	28B	29	30A	30B
Limestone: (9)															
(10)						4		1		1		1			
Marble: (1)						5					2		2		
(2)						4									
(3)															
Obsidian: (1)															
(2)															
Rock crystal						1									
Sandstone															
Schist						2									
Serpentine: (1)	6		3	1	3	140		24		3	1		3		
(2)						18					1				
(3)	2					9		3							
(4)						1									
(5)						1									
(6)											1				
Steatite							2				4		14		
Trachyte															
Not known						31		1							

	30C	30D	30E	31A	31B	31C	32A	32B	32C	32D	32E	33	34A	34B	34A/B
Alabaster, Egyptian													5	5	1
Antico rosso						1							6	1	
Banded tufa		1		1								1	1		
Basalt															
Breccia: (1)							1						3		
(2)					1		3								
(3)															
Calcite: (1)															
(2)		2		1											
Chlorite and chlorite schist		1		20	1		9	3		1		31	4(2?)	2	
Conglomerate															
Diorite															
Dolomitic limestone: (1)										1					
(2)		3													
Dolomitic marble		2													
Gabbro						1	1						1?	1	

TABLE 8 (*cont.*)

	30			31			32					33	34		
	C	D	E	A	B	C	A	B	C	D	E		A	B	A/B
Gypsum	I	I
Lapis Lacedaemonius	I	I	I	.
Limestone: (1)	.	.	.	2	.	2	I	.	I	I	.
(2)
(3)	I	.	I	.	3	8	.
(4)	2
(5)	.	.	.	I	2
(6)	I	9	2	.
(7)	.	.	.	I	.	.	I	I	.	.
(8)	.	I	I	I	.
(9)	.	.	.	I
(10)	.	I	.	2	.	I	2	2	.	.
Marble: (1)	.	.	.	7	.	I	I	.	I	.	.	.	3	I	I
(2)	I	.	.	.	I	.	.	.	1?	.	.
(3)
Obsidian: (1)	I	I	.
(2)	I	I
Rock crystal	2	I	.
Sandstone
Schist	1?	I	.	.	.
Serpentine: (1)	.	.	.	5	.	29	7	2	17	2	I	2	9	2	.
(2)	.	.	.	3	.	.	6	.	.	2
(3)	.	.	.	2	.	2	2
(4)	I	.	.	.
(5)	.	.	.	I	.	.	I	I	.	.	.
(6)	I	.	.
Steatite	.	.	.	2	I	.	2	2	.	.
Trachyte	I
Not known	.	.	.	I

	34				35	36			37				38		39
	C	D	E	F		A	B	C	A	B	C	D	A	B	
Alabaster, Egyptian	.	.	2	.	2
Antico rosso	I	.	.
Banded tufa	2	2	.	9
Basalt
Breccia: (1)	I	.	.	I	.	I
(2)
(3)

TABLE 8 (*cont.*)

	34				35	36			37				38		39
	C	D	E	F		A	B	C	A	B	C	D	A	B	
Calcite: (1)	2	1
(2)	1	.	1
Chlorite and chlorite schist	2	7	.	1	.	1	1	7	8	23	7
Conglomerate
Diorite
Dolomitic limestone: (1)
(2)
Dolomitic marble	1
Gabbro
Gypsum	1	.	.	.
Lapis Lacedaemonius
Limestone: (1)	1	.	1
(2)	1
(3)	1	1
(4)
(5)	10	.
(6)	1	2	1
(7)
(8)	.	.	2
(9)
(10)	1	.
Marble: (1)	1	.	.	22	.	1	.	.	.
(2)	2	.	.
(3)
Obsidian: (1)
(2)	.	.	.	2
Rock crystal
Sandstone
Schist	2	.	.	.	3	.
Serpentine: (1)	1	9	.	4	1	1	.	.	.	14	.	2	7	2	.
(2)	1	.	.	.	7	.	1	.	.	.
(3)	1	.	.	.	3	.	.	.	1	.
(4)	.	.	.	1
(5)	.	.	.	1
(6)	1	.	.	.
Steatite	2	9	.	3	.	4
Trachyte
Not known

TABLE 8 (*cont.*)

	40	41	42 A	B	C	D
Alabaster, Egyptian	.	.	.	7	.	7
Antico rosso
Banded tufa	.	3	1	1	.	.
Breccia: (1)	.	1	1	1	.	1
(2)
(3)	.	.	1	.	.	.
Calcite: (1)	.	.	1	.	.	.
(2)	1	.
Chlorite and chlorite schist	.	4	3	.	.	2
Conglomerate
Diorite
Dolomitic limestone: (1)
(2)
Dolomitic marble	.	.	.	1	.	1?
Gabbro	.	.	.	5	.	.
Gypsum	.	.	.	3	.	.
Lapis Lacedaemonius
Limestone: (1)	.	.	2	.	1	.
(2)
(3)	.	.	.	1	.	.
(4)	.	2
(5)
(6)
(7)	.	.	.	1	.	.
(8)	.	.	.	1	.	1
(9)	1
(10)
Marble: (1)	.	1	3	2	.	1
(2)
(3)
Obsidian: (1)
(2)	.	.	.	1	.	1
Rock crystal	.	.	.	6	1	.
Sandstone
Schist
Serpentine: (1)	19	6	6	5	.	4
(2)	.	.	.	1	.	.
(3)	.	1	.	2	.	.
(4)
(5)	.	1
(6)
Steatite
Trachyte
Not known

IV

MANUFACTURE

THE EVIDENCE

WORKSHOPS

In spite of the large number of stone vessels the evidence for the details of their manufacture is tantalisingly slight.[1] Nearly all the vases are finished products so give little help. There are however about a dozen unfinished pieces which do provide evidence. Several stone vase makers' workshops have been found but from none were there any tools. At Mallia a room of MM I date gave much evidence for stone-working including obsidian for razors, steatite for seals and chlorite for double-axe moulds, several of which were found. But there was no evidence for stone vase making except the occurrence of a block of white-spotted obsidian, **P 627**, and another block, possibly antico rosso (see chapter III, under these materials). The obsidian may have been for vases, though we have no actual vases earlier than MM III. Another room in the Palace does seem to have been a stone vase maker's workshop because it contained a large unfinished bridge-spouted bowl (Chapouthier, Demargne & Dessenne 1962, 8 and pl. XLIII, HM 2250). The room is dated MM I–LM I. At Zakro Platon (1964b, 350) speaks of a workshop in the Palace (LM IB) with raw material, 'steatite and porphyry'. In the LM I settlement on Mochlos there was an unfinished cup, HM 1172, **P 628**, which demonstrates manufacture on the site (Seager 1909, 280 and fig. 4 top left).

At Knossos five areas indicate that manufacture in stone took place: the Sculptor's Workshop in the Domestic Quarter of the Palace (LM IIIA 2 early), where the unfinished giant amphora with spiralform decoration and the smaller undecorated example were found (type 25); a gypsum vase maker's workshop above the West Magazines (LM IIIA 1) (Warren 1967b); the Lapidary's Workshop on the southern borders of the Palace (Evans 1900–01, 20; *PM*, IV, 595 sqq.; Boardman 1963a, 12–13 and fig. 3); a stone lamp maker's workshop in the MM III House of the Fallen Blocks below the Palace on the south; and an area on the north side of the Royal Road, west of the Arsenal (1957–61 excavations). The evidence given by the first is solely the two amphoras; the gypsum workshop contained parts of un-

[1] Apart from Seager's fairly brief account (1912, 99–100) there has been no detailed discussion of how the vases were made.

finished vases and waste pieces; the third was connected with the manufacture of seals, not vases;[1] the fourth contained the remains of at least eight lamps, one with the wick-cuttings still unmade; the last, not defined architecturally, produced a large series of bore cores (see below) and waste pieces, the latter mostly of steatite. Thus the evidence provided by workshops consists of unfinished vases and unworked raw material or workers' waste.

TOOLS

Although no tools have been found in actual association with stone vase manufacture it is possible that some may have been so employed. Flat-edged chisels and pointed tools (e.g. from LM I contexts at Palaikastro, Dawkins 1923, pl. XXV N, O, P, Q, R, and Gournia, Boyd Hawes 1908, pl. IV 9–18) may well have been used for working the surfaces of the stone (cf. Appendix, pp. 164–5). Deshayes (1960, I, 46–50; II, nos. 182, 185–6, 188, 193) has listed drills with a solid bit from Crete; these might have been used for drilling out vases, as might eight tubular objects from Zakro (HM Zakro cases). Four are from the Palace (LM IB) and four from the LM IB House A in the old excavations (Hogarth 1900–01, 132 and fig. 44 centre). These are conical in shape, solid and sometimes square in section at the thin end, fairly thick at the open, circular end. The thickness of the walls at the open end makes it doubtful if they were for drilling vases. Indeed they may not have been drills at all. There are only two bronze cylinders, from Gournia (Boyd Hawes 1908, pl. IV 66), and there is nothing to suggest these were used as drills.

The negative character of this evidence from metalwork, the rarity of solid drills and no demonstrable tubular drills, strongly suggests that the usual drill for vase manufacture was a hollow reed. They would have been cheap and plentiful. Large reeds several centimetres in diameter are found in abundance in many parts of Crete today and their existence in Minoan times is demonstrated by impressions in roof plaster from EM II houses at Myrtos. In ancient Egypt the hollow reed was usual for vase making (see below).

Certain tools which Casson (1933, 10, 33) showed were used in sculpture and other forms of stonework may well have been present in the vase-maker's kit: punches for getting the new material down to roughly the shape of the vase (see below), knives for detailed work such as the carving of relief scenes on soft stones, and the cutting compass. This instrument seems to have been introduced by the Mycenaeans since it was used for circles (and left its hole in the centre) on the Treasury of Minyas

[1] The 'chessmen' (Boardman 1963 a, fig. 3) may be bore cores, reused as their top ends are moulded. They are not now traceable.

and does not appear in Crete before LM II–IIIA, when we find it in use on the unfinished giant amphora from Knossos and on the Throne Room alabastrons.

Another group of objects used by the lapidary are certain stone grinders. These, approximately spherical but with roughened surface, have a segment cut out by a drill (fig. 5 A), showing that they were probably used as wedges to keep the drill straight inside the vase (fig. 5 B). Several of these stones turned up in the recent Knossos and Palaikastro excavations (Sackett, Popham & Warren 1965, 312 no. 74) and one was published from Gournia (Boyd Hawes 1908, pl. III 5), without explana-

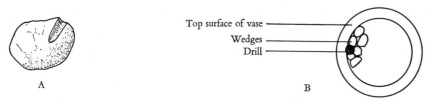

Top surface of vase
Wedges
Drill

A B

FIGURE 5. STONES USED AS WEDGES IN THE DRILLING OF A STONE VASE

tion of its use. Stone grinders (without the segment) were used in Egyptian stone vase making; ten were found at Hierakonpolis (Quibell & Green 1900–2, II, 17, pls. LXII, LXVIII) and there is a fine granite example from Amarna in the Petrie Collection at University College, London (UC 374).

Other stone tools, such as burins or points of emery (see below) or quartz set in a handle or simple pieces of such materials were probably used for engraving details and rubbing down surfaces.

BORE CORES

Further evidence for manufacturing techniques is supplied by the bore cores, drilled out from the interior of vases and usually thrown away. The Knossos excavations

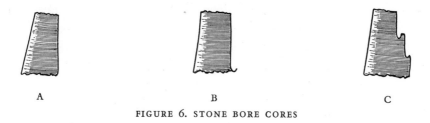

A B C

FIGURE 6. STONE BORE CORES

have for the first time produced a large series, over fifty. The cores are slightly conoid in shape and have very fine horizontal rings produced by the drill (figure 6).

Sometimes the core has a curved edge at the bottom, produced by the drill

(figure 6 B); other cores show where the sides of the drill have cut into them in the removal of other cores, thus demonstrating the thickness of the walls of the drill, not above 2 mm. (figure 6 c). All cores have a roughened bottom surface where they were broken away from the vase with the help of abrasive powder. The Knossos cores are hardly ever above 3.0 cm. in diameter but one in gabbro from the Mochlos town-site has a diameter of 4.3 cm. and preserves its drill grooves (HM 1593, **P 629**).

The number of Knossos cores, fifty-two, is sufficient for the figures relating to their materials to have some significance. Forty-eight are of serpentine and of these thirty-eight are of the commonest variety (see chapter III, Serpentine), and ten of the yellowish green/grey form with a dense network of black veins. The remaining four cores are of banded tufa, breccia and two of gabbro. These figures correspond to the ratio of serpentines to other materials among the whole corpus of vases (table 8).

ABRASIVE POWDER

In the drilling of a vase the actual cutting was not done by the tool but by abrasive powder fed into the hole. It has been assumed that the powder used was emery (e.g. Evans, *PM*, I, 14; Casson 1933, 91 sqq., 36) but it has only recently been possible to demonstrate this. Traces of a blue/grey powder adhering to four of the Knossos bore cores proved on analysis to be emery. The cores were from mixed contexts; one was LM IB–II/IIIA and the others were not earlier. A worker's waste piece of Egyptian alabaster from an LM IA level bore traces of a powder which contained at least some quartz and almost certainly emery. An actual chip of emery came from a mixed level. As yet there is insufficient evidence for determining the source of the Knossian emery. Naxos has the major deposits in the Aegean but the material also occurs on Samos and in several places in western Anatolia (cf. Lucas 1962, 91, 294–5; *Encyclopaedia Britannica, sub* 'Emery').

Emery is very hard (8 on Mohs' scale) and it would have been very difficult to reduce to powder. For all vase materials except rock crystal, powdered quartz or quartz sand would have been sufficient (hardness about 7). Deposits of quartz are not uncommon in Crete and there were many waste pieces from the Knossos excavations. Probably some form of quartz was used in all periods, with emery coming in as well from MM III or LM I. Crushed obsidian may also have been used. But emery was found on bore cores of banded tufa, breccia, gabbro and serpentine, which shows that it was not reserved for only the hardest materials.

HOW THE VASES WERE MADE

By using the evidence discussed above and by citing unfinished vases we may consider that stone vessels in Crete were made as follows (cf. Appendix, pp. 164–5 below).

The lump of raw material was first shaped roughly into the vase form with a chipping hammer or chisel, the marks of which were visible (**P 628**), and then the interior was drilled out, often leaving very marked drill rings (**P 630–1**). The abrasive powder actually did the cutting. This stage, with roughly shaped exterior and drilled interior, is well illustrated by a small bowl from Platanos (**P 632**). Frequently on EM–MM I/II vases a raised pimple is left on the base inside after the drilled core had been detached. Three other vases are instructive here. From Mallia comes the large unfinished jar already mentioned (HM 2250). The body has been finished but the spout and handle left solid. The cutting out of the huge central core, 15.7 cm. in diameter, had only just begun. Also from the Palace comes an unfinished hemispherical bowl. The sides and base are finished but left rough and about half the interior has been removed, in this case not by drilling but with gouger and scraper (HM 2239, Chapouthier, Demargne & Dessenne 1962, 57, and pl. XLIII). Lastly a vase from Palaikastro (HM 628*) has a rough punch-marked exterior, partly finished, and the interior drilled out. The final process in making the vase was to finish and polish the outside, probably with a little oil, after incised or relief decoration, if any, had been added.

For the earliest vases, of chlorite and chlorite schist, made in EM II–III, a flat-edged chisel was used inside as well as outside. The marks of it are usually visible on the inside. Then the tubular drill, very probably a hollow reed, came into use in EM III/M I and was regularly employed. However one point suggests that by MM III–LM I if not earlier some form of metal drill or cutter was also used. Many MM III–LM vases, e.g. Blossom Bowls, have large internal diameters, c. 10.0 cm., whilst that of the Mallia vase is 15.7 cm. It is most unlikely that reeds existed large enough to produce holes of such size. The presence of drill rings on the interiors of even larger vases like Bucket-Jars is even more decisive. Presumably either the vase was rotated under a fixed drill or by being stuck on to a rotating wheel (cf. Appendix) or the vase was fixed and a large weighted drill turned by hand with some kind of bar or crank. The methods with rotating vase would have been easier and more efficient, but the method with fixed vase was that used in Egypt (see below).

From MM III onwards highly skilled and specialised workmanship was employed. Regular, sharp-edged, horizontal flutings decorated material as hard as obsidian, as

in the case of the Zakro chalice (**P 195**). To achieve these the vase was presumably rotated against a fixed cutting instrument with a point of emery, quartz or rock crystal, or such a cutting instrument was applied by hand as the vase was rotated. Again great accuracy of workmanship was required to produce the pyxis lid of rock crystal (type 27 II A) with walls eight-tenths of a millimetre thick! The Zakro rock crystal rhyton was carved in one piece so that perhaps the interior undercutting of the shoulder was done diagonally with a pointed tool of emery, tiny piece by tiny piece, as Quibell records for an amethyst vase in Egypt (1935, 77–8). This rhyton has a separate neck ring of \mathbb{C} profile rock crystal pieces, each joined by a tiny gold cover and each being of incredible thinness. This vase (*Du*, January 1967, cover picture) is the greatest *tour de force* of the Minoan lapidaries, since it required such intricate small-scale work in the hardest material used for stone vessels. For workmanship of this quality to be repeated the world had to wait three thousand years until the great vase-makers of Venice, Prague, France and Germany adorned the tables of the courts of Europe with their products.

In the case of vases with relief scenes, which are made in softer stones, chlorite and serpentine, high artistic as well as technical qualities are apparent. Here the lapidary's art comes near that of the sealmaker who produced complete scenes with human figures, animals or vegetation on very hard stones on such a tiny scale. The sealmaker used a series of fine drills but the carver of relief scenes on vases, working on a larger scale and attempting naturalistic pictures, could not use drills producing obvious circles and segments. He presumably employed some light kind of chisel or knife and pointed tool for picking out the shapes.

Another manifestation of the skill and ingenuity of the MM III–LM I lapidaries is found in the adaptation of fine large Egyptian vases. One of two early Dynastic bowls found at Zakro had its handles fitted with bronze wire loops and its flat collar cut out to make a separate base ring, the remaining part of the collar being carved with MM III–LM I ribbed decoration. The other had a Minoan spout added and its handles removed (see type 43 A 3 and A 8). An XVIIIth Dynasty alabastron from Mallia was inverted and converted, with additions of neck, base and handles, into an elaborate Minoan vase (type 42 B, HM 2393). A vase from Shaft Grave V at Mycenae, certainly an MM III–LM I import (partly because there are no Mainland stone vases at this date), is another XVIIIth Dynasty alabastron adapted and given gold fittings (type 42 B, NM 829). A third alabastron was converted into a magnificent ewer (type 19 B, NM 3080), given a separate neck and handle and exported to Mycenae.

Another technique was the application of gold leaf or bronze. The earliest vases

so far known to have been covered with gold leaf are the eleven limestone miniatures of an MM II cult set from Phaistos (type 20 A). In the original stone the vases are unattractive and their appearance was enhanced by the coverings. In MM III–LM I we know of three vases that were originally covered with gold leaf, the Palaikastro rhyton with a charging boar, the Zakro Peak Sanctuary rhyton (*Du*, January 1967, p. 53, in colour) and a circular table from Knossos (type 38 A). Evans first developed the theory of gold leaf covering for relief vases (*PM*, I, 675–6) and seals and the Zakro rhyton came as a brilliant confirmation. We do not know however, though it remains possible, that all such vases were so covered.

Apart from gold leaf we also have gold fittings to stone vases in MM III–LM I, as on the converted alabastron from Mycenae (NM 829) and on the Zakro rock crystal rhyton. One vase, a fragment of a chalice from Zakro (type 15) was covered with bronze. Two others were covered not with metal but with red paint. These are a white limestone lamp from Phaistos (type 24 II A 3) and a tall lampstand from Palaikastro in the same material (type 24 III). On this the raised band round the top surface was painted.

We cannot say definitely why the Minoans sometimes chose to cover their stone vessels in this way. It may have been purely for decoration, to enhance the appearance, or to provide a cheaper substitute for an all-metal vase (as in the case of clay funerary vases covered with tin foil, probably substitutes for silver vases, Immerwahr 1966).

Finally we may consider pictorial representation of stone vase making from Egypt, to supplement the Minoan evidence, although even in Egypt, with hundreds of thousands of stone vessels, not all the details of the manufacturing processes are known (Quibell 1935, 77–8; Emery 1961, 214–15). This Egyptian evidence must be used with caution for there is no proof that the stages of manufacture were the same in Crete. In at least one particular, finishing the outside of the vase before the interior was begun (Quibell, Emery, *op. cit.*) the Egyptians differed from the Minoans, who worked both areas at the same time. But the Minoan lapidaries may well have used similar tools. The Egyptian pictures (figure 7) show the use of a tool with eccentric handle and attached stone weights for extra rotating power. A third picture (**P 633**) is the most interesting. This shows a workman operating a bow drill (a practice still to be seen at Luxor in the manufacture of ivory ornaments) with a reed split at the top. Beside the stand is a cup with what seems to be a spoon in it. Surely this is the cup for the abrasive powder which was spooned into the drilled hole. This same process with bow drill and split reeds, and cup with abrasive powder, is shown on another XVIIIth Dynasty painting, in the tomb of Neferrompet (time

of Rameses II), at Thebes (Wreszinski 1923, 1, pl. 73 *a*). We have seen above that methods and tools similar to these were probably employed in Crete.

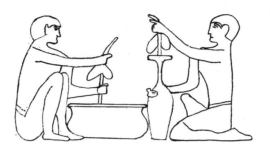

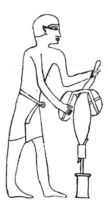

FIGURE 7. OLD KINGDOM REPRESENTATIONS OF STONE VASE MANUFACTURE

Appendix[1]

At Lizard Town in Cornwall the variegated local serpentine is used to make vases, lighthouses and other small ornaments. This industry began in the nineteenth century with a single factory doing large-scale ornamental work such as lecterns and pulpit fittings. The company became bankrupt in the nineteenth century and from its dissolution sprang the one-man businesses of the present day.

The method of making a stone vase is as follows: (1) the block of serpentine is roughly shaped on the knees with a chipping hammer to about the size of the vase;

[1] My informant (June 1966) on the history and methods of stone vase manufacture in the Lizard was Mr H. Curnow. He also very kindly demonstrated various details of manufacture.

(2) the block is then heated and stuck on to a chuck (a lead head) with adhesive (resin, red wax, plaster of Paris and tallow); (3) the lead head is then fitted horizontally to a power lathe (1 h.p.) and the rotating block is cut with a pointed chisel and smoothed with a flat- or round-headed chisel (with tungsten carbide blades) applied against it; the interior is cut out in small fragments, splinters and powder with chisels worked into the rotating block at an angle, i.e. no large core is extracted as in the Minoan method; (4) the completed vase is then polished with two grades of emery powder and water, with jeweller's rouge or crocus powder and finally with a smear of olive oil on a chamois leather. A skilled craftsman makes about six small vases in a day or a large bowl, c. 20.0 cm. in diameter, in two days. It takes as long to polish as to cut the vase. One price given for the purchase of the blocks of serpentine was £2 per ton. The cheapest artefacts sell from about 6s.

This modern method of stone vase manufacture, based as it is on the power lathe, would not appear to have a great deal in common with the Minoan method, based on the hollow reed or metal drill.[1] But if the Minoans did rotate the vase (perhaps stuck on a potter's wheel) in the MM III–LM period then flat-ended and other types of chisel applied to it would have produced the finished object. The external horizontal grooves and flutings suggest that vases were rotated in some way. Perhaps the method with rotating reed and fixed vase was regular in the EM and early MM periods and that method continued together with the more efficient and advanced one of rotating vase and fixed or hand-held chisel or reed or metal drill from MM III–LM IIIA. It would have been natural too to use olive oil in the polishing.[2]

[1] But thirty years ago, before the introduction of the power lathe, the methods were much closer! Casson (1933, 39) recorded that the raw material was fixed in plaster held in a vice on a circular board, which was revolved by a foot-pedal (like a potter's wheel).

[2] Cf. Theophrastus, Περὶ τῶν λίθων, 74, who writes of the oiling of vases on Siphnos to make them dark.

V

USAGE AND PURPOSE

The vases may be grouped into four classes for discussion of their functions: funerary, ritual, palatial and domestic. The groups are not mutually exclusive. The difference between palatial and domestic vases is one of quality, both classes being functional. Many of the ritual vases are from the palaces, and examples of the EM II–MM I funerary types are sometimes found in settlement contexts. The Blossom Bowl (type 5) and the less common Grooved Bowl (type 9) illustrate the slightly arbitrary nature of the divisions, for these are found in domestic and tomb contexts alike. Their purpose is not certain; they are perhaps too fine for ordinary household use, but might have been used for pestling the more precious powders or for storing valuable ointments, perfumes or spices.

To the first category belong the hundreds of small vases from the EM II–MM I tombs, especially in the Mesara and at Mochlos, Palaikastro and Trapeza. The purpose of depositing them with the dead was presumably either to provide objects for the journey to or for life in the after-world or, which is really a ritual usage, for the offering of libations at the time of burial or subsequently. A third possibility is that it was simply the custom to put a dead person's possessions beside him, although this seems more sensible in the case of weapons, tools, seals or jewellery than of small stone or clay vases, the vases hardly being objects of use in the person's lifetime. But it is possible that some of the larger stone vessels found in tombs were used during lifetime, for example the fine large spouted bowls from Mochlos or the open serpentine bowls with lugs or horizontal handles from Galana Kharakia. But these vases are few and the majority of those in the tombs are too small for any practical purpose. Sometimes vases are found in everyday use, as in the MM I–II Palace at Phaistos and during the same period at Mallia, or in the LM IB Block X hoard from Palaikastro, which are otherwise found in the tombs in large numbers: little cylindrical pots, a miniature alabastron, an occasional bird's nest bowl are examples. However these instances are not common and the funerary types are on the whole separate. One type, the teapot, is found in tombs but may also have been of practical use and put with the dead to be of use to them. The teapots are few and copy the domestic and funerary clay forms.

Many of the stone vases were clearly made for ritual usage only. The MM III–LM I

rhytons are the most obvious case. Their presence in the Central Shrine Treasury at Knossos and in that at Zakro bears out what is deduced from their form, with a hole in the base for pouring libations. Some were sent as presents or tribute to Egypt, for this is one of the main Minoan types depicted on the Egyptian tomb paintings. That chalices and ewers were also ritual vases is shown by the Tiryns Treasure ring, the Knossos Camp Stool fresco and their occurrence in the shrine treasuries. The shell vases were almost certainly for the same purpose since triton shells are frequently found in peak sanctuaries. Libation tables occur regularly in sacred caves, on peak sanctuaries (Petsofa) and in the palaces and houses, sometimes suggesting a ritual purpose, like those among the religious furniture of the Temple Repositories. Again some have Linear A inscriptions, religious in character because of their find contexts. The same is true of stone ladles (type 23), though probably not for the earliest ones of chlorite. Block vases or kernoi are another type which very probably have a ritual purpose. They are found in tombs from late EM II–LM III and their peculiar form, cylindrical cups linked in a variety of ways, suggests that they were for libations or offerings (cf. Xanthoudides 1905–6).

The third and fourth classes, Palatial and domestic, are somewhat arbitrarily divided, the former covering large and/or high quality vases found in the palaces, the latter vases of practical purpose found in the villas and towns. Many of the latter were also used in the palaces. Domestic vessels are large open bowls with lugs or handles (type 10 B), bucket-jars (type 14), the deep cups imitating the LM I clay form (type 17 E), the larger jugs (type 22), large stone lids (type 27 II B), rectangular tables on four short legs (type 38), tankards (type 40) and the trachyte mortars (type 45), as well as some miscellaneous vases (type 42). Palatial are the magnificent large basins (type 2), bridge-spouted bowls (type 13), some fine large jugs (type 22), most of the large amphoras or pithoi (type 25), the imitations of early Dynastic vases (type 30 A), the tall goblets from A. Triadha (type 39), many of the miscellaneous vases (type 42) and many of the Egyptian vases (type 43). The large gypsum Throne Room alabastrons are again palatial, though they may have had a ritual function like the rhytons. Lamps are found from MM I to LM III A. The finest examples, such as the Lotus Lamp from Knossos and the two with ivy scrolls in relief on their pedestals, from Knossos and Palaikastro, are also palatial. But lamps were always functional and are found in palaces, villas and towns alike.

VI

THE RELATION OF
THE STONE VASES TO CLAY AND
METAL FORMS

The relationship of clay, metal and stone shapes is complicated and may best be represented in tabular form. From the table it will be seen that over half the types occur only in stone, of which occasional clay imitations are made. The few clay Blossom Bowls or the clay Grooved Bowl (type 9) are instances. Then about another quarter of the stone types is found commonly in clay; often there are no precise parallels between the two media but rather stone and clay types run their separate though generally similar courses. Hence we cannot derive one form from the other but may observe that both flourished at the same time. The remaining quarter consists of stone types which are imitations of clay or metal forms. Teapots for example are not a natural shape in stone and would have been difficult to work. They imitate the common EM II–MM I clay shapes. Vapheio cups are rare in stone and are clearly dependent on clay and metal originals.

The relationship is what one might expect of a particular class of material within a richly productive culture as a whole, namely a major part peculiar to that class and other parts common to or dependent on different classes of material. We see both independence and an interesting interaction with other media which is very typical of the Minoan civilisation. At most points in their history Minoan craftsmen and artists in one medium were aware of what was going on in another.

Note to Table 9

[1] In table 9 references are not given where the classification is obvious, for example that stone Vapheio cups imitate a metal form or that rhytons are found as frequently in clay as in stone. Plain bowls with or without moulded base (types 31–2) are not included since open bowls are so popular throughout all Minoan periods that there is no necessary relation between stone and clay forms. For the relation of various individual miscellaneous vases to clay forms see type 42. Clay and metal parallels are also sometimes discussed in the introductions of the types in chapter II.

TABLE 9. THE RELATION OF STONE TYPES TO
CLAY AND METAL TYPES[1]

Types purely stone	Stone types some-times imitated in clay	Types found in stone or clay	Clay or metal types sometimes imitated in stone
2 Basins	1 A Miniature alabastrons (3)	10 B Bowls with lugs (13)	1 B Large alabastrons (22)
4 Block vases	3 Bird's nest bowls (4)	19 Ewers (14)	11 Spouted bowls with handles at 90° (23)
6 Bowls, curved profile	5 Blossom bowls (5)	20 Jars with incurved or flaring sides (15)	13 B Bridge-spouted bowls (24)
7 Bowls, curved profile and shoulder lugs	9 Grooved bowls (6)	21 Jars with straight/sloping sides (15)	16 Conical cups (LM I clay form)
8 Bowls, carinated profile and everted rim	14 Bucket-jars (7)	22 Jugs (16)	
	15 Chalices ? (8)	24 Lamps (17)	
11 A Type 11 A bowls	23 Ladles (9)	25 Large amphoras or pithoi (18)	17 C Carinated MM cups (25)
12 Bowls with vertical grooves	26 2 B Libation tables (1)	27 11 B Large lids	17 E LM I type cups (26)
13 A Bridge spouted bowls, white inlay	27 1 Small lids	33 C Cylindrical pyxides (see type 33C)	17 F Vapheio cups
	29 A Miniature goblets (10)	34 Rhytons	28 Miniature amphora (27)
17 A EM–MM I cups	30 C Egyptian carinated bowl (11)	37 Spouted bowls (19)	29 B Vasilike Ware goblets (28)
18 Cylindrical jars (cf. n. 15)	40 Tankards (12)	42 A Pedestal bowls (20)	41 Teapots (see type 41)
26 Libation tables (1)		43 1 Egyptian XVIIIth Dynasty alabastrons (21)	
28 Miniature amphoras			
30 A, B, D Imitations of Egyptian vases			
33 Pyxides			
35 Shell vases			
36 Small pots			
38 Tables (2)			
39 Tall goblets			
A	*B*	*C*	*D*

(1) In MM times large red/brown burnished clay examples are found, especially at Phaistos (Levi 1957–8, 197 and fig. 6 (MM I), Pernier 1935, figs. 96, 173, 182 (all MM II), 235 (fill over MM II destruction). They are closely comparable to large clay lamps, save for the absence of wick cuttings. But this type of large clay table is not found in stone, small stone forms being in vogue at this date (see type 26). One stone form, type 26 2 B, has a clay imitation, from Potamies Pedhiadha (N.F.C.), *Arch. Delt.* **15** (1933–5), Παρ. 55 and 57, fig. 13.

(2) In LM I low, circular, painted plaster tables are common (e.g. at Nirou Khani, Xanthoudides 1922) but have no connexion with stone examples.

(3) HM unnumbered F 59 2804, clay imitation from Kamilari.

(4) Mallia (MM I, cemetery), H. & M. van Effenterre 1963, pls. XXV 8476, XXVII 8524. Hierapetra Museum 184*. Xanthoudides 1924, pl. XX 4250 for an example with raised collar.

(5) An LM I clay vase from Gournia (Boyd Hawes 1908, pl. V 12) has a wavy band in relief on the shoulder and is reminiscent of stone Blossom Bowls. There are actual LM I imitations from Kythera (*Arch. Reps. for 1963–4*, 25, fig. 30). There is another, unpublished (mentioned Platon 1956, 416), from the LM IIIB Tepheli tomb. It has a small raised collar and the flowers are roughly incised without understanding of their proper form. Hence it was probably made in LM IIIB, imitating a stone survival.

(6) One clay imitation: FM GR. 18.1907*, from Palaikastro (N.F.C.).

(7) Clay examples: from Mallia, where the type is so popular in stone, Demargne & de Santerre 1953, 83 no. 3 and pl. XXXIX 4 (House Za, LM I); Phaistos, Pernier & Banti 1951, 176–7, fig. 107 left (LM I); Hierapetra Museum 135.

(8) No clay or metal examples survive but a metal prototype for the horizontally fluted and quatrefoil chalices from Zakro (Platon 1964 b, figs. 12–13) and Kea is highly probable. One chalice fragment (HM 2792) was covered with bronze (see type 15).

(9) *PM*, I, fig. 460 in clay.

(10) Hall 1912, fig. 22 D in clay (Sphoungaras).

(11) *PM*, I, fig. 127 f.

(12) From Mallia, Demargne & de Santerre 1953, pl. XLI 3 right (House Za, LM I).

(13) In clay: Mallia, Demargne & de Santerre 1953, 34 no. 7851 and pl. XIV (MM I); Phaistos, Levi 1957–8, fig. 57 a, b (MM II); Kastellos Lasithi, H. W. & J. D. S. Pendlebury & M. B. Money-Coutts 1937–8, fig. 10 5 (MM); Trapeza, *B.S.A.* 1935–6, 34, fig. 8 no. 103 and pl. VIII (MM I); Mochlos, Seager 1912, 86 and fig. 50 no. 91 (N.F.C.).

(14) See type 19 in chapter II.

(15) Comparable with type 21 and of the same date (MM I), but not influencing or being influenced by it, is the standard MM I clay tumbler (dark ground with a white band below the rim or light ground with a dark band; e.g. H. W. & J. D. S. Pendlebury 1928–30, pl. XII a 5, 7, 9; b 2, 5). Similarly, comparable with type 20 are the common MM I tumblers with flaring or slightly incurved sides, e.g. Hatzidhakis 1915, fig. 4 lower row 2nd from left; Xanthoudides 1924, pl. XXXVI B 5018. These clay tumblers do not have the markedly incurved sides sometimes found in stone examples. With type 21 one may also compare, but with the same conditions of no influence, the common MM I one-handled cup with straight, sloping sides, e.g. Xanthoudides, *ibid.* 5102, 5119.

(16) As with type 20 the stone jugs are similar to the clay ones but run parallel rather than coincide exactly in shape. The stone forms regularly have a fairly carinated belly, those of clay a rounded one (e.g. Dawkins 1923, pl. IX a–c).

(17) Large low-pedestalled clay lamps with red/brown paint, highly polished, are found in

MM I–II and are more common than their stone equivalents. Examples: Levi 1957–8, fig. 84, Phaistos Room LXV, MM I B (Phase I a); Boyd Hawes 1908, pl. II 73, Gournia, MM; *PM*, I, 168 and fig. 118a 12, Knossos Vat Room, MM I A; Knossos RR/59/P 289*, P 290*, Knossos, MM II A; Dawkins 1923, 130 no. VIII and pl. XXVIII K, Palaikastro, MM; Demargne & de Santerre 1953, pl. IX 8532, House A, MM I (mainly); H. & M. van Effenterre 1963, pl. XXXI 8534, 8535, Mallia, MM I cemetery; *ibid.* pl. XXXIV 8539 (no pedestal), MM I cemetery; Xanthoudides 1924, pl. XXXVII 5094, Porti, MM; H. W. & J. D. S. Pendlebury & M. B. Money-Coutts 1935–6, fig. 12 3–5 and pl. 6 2, Kastellos Lasithi, MM III. There are a few LM I examples: Boyd Hawes 1908, pl. II 75, Gournia; Chapouthier & Joly 1936, 41 and pl. XXXI c, Mallia Palace; Deshayes & Dessenne 1959, 47, Mallia House Zγ; Bosanquet & Welch 1904, 209 (9 LM I clay imitations, at Phylakopi).

The hand lamp with a straight, stick handle is very common in clay in MM times, rare in LM; in stone a few MM examples are known, rather more are LM I (see type 24 IV). Clay examples: Pernier 1935, figs. 104 right, 119 left, 125 (MM II), fig. 236 (MM), Phaistos; Xanthoudides 1906, pl. X, Khamaizi; 1924, pls. XXXVI a 5015, 5020, XXXVII, Mesara; Dawkins 1923, pl. XXVIII E, F, Palaikastro. Two LM I examples are Deshayes & Dessenne 1959, pl. XII 3 left and upper right, House Zb, Mallia.

(18) HM 20 and perhaps HM 24 may be copying the form of the LM II Palace Style amphora. On the NM Medallion pithos see type 25.

(19) Xanthoudides 1924, pl. VI 5054, from Porti; pl. L 6915, 6892, from Platanos; Seager 1912, fig. 48 28, from Mochlos.

(20) In clay: Demargne & de Santerre 1953, 15 nos. 8545, 8547 and pl. IX, Mallia, Villa A, MM I; H. & M. van Effenterre 1963, pl. XXVII 8546, Mallia cemetery, MM I.

(21) The form is often imitated in clay from LM I B to LM III A. Examples: A. Triadha, Zervos 1956, pl. 541; Kalyvia Mesara, *ibid.* pls. 734, 737; Knossos, *ibid.* pl. 560; Mochlos, Seager 1909, 282, fig. 5.

(22) See type I B.

(23) An LH III/LM III clay form. Cretan examples: Bosanquet 1923, fig. 69 3; Boyd Hawes 1908, pl. X 29, 38; Hatzidhakis 1918, fig. 11 6.

(24) A standard MM I B–II 'Kamares' shape. Examples in all Levi's publications; cf. n. 25. Marinatos & Hirmer 1960, pl. VII. See type 13 B.

(25) The carinated thin-walled cup is standard in MM I B–II. Many are shown in Levi's Phaistos excavation reports. See also Zervos 1956, pls. 333, 338, 340, 375. For the crinkly rim imitations of a metal form see type 17 C.

(26) Cf. Bosanquet 1923, fig. 49 bottom right. There are good unpublished examples from Zakro Building A Rooms I and O. Also Hood 1962, fig. 6, from the Knossos LM I B deposit.

(27) A miniature gypsum amphora imitates the large clay Palace Style amphoras. See type 28.

(28) The standard Vasilike Ware goblet shape (Seager 1905, pl. XXXIV I).

A chronological analysis of these relationships shows that imitations of stone in clay and *vice versa* and the occurrence of forms common to clay and stone began in EM II with miniature goblets, pyxides and teapots. The complexity of the links increased as the number of types increased in late EM II–MM I/II and was maintained in MM III–LM III A, when some six stone forms are imitated in clay, seven clay or metal in stone and six other forms are found in clay and stone. Thus there was no falling off as long as stone vases were made. Table 10 shows the chronology of the

relationships. Columns *B*, *C* and *D* follow the previous table, the numbers are those of the types.

The relationship of stone to metal types is, as one would expect, not especially close. Stone is suitable for forms with thick walls and bases, metal for thin-walled vases displaying plasticity and delicate small-scale decoration. So we find only occasional imitations of metal forms in stone, beginning in M M 1B/II, as with crinkly rim cups (type 17 C), and later with Vapheio cups (17 F) and perhaps Chalices. Stone ewers and rhytons have parallels in bronze and silver (*PM*, II, fig. 411 ewers; III, 89 sq., conical siege rhyton; II, fig. 333, silver bull's head rhyton) but neither medium is dependent on the other. These great vases look equally at home in clay, metal or stone. Again relief scenes on stone, metal or ivory are a form of decoration common to all three media but we cannot say that any one is dependent on or derives from any other. It is possible that the idea of such scenes was taken from wall paintings but if so they have been transformed by the relief technique.

TABLE 10. RELATIONSHIP OF STONE AND CLAY VASE TYPES
BY CHRONOLOGICAL PERIODS

	B	C	D
EM II early	29 A	33 C	29 B, 41
EM II late–MM I/II	I A, 3, 23, 27 I, 29 A, 30 C	10 B, 20, 21, 22, 24, 37, 42 A	13 B, 17 C, 41
MM III–LM IIIA	5, 9, 14, 15 ?, 26 I B, 40	19, 24, 25, 27 II B, 34, 43 I, 17 F, 28	I B, 11, 13 B, 16, 17 E,

Where the lapidary does borrow from the metalsmith's art is in decoration; the sharp-edged, horizontal fluting, arcades, ribbing and vertical flutings on bridge-spouted bowls, chalices, ewers and rhytons are surely taken over from metalwork (cf. the bronze and silver ewers with fluting and arcades, *PM*, II, fig. 411).

One other aspect of the clay and stone relationship is the painted decoration on clay vases in imitation of the appearance of certain stones. It must be stressed that the clay vases, save in special cases like the imitation of the white-spotted obsidian bowl (*PM*, I, fig. 127*f*), do not imitate the *shapes* of the stone vases, but only the appearance of the stones. The following are stones imitated.[1]

Banded Tufa. Pelagatti 1961–2, pl. I Γ 4. Actual clay colours, cream-orange banded. Phaistos Room LV. MM II. For the stone see **P 213**, **P 284**.

[1] The subject has also been discussed by W. Schiering (1960).

Breccia. Dawkins 1923, 13, fig. 8. MM IB, from Palaikastro. Thin white veins outlining thick black veins on a light ground with black flecks. *PM*, I, fig. 176, same pattern, MM IB/II. *PM*, I, fig. 127*b*, white outlining red veins. Knossos Excavations (1957–61), at least a dozen thin-walled bowls and tumblers with a red ground and thick black veins which are occasionally outlined with fine white veins, from MM IB levels; spouted bowl with black ground and red veins outlined with white, MM IIA level. H. & M. van Effenterre 1963, 111 no. 7889 and pls. XIV and XLII 3, Mallia, MM I.

Conglomerate ? Several vases have splodgy white decoration on a dark ground which may be imitating conglomerate or breccia (N.B. only 2 conglomerate vases!). *PM*, I, fig. 127*g*; fig. 179, Knossos and Kamares Cave, MM II. Seager 1916, pl. IV, pithos from Pakhyammos, MM III. *PM*, I, pl. VII (right) shows an MM III jug with a very stylised imitation.

Limestone or Banded Marble. H. & M. van Effenterre 1963, pl. XLII 7889, Mallia cemetery, MM IB–II. Levi 1961–2, fig. 48*d*, Kamilari, MM II. *Ibid.* fig. 162, Phaistos Room LXXIII, MM II. Knossos Excavations, unpublished cup from MM IB level (E 41 A) with brown/black ground and straight thin white stripes. **P 281** for the stone.

Obsidian, white-spotted. *PM*, I, fig. 127*f*, imitation of white-spotted, carinated bowl. See chapter III under Obsidian.

No form of green paint was known to the Minoans so there was no imitation of chlorite or serpentine.

An interesting fact which emerges is that with the exception of obsidian such copyings of the appearance of stones as were made seem confined to the MM IB–II period (eighteenth century B.C.). White spots on a black ground was a fashionable style at least in MM III. The raw material was being imported in MM I–II (chapter III).

VII

VASES WITH RELIEF SCENES

For a pictorial glimpse at certain aspects of Minoan life the stone vases with relief scenes form a most interesting and attractive class of evidence. As for example on the Vapheio gold cups and the Katsamba ivory pyxis we see on the stone vessels ways in which the Minoans chose to represent themselves in action in their world. The relief scenes at once evoke our attention, response and appreciation because they present themselves with an immediate freshness in their capture of the fleeting moment. This captivation is not achieved, as in later art, by the portrayal of known individuals, since the physiognomy of most figures is similar and head and face types are in the same general style from one scene to another. Rather it comes through the impact of the scene as a whole, through a vigorous or definite action momentarily arrested. The 'Harvester' Vase is the supreme example. Together with this delight in human and animal action we find a close interest in marine life, dolphins, octopuses and rock work, and also in nature. Trees, shrubs, flowers and grain are often wonderfully true to life.

The 'Harvester' Vase, the Boxer Vase and the Chieftain Cup come from the royal villa at A. Triadha. From the palace at Zakro we have the Peak Sanctuary Rhyton, originally covered with gold leaf like the charging boar fragment from Palaikastro. From Katsamba there is a handle fragment beautifully carved with a line of argonauts and from a chamber tomb at Mycenae a rhyton with octopuses and rock work. Apart from these pieces and an unprovenienced fragment of a boxer vase in Boston all the rest, twenty out of twenty-eight, come from Knossos.

This distribution and the stylistic uniformity in the representation of human figures and objects suggest that the whole group was produced at the capital and that a few were sent out to the other great sites in the island.

The date of the group is MM III–LM I, although the evidence for this is not as substantial as one would like it to be. No carved relief vases are known from the period of the First Palaces, which gives MM II as a *terminus post quem*.[1] The A. Triadha and Zakro vases come from the LM IB destruction debris of those sites.

[1] We may see the MM I–II libation table with incised doves from Phaistos (Pernier 1935, fig. 113) as a precursor of the relief scenes.

They were thus made in MM III–LM I.[1] Within that period we cannot assign a closer date to the A. Triadha vases, but the naturalistic clumps of flowers on the Zakro rhyton are best paralleled on LM I pottery. Apart from these four only two others are from a dated context, the Knossos Palace destruction debris. One of these is the LM IB Marine Style Ambushed Octopus fragment from the Throne Room. All the rest from Knossos as well as the Katsamba and Palaikastro fragments have no recorded find context and were chance finds. But four of these pieces are carved with LM IB Marine Style decoration of rock work, octopuses or dolphins, which shows that they were made in LM IB. The remainder must be dated MM III–LM I through their close links in subject matter or style with the A. Triadha and Zakro vases. The Mycenae octopus rhyton came from a Late Helladic chamber tomb. It is in the classic LM IB Marine Style and was made in Crete at that time. One octopus, with eight tentacles, is fully preserved, and there is a part of another, both swimming amid rockwork.[2]

That the vases were for religious and ritual purposes is strongly suggested in that all but four are rhytons or fragments of rhytons, one other is a variety of chalice and another is a lid, previously unpublished, with a sacral knot in a floral setting. Further, a number of scenes themselves are concerned with religious ritual: the Zakro rhyton shows a mountain sanctuary guarded by agrimi over the doorway and flanked by poles, or, with St. Alexiou, flagstaffs (Alexiou 1963 a). A fragment from Knossos shows a man bending over a bowl at a mountain shrine and another piece from Knossos, very possibly from the same rhyton as the previous fragment,[3] has part of a procession of men bearing bowls in some kind of offering alongside a building covered with horns of consecration. A finely carved fragment of another rhyton from the same site depicts two men beside a shrine of isodomic masonry with horns of consecration on top, an enclosed tree and the lower part of a pole above. These flagstaffs or poles with rectangular boxes occur again on the Boxer Vase, which suggests that the pugilistic and bull-leaping contests are within a religious setting.

The scenes on the Harvester Vase and the Chieftain Cup are also religious. Sir John Forsdyke produced a brilliant interpretation of the 'Harvesters' as a procession

[1] The materials used for the relief vases are typical for this period: 17 are of serpentine, 2 of serpentine or steatite, 8 of chlorite, 1 of white limestone and 1 of limestone or marble (burnt).

[2] The illustration of this vase in Bossert, *Altkreta*, fig. 275 is wholly inaccurate. See Tsountas 1888, 144 and pl. 7 1.

[3] The scale of the figures in each fragment is about the same, as is the variety of serpentine and the thickness of the fragments. Further there would be a distinct unity of subject: a procession bears bowls of offering up to a shrine (the masonry behind the figures clearly indicates a building rising up a slope) and one figure has already ascended to the shrine and makes his offering into a large bowl or basin.

at the time of sowing and ploughing (Forsdyke 1954). The marchers carry hoes[1] with long osiers temporarily attached and have suspended from their wrists bags probably containing the seed corn. A priest leads them and singers and a sistrum player join in. The whole scene bears a remarkable resemblance to the English Plough Monday processions. Forsdyke also wrote on the Chieftain Cup (1952) in which he expanded Evans' religious interpretation (*PM*, II, 792). A procession of men bearing hides, which have many ritual connexions, is headed by a man who may well be a priest since he carries a lustral sprinkler over one shoulder. They are approaching another figure who holds a staff and whom Forsdyke interprets as the king himself.

These religious scenes form one main class of representation. The other depicts marine life. Much the finest piece is the Ambushed Octopus, as Evans named it, from the Throne Room at Knossos. The creature hides behind an exotic spread of rock work, one eye alone revealed. Strength, naturalism, humour and freshness are delightfully conveyed. Work of this quality is only equalled by the contemporary gold cup from Dendra with its four sinuous, swimming octopuses (Persson 1931, 43 sqq., frontispiece and pls. IX–XI. Marinatos & Hirmer 1960, pl. 197). Another fine LM IB piece is the octopus rhyton from Tomb 26 at Mycenae. It is the best preserved Marine Style stone vase. A peculiar white limestone rhyton, found at Mavro Spelio, Knossos, after the excavations, must be included in this marine group. The lower part is preserved and on it are two octopus tentacles symmetrically placed in high relief. Presumably the rest of the octopus was carved higher on the body of the vase. The finished product must have presented an extraordinary appearance. The surviving tentacles are naturalistic and date the rhyton to LM IB. On two fragments from Knossos dolphins appear swimming amid rock work. A last piece deserving remark is the finely carved handle fragment found at Katsamba. It is probably from a handle made separately for a conical rhyton. A line of argonauts are sailing along. Although their being shown in a line gives a slightly stylised effect to the whole composition the carving is fairly naturalistic and the argonauts are comparable to those, also in a line, on the Dendra gold cup (Persson 1931, pl. IX. Marinatos & Hirmer 1960, pl. 196 below).

Boxing and bull-leaping are the subject of several scenes, both occurring on the Boxer Vase. We have noticed that the flagstaff or pole with box forms part of the scene and suggests that sports had a ritual or religious character. Apart from the

[1] Forsdyke illustrated an Egyptian single-bladed hoe as a parallel for those on the vase, *ibid*. pl. 1c. An even closer parallel (though still not precisely similar), of Late Bronze Age date, comes from Cyprus, Catling 1964, 93 and pl. 8h (called a hammer-adze).

A. Triadha rhyton two or three other pieces depict boxing. One of these is a newly published fragment in Boston (Benson 1966). It is a rim fragment showing a man with long hair and ringlets round his forehead. He reproduces almost exactly an advancing boxer from the lowest zone of the Boxer Vase itself. Much of the rim of the Boxer Vase is restored and it is not impossible that the Boston piece is an actual fragment of the A. Triadha vase.[1] Another boxer fragment, from Knossos (*PM*, 1, 690 and fig. 510. Zervos 1956, pl. 480) is rather worn but seems not so finely carved. Apart from the bull-leaping scenes on the Boxer Vase we find them again on another fragment, previously unpublished, from Knossos.

There remain eight other pieces with relief decoration. One is the well-known bearded archer from Knossos, apparently in a rocky setting. He resembles archers on the silver siege rhyton from Mycenae.[2] There is no reason to suppose that he is un-Minoan. The carving is entirely typical.[3] Another bearded Minoan, probably a priest, occurs on a Minoan seal (*PM*, IV, 216 sqq. and fig. 167 *b*. Zervos 1956, pl. 646 centre). Another fragment from Knossos, enigmatically small, shows a man leading off a billy-goat, with a helmet below; on another there is a superlatively carved figure of a man in excellent relief. This may have been part of a boxing or bull-leaping scene. From Palaikastro the Charging Boar fragment is probably part of a hunting scene, rarely represented in Crete, though now we have the Katsamba ivory pyxis which shows a man running away from a bull with his spear pointed at the horns of the beast (Alexiou 1963 *b*, pls. 156–7). Three other fragments carry relief decoration, though not representational scenes. Two of these have bands of grain in relief, in one case alternating with cable or rope decoration and foliate band.

[1] Benson, *op. cit.* 40, rightly cites comparative measurements of figures from the vase and the fragment and concludes that the latter cannot be from the Boxer Vase but from another very like it, slightly smaller. However several of his measurements indicate differences of only a millimetre or two. On large stone vases such differences are too small to be significant. Nor need the difference in colour be significant. The Boston piece is described as 'rich, dark brown', whilst the Boxer Vase is typical blue/grey/black serpentine. Now the Peak Sanctuary rhyton was found in different parts of the Zakro Palace. Part of it is dark brown, the rest green/grey. The latter is the natural colour of the material, chlorite; the brown colour of the other part is due to the fire which destroyed the Palace.

Having said this we must admit two points, which show that we cannot say for certain whether the Boston piece is from a different or the same vase: (1) We do not know whether the colour difference works for serpentine; indeed the brown colour of the Boston piece suggests it is chlorite (burnt), like the Zakro rhyton, so that it would be from a different vase. (2) The scale of the figures on the fragment and on the top frieze of the vase is, as Benson shows, different. Apparently the top frieze of the Boston vase must be restored as somewhat smaller than that of the A. Triadha vase.

[2] Marinatos & Hirmer 1960, pl. 174. The building defended in this scene, tiered and of isodomic masonry, looks typically Minoan. Cf. Hooker 1967, 269–70.

[3] Note the usual well-muscled body, demarcation of the ribs by incised lines, and the large eye.

The third fragment, recently found in unprovenienced material from Knossos, is carved in low relief with figure-eight shields and interwoven raised bands. These are puzzling, too large to be straps for the shields. Also in the field is a little carved rosette. The piece is a fragment of a rhyton and is burnt. It may well have formed part of the burnt destruction debris of the Palace and, in view of its subject, be of LM II–III A I manufacture.

It was remarked above that the stylistic unity of the relief scenes suggested manufacture of the whole group of vases at one centre, namely Knossos. We must now examine the evidence for this, before going on to consider the spatial construction of the scenes.

A whole range of objects, human figures and details of these are rendered in a style closely comparable from vase to vase. The figures with hides on the Chieftain Cup, the priest or leader of the 'Harvesters', most figures on the Boxer Vase, those on the Boston fragment and the boxer on a Knossos fragment all have hair carved in exactly the same manner with long, thin, wavy tresses. On the Boxer Vase in bands two and four and on the Boston fragment the hair round the forehead is in circular ringlets.[1] The 'Harvesters', the Boxers on the Boxer Vase and on the Boston fragment all have their girdles rendered in just the same manner with a short, curving tail behind. The Chieftain on his cup and the Boxer Vase figures in bands one and three have their leggings in the same style, with incised horizontal bindings (below, n. 1). Isodomic shrine buildings surmounted by horns of consecration all in the same careful technique appear on the Peak Sanctuary rhyton, the Knossos fragment with men bearing offering bowls, and the fragment with two men, a sacred tree and a shrine. The Peak Sanctuary rhyton and the Knossos mountain shrine fragment both have their mountain landscapes rendered in exactly the same incised, impressionistic technique. The leaping agrimi on the lower part of the Peak Sanctuary vase is closely parallel to that dragged off by a man on the Knossos fragment. The Zakro agrimis resting over the architrave of the sanctuary seem to be paralleled on a small piece from Knossos with part of a leg resting on a box pillar and architectural moulding. On the Marine Style vases we find rock work, octopuses and dolphins rendered in exactly the same manner from vase to vase. Finally there is a close general similarity in the representation of the male form,[2] well muscled, sinewy and lissom.

[1] As it is on the figure tethering the bull on Vapheio Cup B. His leggings are bound with horizontal strappings (Marinatos & Hirmer 1960, pl. 184).

[2] It is an interesting fact that all the human figures represented on stone vases are male. This is worth bearing in mind when the ritualistic and religious purpose of the vases is considered.

In the construction of the relief scenes as a whole we are interested to discover how far the Minoans progressed towards an understanding of perspective, of functionally coherent representation in space, or whether they were not concerned with or simply ignorant of such possibilities of representation. Only the completely preserved scenes of the Harvester, Boxer and Peak Sanctuary vases are admissible as evidence, though we may include the Knossos mountain sanctuary fragment as it preserves a main part of a scene.

On the Peak Sanctuary rhyton we find some achievement in realistic spatial relationships. The agrimis are firmly and functionally related to the shrine, the flying bird seems to belong to the shrine and the horns of consecration. But the spatial relationship of the shrine to the scene as a whole is totally undefined; the great building is set suspended over the rocky outcrops. The leaping agrimi below is entirely self-contained, unrelated to the rocks around him. He is a fine illustration of the self-containedness of individual Minoan figures whose 'actions are rarely purposeful and have their fulfilment in themselves' (Groenewegen-Frankfort 1951, 200). He is not really deliberately going anywhere, he is almost floating amid the rocks.

The mountain sanctuary fragment from Knossos shows a more successful understanding of the problem of functional representation in space. Among the rocks a well-conceived line defines the mountain crest and realistically relates the shrine to the rocks and the human figure to the shrine. Without this subtle line all would be suspended in space again.

With the Boxer Vase and the Chieftain Cup the problem of spatial relationship to the setting does not apply, because of the use of a ground-line. The bands of figures are all related to this and there is no depth of field as the figures are only one deep.

An analysis of the spatial coherence of the 'Harvester' Vase is hampered because the lower part of the scene is missing. We do not know whether the figures walk along a single ground line or whether anything happened on the missing lower part of the vase. The continuous procession suggests there was a ground-line.

Even when these limitations are admitted this vase is a masterpiece, displaying much the greatest achievement in Minoan spatial representation. Twenty-seven figures form the thronging, festive procession which extends in a continuous sweep all round the vase. A rhythmic strength runs through the whole scene, giving it unity and coherence. The artist has caught this dynamic rhythm and arrested it for a single moment. His success is astonishing. The individual figures are related to those before and behind and also, wherein lies the real technical quality of the work, to those on each side of them. In a field only a few millimetres deep two, three or even four figures are rendered side by side. Because of this slight depth of field the

figures further away from the spectator are not made smaller but in several cases they are shown in lower relief merging into the background. In this way a kind of perspective is achieved. The basic similarity of posture of most of the procession is varied by the different positions of the sistrum player, the man who turns back and the man who has fallen or stoops. The triumph in comprehension of these spatial relationships is enhanced by the clashing interplay of the long osiers carried by the marchers. We have here the supreme illustration of that intense delight in action and movement momentarily arrested, of what Furumark (1965, 90) has most aptly called the *nunc stans* of Minoan art.

NOTE A
ARTISTS

On the evidence of the distribution, centred on Knossos, and of the close stylistic links between many pieces in points of detail, it was suggested above that one workshop produced the vases with relief scenes. It would be of further interest if we could show that the same artist produced more than one vase and if we could identify different members within the school. However the kind of evidence that is necessary for such analyses, for example minute but subtly different ways of rendering anatomical detail, is meagre. It would, I think, be unwise to conclude that for example two different artists were at work because the ribs of the 'Harvesters' are usually shown by very short diagonally placed incisions and those of the Chieftain by horizontally placed incisions extending over the whole torso. We may note however that the face, hair and figures of the Boxer Vase and the Boston fragment are so alike as to suggest the same artist for both works (unless the fragment is actually from the vase), that the face of the boxer on the Knossos fragment is different in style and suggests another artist, and that the face and figure of the man on the Knossos mountain sanctuary fragment is in turn different from any of these and suggests a third artist. This man may also have produced the Zakro Peak Sanctuary vase since the schemes of the compositions and the renderings of the rocky landscape are much alike.

CATALOGUE

For the details see chapter II.

Chalices (type 15)
HM 341, A. Triadha. The Chieftain Cup.

Lids (type 27)
HM 2554, Knossos. Sacral knot in floral setting.

Plain Bowls (type 31)

HM 2358, Knossos. Fragment, ? with masonry above and an object below.

Rhytons (type 34)

Type A

HM 255, Knossos. Fragment with boxers.

HM 257, Knossos. Archer.

HM 342, A. Triadha. The Boxer Vase.

HM 426, Knossos. Fragment, men bearing vessels below shrine. Probably from the same vase as HM 2397 below.

HM 993, Palaikastro. Fragment with charging boar.

HM 2329, Knossos. Fragment, ? with two boxers.

HM 2397, Knossos. Fragment with man in mountain sanctuary.

HM unnumbered, Knossos. Fragment with figure-eight shields and rosette.

AM AE 1247, Knossos. Fragment with man going left below isodomic shrine with horns of consecration and tree.

AM AE 1569, Knossos. Fragment from bull-leaping scene, with part of a man preserved.

AM 1938. 604, Katsamba. Handle fragment with argonauts.

Boston Museum of Fine Arts, unprovenienced. Fragment with boxers.

Type B 2

HM 2229, Knossos, Mavro Spelio. Part of rhyton with octopus tentacles in high relief.

HM 2764, Zakro. The Peak Sanctuary Rhyton.

HM unnumbered, Knossos. Fragment of top of rhyton with Marine Style rock work on preserved upper part of body.

Type C

HM 184, A. Triadha. The 'Harvester' Vase.

HM 254, Knossos. The Ambushed Octopus fragment.

AM 1938.605, Knossos. Fragment with rock work and a dolphin.

AM 1938.698, Knossos. Fragment with a man dragging off a goat, and a helmet below.

NM 2490, Mycenae Tomb 26. Octopus rhyton, made in two parts.

Type F

HM 256, Knossos. Fragment with part of a man preserved in excellent relief.

HM 258, Knossos. Fragment with pole and box and agrimi? on top.

AM 1924.41, Knossos. Fragment with part of an octopus and rock work.

BM 1907 1–19 207, Knossos. Fragment with rock work and a dolphin.

KSM (unprovenienced material), Knossos. Fragment with grain in relief.

Miscellaneous Vases (type 42)

HM 2169, Knossos. Fragment with foliate band, rope pattern and grain in relief.

VIII

THE HISTORY
AND DEVELOPMENT OF MINOAN
STONE VASES

EARLY MINOAN TO MIDDLE MINOAN I–II

Stone vases are not found in any of the EM I deposits.[1] In view of the extent
of these deposits, especially at Lebena, Kyparissi (Kanli Kastelli) and Pyrgos, it
seems certain that vessels of stone were not made in Crete until after this long period.

Vases of chlorite or chlorite schist with incised and relief-spiral decoration first
appear in the early part of EM II, when Vasilike Ware is found in association with
fine grey incised wares.[2] Only one of this earliest group is from a settlement (Phaistos,
type 33 A). The remainder with known contexts are from burials. Yet the Phaistos
vase shows that even in the earliest period usage was domestic as well as funerary.
The vases are distributed all over the island: in the Mesara at A. Triadha, Koumasa,
Lebena, Marathokephalon, Phaistos and Platanos; in north central Crete at Trapeza
and Vrakhasi; and in the east at Itanos, Maronia, Mochlos, Palaikastro and Zakro.
The well-known stone hut pyxides from Amorgos, Melos, Naxos and Syros should
be contemporary with the earliest Cretan group because of their relief spirals,
fretwork and incised decoration. It is not impossible that they are Cretan. The stone
relief-spiral pyxides in Crete are an integral part of the earliest Cretan group and

[1] For the doubtful position of three pieces from the 'Late Neolithic' houses at Knossos see type 43.

[2] Types 23 A, 33 and 37 A. The clearest stratigraphic evidence comes from Lebena, Palaikastro, Vasilike and
Zakro. At Lebena in Tomb II there was a thick EM I stratum on the floor of the tomb; it merged to EM I–II
above with incised pyxides (about 20!) and Vasilike Ware; the top of this level merged with a mixed
EM II–MM I stratum (Alexiou 1960a; 1961–2. Platon 1959, 370–1. *BCH* 1960, 841–6. *Arch. Reps. for 1959*,
19–20). For the stone vases from this tomb, found immediately above the EM I stratum, and from Tomb IB
(on the floor of the tomb) see type 37 A. At Palaikastro the earliest ossuary produced incised grey wares
and incised and relief-spiral chlorite vases (Bosanquet 1901–2, 290–1. For the vases see types 33 A and F,
and 37 A). At Vasilike the earliest level contained fine grey and Vasilike Wares, above which was the House
on the Hill Top with pure Vasilike Ware (Seager 1905, 1907). At Zakro a cave burial in the gorge produced
a fine grey ware pyxis with incised concentric semicircles, Vasilike Ware and the incised chlorite dog-lid
pyxis (Platon 1964b, 351. Type 33 B). Another dog-lid pyxis came from Mochlos Tomb I, where the only
clay vases were EM II. (Cf. Warren 1965b.) This earliest group seems to be a local invention, quite
unconnected with Egyptian stone types.

Crete has produced a hut pyxis in clay (Banti 1930–1, 171 and pl. XVIId) and several similar to that in stone from Syros (Åberg 1933, fig. 153. *PM*, I, fig. 118 B 3. Xanthoudides 1924, pl. XVIII).

In later EM II through to the end of MM I–II, *c.* 2300–1700 B.C., there is a great increase in the number of types and in the materials used. Many small vessels are found in tombs: miniature alabastrons, bird's nest bowls, block vases, bowls with carinated or curved profile, the same with two lugs on the shoulder, bowls with rim lugs, cups, cylindrical jars, jars with incurved or sloping sides, small jugs, miniature amphoras and miniature goblets, small plain bowls, pyxides, small pots, spouted bowls and teapots. Some types probably began well before the end of EM II, miniature alabastrons, flat bird's nest bowls and block vases for example, since many of these are made of chlorite and have incised decoration. The decoration is usually more elaborate than that of the earlier EM II group and includes white inlays. This suggests stylistic development from the earliest vases. Another pointer towards an EM II date for certain small goblets and for teapots is that they are direct imitations of standard EM II Vasilike Ware types.

Within the Early Minoan period usage is very largely funerary, but this may be due in part to a dearth of evidence from domestic contexts. A miniature amphora came from an EM II level in the settlement on Mochlos, a fragment of an open bowl was found in the EM II settlement at Myrtos, Fournou Korifi (type 31 A), and another fragment in an EM III level at Knossos (type 32 A). In MM I–II stone vessels and lamps were in extensive use in the palaces and houses. They are often the same types as the funerary vases but there are also forms more suitable to domestic contexts: open bowls with horizontal lugs, bucket jars, large lamps and miscellaneous vases. The vases from Mallia and Phaistos form the bulk of the evidence for these Palatial and domestic groups. Their material is nearly always the commonest form of serpentine and the types continue into MM III and later. By contrast the contemporary small funerary vases in a variety of materials seem to cease being made after MM I–II. This coincides with the passing out of use of many of the Mesara tombs and early cemeteries like those of Mochlos and Palaikastro.

Distribution is extensive in north central Crete, the Mesara and the east. Even in the far west there are several examples. The block vase from A. Marina west of Khania was almost certainly brought from the Mesara where it has many parallels, as too were those from Katelionas and Palaikastro in the extreme east. From Khania itself there are several EM II–MM I/II vases as well as an EM II pyxis belonging to the earliest group. Fragments of two stone vases from the islet of Gavdhos were reported by Levi (1927) but they cannot be more closely dated than EM–LM I.

Outside Crete a surprising number of sites received exports: Argos, Asine, Euboea (Oxylithos), Kea, Kythera, Mycenae (Prehistoric Cemetery), Phylakopi and Samos in the Aegean, Gezer in Palestine, and apparently Kahun in Egypt. The export total is forty, which breaks down as shown in table 11.[1]

TABLE 11. DISTRIBUTION AND TOTALS OF EARLY MINOAN TO
MIDDLE MINOAN I–II EXPORTED STONE VASES

Cyclades (Kea 12, Phylakopi 7)	19
Argolid (Argos 2, Asine 2, Mycenae 6)	10
Kythera	6
East Aegean (Samos)	2
Near East (Egypt 1, Palestine 1)	2
Euboea	1
	40

The main receiving centres are those nearest to Crete, with a few outliers on Samos and Euboea and in Egypt and Palestine. The distribution pattern is similar to that of the later period when many more vases were being exported (see below). The trade began in EM III–MM I. This is shown not only by the date of the types but by the contemporary contexts of the pieces from Argos and Asine, the small jug from the Prehistoric Cemetery at Mycenae and a bird's nest bowl from a Middle Cycladic tomb on Kea.

The types exported are as follows: 11 lids, 4 small alabastrons, 4 bowls with rim lugs (three of these are from Kythera, without context, and they cannot be more closely dated than MM I–LM I on the evidence from Crete), 4 superlative bridge-spouted bowls of gabbro from Mycenae, probably of MM II manufacture as they are close in shape to the common bridge-spouted bowls in clay from Knossos, Phaistos and the Kamares Cave, 2 bird's nest bowls, 2 bowls with vertical grooves, 2 carinated bowls with everted rim, 2 jars with flaring sides and 1 block vase, bowl with lugs on the shoulder, cup, jug, libation table, plain bowl with base, pyxis, small pot and spouted bowl.

Of those with known contexts 24 are from settlements and 7 from burials. Of the burials 2 are from contexts contemporary with the *floruit* of the types in Crete (Mycenae, type 22 A; Kea, type 3 A) and 5 are from Late Bronze Age tombs. We cannot say when these five were exported but, as in the case of early Egyptian vases

[1] For the details see the site distribution table and the types in chapter II.

in Crete, it seems more probable that they left at about the time of their *floruit* in Crete rather than later.

From the above evidence can we derive conclusions about the nature of the stone vase trade in this early period, EM III–MM I/II? First there is the predominance of finds from settlement contexts. Here is something of a contrast with usage in Crete, where the majority of vases at this time are from tombs. The types themselves are very representative, with the exception of the four magnificent bridge-spouted bowls of gabbro from Mycenae. These are among the best productions of the Middle Minoan lapidaries and they would have been accounted valuable possessions at Mycenae.

The stone vase exports are part of a wider Minoan economic expansion at this time when Crete first began to play a major part on the international trading scene. Apart from stone exports Middle Minoan I–II pottery was reaching Phylakopi, Kea, Lerna, the Levant and Egypt. It also continued to go to Kythera, where it had appeared first in EM II. The Tod treasure from Egypt indicates an export trade in silver vases.[1] To the island came raw materials, antico rosso from the Peloponnese (type 38), white-spotted obsidian from Gyali in the Dodecanese and apparently black obsidian from southern Anatolia.[2] Metallurgical ideas and techniques were coming from Syria (Branigan 1966; 1967); from Egypt there are some twenty Middle Kingdom scarabs, perhaps brought back as souvenirs by Minoans who had business there. Apart from Melian obsidian there are four Cycladic white marble vases from the Keros–Syros Culture: two cylindrical pyxides from A. Onouphrios (see type 33 c) and two shallow bowls with inturned rims, from Knossos and Trapeza (see type 31 A). Some Cycladic marble figurines were also imported in EM II–III (cf. Renfrew 1964).

This brief account indicates that stone vases of EM III–MM I/II date played a significant part in the first major expansion of Minoan trade.[3] On the nature of the trading mechanisms, whether Minoans took their products abroad or whether foreigners acquired them in Crete, what the system of exchange was, we have little or no evidence. But we have noted some of the foreign products reaching Crete from the Aegean, the Levant and Egypt at this time.

[1] See *PM*, I, 241; II, 132; de la Roque 1950; de la Roque, Contenau & Chapouthier 1953; Kantor 1965, 20–1. Minoan features among the cups are indisputable, so that a beginning for MM IB or MM IIA before 1903 or 1895 B.C. (death of Amenemhet III) needs to be noted.
[2] Renfrew 1966, 66 no. 135, an obsidian blade from the Knossos Vat Room deposit.
[3] For the pottery evidence see especially Smith 1945, Kantor 1947, Hutchinson 1954a. Mr Gerald Cadogan has made a comprehensive study of Minoan foreign relations.

MIDDLE MINOAN III–LATE MINOAN III A
(*c.* 1700–1400 B.C.)

After the major break around 1700 B.C. with the destruction of the first Palaces and the passing out of use of earlier cemeteries we find both continuity and noticeable changes among the stone vases. Most of the domestic types such as bowls with rim lugs, bucket-jars, lamps and several miscellaneous forms continued in use at sites like Mallia, Palaikastro and Pseira. These large vases had almost invariably been made of the commonest form of serpentine, dark blue/black, but down to MM I–II this had been one material amongst many, since so many small forms, of varied materials, were also in fashion. In MM III most of these forms have died out and serpentine becomes by far the commonest stone for vases. Alongside it there is a marked increase in the use of exotic materials. Antico rosso had been once used in MM I (type 38) and white-spotted obsidian was being imported, though vases made of it at this date have not so far been found. Gabbro had been used on a limited scale. From MM III, however, these stones are not infrequently used for fine vases like chalices, shell vases, rhytons and lamps and new stones come in with them for the same types. These stones are imported Egyptian alabaster, lapis Lacedaemonius from Lakonia, obsidian from Anatolia (type 25 B 1), rock crystal and a fine white marble-like limestone. Alongside the continuity of MM I–II large domestic types and a limited survival (types 1 A, 3, 4, 7 B, 8, 12, 18 A, 22 A–B, 26 I, 28) or continued manufacture (7 C, 17 E, 20, 27 I, 31, 32) of small forms many new types begin in MM III.

For MM III itself the stratigraphic evidence is not strong, except from Knossos. There bridge-spouted bowls with shell inlay (type 13 A) and ewers (type 19 A) come from MM III deposits in the Palace, while a bowl with horizontal grooves (type 9 A), a conical cup (type 16), a large lid (type 27 II B) and part of a conical rhyton of Egyptian alabaster (type 34 A) come from MM III levels in the 1957–61 excavations. This is valuable stratigraphic evidence, proving a beginning for these types in this period. The evidence of Galana Kharakia (p. 194 n. 2) suggests that Blossom Bowls also began in MM III.

It is the destruction deposits of the LM IB sites which have produced the bulk of the finds in the MM III–LM IIIA period. This evidence shows that besides the stratigraphically demonstrated MM III new forms others had come into use, namely large Bird's Nest bowls (type 3), Bowls with spout and strap handle (type 11 A), Chalices, large Jugs, Ladles (type 23 B), decorated Lamps, large Amphoras or Pithoi, large Libation Tables, Shell Vases, Tall Goblets and Tankards.

We cannot say, save in a few cases, that these were made in LM I rather than

MM III, so all these new post-MM II types must be dated MM III–LM I. The MM III evidence shows that many were being made in that period. The Marine Style decoration on rhytons and relief foliate bands on lamps show that others were being made in LM IB. We may therefore be reasonably sure that all the new types were being made right through the MM III–LM I period, *c.* 1700–1450 B.C. They are distributed wherever there are sites, palaces, villas, settlements or tombs of this period in Crete. For details of their usage and purpose, see chapter V.

The destruction of all the major sites of the island in LM IB, *c.* 1450 B.C., was the second major disaster for the Minoan civilisation.[1] Only at Knossos was there more or less immediate reoccupation, LM II, by Mycenaeans,[2] but before the final destruction about 1400–1380 B.C. other sites such as A. Triadha, Gournia, Mallia, Palaikastro and Phaistos had been reoccupied on a limited scale, since the earliest reoccupation pottery from them is clearly similar to that from the destruction deposits of Knossos.[3]

During this final 'Knossian' period, LM II–early IIIA 2, *c.* 1450–1400/1380 B.C., many of the MM III–LM I stone vase types are in use in the Palace, and there is one notable innovation. This is the use of white gypsum. Apart from two lids, probably MM IA, from the Knossos Vat Room deposit, the material had not been used for vases before the Knossos destruction deposits. It came in during LM II–IIIA for large alabastrons, one variety of libation table, and some other types. Figure-eight shields in relief and shallow carefully carved spirals are popular for decoration. There was actually a gypsum vase maker's workshop in the Palace just before the destruction (Warren 1967*b*).

In the MM III–LM IIIA period, *c.* 1700–1400 B.C., stone vases were exported in greater numbers than previously and form a substantial part of the artefactual evidence for the 'thalassocracy of Minos' (Warren 1967*a*). That the vases found outside Crete are Minoan products[4] we know not only because of the many parallels

[1] In the writer's view there can no longer be any doubt that this was caused by the great explosion of Santorini. It is to be noted that the traditional archaeological date for the end of LM IB, *c.* 1450 B.C., is well confirmed by the radiocarbon date from wood under the explosion debris on Santorini itself, 1420 ± 100 B.C. See Ninkovich & Heezen 1965, especially pp. 428–9.

[2] For stone vase evidence in support of the presence of Mycenaeans at Knossos in LM II–IIIA early see type I B and pp. 158–9.

[3] For references see Furumark 1941, 104–5. For Mallia add Demargne 1945, pl. x*h*. Deshayes & Dessenne 1959, pls. xlv 5, lix*g*, and others here. H. & M. van Effenterre 1963, pl. xlviii*g* is also near in date. For Phaistos add Levi 1965–6, 381, fig. 78. For the historical point made here cf. exactly Popham 1966, 27–8.

[4] It is not impossible that antico rosso vases (chiefly rhytons) from the Argolid and the lapis Lacedaemonius rhyton from Mycenae were made by a Cretan lapidary on the mainland in LH I–II, since these two materials are from the Peloponnese. But the evidence (many parallels in shape, decorative details and materials in Crete at this date, and also the raw material itself exported to the island) suggests manufacture in Crete and export, like the dozens of other exported vases, chiefly made of Cretan serpentine.

in type and material in Crete but also because stone vessels were not made on the Mainland before LH IIIB and apparently not at all in the Cyclades in the Late Bronze Age, save on Kea. There the settlement at A. Eirene contains strong Minoan elements in the population, if indeed it was not a full Minoan colony.

The distribution of stone vases outside Crete is shown in table 12.

TABLE 12. DISTRIBUTION AND TOTALS OF MIDDLE MINOAN III TO
LATE MINOAN IIIA EXPORTED STONE VASES

Argolid (Argos 6, Asine 2, Dendra 7, Mycenae 44, Nauplion 4)	63
Cyclades (Delos 1, Kea 28, Naxos 1, Phylakopi 11, Thera 1)	42
Lakonia (Kythera 9, Vapheio 5)	14
Attica (Eleusis 1, Thorikos 1)	2
Delphi	2
Troy	2
Syria (Atchana 1, Byblos 1)	2
	127[1]

As in EM III–MM I/II we see that the main areas of contact are the Argolid, the Cyclades and the southern Peloponnese, with a few vases exported to more distant areas. We must also note that the distribution is not entirely representative of the wide commercial contacts of Crete at this time. There are no stone vases from the western Peloponnese, nor from the Dodecanese, though Cretan connexions with both these areas were considerable.[2] The picture of finds in the east Aegean (Troy) is filled out by imported pottery at Miletus, Samos and possibly Chios.[3]

The types exported are typical luxury pieces of this period, as shown in table 13.

Those with known contexts within this period (i.e. known contexts of this period or wider but including it) are distributed between settlements and tombs as shown in table 14.

From these figures we see two things: the exports were more popular for tomb gifts than for settlement usage; but the employment for tomb gifts is much more common than for settlement usage on the Mainland and in Kythera (49 from tombs, 4 from settlements), whereas in the Cyclades the position is reversed (0 from tombs,

[1] The total number of exports from Crete is 172 (40 EM–MM I/II, 127 MM III–LM IIIA, 5 from Kea not datable more closely than MM–LM I). See the distribution table at the end of chapter II.
[2] Cf. Warren 1967a for a summary of the evidence: tholos tombs, Linear A signs, imported pottery and seals, and pithos burials in Messenia; in the Dodecanese the colony at Trianda, possibly one on Karpathos and MM III–LM I vases on Kos.
[3] Warren 1967a. For Miletus see especially Weikert 1959, 182–4 and figs. 1–2 (fig. 2 top left is a fragment of an MM II shell-impressed vase). For Chios see Hood 1965a, 224–5.

TABLE 13. TYPES OF MIDDLE MINOAN III TO LATE MINOAN III A
EXPORTED STONE VASES

Lamps	36
Blossom Bowls	22
Rhytons	15
Chalices	9
Bowls with horizontal grooves or diagonal fluting. Bucket-Jars	5 each
Conical Cups. Lids. Pithoi. Miscellaneous vases	4 each
Bowls with rim spout and strap handle	3
Large Alabastrons. Ewers. Jugs. Ladles. Tankards	2 each
Basin. Bowl with rim lugs. Cylindrical Jar. Libation Table. Plain Bowl with base. Spouted Bowl.	1 each
	127

20 from settlements, 1 votive). This may be due to the accidents of discovery for whereas the cemeteries at Mycenae have been extensively explored, in the Cyclades it is the settlements which we know best. But these differences may indicate varying usages in the two areas. Curiously, of the 15 vases from Late Bronze Age, post-1400 B.C. contexts, 11 are from settlements (Atchana, Kea, Mycenae 8, Naxos) and only 4 from tombs (Dendra). Finally we may note that all types with enough exports for the figures to be meaningful (Lamps, Blossom Bowls, Rhytons, Chalices, Bowls with horizontal or diagonal grooves and Bucket-Jars) can occur in tombs or settlements.

TABLE 14. DISTRIBUTION BY SETTLEMENTS AND TOMBS OF
MIDDLE MINOAN III TO LATE MINOAN III A EXPORTED STONE VASES

Settlements (Byblos 1, Kea 10, Kythera 1, Mycenae 3, Phylakopi 10)	25
Tombs (Argos 6, Asine 2, Dendra 2, Kythera 1, Mycenae 28, Nauplion 4, Thorikos 1, Vapheio 5)	49
Votive (Delos 1)	1

From the information detailed above we may conclude that there was an extensive export trade in stone vases from Crete between 1700 and 1400 B.C. The trade was mainly directed, as it had been earlier, towards the Argolid, the Cyclades and the southern Peloponnese, with a few pieces travelling to more distant sites like Atchana, Byblos and Troy. The vases are luxury pieces, often in exotic stones, often finely decorated with relief carving. They were used in settlements or were accounted

valuable tomb gifts. Some continued in use, for tombs or settlements, after the period in which they had, in all probability, been exported from Crete. Of the organisation of the trade and the systems of exchange we know nothing. We may note however that several raw materials for vases were being imported at this period, from the Peloponnese (antico rosso and lapis Lacedaemonius), the Dodecanese and possibly Anatolia (obsidian) and Egypt (alabaster, perhaps also rock crystal). From Egypt too many XVIIIth Dynasty alabaster vases were arriving.[1] Emery for use in manufacture was also coming to the island, very possibly from Naxos or Samos. To all of these areas went exports of pottery or stone. Perhaps the exports went in exchange for raw materials, but we must be cautious here. Ivory from Syria, copper from Cyprus and tin from an unknown source or sources were also coming to Crete in quantities. Less durable exports such as oil, wine, textiles, wool and timber were probably being sent out. The full trading patterns would be of the greatest interest, but are at present elusive.

POST-PALATIAL LATE MINOAN III

With the destruction of Knossos the long art of stone vase making came to an end in Crete. There are a number of vases from post-1400 B.C. contexts, mostly tombs, but these are almost certainly survivals from earlier periods. Thus we find a fragment of an EM II incised rectangular pyxis with incut ends from an LM IIIB–C level in the Kastelli settlement at Khania, and EM III–MM I/II vases in the LM IIIB–C tombs at Elounda (types 1 A, 3 A, 8, 12 and 21), in an LM IIIA–B tomb at Episkope Pedhiadha (types 6 and 8, Marinatos 1933–5, fig. 5 nos. 5 and 1), in the LM IIIC city at Karphi (types 8, 10 B, 18, 32 D, and 37 B), in the LM III tombs at Khania (types 1 A, 3 A, 20 B), in an LM IIIB tomb at Kritsa (type 32 D), in another at Pakhyammos (type 8 A) and others at Stamnioi Pedhiadha (types 4 E, 32 D).

MM III–LM I and LM II–IIIA early gypsum vases also survive and are found in post-Palatial settlements and tombs at A. Triadha, Liliana Cemetery, LM IIIB (type 28, gypsum), Dhamania, LM IIIB tomb (type 5, Blossom Bowl), Elounda, LM IIIB–C tombs (type 5), Episkope Pedhiadha, LM IIIA 2–B tomb (type 5), Gournes, LM IIIA?–B tombs (types 5, 9, 30 A, 37 D, gypsum, and 42 B, gypsum), Karteros Mapheze, LM IIIB tomb (types 9, 27 II C, gypsum, and 31 C, gypsum), Kephala Khondrou, near Viannos, LM IIIA 2–B settlement (type 24 II A 4), Khania, LM IIIA–B tomb (type 5), Kritsa, LM IIIB tomb (type 5), Mirsine, LM IIIB tomb (type 17 F, gypsum), Palaikastro, LM IIIB reoccupation level in the town (type 5), Stamnioi Pedhiadha,

[1] Amethyst and carnelian for beads and seals were also imported, very probably from Egypt.

LM III, probably B, tomb (type 34) and Tepheli, LM IIIB cemetery (type 3 A, MM III–LM I, Bird's Nest Bowl).

We cannot *prove* that these vases were not made in post-Palatial times, but the evidence is decidedly against it. The EM–MM I/II examples must surely be survivals as the types died out after this early period. The number of MM III–LM IIIA vases is small, twenty-three (of which ten are Blossom Bowls) and each vase has frequent parallels in pre-LM IIIA contexts. It is true that our evidence for post-1400 B.C. settlements is far slighter than for those of earlier date, but such as we have (Kephala Khondrou, near Viannos; reoccupation at A. Triadha, Gournia, Palaikastro, Tylissos and other sites) has produced little or no evidence for stone vases and no evidence at all for new, post-Palatial types. Finally it surely occasions no surprise that a limited number of durable objects should have survived in use after their periods of manufacture.

A few stone vases continued in use beyond the prehistoric age. Two MM I bird's nest bowls were found in the Geometric city of Vrokastro, an EM II incised rectangular pyxis with incut ends in a Geometric context at Dreros, an open spouted bowl in a Geometric cave near Upper Zakro, whilst several libation tables were found in sacred caves at Inatos, Phaneromeni and Psykhro, though at Inatos and Psykhro at least the vases could have been deposited in Minoan times. At Knossos a small EM III–MM I alabastron turned up in a Hellenistic level, and, to take the story further, a sixth-century A.D. bishop's tomb there produced a Blossom Bowl. At Palaikastro a libation table (type 26 2 B) was being used for incense in the nearby church of A. Nikolaos at the beginning of this century.

APPENDIX A

THE MAIN STONE VASE SITES

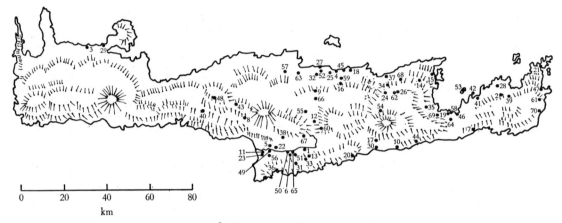

FIGURE 8. THE MAIN STONE VASE SITES

1	A. Eirene	25	Karteros Mapheze	49	Phaistos
2	Akhladhia	26	Kastellos Lasithi	50	Platanos
3	A. Marina	27	Katsamba	51	Porti
4	Amnisos	28	Khamaizi	52	Prasa
5	A. Onouphrios	29	Khania	53	Pseira
6	Apesokari	30	Khondhros	54	Psykhro Cave
7	A. Photia	31	Khristos	55	Pyrgos
8	Apodhoulou	32	Knossos	56	Siva
9	Arkhanes	33	Koumasa	57	Sklavokambos
10	Arvi	34	Krasi	58	Sphoungaras
11	A. Triadha	35	Kritsa	59	Stamnioi Pedhiadha
12	Dhamania	36	Lebena	60	Tepheli
13	Dhrakones	37	Mallia	61	Traostalos
14	Dreros	38	Marathokephalon	62	Trapeza Cave
15	Elounda	39	Maronia	63	Tylissos
16	Episkope Pedhiadha	40	Meixorrouma	64	Vasilike
17	Galana Kharakia	41	Mirsine	65	Vasilike Anoyia
18	Gournes	42	Mochlos	66	Vathypetro
19	Gournia	43	Monastiraki	67	Voros
20	Inatos/Tsoutsouros	44	Myrtos	68	Vrakhasi
21	Itanos	45	Nirou Khani	69	Vrokastro
22	Kalyvia Mesara	46	Pakhyammos	70	Zakro
23	Kamilari	47	Palaikastro		
24	Karphi	48	Patsos Cave		

192

APPENDIX B

LIST OF DATABLE STONE VASE SITES

The list consists of stone vase sites with pottery to date them. Not included are sites without pottery or sites from which stone vases have come but for which there is no recorded find spot or no pottery context of any kind. Stone vases from these sites are dated by reference to parallels in datable contexts. The contexts of vases found on sites outside Crete are stated with the vases in the typology (chapter II).

The dates here assigned are based on the writer's study of the pottery and, in most cases, follow the excavators' dates.

A. Eirene: Tholos E, EM I–II, MM IA, LM reuse.

 Tholos e, EM I–II, MM IA.

 (Xanthoudides 1924, 51–3.)

Akhladhia: MM III–LM I. (Platon 1959, 374–6.)

Amnisos: Villa, MM III–LM I. (Marinatos 1932, 76.)

 'Motel' site (excavations of 1963), LM I.

A. Onouphrios: EM I, MM IA (fig. 108). (Evans 1895.)

Apesokari: Tholos, MM IA (the teapot, pl. 19 6, might be EM III). (Schörngendorfer 1951.)

 Second Tholos, MM I (excavated by K. Davaras in 1963).

Apodhoulou: Villa, MM III–LM I. (Marinatos 1935, 247; Marinatos & Hirmer 1960, 66, 150 and pl. 116.)

Arkhanes/Juktas: MM I, MM II, MM III, LM I. (Xanthoudides 1909. *PM*, I, 153–9 and *PM*, index, 78.)

 Palatial building (excavations of I. Sakellarakis, 1964), LM I.

 Tholos tombs, LM IIIA, EM–MM ossuary (1965 excavations). (Sakellarakis 1965, 1967.)

Arvi: EM I–II (fig. 101).[1] (Evans 1895.)

A. Triadha: Large Tholos, EM I? (Banti 1930–1, 166, fig. 11), EM II, EM III, MM IA–B/II. (Banti 1930–1.)

 Small Tholos, EM II (3-footed pyxis), MM I, MM II, and LM IIIA I reuse. (Paribeni 1904, 677 sqq.)

 Chambers S. of Large Tholos, MM I. (Banti 1930–1.)

 Palace, LM I, LM III reoccupation, plus some MM. The site has never been finally published; references are to preliminary reports. (Halbherr 1902, 1903; Savignoni 1903; Banti 1941–3.)

 Tombs. LM III. (Paribeni 1904.)

Avdhou: Phaneromeni Cave, LM I–Archaic. Three stone libation tables, not traced by the writer and so not included in Type 38. (Marinatos 1937, 222.)

[1] The stone vases are EM III–MM I. Evans published one clay vase (fig. 101) but refers to others (p. 123). There is moreover some doubt about the location of the find spot at Arvi. Hood, Cadogan & Warren in 1962 were unable to find traces of the early burials to which Evans refers. On the site see Hood, Warren & Cadogan 1964, 91–2.

Dhamania: Tomb, LM IIIB. (Xanthoudides 1916.)

Dhrakones: Tholoi Δ and Z, MM IA, with LM III reuse of Z. (Xanthoudides 1924, 76–80.)

Dreros: Geometric (context of EM II pyxis). (Van Effenterre 1948, 40.)

Elounda: LM IIIB–C.[1] (Van Effenterre 1948.)

Episkope Pedhiadha: Tombs, LM IIIA 2–B. (Marinatos 1933–5; Platon 1952a, 473–4; 1952b, 619–24.)

Galana Kharakia: MM I–? LM I. (Platon 1954a, 512; 1956, 416–17; *B.C.H.* 1955, 304 and fig. 18.)[2]

Gournes: Early ossuaries, MM IA. (Hatzidhakis 1915; 1918.)
Chamber tombs, LM IIIA ?–B. (Hatzidhakis 1915; 1918.)

Gournia: EM II (ossuaries and a little under LM I town), EM III (mainly North Trench), MM I, MM III, LM I (Town), LM III (Town and larnax burials). (Boyd 1905; Hall 1905; Boyd Hawes 1908.)

Inatos: Post-Minoan cave (excavated by K. Davaras, 1962) with libation table.

Kalyvia Mesara: Tombs, LM I?, LM IIIA I, LM IIIA 2, LM IIIB. (Savignoni 1904.)

Kamilari: MM I, MM II, MM III, LM I, LM IIIA (bird alabastrons). (Levi 1961–2.)

Karphi: LM IIIC. (*B.S.A.* 1937–8; Seiradaki (Money-Coutts) 1960.)

Karteros Mapheze: LM IIIB. (Marinatos 1927–8.)

Kastellos Lasithi: EM II–III, MM I, MM III, LM I? (H. W. & J. D. S. Pendlebury & M. B. Money-Coutts 1937–8, 6–56.)

Katsamba: Neolithic (House), MM IIIB–LM I, LM II–IIIA I (Cemetery). (Alexiou 1952; 1954b; 1955; Platon 1955, 565; 1956, 415–16; 1957a, 336; 1959, 385; Hutchinson 1954b; Ἔργον 1963, 177–83 (1963 Tomb); Alexiou 1965; 1967).

Khamaizi: MM IA (plus one EM III ?). (Xanthoudides 1906.)

Khamalevri: MM I–LM III surface sherds. (Hood, Warren & Cadogan 1964, 65–6, 96–7.)

Khania: Tombs, LM III (Mackeprang 1938; Jantzen 1951). Settlement, EM II–LM IIIC. (*Arch. Reps. for 1965–6*, 24; Tzedhakis 1965.)

Khondhros: Kephala Settlement, LM IIIA 2–B.

[1] The Στοὺς Τράφους cemetery from which the stone vases came is LM IIIB–C (van Effenterre 1948). It contained *inter alia* several stirrup vases. But of the 9 stone vases 7 are certainly MM I survivals (cf. the incised EM II pyxis from Dreros). Near to Στοὺς Τράφους there was an MM I cemetery at Μαυρικιανό so the stone vessels may well have been handed down as relatively valuable funeral gifts in this poor and backward district. (Van Effenterre is wrong in supposing these stone vases to be actual products of LM IIIB–C, for there are many parallels, all dated to EM III–MM I. See p. 190.)

[2] There is a difficulty in dating burial cave A, which contained about 30 MM pithos burials (there is no evidence for anything earlier than MM I, despite Platon's general remarks about 'pre-Palatial' material). The deposit contained a Blossom Bowl of canonical form (no other instances occur before LM I) and a flattened cylinder seal (an MM III–LM I shape). It also contained a bronze dagger with central midrib, for which Dr Keith Branigan tells me the closest parallels are LM I. Apart from these objects the deposit is homogeneous MM I, but it does look as though burials continued to at least MM III, if not LM I. There is very little pottery (examined by the writer with the generous permission of Professor Platon). One flat plate with interior decoration resembling tortoiseshell ripple might as easily be MM III as MM I.

Rousses, MM III–LM I.[1]

Tourkissa, MM III–LM I.

Boubouli, EM III?–MM I.

(Platon 1957b; 1959, 369; 1960a, 511; Έργον 1957, 85–91; 1959, 134–42; 1960, 202–8.)

Khristos: Tholos X, MM IA. (Xanthoudides 1924, 70–2.)

Knossos: All periods from Early Neolithic to LM IIIC. See table 5 (p. 119) for the main sites. The main publications are: Evans 1899–1900 – 1904–5, 1914; PM, I–IV; J. D. Evans 1964; Furness 1953; Hogarth 1899–1900a; Forsdyke 1926–7; H. W. & J. D. S. Pendlebury 1928–30; Hood 1956; Hood in Arch. Reps. for 1957–61, 1958 (I.L.N.), 1959; 1961–2; 1962 (I.L.N.); Hood, Huxley & Sandars 1958–9; Hood & de Jong 1952; Hutchinson 1956a, 1956b; Palmer 1963a; Boardman 1963a; Platon 1957a, 332–3 (Sellopoulo), 338 (Palace); Popham 1964a, b, 1965, 1966.

Koumasa: Tholos A, EM I–II. Tholos B, EM I–II, EM III, MM IA? (vases 4156, 4234).

Tholos E, MM I. Ossuary Γ, EM II. Area AB, EM II. Area Δ, EM II, MM I. Area Z, MM IA–? B (vase 4977). Settlement, MM I–LM. (Xanthoudides 1924, 3–50.)

Kritsa: Tombs, LM IIIB. (Platon 1951a, 444.)

Lebena: Tomb I, EM II, MM IA. Tomb I B, EM II, MM I. Tomb II, EM I, EM II, MM IA. Tomb II A, EM II, MM IA. Tomb III, EM II, MM I. (Alexiou 1959b, 1960a, 1960b, 1961–2; Platon 1958a, 470; 1959, 370–1; Platon & Davaras 1960a, 509–10; Arch. Reps. for 1958–60. B.C.H. 1959, 742–5; 1960, 841–6; 1961, 886–91.)

Mallia: Palace, EM II, EM III, MM IA, MM IB, MM II, MM III?, LM IA–B, LM III.

Houses. A: mainly MM I with a little MM III–LM I. Others: MM I, LM IA–B, LM IIIA–B.

Quartiers. Γ: mainly MM I with a very little MM III–LM I. Others: EM II, EM III, MM IA, MM II.

Cemeteries, EM II, EM III, MM IA, MM IB, LM I, LM IIIA I.

Khrysolakkos, MM I.

Dépotoirs du Bord de la Mer, MM I.

Sanctuary, MM II.

(Chapouthier & Charbonneaux 1928; Chapouthier & Joly 1936; Chapouthier & Demargne 1942; Demargne 1945; Demargne & de Santerre 1953; Deshayes & Dessenne 1953; Chapouthier, Demargne & Dessenne 1962; H. & M. van Effenterre and others 1963; Poursat 1966.)

Marathokephalon: EM II, EM III, MM IA. (Xanthoudides 1918, Παράρτημα 15–23.)

Meixorrouma: LM I Villa site. (Alexiou 1960b, 272. B.C.H. 1961, 893.)

Mirsine: Early Tholos, EM II, EM III, MM I. (Platon 1959, 372–4;[2] B.C.H. 1960, 281.)

Tombs, LM IIIB. (Platon 1959, 372–4; B.C.H. 1960, 281.)

[1] The Rousses house shrine was almost certainly destroyed in LM IB. Platon dates it MM III–LM IA but the pottery published by him (1957b, pl. 74) contains many footed conical cups typical of LM IB destruction deposits and a typical amphora with many LM IB parallels at Zakro. (Cf. Hood, Warren & Cadogan 1964, 82.)

[2] Dr Platon has kindly allowed me to study the vases from this important north-east Cretan tholos. They include a dark burnished cover ⌐⌐ , EM II, a long-spouted teapot of buff clay, EM II, white on black and white on brown round-bottomed cups, EM III, a hand-lamp, open bowls with handles and a low-bellied miniature jug with incised decoration on the neck (Central Cretan MM IA), and two wheel-made cups, one carinated (MM IB). The tholos contained pithos, larnax and pit burials.

Mochlos: Tombs: I, EM II (see Warren 1965b for Tombs I, VI, XI and XIX). II, EM II, EM III, with MM III–LM I stratified above. III, MM I, MM III. IV, EM III. V, EM II?, EM III. VI, EM II. VIII, EM II, EM III. XI, EM II in north-west corner, MM IA on east side. XII, MM III–LM I. (See p. 59 n. I.) XIII, EM II, EM III, MM IA. XVI, EM II, EM III, MM IA. XVIII, EM II?, EM III. XIX, EM II. XX, EM II, MM III–LM I. XXI, EM III. (Seager 1912.)

 Town: EM I, EM II, EM III, MM I, LM I. (Seager 1909.)

Monastiraki: Settlement, including 'palace', MM I–LM I. (Kirsten 1951.)

Myrtos: Pyrgos site. Surface sherds, EM II–LM I. (Hood, Warren & Cadogan 1964, 93–8.)

 Fournou Korifi, EM II (excavated by the writer).

Nirou Khani: Villa, LM IB. (Xanthoudides 1922.)

Pakhyammos: EM III (pl. II no. Ib; XI no. XIc), MM I, MM III, LM I. (Seager 1916.) LM IIIA 2–B tomb. (Alexiou 1954a.)

Palaikastro: All periods from Late Neolithic (Magasa) to LM IIIC, except MM II and LM IA as distinct phases with deposits. (Bosanquet 1901–2a; Bosanquet 1902–3. Dawkins 1902–3; Tod 1902–3; Dawkins 1903–4. Curelly 1903–4; Dawkins 1904–5, 1905–6; Bosanquet 1923; Dawkins 1923; Hutchinson, Eccles & Benton 1939–40; Sackett 1963; Sackett, Popham & Warren 1965.)

Patsos: Cave of Hermes Kranaios, LM I sherds. (Alexiou 1960b, 272; Hood & Warren 1966, 185–7; Warren 1966.) The Bird's Nest Bowl (Alexiou 1960b, 272; *Arch. Reps. for 1960–1*, 25) has not been traced by the writer and so is not included in type 3.

Petras Siteia: MM–LM I (fig. 2, EM III?). (Bosanquet 1901–2b, 282–5.)

Phaistos: Neolithic, EM I, EM II, EM III, MM I, MM II, MM III?, LM IB, LM IIIB. (Pernier 1935; Pernier & Banti 1951; Levi 1952–4; 1955–6, 292–302; 1957–8; 1961–2; Fiandra 1961–2; Pelagatti 1961–2.)

Platanos: Tholos A and annexes, EM II, MM IA, MM IB (vase 6862).

 Tholos B, EM III (vase 6913), MM IA–B.

 Tholos Γ, EM II (vase 6873), MM I.

 Other burials, EM II (vase 6894), MM I.

 (Xanthoudides 1924, 88–125; Platon 1953, 492; 1955, 568 (stone and clay vases from Platon's annex to Tholos A).)

Porti: Tholos Π, EM II (Xanthoudides 1924, pl. XXXIV top row), EM III? (vase 5062), MM IA, MM IB (vases 5064, 5102).

 Ossuary, MM IB/II.

 (Xanthoudides 1924, 54–69.)

Prasa: House A, MM I, MM III–LM I. House B, MM III–LM I. (Platon 1951b.)

Pseira: EM II, EM III, MM I, MM III, LM IB. (Seager 1910.)

Psykhro Cave: MM IA–B (fig. 33), LM I, LM IIIC, Geometric, Archaic, Roman. (Hogarth 1899–1900b; Boardman 1958; 1961.)

Pyrgos: LM I burial. (*PM*, II, 75.)

Siva: North Tholos and South Tholos, EM I–II (fig. 20), EM II (fig. 24), EM III (sherd with white painted bands), MM I? (beginning of barbotine decoration). (Paribeni 1913.)

Sklavokampos: Villa, LM IB. (Marinatos 1939–41.)

Sphoungaras: Neolithic deposit. Deposit A, EM II, EM III. Deposit B, EM II, MM I. There are also MM I, MM III and LM I pithos burials, but the stone vases are from the early deposits. (Hall 1912.)

Stamnioi Pedhiadha: LM III (probably B). Stone vases all survivals. (Platon 1952a, 475; 1952b, 624–8.)

Tepheli: LM IIIB. Stone vase from cemetery but not in a context. (Platon 1956, 416.)

Traostalos: MM I Peak Sanctuary. For the site *Arch. Delt.* **18**, 1963, Χρονικά, 313.

Trapeza: Neolithic, Subneolithic, EM I, EM II, EM III, MM I (with some imported MM II). (H. W. & J. D. S. Pendlebury & M. B. Money-Coutts 1935–6, 1937–8.)

Tylissos: EM II (1934, pl. XX 2), EM III, MM IA–B, LM IA–B, LM III (1921, 83–6). (Hatzidhakis 1921, 1934.)

Vathypetro: Villa, LM IB. (Marinatos 1949, 100–9; 1950; 1951, 258–72; 1952; 1953, 298; 1955, 309–10; 1956, 223.)

Voros: Tholos A and Tholos B, MM IA, MM IB/II. (Marinatos 1930–1.)

Vrokastro: MM I, LM III, but mainly Geometric. (Hall 1914.)

Zakro: Palace and Houses, EM III–MM I, MM III, but mainly LM IB.

Pits, LM IA.

Cave burials in Gorge, EM II, EM III, Geometric.

(Hogarth 1900–1; Platon 1963; 1964a, b; Έργον 1961, 221–8; 1962, 159–70; 1963, 159–77.)

APPENDIX C

MUSEUM CONCORDANCE

Stone vases are sometimes cited in publications with their museum numbers (e.g. in Xanthoudides, *Vaulted Tombs of Mesara*). The concordance lists museum, type, drawing and photograph numbers to enable any vase so published to be traced in the typology (chapter II). Unnumbered vases (chiefly Herakleion and mostly unpublished) are not included unless they are illustrated here. Egyptian and Syro-Palestinian vases found in Crete are included, as are, in separate lists, Egyptian vases from Egypt and Cycladic vases from the islands used as illustrations.

HM = Herakleion Museum (Stone Catalogue). D = Drawing. P = Photograph. G (e.g. 43 G) = HM Glass Catalogue. S (e.g. 110 S) = HM Sculpture Catalogue.

HERAKLEION MUSEUM, CRETE

HM	Type	D	P	HM	Type	D	P
1–2	3	.	.	32	24 II A 2	.	.
2 BIS	27 I B	.	.	33	24 II B	.	.
3	30 A	.	.	34	34 A	.	471
4	8 G	.	135	35	34 A	.	465
5–6	5	.	.	36	34 B 2	.	485
7	30 A I	.	404	37	34 B I	.	482
8	24 II C	.	.	37 BIS	34 B	.	.
9	18 A	.	.	38	34 B I	.	479
13	see 33 C	.	458	39	34 B I	.	483
14	see 33 C	.	459	40	34 B 2	.	484
15	25	.	.	41	34 B 2	.	.
17	8 C	.	.	42	34 B I	.	481
17 BIS	27 I B	.	.	43	34 B	.	.
20	25	.	322	43 G	42 B	.	579
21	42 B	.	578	44	34 E	.	.
21 BIS	27 II B	.	578	45	35	.	.
22	25	.	323	46	43 J	.	617
23	25	.	324	47	43 I	.	608
23 BIS	27 II B	.	324	48	43 H	.	605
24	25	.	.	49	42 B	.	580
25	14	.	.	50	22 C	166	281
27–30	24 II B	.	.	51	20 C	.	.
31	24 II C	.	.	52	42 B	.	581

HM	Type	D	P	HM	Type	D	P
53	32 E	244	448	134	26 7 B	183	345
54	26 2 B	.	.	134 BIS	33 A	.	.
55	26 6	.	344	134 A–B	37 A	.	.
56	43 A	314	592	135	37 A	282	531
57	3	.	.	136–7	37 B	.	.
59	32 D	.	447	138	8 C	.	.
60	25	.	325	139	6 A 1	.	.
61–2	1 B	.	.	140–3	3	.	.
63–4	27 II C	.	.	144	6 B 2	.	.
65	38 A	.	549	145	12	113	184
66	24 II B	.	.	146	20 B	.	.
72	38 A	.	.	147	28	.	364
73–6	24 II A 13	.	.	148	4 A	.	42
77–8	24 II A 1	.	.	150	9 A	.	.
80–2	5	.	.	151	8 C	.	.
83	9 A	.	.	151 G	18 B	.	.
84	9 A	100	.	152	3	.	.
88	8 J	91	141	153	27 II B	.	.
89–90	40	.	.	155	24 IV	.	.
91	41 C	.	.	168	7 B	.	.
92	40	.	.	168 BIS	27 I B	.	.
93	22 D	.	.	169	7 C	.	.
94	5	.	.	172 1	27 I C	.	.
96	7 B	.	.	172 2–4	27 I A	.	.
98	3	.	.	174	8 B	.	.
99	45	.	625	175	43 I	.	607
101	24 II B	.	.	176	43 H	.	.
102	26 8	.	346	177	35	.	498
103	34 A	.	468	178	30 B	226	406
104	24 II B	.	.	179	28	.	359
105	5	.	.	179 S	43 J	.	.
106	24 III	.	.	180	17 B	.	215
108 S	43 J	.	.	181	3	.	.
109–10	37 B	.	.	182	24 II B	.	.
110 S	42 C	.	587	183	24 II A 1	.	.
115	40	.	.	184	34 C	.	.
125	7 B	.	.	184 BIS	27 II A	.	.
126	42 B	311	582	185	2	.	.
127	24 II A 1	.	.	186	24 V	.	319 a–b
128	43 F	324	600	187	23 B	172	291
133	24 II A 10	.	.	188	26 I A	.	328

HM	Type	D	P	HM	Type	D	P
189	26 I F	.	336	243	3	.	.
190	26 I G	.	337	254	34 C	.	.
191	26 I C	.	.	255	34 A	.	472
192	26 I D	.	.	256	34 F	.	496
193	22 D	169	285	257	34 A	.	473
194	13 B	.	.	258	34 F	.	495
195	20 A	.	.	259	34 D	.	490
196	3	.	.	261	42 A	.	.
197	21 C	.	.	263	43 J	.	.
199 1–3	27 I B	.	.	265	41 C	.	562
199 4–10	27 I A	.	.	271	26 I A	.	327
199 11	27 I C	.	.	272	26 I A	175	.
203	26 I C	.	.	273–4	26 I A	.	.
204	21 C	.	.	280	42 B	.	583
205	21 C	.	271	290–1	5	.	.
206–7	21 C	.	.	292	3	.	.
208	31 A	.	.	292 BIS	27 I B	.	.
209	24 II A 3	.	.	293–9	3	.	.
210	24 II A 12	.	.	301	7 C	49	.
211	24 I	.	293	303	3	.	.
212–13	3	.	.	304	6 C	34	81
214	26 I D	.	335	305–7	3	.	.
215	26 8	.	.	308	6 A 2	24	.
216	26 I B	.	331	309	I A	.	.
217	26 I B	.	.	311	3	.	.
218	8 C	.	.	313 1–4, 10–14	27 I B	.	.
219	I A	.	.				
220	3	.	.	313 5–6, 8–9, 15	27 I A	.	.
221	6 A 2	.	.				
223	4 A	.	.	313 7, 16	27 I C	.	.
224	42 A	.	573	315	27 I C	.	.
225	26 I B	.	.	316	26 I G	178	.
226	36 A	265	507	317	18 A	.	.
227	22 D	170	286	317 a	37 D	.	547
228	22 A	.	.	318	37 B	.	542
230	27 II A	.	.	319	27 I A	.	.
235	33 A	.	451 a–b	320	II A	.	179
236	8 D	74	120	321	10 B	.	.
237	3	.	.	322	26 5	.	.
238	6 C	.	.	323	24 II A 9	.	.
242	27 I B	.	.	324	14	.	.

HM	Type	D	P	HM	Type	D	P
325	26 7 B	.	.	379	20 B	.	.
326	24 IV	.	.	380	4 E	.	55
333	26 I E	.	.	381	30 D	.	417
334	4 A	.	41	382	30 D	.	418
335	34 A	.	.	384	42 C	.	.
336	34 A	.	467	391	43 D	.	598
337	34 A	.	.	402–4	45	.	.
338	39	.	.	405	38 B 2	.	.
339	39	299	551	423	9 B	.	150
340	30 D	.	416	424	36 B	268	513
341	15	.	197	426	34 A	.	474
342 = 498	.	.	469	434	24 II A I	.	.
= 676	34 A	.	.	435	24 III	.	.
343	43 I	.	606	436	24 II B	.	.
345	25	.	321	437	24 II C	.	.
346	8 K	.	145	438	26 2 B	.	.
347	21 B	.	270	439	24 II A 6	.	.
348	17 E	.	226	440	3	.	.
349	22 C	.	.	441	31 A	236	.
350	30 A	218	394	442	5	.	.
351	30 A	219	.	443	26 5	.	.
352	30 A	220	395	444	17 F	148	237
353	30 A	.	396	445	17 E	.	.
354	42 B	.	575	446	17 E	142	227
355	42 B	.	576	447	4 E	.	.
356	41 B	.	559	448	4 B	.	47
357	24 II A 2	.	297	450	31 A	.	.
358	24 II A 7	.	.	451	24 V	.	317
359	24 II A 7	.	306	452	24 V	.	318
360	35	.	497	453–4	22 A	.	.
361	27 I C	191	350	455	37 B	.	.
362	28	.	.	456	7 B	.	89
363–8	3	.	.	457	7 B	.	.
370	6 B 2	.	79	458	7 B	.	90
371–2	32 A	.	.	459	7 B	.	.
373	I A	.	I	460	6 A 2	.	73
374	10 C	.	171	461	6 A 2	25	74
375	11 B	.	181	462	6 C	.	.
376	17 A	120	199	463	6 A 2	.	.
377	17 C	.	218	464	6 A I	.	.
378	20 B	.	256	465–6	3	.	.

HM	Type	D	P	HM	Type	D	P
467	6 B 2	.	80	555	3	.	.
468	3 B	.	30	556	22 A	.	.
469	6 A 2	26	.	557	8 C	.	.
470	41 C	.	561	560	41 B	.	.
471	8 D	.	.	561	24 II C	.	.
472	31 A	.	.	562	26 7 A	.	.
473	32 A	.	.	564	6 C	.	82
478–9	27 I A	.	.	565	6 A 2	.	.
480–4	27 I B	.	.	576	26 2 A	.	.
485	27 I A	.	.	583	8 K	95	.
486	27 I B	.	.	585	26 3	.	341
487	27 I C	.	.	587	19 A	.	.
488	27 I A	.	.	590	43 E	322	599
489	27 I B	.	.	591	30 C	228	409
491 α	17 C	.	221	598	13 B	.	189
491 β	17 C	.	222	599	14	.	192
491 γ	13 B	.	190	600	43 J	.	618
491 δ	33 D	.	.	601	43 I	.	609
491 ε	33 C	.	.	602	43 I	.	610
491 ζ	33 D	.	461	603	43 I	.	611
492	24 II A 4	.	.	604	43 I	.	612
493	24 II A 9	.	.	605	43 J	.	619
498 = 342				606	43 I	.	613
499	34 A	.	.	607	43 J	.	620
502	43 I	.	616	608	43 J	.	621
503	33 A	.	453	609	43 J	.	622
504	16	.	.	610	7 B	.	.
505	35	.	499	611	43 G	325	602
509–10	27 I C	.	.	612	24 II A 2	.	.
511 1	27 I B	.	.	613	24 II A 2	.	298
511 2	27 I B	.	.	614 1–3	27 I A	.	.
512	27 I B	.	.	614 4	27 I B	.	.
544	38 B 2	.	.	616	24 II B	.	.
545	10 D	III	176	617	24 II C	.	.
546	22 B	.	280	618	26 2 B	.	.
547	42 B	.	577	619	12	.	182
548	4 E	.	.	620	10 A	.	.
549	3	.	.	621	4 A	.	43
550	12	.	.	622	4 A	.	44
551–3	3	.	.	623	5	.	.
554	1 A	.	2	624	5	20	.

HM	Type	D	P	HM	Type	D	P
625	5	.	.	676 = 342			
626	3	.	.	677	4 B	.	46
627	9 A	.	.	678	4 A	15	34
629	6 B 2	.	.	679	4 A	.	35
630	3	.	.	680–1	4 A	.	.
631	33 G	258	.	682	4 C	16	48
632	3	.	.	683	4 C	.	.
633	10 C	.	172	684	4 A	.	.
634	10 C	.	.	686	22 D	167	.
635	32 A	.	438	687	5	19	59
636	8 A	53	.	688	3	.	.
637	33 A	.	450	689	20 B	.	.
638	8 C	.	.	690	21 A	.	.
638 BIS	27 I A	.	.	691	20 B	.	.
639–40	8 C	.	.	692	20 A	.	.
641	7 A	37	.	692 a	23 A	.	287
642	37 B	.	.	693	27 I C 7	.	.
642 BIS	27 I A	.	.	694	32 A	.	.
643	8 J	90	140	695	17 A	.	.
644–5	8 C	.	.	696	3	.	631
646	41 A	.	556	697	7 A	38	.
647	3	.	.	698	8 G	.	.
648	8 C	.	.	699	3	.	.
649–50	37 B	.	.	700	3 B	.	29
651	29 A	.	370	701–3	3	.	.
652	33 D	252	.	704	6 A I	.	69
654	28	.	.	705–6	3 B	.	.
655	28	198	358	707–10	3	.	.
656	36 C	274	518	711	7 A	.	.
657	29 A	206	.	712	1 A	.	.
658	36 C	275	519	713	3	.	.
659	36 C	.	520	714	8 H	.	.
660	30 D	229	419	715	8 D	75	121
661	21 A	158	.	716	1 A	.	4
662	20 A	.	.	717	36 A	.	509
663	30 D	230	420	718	37 C	298	546
664	22 D	.	283	719–20	37 B	.	.
665	8 C	.	.	721–2	17 A	.	.
666	43 G	327	604	723	37 B	.	.
667	36 A	260	502	724	22 A	.	.
675	8 C	.	.	725	37 B	.	.

HM	Type	D	P	HM	Type	D	P
726–7	22 A	.	.	782	20 B	.	.
728–9	20 B	.	.	783	3	.	.
730	20 A	150	250	784	8 B	.	.
731	20 A	.	.	785	20 B	.	.
732–3	20 B	.	.	786	27 I C	.	.
734	32 B	.	443	794–814	3	.	.
735	32 B	242	444	815	7 B	.	.
736	32 A	.	.	816	7 B	44	91
737	37 B	.	.	817	1 A	.	.
738	31 A	.	.	818	6 C	36	.
739	8 B	.	105	819–21	8 C	.	.
740	17 A	133	211	822	32 B	.	.
741–3	17 A	.	.	823–4	20 B	.	.
744	17 A	121	.	824 BIS	27 I A	.	.
745	17 A	122	200	825	20 B	.	.
746	10 A	.	.	826	18 A	.	.
747	37 B	.	.	827	21 A	.	.
748	31 B	.	434	828	20 B	.	.
749	4 D	.	.	829	37 B	.	.
750	8 C	.	.	830	10 C	.	.
751	33 D	254	463	831	17 A	.	.
752	33 G	257	464	832	31 B	.	.
753	31 A	.	.	833	37 B	.	.
754	32 A	.	.	834	31 A	.	.
755	33 D	.	.	835–6	37 B	.	.
756	8 B	.	.	837	31 A	.	.
757	17 A	.	.	838	6 C	.	.
758–9	27 I A	.	.	839	1 A	.	.
760	3	.	.	840–3	27 I A	.	.
761	20 B	.	257	844	10 A	.	.
762–71	3	.	.	845	4 D	.	.
772	7 A	.	.	846–7	33 F	.	.
773	8 B	.	.	848	36 C	.	.
774	6 A I	.	.	849	29 A	.	371
775	17 A	.	.	875	27 I B	.	.
776	21 A	.	.	876	27 I A	.	.
777	32 A	.	.	882–4	1 B	.	.
778	21 A	.	.	885	34 A	.	466
779	8 H	.	.	886	42 D	.	.
780	22 A	.	.	887	42 B	.	.
781	8 I	84	.	888–90	5	.	.

HM	Type	D	P	HM	Type	D	P
891	10 B	108	167	943	5	.	.
892	17 D	.	.	944	3	.	.
895	5	.	.	945	5	.	.
896	10 E	.	177	993	34 A	.	.
897	10 E	.	.	995	34 D	.	.
898	37 B	.	539	1004	4 D	18	.
899	10 D	.	.	1006	10 B	.	.
900	10 B	.	165	1008	35	.	500
901	17 E	143	228	1010	14	.	.
902	17 E	.	229	1013	33 B	.	456 a–b
903	17 E	.	230	1017	26 I B	.	.
904	17 E	.	231	1020	3	.	.
905	17 E	144	232	1021	8 G	.	.
906	10 D	.	175	1022	18 A	.	239
907	23 B	.	290	1023	3	.	.
908	8 D	77	123	1024	4 D	.	53
909	30 B	227	407	1025	4 C	.	.
910	1 A	.	6	1026	4 D	.	54
911	43 B	315	594	1027	4 C	.	.
912	34 B 2	.	486	1028	7 A	.	85
913	18 B	.	247	1031	3	.	.
914	4 E	.	56	1033	18 A	.	245
916–17	3	.	.	1034	21 A	.	269
918	3 B	14	31	1042	17 A	129	207
919	3	.	21	1043	17 A	130	208
920–2	3	.	.	1044	17 A	131	.
923	8 C	.	.	1045	17 A	.	.
924	17 A	128	206	1046	17 A	.	209
926	27 I A	.	.	1047	17 A	132	210
929	27 II B	.	.	1048	10 C	.	.
930	17 E	145	233	1049	10 A	.	154
931	17 E	146	234	1050	17 A	.	.
932	3	.	.	1051	33 D	.	.
933	24 II A 2	.	.	1052	10 A	.	.
934	10 A	.	.	1053	8 C	.	.
937	24 II A 13	.	.	1054	8 G	.	.
938	24 III	.	.	1055	17 D	140	.
939	45	328	626	1056	4 D	17	52
940	45	.	.	1057	30 D	234	426
941	24 II A 1	.	.	1061	10 C	110	173
942	26 4	181	.	1062	20 B	.	.

HM	Type	D	P	HM	Type	D	P
1063	10 A	.	.	1109	24 II A 3	.	301
1064	17 B	137	217	1110	11 A	.	.
1065	3	.	.	1111	24 IV	.	316
1066–7	31 A	.	.	1112	11 A	.	180
1068	37 B	.	.	1113	11 A	.	.
1069	17 D	141	.	1114	37 B	.	.
1070	8 I	.	.	1115	20 B	.	262
1071	8 C	.	.	1115 BIS	27 I B	.	.
1072	8 H	.	.	1116	40	.	553
1073	8 A	.	.	1117	40	.	554
1074	27 I A	.	.	1118	18 A	.	242
1075	8 B	.	111	1119	18 A	.	243
1076	17 A	.	.	1119 BIS	27 I B	.	.
1077	32 A	.	.	1120	18 A	.	244
1078	8 C	.	.	1121	20 B	.	.
1079–80	37 B	.	.	1122	27 I B	.	.
1081	17 A	.	.	1123	15	117	.
1082	8 C	.	.	1124	4 A	.	45
1083	8 B	.	.	1125	10 B	.	.
1084	37 B	.	.	1126	34 B 2	259	488
1085	21 A	.	.	1128	5	.	62
1086	8 I	87	139	1129	5	.	.
1087	3	.	.	1129 BIS	27 I A	.	.
1088	6 A I	.	.	1130	5	.	63
1091	30 A	221	397	1130 BIS	27 I A	.	.
1092	28	.	.	1131	9 A	.	147
1093	26 I F	.	335a	1131 BIS	27 I B	.	.
1096	14	.	.	1132	9 A	.	.
1096 BIS	27 II B	.	.	1132 BIS	27 I A	.	.
1097	14	.	.	1132 A	5	.	64
1098	10 B	.	.	1133	5	.	.
1099	26 3	.	.	1133 BIS	27 I B	.	.
1100	24 II B	.	.	1134	9 A	.	.
1101	24 II C	.	313	1134 BIS	27 I C	.	.
1102	24 II B	.	.	1135	3	.	24
1103	24 II A 8	.	309	1136	3	.	.
1104	24 II A I	.	.	1137	3	.	18
1105	24 II A I	.	296	1138	3	.	17
1106	24 II A 3	.	300	1138 BIS	27 I C	.	.
1107	24 II A 7	.	308	1139	3	.	.
1108	24 II A 7	.	.	1139 BIS	27 I B	.	.

206

HM	Type	D	P	HM	Type	D	P
1140	12	.	185	1192	37 B	.	.
1141	6 A 2	28	.	1193	37 B	286	.
1142	3 B	.	32	1194	37 B	.	.
1143	3	.	26	1195	37 B	287	534
1143 BIS	27 I B	.	26	1196–8	37 B	.	.
1144	3 B	.	.	1199	42 A	306	569
1145	8 K	.	146	1200	42 A	307	570
1146	3 B	.	33	1201	22 D	168	284
1147	6 A 1	.	.	1202	41 D	304	565
1148	6 A 2	.	76	1203	41 A	302	557
1149	6 A 2	.	.	1204	37 B	291	538
1150	6 A 1	.	.	1205	22 A	162	274
1151–2	3	.	.	1206	22 A	163	275
1153	8 C	.	.	1207	22 A	164	276
1154	8 F	.	133	1207 BIS	27 I C 7	194	276
1155	6 C	.	84	1208–10	22 A	.	.
1156	7 B	47	95	1211	37 B	296	544
1156 BIS	27 I B	.	.	1212	22 A	165	277
1157	7 B	48	96	1213	17 A	.	.
1158	7 A	.	.	1214	17 A	134	212
1159	7 C	51	98	1215	17 A	135	213
1168	24 II A 3	.	.	1216	17 A	.	.
1169	24 II A 13	.	.	1217	17 A	123	201
1170	8 K	93	134	1218	17 A	.	.
1171	UNFINISHED	.	.	1219	17 A	.	202
1172	UNFINISHED	.	628	1220	17 A	.	.
1173–4	38 B 2	.	.	1221	17 A	124	203
1175	10 B	.	.	1222	17 A	.	.
1176	37 B	289	536	1223	17 A	125	.
1177	10 A	102	153	1224	17 A	126	204
1178	8 A	55	.	1225	17 A	127	205
1179	37 B	290	537	1226	17 A	136	214
1180	8 B	60	107	1227	37 B	295	543
1181	8 A	.	101	1228	20 B	.	.
1182	8 B	.	.	1228 BIS	27 I A	.	.
1183	8 A	56	102	1229	42 A	308	571
1184	16	294	.	1230	29 B	216	388
1185	16	118	.	1231	8 E	80	127
1186	37 B	.	.	1232	8 E	81	128
1187–90	37 B	.	.	1233	42 A	309	572
1191	37 B	285	533	1234	28	199	360

HM	Type	D	P	HM	Type	D	P
1235	29 A	208	373	1277	10 A	.	152
1236	28	200	361	1278	40	300	552
1237	36 C	279	526	1279	24 IV	174	.
1238	28	201	362	1280	8 C	73	119
1239	36 A	261	503	1281	8 B	59	106
1240	29 A	205	369	1282	33 B	250	457
1241	29 A	209	374	1283	10 A	.	156
1242	29 A	210	375	1284	10 A	.	157
1243	29 A	211	376	1285	10 A	104	159
1244	28	202	363	1286–7	37 B	.	.
1245	36 A	262	504	1288	10 A	.	.
1246	36 A	263	505	1289	10 A	103	.
1247	36 B	269	514	1290	10 A	.	.
1248	29 A	212	377	1291	10 A	.	158
1249	36 A	266	510	1293	29 A	213	378
1250	36 A	264	506	1294	30 D	232	423
1251	10 A	.	.	1295	36 B	271	515
1252	20 B	.	.	1296	36 B	272	516
1253	36 B	270	.	1297	8 B	62	109
1253 BIS	27 I C	189	.	1298	31 A	235	430
1254–5	3	.	.	1299	8 C	64	.
1256	3	.	22	1300	8 C	65	.
1257	12	112	183	1301	8 C	66	.
1258	UNFINISHED	.	.	1302	29 A	214	379, 630
1259	3	.	.	1303	37 B	.	.
1260	8 J	92	142	1304	8 B	.	.
1261	6 A I	.	70	1307	26 5	.	343
1262	8 C	67	114	1309	24 IV	.	315
1263	8 C	68	.	1341	26 4	.	342
1264	8 C	69	115	1342	32 A	.	.
1265	8 C	63	112	1343	32 A	.	442
1266	31 A	.	428	1345	8 C	.	.
1267	8 A	57	103	1354	27 I B	.	.
1268	8 B	61	108	1364	19 A	.	249
1269	31 A	.	429	1365	34 B I	.	.
1270–2	31 A	.	.	1366	13 A	114	187
1273	8 C	.	.	1367	13 A	.	188
1274	31 A	.	.	1368 = 1550	34 D	.	489
1275	8 D	76	122	1513	42 A	.	574
1275 BIS	27 I A	186	122	1514	26 I C	177	333
1276	27 II A	197	352	1515	24 II A 2	.	.

HM	Type	D	P	HM	Type	D	P
1520	31 A	.	.	1597	27 I A	.	.
1521	20 A	.	.	1599	27 I A	192	.
1533	3	.	.	1601	5	.	.
1534	8 G	.	.	1602	23 B	.	.
1535	8 A	.	.	1606	8 D	79	125
1536	37 B	.	.	1607	10 C	.	.
1542	5	.	.	1608	3	.	16
1543	36 C	.	521	1609	3	.	.
1545	23 B	.	.	1610	33 D	253	.
1547	4 B	.	.	1611	32 B	.	445
1548	24 II C	.	.	1612	37 B	.	.
1550	24 III	.	.	1613	3	.	.
1550 BIS				1614	10 A	.	.
= 1368	34 D	.	489	1615	10 A	106	160
1551	24 III	.	.	1616	27 I B	.	.
1552	25	.	.	1619	4 B	.	.
1553	14	.	.	1620	4 A	.	36
1554	8 K	.	.	1621 (in NM)	4 A	.	.
1555	42 B	.	.	1622	4 A	.	37
1556	26 3	.	.	1623–5	4 A	.	.
1557	24 II A I	.	.	1626	4 A	.	38
1558	7 A	.	88	1627–8	4 A	.	.
1559	26 8	.	.	1629	4 A	.	39
1560–1	27 II B	.	.	1630	4 A	.	40
1562	27 I B	.	.	1631	4 C	.	.
1563	27 II B	.	.	1632	4 C	.	49
1565	38 A	.	.	1633	4 C	.	50
1570	12	.	186	1634	4 C	.	51
1572	27 I A	.	.	1635–6	4 C	.	.
1573	34 B I	.	480	1637	30 D	.	425
1583	43 I	.	614	1638	21 A	.	.
1584	43 I	.	.	1639	36 C	.	.
1585	26 4	.	.	1640	36 C	.	527
1586	26 7 A	.	.	1641	36 C	.	.
1590	10 B	.	.	1642–3	20 A	.	.
1591	18 A	149	.	1644	20 A	152	255
1592	10 A	101	.	1645	20 A	.	.
1593	BORE CORE	.	629	1646	20 B	.	.
1594	BORE CORE	.	.	1647	21 A	.	.
1595	16	119	198	1648	21 A	.	265
1596	37 B	288	535	1649	21 A	.	.

HM	Type	D	P	HM	Type	D	P
1650–1	20 B	.	.	1823	3	6	.
1652	21 A	.	.	1824–33	3	.	.
1653–5	20 B	.	.	1834	3	.	15
1656	21 A	.	.	1835–48	3	.	.
1657–63	20 B	.	.	1849	3	.	13
1664	31 A	.	.	1850–7	3	.	.
1665	28	203	365	1858	6 A 1	23	71
1666–7	28	.	.	1859	3	.	.
1668	28	.	366	1860	7 A	.	87
1669–70	28	.	.	1861	7 A	.	.
1671	28	.	367	1862	7 A	40	.
1672	28	204	368	1863–4	7 A	.	.
1673	29 A	.	380	1865	6 B 2	.	.
1674	20 A	.	.	1866	6 B 1	.	.
1675	36 A	.	508	1867	32 A	241	439
1676–80	8 C	.	.	1868	6 B 2	.	.
1681–2	1 A	.	.	1869	37 B	.	.
1683	1 A	.	7	1870	31 A	.	.
1684	1 A	.	8	1871	8 C	.	113
1685–8	1 A	.	.	1872–4	37 C	.	.
1689	1 A	3	9	1875	UNFINISHED	.	632
1690–3	1 A	.	.	1876	8 H	.	138
1694	8 H	.	137	1877	8 H	.	.
1695	8 H	.	.	1878–9	8 C	.	.
1696	3 B	.	.	1880	6 C	.	83
1697	36 A	.	.	1881	6 A 1	.	.
1698–9	3 B	.	.	1882	8 I	.	.
1700–2	3 B	.	.	1884–5	37 B	.	.
1703–32	3	.	.	1886	41 B	.	560
1733	3	11	23	1887	17 E	.	235
1734–8	3	.	.	1888	31 A	238	431
1739	3	7	.	1889–90	10 A	.	.
1740–71	3	.	.	1891	37 B	.	.
1772	3	5	.	1892	17 A	.	.
1773–86	3	.	.	1893	17 D	.	225
1787	3	10	25	1894	42 C	.	588
1788–1800	3	.	.	1895	42 A	.	.
1801	3	8	.	1896	27 I B	.	.
1802–18	3	.	.	1901	3	.	.
1819	3	.	14	1902	31 B	239	435
1820–2	3	.	.	1903	21 A	.	266

HM	Type	D	P	HM	Type	D	P
1904	30 D	233	424	2000–1	21 A	.	.
1904 *a*	33 A	247	454	2002	20 B	.	.
1906	36 C	.	.	2003	21 A	.	267
1907	3	.	.	2004	21 A	.	.
1910–11	37 C	.	.	2005	21 A	.	268
1912	37 B	.	.	2014	6 B 1	.	.
1913	17 A	.	.	2015	6 A 2	.	.
1914–15	37 B	.	.	2017	20 B	.	263
1916	36 A	267	511	2017 BIS	27 I B	.	263
1917	3	9	.	2018–19	20 B	.	.
1918–59	3	.	.	2020	29 A	207	372
1960–1	3 B	.	.	2021	30 D	231	422
1962	18 A	.	.	2022	36 C	277	524
1963–4	3	.	.	2023	28	.	.
1965	7 A	.	.	2024	36 C	278	525
1966	1 A	.	.	2025	37 B	293	541
1967–8	8 C	.	.	2026–7	8 C	.	.
1969	6 A 1	.	.	2028	3	.	.
1970	6 B 2	.	.	2029	10 A	105	.
1971–2	32 A	.	.	2030	17 A	.	.
1973	8 C	.	.	2031	31 A	.	427
1974	10 A	.	.	2032	33 C	.	460
1975	32 A	.	.	2033	27 I B	.	.
1976–7	8 C	.	.	2034	27 I A	.	.
1978	31 B	.	.	2041	5	.	.
1979–81	31 A	.	.	2042	30 A	223	399
1982	32 A	.	.	2043	42 B	.	.
1983	27 I A	.	.	2044	9 B	.	.
1984–5	27 I B	.	.	2045	37 D	.	.
1986	27 I A	.	.	2045 BIS	27 I A	.	.
1987–8	1 A	.	.	2046	36 C	.	530
1989	8 G	.	.	2047	3 B	.	.
1990	36 B	273	517	2048	8 C	.	.
1991	28	.	.	2067	32 E	.	.
1992	17 A	.	.	2068	10 B	107	164
1993	4 A	.	.	2069–70	3	.	.
1994	20 A	.	.	2071	7 B	.	.
1995–6	28	.	.	2077–8	24 II B	.	.
1997	23 A	171	288	2079	24 II A 4	.	303
1998	20 B	156	.	2080	24 II A 7	.	307
1999	21 A	.	.	2081	5	.	60

HM	Type	D	P	HM	Type	D	P
2082	38	.	.	2130	6 A 1	.	.
2083	30 A	.	401	2130 BIS	27 I A	.	.
2086	41 A	301	555	2132	5	.	.
2087	20 B	157	261	2133	9 A	.	.
2088	1 A	4	10	2134	24 IV	.	314
2089	26 I B	.	.	2141	34 C	.	488a
2090	8 C	.	.	2142	43 I	.	615
2091	24 II A 13	.	.	2143	40	.	.
2092	43 A	312	589	2144	17 D	.	223
2094	10 D	.	174	2145	17 D	.	224
2095–6	3	.	.	2146	30 A	225	403
2097	24 II A 1	.	294	2148–52	5	.	.
2098	17 F	147	236	2153	9 B	.	148
2099	26 6	.	.	2154	3 B	.	.
2100	26 2 B	.	340	2155–9	3	.	.
2101	23 B	.	.	2160	3 B	.	.
2102	23 B	.	289	2161–2	3	.	.
2103	42 B	.	584	2163	6 A 2	27	.
2104	34 D	.	491	2163 BIS	27 I A	.	.
2105	20 B	.	260	2164	3	.	.
2108	15	.	196	2165	31 C	.	.
2110	24 II C	.	.	2169	42 B	.	585
2111	42 A	.	.	2170	43 G	326	603
2112	14	.	.	2171	43 J	.	.
2113	41 D	.	563	2172	26 2 A	.	338
2114	26 I D	.	334	2173	1 A	.	3
2115	3	.	.	2176	9 A	.	.
2116	5	.	61	2177	31 C	.	.
2117	9 B	.	149	2178	27 II C	.	.
2118	3 B	13	.	2180	27 I A	.	.
2119	20 A	.	252	2181	27 I B	.	.
2121	22 A	160	272	2192	8 E	.	126
2122	3	.	.	2193	8 H	.	136
2123	14	115	191	2194	8 C	70	116
2124	42 A	.	567	2195	8 C	71	117
2125	10 B	.	168	2196–7	8 A	.	.
2126	10 B	109	169	2198	31 C	.	.
2127	10 B	.	162	2199	20 B	153	258
2128	36 C	276	523	2200	20 B	.	.
2129	6 A 2	.	.	2201	20 A	.	253
2129 BIS	27 I B	.	.	2202	20 B	.	.

HM	Type	D	P	HM	Type	D	P
2203	20 A	.	.	2249	24 II A 13	.	.
2204	10 A	.	.	2251	33 D	.	.
2205	18 A	.	240	2252	10 B	.	.
2206	6 B 2	.	78	2253	36 A	.	512
2207–8	3	.	.	2260	34 A	.	.
2209	3	.	27	2265	27 I A	.	.
2210	42 A	.	.	2267	23 A	.	.
2211	6 A 2	.	75	2268	3	.	19
2212	7 C	50	97	2268 BIS	27 I B	.	.
2213	7 B	45	.	2269	3	.	20
2214	7 B	.	92	2270	6 A 1	.	.
2215	7 B	.	.	2271	7 A	.	.
2216	7 B	.	93	2272	20 B	.	.
2217	1 A	1	.	2275	27 I C	188	.
2218	1 A	2	5	2276	43 G	.	601
2219	1 A	.	.	2277	3	.	.
2220	17 A	.	.	2278	27 II B	.	.
2221	27 I C	.	.	2279	27 I A	.	.
2222	27 I B	.	.	2280	13 B	.	.
2223	27 II	.	.	2281–2	18 B	.	.
2224	10 C	.	.	2283	44	.	624
2225	10 B	.	.	2284	18 B	.	.
2226	24 II A 13	.	.	2285	27 II C	.	353
2229	34 B 2	.	487	2286	6 A 1	21	65
2230	37 B	.	.	2286 BIS	7 B	.	.
2231	8 C	.	.	2287	26 5	.	.
2232	7 B	46	.	2288	42 A	.	568
2232 BIS	27 1 B	.	.	2289	17 B	.	216
2233	17 C	.	220	2290	22 B	.	278
2234	27 I C	193	351	2291	18 A	.	241
2235	7 B	.	94	2292	1 A	.	.
2236	8 F	.	132	2293	7 A	39	86
2237	5	.	.	2294	27 II B	.	.
2238	42 B	.	.	2295	27 I C	.	.
2240	20 B	.	.	2296	27 I A	.	.
2241	20 B	.	259	2297	27 I B	.	86
2242	22 A	.	.	2298	27 I B	.	.
2243	22 C	.	.	2299	27 I A	.	.
2246	10 B	.	.	2300	27 I B	.	.
2247	8 C	.	.	2301	27 I A	.	.
2248	8 F	.	.	2302–6	27 I B	.	.

HM	Type	D	P	HM	Type	D	P
2307	17 D	139	.	2367	8 A	.	.
2308	31 C	.	.	2368	8 B	.	.
2309	24 II A 5	.	.	2369–70	31 A	.	.
2310	3	.	.	2371	31 A	.	432
2311	31 C	.	437	2372	31 A	.	433
2312	38 B 2	.	.	2373	31 A	.	.
2313–14	14	.	.	2374–5	27 II A	.	.
2315	4 A	.	.	2376	29 A	.	383
2316	41 B	.	.	2377	29 A	.	384
2317 & AM				2378	29 A	.	385
1938.416	38 A	.	.	2379–80	29 A	.	.
2319	38 B I	.	550	2381	29 A	.	386
2320	38 A	.	.	2382	29 A	.	.
2321	24 II A I	.	.	2382 BIS	27 I B	.	.
2322	38	.	.	2383	8 I	89	.
2323	24 II A 13	.	.	2384	18 A	.	245
2324–5	3	.	.	2385	29 B	217	389
2327	42 A	.	.	2386	29 B	.	392
2328	4 A	.	.	2387	29 B	.	393
2329	34 A	.	475	2388	29 B	.	390
2331	32 C	.	446	2389	29 B	.	391
2332	20 B	.	.	2393	42 B	.	.
2333	14	.	.	2394	26 I A	.	.
2334	30 A	.	400	2395	41 A	303	558
2338	27 I C	.	.	2396	32 C	243	.
2339	33 A	246	452 a–b	2397	34 A	.	476
2340	33 A	.	.	2398	8 K	.	.
2341	26 I A	.	.	2399	27 I B	.	.
2342–6	5	.	.	2402	8 A	.	.
2347	22 C	.	282	2403	43 J	.	623
2348	24 II A 5	.	305	2404	5	.	.
2349	5	.	.	2405	9 A	.	.
2350	37 C	.	.	2406	5	.	.
2358	31 C	.	436	2407	27 I A	.	.
2359	37 A	.	.	2408	42 B	.	.
2360	37 B	.	.	2409	43 J	.	.
2361	10 A	.	151	2410	43 A	313	.
2362	10 A	.	.	2411	43 J	.	.
2363	10 A	.	155	2412	31 C	.	.
2364–5	10 A	.	.	2413	19 A	.	.
2366	8 E	.	131	2414–16	5	.	.

HM	Type	D	P	HM	Type	D	P
2417	6 B 1	.	.	2471	10 B	.	.
2418	38 B 2	.	.	2474	24 IV	.	.
2419	24 II A 13	.	.	2475	24 II B	.	.
2420	24 II A 6	.	.	2476	4 A	.	.
2421	14	.	193	2478	26 I B	.	330
2422	38	.	.	2479	18 B	.	246
2423	42 B	.	.	2480			
2424	22 A	161	273	2487	37 A	283	532
2425	3	.	.	2488	33 D	.	462
2426	3	12	28	2489	31 A	.	.
2427	3	.	.	2490	37 B	.	.
2428	14	.	194	2491	17 A	.	.
2429	24 II C	.	312	2492	6 A 2	.	.
2430	24 II A 6	.	.	2493	8 C	.	.
2431	24 II A 7	.	.	2494	8 J	.	.
2432	24 II A 4	.	302	2495	32 A	.	.
2433	24 II A 1	.	.	2496	8 C	.	.
2434	3 B	.	.	2497	36 A	.	.
2435	10 D	.	.	2498	8 H	.	.
2438	10 B	.	166	2499	32 A	.	.
2440	24 II B	.	.	2500	32 A	.	.
2441	24 V	.	.	2501	6 B 2	.	.
2442	4 E	.	57	2502–3	31 A	.	.
2443	22 B	.	.	2504–7	21 A	.	.
2444	26 8	.	347	2509 A	27 I A	.	.
2445	24 II A 13	.	.	2509 B	27 I C	.	.
2446–7	24 II A 1	.	.	2510	27 I B	.	.
2448	3	.	.	2511	37 B	.	.
2449	12	.	.	2512	17 A	.	.
2450	34 A	.	.	2513	21 A	.	.
2452	7 B	.	.	2514	28	.	.
2453	8 J	.	.	2515	36 C	.	528
2454	32 C	.	.	2516	36 C	.	529
2459	4 E	.	58	2517	29 A	.	381
2460	27 I A	.	.	2518	29 A	.	382
2461	14	.	.	2519	37 B	.	.
2461 BIS	27 II B	.	.	2520–1	17 A	.	.
2462	32 D	.	.	2522–3	17 D	.	.
2463	5	.	.	2524	32 A	.	440
2468–9	24 II B	.	.	2525	8 B	.	.
2470	24 II A 4	.	304	2526	8 B	.	110

HM	Type	D	P	HM	Type	D	P
2527	32 A	.	.	2573	3	.	.
2528	32 A	.	441	2574	20 B	155	.
2529	8 I	85	.	2575	26 I B	.	.
2530	8 I	86	.	2577	24 V	.	320
2531–3	31 A	.	.	2578	20 B	.	.
2534–5	21 A	.	.	2579	8 D	.	.
2536	27 I C	190	.	2580	6 A I	.	.
2537	32 A	.	.	2582	10 B	.	.
2538	27 I A	.	.	2583	22 B	.	.
2541	8 E	83	130	2589	26 I A	.	326
2542	20 B	154	.	2591	41 D	.	564
2542 BIS	27 I A	.	.	2593	26 3	.	.
2543	32 A	.	.	2594	5	.	.
2544	22 B	.	279	2595	8 G	.	134
2545	31 A	.	.	2596	6 A I	.	67
2546	10 B	.	170	2597	6 A I	.	68
2547	18 B	.	248	2598	7 B	42	.
2547 BIS	27 I C 7	.	248	2599	6 A I	.	.
2548	42 A	310	254	2600	6 A 2	.	72
2549	32 A	240	254	2601	31 A	.	.
2550	20 A	.	254	2602	3	.	.
2551	26 I B	.	332	2603	27 I A	185	.
2552	17 C	138	.	2604	3	.	.
2553	32 E	245	449	2605	5	.	.
2554	27 II D	.	354	2606	32 C	.	.
2556	26 5	.	.	2609	22 A	.	.
2557	33 F	.	.	2610	37 B	284	.
2558	10 C	.	.	2613	10 B	.	.
2559	7 C	.	.	2617	32 C	.	.
2560	20 B	.	.	2618	7 C	.	99
2561	22 B	.	.	2619	29 A	.	.
2562	24 I	.	.	2620	33 E	.	.
2563	26 8	.	.	2621	31 A	.	.
2564	12	.	.	2625	30 A	224	402
2566	10 C	.	.	2626	37 B	292	540
2567	21 A	159	264	2628	3	.	.
2568	32 A	.	.	2630	26 I D	.	.
2569	4 E	.	.	2633	33 A	.	455
2570	26 I A	176	329	2634–5	27 I A	.	.
2571	7 B	.	.	2636	10 B	.	.
2572	24 I	.	.	2643	10 D	.	.

HM	Type	D	P	HM	Type	D	P
2644	17 E	.	.	2727	34 B 1	.	.
2658	24 IV	.	.	2728	42 B	.	.
2665	21 C	.	.	2729–32	34 A	.	.
2666	6 A 1	.	.	2733	34 B 1	.	.
2667	3	.	.	2734	15	.	.
2671	26 7 B	.	.	2735	8 K	99	.
2672	21 C	.	.	2736	43 H	.	.
2673	26 7 B	.	.	2737	20 C	.	.
2674	26 7 A	.	.	2738–42	21 C	.	.
2675	21 C	.	.	2743	42 B	.	.
2676	26 7 B	.	.	2744–5	34 A	.	.
2677–9	26 7 A	.	.	2746	34 B 1	.	.
2680	17 F	.	.	2747–8	34 A	.	.
2681–2	26 7 A	.	.	2749	34 B 2	.	.
2683	26 7 B	.	.	2749 BIS	34 B 2	.	.
2684	24 III	.	.	2750	34 B 1	.	.
2685	26 7 A	.	.	2752–3	21 C	.	.
2686–7	21 C	.	.	2754	3	.	.
2689	24 II B	.	.	2755	21 C	.	.
2690	26 7 B	.	.	2756	27 I B	.	.
2693	24 II A 7	.	.	2757	19 B	.	.
2694	34 B 1	.	.	2758	34 B	.	.
2695	43 A	.	593	2759	19 B	.	.
2696	34 A	.	.	2760–1	21 C	.	.
2697	34 B 2	.	.	2762	34 B	.	.
2699	34 B 1	.	.	2763	42 D	.	.
2700	17 E	.	.	2764	34 B 2	.	.
2701–10	21 C	.	.	2765	22 B	.	.
2711	15	.	.	2767	18 A	.	.
2712	34 B 1	.	.	2768	7 B	.	.
2713	34 D	.	.	2773	27 I A	.	.
2714	43 A	.	591	2777	15	.	.
2715–17	21 C	.	.	2779	42 D	.	.
2718	19 B	.	.	2780	21 C	.	.
2719	33 B	.	.	2783 i	34 A	.	.
2720	42 B	.	.	2783 ii	34 A	.	.
2721	34 B 1	.	.	2784	10 D	.	.
2722	34 B	.	.	2789	24 II A 6	.	.
2724	34 A	.	.	2790	34 D	.	.
2725	15	.	195	2790 BIS	24 II A 6	.	.
2726	15	.	.	2791	24 II C	.	.

HM	Type	D	P	HM	Type	D	P
2792	13 A	.	.	2868	17 D	.	.
2792 BIS	15	.	.	2869–70	27 I A	.	.
2793	32 A	.	.	2871	24 II B	.	.
2793 BIS	15	.	.	2882	14	.	.
2794	21 A	.	.	2883	43 D	320	596
2794 BIS	15	.	.	2884	32 D	.	.
2795	42 D	.	.	2885	27 I A	.	.
2796–17	32 A	.	.	2899	4 A	.	.
2798	27 I B	.	.	2899 BIS	27 I C	.	.
2799	I A	.	.	2901	26 I A	.	.
2800	3	.	.	2902	3	.	.
2801	21 A	.	.	2903	24 II A I	.	.
2802	20 A	.	.	2904	14	.	.
2803	20 B	.	.	2909	17 E	.	.
2804	20 A	.	.	3041	34 B I	.	.
2805–11	3	.	.	3042	37 D	.	.
2812	6 A I	.	.	3050	43 D	.	.
2813–17	3	.	.	3051	8 J	.	.
2818	24 II A I	.	.				
2820	3	.	.				
2821	I A	.	.	**HM unnumbered**	**Type**	**D**	**P**
2822–3	3	.	.	A. Triadha N.F.C.	33 C	251	.
2824	20 A	.	.	Galana Kharakia (B 16)	7 B	43	.
2825–34	20 B	.	.	„ „ (B 27)	6 A I	22	.
2834 BIS	27 I A	.	.	„ „ (B 29)	6 B I	32	.
2835–47	3	.	.	Kamilari F 59 2746	30 D	.	421
2847 BIS	27 I C	.	.	Katsamba 1957	43 D	321	597
2848	6 B 2	33	.	Knossos	34 A	.	478
2848 BIS	27 I A	.	.	Knossos Vat Room	41 D	.	.
2849–58	3	.	.	Knossos (Crystal lid)	27 II A	196	.
2860	9 A	.	.	Lebena Tomb I B (20)	37 A	280	.
2861	3	.	.	Lebena Tomb II (158a)	37 A	281	.
2861 BIS	27 I A	.	.	Mallia Palace	20 A	151	251
2862	10 C	.	.	„ Houses	10 B	.	163
2863	3	.	.	„ Houses ?	37 D	.	548
2865	32 A	.	.	Mesara N.F.C.	29 A	.	387
2866	26 I D	.	.	Mochlos N.F.C.	29 A	215	.
2867	22 A	.	.	Pseira ? N.F.C.	8 I	88	.
				Sklavokampos (shell vase)	35	.	501

ASHMOLEAN MUSEUM, OXFORD

AM	Type	D	P	AM	Type	D	P
AE 1	26 8	.	.	AE 1502	8 K	96	.
AE 2	26 5	182	.	AE 1505	16	.	.
AE 203	37 B	.	.	AE 1569	34 A	.	.
AE 204	30 A	222	398	1909.343	19 A	.	.
AE 205	3	.	.	1909.373	27 I A	.	.
AE 206	7 B	.	.	1909.374	8 B	.	.
AE 207	8 D	.	.	1909.375	33 F	255	.
AE 208	18 A	.	238	1910.199	24 II C	.	311
AE 209 a	27 I B	.	66	1910.200	24 II B	.	.
AE 209 b	6 A 1	.	66	1910.201	43 A	.	590
AE 210 a	8 C	.	.	1910.202	24 II A 1	173	295
AE 210 b	27 I B	.	.	1910.203	24 II A 6	.	.
AE 211	26 7 A	.	.	1910.283	43 E	.	.
AE 212	9 A	.	.	1911.611	I B	.	12
AE 213	5	.	.	1916.49	10 B	.	.
AE 214	8 C	.	.	1923.661	26 8	.	.
AE 215	3	.	.	1924.30	8 A	54	100
AE 216	7 B	.	.	1924.31	10 B	.	161
AE 217	42 B	.	586	1924.38	43 G	.	.
AE 218	17 C	.	219	1924.39	24 II A 11	.	.
AE 219	26 3	180	.	1924.40	24 II A 4	.	.
AE 220	4 A	.	.	1924.41	34 F	.	.
AE 221	27 I A	.	.	1924.42	24 II A 2	.	.
AE 384	43 B	316	595	1924.43	27 I B	.	.
AE 385	5	.	.	1924.44	27 I A	.	.
AE 501	34 B 1	.	.	1924.168	28	.	.
AE 767	I B	.	11	1931.976	27 I A	.	.
AE 768	27 II C	.	.	1936.590	36 C	.	522
AE 769	23 B	.	.	1938.408	43 C	319	.
AE 784	34 E	.	493	1938.409 a	43 E	.	.
AE 800	26 3	.	.	1938.409 b	43 C	.	.
AE 825 2	27 I A	.	.	1938.416	38 A	.	.
AE 835–7	13 A	.	.	& HM 2317			
AE 850	19 A	.	.	1938.427	23 B	.	.
AE 890	10 E	.	178	1938.434	8 A	.	.
AE 962	37 C	297	545	1938.435	27 I B	.	.
AE 1181	34 E	.	.	1938.462	19 A	.	.
AE 1247	34 A	.	477	1938.464	8 K	97	.
AE 1500	19 A	.	.	1938.465	19 A	.	.

AM	Type	D	P	AM	Type	D	P
1938.466	8 K	98	.	Unnumbered 3	31 C	.	.
1938.468	24 II A I	.	.	„ 6–7	34 A	.	.
1938.469	13 A	.	.	„ 8	43 B	.	.
1938.582	21 A	.	.	„ 9	43 C	318	.
1938.583	43 E	323	.	„ 14	8 K	.	.
1938.584	31 C	.	.	„ 15	40	.	.
1938.603	34 D	.	.	„ 20	43 C	.	.
1938.604	34 A	.	470	Bomford Coll.			
1938.605	34 C	.	.	289	8 A	.	.
1938.606	24 II A 2	.	.	290	20 A	.	.
1938.607	42 B	.	.	291	37 B	.	.
1938.618	5	.	.	291 BIS	4 C	.	.
1938.653	43 A	.	.	292	8 C	.	.
1938.698	34 C	.	488*b*	293	17 E	.	.
1938.799	34 D	.	.	295	3	.	.
1938.843	17 E	.	.	295 BIS	24 II B	.	.
1938.872	26 8	.	.	296	32 A	.	.
Unnumbered 1	34 E	.	.	297	I A	.	.
„ 2	43 E	.	.				

A. NIKOLAOS MUSEUM, CRETE

	Type	D	P		Type	D	P
48	5	.	.	1081	3 B	.	.
62	6 A I	.	.	1089	10 A	.	.
170	5	.	.	1090	3	.	.
171	32 D	.	.	1093	8 C	.	.
263	5	.	.	1695	36 C	.	.
264	3	.	.	1696	37 B	.	.
278	41 A	.	.	No. not known	8 I	.	.
280	37 B	.	.				

BOSTON MUSEUM OF FINE ARTS

Type	D	P
34 A	.	.

BRITISH MUSEUM, LONDON

BM	Type	D	P	BM	Type	D	P
1907 I–19 106	27 I C	187	349	1907 I–19 108	27 I B	.	.
1907 I–19 107	27 I A	.	.	1907 I–19 152	40	.	.

APPENDIX C: MUSEUM CONCORDANCE

BM	Type	D	P	BM	Type	D	P
1907 1–19 217	34 F	.	494	1914 3–21 1	5	.	.
1907 1–19 227	8 D	78	124	1921 5–15 23	8 A	58	104
1907 1–19 228	31 A	237	.	1921 5–15 24	8 C	72	118
1907 1–19 229	26 I E	.	.	1921 5–15 25	3	.	.
1907 1–19 230	24 II A 3	.	299	1921 5–15 26	22 A	.	.
1907 1–19 231	26 8	184	348	1921 5–15 27	8 K	94	144
1907 1–19 232	26 2 A	179	339	1921 5–15 28	8 E	82	129
1907 1–19 442–3	22 A	.	.	1935 10–16 1	31 A	.	.
1911 6–20 9	27 I B	.	.	1935 10–16 2	8 C	.	.
1911 6–20 10	27 I B	.	.	1935 10–16 3	4 D	.	.
1911 6–20 11	6 B I	31	77	1935 10–16 4	37 B	.	.
1911 6–20 12	10 A	.	.	1950 1–25 1	24 II A 8	.	310a–b
1912 7–8 19	41 D	.	566	1965	27 I A	.	.

DELOS MUSEUM

	Type	D	P		Type	D	P
No. not known	34 A	.	.	No. not known	5 ?	.	.

DETROIT INSTITUTE OF ARTS

	Type	D	P
66.43	5	.	.

ELEUSIS MUSEUM

	Type	D	P
No. not known	24 II A 2	.	.

FITZWILLIAM MUSEUM, CAMBRIDGE

	Type	D	P		Type	D	P
GR.144.1907	3	.	.	GR.207.1907	3	.	.
GR.201.1907	26 3	.	.	GR.208.1907	27 I C	.	.
GR.202.1907	5	.	.	GR.9.1936	8 B	.	.
GR.206.1907	10 D	.	.				

GORTYN MUSEUM, CRETE

	Type	D	P
Unnumbered	26 I D	.	.

HIERAPETRA MUSEUM, CRETE

	Type	D	P		Type	D	P
94	24 II B	.	.	396	31 C	.	.
95	24 II C	.	.	397–8	45	.	.
96	24 II A 16	.	.	399	24 II B	.	.
97	24 I	.	.	400	24 II B	.	.
98	24 II A 13	.	.	Unnumbered (6)	37 B	.	.
99–100	38 B 2	.	.	,, (3)	10 A	.	.
343	27 I C	.	.	,, (2)	10 B	.	.
344	27 I B	.	.	,,	17 B	.	.
346	27 I A	.	.	,,	8 A	.	.
348–9	27 I B	.	.	,,	8 E	.	.
350	27 I A	.	.	,,	6 B 1	.	.
353	27 I C	.	.	,,	22 B	.	.
355	27 I C	.	.	,,	27 I A	.	.
374	26 7 A	.	.	,,	27 I B	.	.
376	17 A	.	.	,,	27 I C	.	.
379	22 B	.	.	,,	26 5	.	.

Figures in brackets, e.g. (2), indicate the number of vases of the type.

ISTANBUL MUSEUM

	Type	D	P
2496	I A	.	.

KEA

(Excavation numbers; imported Minoan vases)

	Type	D	P		Type	D	P
K 0.1	20 A	.	.	K 1.417	27 I A	.	.
K 0.9	5	.	.	K 1.442	27 I A	.	.
K 0.14	15	.	.	K 1.457	15	.	.
K 1.25	27 I A	.	.	K 1.552	14	.	.
K 1.84 A–B	15	.	.	K 1.572	14	.	.
K 1.134	40	.	.	K 1.573	5	.	.
K 1.333	32 C	.	.	K 3.95	9 A	.	.
K 1.369	27 II A	.	.	K 3.101	27 II A	195	.
K 1.372	31 C	.	.	K 3.102	27 I A	.	.
K 1.410 A, B	37 B	.	.	K 3.119	5	.	.
K 1.412	27 I A	.	.	K 3.207	5	.	.

APPENDIX C: MUSEUM CONCORDANCE

	Type	D	P		Type	D	P
K 3.319	26 I D	.	.	K 6.16	27 I C	.	.
K 3.599	10 B	.	.	K 6.93	23 B	.	.
K 4.74	31 C	.	.	K 6.116	5	.	.
K 4.110	5	.	.	K 6.119	36 A	.	.
K 4.140	3	.	.	K 6.153	27 I A	.	.
K 4.213	9 A	.	.	K 6.302	11 A	.	.
K 4.305	24 II A 1	.	.	K 6.340	14	.	.
K 4.306	12	.	.	K 6.342	24 II A 9	.	.
K 4.328	16	.	.	K 6.377	27 I A	.	.
K 4.354	27 I A	.	.	K 6.381	10 B	.	.
K 4.451	14	.	.	K 7.23	12	.	.
Unnumbered	37 D	.	.				

KHALKIS MUSEUM

	Type	D	P
401 G′	1 A	.	.

KHANIA MUSEUM, CRETE

	Type	D	P		Type	D	P
1009	43 I	.	.	1044–5	27 I A	.	.
1010	5	.	.	1046	27 I C	.	.
1016	3	.	.	Apodhoulou lid	27 II A	.	.
1019	1 A	.	.	Unnumbered	33 F	.	.
1023	20 B	.	.	,,	3	.	.
1024	4 C	.	.				

KNOSSOS STRATIGRAPHICAL MUSEUM

MATERIAL FROM EVANS' EXCAVATIONS

	Type	D	P		Type	D	P
B I 13, 253	31 A	.	.	Unprovenienced	21 B	.	.
E I 7, 620	31 A	.	.	,,	6 A 1	.	.
H I 2, 788	43 C	317	.	,,	7 A	.	.
M IV, 1242	42 D	.	.	,,	12	.	.
Unprovenienced	4 C	.	.	,, (2)	27 I B	.	.
,,	10 E	.	.	,,	27 II B	.	.
,,	31 C	.	.	,, (2)	13 A	.	.
,,	17 C	.	.	,,	34 F	.	.
,,	8 A	.	.	,, (2)	35	.	.

Type	D	P		Type	D	P
Unprovenienced 19 A	.	.	Unprovenienced			
„ 2	.	.	(6) 24 II B	.	.	
„ 26 6	.	.	„ 24 IV	.	.	
„ (5) 24 II I A	.	.	„ (5) 30 A	.	.	
„ 24 II A 3	.	.	„ 42 D	.	.	
In Strat. Mus. ? 24 II A 13	.	.	„ 43 A	.	.	
„ 24 II B	.	.	„ (4) 43 I	.	.	

Figures in brackets, e.g. (2), indicate the number of vases of the type.

MATERIAL FROM 1957–61 KNOSSOS EXCAVATIONS ILLUSTRATED HERE

	Type	D	P
RR/61/315	24 I	.	292
Bull's Head Rhyton	34 D	.	492

MATERIAL FROM 1962–3 PALAIKASTRO EXCAVATIONS

	Type	D	P		Type	D	P
PK/62/5	10 B	.	.	PK/62/49	24 II A 6	.	.
PK/62/6	10 B	.	.	PK/62/55	45	.	.
PK/62/17	10 E	.	.	PK/63/67	5	.	.
PK/62/23	3	.	.	PK/63/105	27 I A	.	.
PK/62/24	17 E	.	.	PK/63/122	26 I A	.	.
PK/62/39	27 I A	.	.	PK/63/153	38 B 2	.	.
PK/62/45	38 B 2	.	.	PK/63/156	10 A	.	.
PK/62/46	38 B 2	.	.	PK/63/180	38 B 2	.	.
PK/62/47–8	17 E	.	.	PK/63/187	24 II A I	.	.

MATERIAL FROM CRETAN SITES

	Type	D	P		Type	D	P
Khamalevri	8 C 2	.	.	Myrtos (Pyrgos)	6 A I	.	.
Myrtos (Pyrgos) (4)	31 C	.	.	„	27 I A	.	.
„ (2)	32 C	.	.	„ (2)	24 II A I	.	.
„	20 A	.	.				

Figures in brackets, e.g. (2), indicate the number of vases of the type.

KYTHERA MUSEUM

	Type	D	P		Type	D	P
Excavation no.							
432	3	.	.	No. not known	9 A	.	.
6076	5	.	.	No. not known	40	.	.

Kythera Mus.

	Type	D	P		Type	D	P
21–2	10 B	.	.	27	10 B	.	.
23–5	5	.	.	47	24 II B	.	.
26	20 B	.	.	No. not known	24 II A 2	.	.

LEIDEN MUSEUM

	Type	D	P		Type	D	P
1935 14 I	24 II A I	.	.	1935 14 IV	27 I A	.	.
1935 14 II	3 B	.	.	1935 14 V	6 B 2	.	.
1935 14 III	6 A 2	.	.	1935 14 V BIS	5	.	.

METROPOLITAN MUSEUM, NEW YORK

	Type	D	P		Type	D	P
11.186.65	5	.	.	24.150.8	8 B	.	.
14.89.13	24 II A I	.	.	25.191	6 A I	.	.
14.89.14	40	.	.	26.31.429	37 B	.	.
14.89.15	6 A 2	.	.	26.31.430	11 A	.	.
14.89.16	27 I A	.	.	26.31.431	3	.	.
24.150.1	5	.	.	26.31.432	10 A	.	.
24.150.2	5	.	.	26.31.433	5	.	.
24.150.3	37 B	.	.	26.31.434	3 B	.	.
24.150.4	3	.	.	26.31.435	8 I	.	.
24.150.5	41 D	.	.	26.31.436	5	.	.
24.150.6	17 B	.	.	53.5.1	7 A	.	.
24.150.7	20 B	.	.	53.5.2	5	.	.

NATIONAL MUSEUM, ATHENS

NM	Type	D	P	NM	Type	D	P
389	42 B	.	.	2263	26 6	.	.
592	22 D	.	.	2490	34 C	.	.
600	15	.	.	2669	34 A	.	.
829	42 B	.	.	2706	34 D	.	.
854	15	116	.	2769	1 B	.	.
1322	24 II A 2	.	.	2778	43 D Mainland	.	.
1851–3	16	.	.	2790	25	.	.
1851	43 I Mainland	.	.	2878	13	.	.
1889	43 I Mainland	.	.	2918	23 B	.	.
1890	43 I Mainland	.	.	2921	24 II A 4	.	.
1902–3	24 II A I	.	.	3050	13 B	.	.

NM	Type	D	P	NM	Type	D	P
3080	19 B	•	•	6231	33 E	•	•
3159	24 II B	•	•	6247 1–2	34 D	•	•
3160	24 II B	•	•	6248	34 D	•	•
3161	24 II A 2	•	•	6251	43 I Mainland	•	•
3163	I B	•	•	6252	43 J Mainland	•	•
3167 ?	24 II A 2	•	•	7315	24 II A I	•	•
3225	42 B	•	•	8538	42 C	•	•
3225 ?	43 J Mainland	•	•	No. not known			
3336	43 I Mainland	•	•	(Mycenae)	2	•	•
3338	5	•	•	(Mycenae)	5	•	•
3338 (2)	24 II A I	•	•	(Phylakopi)	5	•	•
3338 (2)	24 II A 2	•	•	(Phylakopi)	7 B	•	•
3339	18 B	•	•	No. not visible			
3522	15	•	•	(Mycenae)	II B	•	•
3523	43 I Mainland	•	•	No. not known			
3524	14	•	•	(Dendra)	24 II B	•	•
3524 BIS	43 J Mainland	•	•	(Phylakopi) (2)	24 II A I	•	•
3946	22 B	•	•	(Phylakopi)	24 II A 4	•	•
3964	15	•	•	(Phylakopi)	24 II A 9	•	•
4559	4 E	•	•	(Phylakopi)	24 II B	•	•
4578	21 A	•	•	(Mycenae, Tomb			
4920	19 B	•	•	of Clytemnestra)	25	•	•
4921–2	13 B	•	•	(Mycenae, Tomb			
4923	43 J Mainland	•	•	of Clytemnestra,			
4924–5	24 II A 2	•	•	antico rosso)	25	•	•
5807	24 II A I	•	•	(Mycenae)	27 II C	•	•
5808 I	9 A	•	•	(Phylakopi) (3)	27 I A	•	•
5808 2	9 B	•	•	(Phylakopi) (2)	27 I C	•	•
5808 3 (2)	5	•	•				

Figures in brackets, e.g. (2), indicate the number of vases of the type.

NAUPLION MUSEUM

	Type	D	P		Type	D	P
8352	34 A	•	•	Unnumbered			
8875	24 II B	•	•	Mycenae			
10002	24 II A 2	•	•	59.230	43 I Mainland	•	•
10808	22 A	•	•	64.128	34 D	•	•
11505	43 D Mainland	•	•	64.253	34 D	•	•
12356	43 I Mainland	•	•	64.254	24 II A 2	•	•
12359	43 I Mainland	•	•	64.774	43 I Mainland	•	•

	Type	D	P			Type	D	P
No. not known					Unnumbered			
Dendra	24 II A I	.	.		Dendra	24 II A I	.	.

NAXOS MUSEUM

	Type	D	P
339	5	.	.

NEAPOLIS MUSEUM, CRETE

	Type	D	P			Type	D	P
I	21 A	.	.		7	3 B	.	.
2	3	.	.		8	8 D	.	.
3	12	.	.		9	I A	.	.
4	3	.	.		194	5	.	.
5–6	5	.	.					

ROYAL ONTARIO MUSEUM, TORONTO

	Type	D	P
931.23.1	24 II B	.	.
964.116	12	.	.

OTAGO UNIVERSITY MUSEUM, NEW ZEALAND

	Type	D	P			Type	D	P
E.28.4	12	.	.		E.54.57	8 C	.	.
E.54.55	3	.	.		E.54.58	20 B	.	.
E.54.56	6 B I	.	.					

UNIVERSITY OF PENNSYLVANIA MUSEUM

MS	Type	D	P		MS	Type	D	P
4148	5	.	.		4176	24 II A 9	.	.
4149	3	.	.		4177	24 II C	.	.
4152	22 A	.	.		4503	40	.	.
4152 BIS	27 I A	.	.		4504	3	.	.
4153	9 A	.	.		4505	7 B	.	.
4154	26 I A	.	.		4506	6 B 2	.	.
4157	24 II A I	.	.		4507	6 A I	.	.
4158	20 B	.	.		4509	6 A 2	.	.
4164	31 C	.	.		4512–13	24 II A I	.	.

MS	Type	D	P	MS	Type	D	P
4514	5	.	.	4533	40	.	.
4515	24 II A I	.	.	4533 BIS	27 I A	.	.
4516	3	.	.	4534	18 A	.	.
4517	40	.	.	4535	6 A 2	30	.
4518	6 A 2	29	.	4536	7 C	52	.
4519	10 A	.	.	4537	3	.	.
4520	18 A	.	.	4539	42 A	.	.
4521	10 B	.	.	4540	37 B	.	.
4522	7 B	.	.	4541	20 B	.	.
4523	8 C	.	.	4543	17 A	.	.
4524	7 B	.	.	4544	3	.	.
4525	15	.	.	4545	6 A II	.	.
4526	7 A	41	.	4546	4 C	.	.
4527	8 I	.	.	4591	22 D	.	.
4528	17 F	.	.	4626	24 II A 7	.	.
4529	9 A	.	.	4650	24 II B	.	.
4530	10 A	.	.	4693	42 A	305	.
4531	24 II A I	.	.	4754	3	.	.
4532	29 A	.	.	No. not known 45		.	.

PHAISTOS STRATIGRAPHIC MUSEUM
(Excavation numbers)

	Type	D	P		Type	D	P
F 55 934 a	10 C	.	.	F 59 2925	7 A	.	.
F 56 2083	10 C	.	.	F 59 2926	20 A	.	.
F 57 2372	24 II A 6	.	.	F 59 2930	20 A	.	.
F 57 2374	3	.	.	F 59 2954	3	.	.
F 59 2548	I A	.	.	F 59 3076	20 B	.	.
F 59 2549	8 F	.	.	F 59 3077	3	.	.
F 59 2564	3	.	.	F 59 3083	32 C	.	.
F 59 2846	27 I C	.	.	F 59 3145	3	.	.
F 59 2879 a	20 B	.	.	F 59 3166	6 C	35	.
F 59 2879 b	21 A	.	.	F 59 3269	3	.	.
F 59 2880	32 A	.	.	F 59 3277	6 B 2	.	.
F 59 2881	3	.	.	F 59 3391	27 I C	.	.
F 59 2883	32 A	.	.	F 59 3461 a	18 A	.	.
F 59 2884	20 B	.	.	F 60 3461 b	I A	.	.
F 59 2894	20 B	.	.	F 60 3531	10 B	.	.
F 59 2906 a	21 A	.	.	F 63 4369	28	.	.
F 59 2906 b	18 A	.	.	F 63 4423 b	27 I C	.	.

	Type	D	P		Type	D	P
F 63 4536	10 B	.	.	Kamilari unnumbered 28		.	.
Kamilari unnumbered	10 A	.	.	,, ,, 1 A		.	.
,, ,,	10 C	.	.	Phaistos unnumbered 24 I		.	.

MUSEO PREISTORICO DI PIGORINI, ROME

	Type	D	P		Type	D	P
70377	27 I C	.	.	75156	31 A	.	.
70385	21 A	.	.	75157	3	.	.
71939	24 II A 1	.	.	75158	17 A	.	.
71940	1 A	.	.	75159	4 A	.	.
71941	8 G	.	.	77171–2	21 C	.	.
71942	8 C	.	.	77260	26 I C	.	.
71943	31 A	.	.	77267	12	.	.
71944	3	.	.	77268	13 B	.	.
71949	24 II B	.	.	77269	4 A	.	.
72043	31 A	.	.	77474–82	24 II B	.	.

RETHYMNO MUSEUM, CRETE

	Type	D	P		Type	D	P
Unnumbered	27 I C	.	.	Unnumbered	24 II B	.	.
,,	5	.	.	,,	24 IV	.	.
,,	26 I F	.	.				

RICHMOND, Virginia, Museum of Fine Arts

	Type	D	P
Williams Fund 1957	5	.	.

SAMOS MUSEUM

	Type	D	P
Unnumbered	1 A	.	.
Unnumbered	1 A	.	.

STATHATOS COLLECTION, ATHENS

	Type	D	P		Type	D	P
1	33 A	248	.	3 BIS	33 F	.	.
2	33 A	249	.	4	33 F	256	.
3	33 F	.	.				

Illustrations of Egyptian vases from Egypt (Ashmolean Muesum, British Museum, University College, London (Petrie Collection))

Museum No.	See type	P	Museum No.	See type	P
AM E 416	30 D	410	BM 4695	30 C	408
AM E 1956	30 D	414	BM 62528	28	355
AM E 2196	28	356	BM 63091	30 B	405
AM E 2197	28	357			
AM E 1930.516	30 D	411	UC 18119	30 D	413
AM E 1933.314	30 D	412	UC 18645	30 D	415

BIBLIOGRAPHY

Åberg, N. (1933). *Bronzezeitliche und früheisenzeitliche Chronologie. IV. Griechenland.* Stockholm.

Albright, W. F. (1936-7). The Excavation of Tell Beit Mirsim. II. The Bronze Age. *Annual of the American Schools of Oriental Research*, XVII, 1936-7.

Alexiou, St. (1951). Πρωτομινωϊκαὶ ταφαὶ παρὰ τὸ Κανλὶ Καστέλλι Ἡρακλείου. *Kr. Khron.* 1951, 275-94.

(1952). Νέα στοιχεῖα διὰ τὴν ὑστέραν Αἰγαιακὴν χρονολογίαν καὶ ἱστορίαν. *Kr. Khron.* 1952, 9-41.

(1954a). Ὑστερομινωϊκὸς τάφος Παχυάμμου. *Kr. Khron.* 1954, 399-412.

(1954b). Ἀνασκαφαὶ ἐν Κατσαμπᾶ. *Praktika*, 1954, 369-76.

(1955). Ἀνασκαφαὶ ἐν Κατσαμπᾶ. *Praktika*, 1955, 311-20.

(1959a). Νέα παράστασις λατρείας ἐπὶ μινωϊκοῦ ἀναγλύφου ἀγγείου. *Kr. Khron.* 1959, 346-52.

(1959b). Ein frühminoisches Grab bei Lebena auf Kreta. *AA*, 1959, 1-10.

(1960a). New Light on Minoan Dating: Early Minoan Tombs at Lebena. *ILN*, 6 August 1960.

(1960b). Χρονικά. *Arch. Delt.* 1960, 257-8, 272.

(1961-2). Οἱ πρωτομινωϊκοὶ τάφοι τῆς Λεβῆνος καὶ ἡ ἐξέλιξις τῶν πρωτοανακτορικῶν ῥυθμῶν. *Kr. Khron.* 1961-2, 88-91.

(1963a). Μινωϊκοὶ ἱστοὶ σημαίων. *Kr. Khron.* 1963, 339-51.

(1963b). Ἀνασκαφὴ Κατσαμπᾶ. *Praktika*, 1963, 189-200.

(1965). A Unique Minoan Ivory found near Knossos. *ILN*, 14 August 1965.

(1967) Ὑστερομινωϊκοι τάφοι Λιμένος Κνωσοῦ (Κατσαμπᾶ). Athens.

Allbaugh, L. G. (1953). *Crete. A Case Study of an Underdeveloped Area.* Princeton.

Banti, L. (1930-1). La Grande Tomba a Tholos di Haghia Triada. *Annuario*, **13-14**, 1930-1, 155-251.

(1941-3). I Culti Minoici e Greci di Haghia Triada (Creta). *Annuario*, **3-5**, 1941-3, 9-74.

See also Pernier & Banti.

Ben-Dor, I. (1945). Palestinian Alabaster Vases. *Quarterly of the Department of Antiquities of Palestine*, XI, 1945, 93-112.

Benson, J. L. (1966). A New Boxer Rhyton Fragment. *Boston Museum Bulletin*, LXIV, 1966, no. 335, 36-40.

Benton, S. (1931-2). The Ionian Islands. *BSA*, XXXII, 1931-2, 213-46.

Boardman, J. (1958). Unpublished Linear A Inscriptions in Oxford. *Bulletin of the Institute of Classical Studies*, V, 1958, 11-12.

(1961). *The Cretan Collection in Oxford.* Oxford.

(1963a). The Date of the Knossos Tablets, in *On the Knossos Tablets.* Oxford.

(1963b). *Island Gems.* London.

Borda, M. (1946). *Arte Cretese Micenea nel Museo Pigorini di Roma.* Rome.

Bosanquet, R. C. (1901-2a). Excavations at Palaikastro, I. *BSA*, VIII, 1901-2, 286-316.

(1901-2b). Excavations at Petras. *BSA*, VIII, 1901-2, 282-5.

Bosanquet, R. C. (1902–3). Excavations at Palaikastro, II. *BSA*, IX, 1902–3, 274–89.

(1904). Some 'Late Minoan' Vases found in Greece. *JHS*, XXIV, 1904, 317–29.

1923). The Unpublished Objects from the Palaikastro Excavations. *BSA* Supplementary Paper, no. 1.

Bosanquet, R. C. & Welch, F. B. (1904). *Excavations at Phylakopi in Melos. The Minor Antiquities.* The Society for the Promotion of Hellenic Studies. Supplementary Paper No. 4. London.

Bossert, Th. (1923). *Altkreta.* Berlin.

Boyd, H. (1905). Gournia. *Transactions Pennsylvania*, Part III, 1905, 177–89.

Boyd Hawes, H. (= Boyd, H.) (1908). *Gournia.* Philadelphia.

Branigan, K. (1966). Byblite Daggers in Cyprus and Crete. *AJA*, 1966, 123–6.

(1967). Further Light on Prehistoric Relations between Crete and Byblos. *AJA*, 1967, 117–21.

Brice, W. C. (1961). *Inscriptions in the Minoan Linear Script of Class A.* Oxford.

Brunton, G. (1937). *Mostagedda and the Tasian Culture.* London.

Buchholz, H.-G. (1963). Steinerne Dreifussschalen des ägäischen Kulturkreises und ihre Beziehungen zum Osten. *Jahrbuch*, **78**, 1963, 1–76.

Cann, J. R. & Renfrew, C. (1964). The Characterization of Obsidian and its Application to the Mediterranean Region. *PPS*, XXX, 1964, 111–33.

Carratelli, G. P. (1957). Sulle Epigrafi in Lineare A di Carattere Sacrale. *Minos*, V, 1957, 163–73.

Caskey, J. L. (1953–4). Early Minoan Objects in the Stathatos Collection. *Eph. Arch.* 1953–4, 268–72.

(1962). Excavations in Keos 1960–1961. *Hesperia*, XXXI, 1962, 263–83.

(1964a). Greece, Crete and the Aegean Islands in the Early Bronze Age. *Cambridge Ancient History*. Revised Edition. Fascicle 24.

(1964b). Excavations in Keos, 1963. *Hesperia*, XXXIII, 1964, 314–35.

See also *Troy* (in Abbreviations).

Casson, S. (1933). *The Technique of Early Greek Sculpture.* Oxford.

Catling, H. W. (1964). *Cypriot Bronzework in the Mycenaean World.* Oxford.

Chapouthier, F. (1938). Deux Épées d'Apparat. *Études Crétoises*, V.

Chapouthier, F. & Charbonneaux, J. (1928). Fouilles Exécutées à Mallia. Premier Rapport (1922–1924). *Études Crétoises*, I.

Chapouthier, F. & Joly, R. (1936). Mallia. Deuxième Rapport. Exploration du Palais 1925–6. *Études Crétoises*, IV.

Chapouthier, F. & Demargne, P. (1942). Mallia. Troisième Rapport. Exploration du Palais (1927–1932). *Études Crétoises*, VI.

Chapouthier, F., Demargne, P. & Dessenne, A. (1962). Mallia. Quatrième Rapport. Exploration du Palais (1929–1935, 1946–1960). *Études Crétoises*, XII.

Currelly, C. T. (1903–4). Excavations at Palaikastro III. The Larnax Burials. *BSA*, X, 1903–4, 227–31.

Davaras, K. See Platon (1960).

Davies, O. (1926–7). A New Cretan Inscription. *BSA*, XXVIII, 1926–7, 297.

Dawkins, R. M. (1902–3). Excavations at Palaikastro, II. *BSA*, IX, 1902–3, 290–328.

(1903–4). Excavations at Palaikastro, III. *BSA*, X, 1903–4, 192–226.

(1904–5). Excavations at Palaikastro, IV. *BSA*, XI, 1904–5, 258–92.

(1905–6). Excavations at Palaikastro, V. *BSA*, XII, 1905–6, 1–8.

(1923). The Unpublished Objects from the Palaikastro Excavations. *BSA* Supplementary Paper, no. 1.

Dawkins, R. M. & Droop, J. P. (1910–11). The Excavations at Phylakopi in Melos. *BSA*, XVII, 1910–11, 1–22.

Dawkins, R. M. & Tod, M. N. (1902–3). Excavations at Palaikastro, II. *BSA*, IX, 1902–3, 329–35.

Della Seta, A. (1907). La Sfinge di Haghia Triada. *Rendiconti*, XVI, 1907, 699–715.

Demargne (1902). Antiquités de Praesos et de l'Antre Dictéen. *BCH*, XXVI, 1902, 571–83.

Demargne, P. (1945). Mallia Nécropoles, I. Exploration des Nécropoles (1921–1933). *Études Crétoises*, VII.

See also Chapouthier & Demargne.

Demargne, P. and Effenterre, H. van (1937). Recherches à Dréros. *BCH*, LXI, 1937, 5–32.

Demargne, P. and de Santerre, G. (1953). Mallia Maisons, I. Exploration des Maisons et Quartiers d'Habitation (1921–1948). *Études Crétoises*, IX.

Deshayes, J. (1960). *Les Outils de Bronze de l'Indus au Danube*. Paris.

Deshayes, J. & Dessenne, A. (1959). Mallia Maisons, II. Exploration des Maisons et Quartiers d'Habitation (1948–1954). *Études Crétoises*, XI.

Dörpfeld, W. (1902). *Troja und Ilion. Ergebnisse der Ausgrabungen in den vorhistorischen und historischen Schichten von Ilion, 1870–1894*. Athens.

Dunand, M. (1939). *Fouilles de Byblos*, I. Paris.

Edgar, C. C. (1904). *Excavations at Phylakopi in Melos. The Pottery*. London.

Effenterre, H. van (1948). Nécropoles du Mirabello. *Études Crétoises*, VIII.

Effenterre, H. & M. van *et al.* (1963). Mallia Nécropoles II. Étude du Site (1956–1957) et Explorations des Nécropoles (1915–1928). *Études Crétoises*, XIII.

Ehrich, R. W. (1954 ed.). *Relative Chronologies in Old World Archaeology*. Chicago.

(1965 ed.). *Chronologies in Old World Archaeology*. Chicago and London.

Emery, W. B. (1949). *Great Tombs of the First Dynasty*, I. Cairo.

(1958). *Great Tombs of the First Dynasty*, III. London.

(1961). *Archaic Egypt*. Harmondsworth.

Evans, Sir A. (1895). *The Sepulchral Deposit of Hagios Onouphrios near Phaistos in its Relation to Primitive Aegean Culture*. Supplement to *Cretan Pictographs*, pp. 105–36. London.

(1897). Further Discoveries of Cretan and Aegean Script: with Libyan and Proto-Egyptian Comparisons. *JHS*, XVII, 1897, 327–95.

(1899–1900 to 1904–5). Knossos Excavation Reports. *BSA*, VI–XI.

(1905). The Prehistoric Tombs of Knossos. *Archaeologia*, LIX, 1905, 391–562.

(1914). The 'Tomb of the Double Axes' and Associated Group and the Pillar Rooms and Ritual Vessels of the 'Little Palace' at Knossos. *Archaeologia*, LXV, 1914, 1–94.

(1921, 1928, 1930, 1935). *The Palace of Minos at Knossos*, I–IV. London.

(1929). *The Shaft Graves and Beehive Tombs of Mycenae and their Interrelation*. London.

Evans, Sir A. & Bosanquet, R. C. (1923). The Unpublished Objects from the Palaikastro Excavations. The Inscribed Objects of Stone and Clay. *BSA* Supplementary Paper, no. 1.

Evans, J. & Evans, Sir A. (1936). *The Palace of Minos at Knossos*. Index volume. London.

Evans, J. D. (1964). Excavations in the Neolithic Settlement at Knossos. *BSA*, **59**, 1964, 132–240.

Faure, P. (1966). Les Minerais de la Crète Antique. *Revue Archéologique*, 1966, 45–78.

Fiandra, E. (1961–2). I Periodi Struttivi del Primo Palazzo di Festos. *Kr. Khron.* 1961–2, 112–26.

Firth, C. M., Quibell, J. E, & Lauer, J.-Ph. (1935). *The Step Pyramid*, II. Cairo.

Forsdyke, Sir J. (1926–7). The Mavro Spelio Cemetery at Knossos. *BSA*, XXVIII, 1926–7, 243 sqq.

 (1952). The Chieftain Vase. *Journal of the Warburg and Courtauld Institutes*, XV, 1952, 13–19.

 (1954). The Harvester Vase. *Ibid.* XVII, 1954, 1–9.

Frankfort, H. & Pendlebury, J. D. S. (1933). *The City of Akhenaten*, II. London.

Frend, W. H. C. & Johnston, D. E. (1962). The Byzantine Basilica Church at Knossos. *BSA*, **57**, 1962, 186–238.

Frödin, O. & Persson, A. W. (1938). *Asine. Results of the Swedish Excavations 1922–1930*. Stockholm.

Furness, A. (1953). The Neolithic Pottery of Knossos. *BSA*, XLVIII, 1953, 94–134.

Furumark, A. (1941). *The Mycenaean Pottery. Analysis and Classification*. Stockholm.

 (1950). The Settlement at Ialysos and Aegean History *c.* 1550–1400 B.C. *Opuscula Archaeologica*, VI, 1950, 150–271. (*Acta Instituti Romani Regni Sueciae*, XV.)

 (1965). Gods of Ancient Crete. *Opuscula Atheniensia*, VI, 1965, 85–98.

Georgiev, G. I. (1961). Kulturgruppen in der Jungstein- und der Kupferzeit in der Ebene von Thrazien (Südbulgarien). In *L'Europe à la Fin de l'Âge de la Pierre*, 1961, 45–100. Prague.

Grant, E. (1931, 1932). *Ain Shems Excavations*, I, 1931; II, 1932. Haverford.

Groenewegen-Frankfort, H. (1951). *Arrest and Movement*. London.

Halbherr, F. (1901). Cretan Expedition, XI. *AJA*, 1901, 259–93.

 (1902). Lavori . . . ad Haghia Triada e nella Necropoli di Phaestos . . . 1902. *Rendiconti*, XI, 1902, 433–47.

 (1903). Scoperti ad Haghia Triada presso Phaestos. *Mon. Ant.* XIII, 1903, 5–74.

 (1905). Rapporto sugli Scavi . . . ad Haghia Triada ed a Festo . . ., 1904 [A. Triadha large tholos and Palace/Villa preliminary reports]. *Mem. R. Inst. Lomb.* XXI, 1905, 235–54.

Hall, E. H. (1905). Early Painted Pottery from Gournia. *Transactions Pennsylvania*, Part III, 1905, 191–205.

 (1912). Excavations in Eastern Crete. Sphoungaras. *Penn. Anth. Publ.* III, no. 2, 1912, 41–73.

 (1914). Excavations in Eastern Crete. Vrokastro. *Penn. Anth. Publ.* III, no. 3, 1914, 77–185.

Hall, H. R. (1915). *Aegean Archaeology*. London.

Hankey, V. (1952). Late Helladic Tombs at Khalkis. *BSA*, XLVII, 1952, 49–95.

Hatzidhakis, J. (1915). Πρωτομινωϊκαὶ ταφαὶ παρὰ τὸ χωρίον Γοῦρνες. *Arch. Delt.* I, 1915, 59–63.

 (1918). Μινωϊκοὶ τάφοι ἐν Κρήτῃ. *Arch. Delt.* IV, 1918, 45–87.

 (1921). *Tylissos à l'Époque Minoenne*. Paris.

 (1934). Les Villas Minoennes de Tylissos. *Études Crétoises*, III.

Heezen, B. See Ninkovich, D. & Heezen, B.

Heidenreich, R. (1935–6). Vorgeschichtliches in der Stadt Samos. Die Funde. *Ath. Mitt.* 1935–6, 125–83.

Hogarth, D. G. (1899–1900*a*). Knossos: Early Town and Cemeteries. *BSA*, VI, 1899–1900, 70–85.

 (1899–1900*b*). The Dictaean Cave. *BSA*, VI, 1899–1900, 94–116.

 (1900–1). Excavations at Zakro, Crete. *BSA*, VII, 1900–1, 121–49.

Hood, M. S. F. (1956). Another Warrior Grave at Ayios Ioannes near Knossos. *BSA*, **51**, 1956, 81–99.

(1957–1961). In *Arch. Reps.* for those years, 1957 for Sellopoulo.

(1958). The Largest Ivory Statuettes to be found in Greece; and an Early Tholos Tomb; Discoveries during the latest Knossos Excavations. *ILN*, 22 February 1958.

(1959). *Archaeological Survey of the Knossos Area*. London.

(1961–2). Stratigraphic Excavations at Knossos, 1957–1961. *Kr. Khron.* 1961–2, 92–7.

(1962). Sir Arthur Evans Vindicated: a Remarkable Discovery of Late Minoan I B vases from beside the Royal Road at Knossos. *ILN*, 17 February 1962.

(1965 a). Excavations at Emporio, Chios, 1952–1955. *Atti del VI Congresso Internazionale delle Scienze Preistoriche e Protostoriche*, II, 1965, 224–7. Rome.

(1965 b). Minoan Sites in the Far West of Crete. *BSA*, **60**, 1965, 99–113.

(1966). The Early and Middle Minoan Periods at Knossos. *Bulletin of the Institute of Classical Studies*, **13**, 1966, 110.

Hood, M. S. F. & De Jong, P. (1952). Late Minoan Warrior Graves from Ayios Ioannes and the New Hospital Site at Knossos. *BSA*, XLVII, 1952, 243–77.

Hood, M. S. F., Huxley, G. & Sandars, N. (1958–9). A Minoan Cemetery on Upper Gypsadhes. *BSA*, **53–4**, 1958–9, 194–262.

Hood, M. S. F. & Warren, P. (1966). Ancient Sites in the Province of Ayios Vasilios, Crete. *BSA*, **61**, 1966, 163–91.

Hood, M. S. F., Warren, P. & Cadogan, G. (1964). Travels in Crete, 1962. *BSA*, **59**, 1964, 50–99.

Hooker, J. T. (1967). The Mycenae Siege Rhyton and the Question of Egyptian Influence. *AJA*, 1967, 269–81.

Hope Simpson, R. & Lazenby, J. (1962). Notes from the Dodecanese. *BSA*, **57**, 1962, 154–75. See also Waterhouse, H. & Hope Simpson, R.

Hughes, H. M. C. & Warren, P. (1963). Two Sealstones from Mochlos. *Kr. Khron.* 1963, 352–6.

Hutchinson, R. W. (1954 a). Minoan Chronology Reviewed. *Antiquity*, 1954, 155–64.

(1964 b). New Materials on the Later Aegean Chronology and History. (Review of Alexiou 1952.) *Antiquity*, 1954, 183–5.

(1956 a). A Tholos Tomb on the Kephala. *BSA*, **51**, 1956, 74–80.

(1956 b). A Late Minoan Tomb at Knossos. *BSA*, **51**, 1956, 68–73.

(1962). *Prehistoric Crete*. Harmondsworth.

Hutchinson, R. W., Eccles, E. & Benton, S. (1939–40). Unpublished Objects from Palaikastro and Praisos, II. *BSA*, XL, 1939–40, 38–59.

Huxley, G. & Coldstream, N. (1966). Kythera, First Minoan Colony. *ILN*, 27 August 1966.

Immerwahr, S. A. (1966). The Use of Tin on Mycenaean Vases. *Hesperia*, XXXV, 1966, 381–96.

Jakovidhes, S. (1954). Ἀνασκαφὴ μυκηναϊκῶν τάφων Περατῆς. *Praktika*, 1954, 89–103.

Jantzen, U. (1951). Die spätminoische Nekropole von Kydonia. In Matz (1951), 72–81.

Kantor, H. (1947). The Aegean and the Orient in the Second Millennium B.C. *AJA*, 1947, 1–103.

(1954). The Chronology of Egypt and its Correlation with that of other Parts of the Near East in the Periods before the Late Bronze Age. In Ehrich (1954), 1–27.

(1965). The Relative Chronology of Egypt and its Foreign Correlations before the Late Bronze Age. In Ehrich (1965), 1–46.

Karo, G. (1930–3). *Die Schachtgräber von Mykenai*. Munich.

Kemp, J. F. (1961). *A Handbook of Rocks* (revised by Grout, F. F.). Princeton, Toronto, London and New York.

Kenna, V. E. G. (1960). *Cretan Seals*. Oxford.

Khalikiopoulos, L. (1903). *Sitia, die Osthalbinsel Kreta's*. Berlin.

Kharitonidhes, S. (1953). Ἀνασκαφὴ ἐν Ναυπλίᾳ. *Praktika*, 1953, 191–204.

Kirsten, E. (1951). Die Grabung auf der Charakeshöle bei Monastiraki, I. In Matz (1951), 27–61.

Kohl, H. & Quitta, H. (1966). Berlin Radiocarbon Measurements, II. *Radiocarbon*, 8, 1966, 27–45.

Kondoleon, N. (1950). Ἀνασκαφὴ ἐν Νάξῳ. *Praktika*, 1950, 269–80.

Lacau, P. & Lauer, J.-Ph. (1959). *La Pyramide à Degrés*. IV. *Inscriptions Gravées sur les Vases*. (Fouilles à Saqqarah). Cairo.

Lazenby, J. See Hope Simpson, R. & Lazenby, J.

Levi, D. (1927). The Southernmost Bound of Europe. *Art and Archaeology*, XXIV, 1927, 176–83.

 (1927–9). Arkhadhes. Una Città Cretese all'Alba della Civiltà Ellenica. *Annuario*, X–XII, 1927–9.

 (1951). *Boll. d'Arte*, 1951, 335–58 (Phaistos excavation report).

 (1952). *Boll. d'Arte*, 1952, 320–39 (Phaistos excavation report).

 (1952–4). La Campagna di Scavi a Festòs nel 1953. *Annuario*, XXX–XXXII, 1952–4, 389–469.

 (1955). *Boll. d'Arte*, 1955, 141–64 (Phaistos excavation report).

 (1955–6). Atti della Scuola. *Annuario*, XXXIII–XXXIV, 1955–6, 292–303 (Phaistos excavation report).

 (1956). *Boll. d'Arte*, 1956, 238–70 (Phaistos excavation report).

 (1957–8). L'Archivio di Cretule a Festòs. *Annuario*, XXXV–XXXVI, 1957–8, 7–192. Gli Scavi a Festòs nel 1956 e 1957. *Ibid.* 193–361.

 (1959). La Villa Rurale Minoica di Gortina. *Boll. d'Arte*, 1959, 237–65.

 (1961–2). La Tomba a Tholos di Kamilari presso a Festòs. *Annuario*, XXXIX–XL, 1961–2, 7–148. Gli Scavi a Festòs negli Anni 1958–60. *Ibid.* 377–504.

 (1965–6). La Conclusione degli Scavi a Festòs. *Annuario*, XLIII–XLIV, 1965–6, 313–99.

Lucas, A. (1962[4]). *Ancient Egyptian Materials and Industries* (revised by Harris, J.). London.

Mackeprang, M. (1938). Late Mycenaean Vases. *AJA*, 1938, 537–59.

Maraghiannis, G. (1911). *Antiquités Crétoises*. Deuxième Série. Candie.

Marinatos, S. (1927–8). Ὑστερομινωϊκὸς λαξευτὸς τάφος ἐν Καρτερῷ Κρήτης. *Arch. Delt.* 1927–8, 68–90.

 (1928). Höhlenforschungen in Kreta. *Mitteilungen über Hohlen und Karstforschung*, 1928, 97–107.

 (1930–1). Δύο πρώιμοι μινωϊκοὶ τάφοι ἐκ Βόρου Μεσαρᾶς. *Arch. Delt.* 1930–1, 137–70.

 (1931). Ἡ ὀρεία κρύσταλλος ἐν Κρήτῃ. *Eph. Arch.* 1931, 158–60.

 (1932). *Praktika*, 1932, 76 (Amnisos villa).

 (1933–5). *Arch. Delt.* 1933–5, Παράρτημα, 49–51 (Giophyrakia deposit), 52 (Episkope Pedhiadha tombs).

 (1935). *AA*, 1935, 247 (Apodhoulou).

 (1937). *AA*, 1937, 224 and 227, fig. 7 (Maronia pyxis), 222 (Phaneromeni Cave).

 (1939–41). Τὸ μινωϊκὸν μέγαρον Σκλαβοκάμπου. *Eph. Arch.* 1939–41, 69–96.

 (1949–56). *Praktika*, 1949, 100–9; 1950, 242–8; 1951, 258–72; 1952, 592–610; 1953, 298; 1955, 309–10; 1956, 223 (Vathypetro Villa).

Marinatos, S. & Hirmer, M. (1960). *Crete and Mycenae* (translated by Boardman, J.). London.

Matz, F. (1951). *Forschungen auf Kreta 1942*. Berlin. See Jantzen, U., Kirsten, E. & Schörngendorfer, A.

Money-Coutts, M. (1936). A Stone Bowl and Lid from Byblos. *Berytus*, III, 1936, 129–36.
　See also Pendlebury, H. W., Pendlebury, J. D. S. & Money-Coutts, M. B.
　See also Seiradaki (= Money-Coutts).

Morgan, J. de (1895). *Fouilles à Dahchour, Mars–Juin 1894*. Vienna.
　(1896–7). *Recherches sur les Origines de l'Égypte*, II. Paris.

Mosso, A. (1910). *The Dawn of Mediterranean Civilization*. London and Leipzig.

Mylonas, G. E. (1932). Προϊστορικὴ Ἐλευσίς. Athens.
　(1957). *Ancient Mycenae*. London.

Ninkovich, D. & Heezen, B. (1965). Santorini Tephra. *Proceedings of the Colston Research Society*, **17**, 1965, 413–53.

Pace, B. (1914). Tracce dell'Epoca Preistorica in Gortina. *Annuario*, I, 1914, 372.

Palmer, L. R. (1963 a). The Find Places of the Knossos Tablets. In *On the Knossos Tablets*. Oxford.
　(1963 b). A Stone Lamp from Knossos. *Kr. Khron*. 1963, 280–306.

Papathanasopoulos, G. A. (1961–2), Κυκλαδικὰ Νάξου. *Arch. Delt*. **17**, 1961–2, 104–51.

Paribeni, R. (1904). Ricerche nel Sepolcreto di Haghia Triada presso Phaestos. *Mon. Ant*. XIV, 1904, 677–756.
　(1913). Scavi nella Necropoli Preellenica di Festo. Tombe a Tholos scoperte presso il Villaggio di Siva. *Ausonia*, VIII, 1913, 13–32.

Pelagatti, P. (1961–2). Osservazione sui Ceramisti del I Palazzo di Festos. *Kr. Khron*. 1961–2, 99–111.

Pendlebury, H. W. & J. D. S. (1928–30). Two Protopalatial Houses at Knossos. *BSA*, XXX, 1928–30, 53–73.

Pendlebury, H. W. & J. D. S. & Money-Coutts, M. B. (1935–6). Excavations in the Plain of Lasithi, I. *BSA*, XXXVI, 1935–6, 5–131.
　(1937–8). Excavations in the Plain of Lasithi, II. *BSA*, XXXVIII, 1937–8, 1–56.

Pendlebury, J. D. S. (1930). *Aegyptiaca*. Cambridge.
　(1939). *The Archaeology of Crete*. London.
　(1948). *John Pendlebury in Crete*. (Essays by and on J.D.S.P.). Cambridge.

Perdrizet, P. (1908). *Fouilles de Delphes*. V. *Monuments Figurés, Petits Bronzes, Terres-Cuites, Antiquités Diverses*. Paris.

Pernier, L. (1904). *Mon. Ant*. XIV, 1904, 313–500. (Phaistos second preliminary report).
　(1925). L'Odeum' nell'Agora' di Gortina presso il Leteo. *Annuario*, VIII, 1925, 1–69.
　(1935). *Il Palazzo Minoico di Festos I*. Rome.

Pernier, L. & Banti, L. (1951). *Il Palazzo Minoico di Festos II*. Rome.

Persson, A. W. (1931). *The Royal Tombs at Dendra near Midea*. Lund.
　(1942). *New Tombs at Dendra near Midea*. Lund.

Petrie, Sir W. M. F. (1901 a). *The Royal Tombs of the Earliest Dynasties*. Part II. London.
　(1901 b). *Diospolis Parva*. London.
　(1937). *Funeral Furniture and Stone and Metal Vases*. British School of Archaeology in Egypt, vol. LIX. London.

Petrie, Sir W. M. F. & Quibell, J. E. (1896). *Naqada and Ballas*. London.

Platon, N. (1948–1960*a*). Archaeological Activity in Crete: *Kr. Khron*. 1948, 589; 1949, 594; 1951*a*, 442–9; 1952*a*, 473–5; 1953, 491–2; 1954*a*, 511–15; 1955, 565–8; 1956, 415–17; 1957*a*, 331–40; 1958*a*, 470–82; 1959, 368–85; 1960*a*, 509–27 (with Davaras, K.).

(1951*b*). Ἀνασκαφὴ μινωϊκῶν οἰκιῶν εἰς Πρασὰ Ἡρακλείου. *Praktika*, 1951, 246–57.

(1952*b*). Ἀνασκαφαὶ ΥΜ III λαξευτῶν τάφων εἰς τὴν περιοχὴν Ἐπισκοπῆς καὶ Σταμνιῶν Πεδιάδος Ἡρακλείου. *Praktika*, 1952, 619–28.

(1954*b*). Ἀνασκαφαὶ περιοχῆς Σητείας. *Praktika*, 1954, 361–8.

(1957*b*). Ἀνασκαφὴ Χόνδρου Βιάννου. *Praktika*, 1957, 136–47.

(1958*b*). Inscribed Libation Vessel from a Minoan House at Prassa, Herakleion. In *Minoica* (ed. Sundwall, J.), 1958, 305–18 and pls. I–II.

(1960*b*). *Arch. Delt*. **16**, 1960, 261 (Χρονικά. Κρήτης).

(1963). Ἀνασκαφαὶ Ζάκρου. *Praktika*, 1963, 160–88.

(1964*a*). A New Major Minoan Palace Discovered: First Excavations at Kato Zakro. Part I. *ILN*, 29 February 1964.

(1964*b*). A New Major Minoan Palace Discovered in Crete: Unique and Beautiful Objects from Kato Zakro. Part II. *ILN*, 7 March 1964.

Popham, M. R. (1964*a*). The Palace at Knossos: A Matter of Definition and a Question of Fact. *AJA*, 1964, 349–54.

(1964*b*). *The Last Days of the Palace at Knossos*. Studies in Mediterranean Archaeology, v. Lund.

(1965). Some Late Minoan III Pottery from Crete. *BSA*, **60**, 1965, 316–42.

(1966). The Destruction of the Palace of Knossos and its Pottery. *Antiquity*, XL, 1966, 24–8.

See also Sackett, H., Popham, M. R. & Warren P. (1965).

Poursat, J.-C. (1966). Un Sanctuaire du Minoen Moyen II. *BCH*, XC, 1966, 514–51.

Quibell, J. E. (1935). Stone Vessels from the Step Pyramid. *Annales du Service des Antiquités de l'Égypte*, XXXV, 1935, 76–80.

Quibell, J. E. & Green, F. W. (1902). *Hierakonpolis*, II. London.

See also Petrie, Sir W. M. F. & Quibell, J. E.

Quitta, H. See Kohl H. & Quitta H.

Raulin, V. (1869). *Description Physique de l'Isle de Crète*. Paris.

Reisner, G. A. (1931*a*). Stone Vessels found in Crete and Babylonia. *Antiquity*, v, 1931, 200–12.

(1931*b*). *Mycerinus*. Cambridge, Mass.

Renfrew, C. (1964). Crete and the Cyclades before Rhadamanthus. *Kr. Khron*. 1964, 107–41.

(1966). Obsidian and Early Cultural Contact in the Near East. *PPS*, XXXII, 1966, 30–72.

Renfrew, C., Cann, J. R. & Dixon, J. E. (1965). Obsidian in the Aegean. *BSA*, **60**, 1965, 225–47.

See also Cann, J. R. & Renfrew, C.

Richter, G. M. A. (1953). *Handbook of the Greek Collection*. The Metropolitan Museum of Art. New York.

Roque, B. de la (1950). *Trésor de Tod*. Cairo.

Roque, B. de la, Contenau, G. & Chapouthier, F. (1953). *Le Trésor de Tod*. Cairo.

Rowe, A. (1940). *The Four Canaanite Temples of Beth-Shan*. Philadelphia.

Sackett, L. H. (1963). New Excavations at a Minoan Site neglected for over Fifty Years: Discoveries at Palaikastro in Eastern Crete. *ILN*, 27 April 1963.

Sackett, L. H., Popham, M. R. & Warren, P. M. (1965). Excavations at Palaikastro, VI. *BSA*, **60**, 1965, 248–315.

Sakellarakis, J. (1965). Arkhanes 1965. Report on the Excavations. *Kadmos*, 1965, 177–80.

(1967). Minoan Cemeteries at Arkhanes. *Archaeology*, **20**, 1967, 276–81.

Santerre G. de (1949). Grand Rhyton de Pierre Trouvé à Mallia. *BCH*, LXXIII, 1949, 1–18.

Santerre, G. de & Treheux, J. (1947–8). Rapport sur le Dépôt Égéen et Géométrique de l'Artémision à Délos. *BCH*, LXXI–LXXII, 1947–8, 148–254.

See also Demargne, P. & Santerre, G. de.

Savignoni, L. (1903). Il Vaso di Haghia Triada. *Mon. Ant.* XIII, 1903, 77–132.

(1904). Scavi e Scoperti nella Necropoli di Phaestos. *Mon. Ant.* XIV, 1904, 501–676.

Schiering, W. 1960. Steine und Malerei in der minoischen Kunst. *Jahrbuch*, **75**, 1960, 17–36.

Schliemann, H. (1886). *Tiryns.* London.

Scholes, K. (1956). The Cyclades in the Later Bronze Age: A Synopsis. *BSA*, **51**, 1956, 9–40.

Schörngendorfer, A. (1951). Ein mittelminoisches Tholosgrab bei Apesokari. In Matz (1951), 13–22.

Seager, R. B. (1905). Excavations at Vasilike, 1904. *Transactions Pennsylvania*, I, Part III, 1905, 207–21.

(1907). Report of Excavations at Vasilike, 1906. *Transactions Pennsylvania*, II, Part II, 1907, 111–32.

(1909). Excavations on the Island of Mochlos, Crete, in 1908. *AJA*, 1909, 273–303.

(1910). Excavations on the Island of Pseira, Crete. *Penn. Anth. Publ.* III, no. 1, 1910, 1–38.

(1912). *Explorations in the Island of Mochlos.* Boston and New York.

(1916). The Cemetery of Pachyammos, Crete. *Penn. Anth. Publ.* VII, no. 1, 1916, 1–30.

Seiradaki, M. (1960). Pottery from Karphi. *BSA*, **55**, 1960, 1–37.

See also Money-Coutts, M. B.

Seltman, C. (1951). A Minoan Bull's Head. *Studies Presented to David Moore Robinson*, I, 1951, 6–15. Washington University, Saint Louis, Missouri.

Smith, S. (1945). Middle Minoan I–II and Babylonian Chronology. *AJA*, 1945, 1–24.

Smith, W. S. (1965). *Interconnexions in the Ancient Near East.* New Haven. London.

Spratt, T. A. B. (1865). *Travels and Researches in Crete*, I–II. London.

Staes, B. (1895). Προϊστορικοὶ συνοικισμοὶ ἐν Ἀττικῇ καὶ Αἰγίνᾳ. Θορικός. *Eph. Arch.* 1895, 221–34.

(1915). Ἀνασκαφαὶ ἐν Κυθήροις. *Arch. Delt.* I, 1915, 191–4.

Stubbings, F. H. (1947). The Mycenaean Pottery of Attica. *BSA*, XLII, 1947, 1–75.

Tod, M. N. (1902–3). Excavations at Palaikastro. II, Hagios Nikolaos. *BSA*, IX, 1902–3, 336–43.

See also Dawkins, R. M. & Tod, M. N.

Tsountas, Kh. (1888). Ἀνασκαφαὶ τάφων ἐν Μυκήναις. *Eph. Arch.* 1888, 119–80.

(1889). Ἔρευναι ἐν τῇ Λακωνίᾳ καὶ ὁ τάφος τοῦ Βαφειοῦ. *Eph. Arch.* 1889, 129–72.

(1898). Κυκλαδικά. *Eph. Arch.* 1898, 137–212.

Tsountas, Kh. & Manatt, J. I. (1897). *The Mycenaean Age.* London.

Tzedhakis, J. (1965). Ἀρχαιότητες καὶ μνημεῖα Δυτικῆς Κρήτης. 1964. *Arch. Delt.* **20**, 1965, 567–70.

Vercoutter, J. (1956). *L'Égypte et le Monde Égéen Préhellénique.* Cairo.

Volgraff, W. (1906). Fouilles d'Argos. *BCH*, XXX, 1906, 5–45.

Wace, A.J.B. (1919–21). Excavations at Mycenae. IV, The Rhyton Well. *BSA*, XXIV, 1919–21, 200–9.

(1921–3). Excavations at Mycenae. *BSA*, XXV, 1921–3.

(1932). Chamber Tombs at Mycenae. *Archaeologia*, LXXXII, 1932.

(1952). Mycenaean Life and Death. *ILN*, 1 November 1952.

(1956). Mycenae 1939–1955. *BSA*, **51**, 1956, 103–31.

Warren, P. (1965 a). Two Palatial Stone Vases from Knossos. *BSA*, **60**, 1965, 154–5.

(1965 b). The First Minoan Stone Vases and Early Minoan Chronology. *Kr. Khron.* 1965, 7–43.

(1966). A Stone Receptacle from the Cave of Hermes Kranaios at Patsos. *BSA*, **61**, 1966, 195–6.

(1967 a). Minoan Stone Vases as Evidence for Minoan Foreign Connexions in the Aegean Late Bronze Age. *PPS*, XXXIII, 1967, 37–56.

(1967 b). A Stone Vase Maker's Workshop in the Palace at Knossos. *BSA*, **62**, 1967, 195–201.

The Early Bronze Age Chronology of Crete. *Proceedings of the VIIth International Congress of Pre- and Protohistoric Sciences, Prague, 1966* (forthcoming).

See also Hood, M. S. F., Warren, P. & Cadogan, G.; Hughes, H. M. C. & Warren, P.; Sackett, L. H., Popham, M. R. & Warren, P.

Waterhouse, H. & Hope Simpson, R. (1960). Prehistoric Laconia. Part I. *BSA*, **55**, 1960, 67–108.

(1961). Prehistoric Laconia. Part II. *BSA*, **56**, 1961, 114–75.

Weikert, C. (1959). Neue Ausgrabungen in Milet. In *Neue deutsche Ausgrabungen im Mittelmeergebiet und im vorderen Orient*, 1959, 181–96. Berlin.

Weinberg, S. (1965). The Relative Chronology of the Aegean in the Stone and Early Bronze Ages. In Ehrich (1965), 285–320.

Wolters, P. (1891). Marmorkopf aus Naxos. *Ath. Mitt.* XVI, 1891, 46–58.

Woolley, Sir L. (1953). *A Forgotten Kingdom*. London.

Wreszinski, W. (1923). *Atlas zur altägyptischen Kulturgeschichte*, I. Leipzig.

Xanthoudides, S. (1905–6). Cretan Kernoi. *BSA*, XII, 1905–6, 9–23.

(1906). Προϊστορικὴ οἰκία εἰς Χαμαῖζι Σητείας. *Eph. Arch.* 1906, 117–54.

(1909). Μινωϊκὸν σκεῦος ἐνεπίγραφον. *Eph. Arch.* 1909, 179–96.

(1916). Μυκηναϊκὸς τάφος Δαμανίων. *Arch. Delt.* II, 1916, 171–8.

(1918). Μέγας πρωτομινωϊκὸς τάφος Πύργου. *Arch. Delt.* IV, 1918, 136–70. Παράρτημα, 15–23 (Aspre Petra and Marathokephalon).

(1922). Μινωϊκὸν μέγαρον Νίρου. *Eph. Arch.* 1922, 1–25.

(1924). *The Vaulted Tombs of Mesara* (translated by Droop, J. P.). London.

Zervos, Ch. (1956). *L'Art de la Crète Néolithique et Minoenne*. Paris.

(1957). *L'Art des Cyclades du Début à la Fin de l'Âge du Bronze*. Paris.

All measurements in the sections of line-drawings and plates are given in centimetres: e.g. 5·65 = 5·65 cm.

Pres. stands for preserved.

1. ALABASTRONS

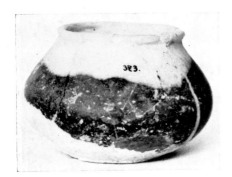

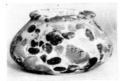

P 2 Ht. 3.6

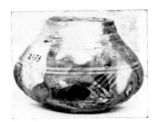

P 3 Ht. 5.9

P 1 Ht. 5.28

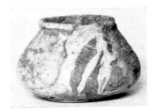

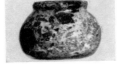

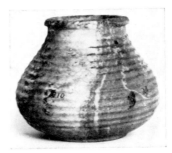

P 4 Ht. 4.35

P 5 Ht. 4.1

P 6 Ht. 5.6

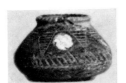

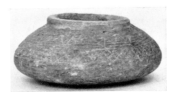

P 7 Ht. 3.8

P 8 Ht. 3.5

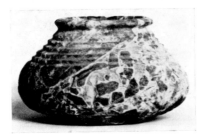

P 9 Ht. 5.6

P 10 Ht. 3.2

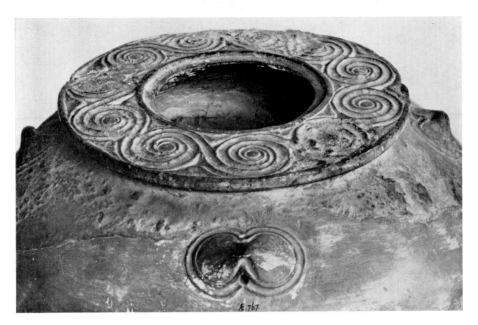

P 11　　Ht. 12.4

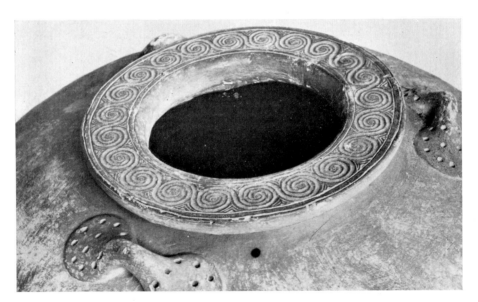

P 12　　Ht. 12.9

3. BIRD'S NEST BOWLS

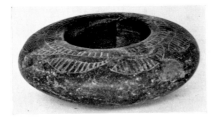

P 13 Ht. 3.95

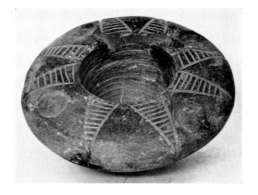

P 14 Ht. 3.5

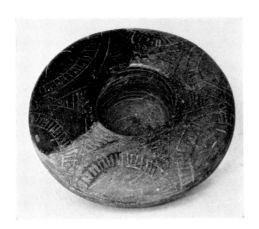

P 15 Ht. 3.4

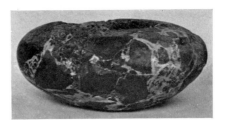

P 16 Ht. 4.6

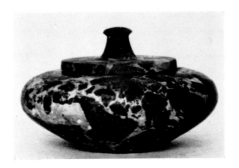

P 17 Ht. 4.1

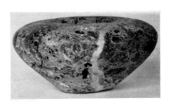

P 18 Ht. 4.58

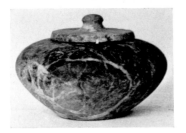

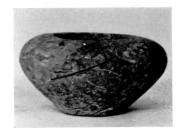

P 19 Ht. 4.1 P 20 Ht. 4.4

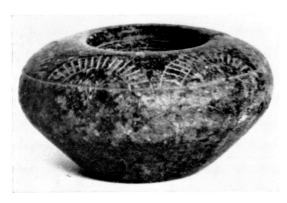

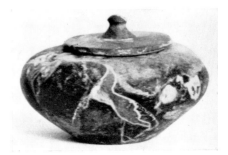

P 22 Ht. 3.1

P 21 Ht. 3.45

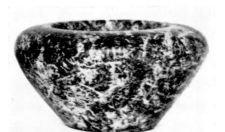

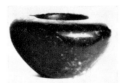

P 23 Ht. 3.55 P 25 Ht. 4.15

P 24 Ht. 5.9

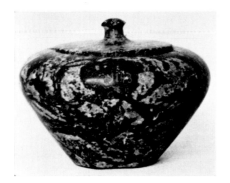

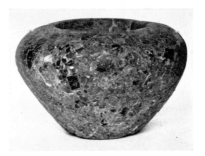

P 27 Ht. 5.2

P 26 Ht. 6.6

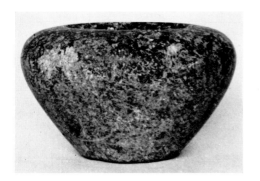

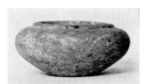

P 29 Ht. 3.15

P 28 Ht. 7.65

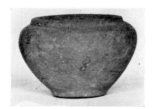

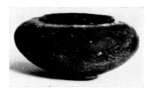

P 31 Ht. 3.82

P 30 Ht. 3.9

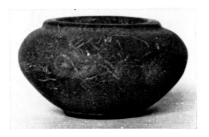

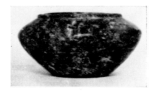

P 33 Ht. 4.3

P 32 Ht. 4.6

4. BLOCK VASES (KERNOI)

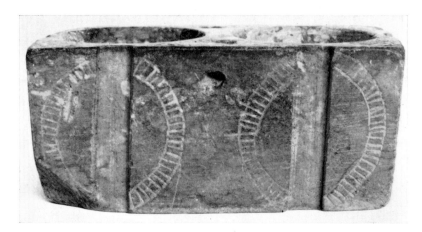

P 34 Ht. 4.9

P 35 Ht. 3.85

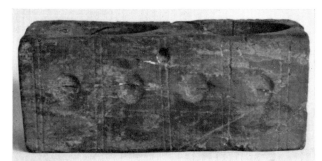

P 36 Ht. 5.6

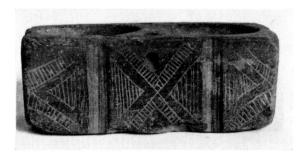

P 37 Ht. 4.5

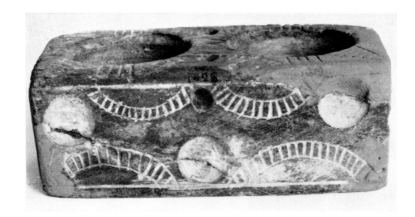

P 38 Ht. 3.8

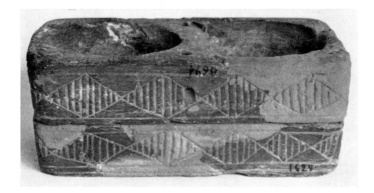

P 39 Ht. 3.55

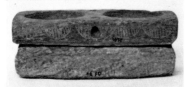

P 40 Ht. 3.6

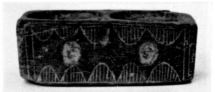

P 41 Ht. 3.8

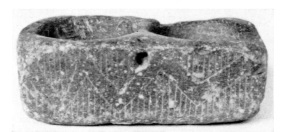

P 42 Ht. 3.0

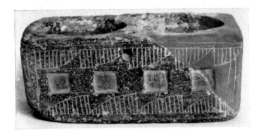

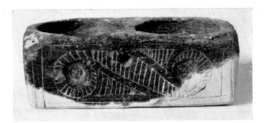

P 43 Ht. 5.0

P 44 Ht. 4.25

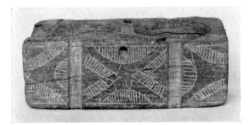

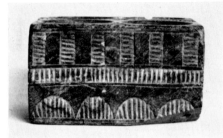

P 45 Ht. 4.9

P 46 Ht. 5.1

P 47 Ht. 2.9

P 48 Ht. 2.25

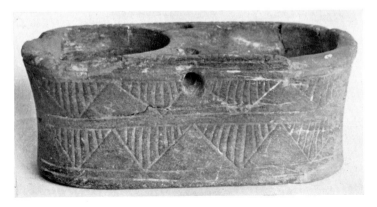

P 49 Ht. 3.82

P 50 Ht. 3.6

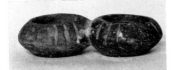

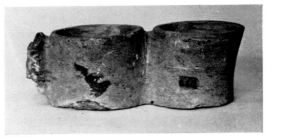

P 52 Ht. 2.5

P 53 Ht. 3.4

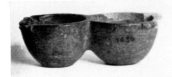

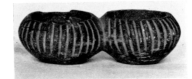

P 54 Ht. 2.4

P 55 Ht. 5.25

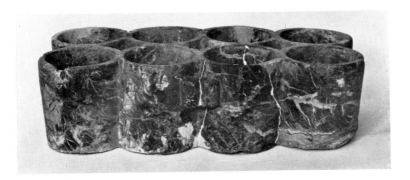

P 56 Ht. 7.55

P 58 Ht. 6.0

P 57 Ht. 5.8 approx.

5. BLOSSOM BOWLS

P 59 Ht. 7.5

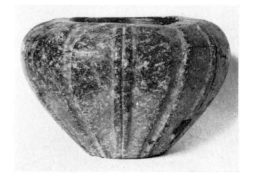

P 60 Ht. 10.55

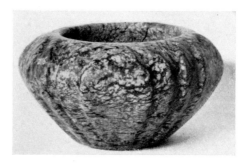

P 61 Ht. 6.88

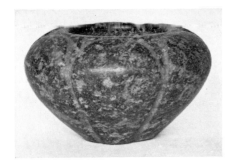

P 62 Ht. 9.6

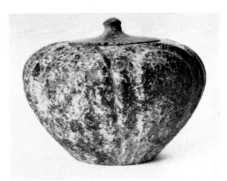

P 63 Ht. 8.6

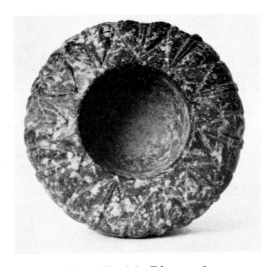

P 64 Ht. 6.65. Diam. 11.85

6. BOWLS WITH CARINATED OR CURVED PROFILE

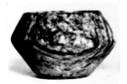

P 65 Ht. 4.0

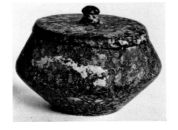

P 66 Ht. 5.0

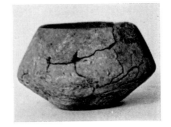

P 67 Ht. 4.9

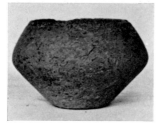

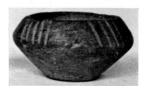

P 69 Ht. 3.6

P 68 Ht. 5.1

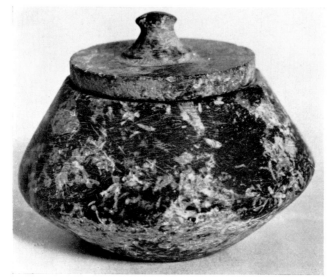

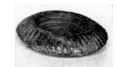

P 71 Ht. 1.9

P 70 Ht. 2.9

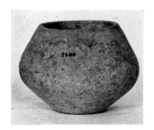

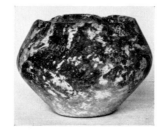

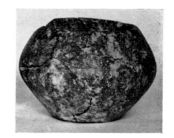

P 72 Ht. 5.1

P 73 Ht. 6.1

P 74 Ht. 6.08

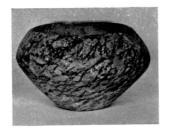

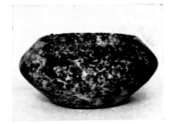

P 75 Ht. 4.65

P 76 Ht. 4.0

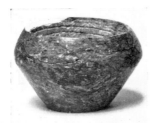

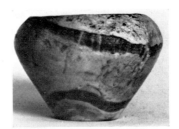

P 77 Ht. 4.6

P 78 Ht. 6.4

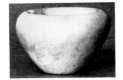

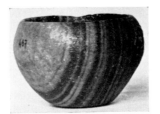

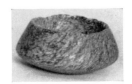

P 79 Ht. 4.2

P 81 Ht. 3.95

P 80 Ht. 4.5

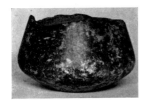

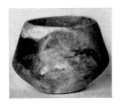

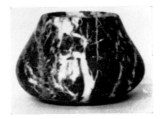

P 82 Ht. 4.0

P 83 Ht. 4.7

P 84 Ht. 5.5

7. BOWLS WITH CARINATED OR CURVED PROFILE AND LUGS ON THE SHOULDER

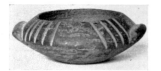

P 85 Ht. 3.1

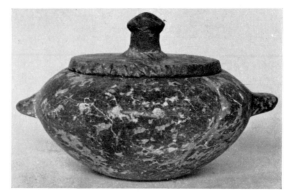

P 86 Ht. 4.7

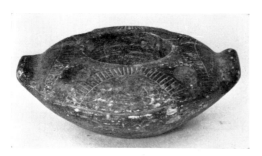

P 87 Ht. 3.8

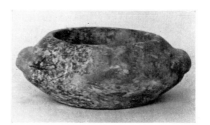

P 88 Ht. 5.75

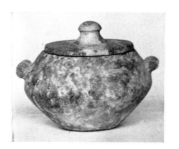

P 89 Ht. 5.85

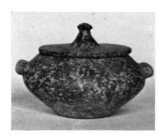

P 90 Ht. 4.42

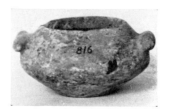

P 91 Ht. 5.15

P 92 Ht. 4.2

P 93 Ht. 4.15

P 94 Ht. 10.4

P 95 Ht. 4.75

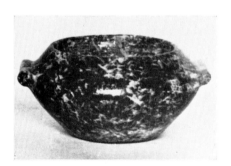

P 96 Ht. 4.75

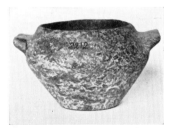

P 97 Ht. 6.25

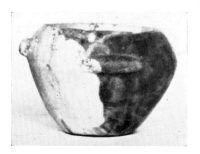

P 98 Ht. 5.1

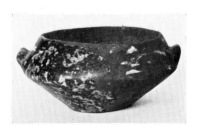

P 99 Ht. 6.65

8. BOWLS WITH CARINATED OR CURVED PROFILE AND EVERTED RIM

P 100 Ht. 3.68

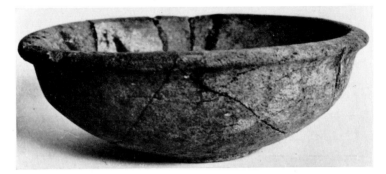

P 101 Ht. 3.55

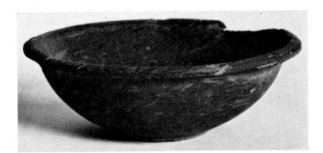

P 102 Ht. 2.7

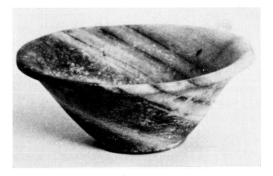

P 103 Ht. 3.35

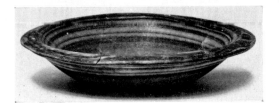

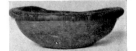

P 105 Ht. 2.2

P 104 Ht. 3.9

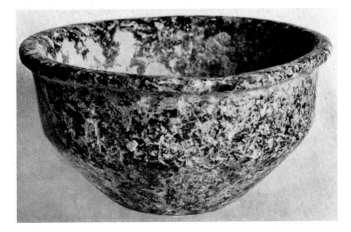

P 106 Ht. 5.1

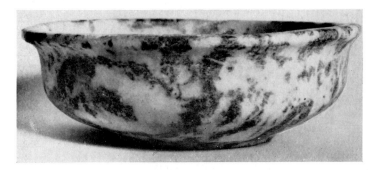

P 107 Ht. 3.8

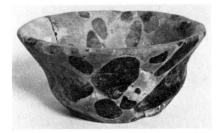

P 108 Ht. 2.95

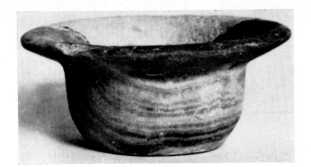

P 109 Ht. 2.45

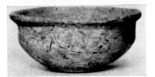

P 110 Ht. 3.2

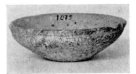

P 111 Ht. 2.6

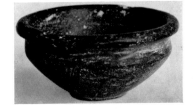

P 112 Ht. 2.6

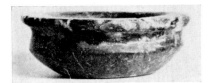

P 113 Ht. 1.25

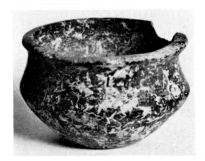

P 114 Ht. 3.0

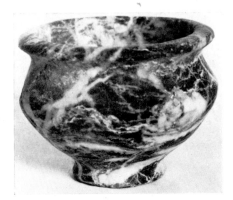

P 115 Ht. 3.6

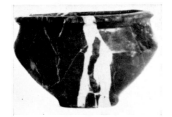

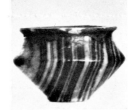

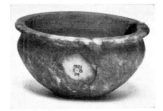

P 116 Ht. 5.7

P 117 Ht. 4.5

P 118 Ht. 4.2

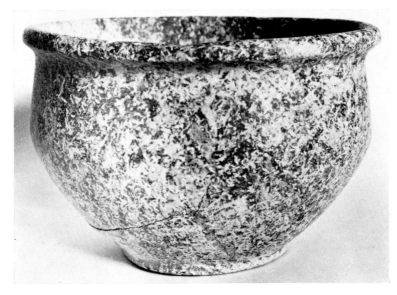

P 119 Ht. 8.4

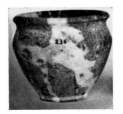

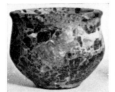

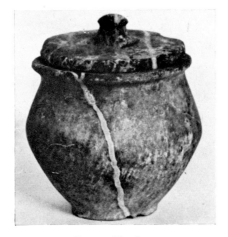

P 121 Ht. 4.4

P 120 Ht. 6.0

P 122 Ht. 6.95

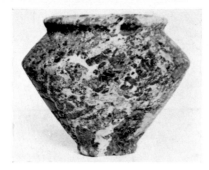
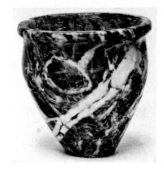

P 123 Ht. 10.05

P 124 Ht. 6.75

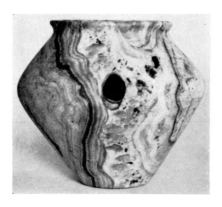
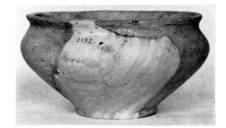

P 126 Ht. 6.18

P 125 Ht. 8.85

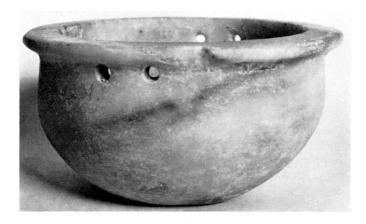

P 127 Ht. 5.9

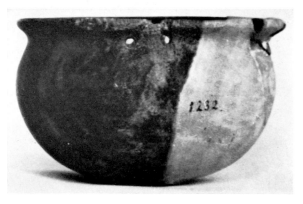

P 128 Ht. 6.6

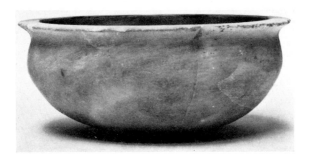

P 129 Ht. 6.4

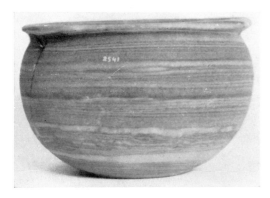

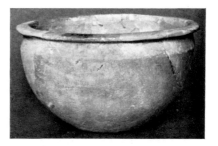

P 131 Ht. 7.85

P 130 Ht. 9.2

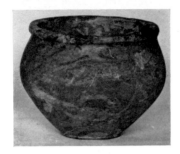

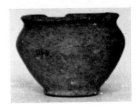

P 132 Ht. 8.2

P 133 Ht. 5.5

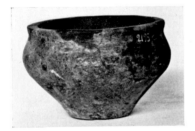

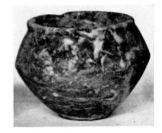

P 134 Ht. 6.72

P 135 Ht. 5.4

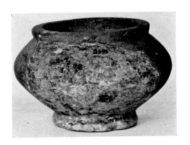

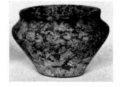

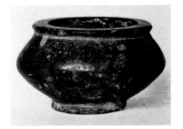

P 137 Ht. 4.5

P 136 Ht. 5.8

P 138 Ht. 6.95

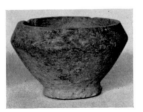

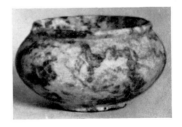

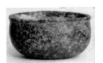

P 141 Ht. 3.8

P 139 Ht. 4.6

P 140 Ht. 4.6

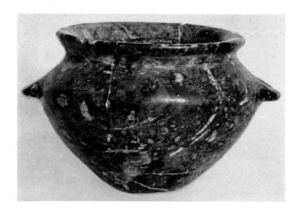

P 142 Ht. 5.6

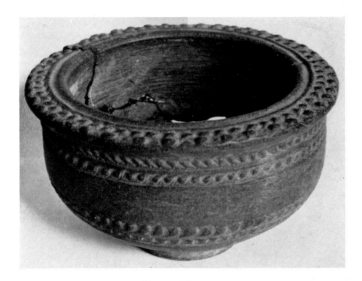

P 143 Ht. 6.35

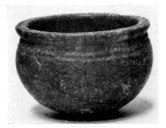

P 144 Ht. 5.6

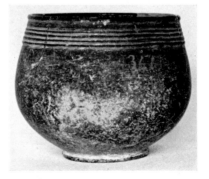

P 145 Ht. 10.2

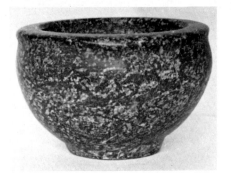

P 146 Ht. 8.1

9. BOWLS WITH HORIZONTAL GROOVES OR DIAGONAL FLUTING

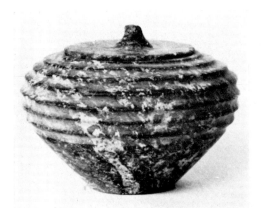

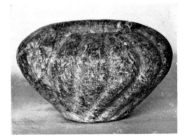

P 148 Ht. 6.9

P 147 Ht. 8.25

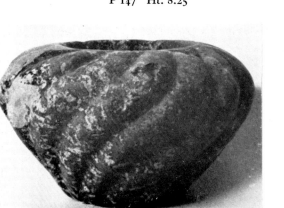

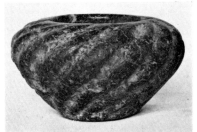

P 150 Ht. 6.9

P 149 Ht. 8.1

10. BOWLS WITH RIM LUGS OR HANDLES

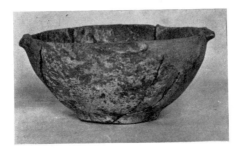

P 151 Ht. 3.38

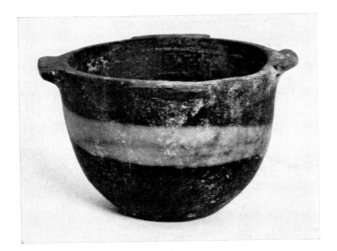

P 152 Ht. 3.3

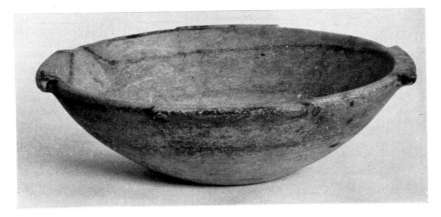

P 153 Ht. 4.0

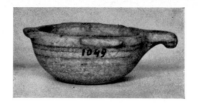

P 154 Ht. 1.9

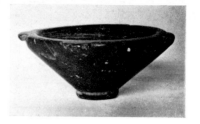

P 155 Ht. 2.6

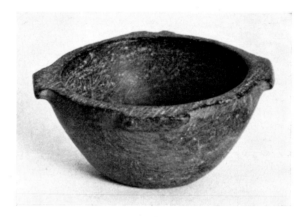

P 156 Ht. 2.25

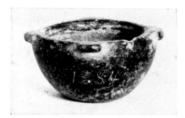

P 157 Ht. 1.3

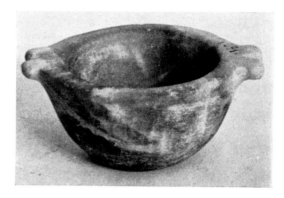

P 158 Ht. 1.98

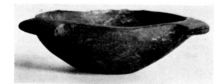

P 159 Ht. 1.8

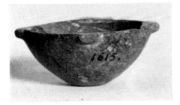

P 160 Ht. 2.5

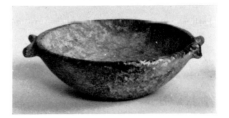

P 161 Ht. 3.25

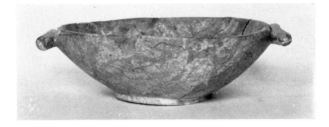

P 162 Ht. 6.2

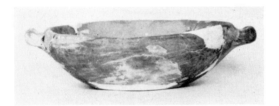

P 163 Ht. 5.4

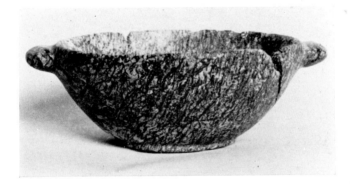

P 164 Ht. 7.0

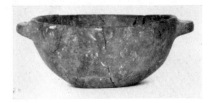

P 165 Ht. 6.2

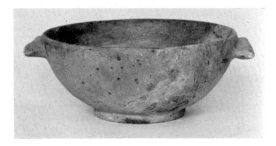

P 166 Ht. 6.5

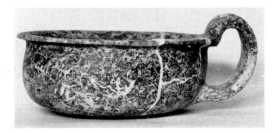

P 167 Ht. 7.3

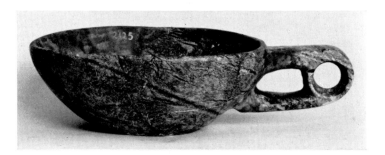

P 168. Ht. 8.9

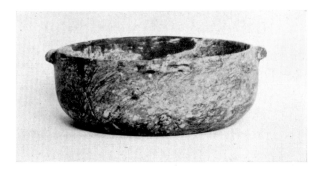

P 169 Ht. 7.0

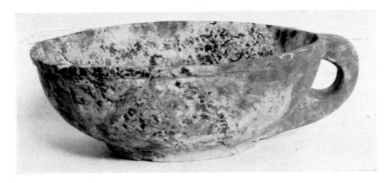

P 170 Ht. 6.5

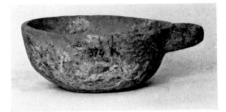

P 171 Ht. 4.9

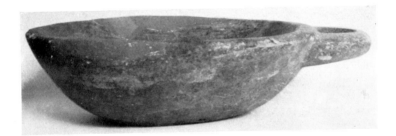

P 172 Ht. 5.35

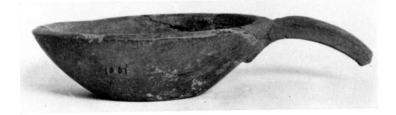

P 173 Ht. 4.4

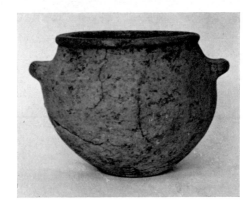

P 174 Ht. 11.0

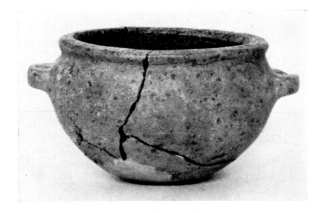

P 175 Ht. 7.6

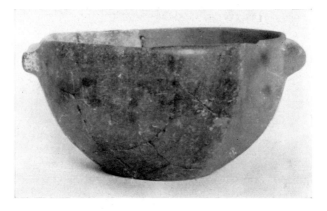

P 176 Ht. 7.85

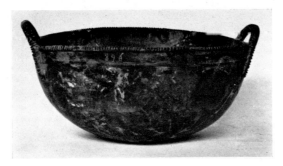

P 177 Ht. 9.6

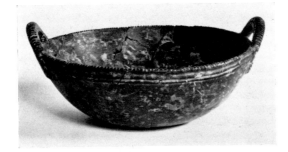

P 178 Ht. 6.1

11. BOWLS WITH RIM SPOUT AND STRAP HANDLE AT RIGHT ANGLES TO SPOUT

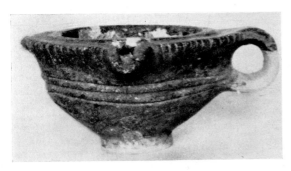

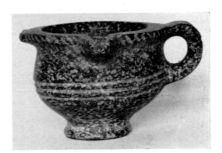

P 180 Ht. 8.35

P 179 Ht. 6.9

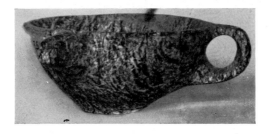

P 181 Ht. 5.65

12. BOWLS WITH VERTICAL GROOVES

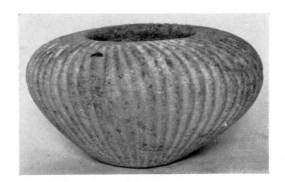

P 182 Ht. 8.4

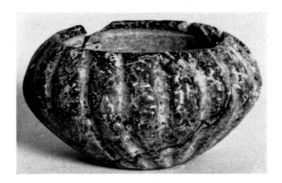

P 183 Ht. 4.35

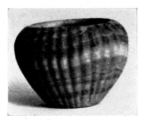

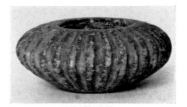

P 184 Ht. 3.1

P 185 Ht. 2.75

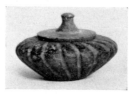

P 186 Ht. 2.65

13. BRIDGE SPOUTED BOWLS

P 187 Ht. 15.3 approx.

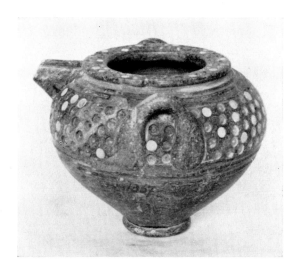

P 188 Ht. 10.25

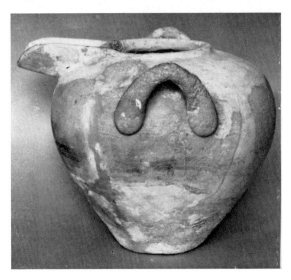

P 190 Ht. pres. 4.3

P 189 Ht. 23.9

14. BUCKET-JARS

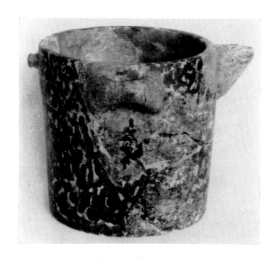

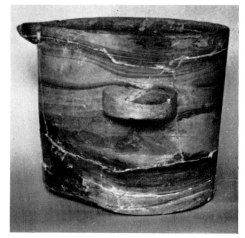

P 191 Ht. 20.6

P 192 Ht. 19.15

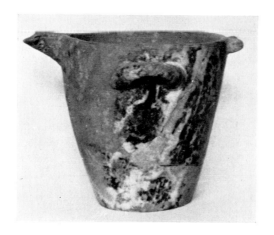

P 193 Ht. 15.3

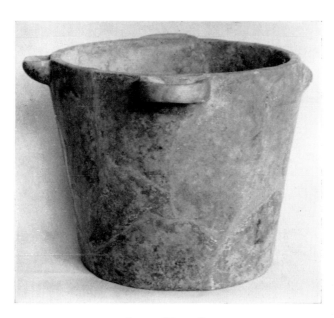

P 194 Ht. 24.8

15. CHALICES

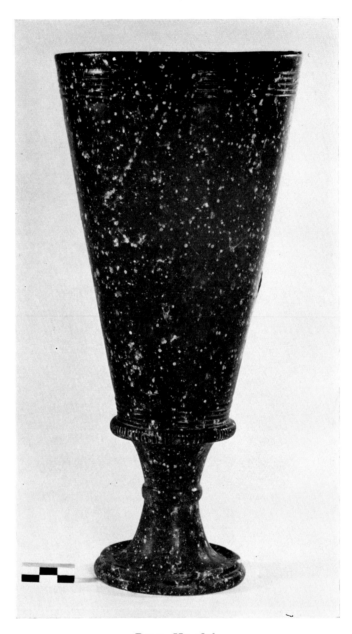

P 195 Ht. 28.6

P 196 Ht. 6.85

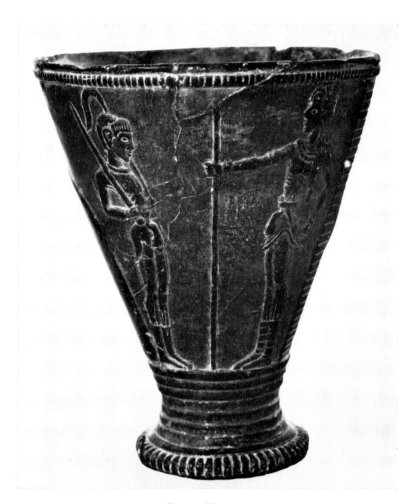

P 197 Ht. 11.5

16. CONICAL CUPS

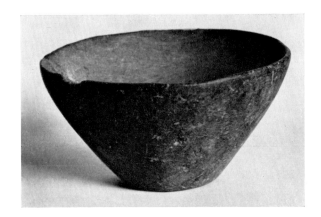

P 198 Ht. 3.6

17. CUPS

 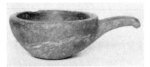 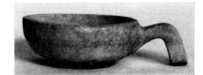

P 199 Ht. 1.55 P 200 Ht. 2.5 P 201 Ht. 2.0

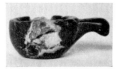 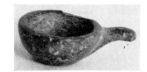

P 202 Ht. 1.7 P 203 Ht. 1.15

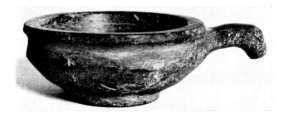

P 204 Ht. 1.75

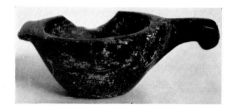

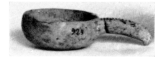

P 205 Ht. 1.5

P 206 Ht. 2.5

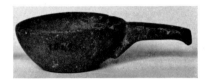

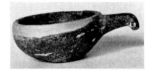

P 207 Ht. 2.6

P 208 Ht. 2.3

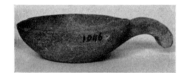

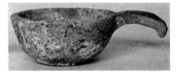

P 209 Ht. 1.95

P 210 Ht. 2.45

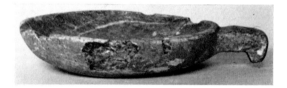

P 211 Ht. 2.7

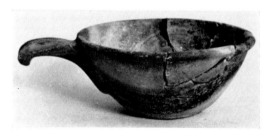

P 212 Ht. 4.6

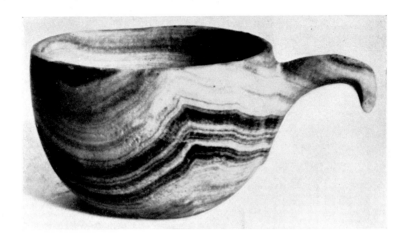

P 213 Ht. 4.0

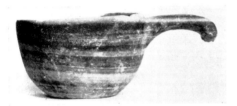

P 214 Ht. 6.2

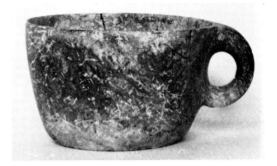

P 215 Ht. 8.0

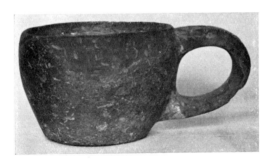

P 216 Ht. 6.9

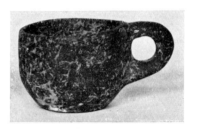

P 217 Ht. 5.35

P 218 Ht. 3.3

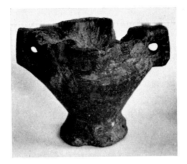

P 219 Ht. 7.48

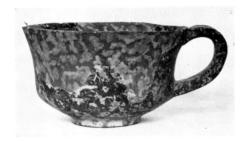

P 220 Ht. 6.05

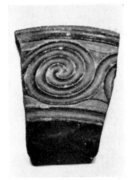

P 221 Ht. pres. 5.1

P 222 Ht. pres. 4.4

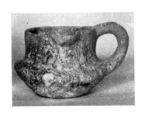

P 223 Ht. 5.15

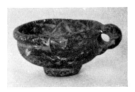

P 224 Ht. 1.9

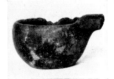

P 225 Ht. 3.48

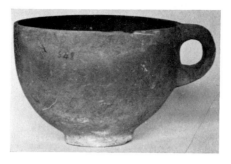

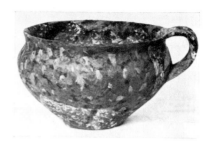

P 226 Ht. 8.3

P 227 Ht. 8.7

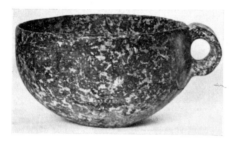

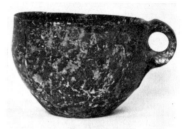

P 228 Ht. 8.1

P 229 Ht. 8.7

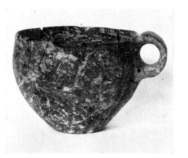

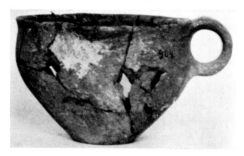

P 230 Ht. 8.7

P 231 Ht. 8.3

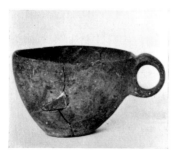

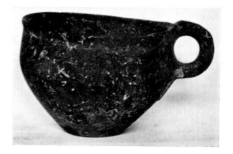

P 232 Ht. 7.55

P 233 Ht. 10.3

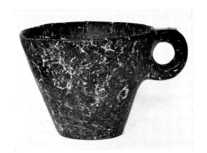

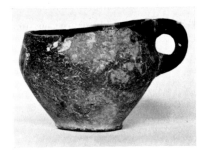

P 234 Ht. 8.95

P 235 Ht. 7.45

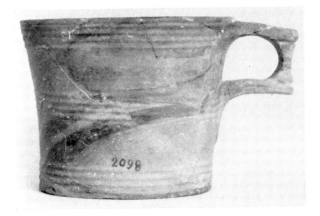

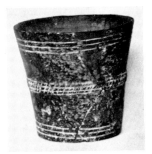

P 237 Ht. 10.3

P 236 Ht. 8.0

18. CYLINDRICAL JARS

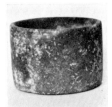

P 238 Ht. 5.45

P 239 Ht. 5.15

P 240 Ht. 4.38

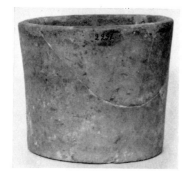

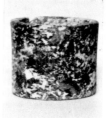

P 242 Ht. 4.23

P 241 Ht. 11.95

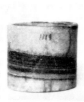

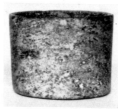

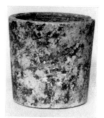

P 243 Ht. 3.65

P 244 Ht. 4.68

P 245 Ht. 5.2

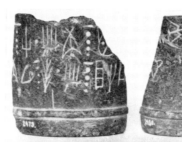

P 246 Ht. 6.55

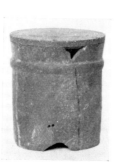

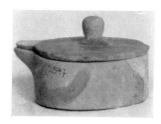

P 248 Ht. 3.35

P 247 Ht. 10.0

19. EWERS

P 249 Ht. 47.0

20. JARS WITH INCURVED OR FLARING SIDES

P 250 Ht. 5.4

P 251 Ht. 5.72

P 252 Ht. 5.6

P 253 Ht. 6.1

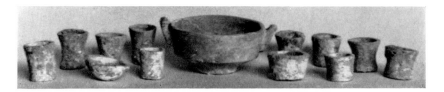

P 254 Hts. various *c.* 3.0-4.0

P 255 Ht. 5.35

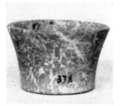

P 256 Ht. 3.85

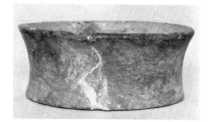

P 257 Ht. 4.85

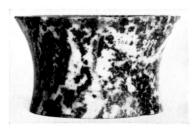

P 258 Ht. 5.85

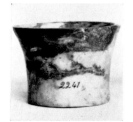

P 259 Ht. 4.42

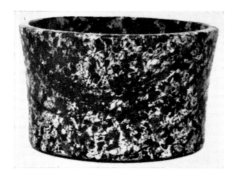

P 260 Ht. 6.3

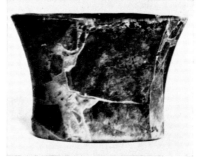

P 261 Ht. 5.75

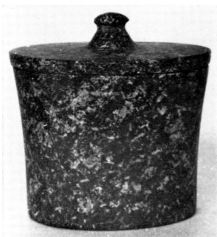

P 262 Ht. 6.4

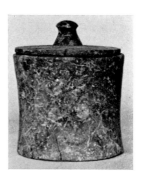

P 263 Ht. 5.8

21. JARS WITH STRAIGHT SLOPING SIDES

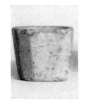

P 264 Ht. 3.6

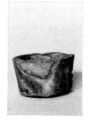

P 265 Ht. 2.55

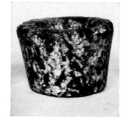

P 266 Ht. 4.68

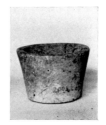

P 267 Ht. 3.37

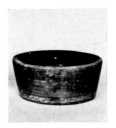

P 269 Ht. 3.95

P 268 Ht. 2.62

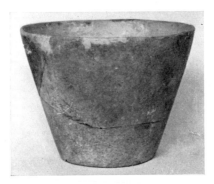

P 271 Ht. 3.95

P 270 Ht. 12.7

22. JUGS

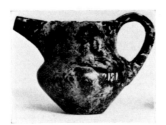

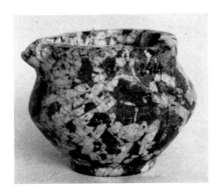

P 272 Ht. 5.8

P 273 Ht. 4.32

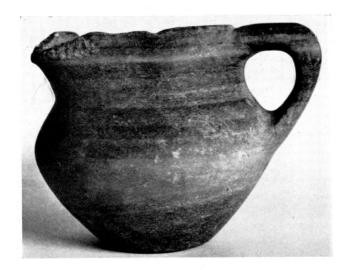

P 274 Ht. 6.1

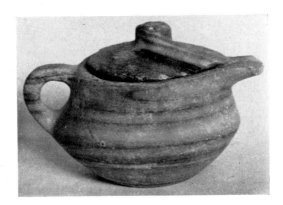

P 275 Ht. 4.7

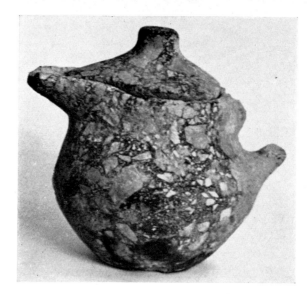

P 276 Ht. 6.6

P 277 Ht. 3.2

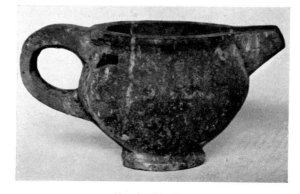

P 278 Ht. 8.75

P 279 Ht. 9.15

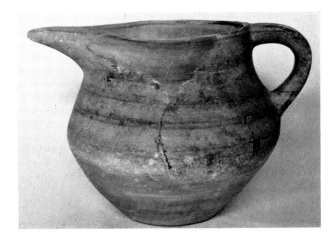

P 280 Ht. 12.8 approx.

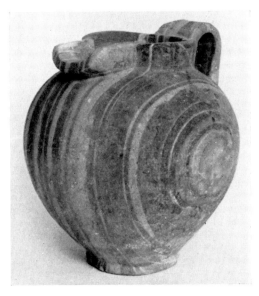

P 281 Ht. 20.6

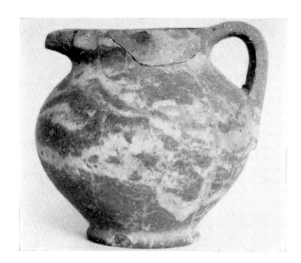

P 282 Ht. 11.2

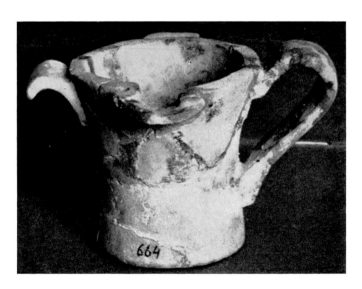

P 283 Ht. 6.9

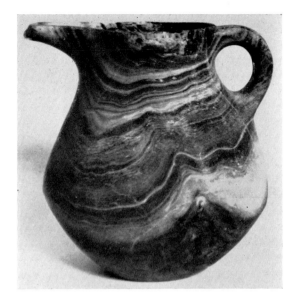

P 284 Ht. 12.2

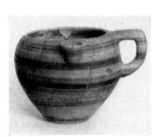

P 285 Ht. 9.9 approx.

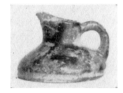

P 286 Ht. 4.4

23. LADLES

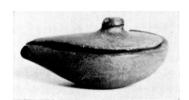

P 287 Ht. 2.4

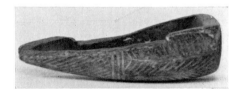

P 288 Ht. 2.4

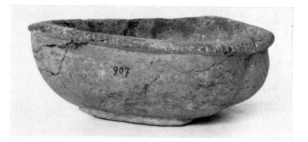

P 290 Ht. 5.55

P 289 Ht. 3.1

P 291 Ht. 3.6

24. LAMPS

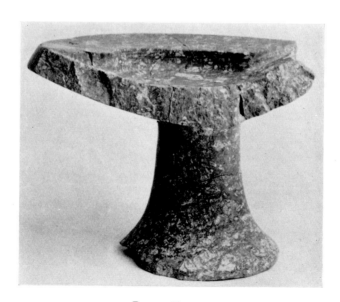

P 292 Ht. 24.4

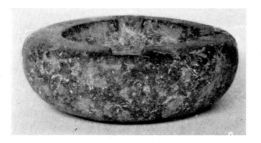

P 293 Ht. 9.8

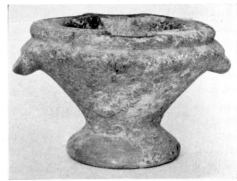

P 294 Ht. 7.75

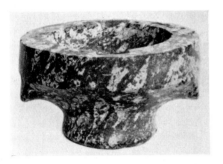

P 295 Ht. 7.05

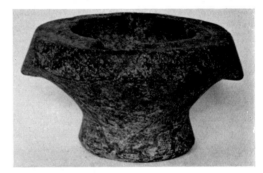

P 296 Ht. 10.25

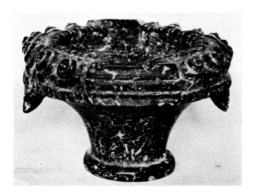

P 297 Ht. 7.8

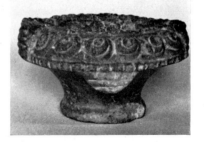

P 298 Ht. 8.6

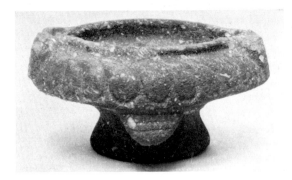

P 299 Ht. 7.8

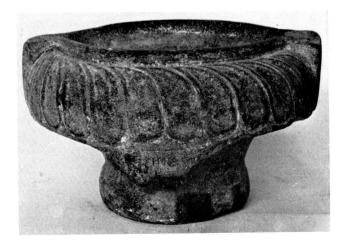

P 300 Ht. 11.2

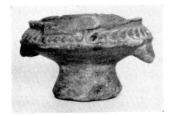

P 301 Ht. 4.6

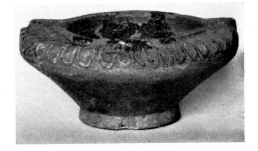

P 302 Ht. 8.6

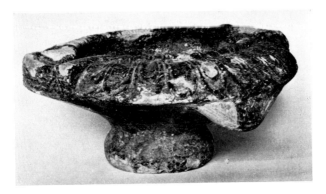

P 303 Ht. 11.5

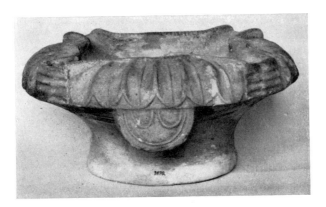

P 304 Ht. 12.7

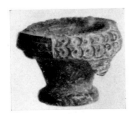

P 305 Ht. 5.23

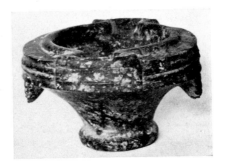

P 306 Ht. 6.55

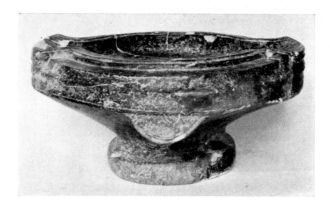

P 307 Ht. 13.2

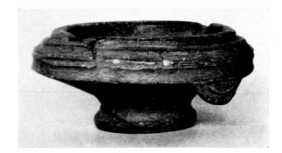

P 308 Ht. 5.6

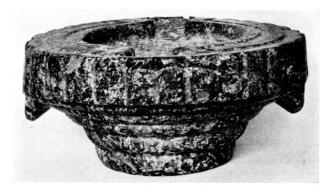

P 309 Ht. 12.8

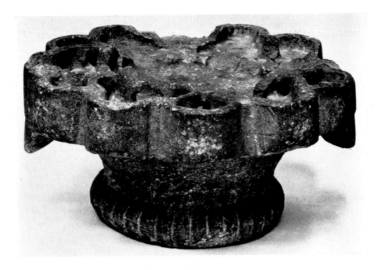

P 310a Ht. 16.15

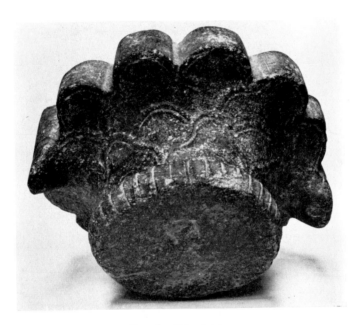

P 310b Ht. 16.15

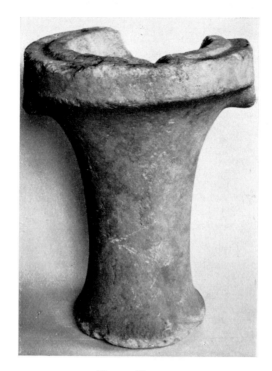

P 311 Ht. 34.2

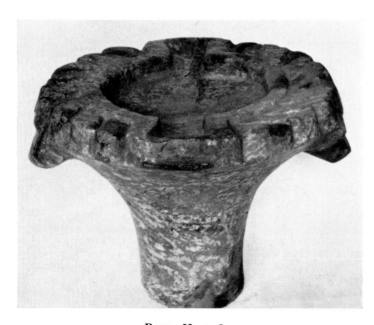

P 312 Ht. 20.8

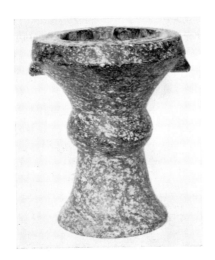

P 313 Ht. 23.2

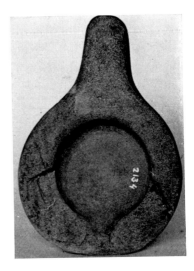

P 314 Ht. 3.9

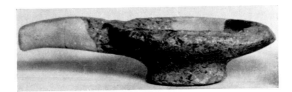

P 315 Ht. 4.5

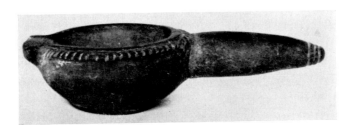

P 316 Ht. 4.4

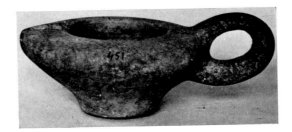

P 317 Ht. 6.1

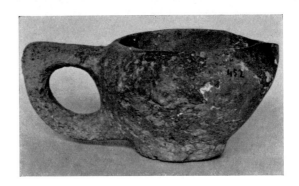

P 318 Ht. 6.85

P 319a Ht. 5.4

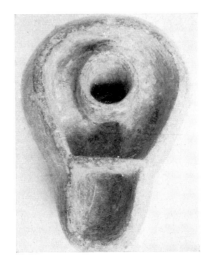

P 319b Ht. 5.4

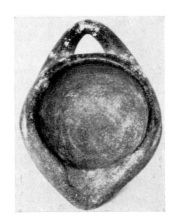

P 320 Ht. 4.4

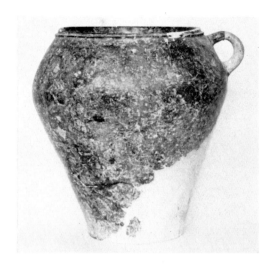

P 321 Ht. 22.3

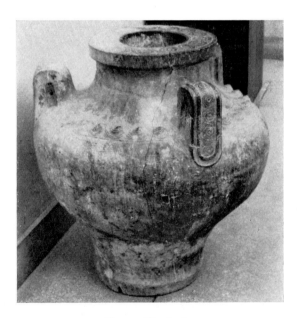

P 322 Ht. 67.6

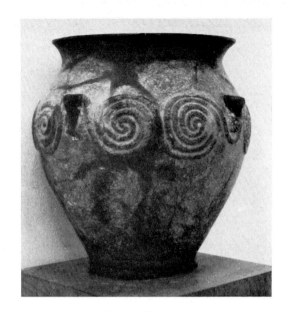

P 323　Ht. 49.0

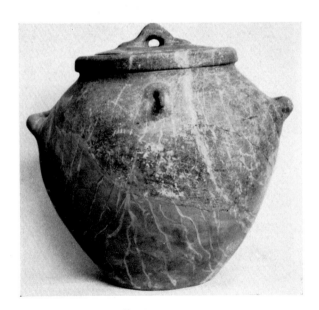

P 325　Ht. 35.8

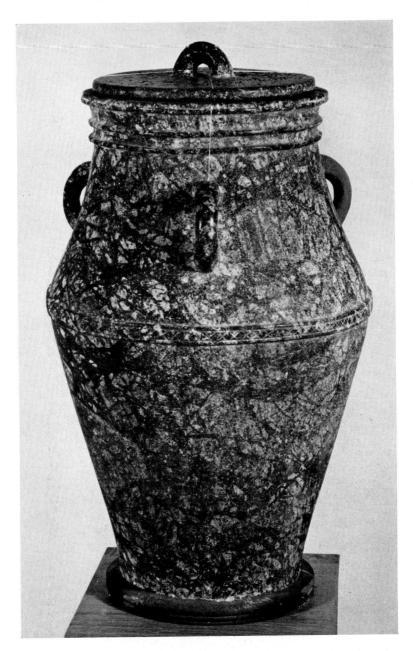

P 324 Ht. 57.5

26. LIBATION TABLES

P 326 Ht. 5.3

P 327 Ht. 5.8

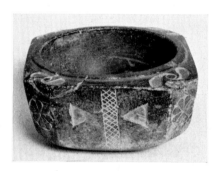

P 328 Ht. 6.3

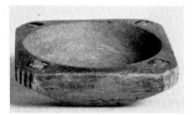

P 329 Ht. 3.4

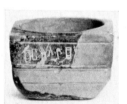

P 330 Ht. 7.0

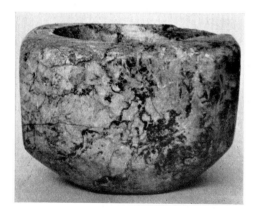

P 331 Ht. 8.9

P 332 Ht. 8.2

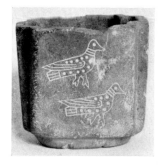

P 333 Ht. 8.35

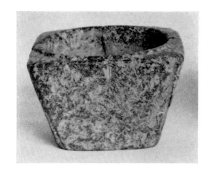

P 334 Ht. 6.75

P 335a Ht. 5.08

P 335b Ht. 5.8

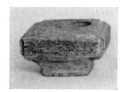

P 336 Ht. 5.4

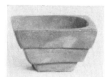

P 337 Ht. 5.18

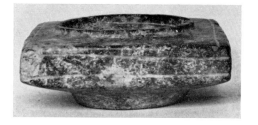

P 338 Ht. 4.85

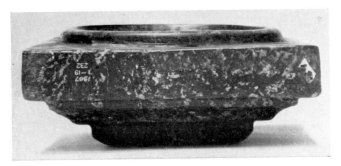

P 339 Ht. 7.1

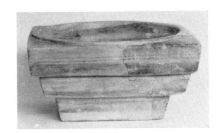

P 340 Ht. 9.2

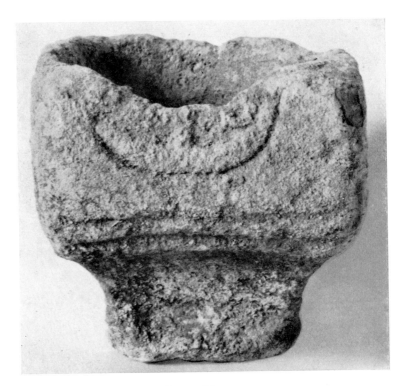

P 341 Ht. 10.4

P 342 Ht. 18.2

P 343 Ht. 7.1

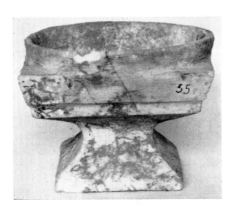

P 344 Ht. 9.5

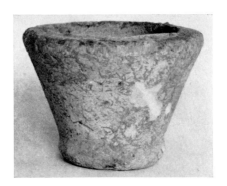

P 345 Ht. 8.75

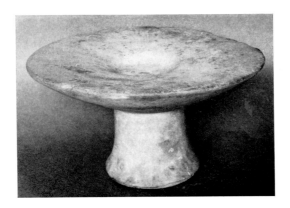

P 346 Ht. 15.25

P 347 Ht. 8.75

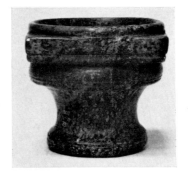

P 348 Ht. 8.45

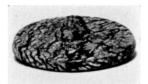

P 349 Ht. 2.3

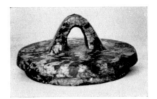

P 350 Ht. 2.85

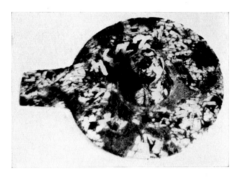

P 351 Ht. 1.75

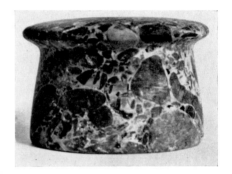

P 352 Ht. 3.8

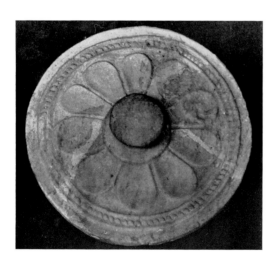

P 353 Ht. 3.45. Diam. 11.9

P 354
Ht. pres. 0.95. Diam. *c.* 10.0

28. MINIATURE AMPHORAS

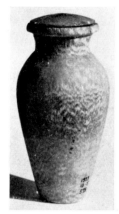

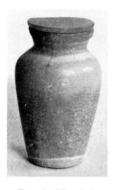

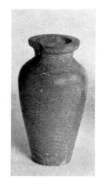

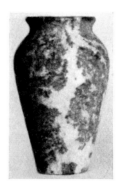

P 356 Ht. 6.6.
Abydos Grave E 123.

P 357 Ht. 5.68.
Abydos Grave E 236.
XII–XIIIth Dynasties.

P 358 Ht. 5.8

P 355 Ht. 7.85. Mostagedda
Tomb 1205. Vth Dynasty.

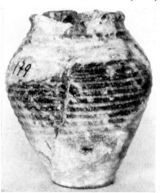

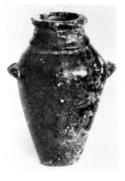

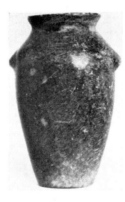

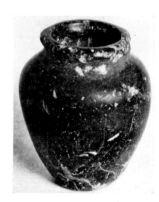

P 359 Ht. 6.2

P 360 Ht. 8.3

P 361 Ht. 7.0

P 362 Ht. 4.1

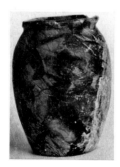

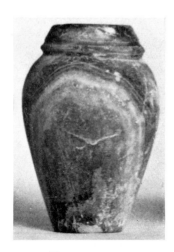

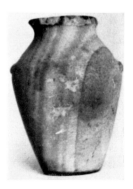

P 363 Ht. 4.5

P 364 Ht. 5.65

P 365 Ht. 7.0

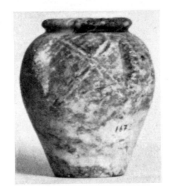

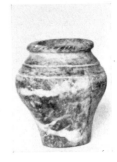

P 366 Ht. 8.52

P 367 Ht. 6.7

P 368 Ht. 5.3

29. MINIATURE GOBLETS

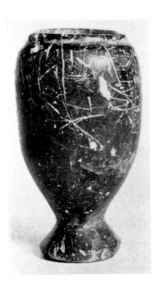

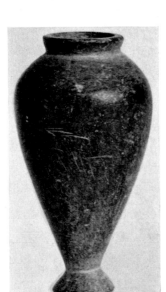

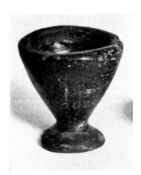

P 370 Ht. 4.68

P 371
Ht. 3.2

P 372 Ht. 3.45

P 369 Ht. 4.8

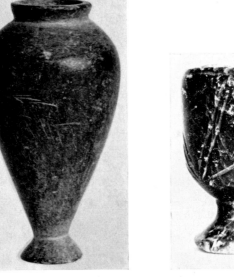

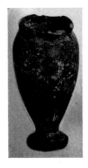

P 375 Ht. 4.05

P 373 Ht. 9.0

P 374 Ht. 5.85

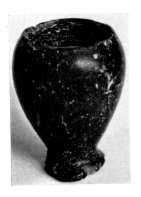

P 376 Ht. 3.7

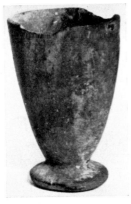

P 377 Ht. 5.6

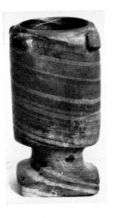

P 378 Ht. 5.25

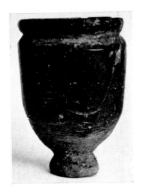

P 379 Ht. 3.9

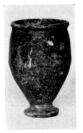

P 380
Ht. 6.5

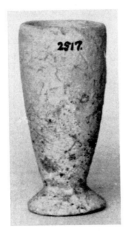

P 381 Ht. 5.42

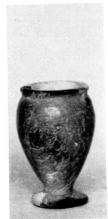

P 382 Ht. 3.4

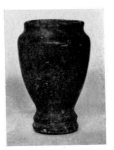

P 383 Ht. 4.6

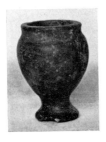

P 384 Ht. 4.0

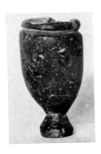

P 385 Ht. 4.75

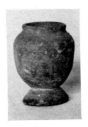

P 386 Ht. 3.25

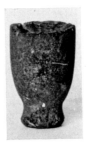

P 387 Ht. 4.4

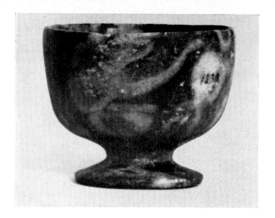

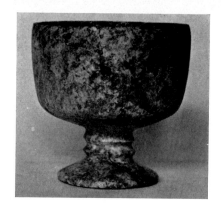

P 388 Ht. 5.75

P 389 Ht. 6.85

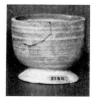

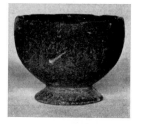

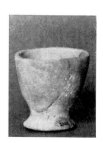

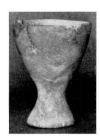

P 390 Ht. 4.4

P 391 Ht. 3.3

P 392 Ht. 5.35

P 393 Ht. 7.2

30. MINOAN IMITATIONS OF EGYPTIAN VASES

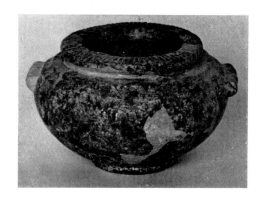

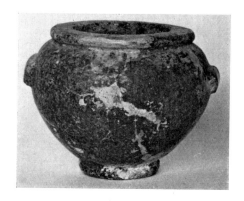

P 394 Ht. 8.5

P 395 Ht. 8.75

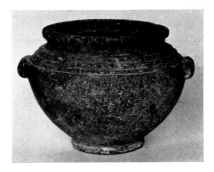

P 396 Ht. 8.1

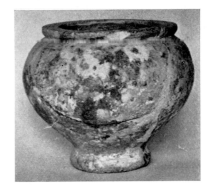

P 397 Ht. 12.3

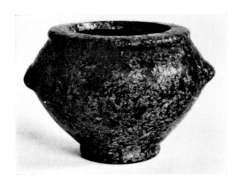

P 398 Ht. 8.6

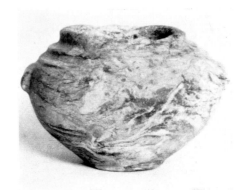

P 399 Ht. 7.15

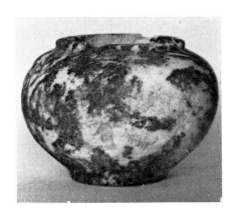

P 400 Ht. 7.9

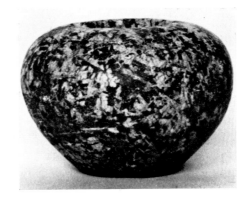

P 401 Ht. 8.1

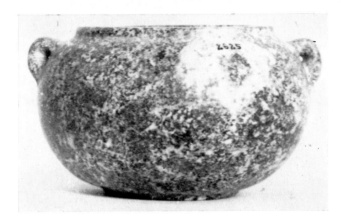

P 402 Ht. 6.1

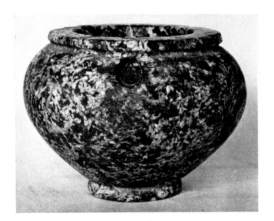

P 403 Ht. 8.9

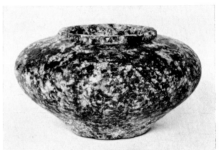

P 404 Ht. 7.3

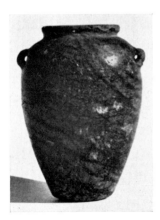

P 405 Ht. 7.5. Mostagedda.
Middle-Late Predynastic
Cf. P 594.

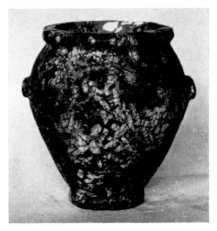

P 406 Ht. 10.0

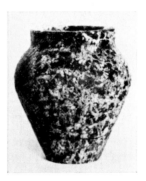

P 407 Ht. 8.18

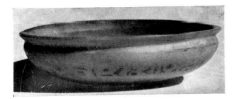

P 408 Ht. 4.1. Name of IDY,
Lector-Priest. VIth Dynasty. BM 4695

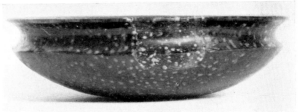

P 409 Ht. 4.65 approx.

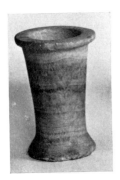

P 410 Ht. 7.1
El Kab Grave 198
IIIrd–VIth Dynasties

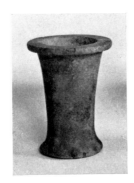

P 411 Ht. 6.6
Mostagedda Grave 3540.
Vth Dynasty

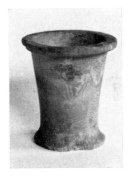

P 412 Ht. 6.25
El Kab IVth Dynasty

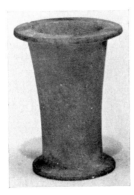

P 413 Ht. 55.5
Qua Tomb 914.
IX–XIth Dynasties

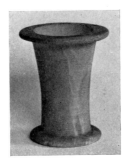

P 414 Ht. 6.7
Dendereh Grave 543
XIth Dynasty

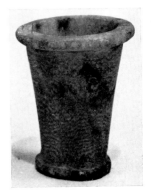

P 415 Ht. 5.8
Harageh Tomb 661
XIIth Dynasty

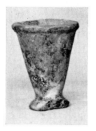

P 416 Ht. 4.0

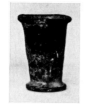

P 417 Ht. 3.45

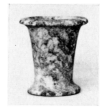

P 418 Ht. 3.52

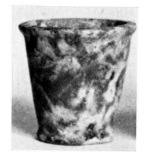

P 419 Ht. 4.35

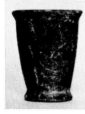

P 421 Ht. 5.2

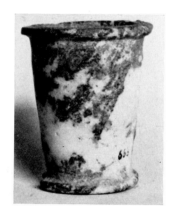

P 420 Ht. 5.32

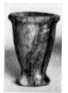

P 422
Ht. 4.1

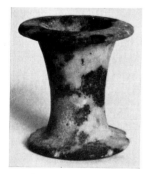

P 423 Ht. 4.05

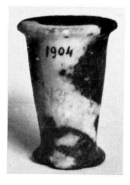

P 424 Ht. 4.6

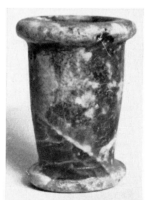

P 425 Ht. 5.4

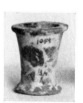

P 426 Ht. 3.7

31. PLAIN BOWLS

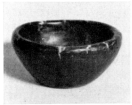

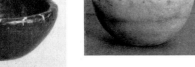

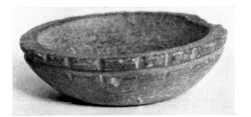

P 427 Ht. 1.7

P 428 Ht. 3.85

P 429 Ht. 1.5

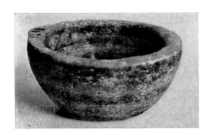

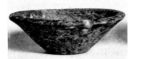

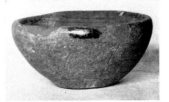

P 431 Ht. 2.8

P 430 Ht. 1.9

P 432 Ht. 2.6

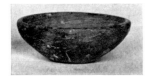

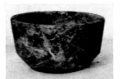

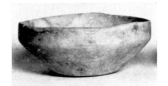

P 433 Ht. 1.6

P 434 Ht. 3.1

P 435 Ht. 3.9

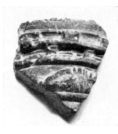

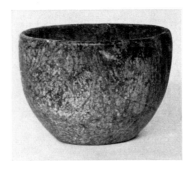

P 436 Ht. pres. 3.9

P 437 Ht. 6.6

32. PLAIN BOWLS WITH MOULDED BASE

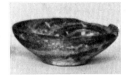

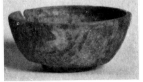

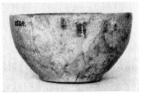

P 438 Ht. 2.05

P 439 Ht. 3.45

P 440 Ht. 3.58

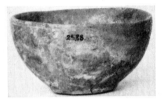

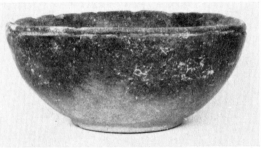

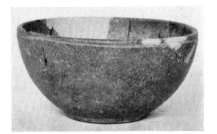

P 442 Ht. 3.8

P 441 Ht. 4.0

P 443 Ht. 6.15

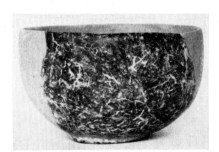

P 444 Ht. 6.1

P 445 Ht. 5.2

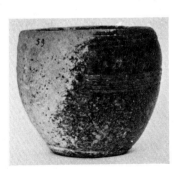

P 446 Ht. 8.6

P 447 Ht. 7.3

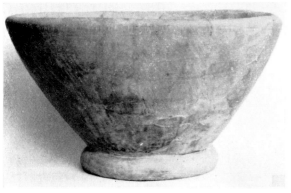

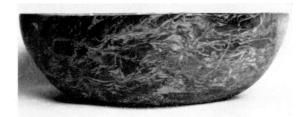

P 449 Ht. 9.35

P 448 Ht. 18.6

33. PYXIDES

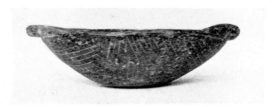

P 450 Ht. 2.55

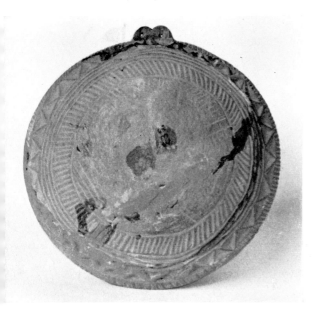

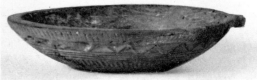

P 451a Ht. 2.85
P 451b Ht. 2.85

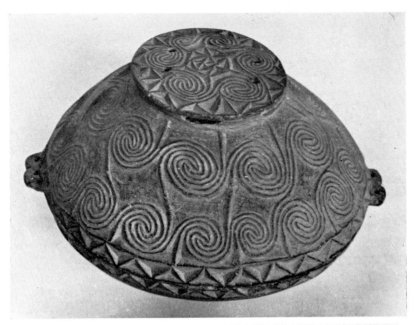

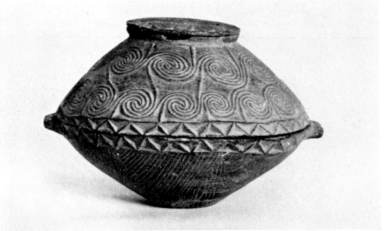

P 452a Ht. 11.85
P 452b Ht. 11.85

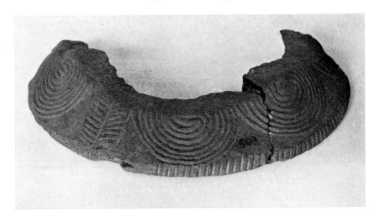

P 453 Ht. pres. 2.1

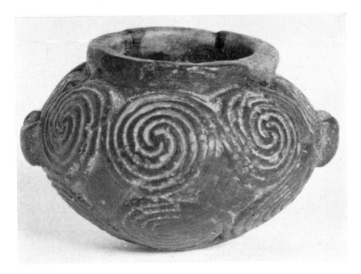

P 454 Ht. 2.25

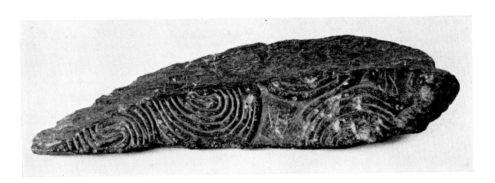

P 455 Ht. pres. 3.9

 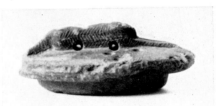

P 456a Ht. 2.28
P 456b Ht. 2.28

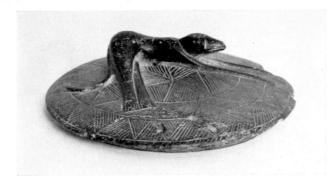

P 457 Ht. 3.0

P 458 Ht. 5.45

P 459 Ht. 5.1

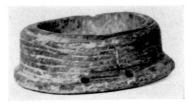

P 460 Ht. 2.65

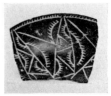

P 461 Ht. pres. 1.8

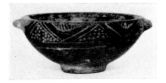

P 462 Ht. 2.85

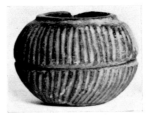

P 463 Ht. 5.0

P 464 Ht. 1.8

34. RHYTONS

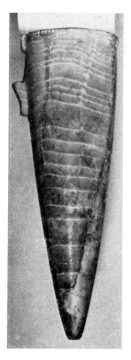

P 465 Ht. 36.7

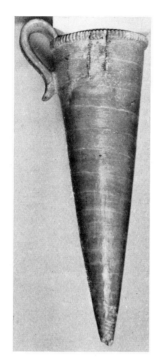

P 466 Ht. 40.0

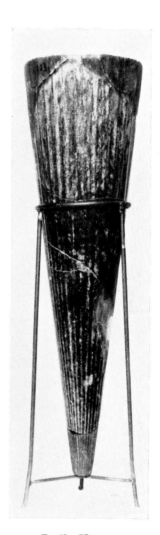

P 468 Ht. 33.3

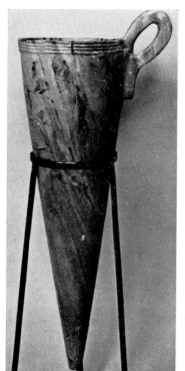

P 467 Ht. 39.8

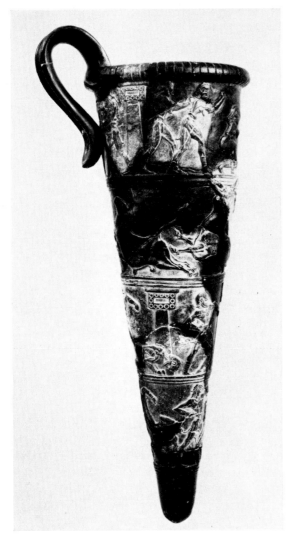

P 470 Ht. pres. 4.9

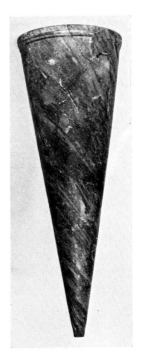

P 469 Ht. 44.85

P 471 Ht. 39.4

P 473 Ht. pres. 2.95

P 474 Ht. pres. 5.15

P 472 Ht. pres. 6.4

P 475 Ht. pres. 3.3

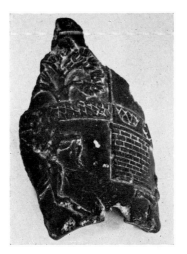

P 477 Ht. pres. 8.85

P 478 Ht. pres. 10.0

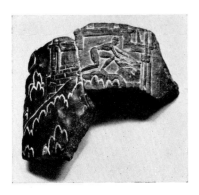

P 476 Ht. pres. 5.9

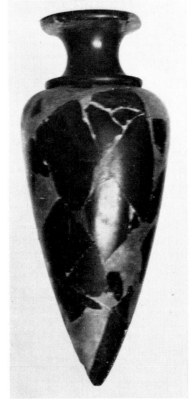

P 480 Ht. 22.6

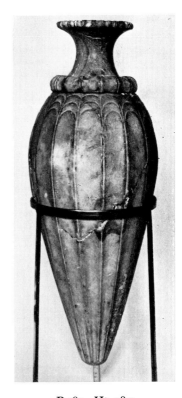

P 481 Ht. 38.2

P 479 Ht. 34.5

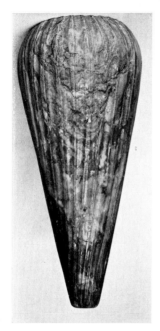

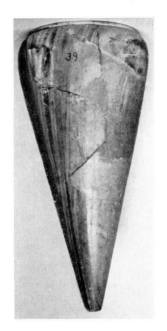

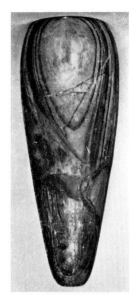

P 484 Ht. 31.2

P 482 Ht. 32.7

P 483 Ht. 30.1

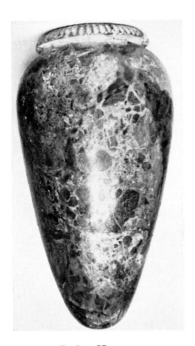

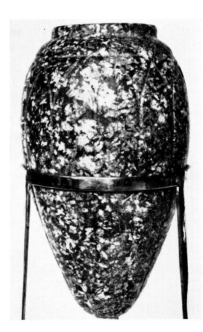

P 486 Ht. 19.0

P 485 Ht. 32.4

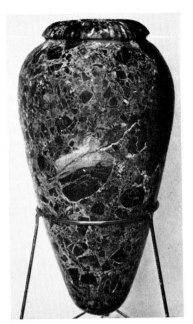

P 488a Ht. 32.45

P 489 Ht. 20.0

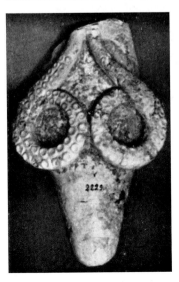

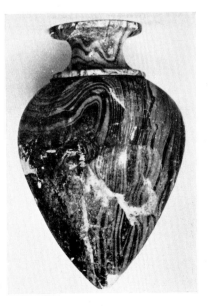

P 488c Ht. 3.85 × 4.1

P 487 Ht. pres. 18.4

P 488b Ht. 23.0

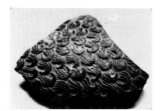

P 490 Ht. 5.0 × 5.05

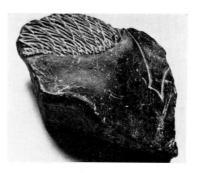

P 491 Ht. 7.1 × 4.7

P 492 Ht. pres. 10.6

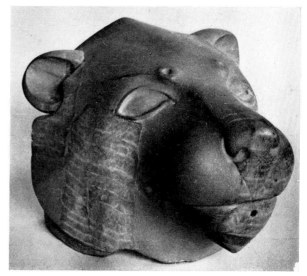

P 493 Ht. 13.5 approx.

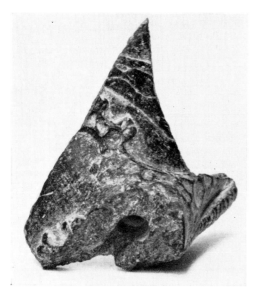

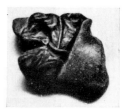

P 495 Ht. pres. 2.5

P 496 Ht. 4.3 × 3.6

P 494 Ht. 5.8 × 3.75

35. SHELL VASES

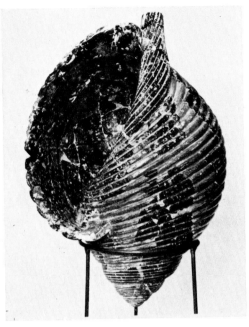

P 497 Ht. 28.5

P 498 Ht. 29.6

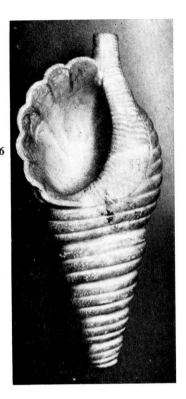

P 499 Ht. 37.0 approx.

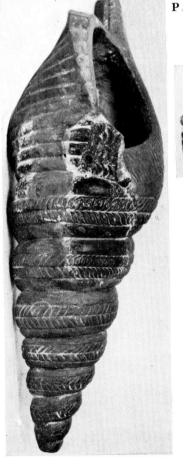

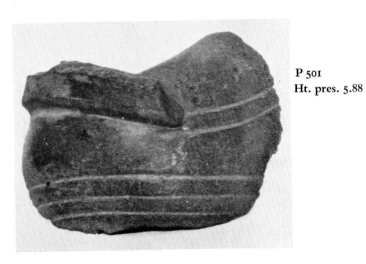

P 500 Ht. 5.2 × 6.25 (largest fragment)

P 501
Ht. pres. 5.88

36. SMALL POTS

P 502 Ht. 3.45

P 503 Ht. 4.6

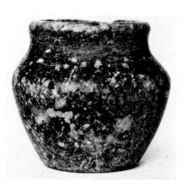

P 504 Ht. 3.4

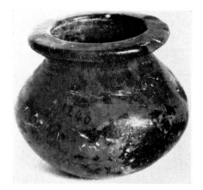

P 505 Ht. 3.75

P 506 Ht. 3.8

P 507 Ht. 5.5

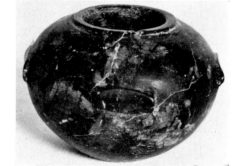

P 510 Ht. 4.3

P 508
Ht. 4.03

P 509 Ht. 2.7

P 511 Ht. 3.0

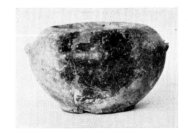

P 512 Ht. 4.7

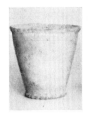

P 513 Ht. 4.6

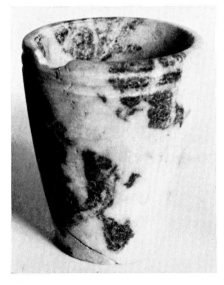

P 514 Ht. 4.75

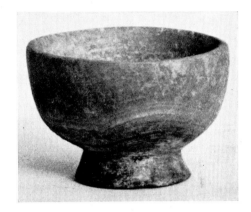

P 515 Ht. 2.7

P 516 Ht. 2.4

P 517 Ht. 3.45

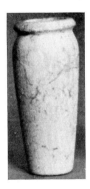

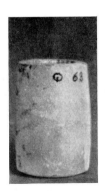

P 518 Ht. 6.1 P 519 Ht. 4.5

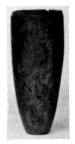

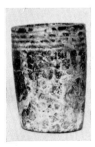

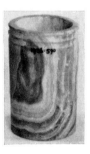

P 520
Ht. 7.4

P 521 Ht. 7.85

P 522 Ht. 6.68

 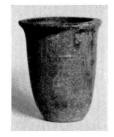 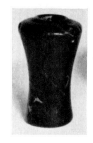 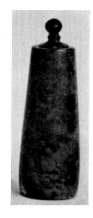

P 523 Ht. 6.45 P 524 Ht. 4.4 P 525 Ht. 3.45

P 526 Ht. 7.05

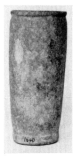

P 527 Ht. 8.1 P 528 Ht. 5.18 P 529 Ht. 5.32 P 530 Ht. 5.25

37. SPOUTED BOWLS

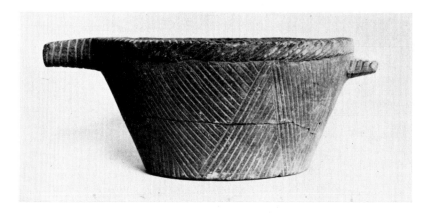

P 531 Ht. 4.85

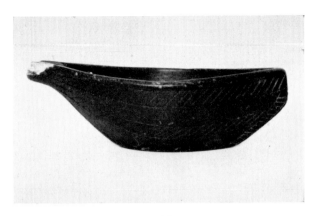

P 532 Ht. 3.5

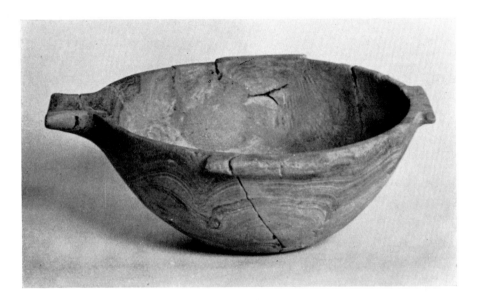

P 533 Ht. 5.5

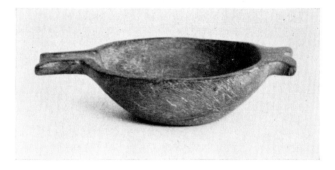

P 534 Ht. 2.3

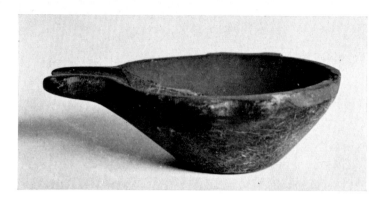

P 535 Ht. 2.5

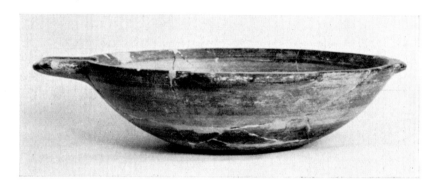

P 536 Ht. 6.7

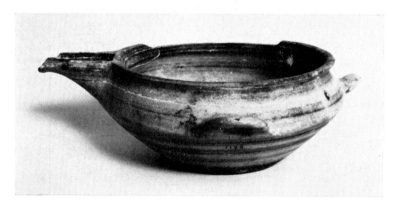

P 537 Ht. 8.1

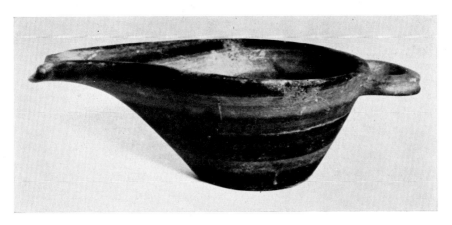

P 538　Ht. 6.5

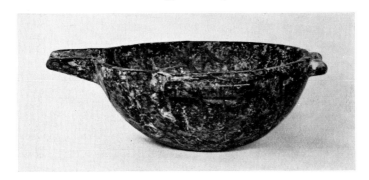

P 539　Ht. 7.75

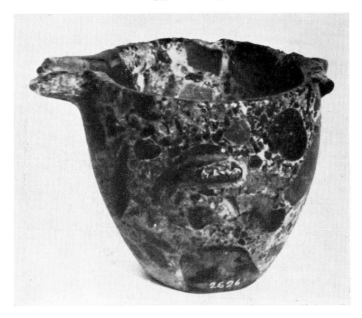

P 540　Ht. 5.7

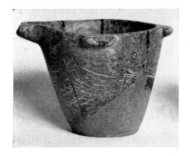

P 541 Ht. 4.75 approx.

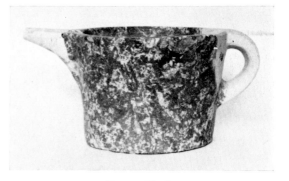

P 542 Ht. 8.4

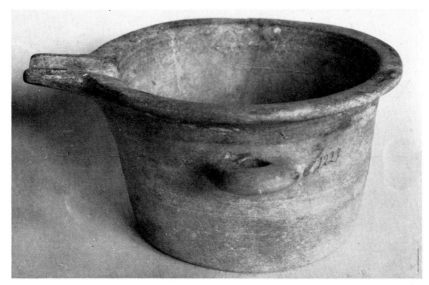

P 543 Ht. 6.95

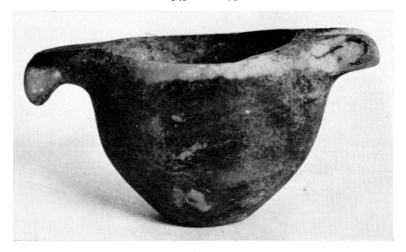

P 544 Ht. 3.05

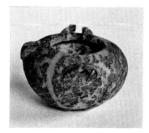

P 545 Ht. 4.35

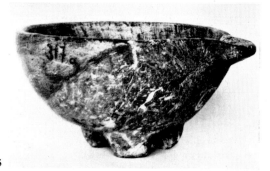

P 547 Ht. 7.05

P 546 Ht. 3.25

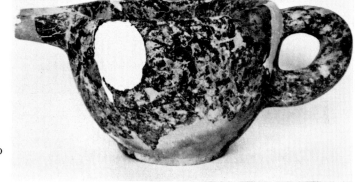

P 548 Ht. 9.0

38. TABLES

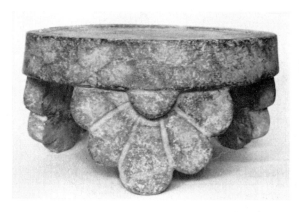

P 549 Ht. 14.9

P 550 Ht. 7.2

39. TALL GOBLETS

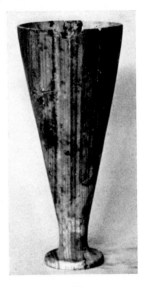

P 551 Ht. 24.0

40. TANKARDS

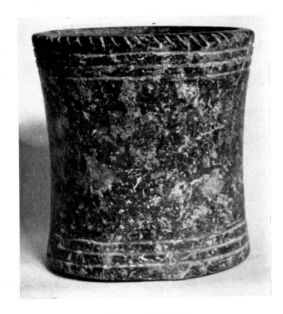

P 552 Ht. 10.6

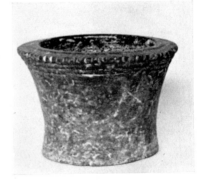

P 553 Ht. 6.5

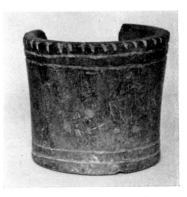

P 554 Ht. 7.65

41. TEAPOTS

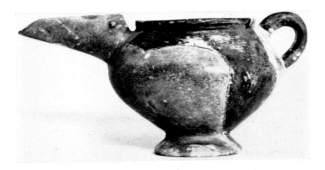

P 555 Ht. 8.05

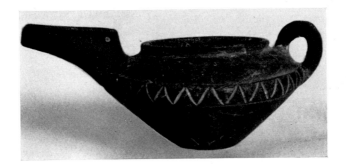

P 556 Ht. 6.9 approx.

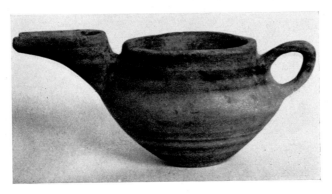

P 557 Ht. 6.5

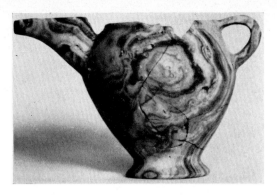

P 558 Ht. 8.65

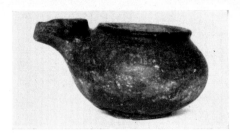

P 559 Ht. 5.45

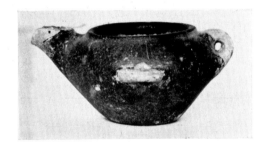

P 560 Ht. 5.5

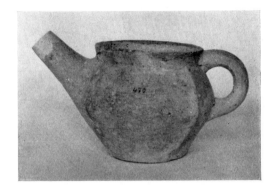

P 561 Ht. 8.3

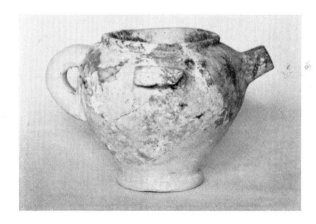

P 562 Ht. 11.6

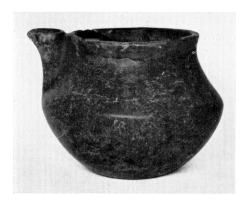

P 563 Ht. 11.85

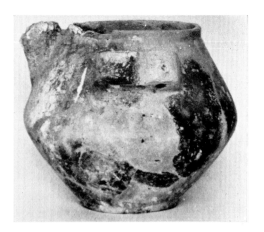

P 564 Ht. 14.6

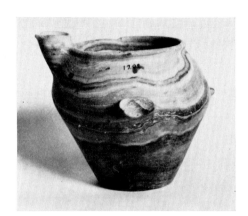

P 565 Ht. 10.75

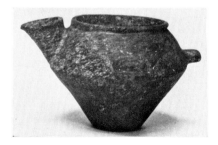

P 566 Ht. 6.8

42. MISCELLANEOUS VASES

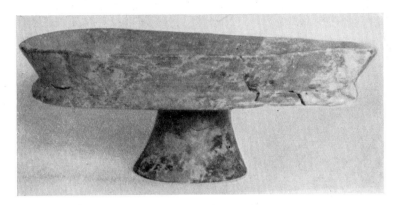

P 567 Ht. 11.8

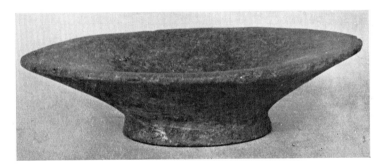

P 568 Ht. 3.95

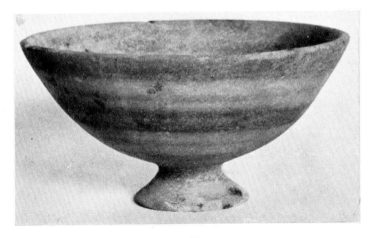

P 569 Ht. 7.3

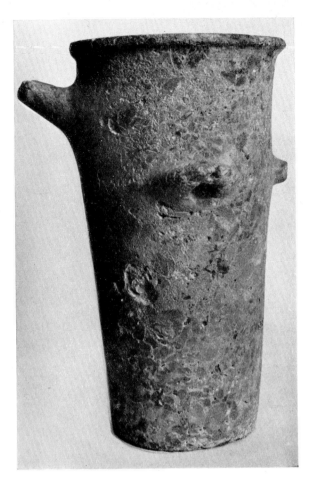

P 572 Ht. 16.55

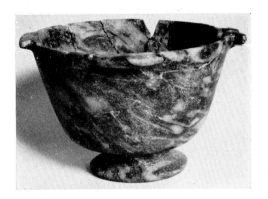

P 570 Ht. 10.2

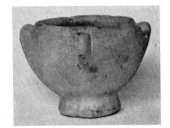

P 571 Ht. 6.25

P 573 Ht. 2.6

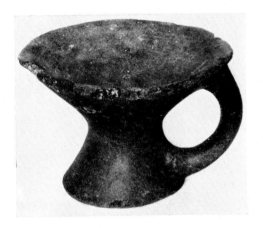

P 574 Ht. 8.9

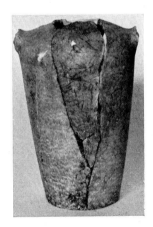

P 575 Ht. pres. 12.7

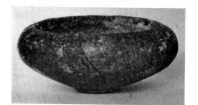

P 576 Ht. 4.98

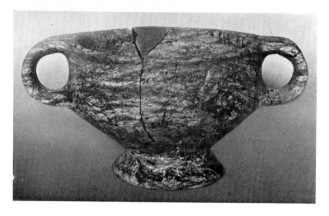

P 577 Ht. 9.0

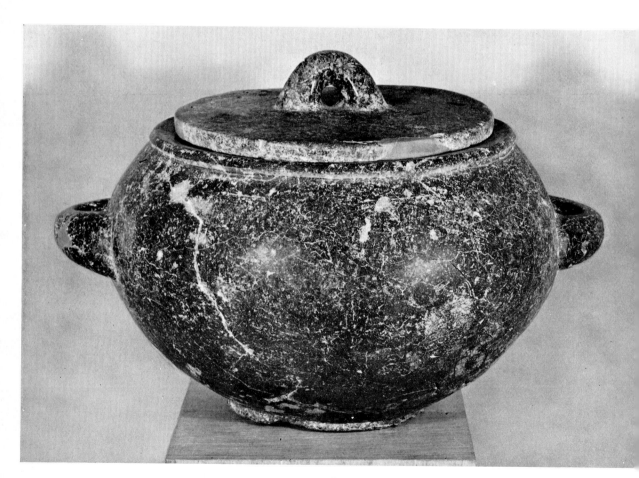

P 578 Ht. 32.0

P 579 Ht. pres. 5.0

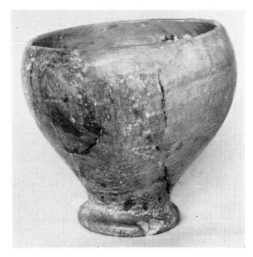

P 580 Ht. 14.3

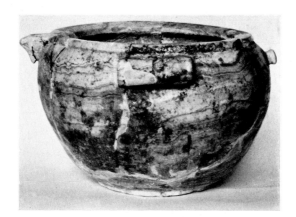

P 581 Ht. 19.9

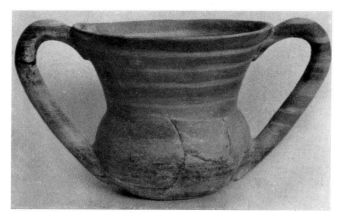

P 582 Ht. 10.95

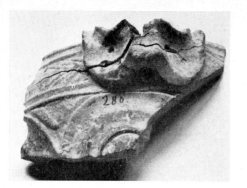

P 583 Ht. pres. 5.75

P 584 Ht. 26.3

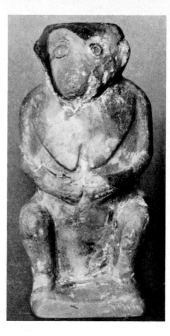

P 587 Ht. 9.3

P 585 Ht. pres. 8.5

P 586 Ht. 4.4

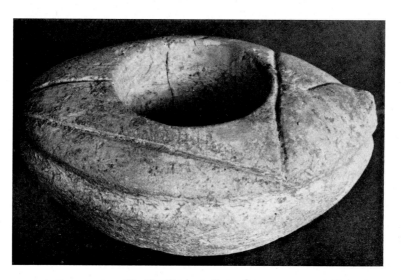

P 588 Ht. 14.4. Length 11.0

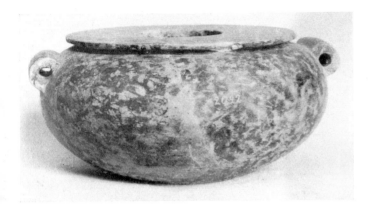

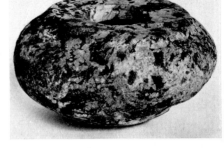

P 590 Ht. 11.2

P 589 Ht. 13.55 approx.

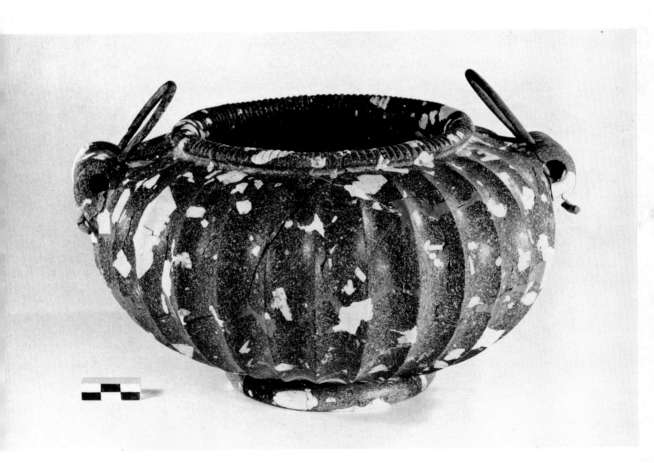

P 591 Ht. 12.0

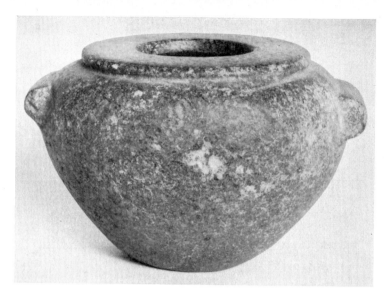

P 592 Ht. 11.55

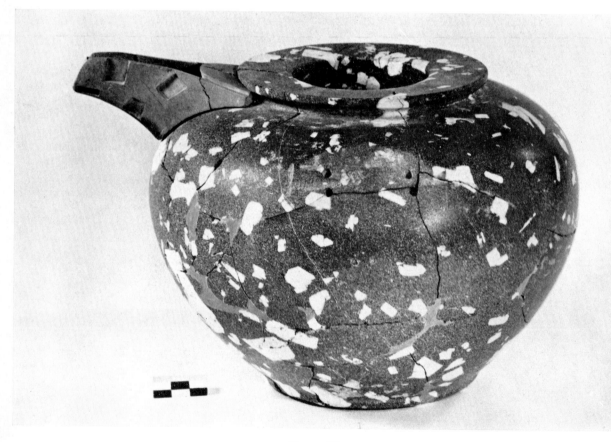

P 593 Ht. 17.25

P 594 Ht. 9.45

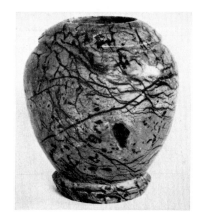

P 595 Ht. 11.3

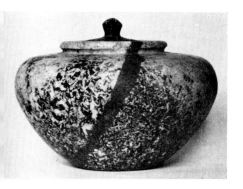

P 596 Ht. 11.5

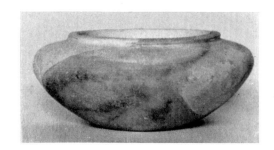

P 597 Ht. 6.7

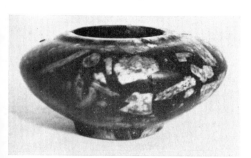

P 598 Ht. 1.7

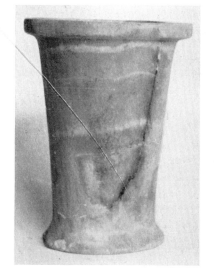

P 600 Ht. 10.08

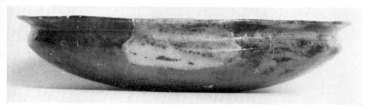

P 599 Ht. 4.3

P 601 Ht. 7.9

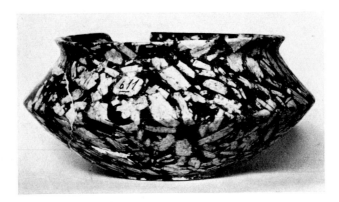

P 602 Ht. 13.4

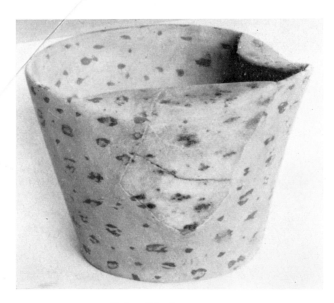

P 603 Ht. 8.1 approx.

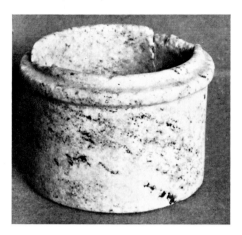

P 604 Ht. 4.25

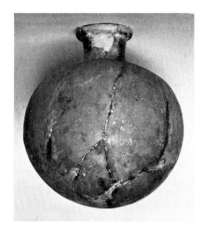

P 605 Ht. 18.0

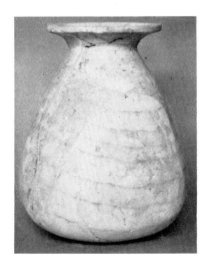

P 606 Ht. 20.2

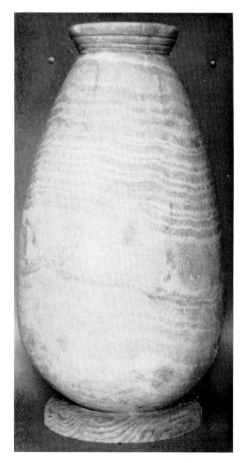

P 607 Ht. 46.0 (on wooden stand)

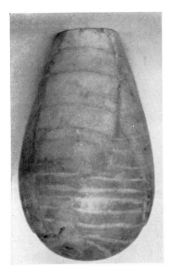

P 608 Ht. 24.2

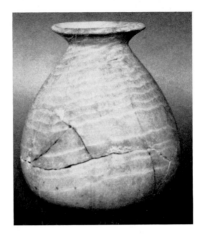

P 609 Ht. 18.85

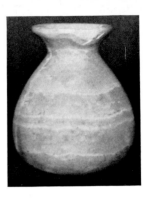

P 610 Ht. 10.15

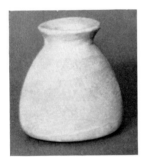

P 611 Ht. 7.4

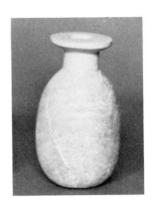

P 613 Ht. 10.1

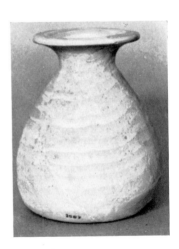

P 614 Ht. 11.1

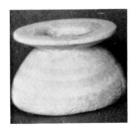

P 612 Ht. 5.2

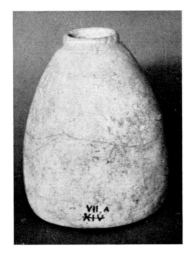

P 615 Ht. 16.25

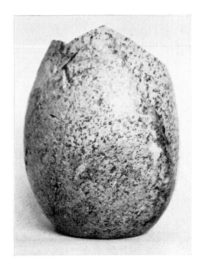

P 616 Ht. pres. 26.1

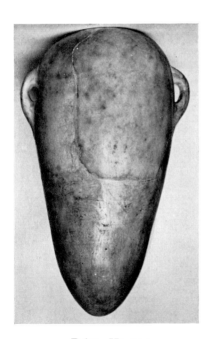

P 617 Ht. 34.2

P 618 Ht. 24.9

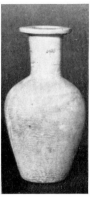

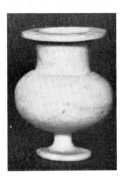

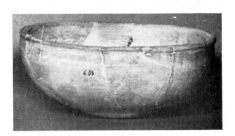

P 621 Ht. 8.4

P 620 Ht. 9.55

P 619 Ht. 11.4

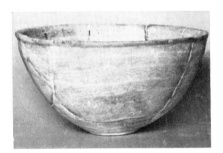

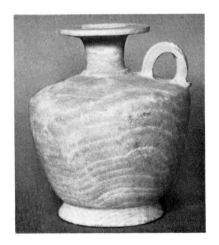

P 622 Ht. 10.28

P 623 Ht. 17.3

44. SYRO-PALESTINIAN FOOTED CUP

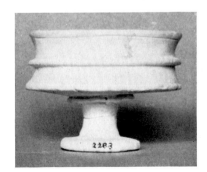

P 624 Ht. 6.0

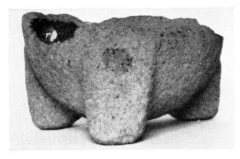

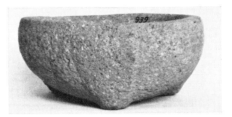

P 626 Ht. 9.9

P 625 Ht. 8.0

P 627 Ht. 9.3. Length 18.0. Width 11.7. Block
of white-spotted obsidian. Mallia Palace.

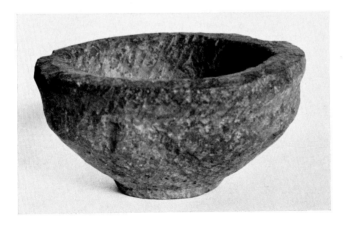

P 628 HM 1172. **Ht. 4.7**

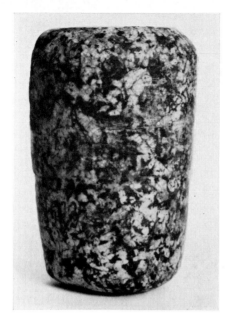

P 629 HM 1593. **Ht. 7.35** P 630 HM 1302. **Ht. 3.9**

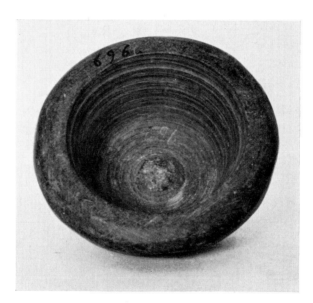

P 631 HM 696. **Ht. 3.1**

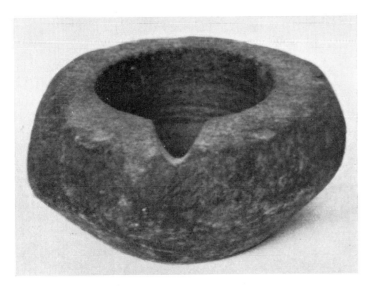

P 632 HM 1875. **Ht. 3.35**

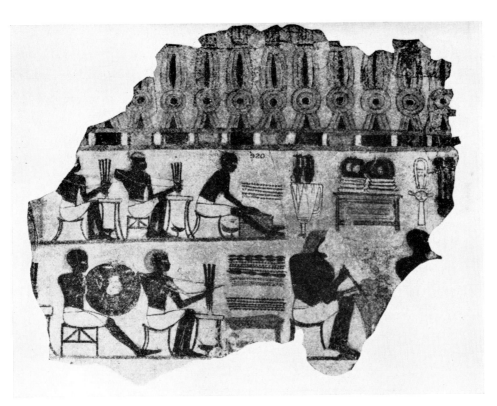

P 633 Workmen using bow drills, split reeds and abrasive
powder. From Thebes, XVIIIth Dynasty. (Budge, *Wall
decorations of Egyptian Tombs* (1914), fig. 8.)

1. ALABASTRONS

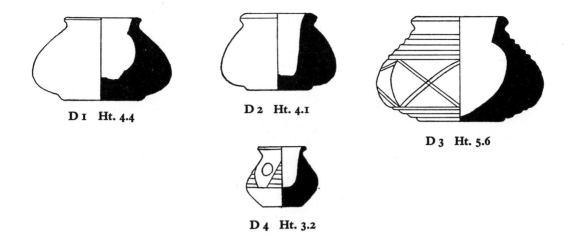

D 1 Ht. 4.4

D 2 Ht. 4.1

D 3 Ht. 5.6

D 4 Ht. 3.2

3. BIRD'S NEST BOWLS

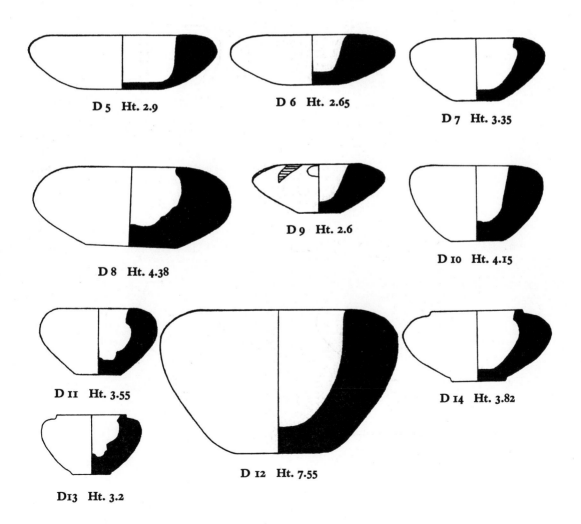

D 5 Ht. 2.9

D 6 Ht. 2.65

D 7 Ht. 3.35

D 8 Ht. 4.38

D 9 Ht. 2.6

D 10 Ht. 4.15

D 11 Ht. 3.55

D 12 Ht. 7.55

D 14 Ht. 3.82

D13 Ht. 3.2

4. BLOCK VASES (KERNOI)

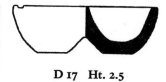

D 16 Ht. 2.25

D 15 Ht. 4.9

D 17 Ht. 2.5

D 18 Ht. 1.15

5. BLOSSOM BOWLS

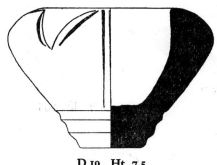
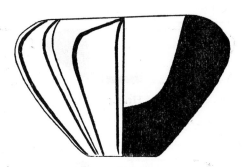

D 19 Ht. 7.5

D 20 Ht. 7.65

6. BOWLS WITH CARINATED OR CURVED PROFILE

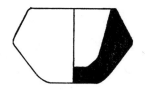

D 21 Ht. 4.0

D 22 Ht. 5.3

D 23
Ht. 1.9

D 24
Ht. 4.35

D 25
Ht. 6.08

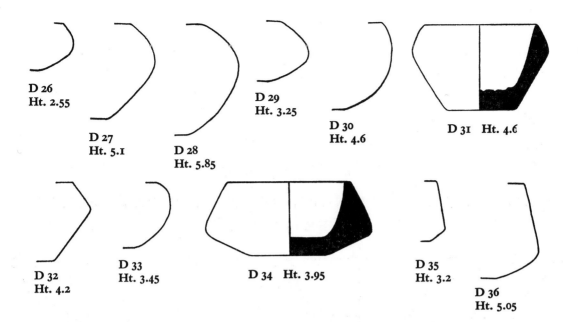

D 26
Ht. 2.55

D 27
Ht. 5.1

D 28
Ht. 5.85

D 29
Ht. 3.25

D 30
Ht. 4.6

D 31 Ht. 4.6

D 32
Ht. 4.2

D 33
Ht. 3.45

D 34 Ht. 3.95

D 35
Ht. 3.2

D 36
Ht. 5.05

7. BOWLS WITH CARINATED OR CURVED PROFILE AND LUGS ON THE SHOULDER

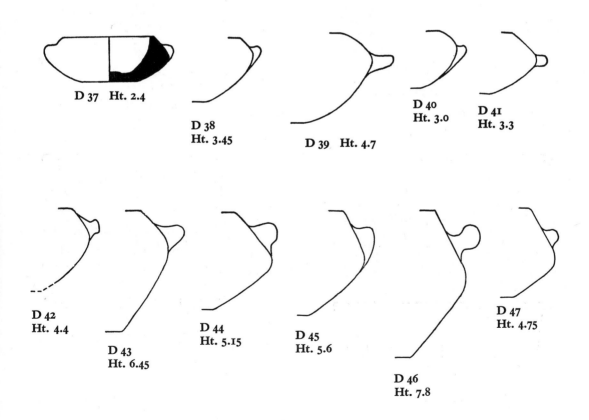

D 37 Ht. 2.4

D 38
Ht. 3.45

D 39 Ht. 4.7

D 40
Ht. 3.0

D 41
Ht. 3.3

D 42
Ht. 4.4

D 43
Ht. 6.45

D 44
Ht. 5.15

D 45
Ht. 5.6

D 46
Ht. 7.8

D 47
Ht. 4.75

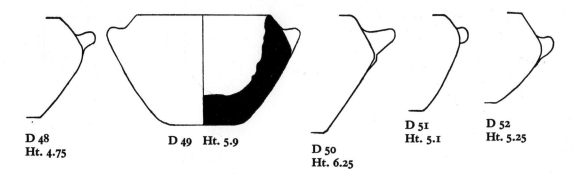

D 48
Ht. 4.75

D 49 Ht. 5.9

D 50
Ht. 6.25

D 51
Ht. 5.1

D 52
Ht. 5.25

8. BOWLS WITH CARINATED OR CURVED PROFILE AND EVERTED RIM

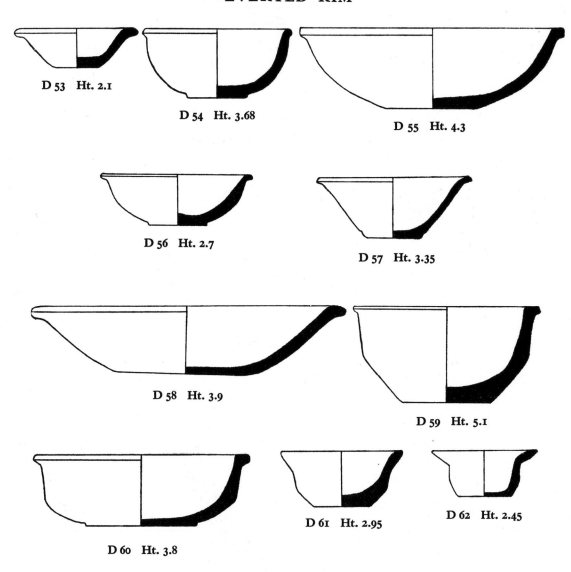

D 53 Ht. 2.1

D 54 Ht. 3.68

D 55 Ht. 4.3

D 56 Ht. 2.7

D 57 Ht. 3.35

D 58 Ht. 3.9

D 59 Ht. 5.1

D 60 Ht. 3.8

D 61 Ht. 2.95

D 62 Ht. 2.45

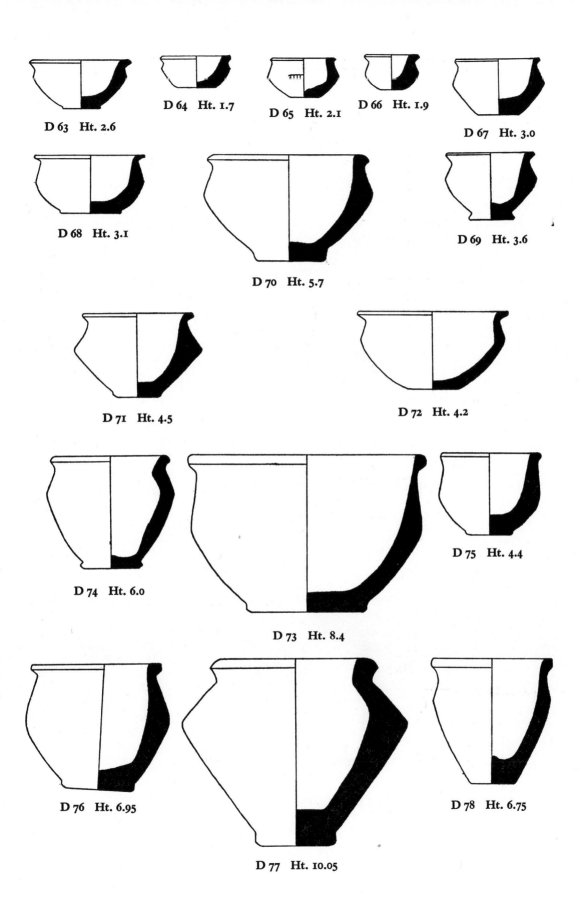

D 63 Ht. 2.6

D 64 Ht. 1.7

D 65 Ht. 2.1

D 66 Ht. 1.9

D 67 Ht. 3.0

D 68 Ht. 3.1

D 70 Ht. 5.7

D 69 Ht. 3.6

D 71 Ht. 4.5

D 72 Ht. 4.2

D 74 Ht. 6.0

D 73 Ht. 8.4

D 75 Ht. 4.4

D 76 Ht. 6.95

D 77 Ht. 10.05

D 78 Ht. 6.75

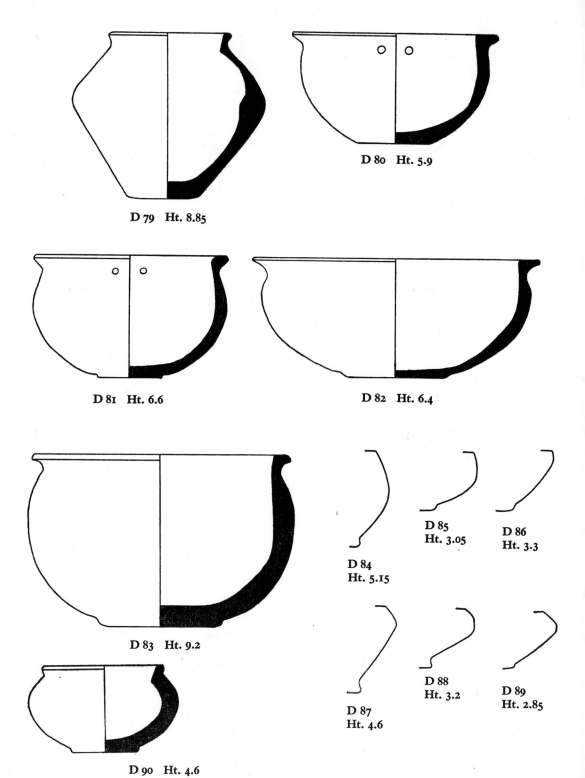

D 79 Ht. 8.85

D 80 Ht. 5.9

D 81 Ht. 6.6

D 82 Ht. 6.4

D 83 Ht. 9.2

D 84
Ht. 5.15

D 85
Ht. 3.05

D 86
Ht. 3.3

D 87
Ht. 4.6

D 88
Ht. 3.2

D 89
Ht. 2.85

D 90 Ht. 4.6

246

D 91 Ht. 3.8

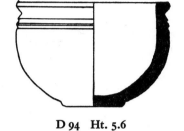

D 92 Ht. 5.6

D 93 Ht. 6.35

D 94 Ht. 5.6

D 95
Ht. pres. 4.35

D 96
Ht. pres. 4.9

D 97 Ht. pres. 5.4

D 98
Ht. pres. 5.3

D 99 Ht. 10.4

9. BOWLS WITH HORIZONTAL GROOVES OR DIAGONAL FLUTING

D 100 Ht. 7.25

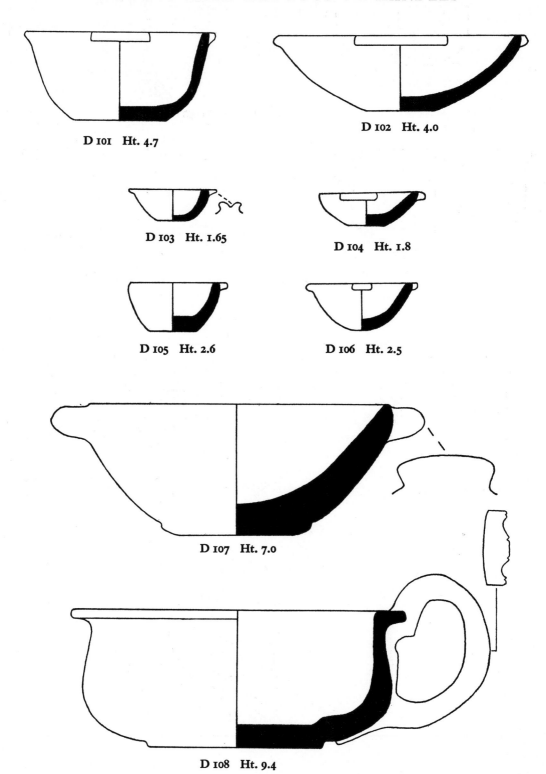

D 101 Ht. 4.7

D 102 Ht. 4.0

D 103 Ht. 1.65

D 104 Ht. 1.8

D 105 Ht. 2.6

D 106 Ht. 2.5

D 107 Ht. 7.0

D 108 Ht. 9.4

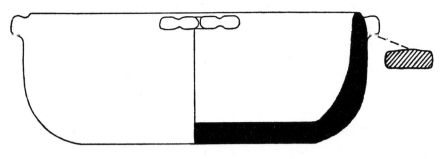

D 109 Ht. 7.0

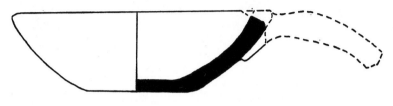

D 110 Ht. 4.4

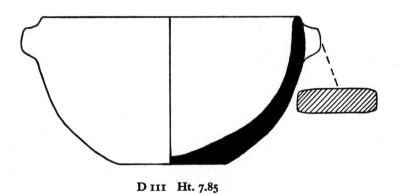

D III Ht. 7.85

12. BOWLS WITH VERTICAL GROOVES

D 113 Ht. 3.1

D 112 Ht. 4.35

13. BRIDGE-SPOUTED BOWLS

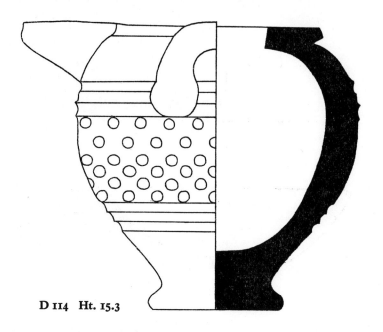

D 114 Ht. 15.3

14. BUCKET-JARS

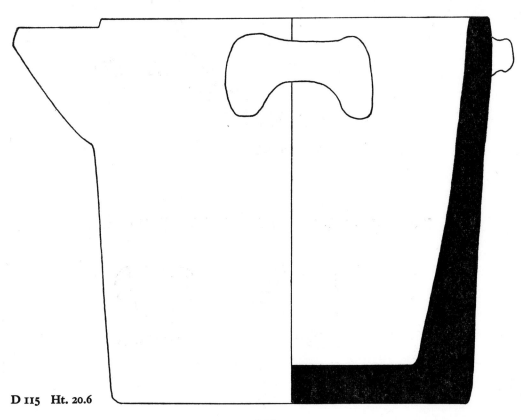

D 115 Ht. 20.6

15. CHALICES

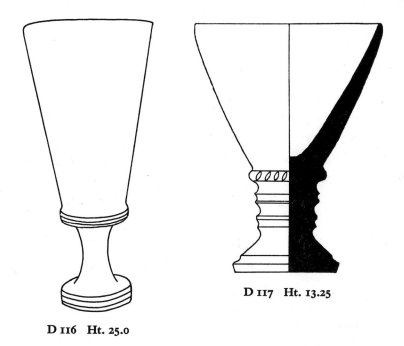

D 116 Ht. 25.0

D 117 Ht. 13.25

16. CONICAL CUPS

D 118 Ht. 3.95

D 119 Ht. 3.6

17. CUPS

D 120 Ht. 1.55

D 121 Ht. 1.8

D 122 Ht. 2.5

D 123 Ht. 2.0

D 124
Ht. 1.15

D 125 Ht. 2.25

D 126 Ht. 1.75

D 127 Ht. 1.5

D 128 Ht. 2.5

D 129 Ht. 2.6

D 130 Ht. 2.3

D 131 Ht. 1.7

D 132 Ht. 2.45

D 133 Ht. 2.7

D 134 Ht. 4.6

D 135 Ht. 4.0

D 136 Ht. 6.2

D 137 Ht. 5.35

D 138 Ht. 4.3

D 139 Ht. 3.05

D 141 Ht. 4.95

D 140 Ht. 3.75

D 142 Ht. 8.7 D 143 Ht. 8.1 D 144 Ht. 7.55

D 145 Ht. 10.3

D 146 Ht. 8.95

D 147 Ht. 8.0

D 148 Ht. 10.3

18. CYLINDRICAL JARS

D 149 Ht. 4.75

20. JARS WITH INCURVED OR FLARING SIDES

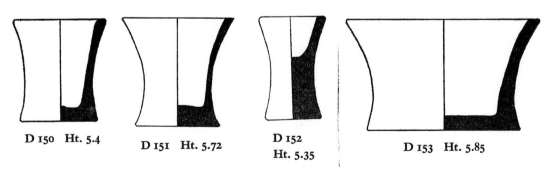

D 150 Ht. 5.4

D 151 Ht. 5.72

D 152
Ht. 5.35

D 153 Ht. 5.85

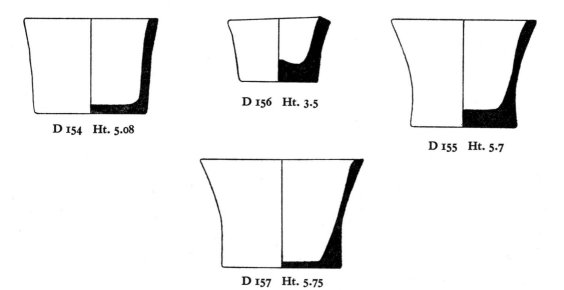

D 154 Ht. 5.08

D 156 Ht. 3.5

D 155 Ht. 5.7

D 157 Ht. 5.75

21. JARS WITH STRAIGHT SLOPING SIDES

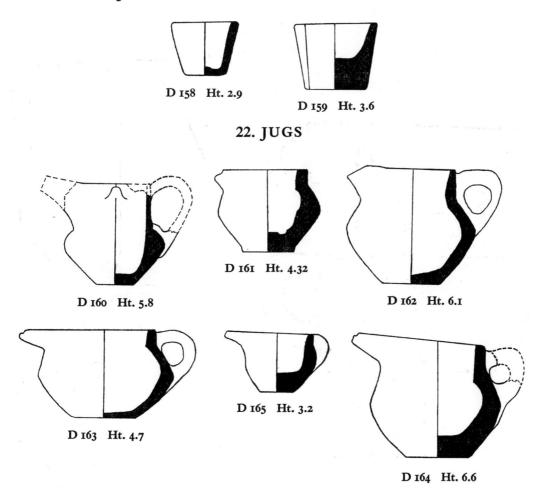

D 158 Ht. 2.9

D 159 Ht. 3.6

22. JUGS

D 160 Ht. 5.8

D 161 Ht. 4.32

D 162 Ht. 6.1

D 163 Ht. 4.7

D 165 Ht. 3.2

D 164 Ht. 6.6

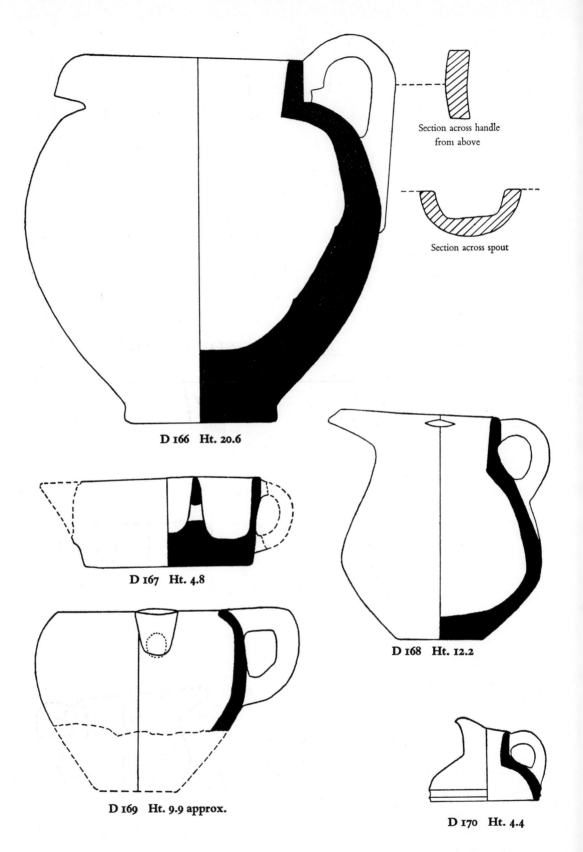

Section across handle from above

Section across spout

D 166 Ht. 20.6

D 167 Ht. 4.8

D 168 Ht. 12.2

D 169 Ht. 9.9 approx.

D 170 Ht. 4.4

23. LADLES

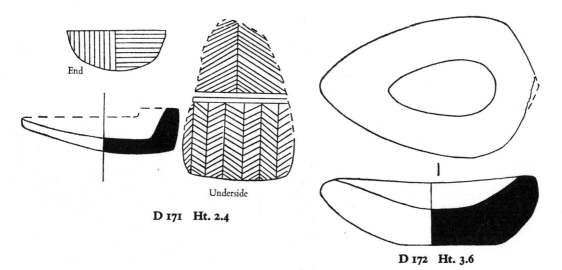

End

Underside

D 171 Ht. 2.4

D 172 Ht. 3.6

24. LAMPS

D 174 Ht. 3.2

D 173 Ht. 7.05

26. LIBATION TABLES

D 175 Ht. 5.5

D 176 Ht. 3.4

D 178 Ht. 5.3

From
Above

D 177 Ht. 8.35

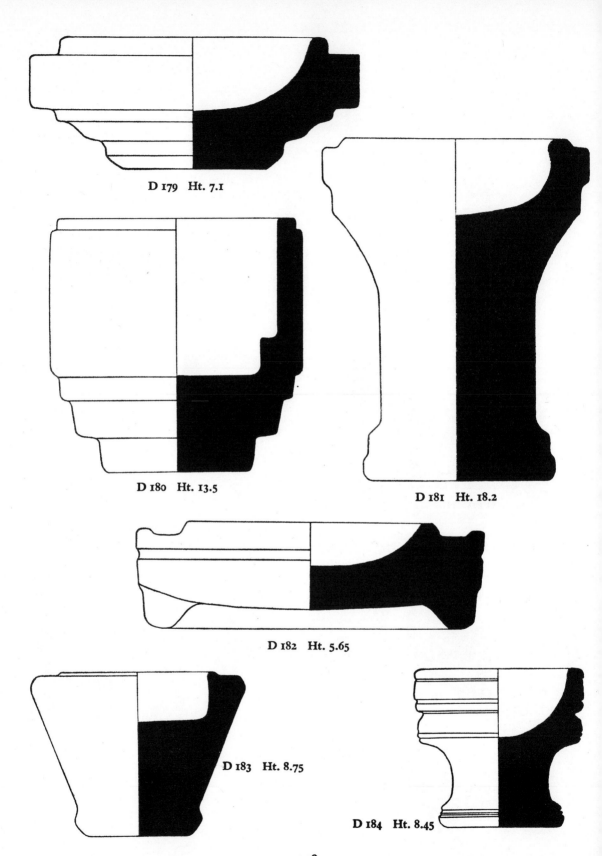

D 179 Ht. 7.1

D 180 Ht. 13.5

D 181 Ht. 18.2

D 182 Ht. 5.65

D 183 Ht. 8.75

D 184 Ht. 8.45

27. LIDS

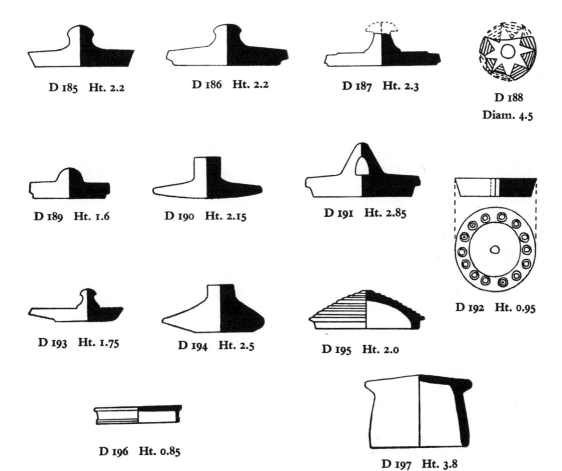

D 185 Ht. 2.2

D 186 Ht. 2.2

D 187 Ht. 2.3

D 188
Diam. 4.5

D 189 Ht. 1.6

D 190 Ht. 2.15

D 191 Ht. 2.85

D 192 Ht. 0.95

D 193 Ht. 1.75

D 194 Ht. 2.5

D 195 Ht. 2.0

D 196 Ht. 0.85

D 197 Ht. 3.8

28. MINIATURE AMPHORAS

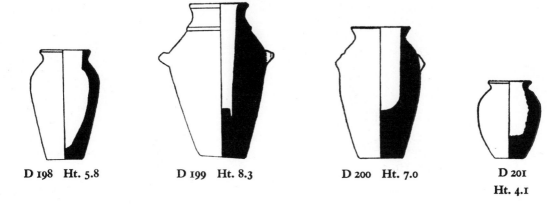

D 198 Ht. 5.8

D 199 Ht. 8.3

D 200 Ht. 7.0

D 201
Ht. 4.1

D 202 Ht. 4.5

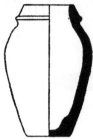

D 203 Ht. 7.0

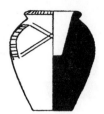

D 204 Ht. 5.3

29. MINIATURE GOBLETS

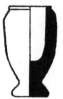

D 205
Ht. 4.8

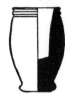

D 206
Ht. 4.45

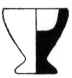

D 207
Ht. 3.45

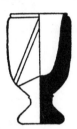

D 209
Ht. 5.85

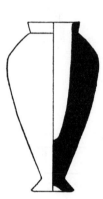

D 208 Ht. 9.0

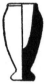

D 210
Ht. 4.05

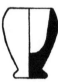

D 211
Ht. 3.7

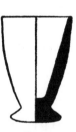

D 212
Ht. 5.6

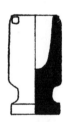

D 213
Ht. 5.25

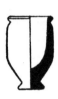

D 214
Ht. 3.9

D 215
Ht. 3.8

D 216 Ht. 5.75

D 217 Ht. 6.85

30. MINOAN IMITATIONS OF EGYPTIAN VASES

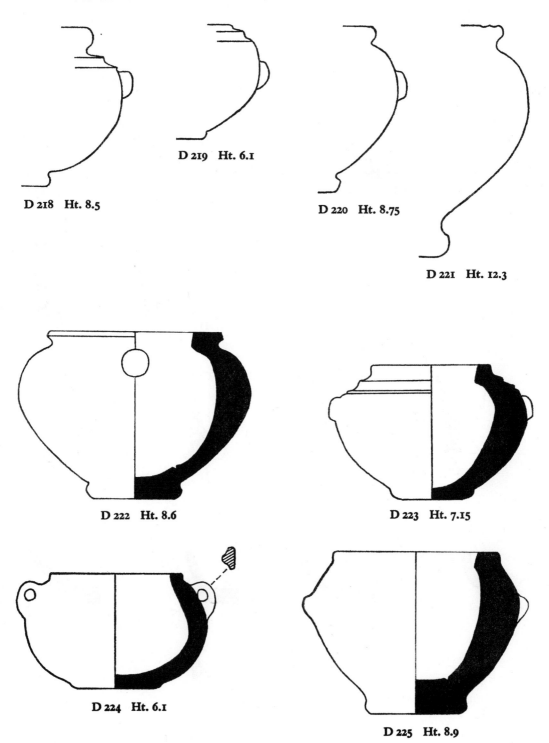

D 218 Ht. 8.5

D 219 Ht. 6.1

D 220 Ht. 8.75

D 221 Ht. 12.3

D 222 Ht. 8.6

D 223 Ht. 7.15

D 224 Ht. 6.1

D 225 Ht. 8.9

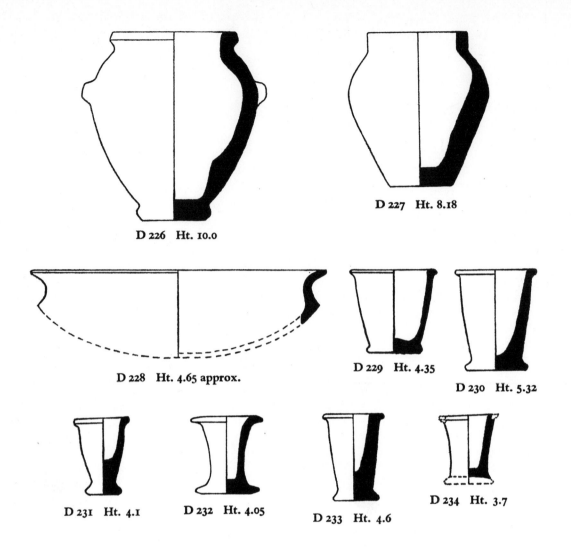

D 226 Ht. 10.0

D 227 Ht. 8.18

D 228 Ht. 4.65 approx.

D 229 Ht. 4.35

D 230 Ht. 5.32

D 231 Ht. 4.1

D 232 Ht. 4.05

D 233 Ht. 4.6

D 234 Ht. 3.7

31. PLAIN BOWLS

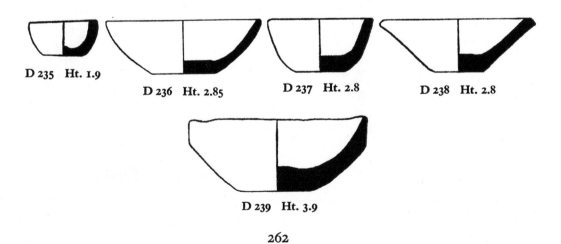

D 235 Ht. 1.9

D 236 Ht. 2.85

D 237 Ht. 2.8

D 238 Ht. 2.8

D 239 Ht. 3.9

32. PLAIN BOWLS WITH MOULDED BASE

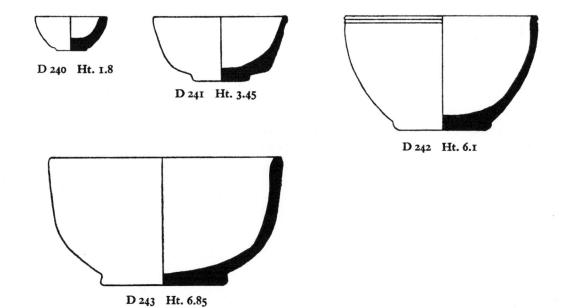

D 240 Ht. 1.8

D 241 Ht. 3.45

D 242 Ht. 6.1

D 243 Ht. 6.85

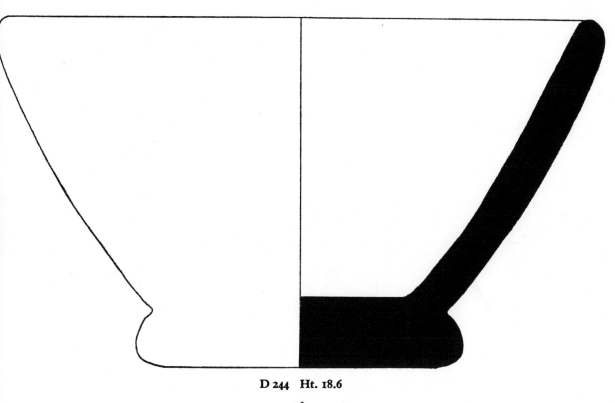

D 244 Ht. 18.6

D 245 Ht. 9.35

33. PYXIDES

D 246 Ht. 11.85

D 247 Ht. 2.25

D 248 Ht. 2.4

D 249 Ht. 4.2

D 250 Ht. 3.0

D 251 Ht. pres. 3.15

D 252 Ht. 3.85

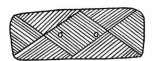

D 253

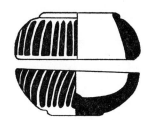

D 254 Ht. 5.0

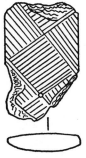

D 255 Ht. 0.75

D 256 Ht. 0.87

D 257 Ht. 1.8

D 258 Ht. 6.25

34. RHYTONS

D 259 Ht. 32.45

36. SMALL POTS

D 260 Ht. 3.45 D 262 Ht. 3.4 D 263 Ht. 3.75 D 264 Ht. 3.8

D 261 Ht. 4.6

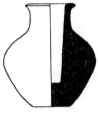 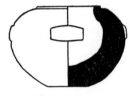 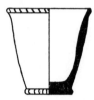

D 266 Ht. 4.3 D 267 Ht. 3.0 D 268 Ht. 4.6

D 265 Ht. 5.5

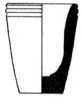 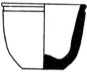 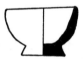

D 271 Ht. 2.7 D 272 Ht. 2.4]

D 270 Ht. 3.5 D 273 Ht. 3.45

D 269 Ht. 4.75

D 275
Ht. 4.5 D 277
Ht. 4.4

D 274
Ht. 6.1 D 276 Ht. 6.45

D 279
Ht. 7.05

D 278 Ht. 3.45

37. SPOUTED BOWLS

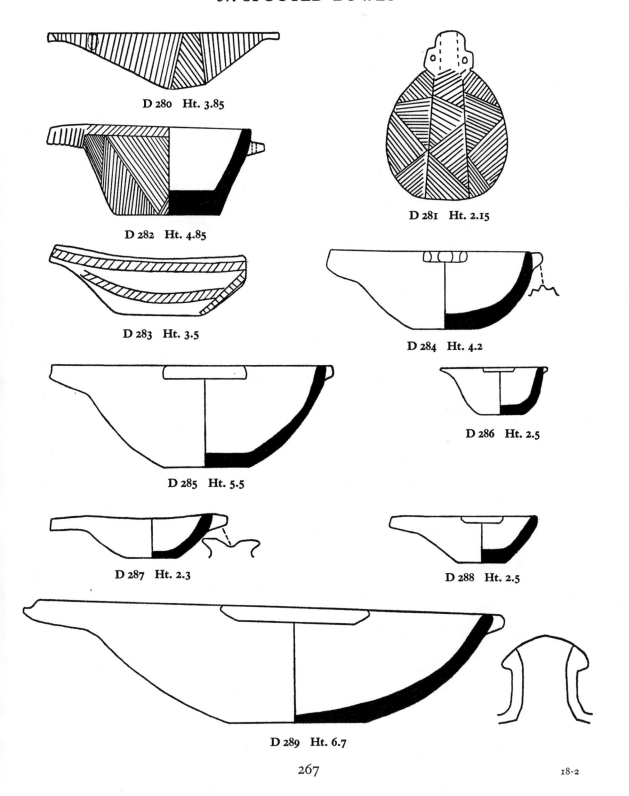

D 280 Ht. 3.85

D 281 Ht. 2.15

D 282 Ht. 4.85

D 283 Ht. 3.5

D 284 Ht. 4.2

D 285 Ht. 5.5

D 286 Ht. 2.5

D 287 Ht. 2.3

D 288 Ht. 2.5

D 289 Ht. 6.7

18-2

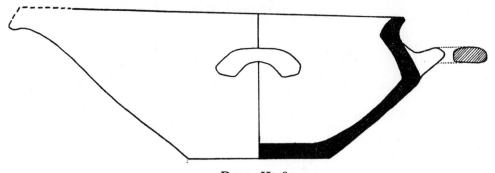

D 290 Ht. 8.1

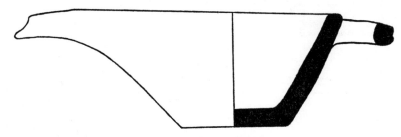

D 291 Ht. 6.5

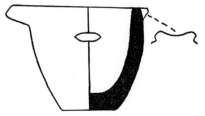

D 292 Ht. 5.7

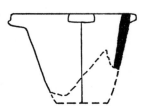

D 293 Ht. 4.75 approx.

D 294 Ht. 4.7

D 295 Ht. 6.95

D 297 Ht. 4.35

D 296 Ht. 3.05

D 298 Ht. 3.25

39. TALL GOBLETS

D 299 Ht. 24.0

40. TANKARDS

D 300 Ht. 10.6

41. TEAPOTS

D 301 Ht. 8.05

D 302 Ht. 6.5

D 303 Ht. 8.65

D 304 Ht. 10.75

42. MISCELLANEOUS VASES

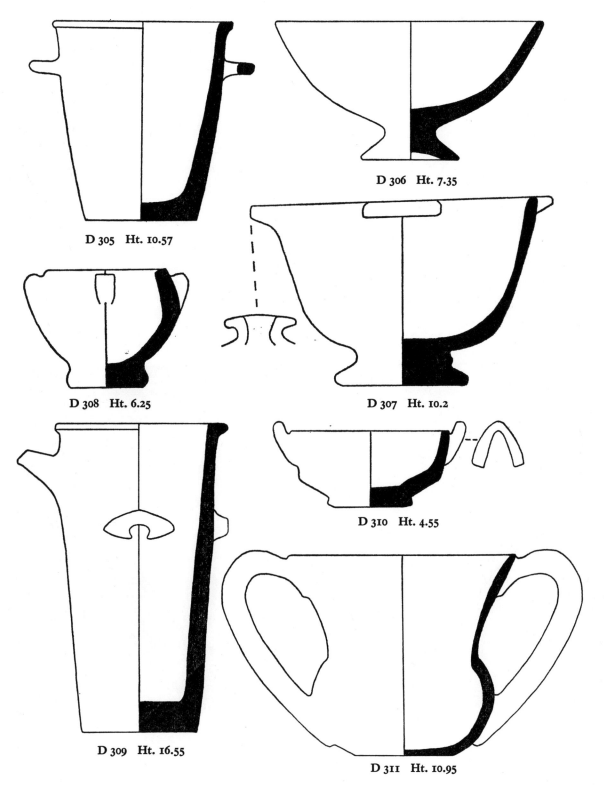

D 305 Ht. 10.57

D 306 Ht. 7.35

D 308 Ht. 6.25

D 307 Ht. 10.2

D 310 Ht. 4.55

D 309 Ht. 16.55

D 311 Ht. 10.95

271

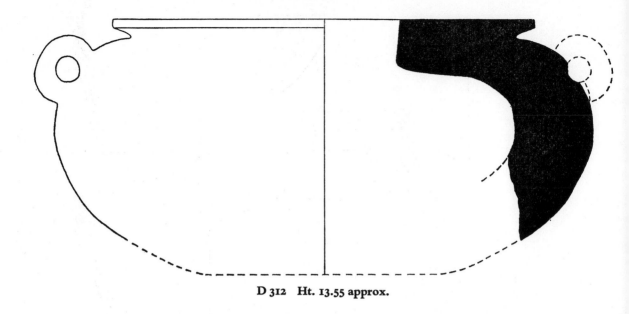

D 312 Ht. 13.55 approx.

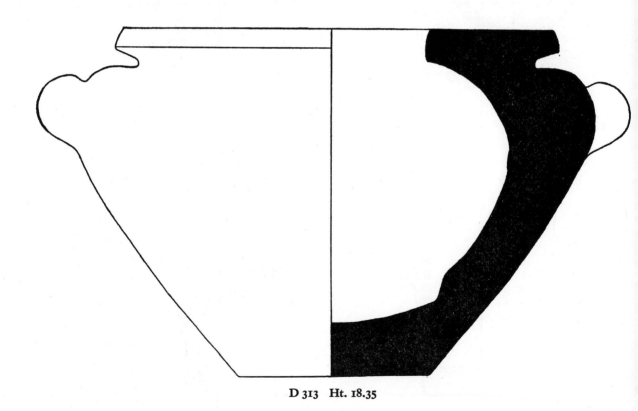

D 313 Ht. 18.35

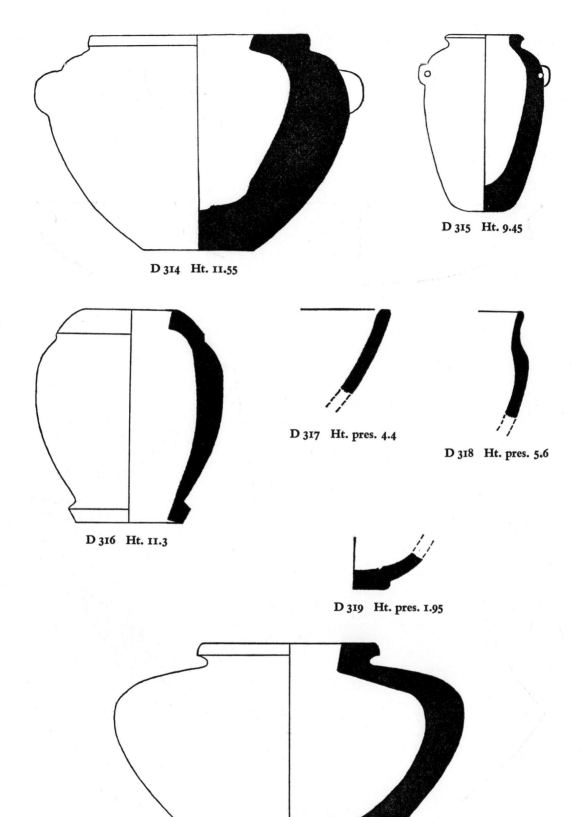

D 314 Ht. 11.55

D 315 Ht. 9.45

D 316 Ht. 11.3

D 317 Ht. pres. 4.4

D 318 Ht. pres. 5.6

D 319 Ht. pres. 1.95

D 320 Ht. 11.5

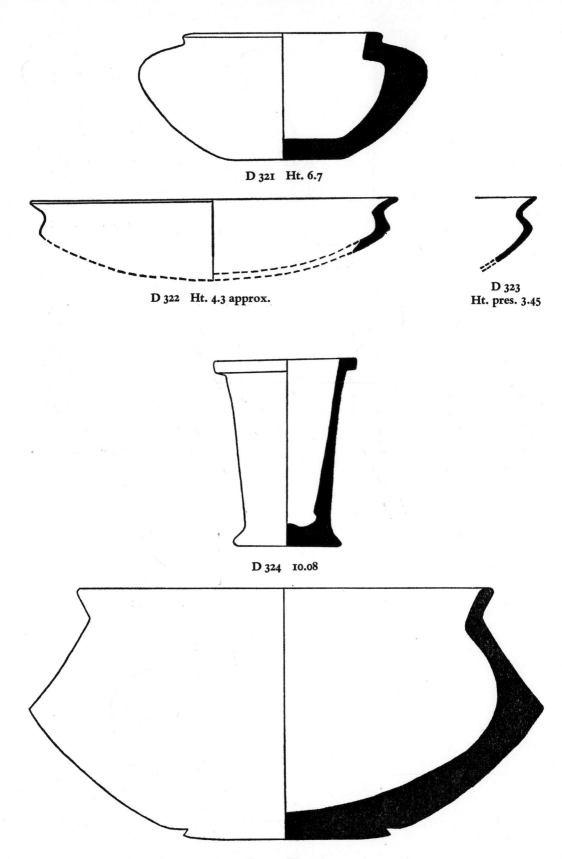

D 321 Ht. 6.7

D 322 Ht. 4.3 approx.

D 323
Ht. pres. 3.45

D 324 10.08

D 325 Ht. 13.4

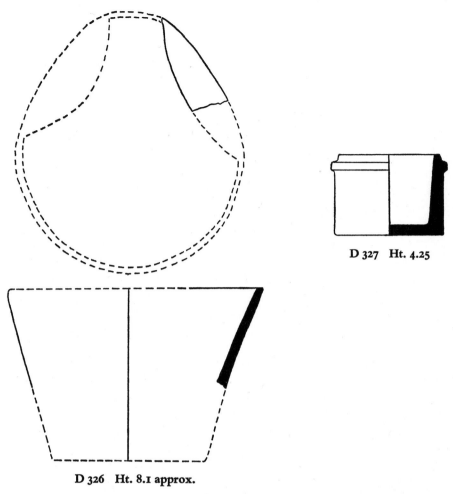

D 327 Ht. 4.25

D 326 Ht. 8.1 approx.

45. SYRO-PALESTINIAN TRIPOD MORTARS

D 328 Ht. 10.1

ADDENDA

1. ALABASTRONS

A. *Zakro* HM. Gabbro. Horizontal grooves. Palace. LM IB. (Platon, *Praktika*, 1966, pl. 129 a.)

3. BIRD'S NEST BOWLS

A. Myron HM. Two bowls. EM–MM I burials. (Ἔργον 1967, 117–18.)
Zakro HM. Chlorite ? Palace. LM IB. (Platon, *Praktika*, 1966, pl. 133 b.)
Dendra Red limestone★. Trench P. 1962. MH–LH I. (Information from Dr P. Åstrom.)
Mycenae Serpentine★. MM I–LM I high shouldered form. LH IIIA. Excavated 1968. (Information from Lord William Taylour.)

4. BLOCK VASES

D. *Lebena* HM unnumbered (Λ II A 23)★. Tomb II A. MM IA level. (Information from Dr St. Alexiou.)
E. *Zakro* HM. Serpentine. Three conjoined cups in trefoil shape. Cf. Galana Kharakia and Palaikastro examples. Palace. LM IB. (Platon, *ibid.*, pl. 134 b left.)

17. CUPS

D. *Zakro* HM. Serpentine. Small spout at right angles to handle. Cf. HM 2144 and HM 2307. Palace. LM IB. (Platon, *ibid.*, pl. 134 b right.)
F. *Zakro* HM. Serpentine ? Vapheio type handle. (*Ibid.* 252.)

24. LAMPS

II A I
Pylos Fragments of two lamps. Serpentine ? Palace. LH IIIB. (Blegen & Rawson, *The Palace of Nestor at Pylos*, I, 71 and fig. 269 nos. 8–9.)

II A 2
Pylos Ht. 14.5. White marble-like limestone. Palace. LH IIIB. (*Ibid.* 242–3 and figs. 190, 271 (1 a, 1 b), 272 (1–2).)

II A 3
Zakro HM. Antico rosso ? Palace. LM IB. (Platon, *op. cit.* pl. 134 a.)
Pylos NM 7809. Fragment. Palace. LH IIIB. (Blegen & Rawson, *op. cit.* 59 and fig. 269 no. 12.)

II B
Herakleion HM. Serpentine. Athanatoi. N.F.C. but from area of LM III tombs. (Ἔργον, 1967, 123–4 and fig. 126.)

II B or C
Pylos Base fragment. Veined purplish red stone. Palace. LH IIIB. (Blegen & Rawson, *op. cit.* 64 and fig. 271 no. 5.)

26. LIBATION TABLES

7 B *Zakro* HM. Soft white limestone. Horizontal mouldings round pedestal. Two pendent handles. Palace. LM IB. (Platon, *op. cit.* pl. 144 *a*.)

33. PYXIDES

C. *Zakro* HM. Breccia ? (black stone with red veins). Cylindrical; incised circles; disk-shaped lid with flange fitting body of vase. Palace. LM IB. (*Ibid.* 152.)

35. SHELL VASES

Zakro HM. Chlorite ? Palace. LM IB. (*Ibid.* 151 and pl. 132 *a*.)

42. MISCELLANEOUS VASES

Zakro HM. Serpentine ? Cylindrical vase with three horizontal bands of flutings and raised ribs, below rim, at centre, and above everted base. Palace. LM IB. (*Ibid.* 147 and pl. 129 *b*.)

43. EGYPTIAN VASES?

Pylos Fragment. Porphyritic rock, which is probably Egyptian. Shape not known but possibly bowl like type 43 **A 8–9**, with hole for separate spout. (Blegen & Rawson, *op. cit.* 65, 71 and figs. 268 bottom right, 269 no. 11.)

At A. Kyrillos south of the Mesara J. Sakellarakis has excavated a plundered circular tomb. There were fifty-one stone vases of Mesara types (Ἔργον, 1967, 116–17). Other stone vases have been found in the Zakro Palace (Platon, *Praktika*, 1966, 147; Ἔργον, 1967, 108, 111) and nearby at Pezoules Kephalas, MM I burial enclosures (Ἔργον, 1967, 113–15; *Praktika*, 1967, 190–4 and pls. 170 *b*, 173 *b*).

3 December 1968

INDEX

For stone vase sites, see chapter II (with table 5, pp. 117–23) and Appendices A and B (pp. 192–7). For stone vase types, see chapter II. For materials, see chapter III and tables 6–8 (pp. 143–56)

Hope Simpson, R., 126, 133
Hughes-Brock, H., 134
Hutchinson, R. W, 89 n. 1, 124

inlay decoration, 5, 12, 33–4, 63, 89, 96

Jericho, 113

Kakon Oros, Herakleion, 127–8, 134
Karanovo, 2
Karo, G., 104
Katsamba ivory pyxis, 174, 177
Keftiu, 22
Kenna, V. E. G., 133
Khalikiopoulos, L., 124
Khania, 183, *see also* Late Minoan III
Knossos, 1–2, 6, 107, 132, 142, 157–60, 174–9, 183, 186–7, 191

Late Minoan III (post-Palatial), stone vases in LM III contexts, 11, 70–1, 78, 80, 132, 190–1
Late Neolithic, Knossos, stone vases, 106, 109 n. 1
Lebena, 1, 93
Lerna, 2
Linear A and other inscriptions on stone vases, 34, 37, 42, 49, 62–5, 67, 70, 101, 167

Mallia, 100, 124, 157, 161, 183, 186–7
Marinatos, S., 81, 137
Marine Style, LM I B, 56, 84, 88, 175, 187
Martin, G., 111 n. 1
Megiddo, 113
metal, imitations in stone, 30, 36, 38–9, 57, 85, 89, 102, 168–9, 172
Mochlos, 135, 157, 183
Money-Coutts, M., 82 n. 1
Mycenae
 bridge-spouted bowls, gabbro, 33–4, 184–5
 Egyptian vases, 107–8, 114–15
 Octopus rhyton, 174–6
 prehistoric cemetery, 47, 184
 Rhyton Well, 86, 90, 133
 silver siege rhyton, 55, 172, 177
Mycenaean influence at Knossos, 5–6, 158–9, 187

Myrtos, EM II houses, 158

Nockolds, S. R., 138 n. 2

Palaikastro, 177, 186–7, 191
Papastamatiou, J., 116 n. 1, 124, 131, 138 n. 2
Pareyn, C., 124
Perati, 104
Persson, A. W., 49 n. 1
Phaistos, 1–2, 163, 182–3, 187
Pseira, 186

Quibell, J. E., 162

Raulin, V., 124
red paint on stone vases, 54, 59, 63, 163
relief decoration on stone vases, 25, 71, 77, 84–90, 102, 162, 174–81
Renfrew, C., 134

Sarakina valley, Crete, 130, 138, 140
Seager, R. B., 59 n. 1, 157 n. 1
Senmut, Tomb of, 22
Smith, H. S., 108 n. 1
Smith, W. S., 106 n. 1
Spratt, Admiral T. A. B., 124, 139
stone vases, Minoan
 earliest group (EM II A), 48–9, 80–3, 93–4, 130, 142, 161, 171–2, 182–3
 exports, 51–2, 184–5, 187–90
 hardness, 143
 origins, 93, 182 n. 2
 unfinished vases, 80, 157, 161
 usage and purpose, 28 (PK/63/156*), 62, 166–7, 175–6, 183–4, 188–90
stones, imitated in painted decoration, 172–3

Taramelli, A., 1
Tiryns
 gold ring, 36, 47, 167
 stone pyxis, 81
tools, 158, 161–4
Troy, 2

Vapheio gold cups, 174